Women
Artists
in Expressionism

Shulamith Behr

Women
Artists
in Expressionism

From Empire to Emancipation

Princeton University Press
Princeton and Oxford

Published by Princeton University Press, 41 William Street, Princeton, New Jersey 08540

In the United Kingdom: Princeton University Press, 99 Banbury Road, Oxford OX2 6JX

press.princeton.edu

Front cover: Detail of Gabriele Münter, *Portrait of Anna Roslund*, 1917, oil on canvas, 94 × 68 cm, New Walk Museum, Leicester. DACS, London © DACS 2021.

Illustrations in front matter: p. ii, detail of fig. 154; p. x, detail of fig. 131; p. xi, detail of fig. 131

Illustrations in chapter openers: p. xii, detail of fig. 8; p. 28, detail of fig. 17; p. 54, detail of fig. 39; p. 84, detail of fig. 95; p. 124, detail of fig. 116; p. 154, detail of fig. 152; p. 188, detail of fig. 195

All Rights Reserved

ISBN 978-0-691-04462-0

ISBN (e-book) 978-0-691-24096-1

British Library Cataloging-in-Publication Data is available

The Trustees of the Marie-Louise von Motesiczky Charitable Trust and the AKO Foundation made generous donations toward the images and permissions expenses. Publication of this book has also been aided by a grant from the Millard Meiss Publication Fund of CAA.

Designed by Jeff Wincapaw

This book has been composed in Adobe Jensen

Printed on acid-free paper. ∞

Printed in Italy

10 9 8 7 6 5 4 3 2 1

In memory of Hilda and Teddy

Contents

Preface

This book has evolved against a background of an academic career that is dedicated to the field of German modernism. Arising from specialist interests in cultural identity, politics, and gender, *Women Artists in Expressionism* charts a selection of protagonists within the theme—from empire to emancipation—and investigates their divergent responses to the dramatic historical events and structural transformations during the early twentieth century. It reveals their efforts, with greater or relative success, to negotiate the competitive market economy of the late Wilhelmine Empire and uncertainties of the early Weimar Republic. The chronology embraces the period from around 1890 until 1924 and, while the study is context-bound, considerations of the so-called end of Expressionism, its defamation during the 1930s, and its afterlife in exile are vital to its narration.

The sequence of chapters explores the richness of women's engagement in, and the shaping of, Expressionism: the posthumous critical reception of Paula Modersohn-Becker as a prime agent of the feminization of the movement, Käthe Kollwitz's interaction with the Expressionist milieu and the forging of a career in the graphic medium as a vehicle for both technical innovation and sociopolitical commentary, and the dynamic relationship between Marianne Werefkin and Gabriele Münter, especially their different national and cultural origins and paths toward Expressionism in the Blaue Reiter. Further chapters examine the role of Herwarth and Nell Walden's dealership in promoting women Expressionists during the First World War, particularly in the neutral countries, focusing on Münter's encounter with Sigrid Hjertén in Stockholm. Transcultural and transnational considerations underlie Swedish-born Nell Walden's emergence as an artist in her own right, as well as Dutch-born abstractionist Jacoba van Heemskerck, who was regarded as an honorary German Expressionist. An epilogue argues that exiled women artists, such as Marie-Louise von Motesiczky, were able to draw on the feminized legacy of Expressionism as a vehicle of creative resistance and survival.

The chapters are underpinned by the writings of the contemporary social theorist Lu Märten who, in her treatise *Die Künstlerin* (1914), emphasized the necessity to socialize women's experience of modernity. Her sociological concept of the "woman artist" as "worker" is indispensable to arguments linking sexual politics and notions of futurity to women's involvement in avant-gardism. Interrogation of women's roles as patrons, collectors, and dealers (with a regional emphasis on the art historian Rosa Schapire in Hamburg and the dealer Johanna Ey in Düsseldorf) underscores their extended public sphere. In examining early twentieth-century support of modern art in Germany, Jürgen Habermas's liberal model of a "democratic public sphere" serves as a meaningful framework, albeit in light of feminist critical intervention in the field. An introductory chapter lays out these methodologies, the thrust of the study uncovering the importance of women's emancipative ideals, wittingly or unwittingly, to the development of Expressionist avant-garde culture.

Abbreviations and Archives

FMW: Fondazione Marianne Werefkin (Archive), Museo Comunale d'Arte, Ascona

GMJES: Gabriele Münter- und Johannes Eichner-Stiftung, Städtische Galerie und Kunstbau im Lenbachhaus, Munich

KN: Alexandra von dem Knesebeck, ed., *Käthe Kollwitz: Werkverzeichnis der Graphik*, 2 vols. (Bern: Kornfeld, 2002)

NKVM: Neue Künstlervereinigung München (Munich New Artists' Association)

NT: Otto Nagel and Werner Tim, eds., *Käthe Kollwitz: Die Handzeichnungen* (Stuttgart: Kohlhammer, 1980)

SBPK: Handschriftenabteilung, Staatsbibliothek Preußischer Kulturbesitz, Berlin

WIA: Warburg Institute, London

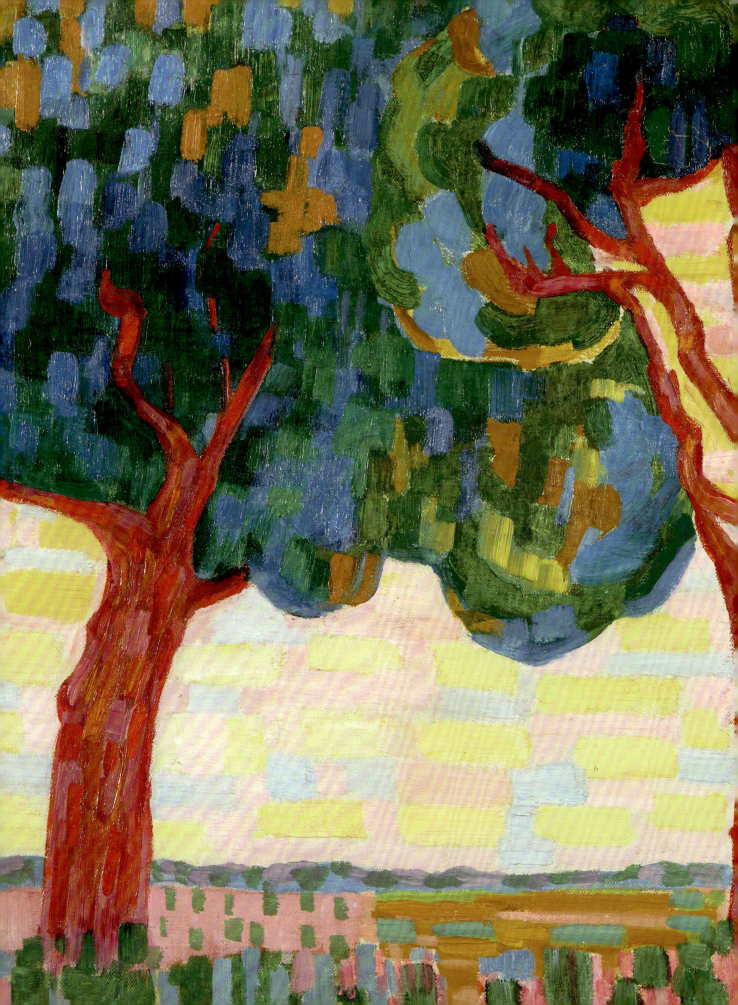

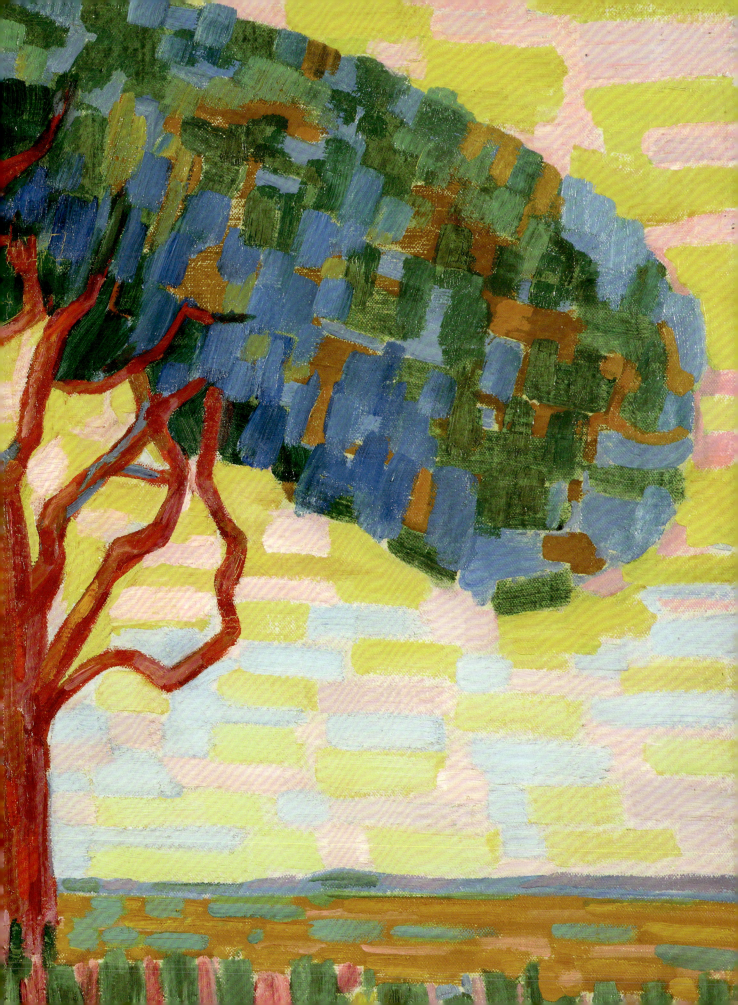

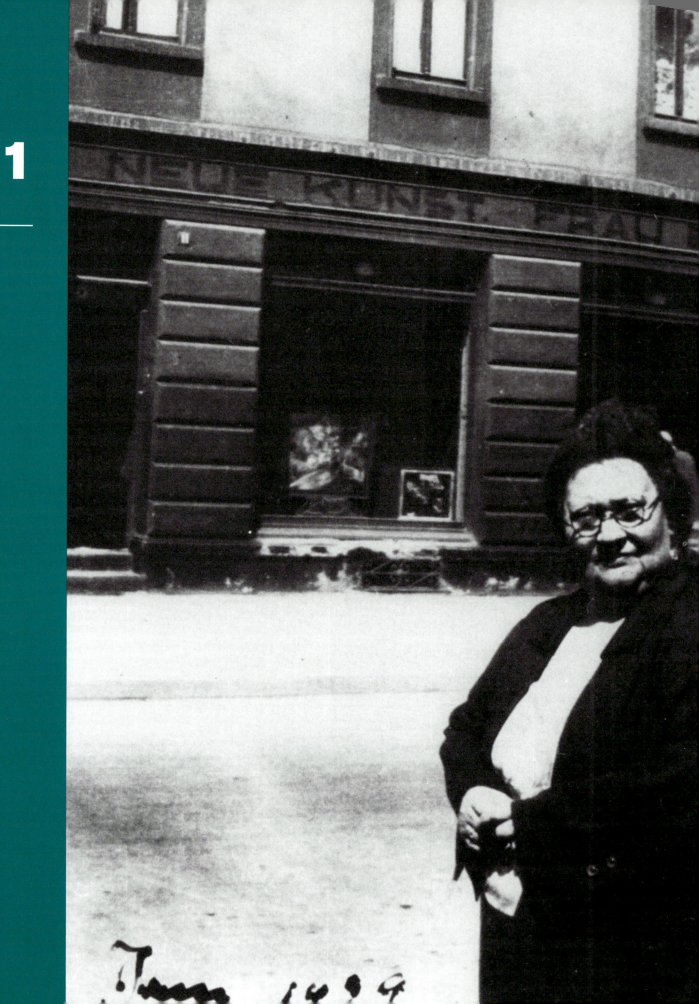

WOMEN ARTISTS, EXPRESSIONIST AVANT-GARDE CULTURE, AND THE PUBLIC SPHERE

> Paula Modersohn is thus a woman Expressionist. She was the earliest Expressionist of modern painting in the German field.

> Paula Modersohn-Becker is venerated . . . as the crown princess of Expressionism, she stands there as the prophetess (of Worpswede) . . . It is a painful duty to confirm the opposite, that for us the talent of this woman painter appears more trivial than deep.

Seven years separate the two epigraphs cited above. The author of the first was the critic Anton Lindner, who reviewed a posthumous exhibition of Modersohn-Becker's works in 1914 for a daily newspaper, the *Neue Hamburger Zeitung*.[1] The second dates from 1921 and was written by the well-known art historian and critic Karl Scheffler. Here he was reviewing a recently published monograph on the artist for the widely circulated specialist journal *Kunst und Künstler*.[2] While both authors testify to the consensus that Modersohn-Becker was *the* preeminent Expressionist painter, an initiator of a movement, which by 1914 permeated German metropolitan culture at many levels, Scheffler nonetheless found her talent highly overrated. Notorious for his hostility toward the very notion of a woman artist, particularly as argued in his publication *Die Frau und die Kunst* (1908), Scheffler was clearly baffled by the phenomenon of Modersohn-Becker. In 1909, after attending the memorial exhibition of her works that traveled from Bremen to Berlin, he criticized her paintings as mere experiment. Yet he acknowledged that they evinced "a sincere struggle for truth and pure feeling for nature" and that she brought "an intensity of an almost mystical kind to expression."[3]

However, my purpose in introducing these reviews at this juncture is neither to emphasize the ambivalent reception of the artist after her untimely death in 1907, nor to underscore prejudiced societal attitudes toward women practitioners, but rather to highlight the fact that cultural identity in Expressionist art and its critical discourses was not exclusively gendered male. To be sure, Scheffler's comments unwittingly attest to the intriguing specter of the feminization of the movement: Modersohn-Becker as the "crown princess of Expressionism." Why then, we are led to inquire, have narratives of Expressionism so rarely observed women artists' participation? Whereas it was mainly in the last thirty years of the twentieth century that feminist intervention substantially altered the course of cross-disciplinary scholarship, the answers to the question as to why women artists disappeared from the text after 1933,

1 Anonymous, *Confiscated Works of Paula Modersohn-Becker and Franz Marc in the Depot Niederschönhausen*, Berlin, October 1938, photograph, Stiftung Preußische Kulturbesitz, Berlin

only to reappear at the end of the twentieth century, are complex. They encompass the fields of history, sexual and cultural politics, and the historiography of art history. Certainly, a major factor for the exclusion of women artists from accounts of early twentieth-century German modernism arises from the impact of the Third Reich between 1933 and 1945. At a time when they could have been enjoying the conjunction of their emancipation (achieved in 1919) with the benefits of a pluralistic art market, women modernists' careers were blighted.

Indeed, the art historian Ingrid von der Dollen has recovered the careers of more than four hundred women artists who were active during the Weimar period (1919–33).[4] She introduces the text by a methodological inquiry into the *doppelte Verschollenheit* (double absence) of women "expressive realists" who, if they didn't perish during the Third Reich, were marginalized and ignored in the postwar years by discriminatory cultural practices and the promotion of modernist abstraction in West Germany. While the label "expressive realists" is problematic given the

eclecticism of the modern period, the generational model serves as a unifying element.[5] Born between 1890 and 1910, this so-called *verschollene Generation* (lost or forgotten generation) suffered an ignominious fate.[6] Yet this was inevitably the case, too, for the generation of women Expressionists born in the late 1860s, 1870s, and 1880s.

In the tragic case of Olga Oppenheimer, who was born in 1886, her precarious mental health and Jewish identity led to her deportation and murder in Poland in 1941.[7] Her oeuvre, curtailed as it was through illness, was lost and dispersed, and only a few works remained in the hands of family members. Never as favorably courted as their male colleagues in the institutional endorsement of modernism during the 1920s, women Expressionists' works were nonetheless associated with "degenerate art" and confiscated in the Nazi purge of public collections. Not only was Modersohn-Becker represented in the infamous *Entartete Kunst* (Degenerate Art) exhibition in Munich in 1937, but her works were also seized from the Kunsthalle in Bremen and Hamburg, the Folkwang Museum in

Essen, the Kestner Museum in Hanover, and the Von der Heydt Museum, formerly the Städtische Bildergalerie, in Wuppertal-Elberfeld.[8] Alongside those of Franz Marc, one can view a selection of her paintings in a photograph of the Depot in Schloß Niederschönhausen, Berlin (fig. 1), which was used for storing confiscated works in order to elicit foreign currency from potential buyers.[9]

On a methodological level, while one has to be wary of interpreting the historical trajectory from empire to Holocaust as "inevitable," its legacies are ever present in tracing the cultural production of the early twentieth century.[10] In addition, since they were predominantly held in private or family collections, women artists' oeuvres and journals were destroyed or fragmented during Allied bombing.[11] Whether they retreated into so-called inner emigration or managed to eke out a living in exile, few women artists were recuperated in the immediate postwar period. Since the 1950s, art historians took as their yardstick a rather selective reading of the critical framework that both originated and defined the term "Expressionism," one that harbored the paradigm of male artistic genius. This they could find in the first documentary history of the movement, *Der Expressionismus*, published in 1914, in which the art critic and newspaper *feuilletonist* Paul Fechter (1880–1958) established parentage for the movement in the Norwegian artist Edvard Munch and progeny in the works of Brücke artists (mainly Max Pechstein), the Blaue Reiter, and individuals such as Oskar Kokoschka and Ernst Barlach.[12] The overarching narrative has not changed substantially, with the exception of new evidence and emphasis on other regional manifestations of the movement, activities during the First World War, and the recognition of a later, second generation of Expressionists, who participated in the revolutionary fervor of the early Weimar Republic.[13]

Although trends in the secondary literature have made immense strides in devoting attention to the broader issues of art, society, and cultural politics, their focus mostly dwells on the contribution of male protagonists, whether artists, sculptors, writers, supporters, or promoters of the movement. The problematic manner in which gender is inscribed within modernist theory and practice clearly lies at the heart of evaluating women's role in Expressionism. In 1980, the American feminist art historian Alessandra Comini challenged this litany, concluding her essay "Gender or Genius? The Women Artists of German Expressionism" with the hope that "[i]n the future, when we think of German Expressionism, perhaps we shall not think, teach and exhibit exclusively in terms of Munch, or Kirchner, or Kandinsky, but rather expand our scope to embrace the individual and fascinating qualities of Münter and her co-travelers, Kollwitz and Modersohn-Becker, in their different routes toward Expressionism."[14] Comini was not alone in inquiring into notions of "gender difference," since German feminist art historians forged their own paths, as evidenced in the catalog accompanying the exhibition *Künstlerinnen International, 1877–1977* and in the various publications arising from the conferences of the group Women Art Historians.[15]

Concurrently, in pivotal interdisciplinary studies, the cultural historian Renate Berger scrutinized the patriarchal institution of art and rigorously anchored women's production in social history.[16] In 1988, my introduction *Women Expressionists* provided a survey, taking into consideration the works of Kollwitz, Modersohn-Becker, Münter, Marianne Werefkin, Erma Bossi, Clara Anna Maria Nauen, Olga Oppenheimer, and other artists deemed Expressionist, such as Jacoba van Heemskerck from Holland and the Swedish artists Sigrid Hjertén and Vera Nilsson.[17] Since then, advances in research have expanded the field in considering specific centers of training, such as the Mal- und Zeichenschule des Vereins der Berliner Künstlerinnen und Kunstfreundinnen (Painting and Drawing School of the Association of Berlin Women Artists and Women Supporters of Art), a pioneering, privately funded painting and drawing school for women artists started in 1868.[18] The implications of regional identity were further explored in relation to the group of Rhenish women Expressionists, the Munich circle around the Neue Künstlervereinigung München (Munich New Artists' Association; hereafter NKVM) and Blaue Reiter, and those belonging to the Hamburg Secession.[19]

In 1992, Annegret Hoberg, well-known curator at the Städtische Galerie im Lenbachhaus und Kunstbau in Munich, was instrumental in staging the traveling exhibition *Gabriele Münter, 1877–1962*, the first major retrospective of the woman artist's oeuvre.[20] Alexandra von dem Knesebeck's formidable publications and compilation of the definitive *Käthe Kollwitz: Werkverzeichnis*

der Graphik have proved invaluable to the field.[21] Further monographic studies, among them Elizabeth Prelinger's *Käthe Kollwitz*, Reinhold Heller's *Gabriele Münter: The Years of Expressionism, 1903–1916*, and Diane Radycki's *Paula Modersohn-Becker: The First Modern Woman Artist* have become beacons of scholarship and interpretation in the historiography.[22] Gisela Kleine's biographical study *Gabriele Münter und Wassily Kandinsky* and Bibiana Obler's publication *Intimate Collaborations: Kandinsky and Münter, Arp and Taueber*, moreover, highlight the phenomenon of "significant others," its relevance to early twentieth-century modernism, and methodological challenges to art-historical inquiry.[23]

Just as Comini states in the above quotation that it is important to acknowledge women artists' "different routes toward Expressionism," so the feminist literary historian Barbara D. Wright, who terms women the "intimate strangers" of the movement, warns us against interpreting their role "in traditional, stereotypical categories of binary thinking about the nature of masculinity and femininity."[24] How to escape this mindset is the departure for chapters in this book, their arguments being underpinned as much by art-historical evidence as by gender theory, which questions the binary norms that operate as regulatory practices in society. What challenge, the philosopher of gender and sexuality Judith Butler queries, does deviation from this symbolic hegemony pose "that might force a radical rearticulation of what qualifies as bodies that matter?"[25] Here the terminology employed, that is, "matter [of the body]" with its multiple implications as a material form and as a topic of discourse, is relevant to the sections below. The term *Malweiber* (women painters), for example, is representative of the gender problems that permeated the art world of fin-de-siècle Germany. How could the distinctiveness of women artists' struggles and contribution be embodied within the world of *Künstler* (gendered male) as well as within Expressionism? Certainly, the nonfixity of the movement known as Expressionism is amenable to further scrutiny in terms of its emergence and terminology.

The problems of defining the word "Expressionism" and its application to these very diverse artists mean that the issues of individual and group identity are not easily resolved.[26] In particular, their various origins and the inconsistent features of their training complicate notions of group cohesion. Women artists' insecure social and professional status need to be viewed in light of broader debates concerning the "woman question" and the concurrent "transformation of higher learning." With gradual professionalization of new fields such as teacher training and higher technical or business education, *Bildung*, or classical education and cultivation—a lineage aspired to among the German bourgeoisie—gave way to *Ausbildung*, or professional training.[27] However, by the time the doors of universities were opened to women, a general devaluation of the humanities and a concomitant increase in popular respect for scientific-technological fields had taken place. Women's educational advancement lagged behind, and the inconsistencies of their career structures signal their equivocal position in relation to modernizing processes.

Status and Deviant Body of the Woman Artist

During the nineteenth and early twentieth centuries, the various teaching schools of the Royal Academy in Wilhelmine Germany were limited to male students, as were the gymnasia and universities. In 1908, Prussia was the last state to allow women to matriculate, or gain their *Abitur* (equivalent to a high school diploma) for university entrance.[28] Concordant with the rise of the bourgeoisie in German society, the Allgemeiner Deutscher Frauenverein (General German Women's Association), which was founded in 1865, agitated both for women's equality and their need to find paid work. They argued for the access of women to educational institutions in view of the necessity for the growing number of single middle-class women, the so-called *höhere Töchter* (bourgeois "young ladies"), to find employment as governesses or teachers.[29] Apparently, in 1890, between 16 and 25 percent of upper- and middle-class women did not get married. Teaching was one of the few careers that parents accepted as appropriate to their daughters' social status and was certainly higher on the list of priorities than the choice of becoming an artist.

Yet, equally, in the field of the arts, the agitation for women's access to higher educational outlets led to the formation of various *Vereine* or associations, the painting and drawing school of the Verein der Berliner Künstlerinnen und Kunstfreundinnen (Association of Berlin Women Artists and Women Supporters of Art) being founded

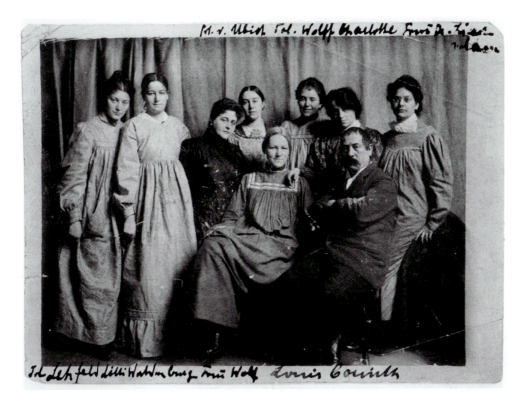

2 Anonymous, *Lovis Corinth's School for Women Painters*, Berlin, 1902 (Charlotte Berend stands immediately behind Corinth), photograph, Germanisches Nationalmuseum Nürnberg, Deutsches Kunstarchiv, DKA_NLCorinth-Lovis_IB254–0002

around a private bequest in 1868. In 1882, this was followed by the formation of the women's academy of the Münchner Künstlerinnenverein (Munich Women Artists' Association).[30] As we will see, Kollwitz, Modersohn-Becker, and Münter all pursued part of their initial instruction within such institutions.

However, due to the expense and unsystematic quality of formal education, feminist practitioners and campaigners called for reform. In 1913, in a lecture in Frankfurt am Main entitled "Das Kunst-Studium der Frauen" (The Art Education of Women), Henni Lehmann (1862–1937), a Berlin-born artist and social activist, revealed that state subsidies for academic training meant that male artists paid only 120 marks per annum, while private training for women cost a minimum of 765 marks.[31] In the same year, the constitutive discourses surrounding the professionalization of the woman artist gathered momentum with the formation of the Frauenkunstverband (Women Artists' Union) under the leadership of Käthe Kollwitz.[32] In arguing for equal rights in art education, public commissions, and exhibiting opportunities, Lehmann and Eugenie Kaufmann (1867–1924) gathered statistical information

in stating their cause.[33] In her lecture, Lehmann argued effectively that the women's movement had successfully secured entrance to the intellectual professions, for which university study formed the basis.[34] Behind these, however, lay those occupations for which *Ausbildungsmöglichkeiten* (professional training possibilities) were scarce and expensive. In order to differentiate serious artists from the "herds of dilettantes," Lehmann pressed for women's equal access to state academies and their high art traditions.

In case one should think that she was out of touch with modern tendencies, one notices that Lehmann added, "We place artistically a Manet-painted asparagus higher than some large battle painting. The 'how', not the 'what' defines the value of the work of art."[35] In view of their identification with modern trends, many women chose to continue their training in studios run by individuals. The privileged could opt for the route of attending private "ladies' classes" offered by former academicians like Lovis Corinth who, in turn, were able to subsidize and finance their own careers by such methods.[36] As shown in a studio photograph of 1902 (fig. 2), there was no shortage of aspiring women artists; see Charlotte Berend (1880–1967),

Corinth's favorite model and future wife, posing immediately behind him. The daughter of a German Jewish merchant and banking family, Berend's career, while indicative of the acculturation of bourgeois Jewish women and demographic identity of Corinth's circle of patrons, was increasingly subservient to her husband's.

The Kunstgewerbeschulen (Schools of Applied Art), the first founded in Munich in 1868 and in Hamburg in 1896, further attracted a high proportion of female enrollment.[37] A Kunstschule für Mädchen (Art School for Young Women) was established in 1868, coincident with the founding of Die Kgl. Kunstgewerbeschule München (The Royal School of Applied Arts of Munich). Although transformed from a privately funded Kunstgewerbeverein (Arts and Crafts Association) into an official institution, women were charged for their tuition. In 1872, women were permitted entrance to the Münchner Kunstgewerbeschule (School of Applied Arts of Munich) but were taught separately from their male colleagues until the year 1917. The teaching schools of the academies were also only officially opened to women with their emancipation in 1919. Yet, in 1908, Ida Kerkovius (1879–1970) continued her training under Adolf Hölzel at the Damen Malschule (Painting School for Ladies), founded at the State Academy of Fine Arts in Stuttgart and, by 1911, advanced to the position of teaching assistant.[38] This was an unusual case, however; women gained access to state-run institutions at a time when most talented male students had already rejected the fundamental tenets of academicism.[39]

The 1890s in Germany, for instance, witnessed the founding of urban-based secessions and independent artists' groups, which veered away from academic and related professional associations. It was rare, however, even in the ranks of the newly formed secessions, for women artists

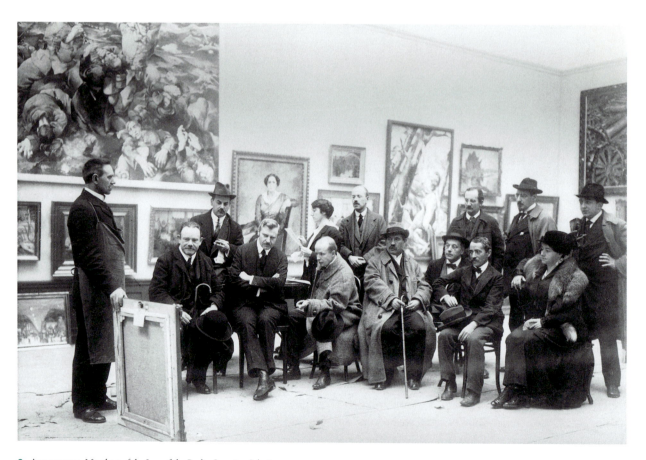

3 Anonymous, *Members of the Jury of the Berlin Secession Selecting Paintings for an Exhibition*, 1915, photograph, Ullstein Bild

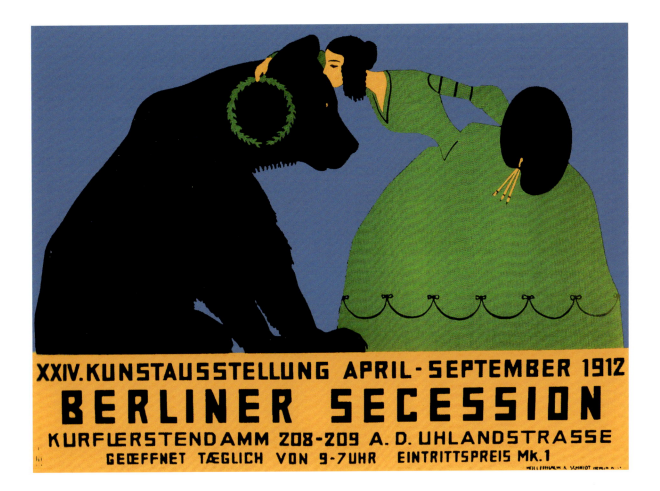

XXIV. KUNSTAUSSTELLUNG APRIL-SEPTEMBER 1912
BERLINER SECESSION
KURFLERSTENDAMM 208-209 A. D. UHLANDSTRASSE
GEŒFFNET TÆGLICH VON 9-7UHR EINTRITTSPREIS MK.1

to gain a foothold in the male hierarchy; only Kollwitz and Berend-Corinth—the latter seated on the right in a photograph of members selecting paintings for an exhibition (fig. 3)—achieved equivalent status on the jury of the Berlin Secession. Thomas Theodor Heine's poster for the 1912 Berlin Secession exhibition well demonstrates the improbability of women artists' being taken seriously, as the dilettantish young wisp, personified as the muse Pittura and merely adorned with palette and paintbrushes, is portrayed showering her attentions on Berlin's symbol of masculine prowess (fig. 4).[40] Such images detract from the concurrent professional commitment of a woman like Kollwitz who, in the midst of great dissension within the ranks of the Secession, continued to dedicate her time serving in what she considered a demeaning status of second secretary on the jury for the summer, autumn, and spring exhibitions well into 1913.[41]

4 Thomas Theodor Heine, *Poster for the Berlin Secession*, 1912 (designed 1901), color lithograph, 66.5 × 91 cm

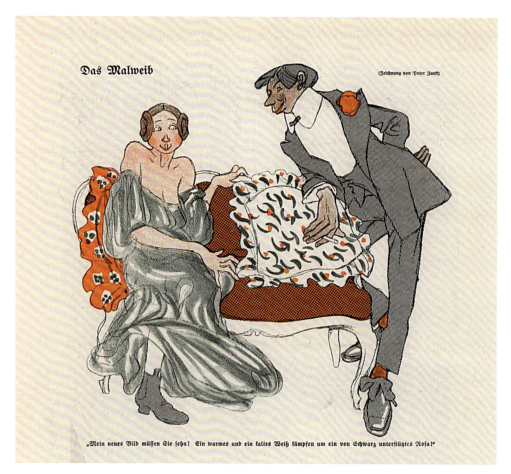

Das Malweib

(Zeichnung von Peter Zankl)

„Mein neues Bild müffen Sie fehn! Ein warmes und ein kaltes Weiß kämpfen um ein von Schwarz unterftüytes Rofa!"

5 Peter Zankl, "Das Malweib," *Simplicissimus* 12, no. 31 (October 28, 1907): 484: "Mein neues Bild müssen Sie sehn! Ein warmes und kaltes Weiß kämpfen um ein von Schwarz unterstütztes Rosa!"

At the turn of the century, the increasing visibility of women artists in studio life and the art world appeared to threaten the hegemony of male artistic identity and practice. *Malweiber*, as they were called, became the target of caricaturists in the specialist media press. In art and literary journals, they were portrayed either as immodestly clad, albeit unbecoming, or as severely masculinized, clearly unsuited to the task in both cases. *Simplicissimus*, for instance, a satirical weekly magazine, started in 1896 in Munich by the publisher Albert Langen, notwithstanding their brash and politically daring content, lampooned the *Malweiber* in a light and modern graphic style consistent with Jugendstil, the equivalent of the Arts and Crafts movement in Germany. In Peter Zankl's sketch of the Munich salon milieu (fig. 5), a young woman painter is shown as sexually provocative, her figure and gestures emulating the curvilinear designs of the sofa and repeat pattern of the modern decorative furnishings.[42] Pretentiously, she

entices the "decadent," fashionable male with a description of her latest (abstract) painting as a battle between warm and cold colors.

However, Bruno Paul portrays the *Malweib* as lanky and unfeminine (fig. 6). Watching over the shoulder of the male artist, who shows her how to paint, the woman is informed: "You see, miss, there are two sorts of women painters: there are some who want to marry and the others also have no talent!"[43] While the "constitutive constraints" on modern artistic identity in Germany were applicable to both genders, societal constructions of the terms "woman" and "artist" were mutually exclusive. According to the art historian Scheffler, whose reviews of Modersohn-Becker we encountered earlier, "atrophy, sickliness or hypertrophy of sexual feelings, perversion or impotence" resulted from women's rejection of their biological destiny.[44] In seeking to become original artists, they turned into a defeminized "third sex":

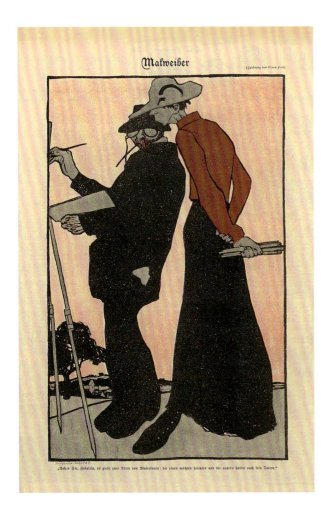

Malweiber

(Zeichnung von Bruno Paul)

"Sehen Sie, Fräulein, es giebt zwei Arten von Malerinnen: die einen möchten heiraten und die andern haben auch kein Talent."

6 Bruno Paul, "Malweiber," *Simplicissimus* 6, no. 15 (July 1, 1901): 117: "Sehen Sie, Fräulein, es gibt zwei Arten von Malerinnen: die einen möchten heiraten und die andern haben auch kein Talent!"

dualities plagued the Munich-based Russian artist Marianne Werefkin, who found it necessary to invent a third self, as she noted in her journal in 1905:

> I am not cowardly and I keep my word. I am faithful to myself, ferocious to myself and indulgent to others. That is, I, the man. I love the song of love—that is I, the woman. I consciously create for myself illusions and dreams, that is I the artist . . . I am much more a man than a woman. The desire to please and to pity alone makes me a woman. I hear and I take note . . . I am neither man nor woman—I am I.[48]

In Scheffler's comments, too, we find the common alignment of women's artistic endeavors with the dilettantish. She could only impersonate male artists' sensitive creativity. While bearing similarity, her work was also considered dissimilar in disguising "manly art forms." The notion of *différance*, as espoused by the cultural philosopher Jacques Derrida, well characterizes the movement of signification that welds together difference and deferral, "presence-absence" that typified women practitioners' relationship to early modernism.[49]

Between 1890 and 1920, the period in which women artists became visible in the public sphere, male critics appeared to lack the experience and vocabulary to assess this phenomenon. Concurrently, official reaction and conservative critical reception viewed the modern art world as an attack on the social body. Here they invoked the ideas of the Hungarian-born physician and amateur art historian Max Nordau as disseminated in his well-known book *Entartung* (Degeneration), which was published in two volumes between 1892 and 1893.[50] In this text, he employed terminology evolved within the legal and medical disciplines, equating modern stylistic tendencies with criminality and hysteria. When dedicating his book to the Turin-based anthropologist and psychiatrist Cesare Lombroso, Nordau declared that "degenerates are not always criminals, prostitutes, anarchists, and pronounced

If she forces herself to be artistically creative, then she immediately becomes mannish. That is to say: she cripples her sex, sacrifices her harmony and, with that, surrenders out of hand every possibility of being original . . . Therefore, since woman cannot be original, she can only attach herself to men's art. She is the imitatrix par excellence, the empathizer who sentimentalizes and minimizes manly art forms . . . She is the born dilettante.[45]

Evidently, the language of the new sciences of eugenics and sexology, while increasing an understanding of sexuality and the body, was readily accepted by popular and media culture as a vehicle for stigmatization.[46] Wilhelmine societal norms set up a binary opposition in which sexual identity could be "performed" only in relation to heterosexuality, hence the considered deviancy of the woman artist's body as a *Mannweib* or "manwoman."[47] No wonder such

lunatics; they are often authors and artists."[51] Such ideas became common to the rhetoric of both the detractors and supporters of Expressionism. Women artists were a volatile presence in this narrative, one that embraced the implications of modernity and the conflicting challenges of pre-emancipation womanhood.

Expressionism, the Foreign, Modern, and Avant-Garde

Interestingly, the word "Expressionism" had its origins in this shifting ambience between tradition and the modern.[52] In fact, it was initially applied to a selection of French and not German artists, the term "Expressionisten" being employed in the foreword to the catalog of the twenty-second spring exhibition of the Berlin Secession held in April 1911.[53] Apart from Picasso, most of these artists were associated with the circle of Matisse—Braque, Derain, Friesz, Dufy, Marquet, van Dongen, Puy, and Manguin. Given the largely Impressionist leanings of the Secession, the collective term "Expressionisten" was a convenient way of signifying the "newest directions" (viz., Fauvism and early Cubism) in French art. Fundamentally, the word signaled the distinction between the Impressionist recording of external appearances and the Expressionist response to the imperatives of an inner world. By this time, the engendering of Impressionism as feminine and as celebrating sensory experiences was well established in critical discourse.[54]

Many of the women artists we are considering were familiar with modern French art, which they could view in public collections, at secessionist or private dealers' exhibitions. Indeed, notwithstanding the conservative backlash of Wilhelm II, German museum directors, such as Hugo von Tschudi at the Berlin National Gallery or Gustav Pauli at the Bremen Kunsthalle, avidly acquired works by Cézanne and Van Gogh long before official French culture realized their value. Yet, women artists sought out cosmopolitan experience; travel provided both a release from the strictures of bourgeois society and the experience abroad of avant-garde subcultures and metropolitan life. In Paris, the Académie Julian, founded in 1868, was the first to offer women training comparable to the official École des Beaux-Arts, which did not accept women until 1897.[55] However,

at the Julian, women were charged much higher fees than their male colleagues; after an initial trial of mixed classes, male and female students were separated. Posthumous publication of the journal of the gifted Ukrainian artist and feminist Marie Bashkirtseff, who began her art studies at the Académie Julian in earnest in 1877 until her untimely death in 1884, offered a precedent for many aspiring women artists.[56] Next to the expensive Julian, the Académie Colarossi was the most well known, especially for drawing from the nude and the challenges of croquis—short, spontaneous sketches of models, who changed their poses every half hour.[57]

Hence, the private academies in Paris—Colarossi, Julian, and Matisse—attracted many foreign students. As we can see in Arvid Fougstedt's ink drawing of *Matisse Teaching Scandinavian Artists in His Studio* (fig. 7), Matisse's praise for Sigrid Hjertén's work met with much surprise among the predominantly male attendees. Interestingly, Matisse's concepts of expression, as advanced in his well-known theoretical treatise of 1908 "Notes d'un Peintre" (Notes of a Painter), were publicized by young women artists who attended his school.[58] In 1909 it was translated into German by the sculptor Marg or Greta Moll for the specialist journal *Kunst und Künstler* (Art and Artists) and the Swedish woman painter Hjertén popularized his ideas in the Stockholm daily newspaper *Svenska Dagbladet* in 1911.[59] In this treatise Matisse had famously claimed, "I am unable to distinguish between the feeling I have about life and my way of translating it."[60] Such concepts of vitalism certainly resonated with both German and Scandinavian artists' ambitions to achieve an authentic and innovatory aesthetic.

However, while the international referents of Expressionism were maintained until 1914, the term accrued specifically German connotations when the aforementioned critic Paul Fechter, while acknowledging its decorative, cosmopolitan associations, invested it with implications of the instinctual, the emotional, and the spiritual—"the metaphysical necessity of the German people."[61] Drawing heavily on the art historian Wilhelm Worringer's (1881–1965) professorial thesis, *Formprobleme der Gotik* (Form in Gothic), which was published in 1911, Fechter constructed a genealogy for contemporary artistic identity based on the anticlassical features of the German Gothic past.[62] Yet an

overemphasis on the nationalistic features of Fechter's text as canonical tends to conceal criticism of its premises. Rosa Schapire (1874–1954), for instance, one of the first women to qualify in the art-historical discipline in Germany, decried its selective methodology and wrote: "It may be that the time is not yet ripe to write this book, and that it is an ominous sign of the hustle and bustle of the new when one seeks already to fix in words a movement that extends across Europe and is barely a decade old."[63] Similarly, other leftist art historians and critics offered a nuanced, counterandrocentric and internationalist promotion of Expressionism on the eve of and during the war; the writings of the Marxist Wilhelm Hausenstein (1882–1957) are a case in point.

Although distancing himself from Worringer's psychological taxonomy of style, Hausenstein nonetheless saw the nonnaturalistic art of the Gothic and the Baroque as metaphysical and communal (organic) as opposed to the Naturalism of the Greco-Roman and Renaissance traditions; he regarded the latter as serving the private pleasure of capitalist-orientated societies (critical). His sociology of style was dependent on a Saint-Simonist characterization of these dual historical epochs and their dialectical succession.[64] Thereby, in his book *Die Bildende Kunst der Gegenwart* (Visual Art of the Century), the manuscript of which was completed in 1913, Hausenstein supported the abstracting and spiritual directions of Wassily Kandinsky's oeuvre, hailing this form of Expressionism as imminent and leading to a new social order by virtue of its antimaterialism.[65] While Hausenstein still retained a nineteenth-century art-historical emphasis on national schools, he was firmly internationalist in promoting French and Russian art, and in a catalog essay entitled "Die Neue Kunst," he instructively seized on Werefkin's paintings as symptomatic of the futurity and collective coordinates of Expressionism.[66] Hence, the methodology adopted in this study works

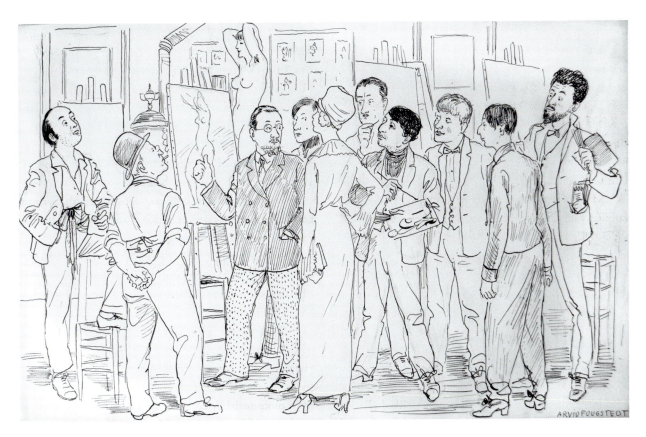

7 Arvid Fougstedt, *Matisse Teaching Scandinavian Artists in His Studio*, 1910, pen and ink on paper, 49.5 × 30.5cm, Borås Konstmuseum, Borås

outward from the evidence and does not merely attempt to fit women practitioners into preexistent definitions of the word "Expressionism" or narratives of the movement.

The view that women artists led solitary, individual existences, and that their works were created outside these public debates on the direction that contemporary art should assume, is now outdated.[67] Reading through their journals and correspondence, one ascertains that they did not consider themselves external to the discourses of cultural politics, regional, or national formation. In 1912, Gabriele Münter, for instance, wasn't immune to deploying anti-Semitic stereotypes when characterizing the gallery dealer Hans Goltz as a *schlimmer Jude* (a petty-minded Jew), even though he was not Jewish.[68] So normalized were these tropes in the common vernacular that Münter possibly never associated them with inherent racism; indeed, in 1917, while in Scandinavia, she publicly defended the Expressionist Isaac Grünewald from virulent anti-Semitism.[69] In the case of the Dutch artist Jacoba van Heemskerck, during 1915, with the market for her works residing in Germany, she eschewed French modernism and rigorously embraced what she considered to be "die grosse Kraft von Deutschland" (the great strength of Germany).[70]

As has been well established, detractors of the "foreign" and the "modern" reared their heads in the prewar years as the former Worpswede artist Carl Vinnen (1863–1922) gathered signatures of colleagues in his pamphlet *Ein Protest Deutscher Künstler* (A Protest of German Artists).[71] Here he railed against the acquisition of inferior French works by museum directors and the inflation of the art market, together with the corruptive influence this had on German culture. This attack forced the supporters of early modernism, among them many Expressionist artists, to frame a response.[72] As we will see, women artists were directly or indirectly involved in this affair—Kollwitz surprisingly signing Vinnen's *Protest* and, posthumously, Modersohn-Becker's oeuvre being inscribed within these debates.

These conflicts revealed much about the tensions between city and country, urban and rural, *Zivilisation* and nature that pervaded the cultural criticism of the period. At the same time, they also demonstrated Vinnen's discontent with the rapid changes that overtook patterns of artistic training, production, and display during the

imperial era, his manifesto legitimizing concurrent anti-Semitic outbursts associating "foreignness" with dealership and urban cosmopolitanism.[73] If conservative *Mittelstand* (middle-class) male artists admitted to such insecurities, how much more difficult it must have been for women artists to negotiate a modernizing aesthetic and to secure a niche in the competitive market economy of late imperial Germany.[74] Yet engage they did in the diverse structures of the art world, seeking professional paths within private as well as independent exhibition venues, participating, too, in exhibition organizations limited to female membership.

The expansion of galleries in Berlin during this period pointed to the rising political and commercial status of the city and catered to the interests of this burgeoning clientele, already familiar with developments in Paris. As will be shown, the dealers Paul Cassirer (1871–1926) and Herwarth Walden (1879–1941) were instrumental in promoting women artists. Walden, for instance, provided exhibition opportunities and media promotion for Münter, Werefkin, Van Heemskerck, and Hjertén through his Sturm (Storm) Art Gallery, which was established in Berlin in 1912, and his publishing of the journal *Der Sturm* (1910–32), featuring reproductions of their original graphics and drawings. Dealership also became the preserve of women, the Swedish-born linguist and musician Nell Roslund (1887–1975), who married Walden in 1912, playing a more important role in networking and encouraging women artists than has hitherto been recognized. In her gallery Neue Kunst Frau Ey (fig. 8), the dealer and collector Johanna Ey (1864–1947) forged a space in the public arena without which male avant-garde activity in Düsseldorf could not have flourished.[75]

Evidently, in line with cultural theory, this inquiry directs attention to the range of "institutions, artifacts, and practices" that made up the symbolic universe of Expressionist avant-garde culture. As the art historian Charles Haxthausen has usefully observed, the term "Expressionism" was neither meant as the name of a "coherent art movement, nor as a consistent aesthetic theory, let alone as an identifiable style, but above all as a theory of the avant-garde."[76] Here, Haxthausen uses the term in a broad sense, not merely as an artistic movement but as a social phenomenon. While the term "avant-garde" implies the acceptance of a progressive, modern cultural identity, its meanings

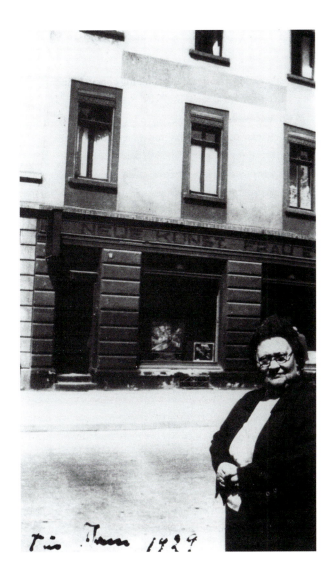

canonic modernists.[79] Drawing in particular on chapter 4 of Sigmund Freud's *Totem and Taboo* (1913), her psychoanalytical methodology points to the oedipal parallels of male artists' *reference* to, *deference* of, and subsequent jettisoning of their predecessors so as to reclaim the coveted niche of male avant-gardism.[80]

Keeping these debates about the nature of the avant-garde, its conceptual processes, gendered, and historical exclusions firmly in mind, avant-gardism in this book embraces a broad field of practitioner, patron, and dealer in a mutually reflexive definition of what constituted modern theory and practice.[81] Urbanization and modernity, the concomitant rise of the middle classes and the struggle for emancipation, were guarantors of women's participation as creators, supporters, and consumers of contemporary artistic production. However, when it comes to locating contemporary theoretical models for women's experiences of modernity in the early twentieth century, one is reliant on the familiar binary oppositions that relegate them to the realms of the biologically reproductive rather than the artistically productive. According to this model, the female remains a subjectively unified whole, cyclical, and beyond the frictions of contingent time and space, a quasi-mythic entity.

Interestingly, this gendering of temporality was characterized by the social theorist Georg Simmel, who established many of the tropes of modernity peculiar to the development of urban culture in Germany during this period. In his two essays "Weibliche Kultur" (Female Culture, 1902) and "Das Relative und das Absolute im Geschlechter-Problem" (The Relative and Absolute in the Problem of the Sexes, 1911), he conceptualized a split between objective (male) and subjective (female) culture by means of which women are excluded from direct participation in the objective culture of the metropolis, in "which the male becomes alienated, objectified and ultimately fragmented under the conditions of modern capitalism."[82]

This theoretical privileging of the male as active in the public milieu (albeit alienating) precludes women from

have been inscribed primarily through the male artistic canon. Indeed, the semantic definitions offered by the cultural historian Peter Bürger in his *Theory of the Avant-Garde*, whereby he differentiates chronologically between an aesthetic-orientated avant-garde and that which altered the praxis and institutions of art, exclude consideration of gendered identity.[77]

Given women's lack of political voice and their tenuous role, the feminist literary historian Susan Suleiman considers the historical status of the female practitioner as one of "double marginality," viewed by patriarchal society as incompatible with professional commitment and regarded as peripheral within avant-garde communities.[78] In her notable publication *Avant-Garde Gambits, 1888–1893: Gender and the Colour of Art History*, the feminist art historian Griselda Pollock further deconstructs the strategies of

Women Artists, Expressionist Culture, Public Sphere

socialization. Therefore, it is appropriate to consider the theories of a progressive woman social theorist, such as the writer and feminist Lu Märten (1879–1970), in order to gauge more effectively contemporary women's experiences of modernity. Notwithstanding her humble upbringing in a Berliner Mietskaserne on Potsdamer Straße, Märten was drawn into the milieu of middle-class social and cultural reform. In light of her background, she had a heightened awareness of the physiognomy of the growing metropolis in relation to the politics of class and gender.[83]

Die Künstlerin (The Woman Artist, 1914)

It is understandable why Lu Märten, in her publication *Die Künstlerin* (The Woman Artist, 1914), negotiated the intellectual terrains of *Wirtschaft* (economics) and *Wissenschaft* (science) in seeking to advance the professional status of women artists in society.[84] Here she anchors the woman firmly in *Gesellschaft* (society), and while *Die Künstlerin* is utopian in aspiration, Märten retrieves the persona of the woman artist from cyclical, temporal rhythms by interposing the values of the transitory, locating women's labor within metropolitan and technological experience. Thereby, she argues forcefully for women's access to academies and similar official institutions. Not that one should overestimate the importance of academic tendencies to artistic development, she adds, but exclusion from such training limited women's access to the mechanisms of economic and social engagement.[85]

At the core of Märten's intervention, however, lies her theorization of why "the whole of women's education . . . still does not count as professional training as for a man."[86] This was due to the ideological assessment of the *Qualitätsarbeit* (valued work) according to the criteria of the *alte Männerkultur* (long-established men's culture):

> At the same time it was the devaluation of work through the machine which—as we mentioned at the beginning—first brought women's work onto the scene—simply as the cheapest and most submissive workforce, as the most willing "hands." This economic disqualification shrouded itself in mystery as a scientific and ethical judgement on women's work as "naturally inferior." This mystification was

ascribed to women's achievement of every kind and every nature. The woman's enslavement was therefore preserved, the revolutionizing of her social being, her economic freedom compared to men's work—had to be hampered and held up. So, from the first, all women's work steps into the economic struggle with the stigma of inferiority.[87]

As relayed in the above passage, Märten subjected the metaphor of the "woman artist" as "worker" to rigorous scientific and economic scrutiny. Only socialization in an economic sense could secure emancipation from the private sphere and the structures of male hegemony. Echoing Simmel's text *Über Soziale Differenzierung* (On Social Differentiation, 1890), which focused on the interactions and interrelations of modern society, Märten foresaw the need for the specialization and differentiation of women's work, a dynamic initiated by technology.[88]

Gesellschaft (society)—"a modernity that offered no exit from a transitory existence"[89]—would secure women's autonomy. Indeed, particularly when compared to the 1920s, Märten's proposed sociological models for the future—one country, one history, one people, one class— lacked the wholeness of a new *Gemeinschaft* (community).[90] Her utopian notions of *Weiblichkeit* (femaleness) and *Mütterlichkeit* (the maternal), while postulated as ideal socialized concepts, were predicated not on outdated historical and scientific legacies of women's essential nature but on psychological and intellectual experiences that were constantly in process:

> So they [women artists] hurry, so they design for the future; things for tomorrow and beyond their time— but not the timeless and eternal—it is in this way that they hurry ahead of society . . . because only their activity and thought, their action and their being is recognizable. And thus every outstanding mind is after all a social, physical creature.[91]

What more appropriate definition of women avant-gardists can we find, one defined by their thoughts and actions—the socialized body—and not by hidebound, essentialist concepts of their gender?

Ultimately, Märten proclaims, socialization has its

impact on the traditional forms of women's erotic life—family and marriage—and gives rise to new androgynous configurations of the female as well as the male artist.[92] Within a classless society, there was neither need to disparage dilettantism nor to speculate "that women have among them still no Goethe and no Beethoven."[93] Märten argued that, with the locus of the aesthetic residing in the quality of production, distinctions between high and low, the fine, applied, and industrial arts were superfluous. Interestingly, this quotation has resonances with the institutional and societal barriers that caused Linda Nochlin, fifty-seven years hence, to raise the question, "Why Have There Been No Great Women Artists?"[94] Nochlin's interventions in the art-historical discipline have helped us to expose how significant first-wave feminist commentators were to declaring Modersohn-Becker and Kollwitz "great women artists" and to offer reasons why this recognition only came to the fore so much later in the twentieth century.

Hence, in upholding Märten's sociological model, this study aligns itself with tendencies in German historiography that question the traditional relegation of women to the private and domestic sphere, and the harnessing of maternalism to intrinsically conservative ideology.[95] Instead, it seeks to uncover the variety of ways in which women engaged meaningfully in public life "despite legal and ideological restraints."[96] Thereby, we encounter several hallmarks of the "public sphere," as laid out by the cultural theorist Jürgen Habermas in his book *Strukturwandel der Öffentlichkeit* (The Structural Transformation of the Public Sphere), published in 1962.[97] As the historian Geoff Eley has observed, Habermas was writing as "a legatee of the Frankfurt School, who resumed their critique of mass culture at the height of the Christian Democratic state and the post-war boom and at a low ebb of socialist and democratic prospects."[98] Hence the book's motivating problematic, in which Habermas perceived a "degeneration" of democratic principles in the Adenauer era, was critiqued through the past—the Enlightenment as the founding moment of progressive modernity.

Notwithstanding the fact that Habermas's usage of the classical liberal model was limited to the late eighteenth and early nineteenth centuries, in early twentieth-century administering and promotion of modern art, we can detect features of what he termed the "democratic bourgeois

public sphere." Here I will not attempt to expand on the controversies generated by Habermas's text in the intervening years. Suffice it to say that feminist commentators have argued constructively that the gender-blindness of Habermas's model needs to be overcome.[99] Indeed, in his essay "Further Reflections on the Public Sphere" (1992), Habermas, who is loath to revise the standard text, acknowledged that structural transformation of the political public sphere proceeded without affecting the patriarchal character of society as a whole.[100]

But we need not credit this observation solely to him since the German Jewish Expressionist writer, poet, and critic Margarete Susman (1872–1966) wrote eloquently regarding women's position in surveying the imperial period, through the November Revolution (1918), to the rise of Nazism. In her essay, "Wandlungen der Frau" (Transformations of Woman, 1933), she traced the journey of the women's movement as a competition with man for his world.[101] But, then, with revolution and emancipation, "when almost overnight the doors to this longed-for world were opened, it entered into the most catastrophic collapse. It became clear: Man no longer had a world to offer woman; all his orders and laws had disintegrated."[102] Commenting on the existential loneliness of the new, autonomous, self-confident woman with great dreams in her heart, Susman concluded: "Upon awakening from a dream as long as European history, woman stands freezing in the emptiness." Acknowledging these ongoing challenges to self-realization, via the vehicle of the notion of the public sphere, chapters of this book examine how we can locate sites where the trafficking of ideas among women provided a tool for imagining and transforming civil society into the political.

Expressionist Avant-Garde and the Public Sphere

The marketing of Expressionism, while being a significant factor in informing a range of supporters, was only one of several conditions that led to an upsurge in the collecting of contemporary art. As the historian David Blackbourn sets out in his introduction to the anthology *The German Bourgeoisie*, the number of entrepreneurs and businessmen rapidly expanded as industrialization took hold in

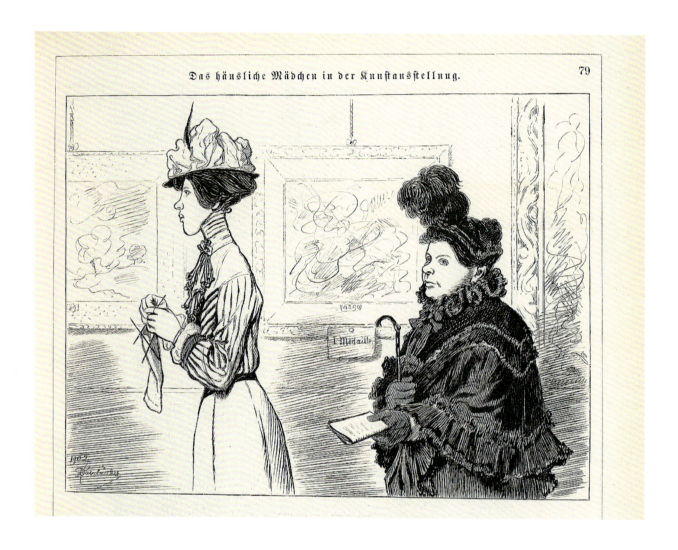

Das häusliche Mädchen in der Kunstausstellung.

9 Adolf Oberländer, "The Housewife at the Art Exhibition," *Fliegende Blätter* 117, no. 2977 (1902): 79, Heidelberg University Library

the latter part of the nineteenth century.[103] He also reveals that the *Bildungsbürgertum*, affluent and educated middle classes (civil servants and university-trained professionals), shared interests in the realms of cultural and social identity. Not included in his account, however, is the phenomenon of bourgeois women's increasing emergence into modern public life and their role as consumers. But here we are not referring to the notional female consumer whose taste was so unfairly disparaged as promoting bad industry and mass production.[104]

Whereas Adolf Oberländer's caricature *The Housewife at the Art Exhibition* (fig. 9), illustrated in *Fliegende Blätter*

in 1902, portrays the stereotypical housewife as disinterested in the modern scribbles in the paintings, Georg Tappert's *Poster for the Extension of the First Exhibition of the Neue Secession* (fig. 10) reveals a newfound respect for the woman viewer. Held in 1910 at the privately owned gallery of Maximilian Macht in Berlin, this important exhibition featured an installation of Brücke works. Apparently, these were hung together on bright red walls in a single room, repeatedly referred to as the *Schreckenskammer* (chamber of horrors) in critical reception.[105] The exhibit also puts on display the most modern methods of marketing. The paintings are simply framed, well spaced against a neutral background, allowing for close and intimate scrutiny more appropriate to semiprivate viewing by a liberal middle-class elite than to a public salon. Just as intriguing is the motif of the single fashionable woman who, though portrayed as

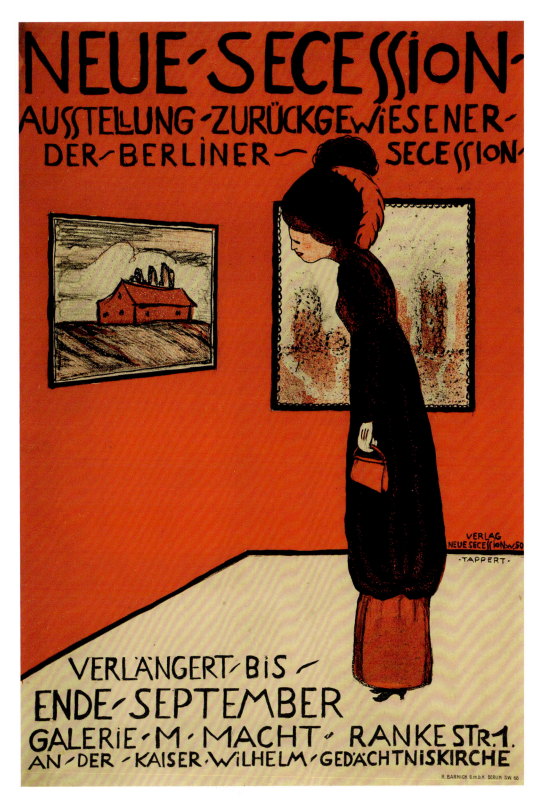

10 Georg Tappert, *Poster for the Extension of the First Exhibition
of the Neue Secession*, 1910, color lithograph, 70 × 47.5 cm,
Museum für Kunst und Gewerbe, Hamburg

both spectator and spectacle, vying with the paintings for our attention, nonetheless appears as an empathetic viewer and as thoroughly absorbed in this process. In this poster she is recognized as a serious and cultivated arbiter of discriminating taste for contemporary avant-garde art.

As participants in debates that called for cultural reform, women patrons therefore constituted a strong social entity in developing direct relationships with artists. This was particularly apparent in regional cities, such as Hamburg, where efforts were made to forge modern identity by mobilizing local institutions, traditions, and culture. Clearly, as Jennifer Jenkins has noted, this view from the province "destabilizes the view at the center . . . by challenging its national focus with the differences and peculiarities of regional perspectives."[106]

Direct contact with contemporary artists was accompanied by the construction of the modern patron and collector, which was informed by the expanding function of the public museum and its societies, by feminist and women's cultural groups, in addition to the role played by "print-capitalism" in the age of modernity. Benedict Anderson has claimed in his account of nation formation that this latter factor "made it possible for rapidly growing numbers of people to think about themselves, and to relate to others, in profoundly new ways" and was critical to the search "for a new way of linking fraternity, power, and time meaningfully together."[107] Yet Anthony D. Smith, in his book *Nationalism and Modernism*, argues that Anderson's claims for the "printed word" neglects other portrayals of nation that stirred people into action, which were oral, audial, and visual rather than literary.[108] Following Smith's cue, it is evident that women's socialization speedily increased via discursive networks as well as through cultural institutions, music, and art. The emergence of women critics, such as Märten and Anna Plehn (1859–1918), and appearance of exhibition reviews in feminist journals suggests that there was an entire parallel discourse of critical reception intended for a female audience. This invention of new traditions of *Frauenkultur* (women's culture) beyond the framework of the proverbial domestic salon was an indicator of women's expanding public sphere.

Interestingly, esoteric movements also played a role in this process. The cofounding of the Theosophical Society in New York in 1875 under the leadership of Helena P. Blavatsky (1831–91) and Henry Steel Olcott (1832–1907) spread its message of "divine wisdom." Based on an amalgam of Western occult practices and Eastern (Hindu and Buddhist) belief systems, Theosophy promoted notions of universal brotherhood, which were anchored in a rejection of Darwinian accounts of natural evolution. Instead, as conveyed in Blavatsky's major opus *The Secret Doctrine* (1888), evolution was considered a cosmogenic force directed toward a metaphysical rather than an earthly explanation of the universe. Such ideas signified not only the appeal of a unifying belief at a time of increasing dissatisfaction with officially recognized religions, but also responded to a gendered sociopolitical imperative; the relationship between alternative or esoteric spirituality and feminism offers an expanded field of inquiry.

In 1907 Annie Besant (1847–1933), a prominent British socialist, theosophist, and women's rights activist, became president of the Theosophical Society, whose headquarters were in Adyar in India. However, as the historian of religion Joy Dixon cautions, the gendering of spiritual experience was a heavily contested field, "the response more complicated, and the women to whom Theosophy appealed more diverse than a straightforward reading of the feminization model would allow."[109] Male theosophists were troubled and considered the implications of feminization, with its links to feminism, as "virility among women."[110]

In early modernism, too, the reception of Theosophy was nuanced in its appeal to a growing audience of creative women in Britain, Northern Europe, and Scandinavia. The abstractionist Hilma af Klint (1862–1944) became a member of the Swedish Theosophical Lodge shortly after its founding in Stockholm in early 1889.[111] She chose to remain unmarried, preferring instead to be a spiritual medium and inspirational force among a group of women. Here we can speak of an avant-garde subculture directed toward a female audience—one dominated by *kvinnokultur* (women's culture) and yet excluded from the annals of modernist discourse. Indeed, it was only in 1986 that af Klint's oeuvre became available to an exhibition-viewing public.[112] For the purposes of this study, however, the focus is on women practitioners who engaged in the world of Expressionist avant-garde culture, exhibitions, dealership, and promotion. Nevertheless, what they shared with

Hilma af Klint was an eventual shift from a theosophical to an anthroposophical outlook. This came about in the German-speaking sections of the movement under the aegis of the Austrian-born philosopher, social reformer, and esoteric Rudolf Steiner (1861–1925).

Between 1888 and 1897, Steiner worked in the Goethe Archive in Weimar, where he edited Goethe's scientific writings. During this period, he held progressive ideas on women's liberation and promoted a Nietzschean form of vitalism and individuality in his publication *Die Philosophie der Freiheit* (The Philosophy of Freedom, 1894). As he stated: "To all who fear an upheaval of our social structure through accepting women as individuals and not as females, we must reply that a social structure in which the status of one half of humanity is unworthy of a human being is itself in great need of improvement."[113] Hence, it is understandable why talented women and feminists were drawn to Steiner's writings. He maintained close correspondence with Rosa Mayreder (1858–1938), a prominent figure in the Allgemeiner Österreichischer Frauenverein (General Austrian Women's Association), which was founded in 1902. In 1897, after his move to Berlin, he secured contacts with bohemian literary and theosophical circles as well as meeting up with the Russian-born actress and his future second wife Marie von Sivers (1867–1948).

Although Steiner became general secretary of the Theosophical Society in Berlin, and Annie Besant appointed him leader of the Esoteric School in 1904, his views differed from the theosophist emphasis on Eastern religions. Instead, Steiner propounded a mystic strain of Christianity (Rosicrucianism), which was mediated through the lens of Goethe's epistemological theories. Critical to this interpretation was the notion of personal agency and creativity in conceiving of "human wisdom" as a spiritual science.[114] Importantly, Steiner admired Sivers's declamatory skills, and women took a prominent role in the performance of his mystery plays (1910–13).[115] Yet, clearly, women's so-called natural skills remained subservient to Steiner's autocratic voice in this relationship. In 1913, following Adyar's promotion of the eighteen-year-old Jiddu Krishnamurti as a World Teacher, Steiner split with the theosophists and founded the Anthroposophical Society in Munich. As will be shown, in addition to Münter in

Munich and Sweden, Van Heemskerck and her patron Marie Tak van Poortvliet in The Hague were familiar with Steiner's ideas, which gathered momentum during the First World War with the move of the headquarters to Dornach in Switzerland.

However emancipated women were as producers, collectors, and patrons of modern art, their status was transitional in sexual politics. While feminist-inspired endeavors had been at an intense pitch for roughly a quarter of a century—in 1865 Louise Otto-Peters founded the Allgemeiner Deutscher Frauenverein (General German Women's Association)—political emancipation was achieved only in 1919. This had a great deal to do with the nature of the major organizational platform of bourgeois women, the Bund Deutscher Frauenvereine (Alliance of German Women's Associations, BDF). Founded in 1894, the BDF took on a new lease on life when Marie Stritt (1856–1928) established a clearly defined radical stance and headed the group from 1899 onward.[116] In 1908, an Imperial Law of Association finally permitted women's participation in politics. But Gertrud Bäumer's (1873–1954) ousting of Stritt in 1910 led to the abandonment of the emancipative ideal by underscoring the differences of female character, contrasting them with the male-dominated structures of industrial society. Particularly in the period leading up to and through the First World War, they stressed the need for "motherly" policies. While maternalism was conceived as a cultural rather than political mission, as has been argued, "social motherhood" as a metaphor for a specifically female approach to social reform proved useful and flexible in gaining a niche in the developing bureaucracy of the welfare state.[117] The enthusiasm of some German feminists for eugenic theory in the early twentieth century was used on the whole to argue not for biological determinism but for women's reproductive self-determination, particularly in the formation of the Bund für Mutterschutz und Sexualreform (Union for the Protection of Mothers and Sexual Reform), a league for the protection of single mothers that was founded by Helene Stöcker (1869–1943) in Leipzig in 1905.[118] So it was left to other organizations, such as the Deutscher Reichsverband für Frauenstimmrecht (German Imperial Suffrage Union), founded in 1902, to agitate for, but not achieve, democratization until the early Weimar period.

While few of the women artists considered in this book, apart from Kollwitz, engaged directly with the feminist movement, many of the women patrons and collectors of Expressionism had links with the organizations mentioned above. German Jewish women were prominent among their ranks, the acculturation of middle-class Jewish women trailing behind that of their male counterparts, who received full political and civic rights in Germany in 1871.[119] As has been observed, more leisure time offered Jewish women the chance to mold their families to the Bildung (education and cultivation) and *Besitz* (new aspirations to wealth and display) of the German bourgeoisie.[120] By 1911, Jewish women made up more than 10 percent of women students at Prussian universities, and they participated in both the leadership and rank and file of the German women's movement.[121] However, there were also nuances in women patrons' political affiliations: the art historian and critic Schapire was associated with socialist politics, whereas Ida Dehmel (1870–1942), a tireless promoter of the vote for women, found a niche within national liberalism. As we will see, however, there was no magical "German Jewish" symbiosis to counteract the forces of anti-Semitism, and within the early decades of the twentieth century, the women's movement was attacked as "anti-German, full of foreign poisonous spirit . . . with few exceptions, being non-German oriental women."[122]

The forthcoming chapters, though loosely chronological, span the late Wilhelmine and early Weimar period from around 1890 to 1924. In line with the frameworks outlined above, these are issue-driven, focusing on particular themes that are synchronous rather than discrete. The content examines distinctions between major art centers, such as Berlin and Munich, and regional identity that informed debates on cultural reform. The period of the First World War looms prominently, not only in terms of developments in Expressionist theory but also in light of the geopolitical climate of the period. Berlin remained an important art center, where women artists from the neutral countries Holland and Sweden found an outlet. Yet, in economic terms, across the classes, women's contribution to agriculture, as much as to munitions, was critical to the war effort.[123] The major thrust of this study is to uncover the relevance of their aspirations for equality, wittingly

or unwittingly, to the shaping of Expressionist avant-garde culture.

Accordingly, the sequence of chapters draws on the explanatory potential of women artists' diaries, journals, writings, and correspondence, either archival or published retrospectively. At the outset, I cast the more familiar figures (Modersohn-Becker, Kollwitz, and Münter) in a new light before introducing less-recognized individuals (such as Werefkin, Hjertén, Van Heemskerck, Nell Walden, and the Dutch patron Marie Tak van Poortvliet) into a richer context of exchanges, setbacks, and achievements than heretofore acknowledged. In line with art historian Isabel Wünsche's mapping of patterns of Expressionist identity beyond Germany's borders, the inquiry extends to Scandinavia and the Netherlands to reveal networks of international connection between women in this milieu.[124] Further interrogation of women's role as patrons, collectors, and dealers within the complex theme of gendered spectatorship serves to underscore their socialization.

Chapter 2, entitled "The Canonizing of Paula Modersohn-Becker: Embodying the Subject and the Feminization of Expressionism" sets the artist against a configuration of post-Bismarckian politics. Modersohn-Becker's upbringing as a *höhere Tochter* invested her with a firm sense of German nationhood, albeit more conservative than expected. However, her commitment to becoming a progressive artist shone through her early training in the private school of the Berliner Künstlerinnenverein and marginalized practice in the Worpswede colony. Via reference to her experiences in Paris, the chapter follows Modersohn-Becker's transition from regionalism to early modernism and the embodiment of subjective agency in her final paintings.

I trace the positive reception of Modersohn-Becker's works and writings following her death in 1907. Notwithstanding the Worpsweden Vinnen's protest against dealers, museum directors, and art critics in promoting French art and neglecting national interests, her oeuvre became prized in both public and private collections. Print capitalism was crucial to the forging of women artists' reputations in the public domain, and the Bremen art historian Sophie Gallwitz (1873–1948) was instrumental in securing the prewar publication of selections of Modersohn-Becker's journals. In exploring the posthumous inscription of the

artist within the critical framework of Expressionism, the findings show how her legacies became entwined with the mid-war intuitionist development in the historiography.

To illuminate this process, I cite theoretical coordinates in journal reviews, as well as in Hermann Bahr's publication of 1916, *Expressionismus*.[125] Yet I argue that the "feminization of Expressionism" should not be interpreted merely in accordance with the discourses of the woman/nature paradigm, but in line with the emancipative ideal, as espoused by Lu Märten. In view of the canonic status of Modersohn-Becker, disseminated knowledge of her ambitious struggle for independence in art and life offered a potent model for women practitioners who sought female lineage within the art-historical trajectory of Expressionism.

In Chapter 3, "Käthe Kollwitz, the Expressionist Milieu, and the Making of Her Career," I explore Kollwitz's complex relationship to the movement. Her formation spanned the late years of the empire, the First World War, and emancipation at the outset of the Weimar era. As witness to the inception and flourishing of Expressionism during this period, Kollwitz's active engagement in the art world makes for an instructive comparison with Modersohn-Becker. I highlight Kollwitz's origins in Königsberg, the importance of the *Freie Gemeinde* (Free Congregation) to her upbringing, and her familial connections to socialist politics. During the 1880s, her training in the Künstlerinnenverein in Munich provides the opportunity to introduce the city as a major art center that vied with Berlin for excellence. The Bavarian capital was the locus not only of her encounter with feminism but also of her experimentation with the intaglio medium. Thereafter, from the outset of her professional life in Berlin and affiliation with the Secession, Kollwitz was uncompromising in seizing on graphic production as a vehicle for both technical innovation and sociopolitical commentary.

From etching through to lithography, she experimented with the hybridity of the surfaces, which arose from the combination of the graphic medium with textured imprints and draftsmanship. While she distanced herself from the Expressionists, the study shows how her works communicated a forceful take on Wilhelm Dilthey's concept of *Erlebnis* and Freudian psychoanalytical theory. Of consideration, too, is the value of gestural drawing in

Kollwitz's wider oeuvre and her turn to sculpture, inspired by Rodin's use of the figure in motion and the function of the part object.

The nub of this chapter revolves around institutional support and critical reception of Kollwitz, in particular through the eyes of the women reviewers' Märten and Anna Plehn. Kollwitz was astute at promoting her oeuvre in relation to dealership and patronage, and this held implications for her honorific retrospective—celebrating her fiftieth birthday—in 1917. I bring to the fore Kollwitz's previously unpublished correspondence with patrons, which shows her preference for her drawings over and above her etchings. Indeed, she offered photographs of the former as a substitute for the original. Rosalind Krauss's deconstruction of both originality and modernism in Rodin's studio workshop proves helpful when questioning Kollwitz's attitudes to authenticity, reproducibility, and the function of the "potential multiple."[126]

In the wake of the November Revolution in 1918, Kollwitz undersigned the first manifesto of the Arbeitsrat für Kunst (Working Council for Art), which was drawn up by Bruno Taut. Official recognition of her talents came with enfranchisement in January 1919; at the age of fifty-three, she was the first woman to be nominated to the Prussian Academy of Fine Arts. Deeply imbricated in the milieu of antiwar pacifism, her efforts to bridge the gap between collective and subjective memory found vital form in the preeminently Expressionist medium of the woodcut, her portfolio *Krieg* (1922) commemorating, as well, the loss of her son Peter in the First World War. Gestalt psychologist Max Wertheimer characterized his viewing experience of Kollwitz's retrospective exhibition as one of "being there," as an intuited moment in which he could access the primordial maternal presence.[127] In a similar outcome to the chapter on Modersohn-Becker, the overall evidence points to Kollwitz as integral to a mid-war feminization of Expressionist theory and its discursive structures.

The book then turns to the prominence of women artists in Munich-based avant-gardism, their transcultural links with developments in Paris allowing insight into their approaches. In the 1890s, as the birthplace of the secessionist movement, Munich offered a progressive milieu with improved and purpose-built exhibiting spaces. Russian nationals were particularly attracted to Schwabing,

home to the academy and university, and they were crucial to the founding of the international exhibiting groups the NKVM (1909–12) and the Blaue Reiter (1912–14). Chapter 4, "Female Avant-Garde Identity and Creativity in the Blaue Reiter: The Possibility of a 'Blaue Reiterreiterin'" acknowledges the relevance of the intimate, creative partnerships of Marianne Werefkin and Alexej Jawlensky and Gabriele Münter and Wassily Kandinsky. However, its main aim is to tease out the dynamic relationship between Werefkin and Münter, their different national and cultural origins and paths toward Expressionism.

The tasks are twofold in considering the status of female identity in male-controlled vanguard groups on the one hand and, on the other, their creativity in light of the strategies outlined in Pollock's account of avant-garde gambits.[128] With the benefit of the Expressionist poet Else Lasker-Schüler's (1869–1945) naming of Werefkin as a "Blaue Reiterreiterin" (Blue Rider/Woman Rider), indicative of a perceived fluidity of gendered authorship, the chapter noticeably revises the well-worn historiography of the movement.[129] Instead, it explores the importance of Werefkin's early training under the painter Ilya Repin in St. Petersburg and centrality to the Russian émigré community in Munich.

Familiar with both Russian and French symbolism, Werefkin favored the aesthetic theories of the Pont-Aven school, and when she resumed painting in 1906, she adopted a mixed medium with a vivid palette and radical stylization. Symptomatic of the avant-garde strategies outlined by Pollock, that of *reference* and *deference* to contemporary tendencies, Werefkin's enigmatic figural landscapes *differenced* the genre in her bid for an expressive, modern art. Twelve years younger than Werefkin, Münter was born in Berlin and raised in Herford. She received training in draftsmanship in Düsseldorf and the chapter follows her travels in North America and the implications of her photographic practice, as both medium and memento, to her artistic formation.

In Munich and travels abroad, Münter's partnership with Kandinsky spurred her easel painting and interest in graphic production, their teaming up with Werefkin and Jawlensky in Murnau, between 1909 and 1912, highlighting the transcultural exchange at work in this social metagroup. Benefiting from the dual inspiration of folk art

and Paris-inspired Synthetism, Münter's bold, painterly landscapes match the avant-garde credentials, as outlined by Pollock. I compare Münter's and Werefkin's works, particularly in their handling of portraits of the same model in Murnau, which allude to tropes of travel—*scènes et types*—found in commercial photographs and guidebooks in the period of empire. They held shared concerns for city/country themes, issues of which, as elucidated in chapter 2 on Modersohn-Becker, were fiercely debated in the cultural politics of the period.

In a discussion of self-portraiture and portraits of each other, I draw attention to the creative energy and rivalry between Werefkin and Münter, characteristics of which are usually reserved for male avant-garde practice. Münter's formative role in the breakaway group of the Blaue Reiter is assessed in light of her still life arrangements of religious folk-art objects. I argue that Münter, as much as Kandinsky, was taken with the theosophical ideas of Rudolf Steiner but toward different ends. Instructively, neither Münter nor Werefkin's works conform to paradigms of autonomy and spiritual abstraction, and they retained immense respect for painterly figuration throughout their careers.

Involvement with Kandinsky and the Blaue Reiter led to Münter's introduction to the Berlin-based dealer Herwarth Walden. The fascinating trail of their correspondence reveals how important his and Nell Walden's networking were to the artist's viability in the public sphere. They were also Werefkin's dealers, and previously unpublished correspondence with the Waldens illuminates the circumstances of the artist's return to Lithuania in November 1913, and subsequent enforced emigration from Germany to Switzerland on August 3, 1914. More favorably received in critical reviews and, indeed, venerated by other members of the Blaue Reiter community, Werefkin's legacy as a Blaue Reiterreiterin has superseded Münter's restless search for artistic integrity within the group. However, this chapter restores her positionality and revises the ideal of male-bonding containment as found in the literature.

Chapter 5, "Europeanism and Neutrality as Active Intervention: Gabriele Münter, *Sturmkünstlerin*, and Swedish Expressionism (1915–20)" commences with an introduction to the indispensable role played by the Walden

couple in promoting Expressionism and women artists during the war. Due to Herwarth's negotiations with the German Foreign Office, he was permitted to export and import works to and from the neutral countries of Sweden, Holland, Denmark, and Switzerland as a form of progressive cultural propaganda. Nell's translations of German newspaper cuttings for a Swedish audience, as well as her own journalism and contacts, provided the context in which Münter went into voluntary exile in Scandinavia. Given the geopolitics at the time, it was inevitable that the artist was drawn into debates regarding internationalism and nationalism, culture and politics.

While Münter's intention was to meet up with Kandinsky in neutral territory, the study aims to uncover her agency and development beyond their partnership and brief reunion for the final time in early 1916. To this effect, I deploy Märten's contentions regarding the socialization of the woman artist as giving rise to new configurations of womanhood, entailing the embodiment and psychology of women's experience. Due to Münter's émigré identity and the expansion of her universe in a more democratic public sphere, it becomes clear that the Stockholm period represented an emancipatory phase in her life and art. Consideration of her interaction with the Swedish Expressionists in general and Sigrid Hjertén in particular, who studied in Paris prior to 1914, raises compelling issues of the cultural politics in neutral Scandinavia.

Bearing in mind the coordinates of Walden's enterprise, the dealer was responsible for selecting works for Münter's solo exhibition, which was held at Gummeson's Gallery in Stockholm in 1916. Since these paintings all dated from the pre-1914 period, it is understandable why her oeuvre was categorized in national terms. Moreover, Kandinsky's essay "Om Konstnären" (On the Artist), which was translated into Swedish for the catalog, defined Münter's creativity in relation to the finest traditions of authentic German art: folk art, poetry, and music. Yet, as in chapter 4, the evidence points to her strategic interplay with avant-garde theory and practice. Issues of figuration and abstraction were seriously debated in the enlightened cultural milieu in Stockholm, in particular in the circle of the psychiatrist Poul Bjerre. I contend that Münter was responsive to these discourses, as well as to Bjerre's ideas on the threat to Europeanism during imperial warfare.

Indeed, examples of his publications can be found in her former library.

I assess Münter's move beyond Kandinsky in relation to an installation that she shared with Hjertén and Malin Gyllenstierna at the Liljevalch's Konsthall in Stockholm in January 1917. Organized jointly by the Swedish Women Artists' Association and the Association of Austrian Women Artists, this extraordinary exhibition demonstrates that international modernism found a niche within the mobilizing forces of women artists' initiatives in preemancipation Sweden. Münter became adept at forging these more informal, transnational partnerships, as in the exhibition she shared with the Swedish Cubist Georg Pauli in the New Art Gallery in May 1917. At this venue, Münter's paintings gave powerful testimony to her involvement with the images, contemplative moods, cropped hairstyles, and fashionable dress of early twentieth-century mature womanhood.

While there is little biographic detail regarding the model—the Jewish woman Gertude Holz—for the works *Sinnende* (*Reflection*), *Zukunft* (*Future*), and *Krank* (*Illness*), we are aware that she was a much admired and close friend of Münter's during 1917. Reference to the archivally held sketches and accompanying notes make it possible to follow the evolution of the compositions as well as verify Münter's preoccupation with notions of temporality. With the aid of previously unpublished material from her sketchbooks of this period, I reveal her interest in Steiner's anthroposophist ideas, as delivered in his four lectures *Human and Cosmic Thought* in 1914.[130] She transcribed a paragraph from the fourth lecture in which Steiner proclaimed the boundlessness of individual thought, which partook of a greater cosmic process. Münter's strongly feminized embodiment of introspection, meditation, and anticipation in this series of paintings was matched by a formal language that advanced all aspects of the canvas into a space-defying metaphysics.

That Münter concurrently requested a Sturm photograph of herself gives credence to Märten's utopian aspirations for the modern *Künstlerin* (woman artist), those based on psychological and intellectual experiences of the socialized body. I argue that, in common with Bjerre's activist promotion of Europeanism during wartime, Münter predisposed herself toward French-inspired Expressionism,

and this continued after her move to Copenhagen in December 1917. As an expatriate in neutral Scandinavia, she could give free rein to her antiwar sentiments and was able to question the traditional values of national belonging and gender identity. Thereby, her works of this period bring forth not only nuances to our understanding of the transnational and transcultural boundaries of Expressionism but also insight into the strength of her unique intervention and commitment to expressive figuration.

If Münter's relationship with Herwarth and Nell Walden secured a modicum of professional identity in the turmoil of mid-war geopolitics, then it was a significant and career-making move for Van Heemskerck. In 1914, Walden became her exclusive agent, and in chapter 6, "The Gender and Geopolitics of Neutrality: Jacoba van Heemskerck, the *Sturm* Circle, and Spiritual Abstraction (1913–23)," I account for the intriguing circumstances in which the artist *differenced* key tenets of German Expressionism. Unlike Münter, who was drawn to Europeanism and pacifism during the war, Van Heemskerck supported the German offensive and assisted Walden's cultural propaganda by translating German press cuttings into Dutch. From her extensive correspondence with the dealers, one gains an understanding not only of the conditions of Dutch neutrality in relation to the Triple Entente but also of Holland's economic ties to Germany and the structures of the art market during the war. As I relay, it was during these years that Van Heemskerck's lifelong companion and patron, Marie Tak van Poortvliet, added many Expressionist works to her valuable collection of the European avant-garde.

Specializing in landscape and the marine genres, Van Heemskerck looked to Paris and the Cubism of Le Fauconnier on the one hand and, on the other, was equally taken with Mondrian's Domburg paintings. However, the axis between Berlin and The Hague intensified after Van Heemskerck exhibited at the Herbstsalon in 1913. She was drawn to Kandinsky's theories on the spiritual in art and the dematerialization of form in his apocalyptic landscapes. Her oeuvre underwent stylistic variation as she experimented with painterly abstraction and the severity of architectonic-bound seascape compositions. Dissemination of her original prints in the pages of *Der Sturm* alerted broader constituencies to her works and she was extolled

in the interdisciplinary circles of the *Sturm*, in particular by the architectural historian Adolf Behne (1885–1948).

Nell Walden's role in administering the *Sturm* receives prominence in this chapter. Through her interaction with Van Heemskerck, we learn of her importance as a dealer and collector in her own right. Moreover, her creative output was aligned with the Expressionist concept of the *Doppelbegabung* (double talent) in exploring the visuality of *Wortkunst* poetry and the evocative grammar of pictorial abstraction. In 1916, Walden made her debut as a painter in the *Sturm* exhibition *Expressionisten Kubisten*, which was held at Herman d'Audretsch's gallery in The Hague and included works by Münter, Hjertén, and Van Heemskerck.

I consider Van Heemskerck's subversion of the Dutch rural landscape as a "picturesque" genre in light of art historian Jane Beckett's writing about Dutch male avant-gardists' mid-war efforts to cleanse and purify rural landscape through geometry, making it safe for urban eyes.[131] In a similar time span to Mondrian, Van Heemskerck's spiritual and utopian mission was generated in various esoteric circles: via membership of Masonic lodges in Amsterdam and The Hague, the Theosophical Society in The Hague, and Steiner's breakaway Anthroposophical Society in Dornach. From Tak van Poortvliet's essays, we gain insight into Van Heemskerck's favoring of the emotional and spiritual coordinates of geometric and curvilinear formal elements, which reinforce intuitionist theories over and above rationalist and masculine schema. Intriguingly, Van Heemskerck's spiritual abstraction offered a nonmechanistic apotheosis of spirit over matter, which appealed to the *Sturm* circle.

The most compelling outcome of this transcultural exchange arose from Van Heemskerck's involvement with glass painting and her adoption of the art and life project of the Expressionist *Gesamtkunstwerk*. Already in 1914, in her insightful communications with Walden, she revealed her familiarity with Bruno Taut's *Glashaus* in Cologne and Paul Scheerbaart's treatise *Glasarchitektur*, which was published by *Der Sturm*. Her project matured during 1918, but by then Van Heemskerck had devised utopian ideals of collaborating with architects in evolving a vital culture into a new environment, what Behne called an *Einheitskunstwerk*, a unified artwork rather than an additive synthesis of the arts.[132]

In 1920, her partnership with the Dutch architect Jan Buijs for the Villa Wulffraat in Wassenaar demonstrates her concern for the role of architecture in coordinating the stained-glass windows, color scheme, and floor coverings. Within the valences of postwar Expressionism, Van Heemskerck was versatile in invigorating the discourses on spiritual abstraction in Germany, and her preoccupation with glass painting steered her toward the futurity of architecture's spiritual potential. But it was Tak van Poortvliet, as significant other, who financed, sustained, and articulated the feminist implications of Van Heemskerck's engagement with the public sphere. The legacies of this remarkably interesting couple remain tangible both in national collections in Holland and in the importance of the Cultural Community of Loverendale in Domburg to the history of agricultural biodiversity.[133]

The discussion of Nell Walden and Tak van Poortvliet as major collectors of contemporary art introduces the themes of chapter 7, "The Formation of the Modern Woman Patron, Collector, and Dealer: From Brücke to Second-Generation Expressionism." It raises how important civic identity and feminist ideas were to women's patronage of male avant-gardism in the regional centers of Germany. The presence of many German Jews in these spheres of activity signaled their participation in the shaping of modernity. Coining the phrase "provincial modernity" for the Hamburg context, historian Jennifer Jenkins illuminates how efforts were made to forge modern identity by reforming local institutions and inventing new traditions.[134] With such sociohistorical models in mind, case studies focus on prominent individuals to emerge in the Wilhelmine and Weimar periods, such as the art historian Schapire in Hamburg and the dealer Ey in Düsseldorf.

Since both protagonists wrote enthusiastically of the key value of museum pedagogy to their formative experiences in the visual arts, the trajectory of the arguments is more wide-ranging in theorizing the nuances of gendered spectatorship. Through the application of Judith Butler's ideas regarding notions of the masquerade and the performative, the study maintains that the female gaze could be a productive instrument of knowledge as well as a mode of institutional critique.[135] In a section that dwells on the arts of beholding and collecting, I underscore the epistemological framework of institutional viewing in light of

the appointment of a new generation of museum directors. They shared ideas governing spectatorship, which stemmed from a neo-Kantian belief in the relevance of emotional feeling to the aesthetic experience. From Hugo von Tschudi in the Nationalgalerie in Berlin to Alfred Lichtwark in the Hamburger Kunsthalle, their openness toward the modern and the foreign went against the grain of Wilhelm II's cultural politics. Dedicated to concepts of Bildung, these directors formed voluntary associations of art lovers so as to fashion the collecting habits of an enlightened bourgeoisie. Women who participated in these associations, such as Mary Warburg (1866–1934) in Hamburg or Irene Eucken (1863–1941) in Jena, were accultured to the arts of beholding and the collecting of modern art via these means.

I explore performative viewing in relation to the Folkwang Museum in Hagen. The director Karl Ernst Osthaus was pivotal to the decentralization of Prussian dominance in museology, and both his private wealth and *völkisch* mission steered him to bring modern visual culture to the Ruhr. He commissioned the architect Henry van de Velde to craft the museum interior around the collection of modern, decorative, and south global art in accordance with Jugendstil ideas of the Gesamtkunstwerk. As an aspiring photographer, Gertrud Osthaus (1880–1975) serves as an intriguing example of the female gaze behind the lens in documenting her encounters with artists, modern painting, and the museum's holdings. Moreover, in 1913, she theorized aspects of the Folkwang experience in an essay in the *Kölnische Zeitung*.[136] Her interests were characteristic of other women patrons and collectors whose aesthetic tastes moved beyond the contemplative and intimate modernism of Jugendstil in favor of the attack on the senses of Expressionist primitivism.

I demonstrate how the Osthaus couple's strategies held implications for women practitioners through the examples of the Expressionist sculptor Milly Steger (1881–1948) and the poet and artist Else Lasker-Schüler. Steger's architectural sculpture of four female nudes on the facade of the Hagen Municipal Theater caught the attention of Lasker-Schüler, whose dedicatory poem seized on the sculptor's appropriation of the male gaze. Lasker-Schüler was not only an exemplar of the performative viewer, but she also adopted the male guise for the purposes of creative autonomy. As a frequent visitor to the Folkwang

in her capacity as an Expressionist poet and artist, her Old Testament themes linked to the wider discourses of the Folkwang collection, albeit that their ostensible Jewish content strained the limits of Osthaus's völkisch project to spur national regeneration.

In investigating the patronage of the Brücke artists' group, which was founded in Dresden in 1905, Kirchner's lists of passive members reveal the extent of their recruitment in regional cities. In Hamburg, where the support of modern art was already well entrenched, eleven of the passive members were women. Their networking arose from the roughly simultaneous phenomenon of the Deutscher Frauenklub (German Women's Club), which spread rapidly in major cities and regional centers of Germany. In Hamburg, the Frauenklub was founded by Bertha Rohlsen (1852–1928) and Ida Dehmel in 1906, and it catered to the cultural and spiritual aspirations of bourgeois women by organizing literary events, recitals, exhibitions, and lectures. Via such networking, Schapire became a passive member of the Brücke, and she thereafter recruited other professional women in her circle. The success of the Frauenklub in cultivating women's patronage of contemporary art, its nexus with feminism, and the rise of female consumerism is demonstrated in relation to Eucken's role in the Jena milieu. She had already commissioned a family portrait from Kirchner in 1915, and in 1916 the artist produced woodcuts for the catalog of her fashion show, which was held on the premises of the Bremen Frauenklub.

In Hamburg, Schapire's activities as a freelance art historian are explored in relation to her intermittent contact with Aby Warburg. While the archivally held correspondence testifies to her marginalization in this elite circle, her methodological outlook was attuned to the neo-Kantian philosophical basis of the Hamburg school, the coordinates of which are richly illuminated in Emily J. Levine's study *Dreamland of Humanities: Warburg, Cassirer, Panofsky, and the Hamburg School*.[137] As can be confirmed in Schapire's reviews of both Emil Nolde's and Karl Schmidt-Rottluff's exhibitions between 1907 and 1910, her criticism bridged the great divide between empiricist and idealist philosophy. The chapter's findings also expose the anti-Semitism that Schapire encountered as a Jewish critic and patron.

Women's promotion of the individual Brücke artists continued after the disbanding of the group in Berlin

in 1913, and this was no different in the case of Schapire's lifelong promotion of Schmidt-Rottluff. She was immensely receptive to his engagement with the applied arts and responded to Expressionism's denunciation of academic hierarchies in favor of the broader implications of modernist primitivism. Against a backdrop of her civic duties during the war, in her cofounding the Frauenbund zur Förderung Deutscher Bildenden Kunst (Women's Society for the Advancement of German Art) with Dehmel, Schapire's acquisition of Schmidt-Rottluff's works for her private collection gathered momentum. In 1921, she commissioned him to design her apartment as a total entity, testifying to the integration of art and life, and to the aesthetic unity of applied and fine art, whether sculpture, relief, or easel art.

In the early Weimar years, within a context of spiritual millenarianism, Schapire published an essay in *Die Rote Erde* (The Red Earth) on Schmidt-Rottluff's religious woodcuts, which offers further insight into her distinctive and idealistic Expressionist critique.[138] In contrast, I show how Johanna Ey's response to Expressionist works in her private collection was more viscerally performative. In particular, in her account of Gert Wollheim's war works of 1919, she wrote of her fear and attraction to its graphic portrayal of the wounded soldier.[139] The dealer's adoption of confrontational tactics to attract a clientele was one of the most intriguing aspects of her interaction with the public. Seizing on the modernity implicit in glass-fronted shops, she seduced the public gaze by allowing artists to display controversial works in the windows of her gallery. Furthermore, Ey encouraged avant-garde transgressive behavior and the notion of spectacle by sponsoring practitioners who attracted official scandal. Although Ey herself was not an artist, a less monolithic view of what constitutes avant-gardism allows for a more fruitful exploration of her dealership as an inroad to gauging women's spectatorship and cultural interaction in Weimar Germany.

In the epilogue, I suitably trace the fate of many of these women during the Third Reich in attempting to account for their disappearance from the text, only to reappear at the end of the twentieth century. Their absence is significant since it emerges that women serve as the unconscious of the Expressionist story. In spring 1915, in Vienna, Freud shifted his focus on death, war, and the role

of censorship to writing his seminal essay on "The Unconscious."[140] The historian of science and physics Peter Galison likens Freud's topographical picture of the unconscious to war-torn Europe and its censorship boundaries.[141] If, as Freud maintained, the psychical act is *"capable of becoming conscious . . .*—that is, it can now, given certain conditions, become an object of consciousness without any special resistance," then the unconscious retains valuable information.[142] Clearly, it is my contention that this interweaving of surface and depth provides Expressionist culture with its rich and multivalent textures.

THE CANONIZING OF
PAULA MODERSOHN-BECKER
Embodying the Subject and the Feminization of Expressionism

In 1914, the critic Anton Lindner reviewed an exhibition of Paula Modersohn-Becker's works held at the Commeter Gallery in Hamburg. This was a posthumous exhibition, since the artist had died tragically young in 1907 at the age of thirty-one, almost three weeks after the birth of her only child Mathilde. Entitling his review "A Remarkable Woman Painter or: What Is Left of Worpswede Art?," Lindner had little difficulty in declaring her an "unrecognized and lonely genius."[1] In fact, he claimed that she was a "einzigartiges Anpassungsgenie" (uniquely adaptable genius) and continued:

> Paula Modersohn is thus a woman Expressionist. She is the earliest Expressionist of modern painting in the German field. She was the fearless and unflinching forerunner of a creative style that today (seven years after her death and about ten years after the genesis of her strongest works) commands the widest range of the visual arts. Therefore, one must characterize her as a remarkable phenomenon (not only from an art philosophical but also from a sexual, scientific viewpoint).[2]

Lindner's forceful review is significant on various levels, but what strikes one as unusual for the time was his admission of the woman artist to the canon of artistic genius.[3]

On the whole, one encounters prejudicial beliefs about women's abilities, as most flagrantly expressed in the words of the notorious Viennese writer Otto Weininger: "A female genius is a contradiction in terms, for genius is simply intensified, perfectly developed, universally conscious male."[4] Interestingly, however, in addition to Lindner acceding to Modersohn-Becker's status, we are informed that this phenomenon held implications (both sexual and scientific) for the body of the woman artist. As we have seen in the introductory chapter, societal constructions of the terms "woman" and "artist" were mutually exclusive, but in this instance, within the developing discourses of Expressionist theory, the engendering of the artist was considered a virtue. What circumstances promoted such adulation and admitted Modersohn-Becker to the ranks traditionally reserved for male artists?

Between 1898 and 1907, she was based mainly in Worpswede, an artists' colony near Bremen, but this was interspersed by four visits to Paris. Her final stay in the capital during 1906 and early 1907 was in fact meant as a separation from her husband Otto Modersohn, whom she had married in 1901. While in Paris she painted monumental canvases of the nude mother and child, still lifes, self-portraits, and portraiture that were considered highlights

11 Paula Modersohn-Becker, *Still Life with Sunflower and Hollyhocks*, 1907, oil on canvas, 90 × 65 cm, Kunsthalle Bremen

12 Paula Modersohn-Becker, *Color Triangle Diagrams*, 1906, pencil and ink on exercise-book paper, 13.3 × 20.6 cm, Paula Modersohn-Becker-Stiftung, Bremen

of her oeuvre. These were informed by the contemporary artistic milieu in which major retrospective exhibitions of Gauguin and Cézanne attracted great attention.[5] The sudden termination of her career soon after her return to Worpswede led critics to mythologize her individual struggle and to compare her fate to that of Van Gogh's.[6]

Many of her paintings bear witness to her introduction of motifs drawn from his works. This applies in particular to *Still Life with Sunflower and Hollyhocks* (1907; fig. 11), which purportedly stood on her easel at the time of her death.[7] However, here they are reinvented, the sunflower and blooms being cast into a subtle set of color coordinates. As we can verify from random pencil and ink diagrams on exercise-book paper dating from around 1906 (fig. 12), Modersohn-Becker was familiar with the principles underlying theories on complementary color that were valued in Fauvist circles. In the larger triangle, we can see a shaded section that indicates an unexpected relationship between the colors green, violet, and blue, a combination that can be found in her palette at the time.[8] No doubt these works resonated with the ongoing vogue in Germany for the works of Van Gogh, the latter's well-known *Still Life: Vase with Twelve Sunflowers* (1888), having been purchased from Angela von Tschudi, wife of the deceased director Hugo, by the Neue Pinakothek in Munich in 1912.[9]

This construction of a "genealogy of genius" was consistent with art-historical methodologies that sought to legitimize modern art by seizing on the personality and cultlike status of the outsider artist.[10] Like Van Gogh, Modersohn-Becker was marginalized within the artistic group, received little public recognition, and sold few works. Apart from members of the Worpswede circle, like the Vogelers or the Rilkes, Louise Brockhaus (1845–1921), who was married to the Leipzig-based publisher Rudolf Brockhaus, was apparently one of the few certain buyers of a still life purchased during Modersohn-Becker's lifetime.[11] What is more, following a highly dismissive review in 1899, the artist refrained from exhibiting in public, participating only in two group exhibitions of Worpswede artists in 1906 and 1907.[12] How dramatically this situation changed after her death in November 1907!

In summer 1908, together with his wife Philine, Franz Vogeler—Heinrich's art dealer brother—assembled the first retrospective of Modersohn-Becker's works in their art gallery the Kunst- und Kunstgewerbehaus Worpswede (Worpswede Arts and Crafts House). Founded in 1905, this gallery was dedicated to the communal principles of Art Nouveau or Jugendstil (as it was articulated in Germany) and provided an outlet for both the fine and applied arts. Soon thereafter, under the auspices of Gustav Pauli and Emil Waldmann, respectively, the director and assistant director of the Bremen Kunsthalle, a major solo exhibition of forty-eight paintings was held, which subsequently traveled to the Paul Cassirer Gallery in Berlin. Since these were also sale exhibitions, by 1913, the Bremen-based reviewer Curt Stoermer revealed that after

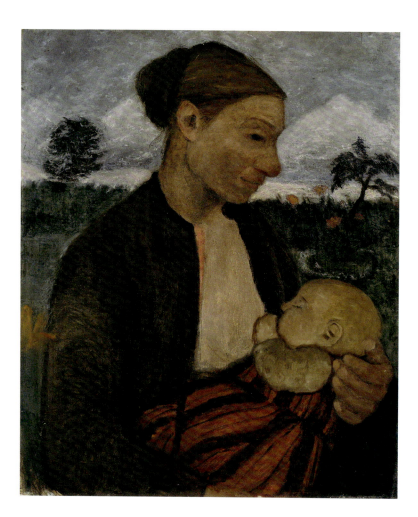

13 Paula Modersohn-Becker, *Mother and Child*, ca. 1903, mixed medium on canvas, 69 × 58 cm, Hamburger Kunsthalle, Hamburg

exhibitions in Hagen, Munich, Jena, and in the private home of Baron von der Heydt in Wuppertal, few works were returned to her estate: "The greatest part are now in permanent hands."[13] As we have seen in Lindner's review at the outset, the passion for her works also reached Hamburg. Indeed Pauli, who in 1914 succeeded Alfred Lichtwark as director of the Hamburg Kunsthalle, published the first monograph on Modersohn-Becker in 1919.[14] It was within this community of supporters, who derived from both official and private spheres, that the legacies of Modersohn-Becker were nurtured, coinciding as they did with an expansion of dealership and an avid collection of contemporary art. Ironically, the growth of the war industry during 1915 had steadily boosted the money supply, and one of the consequences of this increased purchasing power was an investment in artworks, a situation that reached boom proportions by 1917.[15]

Yet the acquisition of Modersohn-Becker's paintings was generated largely in the northern and western provinces, where the desire for progressive, modern, regional identity was forged alongside national aspirations. As we can ascertain from the sample given below, the collectors of her works represent a spectrum of bourgeois and aristocrat involvement in the arts and testify to their mutual interest in promoting civic virtues or communal values, notwithstanding differences of class, politics, business, or professional affiliations. The rebellious artist Heinrich Vogeler, who was the son of a wealthy merchant in Bremen, used his inheritance to transform an old farmhouse in Worpswede into what became known as the Barkenhoff. Designed in the mode of the Arts and Crafts movement, it served as a site of congenial assembly for the "family" of artists as well as functioning as an icon of their objectives for cultural reform. Along with his wife Martha Schröder, who was of humble Worpswede stock, they patronized Modersohn-Becker already in 1906.[16] Similarly, her encounter in Paris with the sculptor Bernhard Hoetger had immense repercussions in that he purchased

significant works from her estate and, given his links with the coffee magnate and patron Ludwig Roselius, contributed to the ongoing canonization of the woman artist in Bremen.[17]

During the First World War, the well-known lawyer Paul Rauert and his wife Martha added Modersohn-Becker's works to their expanding collection of modern German art in Hamburg.[18] This was also the case for the Hanover-based industrialist Herbert von Garvens-Garvensburg, who made use of the domestic interior as a semipublic gallery space.[19] In Elberfeld-Wuppertal, the banker August von der Heydt and his wife Selma accumulated twenty-eight of her works between 1913 and 1918.[20] Deriving as well from a banking family, Karl Ernst Osthaus, the director and founder of the Folkwang Museum in Hagen, purchased her *Self-Portrait with a Camellia Branch* in 1913. In his attempts to foster and develop the public profile of regional and industrial communities, Osthaus was pivotal to the decentralization of Prussian dominance in cultural matters.

Viewed within this context of private and public recognition, it is not surprising to find that a commemorative article "Paula Modersohn (In Memoriam)" was prominently featured in Paul Westheim's *Das Kunstblatt*, a journal that was conceived of as a forum for contemporary art. Issued monthly between 1917 and 1933, it included essays that promoted individual artists (mostly Expressionist) and introduced major collectors.[21] In this belated obituary, the art historian and collector Paul Erich Küppers—founder of the Kestner-Gesellschaft in Hanover—maintained that, with the certainty of a sleepwalker, Modersohn-Becker had followed the path from Naturalism and Impressionism to the monumental simplicity of spiritual *Ausdruckskunst* (expressive art).[22] He considered that the painting *Mother and Child* (ca. 1903) (fig. 13) was no longer a naturalistic likeness but a heroic symbol of motherhood: "The forms in these [Worpswede] works are often still ponderous like lumps of earth . . . the color is still heavy and dull, they are parched, granular, and applied like crumbs, so that the surfaces appear totally rough and weathered."[23] Then he cited extracts from her journal so as to corroborate practice with theory, as Modersohn-Becker wrote: "I must learn how to express the gentle vibration of things, their roughened textures, their intricacies . . . that's the quality that I find so

pleasing in old marble or sandstone sculptures that have been out in the open, exposed to the weather. I like it, this roughened alive surface."[24]

When he discussed the later *Self-Portrait with a Camellia Branch* (1906–7) (fig. 14), cited above, Küppers once again found that her words were illuminating: "As far back as I can remember, I have tried to put the simplicity of nature into the head that I was painting or drawing. Now I have a real sense of being able to learn from the heads of ancient sculpture. What grand and simple insight went into their creation!"[25] Kindled by the examples of Cézanne and Gauguin, and her knowledge of Egyptian sculpture and Fayum mummy portraiture, a reproduction of which resides in the Paula Modersohn-Becker estate (fig. 15), the artist's abstraction of the figure and handling of color had lost its earthbound qualities: "Deep ecstatic eyes gaze upon us . . . here we are seized by the mystery-laden life, that shines out of the eye toward us, here we trace 'the essential, the inexpressible destiny,' the spiritual, that is liberated from the nature-bound outward shape, liberated from an imperfect body, that after all must perish, while the other, the inexpressible triumphs in eternity."[26] Given, as well, the incomplete contour of the hand and the symbolic "immortal" referents of the evergreen camellia branch, the self-portrait, the body of the woman artist, was invested with transcendence. According to Küppers, the "Gothic soul" that was revealed in the mystical color of medieval stained-glass windows was equally at work in these paintings from Modersohn-Becker's final creative years.[27]

Hence, one observes that the internal development within Modersohn-Becker's oeuvre could appeal to overlapping and not necessarily mutually exclusive constituencies: from those that underscored signifiers of German ruralism, to those that viewed cosmopolitanism as important to the ongoing development of contemporary national *Ausdruckskunst*. Intriguingly, therefore, at a time when there was great suspicion of the "modern" and "foreign," we find that the "absent" woman artist was located at *the* nexus of avant-gardism and the complex social transformations brought about by modernity. In exploring the ways in which Modersohn-Becker's legacy was inscribed within the critical framework of Expressionism, the pre- and mid-war publication of her journal and letters secured a unique position within intuitionist theories of art.

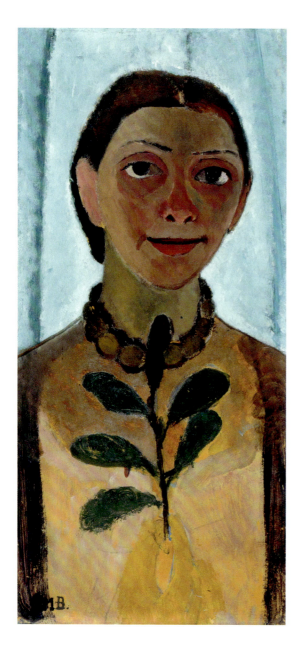

14 Paula Modersohn-Becker, *Self-Portrait with a Camellia Branch*, 1906–7, oil on board mounted on wood, 61.5 × 30.5 cm, Folkwang Museum, Essen

15 *Portrait of a Young Woman*, AD 120–130, encaustic and gold leaf on wood, 34.2 × 16.4 cm, private loan, Reiss-Engelhorn-Museum, Mannheim

In 1913, a selection of fifty letters and journal entries were assembled by the Bremen art historian Sophie Dorothea Gallwitz and published in *Güldenkammer* (Golden Chamber), a literary magazine that was sponsored by Ludwig Roselius's firm Kaffee Hag in Bremen.[28] While she served on the editorial staff of this magazine, Gallwitz also

contributed to the feminist journal *Die Frau*, a monthly publication that was started in 1893 and was edited by the educationalists Helene Lange and Gertrud Bäumer, leading members of the bourgeois women's association (BDF). Far from being a promoter of difference, however, Gallwitz was keen to promote women artists in the interests of forging

a new, shared culture between the sexes.[29] In 1917, ten years after Modersohn-Becker's death, her mother arranged for the publication of a monograph of these writings. The well-known author and poet Rainer Maria Rilke was initially approached to edit these, but he refused on the basis of the truncated selection offered him. The task therefore remained in Gallwitz's hands.[30] As has been observed by the translators of the definitive English-language edition of the artist's correspondence and journal, which was published in 1983, it was via these means that Modersohn-Becker became known primarily as "the author of her own humanly touching but incomplete story."[31] The sections below question the determinist links that have been established between word and image and address the neglected interstices, suggesting that her paintings were audacious in ways that escape circumscription by the more predictable discourses of her writing.

Before examining how the compelling narrative about her life and works was sustained through the First World War—and in what ways this inflects on our understanding of gender, genius, and Expressionism—it is appropriate to consider how her oeuvre came to embrace aspects of the regional, the national, and the modern. Importantly, her position as a woman and artist involved varying and shifting constructions of agency. The notion of "positionality" implies a complex physical and signifying relationship to structures of power, whether parental, societal, political, or institutional.[32] Within a milieu that harbored conflicting social expectations of single upper-middle-class women, Modersohn-Becker's training and career, though compressed into the years 1896 until 1907, serve to illuminate women artists' uneasy negotiation of professional and cultural identity in late imperial Germany.

Embodying the Subject

Modersohn-Becker's writings form the major repository of our knowledge of her private and public life. Her first major biographer, Gustav Pauli, considered that their value lay in her *Betrachtungen* (meditations or observations), which were based far more on feeling or instinct ("the best part of the woman") than on intellect.[33] Clearly such essentialism, which was typical of the mindset of the period, obscures the richness and contingency of her referents. While Modersohn-Becker kept a journal from

the time she was a child, from late 1898 onward she became acquainted with the diaries of Marie Bashkirtseff and strongly identified with the romantic myth of the young artist heroine: "Her thoughts enter my bloodstream . . . if only I could accomplish something!"[34] In a separate album, she also recorded notes and quotations that served as a collection of her reading, and these provide insight into the more complex construction of her artistic persona.

Thus, while her journal provides a "space" in which both personal and aesthetic issues were aired, the process itself harbored elements of the performative and the potential of being addressed to a broader audience.[35] Herein "identity is no longer a transcendental or essential self that is revealed," to quote ethnographer Catherine Russell, "but a 'staging of subjectivity'—a representation of the self as performance."[36] Becker's correspondence also pays homage to certain conventions. In order to retain cohesiveness within the numerous and yet close-knit family clan, letter writing was one of the duties regarded most seriously.[37] While the Becker children were away from Bremen, they were expected to write letters that were timed to arrive on a Sunday.[38] Therefore, we are made keenly aware that the artist's subjectivity—her hopes and aspirations—had a constantly shifting relationship within social givens. Our witnessing of "moments of freedom from social constraints"[39] has much to do with her growing maturity and development of critical distance, evidence of which usually corresponded to her experiences away from home, whether it was Berlin, Worpswede, or Paris, which provide the loci of the subsections below.

Between Bremen and Berlin

Is it meaningful to infer that her early career merely mirrored structures of domination? Here the "social givens" relate to her upper-middle-class background in Bremen and training between 1896 and 1898 at the Drawing and Painting School of the Berlin Women Artists' Association. Becker was born in 1876 in Dresden and was twelve years old when her father Woldemar, a civil engineer, took up a position with the Prussian Railroad Administration in Bremen.[40] At a time of great booms and depressions in the second empire, this Hanseatic League city was thriving commercially due to an expansion of the navy and shipping

trade. She was the third born in a large family of seven children and her mother Mathilde strove to instill values of Bildung in their rearing. Her father was also a member of a circle of *Kunstfreunde*, or "friends of art," who were associated with the local Kunsthalle. As in the case of other cultural centers, Bremen harnessed the energies of a group of charitable and influential citizens whose tasks included the fostering of local arts.

It was probably due to this general influence and her mother's encouragement that Becker discovered her talents, particularly after she attended drawing classes in London during 1892, while spending a few months with wealthy relatives Charles and Marie Hill.[41] Given the transitional status in women's education during the 1890s, her father's insistence that she qualify at a teachers' seminary was in fact fairly progressive for the time. However, his stern, judgmental attitude, which was no doubt spurred on by his own enforced early retirement in 1895, was unnecessarily harsh. When Becker began her training as an artist, he wrote to his wife: "Do you really believe that the child will accomplish something worthwhile or can at least manage to learn how to support herself from it? I doubt it."[42] In view of his attitude, Becker's steadfastness was remarkable, and though she constantly sought approval from her father, it was largely the mother-daughter relationship that sustained her quest.

The maternal line also generated Becker's reliance on conservative models of national formation. Instructively, when Paula was in London, Mathilde made sure that her daughter read two articles on Bismarck.[43] This gives us much insight into the strength of support for the former chancellor across the gender divide and demonstrates the pervasive significance of the Bismarck cult, notwithstanding his enforced resignation in 1890 due to ongoing tensions with Emperor Wilhelm II. The celebrations in honor of Bismarck's eightieth birthday in 1895 gave rise to a further outpouring of patriotic feeling, particularly in the northern, mainly Protestant, regions of Germany.[44] Therefore, it doesn't surprise us that in 1896, during the early months of her enrollment in Berlin, Becker communicated to her father: "Did you know that we were in Hamburg? I was lucky enough to be included. We saw Bismarck, our great old Bismarck . . . I handed a rose to him as his carriage passed by. He took it and sniffed it. I

was deeply moved. It was the first time I ever saw our great, great chancellor—but fate and old age have broken his strength."[45] For Becker, the distance between her idealization of his image and the realities of viewing Bismarck "in the flesh," so to speak, tells us much about the success of mass culture in forging ideas of national belonging through this mythic *Schmied*, or blacksmith, of German unification.[46] On first reading this passage, it is permissible to think that she sought to appease her father by citing her adulation of this suprapatriarch. But, in fact, Woldemar's political affiliations were to the left of center, and his letters reveal concern about the rising tide of right-wing nationalism.[47] As the historian Geoff Eley has observed of the 1890s, while a distinctive post-Bismarckian configuration of politics accepted the framework of a liberal and constitutional public sphere, a powerful extraparliamentary radical-right lobby emerged, for which the Pan German League acted as a kind of ideological vanguard.[48]

The young woman's assured sense of German identity along conservative lines, if anything, was confirmed by her sojourn in Berlin, and even though she admired an exhibition by the dissident art group known as the Eleven at the private gallery of Eduard Schulte, she appeared unaware of secessionist rumblings in the art world.[49] Indeed, she visited the studio of the official sculptor Ernst Wenck, where he was completing a group for the monument to the kaiser, and expressed keen admiration of a "beautiful model" that was in preparation for a fountain.[50] This seamless approach toward both the modern and the traditional possibly helps to explain her hesitancy in embracing feminist causes. She wrote effusively about her experiences, and these attest to an awareness of the immense intellectual, political, and social ferment that pervaded the expanding metropolis of the late 1890s. After attending a lecture entitled "Goethe and Women's Emancipation" by the suffragette Natalie von Milde, Becker claimed to be very familiar with the "catchwords" of women's suffrage. Yet at a time of great mobilization in feminist circles around the restrictive family law provisions of the Bürgerliches Gesetzbuch or Civil Code of 1896, she felt unable to sign a petition and added, "I guess little Paula is going to let the great men of the world carry on and I'll continue to trust in their authority."[51]

Ensconced within the community of the Berlin Women Artists' Association, the twenty-year-old assumed

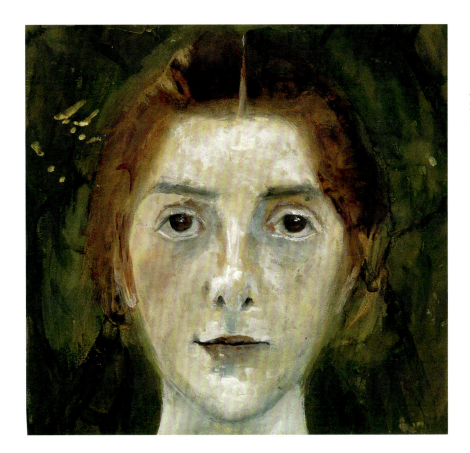

16 Paula Modersohn-Becker, *Self-Portrait, Frontal*, 1897, watercolor on paper, 24.5 × 26.5 cm, Paula Modersohn-Becker-Stiftung, Bremen

the role of a *Mädchen* or young girl who was totally immersed in developing her talents within a competitive environment. And if she appears socially and politically unreconstructed, she was less hesitant when it came to the matter of her tuition. Following a routine that informally paralleled academic training, she quickly spotted the tutors who could further her aspirations. She had unreserved praise for the portraitist Martin Körte, who taught her drawing, and Ludwig Dettmann, a professor from the Berlin Academy who introduced her to painting in oils.[52] In 1897, she was at first ambivalent about her new teacher, the woman artist Jeanna Bauck (1840–1926), who was of Swedish origin and had trained in Dresden, Düsseldorf, and Paris.[53] Becker considered Bauck's approach toward the teaching of drawing, particularly from the model's head, using a grid of horizontal and vertical lines far too formulaic but soon reveled in the experience of painting in "luscious oils" and gave up landscape classes in favor of portraiture under Bauck's guidance.[54]

Indeed, Becker's correspondence reveals the great inconsistencies of training and organization in the school of the Berlin Women Artists' Association. Her concurrent working in oils under the painter Ernst Friedrich differed

from Jeanna Bauck: "While she teaches us to work down from the brightest tones, taking white as the norm, he has us work up from the darkest tones, from shadows."[55] Rembrandt's example is mentioned in the same breath, but Becker showed preference for a more saturated effect of light, what she termed a "living skin in daylight," that appears closer to Bauck's Barbizon-based empiricism. Becker's *Self-Portrait, Frontal* (1897; fig. 16) evinces her woman tutor's emphasis on the conceptual function of drawing in establishing an abstract framework of the oval head and strong horizontals of eyebrows and lips. This is combined with an intense interest in capturing the nuances of modeling against a shadowed and neutral ground, the watercolor medium being stretched to convey the appearance of white impasto highlights. With hindsight, in addition to its precocious strength and connecting gaze, this self-portrait signals Becker's future and unusual deployment of the body fragment and sketch as entities within themselves.

Jeanna Bauck's example was pivotal in other ways as well, since her tuition offered a prospect of corporeal freedom from bourgeois convention and decorum. Given the current fashion for Scandinavian-inspired health cures

and body culture, Bauck related to her female students that Heinrich Lahmann, the well-known naturopath and director of the sanatorium Weisser Hirsch (White Stag) on the outskirts of Dresden, "ordered her to paint without any clothes on so that her skin could breathe."[56] In summer 1898, Becker's rapturous description of her travels through Denmark to Lilleon in Norway and subsequent move to Worpswede revealed a more flagrant conjunction of pantheistic eroticism: "And one surrenders to her, great Mother Nature, fully and completely and without reservation. And says with open arms, 'Take me!'"[57] Yet this paean to nature was also mediated by her acquaintance with Böcklin's landscapes and literary sources—the novels of the Danish author Jens Peter Jacobsen's *Maria Grubbe* (1876) and *Niels Lyhne* (1880)—that were hugely influential in Europe at the end of the nineteenth century.[58] Jacobsen's narrative of the failed poet and atheist Niels Lyhne, which combined the bittersweet elements of romantic tragedy and nature lyricism, found great resonance in an artistic and literary generation schooled in Nietzsche's writings. "Nature" was indeed considered the new tutor of these early modernists, but in view of its appeal to various anti-urban constituencies, its meanings were inflected with shifting ideological associations.[59] For the purposes of the ongoing discussion, Becker's upper-middle-class status guaranteed her ownership of social—if not political—citizenship, her death preceding women's participation rights by the repeal of the Prussian Law of Association in 1908 and the granting of women's suffrage in 1919.[60]

Between Worpswede and Paris

Significantly, Becker's contact with the Worpswede group of artists heightened her awareness of city and country debates. By 1889, in a spirit of antiacademic defiance, Fritz Mackensen and Otto Modersohn founded the colony after completing their studies at the Düsseldorf Academy. Here they were joined by Hans am Ende, a colleague from Munich, as well as in later years by three further Düsseldorf-based students, Carl Vinnen, Fritz Overbeck, and Heinrich Vogeler. Their appropriation of this locale and its inhabitants for new and "authentic" subject matter paralleled discourses in cultural criticism that favored the agrarian over and above the insidiousness of urbanization.

In particular, they were enthused with the almost fanatical writings of the cultural critic Julius Langbehn who, in his tome *Rembrandt als Erzieher* (Rembrandt as Educator, 1890) extolled the virtues of a specifically northern and Protestant German nationalism. In fact, he seized on the northwestern region (to the south of Bremen and Worpswede) as having given rise to the *niederdeutsche* (Low German) peasant, a characterization that he somewhat irrationally attributed to Rembrandt. Spiritual and cultural renewal, while tied to the physiognomy of the rural heartland and the uncorrupted "childlike" peasant, was nonetheless saturated with colonial knowledge, as is revealed in the following passage:

> The Low German colonization reaches spiritually and politically over the whole of Germany, as it reaches economically and materially already for a long while from the Volga up to the Bay of Alaska. The center of these noble aspirations lies in the northwestern lowlands. From here outwards, the Low German way of thinking and morality spreads itself, in a semi-circle, over the temperate zone of our earth; the region of its activity resembles an expanding fan or, if one wants, the artful web of a spider.[61]

Germany's engagement in colonial expansion abroad powerfully reinserted such discourses of racial supremacy within metropolitan society.[62] The acquisition of protectorates in Africa and Oceania from the mid-1880s was echoed by German colonists' search for *Lebensraum* on the European mainland, the vigorous *Drang nach Osten* (Thrust toward the East) that is typical of Langbehn's writing.[63] In their attraction to his ideas, neither the liberal reform nor the abstract utopia entertained by this predominantly middle-class group of artists could escape the implications of imperialism.

While Worpswede was far from a glamorous rural retreat, apart from a large hill known as the Weyerberg that adjoined the village, the environs offered a landscape of extensive low-lying moorland—including the so-called Devil's Moor—and atmospheric, cloud-laden skies. Yet, as has been shown, the tracts of land from which the peasant community wrung meager existences from peat cutting and small-scale farming were far from primordial.[64]

Modernization in the mid-eighteenth century resulted in its specific topography: avenues of birch trees were planted to serve as windbreaks, and narrow canals, which were dug for drainage, led to the Hamme River, along which narrow boats transported peat to Bremen. By the time that Becker settled in, the group had enjoyed considerable success in charting these characteristic landscape motifs that, along with the inclusion of an occasional costumed peasant girl and thatched hut, contributed to a forceful mythology of the region as untainted by industrial connotations.

In an early painting entitled *Moor Canal* (fig. 17), Becker readily adopts motifs that were familiar to the Worpswede repertoire—a sharply receding waterway that cuts through the moorland and leads to a thatched cottage in the distance.[65] Moreover, she heightens the associative qualities of immersing the viewer in nature and conjuring the effects of a moisture-laden atmosphere both in the activated expanse of sky and the reflective surface of the canal. But while this indicates that she easily slipped into an established rather than an invented routine, she also worked against these conventions in refusing to mask the realities of human intervention in the landscape. The canal cuts an irregular groove in the land that is hardly picturesque, alerting us repeatedly to its pictorial function as both facture and illusion. The surrounding moors expose the layering of peat cutting as earth-brown patches of coloration that disrupt an overall harmony of the limited palette. Hence, while the primal qualities of the Worpswede landscape are conveyed in its mood-evoking qualities, the painting resists easy categorization as a mere myth of the place.

Evidently, the artists' colony provided an "emancipatory space"[66] for Becker and a number of women students— Clara Westhoff, Ottilie Reyländer, and Marie Bock, among others—until they themselves were drawn into the imaginary, idealized model of bourgeois family sociability that was adopted in Worpswede.[67] Here, as opposed to Berlin, Becker was able to have her own studio and a freer lifestyle, which made her appear strange to herself. She became aware of the incongruities in her reading taste—at the same time she was enjoying a copy of Bismarck's letters to his bride, she was swept away by Goethe's sensational novel *The Sorrows of Young Werther* and Bashkirtseff's journals: "Bismarck, Werther, Marie Bashkirtseff, Worpswede—all

of that in one little head," she commented.[68] Alerted to the performative elements at the core of her identity, she continued, "I look at the bustle of the world as if I was in the dress circle and, as befits my seat in the theatre, I really don't think much about it. Up to now one has been playing a rather large role on one's tiny stage. The playing has come to an end now."

The theatrical metaphor is useful in considering the seriousness of her project, particularly in that she soon abandoned landscape painting in order to devote herself to observing the various characters on her Worpswede stage. She, too, was caught up in the excitement over

17 Paula Modersohn-Becker, *Moor Canal*, ca. 1900, oil on board, 53 × 32.5 cm, Kunsthalle Bremen, Bremen

Langbehn's ideas, and her encounters with the "peasants" are encoded in a language that reveals the artist's various roles as explorer, ethnographer, and colonizer.[69] Becker's notations in her journal attempt a quasi-scientific validation of her experiences, yet at the same time they betray the sensibilities of her metropolitan-based, upper-middle-class upbringing. While claiming völkisch authenticity for the locals, she declared their "Otherness," their difference:

> One hears a pure Lutheran dialect out here. Every day one hears the coarse and common expressions that really call a thing by its name. When I take the old woman by the arm and lead her up to the door, she says, "First I have to take a piss"—or, "First I have to let my water." Then up comes the dress, and I flee in my virgin chastity.[70]

The term "peasants" must be used reservedly since Becker also focused on inhabitants drawn from the local poorhouse, who were only too grateful to pose as models for the meager fee she could afford. Indeed, their biographies were paradigmatic of the late nineteenth-century dissolution of rural communities and upheaval in social relations. Certainly Becker was aware of the power she exerted in this capacity, acknowledging that "she blushed inside, hating the seducer in me" when bribing the little girl Meta Fijol with a mark to pose undressed for her.[71] Hence, in her writing—and she ventured into the fairy-tale genre— Becker's nostalgic desire for a temporality based on eternal myth, fable, and folklore tended to override the incursions of modern-day existence.[72] She remained undeterred from claiming pious simplicity for the elderly women, autochthonous fecundity for the nurturing mothers, and dream-laden, fantasy worlds for the young maidens.[73]

Can we say that her figural works similarly perpetuated an essentialist mythology of the rural idyll or, as evinced from the landscape above, "differenced" the genre? Her figural compositions were approached traditionally through the production of various croquis in preparation for the final painting. Hence, before 1900, Becker assembled a vast repertoire of sketches that served as ongoing inspiration for her works. In her serial experimentation with various formats, she took heed of her initial instruction under Mackensen.[74] In one of her many early sketches

18 Paula Modersohn-Becker, *Three Composition Sketches towards Seated Old Woman*, 1898–99, pencil on paper, 40 × 26 cm (Sketchbook II/15), Paula Modersohn-Becker-Stiftung, Bremen

toward a composition, *Three Composition Sketches towards Seated Old Woman* (fig. 18), although the initial studies probably derived from the domestic setting as portrayed in the lower left, in the other vignettes Becker opened up the background to reveal the horizon focusing either on the silhouetted avenue of birch trees or on placing the figure frontally against the farm building in the rear. In both instances, Becker set the portrait emblematically against the constructed typicality of the region, signaling to us that she was cognizant of a receptive audience already initiated in the Worpswede phenomenon.

Evolving out of the same motif, the portrait *Seated Old Woman with Cat* (ca. 1904) (fig. 19), although showing an interest in the regional peculiarities of the costume, defies

19 Paula Modersohn-Becker, *Seated Old Woman with Cat*, 1904, oil on board mounted on canvas, 73.3 × 57.8 cm, Kunsthalle, Emden

the agrarian romanticism of Mackensen's peasant imagery. Indeed, in its austerity and interest in physiognomic idiosyncrasies, the painting bears comparison with the ethnographic mug shot. But here the power dynamics of the colonial, as well as the male gaze, are problematized as the image partakes of the viewer's space; the densely woven facture of the gnarled face and hands loom out from the summary blackwash. Startling in their lack of symmetry, the eyes are portrayed as though unseeing or blind. The portrait simultaneously bears a forceful immediacy and elements of alterity. It is understandable why Otto Modersohn agonized at the time: "Paula hates to be conventional and is now falling prey to the error of preferring to make everything angular, ugly, bizarre, wooden. Her colors are wonderful—but the form? The expression! Hands like spoons, noses like cobs, mouths like wounds, faces like cretins."[75] Here he introduced the discourses of medicine and science that categorized deviations from the norm as signs of "degeneracy," symptoms of the negative associations of the "modern" and the "foreign."

Eleven years her senior, Modersohn both admired and fretted over his spouse's talents, revealing that the generation gap was far greater than expected. Even prior to their marriage in 1901, Becker had reassessed modern German

20 Paula Modersohn-Becker, *The Confirmed*, ca. 1903, charcoal on paper, 35.5 × 16 cm, private collection, London

consorts. All of them are still stuck too much in the conventional."[77] While effusive about the native Breton art of Charles Cottet that was exhibited at the exposition, in the company of the sculptor Clara Westhoff it was their first viewing of Cézanne's works at the private gallery Vollard that apparently opened up new perspectives for her.[78]

From Paris, she wrote to her brother Kurt, reminding him of the importance of youth and the "nerve system" of their own generation. She advised him to "embody an idea, to live, that is what I wish for you and for all our German men. They lose their feathers much too soon on the field of battle and become Philistines."[79] As though at a threshold, she displayed Nietzschean conviction in the importance of her own creative agency to the development of a new era, her interest in the notion of youth as a regenerative principle responding to various aesthetic and intellectual imperatives at the turn of the century. The term "Jugendstil," or "youth style," gained currency through circulation in the Munich-based periodicals *Jugend* and *Simplicissimus*. Indeed, as artistic director of the magazine *Die Insel*, Heinrich Vogeler was the most active of the Worpswede group in embracing the interrelationship between art and life. Owing a debt to the Pre-Raphaelites, his illustrations of wistful young girls set in the rural landscape rapidly gained recognition. In producing designs destined (though unfulfilled) for *Jugend* and commercial outlets, Becker, however, evoked the simplified distortions of child art in subsuming the silhouettes of children and young girls into the decorative contours of this international style.[80]

The centrality of childhood to notions of cultural reform were endorsed in her erratic relationship with the poet Rainer Maria Rilke, an interaction that has been sensitively negotiated in author and poet Eric Torgersen's double biography, *Dear Friend: Rainer Maria Rilke and Paula Modersohn-Becker*.[81] Rilke's arrival in Worpswede in August 1900 created both a frisson and intrusion in the artistic "family" community. His Central European and Catholic origins introduced a dimension of foreignness to the *Plattdeutsch* milieu, and though he and Westhoff married and eventually relocated to Paris, Becker sustained contact with them through the remaining years of her life. Rilke's friendship with the Swedish woman feminist and writer Ellen Key (1849–1926) strengthened his dream of a new modern movement.

painting and voiced her independence from the mold of the artist colony. In 1900, she attended the World Exposition in Paris, a key spectacle that represented the politicization of culture and its use as an important factor in the struggle for power between the nations.[76] She detected the compromise between a conservative and a modernist language in the works selected for the section of German contemporary art and wrote perceptively: "Now I can feel how we in Germany are far from being liberated, that we do not rise above things, and that we still cling too much to the past. I sense this now about Liebermann, Mackensen, and

In 1902, in his review of her publication *The Century of the Child*, he brought children and modern artists into close comparison: just as the academies destroyed artistic development, so schooling stifled children's individual creativity.[82] The necessity for artists to retrieve their lost childhood connections to nature proved a dominant theme of his monograph on the Worpswede group, which was published in 1903.[83] Interestingly, in preparing his research for the manuscript, Rilke wrote to each of the five painters requesting "a few memories out of the milieu in which you grew up, the traces of a few important early impressions."[84] Such preoccupations are tellingly consistent with Freud's primordial inscription of childhood as "infantile amnesia," which "turns everyone's childhood into something like a prehistoric epoch" in recovering the beginnings of one's sexual life.[85]

As we have seen, Becker shared similar theoretical preoccupations in wanting to see nature anew and, indeed, even reported to Rilke that she held great admiration for a "portfolio with highly original children's drawings" that she came across in her studio.[86] Unlike the more conventional reverence she displayed toward Otto Modersohn, Becker's initial relationship with Rilke constituted an intense (and at times flirtatious) exchange of like minds. Yet their collaboration went further: while he submitted his verses for her scrutiny, in early 1901 Becker allowed Rilke access to her journal before he had detailed knowledge of her actual works.[87] Their interaction filtered into the creative process and, dating from around 1903, one of her drawings, *Die Konfirmandin* (The Confirmed; fig. 20), corresponds to Rilke's poem of the same title.[88] Written in Paris in May 1903 and published in the volume *Das Buch der Bilder* (The Book of Images), the opening verse reads as follows:

> In white veils the confirmed enter
> deeply into the new green of the garden.
> They have understood their girlhood,
> And what comes now will be something
> changed.[89]

For Rilke, the observed or imagined event of girls, who were dressed in their white confirmation outfits and filed through the streets of Paris into a garden, was resonant with meaning. As with Vogeler, the motif of virginal young girls at the moment of sexual awakening was a compelling fantasy of male subjectivity.[90] Therefore, as the translator of

Rilke's poetry suggests, the word "Bild" designates an image that works as a metaphor—a figurative entity pointing to realities beyond or behind it.[91]

In Becker's charcoal drawing, while the facial profile and arm are clearly delineated, the whole is suffused with gentle, transparent tonalities. Such suggestive symbolism is rare in her work and possibly arises as well from Modersohn-Becker's personal viewing of Rodin's sketches at Meudon during her second visit to Paris in early 1903.[92] Yet, in responding to Rilke's verse, Becker retrieves the "Bild" not of a nymphlike Parisian girl but of an altogether earthier figure—that of Vogeler's bride Martha Schröder.[93] In this manner, the artist populates the visual realm with traces, remembrances, and intimations of Martha's lost childhood, bringing back to life Vogeler's Pygmalion-like project to cultivate the peasant girl as the perfect spouse. Vogeler and Schröder first met in 1894 in Worpswede, when she was fourteen years old, and they married in 1901.

In an inimitable, jarring manner, the disjuncture between rural Naturalism and modernist devices provides some insight into Modersohn-Becker's critique of Rilke's "un-German" beautiful sentences in his monograph on the Worpswede group. Feasibly, Modersohn-Becker was sensitive to the fact that he had referred to her as "femme d'un peintre allemand très distingué" in a letter of introduction to Rodin, and she expressed impatience with Rilke's cosmopolitanism and associations with the "great spirits of Europe."[94]

Whereas a photograph of the artist in her studio around 1905 (fig. 21) would appear to reinforce her clinging to a sense of north German provincial identity, the tensions between her two worlds of Worpswede and Paris were all too real, particularly after her third visit to the capital earlier that year. Photographed in a plain black dress with a white lace collar and wristbands, as though she had just stepped out of a canvas by Vogeler, her pose emulates that of the Raphael Doni portrait reproduction that hangs to her right. As an embodiment of grace and virtue, her femininity contrasts with the ungainly portrayal of the old peasant woman and child in her unframed painting that leans against the heraldic lily wall covering.[95] While for her husband Otto, such works—in their reference to "primitive pictures"—lacked technique and restraint of form,[96] for Rilke, in correspondence with his new patron, the collector

Von der Heydt, they represented a very important stage in the development of her art:

> I found her painting recklessly and directly, as though driven, things that are very Worpswede-like and yet which nobody else had seen or could paint in that way. And they were, in their own very individual way, strangely close to van Gogh and the direction which his painting took.[97]

Paris

In late February 1906, Modersohn-Becker's fourth and final visit to Paris was undertaken in secrecy, a decision in which Rilke and Clara Rilke-Westhoff played a considerable role. Notwithstanding the sanctuary she found in the studio hired from the Brunjes family in Worpswede, in which she could "play Paula Becker," the domestic duties of married life and caring for Modersohn's daughter Elsbeth increasingly eroded the time that she could dedicate to her painting.[98] Of major significance, too, was the lack of consummation of her marriage of five years, a factor that has been acknowledged in the literature.[99]

As in her prior visits to the capital, she enrolled for tuition—on this occasion at the École des Beaux-Arts—in drawing, anatomy, and for a lecture course in art history. Her attraction to Paris had not waned, and her journals and correspondence function as a mirror of her experiences of urban modernity.[100] Here we find ample evidence of the possibility of the flaneuse, Modersohn-Becker feeling just as at home in the crowd walking "along the Seine to the Jardin des Plantes" as viewing the "world promenade past" from a café along one of the boulevards.[101] The woman artist roamed the city and clearly resisted the conventions that circumscribed the movements of middle-class women in the nineteenth century, her in situ charcoal sketches rendering the passing spectacle.

Yet it was precisely in the dialogue between the metropolis and the private studio that she measured her progress, as she wrote to Martha Vogeler of her routine, "I'm living here in a large, bright atelier . . . I love to fall asleep among my paintings and wake up with them in the morning. With faith in God and myself, I'm painting life-size nudes and still life . . . After working all day wrapped up in oneself, this huge city seems so strange in the evening, as if one were looking at a picture book."[102] The intensity and isolation of her period of production suggests a mode of consciousness outside of normal daily existence, a suspension of time consistent with notions of liminality.[103] In the same way as her perceptions of the city seemed mediated by the two-dimensional frame of a "picture book,"

estrangement from Otto Modersohn.[105] The soft pastel colors and the background wallpaper could be construed in terms of a feminine aesthetic, evoking the decorative interiors of Édouard Vuillard. However, unlike his paintings, in which the domestic sphere frequently undermines the visual autonomy of female figures, Modersohn-Becker portrays her body as a corporeal presence.[106]

For its departure, she certainly referred to the grainy photographs of her reflected image that were taken by her sister Herma that spring (fig. 24). However, the face, ruddy in complexion, takes on the modulated planar definition and lozenge-shaped eyes of Egyptian sculpture and, as has been observed, "rare is the image of a naked woman whose head so outweighs her body."[107] Her eyes meet and hold our gaze as we are directed, by way of the string of amber beads, downward past her breasts to the distended abdomen. That she should portray herself in early pregnancy precisely at the time of separation from her husband and nonconsummation of her marriage has led to much speculation, inviting associations with the iconology of the Madonna del Parto.[108] In addition, the maternal fantasy signifies the creative potency of the woman artist, a status that Modersohn-Becker fervently hoped she would achieve by the age of thirty.[109]

On first inspection, then, the self-portrait anchors the personal in the collective, in the world of "anniversaries, family relationships, roles, and careers," to quote Torgersen.[110] Instructively, the painting was produced a few months after her mother, when proffering birthday wishes, revealed her earliest memories of her daughter's birth in Dresden-Friedrichstadt.[111] Feminist art historian Rosemary Betterton interprets this commemorative painting in light of Lacanian notions of regression to a construction of infantile pleasure: "Lacan's account of the acquisition of sexed identity, the mirror image reflects the self as coherent, but this image of coherence is a fantasy."[112] In agreement with Betterton regarding the delusional expectation of coherence, I argue below that the fantasy of maternal subjectivity is based on the disjuncture of part objects (the head and the body) and that the nude self-portrait is better understood as an assault on patriarchal language.

On closer inspection, we find that Modersohn-Becker frames the fantasy of the body within the tropes of high art and avant-garde practice, the robe, draped at hip level,

23 Paula Modersohn-Becker, *Self-Portrait on Her Sixth Wedding Anniversary*, oil on board, 101.8 × 70.2 cm, Kunstsammlungen Böttcherstraße, Paula Modersohn-Becker Museum, Bremen, Paula Modersohn-Becker-Stiftung, Bremen

24 Herma Becker (?), *Paula Modersohn-Becker in Her Paris Studio, Study for "Nude Self-Portrait with Amber Necklace, Half-Length,"* 1906, Paula Modersohn-Becker-Stiftung, Bremen

suggesting a particular source—the *Venus de Milo*. In 1900, she admired the sculpture during her first trip to Paris, and her later interest was possibly rekindled in discussions with Rilke while he attended portrait sittings in her studio.[113] On May 29, 1906, in the company of Ellen Key, Rilke wrote of his visit to the Louvre, where they viewed "the splendid object [*Venus de Milo*] . . . and she appears down there, in front of her curtain, only seeming to wait for such sentimental photographers."[114] Located in the *salles des antiquités* at the Louvre, the statue, which was set against the sumptuous red of a deeply folded curtain, presided over a section of the long gallery lined with other divinities (fig. 25).[115] In emphasizing its installation as public spectacle, Rilke

testified to its importance as a site of pilgrimage, as well its value as a souvenir in mass reproduction.

Besides its erotic allure, the currency of the image as sexualized object was adapted to various disciplines, including those of medical illustration. An extraordinary adaptation of the Melian Venus to the discourses of anatomy and national predisposition can be found in a tome on natural remedies and treatment that was destined primarily for a female readership, and underwent frequent reissues after its initial publication in 1905. In the text *Die Frau als Hausärztin* (The Woman as Family Doctor), the author Anna Fischer-Dückelmann advocated reform dress and the rejection of corsets so as not to hamper the reproductive functions of the woman's body (fig. 26a).[116] Here the "healthy" unfettered torso of the *Venus de Milo*, the drapery just concealing the *mont de Vénus*, is favored over and above the narrow-waist, deformed, and immodest, skeletal structure of the fashion-conscious French lady. The headless torso and drapery of the Venus figure once again supply

25 *Statuary Halls Leading to the Famous Venus de Milo (in Distance), Louvre, Paris*, ca. 1900, gelatin silver print, Underwood and Underwood (America, founded 1881, dissolved 1940s), the J. Paul Getty Museum, gift of Otto Wittman

the departure for promoting a natural form of support for the breasts, as encouraged in Swedish practice (fig. 26b).

Modersohn-Becker's predilection toward Scandinavian-inspired exercise drew on the current vogue for naked body culture (*Nacktkörperkultur*), as conveyed in a letter containing drawings of *Family Life* (figs. 27a and b).[117] Like the serial imagery encountered in comic strips, these thumbnail sketches impart—with deftness, humor, and wit—her efforts to maintain a healthy, toned body. The self-portrait, however, engages with the "reproductive" body of the Venus, and the addition of narrative gestures, rather than imparting an illusion of hiding the genitals (as in the "pudica"), cradle the womb. Given her contact with Rilke's milieu and his meeting with Ellen Key precisely at this time, it is possible that the latter's feminist ideas on sexual difference and the importance of motherhood to national identity could have informed the artist's preoccupations.[118] Rather than a "deformed" stereotype of French femininity, the "vessel" of the body could be interpreted in light of debates in Germany surrounding notions of *Mütterlichkeit* (motherliness). As recounted in the first chapter, such ideas on maternalism were prevalent in both conservative and enlightened quarters of the body politic. But Modersohn-Becker's conceptual leap was more radical than this. In conjoining an overscale, archaized portrait and state of pregnancy into the Western rhetoric of the Aphroditic nude, she confounded the legibility of the type and disrupted the strategies of male scopophilic viewing.

In 1921, Karl Scheffler, for instance, in his review of Gustav Pauli's biography of the artist, seized on this particular work as provocative. Indeed, he argued that "the woman artist tastelessly painted her self-portrait naked from the navel upwards, in the advanced stage of pregnancy, or that she liked painting nude women with children hanging from full, obtrusive, productive breasts, is however no proof of 'Mütterlichkeit.' It is only an indication of tendentious lack of discrimination."[119] Having no way of categorizing such flagrancy, Scheffler subsumed the artist's work within the limited purview of *Frauenkunst* (women's art), whereby Modersohn-Becker pursued a middle path and treated the north German village of Worpswede and its inhabitants "as though it was Gauguin's Tahiti."[120] How revealingly the critic brings together contemporary discourses on the regional, modern, foreign, and colonial

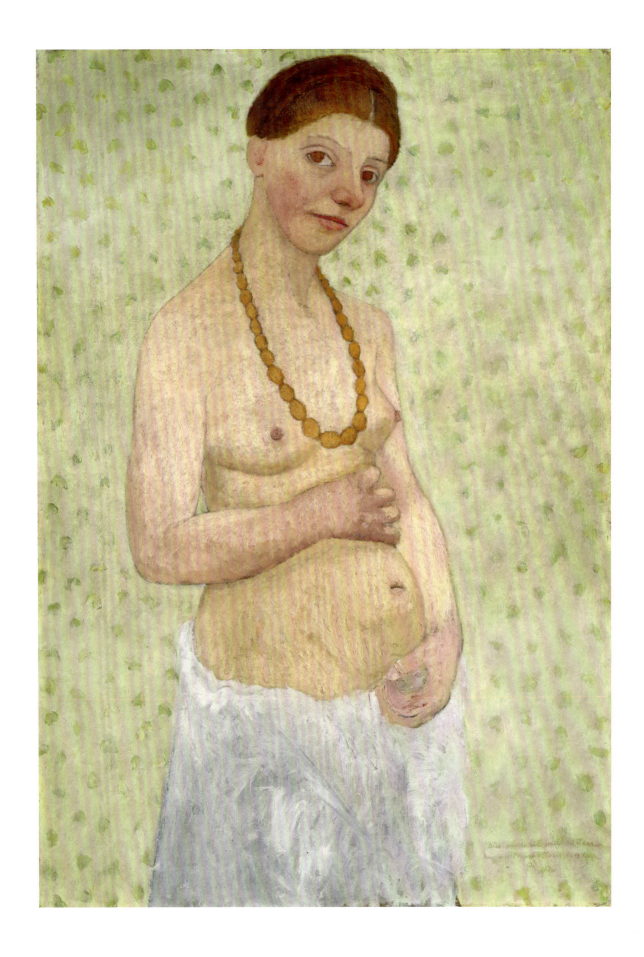

so her configuring of the studio space assumed the "betwixt and between" of her threshold position. In a drawing of her last Parisian studio on the rear of an envelope (fig. 22), while the intersecting flaps of paper appear to function as receding orthogonal lines, the scale of objects to the rear preserve the integrity of the surface. Moreover, the prominence accorded to the vertical and horizontal coordinates of her three paintings signal a redefinition of the observer's status in keeping with the modernist viewing experience in a gallery space.[104]

Modersohn-Becker's life-size nudes and maternal figures are portrayed in just such a local and yet unidentifiable space, their monumental bodies almost squeezing out illusionism, as the medium and process take precedence. Her renewed acquaintance with the works of Gauguin and Cézanne, as well as endorsement from the German sculptor Bernhard Hoetger, who was studying in Paris under Rodin, led her to abandon the specificity of her Worpswede models in favor of a more generalizing primitivism. Nonetheless, the impact of her *Self-Portrait on Her Sixth Wedding Anniversary* (fig. 23) lies in an unusual deployment of global north and south referents, and personal experience and collective memory, resulting in an unexpected relationship between the nude woman artist and the body politic.

While most of her self-portraits are set against a neutral ground or semblance of nature, this painting is supplied with identifiable spatial and temporal coordinates. It was probably located in the "large, bright atelier" mentioned above, on 14 Avenue du Maine in Montparnasse, and started on the fifth anniversary of her marriage (May 25, 1906), since she preceded her signature with an inscription on the base of the painting, "Dies malte ich mit 30 Jahren an meinem 6. Hochzeitstage/P. B." (I painted this aged thirty on my sixth wedding anniversary/P. B.). As Diane Radycki informs us, Modersohn-Becker's use of her maiden name in the initials was a symptom of her

26a and b Illustrations from Dr. Anna Fischer-Dückelmann, *Die Frau als Hausärtztin* (Stuttgart: Süddeutsches Verlags-Institut, 1913), 132, 158, University of Toronto Libraries

("Gauguin's Tahiti"). Yet what was anathema to Scheffler in the hands of a woman artist was evidently the object of veneration for urban-based collectors who were conversant with developments in France. As the art historian Nina Lübbren convincingly argues, primitivism was a permutation of agrarian romanticism, and by the end of the nineteenth century, the image of European peasantry and nature had exhausted itself: "Nostalgia had now to cast its net wider and beyond rural Europe."[121]

Familial pressure and the nagging reality of her economic dependence on her husband accompanied Modersohn-Becker's brief though intense sense of achievement as an autonomous artist. In November 1906, she and Otto reunited in Paris and their marriage was consummated. For Rilke, Paula's resumption of married life and domesticity had compromised her art, yet we are aware that some of her most memorable reinventions of the Worpswede genre were undertaken following her return in March 1907. In his poem "Requiem for a Friend," Rilke also considered the birth of her child a fatal mistake, her

sacrifice resulting in a common, bodily female death rather than in the transcendent work of art.[122] However, for other commentators, particularly at the height of war-weariness, the reproductive configuration of the woman artist and her mortal destiny were not a matter of mere statistics but the substance of a powerful regenerative myth.

The Afterlife of Modersohn-Becker

Interestingly, Gustav Pauli's promotion of Modersohn-Becker's oeuvre anticipated her final return to Germany. In November 1906, four of her paintings were included in a group exhibition devoted to the artists of Worpswede that was held at the Bremen Kunsthalle. Here Pauli attempted to prepare the "untutored glance" of the public for the radical aspects of her powerful talent, which were informed by the "incomparable culture" in Paris.[123] Consistent with their policy of collecting recent French painting, the works of living German artists, and of patronizing regional schools, the Kunsthalle acquired three still lifes from her estate. Instructively, the *Still Life with Apples and Bananas* (1905) drew on the inspiration of Cézanne and, as we have seen, the *Still Life with Sunflower and Hollyhocks* (see fig. 11) on that of Van Gogh. Though her paintings were purchased at a fraction of the price compared to those of Manet, Monet,

27a and b Paula Modersohn-Becker, *Pictures of Family Life on November 3, 1905*, letter with drawings for Frau Becker's birthday, charcoal and pencil on paper, 27.8 × 18.9 cm, Paula Modersohn-Becker-Stiftung, Bremen

or Pissarro, the director's need to defend his acquisition of modern foreign works became interwoven with his promotion of the woman artist.[124]

Soon after her death on November 30, 1907, her name was associated with various exchanges in the local press between what could be considered an enlightened official culture and a conservative bourgeois backlash.[125] In many ways this discourse in the public sphere anticipated the sentiments expressed in the former Worpswede artist Carl Vinnen's essay "Quousque Tandem," which introduced the pamphlet *Ein Protest Deutscher Künstler* (A Protest of German Artists), published in 1911.[126] Ostensibly triggered by the Bremen Kunsthalle's purchase of Van Gogh's painting *Poppy Field*, at what was considered an inflationary price, the protest attacked the role of dealers, museum directors,

and critics in promoting French art and neglecting national interests.[127] While the basis of Vinnen's accusations was indeed fictional, it mobilized dissatisfaction in other regional centers like Munich and Düsseldorf, where the signatures of 118 artists and 16 critics were collected. Many viewed the internationalization of the Berlin art world with great suspicion.

Inevitably, Modersohn-Becker's links with Worpswede and engagement with French avant-garde aesthetics meant that her contribution was circumscribed by the Vinnen affair and her oeuvre categorized as different, as "Other," to his parochial interests. Anton Lindner, for instance, whose exhibition review we encountered in the opening paragraphs of this chapter, also had another agenda for categorizing Modersohn-Becker as an Expressionist. He pointed to the importance of her cosmopolitan experiences in Paris as being essential to counteract provincialism and attested to these by quoting extensively from her letters and journals. Drawing on the polemical debates raised in Vinnen's *Protest*, Lindner cited these as belonging to the

most embarrassing documents of the German provincial spirit, which for a long time served to compromise the newest history of art.[128]

On the eve of the First World War then, it would seem that Modersohn-Becker's works escaped inscription in the chauvinism that was rife among German intellectuals at the time. Interestingly, in the left-wing journal *Die Aktion*, the critic Ludwig Bäumer took Lovis Corinth to task for his nationalistic fervor in attacking modern painting in his lecture "Über Deutsche Malerei" (On German Painting), which was delivered to a student audience in Berlin in 1914.[129] Critical of Corinth's Prussian arrogance, Bäumer seized on the cultural diversity of German art, claiming that Modersohn-Becker's contribution was equally inscribed with genius: "They [her works] are now in the property of people who honor the tremendous scope of this art."[130] His acknowledgment of her oeuvre borders on ideas of the uncanny, of the discovery of that which was hidden or repressed and has now come into the light.

This was also characteristic of the changing historiography of Expressionism. Although documentary histories excluded contemporary women artists from surveys of the period, they nonetheless inscribed issues of gender and ideology into interpretations of the movement. Surprisingly, in 1916, in his book *Expressionismus*, the art and literary critic Hermann Bahr was less dogmatic about the gender of the artist and, in a compelling fantasy, he cited a young woman as the exemplary Expressionist. He located her not in the fashionable city but firmly in German territory, in the untainted Eastern provinces. On entering her studio, it was as though he was suddenly in the center of Paris, the young lady painting after Matisse and Picasso.[131] Although unworldly and untrained (she painted purely for pleasure), she was acquainted with the new painting merely from art magazines. Impelled by the modern artistic will (*Kunstwollen*), she could do no other than follow these instincts: "She paints as she must paint, she can do no other."[132]

Bahr was familiar with art-historical methodologies that explained changes in style according to the concept of *Kunstwollen*, and he was one of the few commentators to refer explicitly to the Weltanschauung as being determined by different modes of perception.[133] Here he distinguished between the *Auge des Leibes* (the eye of the body), which

was characteristic of the Impressionist, and the *Auge des Geistes* (the eye of the spirit, or the soul), which had been inherent in the earliest art (*Urkunst*) and now in Expressionism.[134] From the extract above, the woman painter emerges as the paradigmatic "modern primitive," who was able to access those primal sources of creativity in the face of modernity. Bahr was writing at a time when Germany had suffered staggering reversals on the battlefield and disillusionment had set in with mechanized warfare of a kind that no one had imagined.[135] Fiercely anti-technological and antibourgeois, he characterized the era as a "battle of the soul with the machine," articulating the desire for a prelapsarian state of innocence.[136]

In somewhat cruder terms, these themes dominated the promotion of Modersohn-Becker's works, the faces of her old women, "whose listless pupils gaze from the heaven of an unfamiliar world, no longer troubled by the earthly and temporal," were regarded as archetypal, as the "ur-language" of a woman artist, whose vision was that of "a woman seer or prophetess, that at the same time was child and woman."[137] A tireless supporter of Modersohn-Becker, the critic C. E. Uphoff elaborated on the close relationship between the body of the woman artist and the creative process:

> As a woman artist, Paula Modersohn did not lose her womanhood, and to be a woman means to be a non-programmatic person, always and eternally. She had no aesthetic, moralistic or other criteria, by which application existence somehow always falls too short . . . In order to seize a subject, be it out of the intelligible, be it out of the esoteric world—felt through with all senses, all emotions, all understanding, encompassed at a glance—in other words to be able to experience it, the most fervent relationships between the person and the subject, between the creator and his object is necessary. For this there needs to be no less than union of bodily and psychic identity—a lovingly-felt, passion-thrilled pairing—in reality: the total fervor of procreation.[138]

As we have seen, this reinvention of the maternal as the bearer of culture has its parallel in the annals of the bourgeois feminist movement. Apart from harboring conser-

28 Title page, *Die Aktion* 8, nos. 13–14 (April 6, 1918),
with illustration of Paula Modersohn-Becker drawing, general
collection, Princeton University Library, New Jersey

were featured on its front cover (fig. 28) and reproduced in
other editions during 1918.[139] In the wake of the October
Revolution in Russia, the journal strengthened its critique
of capitalist imperialism and aligned itself with the aims of
proletarian culture.

However, the canonization of Paula Modersohn-
Becker was not a static process. It generated a following
among other women artists, such as Irma Stern (1894–
1966), who was born in South Africa of German Jewish
parents and based in Berlin during the war.[140] Perhaps
having witnessed the joint exhibition of the works of
Modersohn-Becker, Bernhard Hoetger, and Pauline
Kowarzik at the Paul Cassirer Gallery in Berlin in 1916,
Stern's painting *The Eternal Child*, of the same year, marked
her entry into German Expressionism.[141] Knowledge of
Modersohn-Becker's Worspsweden child portraits, as well
as of the artist's letters and journals, offered the stimulus
for Stern's uncompromising portrayal of the emaciated
young girl in urban Berlin. In 1919, in Hamburg, Rosa
Schapire, in her review of Gustav Pauli's monograph on
Modersohn-Becker, was keen to assert that the artist's
works served as progenitors of Nolde's and Schmidt-
Rottluff's subsequent realizations.[142] Consistent with Scha-
pire's feminist and internationalist outlook, she sought to
position Modersohn-Becker's originality both within early
French modernism and in advance of the canonic male
art history of German Expressionism without resorting
to theories of essentialism or chauvinism within cultural
practices.

Starting in 1915, Hoetger and Philine and Hein-
rich Vogeler were instrumental in launching the Paula
Modersohn-Becker Collection, which was funded by
Ludwig Roselius. This led to the opening of the Paula
Modersohn-Becker House in 1927 in Böttcherstraße,
Bremen, a site that was remodeled by Hoetger, the first
museum dedicated to a woman artist (fig. 29). Instructively,
in 1929, the Hanover-born artist Marie von Malachowski
(1880–1943), who befriended Modersohn-Becker at the
Académie Julian in Paris in 1905, rekindled the influence
of her colleague's works.[143] It is understandable how this
sanctuary—in which the primitivized, nude maternal
image was ennobled in a niche—gained regional and
national attention during the Third Reich. Notwithstand-
ing Roselius and Hoetger's pursuit of *völkisch*-Nordic

vative referents of national regeneration during the war,
maternalism was presented as the fostering of a specifically
female culture and regarded as worthy of counteracting
the negative effects of masculine science and industrial
technology.

Unwittingly, in the context of the First World War,
Expressionist intuitionist theory endorsed these tenets
and provided the coordinates for the feminization of the
movement. Although deceased, Modersohn-Becker's oeu-
vre served as her progeny, her images uncannily evoking the
lost simplicity and harmony of the preindustrial idyll. Such
regenerative ideals appealed equally to left-wing consti-
uencies. Edited by Franz Pfemfert, *Die Aktion* was well
known for its antiwar stance, and it is illuminating that
Modersohn-Becker's drawings of Worpswede peasants

29 Bernhard Hoetger, *Paula Modersohn-Becker House*, Böttcherstraße, Bremen, 1927 (destroyed during the Second World War), photograph, Rudolph Stickelmann, image courtesy of Paula Modersohn-Becker-Stiftung, Bremen

ideology and support of the regime, the museum complex was rejected by Hitler and labeled as undesirable "Böttcherstraßen-Kultur" in 1936.[144]

In her essay on contemporary women artists at the millenium, "Mediating Generation: The Mother-Daughter Plot," Lisa Tickner observes, "This is the first generation in which women artists have grown up with both parents."[145] Therein Tickner was able to consider the changing relations of gender and generational models encompassing "strong precursors," as well as anti-genealogical subject positions. However, in the early twentieth century, between empire and emancipation, and, indeed, well into the Weimar period, the evidence points to the importance of "real and elective artist-mothers" to women practitioners' self-determination and negotiation of the public sphere. Serving as a reverse discourse, this genealogy undermines conventional narratives of Expressionism, providing the opportunity to explore how generations of women artists were able to "think through their mothers."

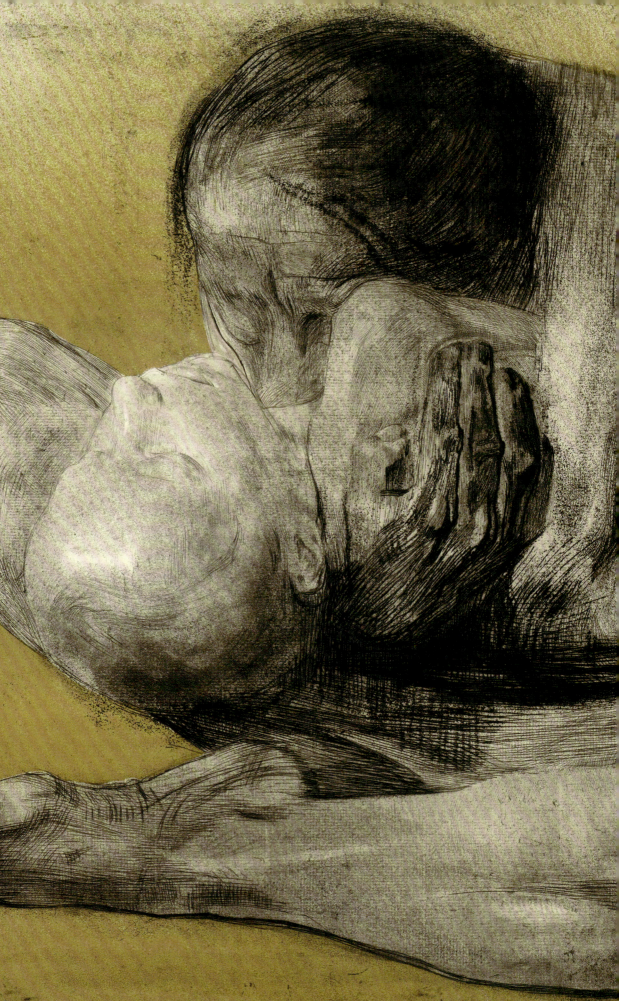

3

KÄTHE KOLLWITZ, THE EXPRESSIONIST MILIEU, AND THE MAKING OF HER CAREER

Alongside the Norwegian artist Edvard Munch, who is often considered the "father" of Expressionism, Käthe Kollwitz (fig. 30) has been proposed as the movement's "mother."[1] In the case of Munch, already in 1912 a major retrospective of his works was organized at the Cologne Sonderbund exhibition in an effort to propound a specifically Northern, as opposed to a French, lineage for Expressionism.[2] However, Kollwitz's relationship to the Expressionist milieu is not as clearly researched in the historiography and, with the exception of Ernst Barlach, she consistently proclaimed remoteness from its major exponents.[3] Indeed, as established in chapter 1, posthumous canonization of Modersohn-Becker seized on her as a progenitor of Expressionism!

Unlike other women artists considered in this book, Kollwitz's name has become canonical, as well known as many male artists of the period, like Grosz or Dix. The literature on her is extremely rich yet monographic, at times encoding her theory and practice as synonymous with the socially engaged content of her work. In the Derridean sense, the power of the name "Kollwitz"—marking her entry into language—has become at once singular and singularly untranslatable.[4] Yet her specialization in draftsmanship and print culture points to a complex negotiation of gendered authorship and the structures of artistic practice in Germany in the late nineteenth and early twentieth centuries. Indubitably, she engaged in the diversification that arose from the immense transformations in the reprographic industry.

The interests of this chapter lie in "renaming," in mapping out the less feted and predictable terrain of Kollwitz's meanings in relation to Expressionist avant-garde culture. In this vein, studies that explore her interaction with the art world and innovative use of graphic media have brought valuable attention to bear on Kollwitz's artistic development.[5] Kollwitz's figuration (mostly, though not exclusively, of proletarian women, mothers, and children) also draws on various though interrelated discourses—art, politics, feminism, medicine, eugenics, war, and revolution. Feminist and psychoanalytical readings of her figural language—predominantly of the maternal body—have yielded much insight into the relationship between sexual politics, feminine difference, and subjective agency.[6] An examination of patterns of critical reception and their engendering of her practice suggest that there is mileage to be gained in considering public recognition and demand for her works among certain constituencies.[7]

Divided into sections, this chapter outlines her pre-1914, mid-war, and early Weimar career, negotiating the interplay between Kollwitz's private and public life in exploring her

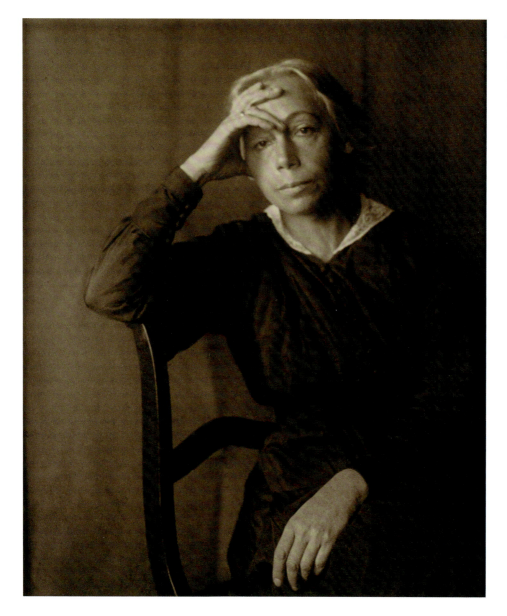

30 Hugo Erfurth, *Käthe Kollwitz*, 1917, bromide silver print, 29.4 × 24.3 cm, Dresden Kupferstich-Kabinett, Staatliche Kunstsammlungen Dresden, Inv.-No. 0919–13

interaction with Expressionism. Clearly, the artist's writings are an important source of reference in this regard; as with Modersohn-Becker, selections of Kollwitz's essays, correspondence, and diaries were published after her death, albeit much later in the century.[8] Functioning as autobiography rather than memoir, as its title suggests, her essay "Erinnerungen" (Recollections, 1923) is frequently interpreted as unmediated testimony; in her psychobiography of Kollwitz, the well-known psychoanalyst Alice Miller construes the artist's writing and imagery as expressive of lingering trauma, the result of a stern upbringing, and guilt over the loss of siblings.[9] However, as has been observed of the autobiographical mode, the role of the narrator is more self-reflective in shaping childhood and adolescence in accordance with the historical present of the adult.[10] Moreover, the complete diaries reveal that the domestic sphere, beyond the fact that the home encompassed her studio as well as her husband's surgery, harbored the potential for social and intellectual challenge, the woman artist's feminism and modernity being inscribed in other relevant ways.[11] In particular, her openness to the new discipline of "psycho-analysis" is significant to this study,

offering greater understanding of the fact that Kollwitz was an informed rather than unwitting commentator when it came to constructing her "Erinnerungen," an admittedly unusual *Lebenslauf* (personal record), for her nomination to the Berlin Academy in the early 1920s.[12]

Important as the Weimar years were to anchoring Kollwitz's activities in the public sphere, the 1920s become all too easily the yardstick by which developments are measured, and for this reason the introductory sections focus on her early artistic formation and relationship to key debates on national culture, the modern, and the foreign.[13] Thereafter, I explore the implications of Kollwitz's first retrospective exhibition in 1917, which was held at the gallery of Paul Cassirer in Berlin and was dedicated to the commemoration of her fiftieth birthday. The exhibition was enthusiastically reviewed in Berlin and at the Dresden venue, the Galerie Emil Richter, previously unpublished correspondence with patrons attesting to demand for her works beyond her capacity for increased production. Kollwitz was no exception to the circumstances in which her works were in demand among progressive museum directors, dealers, and upper-middle-class patrons drawn from the professions. As will become clear, notwithstanding her testimony to the contrary, the coordinates of her theory and practice relate both to avant-gardism and the discourses of Expressionism.

Toward *Griffelkunst*

Although Kollwitz's artistic career was closely intertwined with the metropolis Berlin, consideration of her provincial origins, unconventional upbringing, and training in Munich are critical to exploring her relationship to tradition and modernity. Set against a background of unprecedented social, economic, technological, and political change, her birth as Käthe Schmidt in 1869 in Königsberg (now Kaliningrad) coincided with the flourishing of the city as the capital of East Prussia. Particularly after 1860, when the railroad connecting Berlin to St. Petersburg was complete, Königsberg became an ever more important commercial center. By 1900 its population had grown to 188,000, with a 9,000-strong military garrison. In her essay "Erinnerungen," Kollwitz bore witness to the expanded trade of the city as she recalled her childhood adventures in the lime and coal fields, and subsequent exploration of the bustling harbor, with its ethnic mix of Lithuanian and Russian "Jimkes" (dockers), loading and unloading ships.[14] These "characters" from foreign climes resonated with the literature to which she was exposed and initiated an interest in proletarian types. Tellingly, Ferdinand Freiligrath's poem "Die Auswanderer" (The Emigrants, 1838)—written in his early Romantic phase as a paean to the German experience of immigration to America—served as the departure for her early nonextant drawings on the theme.

Kollwitz pointed to the relevance of her *Mutterboden* (native soil) in other ways as well, highlighting her home environment; her maternal grandfather, Julius Rupp, was the founder of the Freie Gemeinde (Free Congregation) in Königsberg, an evangelical Protestant sect that was established in 1846 prior to the failed liberal revolution.[15] Rebelling against the new orthodoxy that attempted to reintroduce confessional dogma, the Freie Gemeinde turned instead to the origins of the Reformation as embodied in Christ's teachings, advocating discipline, tolerance, and social inclusion.[16] Since young girls were schooled privately within this community, Schmidt's model of nationhood was circumscribed by debates in these circles: the idea of Germany as *Kulturnation*, as inheritor of the Enlightenment philosophical and literary traditions of Kant, Goethe, and Schiller, was critical to her family's positive reception of socialism. Indeed, Schmidt's older brother Conrad (1863–1932) who, unlike his sisters, was permitted to attend a gymnasium (secondary school) and to pursue a degree in economics in Berlin, visited Engels in London and, along with his father, joined the Sozialistische Arbeiterpartei Deutschlands (Socialist Workers' Party of Germany, SAPD) in 1887.[17] Käthe maintained close ties with her siblings; Conrad's role as a literary critic and commentator on the social sciences for various Berlin-based newspapers—*Berliner Volkstribüne*, *Vossische Zeitung*, and *Vorwärts* (the central organ of the Social Democratic Party)—had a lasting impact on her.

The middle of three daughters—two other sons died in infancy—Schmidt's artistic talents, and those of her younger sister Lisbeth (Lise, 1870–1963), were nurtured by her parents. Her father, Carl (1825–98), a mason whose legal career was put on hold due to his role in the Freie Gemeinde, was a compassionate though conservative

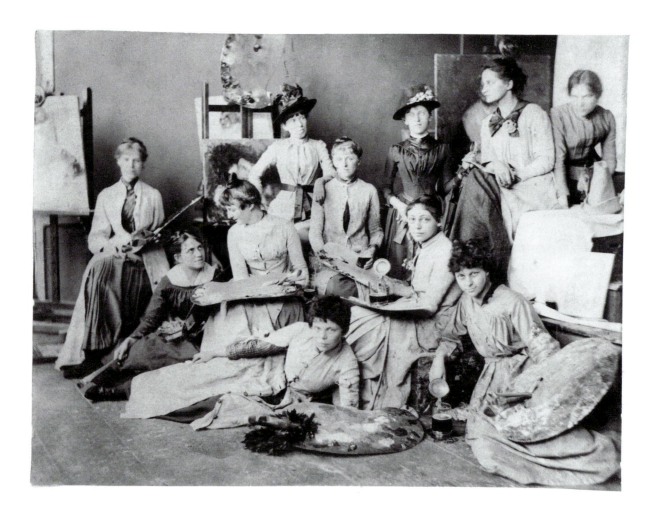

31 Anonymous, *Group Photograph in Ludwig Herterich's Studio of the Women's Academy of the Münchener Künstlerinnenverein*, 1887–88 (Schmidt seated second from right), photograph, Kollwitz Estate

patriarchal figure, who arranged private tuition for her with the engraver Rudolf Maurer and the painter Gustav Naujoks. Carl's predilection for the *große Lessingsche Historie*—the history painting of the Berlin-based academician Carl Friedrich Lessing (1808–80)—provides some indication of her parents' taste.[18] Within this remit, while traveling with her mother, Katharina (1837–1925), to Engadin in Switzerland, Schmidt was drawn to Rubens's works during a visit to the Alte Pinakothek in Munich, the viewing of which she aligned with her reading of Goethe's early poetry, the two pillars of her youthful enthusiasms.[19] From the outset it is clear that the interrelationship between the visual and the literary spurred Schmidt's creative subjectivity. Undoubtedly, her passion for Goethe never waned and, as

her granddaughter later observed, led to a literal *Ritualisierung des Lebens* (ritualization of life) according to the literary, aesthetic, and moral values at work in his writings.[20]

As with other women artists, Schmidt's training was uneven, and in 1886, during her stint at the Drawing and Painting School of the Verein der Berliner Künstlerinnen und Kunstfreundinnen, her draftsmanship was encouraged by her tutor, the Swiss artist Karl Stauffer-Bern. He also referred her to his colleague Max Klinger's etching cycle *Ein Leben* (A Life, 1884), which was among a sequence of portfolios that he produced when less preoccupied with easel painting. In a series of fifteen impressions, Klinger seized on a moralizing tale of sin and suffering, tracing the fate of a woman abandoned by her lover, ostracized by society, and forced to turn to prostitution.[21] Literary representations of prostitution—characteristically in the *Lady of the Camellias* and *La Bohème*—were among the nineteenth century's most popular texts, and these had an impact on the visual arts.[22] Schmidt would return to Klinger and his

theoretical observations on the graphic medium in the early 1890s for, in the interim, her attraction to strong figural characterization and contemporary subject matter was endorsed in unexpected quarters. This was on her return to Königsberg, where she enrolled privately with the artist Emil Neide, a much-admired history painter from the city's academy. Apart from the public commissions of mythological subject matter for the Aula lecture hall in the Albertina University, Neide, the brother of a police commissioner, was well known for his interest in the underworld of criminality and prostitution, which provided the departure for his genre compositions.[23] Indeed, one of his paintings exhibited in 1886, *Die Lebensmüden* (Tired of Life), in its portrayal of the moment prior to a destitute couple's suicide by drowning, earned Neide the title "Raphael of the Vagabonds" among the young moderns in Berlin.[24] In his works she found a gritty yet imaginative handling of a modern tragedy that allowed access to the parallel world of an underclass, of poverty and deprivation "cut off from respectable society by an invisible curtain while shadowing it at every level."[25]

This suggests that the boundaries between "realism" and "salon" art were more fluid than is generally given credit, and in Munich, where Schmidt was encouraged by her father to pursue further artistic training rather than marriage, she encountered a similar phenomenon.[26] Since the 1850s the city's preeminence as an art center was linked to the coexistence of monumental history painting, associated with the academy, and naturalistic modes, rooted in the Artists' Union and bourgeois art market.[27] Schmidt's attendance of the Women's Academy of the Münchner Künstlerinnenverein was concurrent with the great international salons at the Glaspalast (Glass Palace), which were designed to upstage Berlin's new National Exhibition Palace by the Lehrter Bahnhof. Indeed, her tutor, the academician Ludwig Herterich, in his painting submitted to the Glaspalast Jubilee Exhibition of 1888, cultivated a style akin to Manet in treating a subject from recent German history.[28] Schmidt's initial resolve was to become a painter and, in a group photograph in his studio, she is captured bearing palette and brushes, "enjoying the free atmosphere of the 'Malweiber'" (fig. 31).[29] Her use of the loaded term "Malweiber" possibly attests to the lack of seriousness on the part of their instructors; according to her fellow

32 Käthe Kollwitz, *Four Studies of the Female Nude*, 1888–89, charcoal on paper, 55.4 × 42.2 cm, Käthe Kollwitz Museum Köln, NT 23

student and lifelong companion Beate Bonus-Jeep, they were only offered useless instruction and left to their own devices, as long as their fees were paid![30]

The curriculum at the women's school closely mirrored that of the academy in Munich, the distinctions being a matter of intensity and quality rather than structure.[31] It was traditional at its core, with drawing from antique casts, perspective, painting technique, and art history among the required lessons. That life classes and anatomy were part of her program in Berlin and Munich is revealed in Schmidt's *Four Studies of the Female Nude* (1888–89; fig. 32). She shows a keen understanding of corporeality and proportion, employing, from the start, a subtle variation of line that integrates tonal shading. The third sleeping nude shows how adept Schmidt was in investing the formulas of academic training—a classically derived separation of outline from shading—with nuance, immediacy, and considerable skill.

Studies made in Munich at a composition evening, a private initiative of the students, gave her the opportunity to practice multifigure composition.[32] Selecting the theme of "battle," she seized on Émile Zola's novel *Germinal* (1885) as the inspiration for a series, an unusual choice for the historical genre but totally in tune with her penchant for contemporary subject matter. As part of a twenty-novel cycle examining the "social and natural history" of the Rougon and Macquart families under the Second Empire, *Germinal*'s focus on the exploitation of coal miners was popular among the literary group known as the German Naturalists and coincided with a period of their closest affinity with the political ideals of socialism. As in the case of Zola, Schmidt dwelt on the characters' human failings, notably an inheritance of alcoholism, focusing on a drunken brawl between Étienne and another young miner, Chaval, over the fifteen-year-old daughter of Maheu (Catherine). In this way Schmidt's choice, although consistent with the call for "true art" to expose the inequities of class relations, reveals a concern for the sexual politics of the narrative; the battle takes place in the middle ground of a dark tavern, as though mediated through the eyes of the cowering, profile figure of Catherine in the foreground (fig. 33).

For it was in Munich and within a community of like-minded colleagues that Schmidt's socialist credentials were aligned with feminism. As a commentator observed of the city, the modern literary and artistic movement was so closely interlinked with the women's movement that those trends of "the Moderns" were, as a norm, regarded and confounded with those of "the woman."[33] Schmidt attended a lecture given by August Bebel, a founder of the SAPD, and became familiar with his treatise *Die Frau und der Sozialismus* (Woman and Socialism, 1879), a tome that was addressed as much to the bourgeois women's movement as to society at large to urge them to participate in the class struggle.[34] Bebel conjoined the efforts of proletarian women with proletarian men, maintaining that capitalism, just as much as gender, was the barrier to equality and emancipation. Although dependent on Johann Jakob Bachofen's claims in *Das Mutterrecht* (Mother Right, 1861) for the mythical origins and biological evolution of matriarchy,[35] Bebel propounded women's critical presence to the project of socialization; the working class would help writers (or artists) to establish perfect freedom of thought:

> Social life in future will be ever more public. What the trend is may be gathered from the wholly changed position of woman, compared with former times.

33 Käthe Kollwitz, *Scene from Germinal*, 1893, third state, etching, drypoint, and *Schmirgel* on paper, 23.7 × 52.6 cm, Kupferstich-Kabinett, Staatliche Museen zu Berlin, Berlin, KN 19 I

Domestic life will be confined to what is absolutely necessary, while the widest field will be opened to the gratification of the social instincts . . . the altered conditions of social life will also thoroughly revolutionize our literature.[36]

However, Bebel's utopian views regarding women's participation in a democratic public sphere and its spurring of a revolutionary culture remained ideals to aspire to. Since her parents considered the combination of an artistic profession and marriage incompatible, Schmidt's training in Munich was cut short. In correspondence with her colleagues, she conveyed her nostalgia for the intellectual life, social, and artistic spaces of the city, the new journal *Die Kunst für Alle* (Art for All)—founded in 1885 with the express wish of mediating between artists and the ordinary people of the new nation—keeping her abreast of cultural developments.[37] Indeed, following an excursion to Berlin, she reported her dissatisfaction with the mass spectacle of the official exhibition, which contained "so many un-painterly things in a heap," and declared that, notwithstanding "desperate efforts," the *Großstadt* lay far behind the Bavarian capital.[38]

In addition to familiarizing her with key issues of the "modern" and the "foreign" that contributed to the formation of the Munich Secession in 1892, the milieu also provided her with firsthand experience of the diversification that arose from technological changes in reprography. Bonus-Jeep wrote of photography's liberation of etching from its traditionally hidebound associations of copying original paintings and of the many *Radiervereine* (etching societies) that were founded concurrent with advances in photomechanical printing.[39] Schmidt possibly experimented with the intaglio medium and, on her return to Königsberg, learned aquatint with the engraver Rudolf Maurer. At first, in view of her pending marriage and financial restrictions, her turn from painting to etching was considered a practical necessity.[40]

However, once based in the Prenzlauer Berg quarter of North Berlin with her husband Karl (1863–1940), a progressive medical practitioner for a health insurance plan that served Berlin's tailors and their families,[41] Kollwitz's embrace of *Griffelkunst* was no doubt encouraged by debates regarding its cultural efficacy in the call for a renewal of modern German art. Derived from the word for "stylus" and used to designate both prints and drawings, the word *Griffelkunst* was used as a term of preference in Max Klinger's theoretical tract *Malerei und Zeichnung* (Painting and Drawing, 1891), so as to differentiate the practice from reproductive techniques. Against a backdrop of nationalist concern over French achievements and influence, Klinger's strategies were intended as much to defend his own graphic cycles from hostile criticism as to revitalize and promote original etching in Germany.[42] For his polemic Klinger drew on Lessing's *Laokoon* (1766), in which the Enlightenment writer and philosopher distinguished painting from poetry, the former in its reliance on color and space being suited to the depiction of material nature, the latter to more arbitrary signs.[43] In Klinger's treatise the lowly status of the print as "other" to painting is reevaluated: he appropriates the poetic from Lessing and applies it to "drawing," a medium now deemed suitable to the portrayal of fantasy as well as social criticism. "Drawing" gains its independence in printmaking, whereby the suggestive values of chiaroscuro, nuanced line, and the use of the arabesque elicit the powers of the imagination, blending reality with allegory.[44]

While Klinger never directly broached the gendered implications of the medium, his theories draw attention to the conflicts between high and low, painting being associated with the juste-milieu.[45] Thereby, printmaking offered a new (feminine) territory worthy of conquering.[46] Importantly, however, within such theorization "drawing" retains its conceptual and masculine associations.[47] This offers one of the many reasons why commentators were puzzled by Kollwitz's graphics, their "masculine power" and "boldness" of delineation belying the perceived limitations of her gender in cultural and social practice.[48] Indeed, Kollwitz, too, pondered the bisexual makeup of her creativity, believing that the driving and serviceable force in her work was masculine.[49] Opting for a career in the graphic arts was therefore no easy choice for a woman artist in Germany, as the "etching revival" was invested with markers of national significance and confined to the realm of male painter-printmakers, who indeed prided themselves on attaining individuality, imagination, and freedom beyond the shackles of the academy.[50]

Equipped with a Nietzschean-derived belief that creative endeavor would succeed "im Kampfe gegen das

34 Käthe Kollwitz, *Two Self-Portraits*, 1892, etching and engraving on paper, 34.7 × 14.8 cm, Kupferstich-Kabinett, Staatliche Kunstsammlungen, Dresden, KN 12

35 Albrecht Dürer, *Self-Portrait in Fur Coat*, 1500, oil on panel, 67 × 49 cm, Bayerische Staatsgemäldesammlungen, Alte Pinakothek, Munich

Philisterthum" (in the battle against philistinism), Kollwitz engaged with Klinger's reputation as "the Zola of Berlin."[51] Her rigorous exploration of her self-image reveals an ongoing dialectic between subjective agency—the woman printmaker as autodidact—and male self-portraiture.[52] An 1892 etching (fig. 34) elicits the composition in Dürer's well-known painting in the Alte Pinakothek (*Self-Portrait in Fur Coat*, 1500; fig. 35), in which as much attention is paid to the representation of his erudite, schooled hand as to his head.[53] Purportedly fashioned after icons of Christ, Dürer's

self-portrait is emblematic of the productive power of the artist, the Renaissance painter's ascent from craftsman to artist, from manual to intellectual laborer.[54] Representing a "defining moment" in women's self-portraiture, Kollwitz's emphasis on the interrelationship between "hand and head" is prescient with meaning; it signifies her status in a sphere of activity, formerly regarded as manual, which was to become invested with indexical markers of genius.[55]

Contrasting with Dürer's fastidious portrayal of himself in a fur-trimmed coat typical of patricians and humanists, Kollwitz depicts herself in unfashionable worker's attire that reveals her pregnancy with her firstborn son, Hans. Here she draws an analogy between women's creativity and the reproductive body, the gesture of hand-over-heart further alluding to the response of the Virgin Annunciate. As a symbol of the "virginal maternal," the body inviolate, Kollwitz releases herself from her earthly role so as to partake of artistic "ecstasy."[56] Here she pays homage to Rembrandt rather than to Dürer's wiry

linearity, the subtle chiaroscuro values suggesting likeness in addition to the brooding interiority of genius. Along with a sequence of graded *Schmirgel* textures (formed by the imprint of emery, or sandpaper, onto the plate prepared for the etching) in the lower experimental panel, she portrays herself as Melancolia with hand held to head—a muse unto her own creativity—signaling the reflexivity of her strategies. In the absence of a female genealogical link, Rembrandt's self-portraits—as models of sensitivity and authoritative presence—facilitated her interpolation within this genre. Kollwitz's interaction with the Berlin art world further evinced her familiarity with the Rembrandt cult as she responded to the call for cultural reform and the constitutive role of the artist-cum-politician within this process.[57]

The Hieroglyphics of the Drawing

Unlike Modersohn-Becker, Kollwitz took part in the social and cultural politics of artists' associations and attracted critical attention at the outset of her career. Already in 1893, she sought recognition in the annual salon and in the bracing atmosphere of the nonofficial Berlin art world, which was characterized by secessionist-like stirrings. Following the enforced closure of an Edvard Munch exhibition, which was organized by the professional Verein der Berliner Künstler (Association of Berlin Artists), she was involved in the formation of a protest group, known as the Freier Verein der Berliner Künstler (Free Society of Berlin Artists).[58] In June 1893, her participation in their exhibition, alongside artists like Max Liebermann and Munch, pointed to her antiestablishment credentials. At a time when Max Nordau's biased views on French art were being circulated in his influential book *Entartung* (*Degeneration*, 1892), his rhetoric became embedded in the misogynistic language of certain reviewers. The conservative critic Ludwig Pietsch labeled the path adopted by Kollwitz as immoral and anti-German, symptomatic of a larger malaise of cultural degeneracy.[59] The controversy surrounding her portfolio *Ein Weberaufstand* (A Weaver's Rebellion) further revealed her position in relation to the schism between national culture and the modern critique of its standards.

Initiated between 1893 and 1898, Kollwitz's first cycle of prints was inspired by the theatrical venture Die Freie

Bühne (The Free Stage), a private society that featured the more controversial plays of Scandinavian playwrights, such as Ibsen and Strindberg, and those of the Naturalist genre. Following attendance of a performance of Gerhart Hauptmann's *Die Weber* (The Weavers), staged at this venue in February 1893, Kollwitz worked for the next four years on a set of six prints, comprising three lithographs and three etchings. Hauptmann's drama, highlighting the plight of impoverished Silesian weavers preceding the 1844 riots, clearly struck a chord with her earlier concerns for proletarian motifs that were initiated in the docks and taverns of Königsberg. Indeed, the form and content of the series assert their freedom from the theatrical text in evoking parallel discourses—city and country debates, increasing urbanization, and the plight of economic migrants in the ever-expanding population of contemporary Berlin. Accompanied by pithy, single-word titles like *Not* (Poverty), *Tod* (Death), or *Sturm* (Riot), the figures—portrayed in contemporary workers' clothing—conjure the social realities of both rural and urban deprivation, yet Kollwitz looked as much to Munch's example as to contemporary French illustrators, notably Théophile-Alexandre Steinlen, for her departure.[60] As has been argued, the *Weberaufstand* was mediated through the lens of Zola's *Germinal*, Kollwitz transforming Hauptmann's pessimistic conclusion into a Christological soliloquy on future struggles of the proletariat.[61]

Given its focus on the "premeditated coarseness" and imperfect bodies that Nordau so disparaged in his diatribe of Zola's Naturalism, it is unsurprising that, when the portfolio was recommended for a gold medal by the jury of the Great Berlin Art Exhibition in 1898, the honor was vetoed by the minister of culture Robert Bosse on the grounds of its nonconciliatory imagery.[62] Although Wilhelm II endorsed the veto, considering that the award should be "saved for the breasts of deserving men," graphic curator Jay Clarke has shown that other more conservative women printmakers, such as Cornelia Paczka-Wagner in 1890, were not as disadvantaged.[63] Yet Kollwitz had her supporters as well as her detractors; the art historian and critic Julius Elias, an outspoken enthusiast of the Munich Secession and collector of French Impressionist art, forecast a rich artistic future for the young woman.[64] Moreover, the director of the Dresdner Kupferstich-Kabinett, Max

36 Cover illustration, *Die Frau Monatsschrift für das Gesamte Frauenleben unserer Zeit*, 10 (February 1903)

Lehrs, was the first to purchase the portfolio for the collection, following Kollwitz's receipt of a medal at the annual Dresden exhibition. He was also responsible for compiling a catalogue raisonné of her prints in the luxury journal *Die Graphischen Künste* (The Graphic Arts).[65]

In 1899 Kollwitz exhibited in the Berlin Secession, a year after its inception under the leadership of Max Liebermann. By 1901, she had become a committed and long-standing member. Her impact was particularly evident in the context of the Secession's *Schwarz-Weiss* (Black-and-White) exhibitions; in focusing on works on paper, these shows indicated a widening of the market as well as a growing recognition of drawing and the graphic arts as ends in themselves.[66] In his unsigned foreword to the catalog of the first *Schwarz-Weiss* exhibition, Liebermann raised the issue of the "hieroglyphic language of the drawing" as a modern phenomenon, suggesting that the demands made on the collaborative imagination of the viewer to penetrate the allusiveness of the drawing would be rewarded by greater insight into the artist's intellectual and creative processes.[67] Emanating from German Romantic aesthetic theory, hieroglyphic expression was deemed both a "primitive" and sacred language, emblematic though separate from nature.[68] In its transposition to *Griffelkunst*, as we have seen in Klinger's theorization as well, the promotion of this form of expression—as symbolic, poetic, and imaginative—was favored over and above Naturalism and grand narrative.

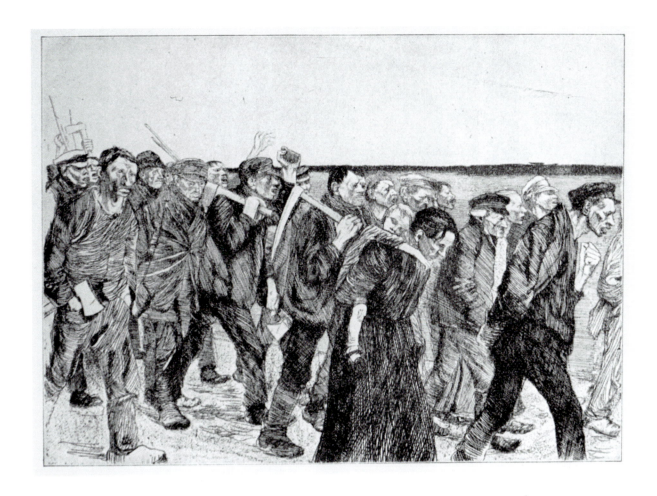

37 Käthe Kollwitz, *Weberzug* (Weavers' March), 1897, reproduction in Lu Märten, "Käthe Kollwitz," *Die Frau* 10 (February 1903): 291

Although Kollwitz exhibited works with general titles, such as *Frau* (Woman), *Akt* (Nude), or *Kopf* (Head), that qualify under the remit of studio art, one has to pose the question as to whether her socially engaged cycles could be categorized within this purview of the Secession. Interestingly, women art critics, in familiarizing a female audience with the unusual characteristics of her oeuvre, considered the issues of gendered authorship as inseparable from political and technical radicalism. It was as a result of Kollwitz's submissions to the second of the *Schwarz-Weiss* exhibitions that the social theorist and writer Lu Märten wrote of the possibility of the "revolutionäre Gesinnung" (revolutionary conviction) behind Kollwitz's work as having previously upset the administration.[69] Surprisingly,

this review appeared in the pages of *Die Frau* (The Woman), a journal that was edited by the educationalist Helene Lange and normally associated with promoting conservative values of female identity. Inspection of the cover illustration (fig. 36), in which a luxuriously foliated tree—representative of the woman/nature paradigm—transcends the insidious effects of the masculine city in the vignette below, perhaps endorses this conclusion. Yet such generalizations bypass the diverse positions of its contributors.[70] Indeed, Märten came from a humble Berlin background and was drawn into a milieu of Marxist social and cultural reform; the details of when and how she first met Kollwitz are uncertain, but no doubt Märten's fascination was linked to her own concerns to promote women's expanding public sphere.

Illustrating her review with a reproduction of one of Kollwitz's bolder images from the Weberaufstand (fig. 37), she further seized on images of women that

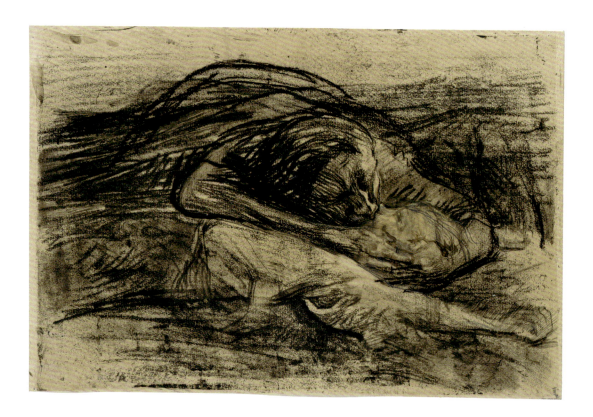

38 Käthe Kollwitz, *Mutter und Toter Sohn* (Mother and Dead Son), 1903, drypoint and etching, overdrawn with charcoal, pencil, brown pen, and brush on paper, 22.5 × 33 cm, Kupferstich-Kabinett, Staatliche Museen zu Berlin, Berlin, Inv.-No.: 190–1911, KN 78 IV

escaped the confines of bourgeois convention; the "wild, defiant strength" of the airborne female nude inspiring the rebellion of the peasants in the etching *Aufruhr* (Uprising, 1899), as well as the "uncanny dance" of the women around the guillotine in *Die Carmagnole* (1901).[71] Based on an interview, and offering a rare glimpse into Kollwitz's studio practice, Märten's text commended the technical quality of the woman artist's work and sought to professionalize her status, Kollwitz balancing her life as practitioner, wife, and mother with teaching.[72] Just as Märten's other writing at the time sought to retrieve for the worker the "lebendiger Ausdruck der Persönlichkeit" (living expression of individuality) in the face of the specialization of labor through mass production,[73] so she declared that Kollwitz's "künstlerische Persönlichkeit" (artistic individuality) and ability brought into disrepute the old saying that "genius can be only male."[74]

Märten's arguments raise several criteria that are pertinent to notions of modern revolutionary theory. The theorist of history and historiography Reinhart Koselleck seizes on the concepts of modernity and revolution as embodying futurity and the experience of an acceleration of historical time. Amid this rapid process of socialization, Kollwitz's subjective agency offered a path to social revolution through venting the political, the previously repressed history of women.[75]

A year later, in her review of Kollwitz's new graphics in *Die Frau*, the art historian and critic Anna Plehn, a close colleague of the artist since their training in Munich, further queried the normative concept of male genius in advancing the distinctive values of the maternal in creativity.[76] In considering Kollwitz's preparatory studies and graphics toward the *Bauernkriegzyklus* (Peasants' War Cycle), on which she worked intermittently between 1902 and 1908, Plehn's review offers an extraordinary account of the cycle's unsteady evolution as well as of the density of the display.[77] Given more space at the eighth exhibition of the Berlin Secession than any other local artist, Kollwitz had a major wall reserved for around twenty to thirty sheets. At that stage she conceived of a sequence of five prints loosely based on Wilhelm Zimmermann's three-volume history of the sixteenth-century peasant uprising.[78] This event was dramatized in Goethe's *Götz von*

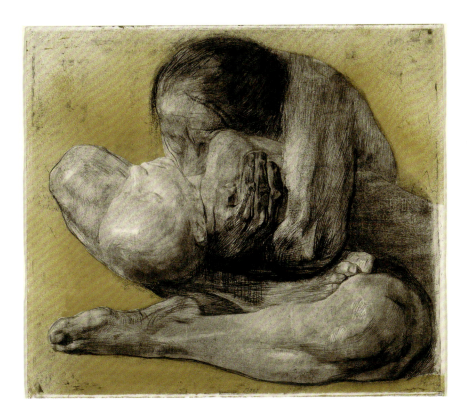

Berlichingen through to Hauptmann's early history play *Florian Geyer*, and was of great significance to the revolutionary heritage of the socialist movement in Germany. Indeed, in the first completed composition for the cycle—*Losbruch* (Outbreak, 1902–3)—Kollwitz seized on the historical figure of the Schwarze Hofmännin (Black Anna), as inciting the peasants' rebellion.[79]

According to Plehn, the fourth scene of the series at the time was planned as a *Begräbnis* (Burial) composition, and a few preliminary sketches match her description, as in the study containing the figure of Black Anna digging a grave in a bleak landscape, lit only by a lantern, her dead son lying across the foreground (1903).[80] However, Plehn also elaborated on a more integrated composition in progress, which can be traced to the etching *Mutter und Toter Sohn* (Mother and Dead Son; fig. 38).[81] While one cannot be certain which of the two extant impressions Plehn witnessed, both states share the characteristics of hybridity in combining the print medium with overdrawing. Here, a woman is portrayed lying on the earth, protectively cradling the head of the child within her arms, her lips pressed to his lower cheek.[82] Whereas the development of this as an independent motif points to Kollwitz's avid interest in Michelangelo's *Pietà* sculpture (1497–1500,

St. Peter's, Rome), here she abandons the representation of Marian decorum in favor of rawness of emotion, the working process being readily proclaimed in vigorous etched lines, hand-painted highlights, and overdrawing in charcoal, pencil, and brown ink. Indubitably modeled after her posed figure and that of her younger son Peter, the work's dramatized subjectivity strains the limits of the cycle's narrative structure and probably accounts for its omission from the final portfolio.[83]

That Kollwitz invested the print medium with the qualities of artistic authenticity, foregoing its historical relationship to the printed word, can be verified in another example on this theme, one of the states of which was exhibited independently of the cycle.[84] *Frau mit Totem Kind* (Woman with Dead Child; fig. 39) is considered a most unusual combination of soft-ground etching with engraving and superimposed gold-sprayed lithographic ground, against which the group is conceived as a sculptural mass.[85] The lifeless child is shown as almost devoured by the nude animalistic mother, an icon—as Angela Moorjani suggests—of the phantasmatic oral mother.[86] In incorporating the lost one's existence, the maternal image encrypts the threatening and idealizing positions of abnormal mourning,[87] Kollwitz's imaginative archaisms—therein Plehn cites

40 Ernst Heilemann, *Triumph des Fortschritts* (Triumph of Progress),
Simplicissimus 14, no. 31 (November 1, 1909): 516; the caption reads,
"Hören Sie mir nur auf mit den Ewigkeitswerten, die sind jetzt euch
passé."

as a protest against Impressionism, her expressive and technical range propelled the futurity of the content.[90]

Hence, in *Die Frau*, as well as in her role as an art critic for *Die Kunst für Alle* and the monthly newspaper *Sozialistische Monatshefte*,[91] Plehn forged a space for Kollwitz within the cultural politics of the Berlin art world, although it is within the format of the latter publications that one can best gauge the modernity of the discursive framework.[92] Notwithstanding her claim that Kollwitz had left all traces of influence behind, it is clear that the artist's subscription to gestural figure drawing, so much a feature of the modern studio ritual, coincided with her interests in developments in Paris, a matter that will be considered below. Given the proliferation of journals and technological invention in publishing at the turn of the twentieth century, it is not surprising that Kollwitz found outlets for her social themes in one of the most prominent of the weekly political and satirical magazines, *Simplicissimus*. Published in Munich, this broadsheet was consistent in its anticlerical, antifeudal stance, and in its extraparliamentary role in demanding reform of state-regulated prostitution.[93] Nevertheless, in participating in widespread debate in Germany on luxury and its corrupting effect on middle-class identity, its satirical images often unfairly targeted bourgeois women as purveyors of decadent consumerism. Typical in this regard is Ernst Heilemann's illustration *Triumph des Fortschritts* (Triumph of Progress; fig. 40), which deploys the techniques of colorful fashion plates in parodying female ostentation, societal mores, and tasteless adjudication over modern tableware design.[94]

In contrast, Kollwitz's series of drawings *Bilder vom Elend* (Pictures of Misery), published between 1908 and 1911, dwell on the tragic consequences of unemployment, alcoholism, domestic violence, and unwanted pregnancy.[95] Her drawing *Heimarbeit* (Work at Home; fig. 41), reproduced in the same issue as the Heilemann, focuses on the domestic conditions of women's work, indicating that the transition from home textile and garment production to factory industry was an uneven and protracted process.[96] The portrayal of the exhausted, collapsed woman is not without reference to characterizations of proletarian physiognomy on the one hand and contemporary medical illustrations of poverty-related diseases on the other, the skin drawn tightly over the cranium pointing

the "Schmerzausdruck" (expression of grief) in the works of Giovanni Pisano—giving new meaning to the desiderata of the "hieroglyphics of the drawing," as cited above. No wonder Plehn wrote of the shock of first viewing this work and of its paralyzing effect on the spectator, claiming that only a woman artist could envision, "what a man's imagination could never see, what a man could probably never feel and what only a woman who is a mother . . . can depict with such vividness."[88] Maternal subjectivity becomes *the* prerequisite for artistic creativity rather than the converse, at a time when the roles of artist and mother were considered mutually exclusive.[89] Indeed, Plehn concluded that Kollwitz had left all traces of influence behind, particularly that of Klinger and the majority of draftsmen of her time;

Bilder vom Elend

I

(Käthe Kollwitz)

— 515 —

41 Käthe Kollwitz, *Bilder vom Elend* (Pictures of Misery), *Simplicissimus* 14, no. 31 (November 1, 1909), 515

to malnutrition.[97] Beyond the experience of her husband's surgery from where she obtained her models, Kollwitz was involved in feminist initiatives that regarded the welfare of the mother as indispensable to the child's development. She became a member of the Bund für Mutterschutz und Sexualreform, a league for the protection of single mothers founded by Helene Stöcker in Leipzig in 1905, a forum in which eugenicist visions of social reform merged with progressive feminist viewpoints.[98] However, in this drawing we find a tension between the uncompromising message and a sensual play of light, as its sharpness reduces to reveal a sleeping toddler, whose pose mirrors that of the mother's.

Kollwitz's "visible language," a phrase coined by the art historian Ernst Gombrich to connote artistic expression that communicates imaginative figural movement, gesture, and, above all, emotion, was what appealed to the specialist art world.[99] In 1908, Hans Singer, an American-born art historian, keeper in the Dresdner Kupferstich-Kabinett and close friend of Klinger, published a lengthy essay in the *Führer zur Kunst* (Guide to Art) series that charted Kollwitz's career, devoting sensitive attention to women practitioners' struggle for recognition.[100] Above all, he singled out the skill and originality of her draftsmanship that emancipated her works from realism, her manipulation of line and tone "arousing the soul of the viewer to a creation of related moods."[101] Conversant with the field of Kantian

epistemology, which claims that the subjective universality of taste lies at the heart of aesthetic experience, such promoters addressed an audience of patrons educated in the visual arts through the rapid expansion of public museums in the late nineteenth century.[102] Via such means they were alerted to aesthetic criteria beyond the representation of objective phenomena, to the image as symbol and expression of interiority. Kollwitz was also taken with this notion of *Erlebnis* (lived experience) as an aesthetic category, as advanced by the philosopher Wilhelm Dilthey in his study of the subjective impact of German Romantic poetry.[103] Whereas the diversity of her artistic production, its content, and audiences readily partook of imperial Germany's rapid structural transformation, her figuration embodies those deeper psychological clefts and conflicts wrought by modernity's onslaught, which were deemed characteristically "Expressionist" in subsequent critical reception.

"Venting" the Expression of the Modern Soul

In a speech celebrating the Berlin Secession's tenth anniversary, Liebermann stressed that, even if secessions should disappear, they would rise again in different forms and under different names: "Those who count as modern today may tomorrow be thrown on the scrap heap by their still modern successors. We are all children of our times."[104] Here, as Karen Lang reminds us in another context, modernism brings in its train the idea of the avant-garde and its narrative of "failed inheritance," which purportedly drives the struggle against tradition and convention in art.[105] Notwithstanding Liebermann's declaration, soon thereafter the Berlin Secession would be riven by internal dissension over just such issues. Moreover, its minimization of any specific national element in art would give rise to xenophobic dismissal of modern art as foreign and otherwise alien. Yet the 1910–11 *Schwarz-Weiss* exhibition was a remarkable success in combining works from international and local sources, being representative of past artists, from Goya to Daumier and Degas, as well as notable contemporary German artists.[106]

Kollwitz's submission of the etching *Tod und Frau* (Death and Woman, 1910; fig. 42) received critical acclaim as achieving the "wild, grandious tone of her best creations."[107] Set within a context in which Hodler displayed

eighty drawings, including his studies of Eurythmy, Kollwitz's highly complex print textures and sculptural embodiment can be seen to resist such codes of Jugendstil ornamentality.[108] The writhing, monumental figure of the woman performs a bizarre and erotic dance with death, whose palpable presence as doppelgänger reminds one of Otto Rank's theorizations on the primitivist and folkloric origins of this doubling. A close colleague of Freud, Rank gathered evidence as to how superstitions around the shadow, arising in Germany and Austria, led to a belief in a guardian spirit.[109] At one and the same time in the graphic, the lunging female body elicits the symptoms of power and submission, pleasure and pain, sexuality and death, with Kollwitz exploring the ambivalences of the emotional drives in ways that suggest her familiarity with psychoanalytical theory through a range of familial and social contacts.

Apart from Karl Kollwitz's circle of associates,[110] she had frequent contact with her first cousin Gertrud Prengel and her husband, cultural theorist Heinrich Goesch, who underwent analysis in Ascona with the controversial figure Otto Gross.[111] Whereas Kollwitz's own transgressive love affair with the Jewish Viennese publisher and dealer Hugo Heller may have ended in 1908, her private erotic drawings, the *Sekreta* (ca. 1909–10), and diary entries of his name are frequently associated with spontaneous, "life-affirming" moments, memories, and dreams.[112] At the other end of the spectrum, in the course of these entries, she confided that her dreams about sexual intercourse—which were rare— were accompanied by an intolerable feeling of mortality.[113] As one of the few nonmedical members of the Vienna Psychoanalytical Association, Heller published Sigmund Freud's early writings, as well as the journal *Imago*.[114]

For Kollwitz, then, it is understandable how Freud became a household name, a higher authority to consult in the realm of the emotions so as "ein Ventil öffnen" (to open a valve) and release pent-up torment. Like Freud, Kollwitz resorted to the hydraulic metaphor, "an irreducibly concrete moment within the history of technology," to signal a flow of abstract, psychic energy.[115] So she divulged in her diary that Freud could be of assistance in analyzing her son Hans, whose overdependence on her judgment and possible lingering sexual attachment caused her so much anxiety.[116] For an artist dedicated to exploring plastic

42 Käthe Kollwitz, *Tod und Frau* (Death and Woman), 1910, fifth state,
etching, drypoint, sandpaper, soft ground, and roulette with imprint
from corn paper and Ziegler's transfer paper, 45 × 45 cm, Department of
Prints and Drawings, British Museum, London, 1949.0411.3947, KN
107 Va

equivalents of the emotional life, her keen eye detected symptoms of the boy's anguish from his gait and countenance: "Peter is so normal and Hans drags himself around with so much agonizing."[117]

Of comparable eminence to Freud's cathartic role, Kollwitz extolled August Rodin as the only modern sculptor able to give material form to a distinctly modernized sense of self—the expression of the soul—that powerfully engages and activates the viewer.[118] In 1904, over a two-month period of study in Paris, she mingled with the circle of German artists, dealers, and intellectuals, who gathered at the Café du Dôme in Montmartre. At the Académie Julian, she undertook preliminary studies in sculpture and was predictably drawn to Rodin, initiating visits to his studio in Rue de l'Université in Paris and at his museum in Meudon.[119] Rodin's works were widely exhibited and represented in public collections in Germany.[120] However,

it was her experiences in Meudon of the staged spectacle of his part sculptures, enthroned by the potent statue of Balzac, and the glass cases containing small plaster models, that had an abiding impact.[121]

The aesthetic taste for Rodin must be set against a background of the neoclassicist Adolf von Hildebrand's "Front" against the French sculptor. In his treatise *Das Problem der Form in der Bildenden Kunst* (The Problem of Form in Painting and Sculpture, 1893), Von Hildebrand sought to revive the Greco-Roman traditions of direct carving, a fixed viewing point, compact form, and clarity of design.[122] In contrast, Rodin was an arch-modeler who exploited the use of a multidimensional viewpoint, distortion, the value of the part object, and reproductive techniques in the interests of expressive emotion and symbolism.[123] Indeed, Kollwitz was not alone in admiring the Promethean restlessness of Rodin's sculpture.[124]

43a and b Käthe Kollwitz, *Abschied* (Farewell), 1910, recto and verso, black crayon on paper, 62.7 × 48.2 cm, Nationalgalerie, Staatliche Museen zu Berlin, Berlin, Inv.-No.: NG 27/6411, NT 617 recto / NT 618 verso

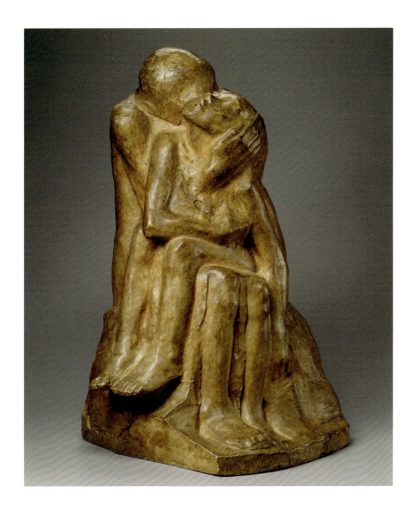

44 Käthe Kollwitz, *Große Liebesgruppe I* (Large Lovers' Group I), 1913, plaster, yellow-brown tint, 74.3 × 45.7 × 48.3 cm, Museum of Fine Arts, Boston, gift of Mr. and Mrs. Hyman W. Swetzoff in memory of Mr. and Mrs. Solomon Swetzoff, 58.390

The social theorist Georg Simmel, whom Kollwitz met in Paris, was equally taken with Rodin and differentiated his work from the Renaissance tradition via the very "motif of movement."[125] At its most fundamental, this referred to Rodin's well-known practice of capturing the kinetics of the moving figure as the departure for sculptural form—"the movement itself built its body."[126] Certainly, the challenges of drawing from the nude in motion became important to Kollwitz at this time and, interestingly, continued to exert an influence on her pedagogy.[127] Most indebted to Rodin, however, are the compositional studies toward *Abschied* (Farewell, 1910; figs. 43a and b), where Kollwitz dispenses with the allegorical figure of death and foregoes gravity. So as to focus on the final embrace between mother and ascendant child, the compositional sketches on the verso and recto offer the barest indication of the part figures, the trajectory of the movement itself "building its body." According to Simmel, this had its correlative in the movement of the "modern soul," which, in contrast to the representation of idealized states of mind in the Renaissance (be it *either* melancholy *or* ecstasy), simultaneously evokes the polarities of alienated psychological existence.[128] If one follows this through, in the case of *Abschied*, it is the poignant conjoining of lingering tenderness and incipient loss.

As the art historian Patricia Berman observes, gestural drawing appeals to the spectator's sense of psychological and sensual engagement.[129] The fragmentary quality and the aesthetics of unfinished statements activate the viewer's imaginative capacity to "complete" the work as a gesture of viewing. Operating as a visual sign of the artist's intuitive will, the hieroglyph generates the source for work in other media that usually requires more conscious decisions, a dynamic that resonated with Kollwitz's turn to sculpture.[130] Instructively, the extant plaster of her *Große Liebesgruppe I* (Large Lovers' Group I, 1913; fig. 44) transforms the elegance of Rodin's iconic *The Kiss* (1901–4, Tate Britain, London)—the marble of which Kollwitz had seen in Paris—into a more tightly bound composition, where the woman is seated in the lap of her male lover.[131] The

eye is drawn from the primitivist, blocklike rendering of the limbs toward her upturned face, Kollwitz devoting most attention to relaying the psychic energy of libidinal coupling. In line with Rodin's works, the externalization of this prioritizes instinctual processes of creation and offers variable—rather than fixed—viewing points as part of the sculptural experience.[132]

Kollwitz's transformation of the allegorical and cyclical (maternal, familial, and domestic motifs of the poor) into a dramatic psychological language became consistent with calls for an epochal, spiritual renewal in modern German art. In 1911 the young writer Max Jungnickel published an article on her in the recently founded newspaper *Die Aktion*, which, along with the journal *Der Sturm*, strongly promoted the Expressionist movement in both art and literature.[133] *Die Aktion* was more radical on an ideological level and, not unexpectedly, Jungnickel prioritized content over form in favoring Kollwitz's proletarianization of the subject matter. A few months later, for the art historian Ernst Cohn-Wiener, she represented the paradigmatic revolutionary artist, the imperatives of the woman's life being more urgent in the fight anew for each freedom.[134] Interestingly, in his recently published two-volume book, he defined *Stilwollen* (stylistic volition) as a concept embodying the creative power of the period.[135] So, too, in his essay, Cohn-Wiener argued that the energetic movement of the revolution underlies all political events and unites the people—"It is artistically exciting, like war."[136]

Yet, while proclaimed an originator of a new style of figuration that counteracted Naturalism and Impressionism, Kollwitz was suspicious of emergent Expressionist tendencies. Whereas, in fact, the same age as Emil Nolde (they were both born in 1867), she perceived herself to be of a different generation, an "outsider" to Expressionism's discursive practices. Indeed, from the late Wilhelmine to the Weimar period, the artist's correspondence and diaries attest to a love/hate relationship with what she termed the "youngest generation," to the extent of suspicion of their national interests. Here we witness her liminal position, embracing modernity and radical politics on the one hand while rejecting modernism on the other. Thereby, we have to balance Kollwitz's self-perception as a bearer of *Können* (skills), and an antimodernist, with evidence of her reception and role in cultural politics.

The "Talented Smears" of the Expressionists

In April 1910, the foundation of the Neue Secession resulted from a major disruption, when the jury of the Berlin Secession rejected the works of more than twenty-seven artists for its twentieth summer exhibition. By mid-May, led by the artists Georg Tappert, Heinrich Richter-Berlin, and Max Pechstein, the Neue Secession launched its first exhibition at the Galerie Maximilian Macht.[137] Naturally, among the debates leading up to its formation, the functions, rights, and purposes of juries were uppermost in the minds of these artists. Interestingly, in April 1910, Kollwitz went to a meeting with those who wanted to create a Jury-freie Kunstschau (Jury-Free Art Show). On this occasion she met Pechstein, Kober, and two other young artists who were refused by the Secession. She recorded the event in her diary, noting her support of the jury-free concept but stating that she found it difficult to identify with these young *refusés* and their shared utopian aspirations. While registering her distaste for traditional salon art, she perceived a shared quality of "talentvolle Schmierereien" (talented smears) among the Neue Secessionists with the sketches of the more gifted academic painters. As she stated: "But they think they are coming Manets."[138]

Caught in this perceived generational dilemma, Kollwitz equally could not endorse French contemporary art and, surprisingly, was among the 118 German artists to undersign Carl Vinnen's *Ein Protest Deutscher Künstler*.[139] As we encountered in chapter 2, this circular signaled a backlash by more conservative artists against museum directors' and dealers' importation of foreign (mainly French) art, Vinnen declaring such influences to be "a great danger for our nationality."[140] This was an action that Kollwitz regretted almost immediately, as she divulged in a letter to her son Hans a month after the publication of Vinnen's protest:

> By the way, yesterday I was for the first time in the "Großen [Berliner Kunstausstellung]."[141] However, the profuse abundance of the mediocre also in sculpture was so depressing that I said to myself I will also quickly go to the National Gallery and see for myself what is rather good ... Then I walked upstairs as well to the French and already in the first

room—where the fine Rodin bust is as well—felt heavy hearted over my signature under the Vinnen Protest. For here I saw once again the French represented by good examples of their work, and I said to myself that German art in any case needs the Latin stimulus. The French are just temperamentally more gifted for painting, the Germans lack a sense of color . . . Naturally, I had had similar thoughts before I undersigned Vinnen, but I was at that time so angry about the latest blessings from Paris, that I signed anyway. I should rather have told myself that the whole Matisse period would have an end that one must patiently await.[142]

By the "latest blessings from Paris" and "whole Matisse period," Kollwitz was probably referring to the now famous twenty-second spring exhibition of the Berlin Secession, which was held in April 1911. As conveyed in chapter 1, apart from Picasso, most of the "foreign" artists included in the exhibition were associated with Matisse's circle. Since the term "Expressionisten" was coined on this occasion to signal the "newest directions" in French art, we can gauge Kollwitz's ambivalence to the spectacle of the display. Here she deploys well-established characterizations of national style, stemming initially from French perceptions of German art, as predominantly a "philosophical art."[143] German artists were understood to attribute greater relevance to drawing and composition in order to convey certain ideas, morals, and heavy sentimental and melancholic themes to the detriment of color and light, thus resulting in a lack of beauty, grace, and sensuality that were considered characteristic of the French.[144]

As Peter Paret has observed in his major study of the Berlin Secession, while Kollwitz cannot be reproached for disliking Matisse, she seemed blind to the implications of associating herself with such regressive forces.[145] As it so happens, however, the Vinnen episode represented a watershed in Kollwitz's career. In October 1911, notwithstanding her wariness about newer trends, Kollwitz, along with Georg Tappert, participated in the founding committee of the Juryfreie Kunstschau. Moreover, her etching of a newborn child, with hands held high, served as the association's gift for its members.[146] Indeed, critical reviews were quick to notice that the omission of a jury allowed for a larger number of women artists to participate.[147] By 1913, Kollwitz regarded her appointment as second secretary to the committee of the Berlin Secession as demeaning of her status.[148] With the Secession's hierarchy in conflict between traditionalists and modernists, Kollwitz, along with thirty-nine members, seceded to form the Freie or Free Secession under the presidency of Liebermann, thus aligning herself with international and nondidactic cultural tendencies.[149] In the same year, along with the artist Henni Lehmann, she formed a new exhibition organization, the Frauenkunstverband (Women Artists' Union), which recognized the necessities of the professional advancement of women artists and new opportunities for display.

One is prompted to inquire how Kollwitz fared within the diversification of her outlets. From 1908 onward, it was the Kunstsalon Emil Richter in Dresden, better known at the time for the annual exhibitions of the Brücke artists (between 1907 and 1909), which dealt with the distribution of her graphic oeuvre. Indeed, under the proprietorship of Hermann Holst and, thereafter, R. H. Meier, the Kunstsalon gained exclusive publication rights and her plates in 1918. Yet more detailed indication of her earnings can be gauged from her granddaughter Jutta Bohnke-Kollwitz who, as editor of the artist's diaries, came across an intriguing list of Kollwitz's annual income for the years 1901 until 1916.[150] This reveals that together with an honorarium that she received for teaching at the art school of the Berlin Women Artists' Association, her net earnings from the sale of her works in 1901 were 2,000 marks, rising to 6,717 marks in 1912. Understandably, in 1915, Kollwitz's income fell sharply, and she was about 780 marks in debt. By 1916, however, her earnings had surged to their highest (6,870 marks). Hence, in the midst of the First World War, as in the case of the demand for Modersohn-Becker's paintings, there was a clamor for Kollwitz's drawings and graphics. Although she nurtured the desire to reach a wide proletarian audience, the growth in the war industry had steadily boosted the money supply, and the works of living artists began to achieve increasing sales in the art market.

Kollwitz's achievement was all the more remarkable, given her mourning over the loss of her eighteen-year-old son, Peter, who volunteered and was killed on the western front in Flanders during the early months of the war (October 23, 1914). In the meantime, her firstborn, Hans

45 Käthe Kollwitz, *Das Opfer* (Sacrifice), 1915, charcoal on gray coloring paper, fixed with shellac, 59 × 44 cm, Käthe Kollwitz Museum Köln NT 722

shows heavy and repeated delineation of the figure, the disproportionate scale of the upheld hand in relation to the body, and a state of unfinish in its pentimenti:

> I work on the presentation. I *had* to change everything—it was a direct compulsion. The figure bent itself forwards automatically under my hands— as after [its] own will. Now it is no longer standing as she was. She bends over completely and offers up her child. In deepest humility.[153]

Wittingly or unwittingly, Kollwitz's articulation of the aesthetic process as being propelled by an external force that guides the artist's hand comes close to Expressionist theory of the time. Of particular relevance are the ideas of the Marxist art historian and critic Wilhelm Hausenstein, whose recently published book *Die Bildende Kunst der Gegenwart* (Visual Art of the Century, 1914) was loaned to Kollwitz by Lu Märten.[154] Hausenstein's definition of Expressionism primarily in terms of "the new figural painting . . . denot[ing] a new consciousness of form, a new basic conviction of art, indeed even a new feeling of life (*Lebensgefühl*)" may have caused Kollwitz to reconsider her associations with the movement.[155] Indeed, in his politicization of the Wölfflinian concept of *Lebensgefühl* as the conditioning style of the period, Hausenstein's sociological interpretation of art defined historical materialism—"the requirement of collective, spiritual adjustment to the economic forces"—as an almost total antinaturalistic force in society.[156]

Just as Kollwitz's loss of her son led her to question "sacrifice" for one's nation, so disillusionment tempered the chauvinism of Expressionism's initial war years. Her mission was expressed in metaphorical terms as an act of surrogacy since, tragically, her son's life as an aspiring art student was cut short:

> Peter was the seed corn—that must not be ground. He himself was the seed. I am the bearer and developer of his corn . . . I am not merely *permitted* to complete my work—I *must* complete it. That appears to me the meaning of all the talk about culture. It [culture] arises only by the individual fulfillment of the spheres of duty. When each recognizes and fulfills

(1892–1971), was serving in an ambulance corps in Belgium. The psychological condition known as "war trauma" is generally reserved for the "active" rather than the "passive" front. In psychoanalytical discussions of its metonymic coordinates, "male hysteria" is considered coeval with shell shock, as well as the penetrative wounds caused by industrial warfare.[151] Yet Freud's reflections on the key instinctual drives in his mid-war text "Zeitgemäßes über Krieg und Tod" (Thoughts for the Times on War and Death, 1915), were precisely dedicated to the suffering "of those who remain at home" rather than the psychology of the combatants, of whom he confessed to know too little.[152] In the case of Kollwitz, the memory of her departed son stalks her diary, as palpable a leitmotif as the doppelgänger "Death" in her imagery, albeit that her creativity served as the vehicle for a reparative vitalism. So, she commented on her reworking of the drawing *Das Opfer* or *Sacrifice* (fig. 45), which

their sphere of duties, *genuine* being comes about. The culture of an entire people can be cultivated, ultimately, out of nothing else.[157]

The phrase from Goethe—"Seed corn must not be ground"—becomes a repeated trope and, not unexpectedly, in November and December 1916, she attended a series of lectures on Goethe that was delivered by the Expressionist writer and politician Gustav Landauer (1870–1919), whose anarchistic and mystical brand of socialism certainly impressed Kollwitz.[158] Her familial inheritance of Judeo-Christian ethics and socialist conscience resonated with mid-war left-wing revolutionary pacifism, the statement above being programmatic of this.[159] Here Kollwitz aimed to bridge gaps between the individual and the collective, personal endeavor, and "authentic" cultural renewal. Indeed, equilibrium between her inner turmoil and outer voice appeared to be restored in the months that she prepared for her retrospective exhibition in 1917. How this exhibition positioned Kollwitz in relation to Expressionism, its attendant discourses, and the advancing of her career is critical to the following section.

The Making of Kollwitz's "Name"

In February 1917, in a timely move, the Kunstsalon Emil Richter purchased a portion of Kollwitz's drawings for 6,000 marks.[160] This was expedient because the transaction preceded by some months Kollwitz's first retrospective exhibition, which was held that year at the Paul Cassirer Gallery in Berlin and traveled thereafter to the Kunstsalon Emil Richter in Dresden and other venues. Dedicated to the commemoration of her fiftieth birthday, the installation included forty-nine of her etchings and lithographs. However, the overall impact was reserved for her drawings, a staggering 159 works, comprising sketches, preparatory studies for her graphics, and drawings toward themes, under the headings "social (1909–16)," "the portrayal of women and children (1905–16)," and "nudes, pastels and self-portraits."

Evidently, Kollwitz was not immune to utilizing a self-portrait (fig. 46) on the cover of the catalog to advertise her talent. Overlooked in the secondary literature, the foreword to the catalog of this exhibition is highly revealing.

It focused on this charcoal drawing (fig. 47), seizing on its tragic character and hard-hitting interiority: "eyes that have seen the darkest [moments]. A mouth, which harbors compassionate pain and scornful greatness."[161] Written by Max Deri (1878–1938), an art historian and critic who actively promoted members of the Neue Secession in the prewar period, the text framed Kollwitz's development within Expressionist theoretical debates; he claimed that she had achieved a "syntax," a language comparable to speech, that only on the basis of an intense familiarity with natural forms was capable of seizing, expressionistically, on a most emphatic experience of emotion.[162]

The traveling retrospective was enthusiastically reviewed, critical reception giving her the respect and status she deserved, as evidenced by previously unpublished correspondence with individual collectors, which attests to the demand for her works. So, she replied to the doctor of medicine Fritz Koenig (February 19, 1918), who wanted to invest in a major drawing of hers:

> At the moment, I really have nothing good here. On the occasion of the 50 year exhibition I sold a great deal. To art dealers and private customers. The exhibition, as far as it is still together, is still travelling. At the moment it is in Mannheim. It should certainly come to Breslau . . . a part of the drawings from the exhibition still belongs to me, another part to art dealers. These force the prices up to a high level.[163]

The extract reveals how imbricated Kollwitz was in the mobilizing forces of cultural and social capital.[164] Yet it further conveys the "value capital" attached to the acquisition of her drawings and her subjective concern for retaining them in her own collection. Fascinatingly, a few days earlier (February 14, 1918) she had informed Koenig that after the war,

> [t]he art dealer Richter in Dresden is editing a portfolio of reproduced drawings, some of them in the original size. Some of the truly characteristic sheets are gathered there. The reproductions will be very good, not much worse than the originals . . . My drawings are something completely different from my etchings.[165]

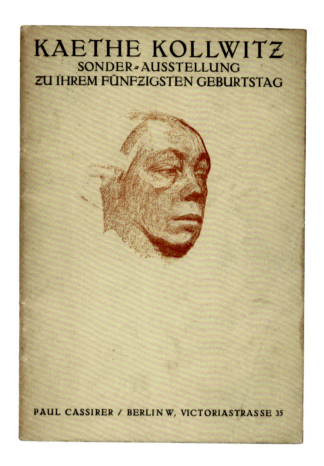

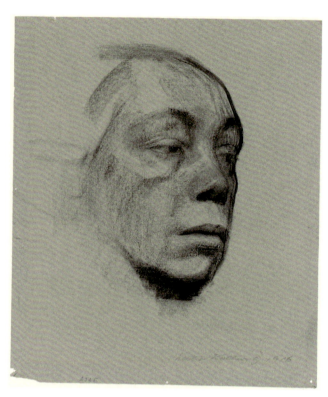

46 Catalog cover from *Kaethe Kollwitz: Sonder-Ausstellung zu ihrem Fünfzigsten Geburtstag* (Special Exhibition on Her Fiftieth Birthday) (Berlin: Paul Cassirer, 1917), with reproduction *Selbstbildnis, Halbprofil nach Rechts* (Self-Portrait, Half Profile from the Right), 1916, Kollwitz Collection, Käthe Kollwitz Museum Köln

47 Käthe Kollwitz, *Selbstbildnis, Halbprofil nach Rechts* (Self-Portrait, Half Profile from the Right), 1916, charcoal on paper, 33.8 × 26.9 cm, Albertina Museum, Vienna, NT 733

As we have seen, in such theorization "drawing" retains its traditional and masculine associations, even though departing from the academic notion of métier as a transmitted tradition and entering the realms of *medium* as modernist invention.[166] Between her attachment to the "authenticity" of her original drawings and distancing of her development from the etching medium, Kollwitz, nonetheless, was challenged by the possibilities of technological reproducibility and the multiple. Indeed, the Kunstsalon Richter published the abovementioned portfolio of twenty-four reproduced drawings in 1921. Instructively, Alexandra von dem Knesebeck, the compiler of the catalogue raisonné of Kollwitz's graphic oeuvre, reports that Kollwitz began signing the facsimiles in the 1920s.[167] For Kollwitz, then, authorship—and for us in an exceedingly postmodern vein—encompassed the original

and its multiple copies. Evidently, when viewed through the lens of the cultural commentator Walter Benjamin's contentions, as conveyed in his magisterial essay of 1935, "The Work of Art in the Age of Technological Reproducibility," Kollwitz seized on advances in the field of photography— notwithstanding their concomitant impact on the "aura" of originality of the work of art—to assist in wider dissemination of her "name."[168]

As the art historian Rosalind Krauss has argued in her essay on the "Originality of the Avant-Garde," postmodernist theory facilitated the tasks of demythologizing the historical period of the avant-garde and modernism, in addition to "deconstructing the sister notions of origin and originality."[169] If, in Krauss's examination of Rodin's sculptural oeuvre, the "potential multiple" emerges at the heart of his studio practice, then this is no less the case for

Kollwitz's processes, so tied as they were to the reprographic industry. In this revision of our understanding of vanguardism, notwithstanding her arguments to the contrary, Kollwitz's name cannot be divorced from its historical entanglement with modernism.

At this stage of her career, beyond the acknowledgment of the art world, official recognition of Kollwitz's talents came with the women's vote in January 1919; at the age of fifty-three, she was the first woman to be nominated to the Prussian Academy of Fine Arts. At a time of intriguing schisms in the art world after the November Revolution in 1918, Kollwitz's lean toward this institution was unusual. Other left-wing artists were active in the Novembergruppe (November Group), which was founded in December 1918 by the artists César Klein, Moris Melzer, Max Pechstein, Heinrich Richter-Berlin, and Georg Tappert. Calling on Expressionists, Futurists, and Cubists to unite, the utopian aims of the group were at the outset indistinguishable from those of the Arbeitsrat für Kunst (Working Council for Art), a soviet-type council that sought to reform the imperial arts administration of the Wilhelmine period. Yet, driven by architects Bruno Taut and, thereafter, Walter Gropius, the Arbeitsrat was radical in attempting to maintain its revolutionary credentials.

In December 1918, the Arbeitsrat published "Ein Architektur-Programm" (An Architectural Program), which Kollwitz undersigned along with the foremost modern architects, painters, sculptors, critics, and art historians. In this it was declared:

> Art and people must form a unity.
> Art should no longer be the enjoyment of the few but the life and happiness of the masses.
> The aim is the alliance of the arts under the wings of a great architecture.[170]

Kollwitz shared the above sentiments and, moreover, since the death of her son, she was dedicated to creating a site-specific public memorial.[171] Just three months later, however, she refrained from adding her name to the reissued manifesto of April 1919. Possibly this may have had something to do with her ambivalent response to the first Arbeitsrat exhibition that was held in March 1919 at Israel Ber Neumann's gallery on the Kurfürstendamm in Berlin.

Entitled "Unbekannte Architekten" (Unknown Architects), this landmark exhibition questioned traditional expectations of the profession by including "utopian drawings" contributed by amateurs and painters alike.[172] "Adequate Expressionist painting," Kollwitz recorded in her diary, "Raptures—also leg-pulling—but interesting."[173]

Here, there was nothing new about her love/hate relationship with Expressionism and, indeed, by this time she was not alone in the critique of the movement's shortcomings.[174] But, in the interim, her acceptance of membership of the academy may have prompted withdrawal from the signatories of the Arbeitsrat. Already the December 1918 program had called for the dissolution of state institutions, such as the Royal Academy of Arts, replacing them with democratized communal bodies. For Kollwitz, the path to recognition and parity was one of continuous struggle, and the need to professionalize her career was clearly paramount. As she stated at the time, Berlin had become a comfort zone, the *Heimat* that she loved, notwithstanding the political strife, violence, and assassinations that were typical of everyday life in the early Weimar Republic.[175] Although part of the establishment—her appointment to the academy was advertised in the weekly *Berliner Illustrirte Zeitung* (fig. 48)—Kollwitz was feted by younger, avant-garde women artists. Take the case of the Dadaist Hannah Höch (1889–1978), who pasted the truncated media image of Kollwitz, pierced with an arrow, at the center of her photomontage *Cut with the Kitchen Knife through the Last Weimar Beer-Belly Cultural Epoch in Germany* (1919–20; fig. 49).[176] Höch's homage not only accedes to Kollwitz's importance in the wider public sphere but, feasibly, also to the modernity underpinning Kollwitz's strategies in the most politically engaged and widely disseminated of her works during this period.

Accompanying the different inflections of revolutionary pacifism, Kollwitz diversified her production, responding to state commissions for posters, on the one hand, and privately sponsored calls for a commemorative graphic to the assassinated Spartacist, Karl Liebknecht, on the other. Of the former, circulated in thousands of copies in Berlin and Prussia, the *Drei Flugblätter gegen den Wucher* (Three Flysheets against Profiteering) were commissioned jointly by local and federal authorities, the Police Office, and the State Commissioner for the

Käthe Kollwitz,
die Malerin und Radiererin, das erste weibliche
Mitglied der Akademie der Künste.
Phot. Hofferichter.

✳

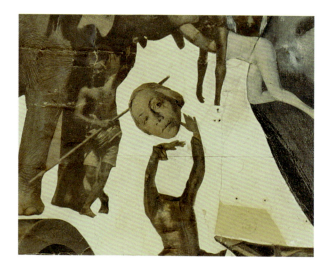

49 Hannah Höch, detail: *Schnitt mit dem Küchenmesser durch die letzte Weimarer Bierbauchkulturepoche Deutschlands* (Cut with the Kitchen Knife through the Last Weimar Beer-Belly Cultural Epoch in Germany), 1919–20, photomontage and collage with watercolor, 114 × 90 cm, Nationalgalerie, Staatliche Museen zu Berlin, Berlin

48 "Käthe Kollwitz, die Malerin und Radierin, das erste weibliche Mitglied der Akademie der Künste" (Käthe Kollwitz, the Painter and Etcher, First Female Member of the Art Academy), *Berliner Illustrirter Zeitung* 28, no. 13 (March 30, 1919): 101

Nation's Nutrition. Appearing in 1920 at a time of desperate postwar shortages, poverty, and spiraling inflation, these flysheets promoted public health while rallying a proletarian audience against usury and the black market. In *Beim Arzt* (At the Doctor) (fig. 50), the imagery seizes on the immediacy of an encounter in a medical surgery and a rather unique portrayal (in Kollwitz's oeuvre) of a doctor examining an emaciated young boy with a stethoscope. The accompanying handwritten text endorses the grim realities of existence in the postwar city, the doctor addressing the hunched, dejected mother: "The patient is undernourished. He needs milk, eggs, meat, and fat on a daily basis." The mother replies: "Doctor, I haven't got enough money, I can't even buy what is available on coupons." The authoritative voice of the professional responds: "That's how profiteering achieves the ruin of our youth. How can you watch this happening? Let us all join the fight against this worst enemy of the nation! Report every profiteer relentlessly.

All public prosecutors' offices and police authorities take your reports."

Typical of socialist policies, the photolithographic multiples aimed at handheld accessibility and, given their narrative portrayal, it is understandable why they have become important resources in their own right for collections devoted to the history of medicine.[177] Yet, at the same time, and typical of avant-garde practice, Kollwitz rejected not only her previous etchings but also her current lithographic processes in the search for a medium that would satisfy the joint desiderata of moral duty and subjective agency. In 1920, her turn to the woodcut was spurred by the viewing of Barlach's prints in the secessionist section of the Great Exhibition.[178] In this preeminently Expressionist medium, she found an outlet for her creative response to the "searing event" of the war on the home front.[179] Published by Emil Richter in 1923 in an edition of four hundred, her antiwar cycle of seven woodcuts, *Krieg* (War), seizes on themes from those of maternal sacrifice and exhilaration of the volunteer to parental loss, widowhood, and national mourning.[180]

When viewing two out of the four preparatory drawings in relation to the woodcut from the series *The Volunteers*, one can understand her attachment to the

remarkable sketches. The draftsmanship traces the material evolution of the theme, at first more gestural and painterly (fig. 51), suitable to lithography, thereafter more defined in terms of relief-plane technique (fig. 52), as Kollwitz highlights the compositional motifs that are destined for deeper cutting. The young, blinded men, portrayed as trailing the dance of death, represent from left to right, her son Peter and comrades Erich Krems in the center, Walter Meier second from the right, and Julius Hoyer on the extreme right.[181] Simultaneously working on a sculptural memorial to her son, it is instructive that the initial title of the sketches started out as "Dixmuiden," the site where Peter fell in Flanders. Yet there are no references to a specific time and place, and in the woodcut *The Volunteers* (fig. 53),

Kollwitz distills the elements into an immediately readable composition. Deeply gouging the wood to heighten the emotional impact, the sweeping figural movement is silhouetted against the stark white of the unprinted paper below. Above, the incised curves of a rainbow unify the black-and-white image on a formal and semantic level.

Kollwitz's honed language in the woodcut medium feasibly took heed of the early gestalt theory of psychologist and family friend Max Wertheimer, whose rapturous notations regarding her 1917 exhibition were recorded verbatim in her diary:

I am writing down here the words that Wertheimer wrote about my work: "that there deep inside us

51 Käthe Kollwitz, *Die Freiwilligen* (The Volunteers), 1920, charcoal and brush on paper, 49.4 × 69.9 cm, Graphische Sammlung, Staatsgalerie, Stuttgart, NT 850

52 Käthe Kollwitz, *Die Freiwilligen* (The Volunteers), 1921, pen and ink with painted white highlights over pencil on paper, 45 × 55 cm, E.W.K., Bern, NT 852

lies something quietly immense, a force of great magnitude and urgent intent, an ardor that wells up in utmost earnest; that in the progress that life has brought about in terms of the economy, state, and humanity, that there amidst the crowded seething mass this nameless weight and greatness silently builds . . . that this same something [is to be found] only in an inexpressible purity [in that] which is called Mother . . . That is what, in the work that is a human being, gives form to the self, a [being] there . . . It is life's innermost essence that has taken shape there, stands there for us, representative of ourselves, a cry there, there, and we are the chorus who knows: in us."[182]

Here Wertheimer reveals his belief that dividing wholes into parts without losing track of the original totality was important to creative thinking.[183] He accounts for the intensity of viewing Kollwitz's work as a "being there," which is underscored as a form of maternalism. Indeed, the Expressionist roots of his phenomenology become apparent, the tendency to distort external appearances of things in an effort to point to the interior of phenomena.[184]

53 Käthe Kollwitz, *Die Freiwilligen* (The Volunteers), 1920–22, woodcut on paper, plate 2 of *Krieg* cycle, 1923, 35 × 49 cm, MoMA, New York; August Klipstein, ed., *Käthe Kollwitz: Verzeichnis des Graphischen Werkes* (Bern: Klipstein, 1955), 178.

Wertheimer's notes further attest to the fluidity of his mid-war ideas in alluding to Freudian theory on the function of unconscious play in child development (the *fort/da* principle) and the return to the self ("ein Schrei Da Da"). Fascinatingly, whereas Freud identifies this form of repetitious play as referencing the absent father "who has been sent to the front," Wertheimer seizes on it as a sublimatory recognition of the primordial maternal presence.[185]

As argued in chapter 2 on the posthumous reception of Modersohn-Becker, Expressionist intuitionist theory offered the coordinates of the feminization of the movement. Obviously, with Kollwitz, this was no less the case. Her turn to the woodblock print facilitated not only an

intensely powerful distillation of her formal means but also signaled her engagement with Expressionist responses to the First World War. The intentions of dissemination of the multiple to a wider audience were both reparative and commemorative, since Kollwitz's *Krieg* was included in pacifist activities surrounding the anniversary of the declaration of the First World War. Along with Otto Dix's print cycle *Der Krieg* (1924), her portfolio was exhibited in the first display at Ernst Friedrich's Anti-Kriegs-Museum (Anti-War Museum), which was founded in Berlin in 1925. Much, one would imagine, to Kollwitz's chagrin and notwithstanding her testimony to the contrary, the coordinates of her practice relate to aspects of Expressionist avant-gardism. These lay in a vital dialectic between tradition and modernity, high and low art, formal autonomy, and reproductive processes, between which categories, as has been argued, the avant-garde as the "bearer of modernism" has been successful in making the tensions visible.[186]

4

—

FEMALE AVANT-GARDE IDENTITY AND CREATIVITY IN THE BLAUE REITER

The Possibility of a "Blaue Reiterreiterin"

Unlike the Künstlergruppe Brücke (Artists' Group Bridge) in Dresden, which was limited exclusively to male practitioners, the Neue Künstlervereinigung München (Munich New Artists' Association, 1909–12; hereafter NKVM) and the Blaue Reiter (Blue Rider, 1912–14) certainly provided more meaningful opportunities for women artists' participation in exhibitions in prewar Germany. Indeed, the NKVM was founded at the residence of the Russian-born artist Marianne Werefkin (1860–1938), a venue well known for its international salons at which the "Baronin" (Baroness), as she was called, was undoubtedly the initiator of cultural discourse.[1] Seventeen years her junior, Gabriele Münter (1877–1962) was also a founding member of the association, having launched solo exhibitions of her paintings and then graphics at the Kunstsalon Lenoble in Cologne and graphics at Friedrich Cohen's bookstore in Bonn during 1908. Until the 1980s, as was usual in narratives of early modernism, their roles were marginalized to that of muse or companion of their respective male partners at the time, Alexej Jawlensky (1864–1941) and Wassily Kandinsky (1866–1944).

Since then, however, the publication of monographs and mounting of retrospective exhibitions have revealed Werefkin's and Münter's importance to Munich-based Expressionism.[2] This in turn has energized feminist-inspired scholarship, which explores aspects of intimate creative partnership and poses questions as to whether such interchanges can escape the limitations imposed by social and psychological constructions of gender.[3] Within the frame of avant-garde gambits, it is possible to discern a period in the lives of this foursome in which one can seize on their combined force as a metagroup within the NKVM.[4] Between 1908 and 1910, their excursions between Munich and the south Bavarian town of Murnau gave rise to vivid landscape painting that abandoned traces of the *plein air* experience to assume the values of Synthetism. Somewhat neglected in the literature, though, is the dynamic between Münter and Werefkin, their contrasting national and cultural origins and routes toward avant-garde practice.[5] Internal changes within their respective oeuvres prior to the outbreak of war also deserve more focused attention.

By December 1911, the public profile of the exhibiting group Blaue Reiter had eclipsed that of the NKVM. From the events leading up to its formation, it can be observed that the Blaue Reiter resonated with the avant-garde ethos of "killing off" its predecessors, a Freudian trope deployed by Griselda Pollock to characterize male artists' rejection of father figures.[6] It is broadly acknowledged that Kandinsky's much-derided, spiritual abstraction was responsible for his, Münter's, Franz Marc's, and Alfred Kubin's secession from the NKVM

on December 2, 1911. So swift was the decision that neither Werefkin nor Jawlensky participated in the initial Blaue Reiter exhibitions.

It was only in November 1912, on the publication of Otto Fischer's controversial book *Das Neue Bild* (The New Painting), that Werefkin, Jawlensky, Wladimir von Bechtejeff, Moissey Kogan, and Alexander Mogilewski seceded from the NKVM.[7] As an art historian and professional member of the latter, Fischer ostensibly wrote a history of the association, but in advocating the importance of "objective reality," he expressed his distrust and suspicion of the abstract and mystical principles at work in Kandinsky's paintings and treatise *Über das Geistige in der Kunst* (Concerning the Spiritual in Art, 1912).[8] Clearly, the issues of abstraction versus figuration were high on Fischer's list of concerns, and his predisposition toward the German tradition in the NKVM, an internationalist group from the outset, is one of the early manifestations of a need to bring order from chaos, to bring modern art in line with bourgeois conservatism.[9]

The desire to clear the slate and start afresh altered the sociology of the new group; the nucleus had expanded to include the young Munich artist Franz Marc (1880–1916) and his future wife, the artist Maria Franck (1876–1955); the Bonn-based couple August (1887–1914) and Elisabeth Macke (1888–1978); and, by 1912, Paul (1879–1940) and musician wife Lily Klee (1876–1946). Born in Berlin, Franck had moved to Munich in 1904 in order to train in the Women's Academy of the Künstlerinnenverein. She met Marc soon thereafter and, in 1905, spent the summer in the Worpswede colony, studying under Otto Modersohn at a time when Modersohn-Becker was at her most productive in this north German provincial setting. Franck developed a rather complicated relationship with Marc, and they were finally able to marry in June 1911.[10] Her cohabitation with him prior to this date challenged social conventions and strained the bond with her parents.

Another recruit was Ukrainian-born artist Elisabeth Ivanowna Epstein (1879–1956), who had joined the Russian colony in Munich in 1898. From 1908 onward, she was based in Paris and, as a consequence of a long-standing friendship with Sonia Terk, who married Robert Delaunay in 1910, Epstein was instrumental in introducing his works to Kandinsky and Marc.[11] However, of the initial band of

women artists who exhibited in the NKVM (Erma Bossi, Emmy Dresler, Carla Pohle, Münter, and Werefkin), only Münter remained.[12]

Indeed, Münter's and Kandinsky's collaboration was transformed by the linkage of his name with that of Marc, as coeditor of the almanac and co-organizer of the two exhibitions. Within a short period, Kandinsky's correspondence with Marc reached an intensity that was comparable to the Russian artist's epistolary exchange with Münter.[13] Whether or not Münter was merely a spectator to this evolving male artistic partnership is an issue that is considered below. That the Blaue Reiter circle was a broad church is revealed in the preface to the exhibition catalog of their first exhibition, which stated that the editors sought to show "by means of the *variety* of the represented forms how the *inner wish* of the artist is embodied in manifold ways."[14] Furthermore, the second exhibition, *Schwarz-Weiss* (Black-White), which was dedicated to works on paper, included not only international participants but also members of the Brücke.[15] As in the case of the wider European avant-garde, the Blaue Reiter held syncretic tastes and regarded child, folk, Oceanic, and African art, Japanese woodcuts, and Egyptian shadow puppets positively within the taxonomy of the primitive.

Along with the paintings of favored artists like Henri Rousseau, Arnold Schönberg, and, indeed, Münter's *Still Life with St. George* (1911; fig. 54), these sources were extolled as possessing a "complicated inner sound" in Kandinsky's diversely illustrated essay "Über die Formfrage" (On the Question of Form), which was published in the almanac *Der Blaue Reiter* in May 1912.[16] A sequence of essays on contemporary art, music, theater, and poetry, the cover design was based on Kandinsky's woodcut of *St. George and the Dragon* (fig. 55), patron saint of both Russia and Murnau, as iconic of modern artists' spiritual mission. The composition quotes directly from local folkart examples of *Hinterglasmalerei* (reverse glass painting; fig. 56), the artist's recourse to previously considered "low art" and craft manifestations—as in Jugendstil— underlying the abstracted linear configuration and unbounded color at work in Kandinsky's practice.

While sharing in this vanguard outlook and the aesthetic predilection for *Hinterglasmalerei*, Münter's fascination with still life arrangements of her Bavarian folk-art

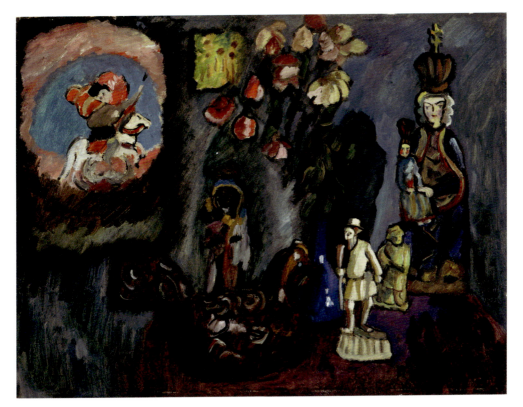

54 Gabriele Münter, *Still Life with St. George*, 1911, oil on board, 51.1 × 68 cm, Städtische Galerie im Lenbachhaus und Kunstbau, Munich, Gabriele Münter Stiftung 1957, Inv.-No. GMS 666

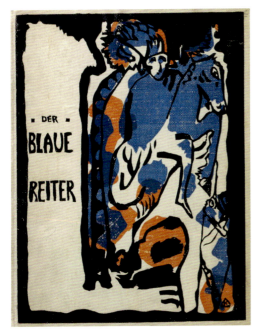

55 Wassily Kandinsky, cover of the Almanac *Der Blaue Reiter* (Munich: Piper, 1914), from 2nd ed. of one hundred, woodcut (electrotype) printed in red, blue, and black on linen-wrapped board. Image: 27.9 × 21.1 cm, Los Angeles County Museum of Art, the Robert Gore Rifkind Center for German Expressionist Studies, purchased with funds provided by Anna Bing Arnold, Museum Associates (83.1.105a)

56 Anonymous, *St. George*, Oberammergau, ca. 1820, *Hinterglasbild*, Gabriele Münter- und Johannes Eichner-Stiftung, Munich

collection, stylizing processes, and themes of childhood was classified within the narrower *weiblich* (feminine) realm of women's art.[17] This is not to denigrate notions of the "feminine" but, indeed, to *interrogate*, as Janet Wolff proposes, the feminine sensibility inscribed within male avant-gardism.[18] Male and female practitioners alike were receptive to trends in late nineteenth-century reform movements that prioritized a Nietzschean "ascent" of culture to nature.[19] This art as life paradigm offered an alternative modernity: a liberation from bourgeois values and subscription to a vital and expressive freedom. Kandinsky, as much as Münter, was engaged in purchasing examples of folk art, in decorating furniture in emulation of Biedermeier or peasant prototypes, and staging interiority through the placement of these items in the urban or rural domestic setting.[20]

For Kandinsky, who had specialist training in Russian peasant law and ethnography, the folk art, onion-domed churches, and environs of Murnau held further national resonances.[21] That the Bavarian experience rekindled memories of Russia can be ascertained in his autobiographical essay "Rückblicke" (Reminiscences, 1913).[22] In 1910, after Werefkin's return visit to Lithuania, such transnational referents became more apparent in her oeuvre, and the interweaving of motifs allows insight into the complex processes of recollection and reinvention in émigré artistic identity. Following on from feminist art-historical exhortations, I argue below that Münter's turn-of-the-century odyssey to North America, and repertoire of visual and emotional memories, set in train her artistic sensibility toward folk-art sources and issues of temporality.[23] Münter's consciousness of formal strategies, and the values she attached to the sketch and scene making, offer important counterevidence to the critical response to her as a naive artist in the historiography.

Of course, we are aware of Kandinsky's androcentric memoir of the title *Der Blaue Reiter* as having arisen from a coffee-table discussion with Marc and his wife Maria: "We both liked blue: Marc—horses, I—riders."[24] For these male artists the color blue, invested with spiritual associations, and the rider motif were richly evocative symbols.[25] They signified a range of meanings, from Christian warrior saints to the masculine virtues of charging medieval knights. Indeed, the horse motif, as representative of

sexual passion, dates from antique and medieval zoological literature. The male rider-cum-artist, thereby, channels or masters the irrational wildness through intellect and self-mastery.[26] Fortunately, notwithstanding their "sidesaddle" status in social history and sexual politics, female identity did not exclude women artists from disciplining the unruly, instinctual passions through creative reasoning and artistic talent.[27]

As noted above, the Blaue Reiter harbored the staging of more complex notions of gendered authorship. Interestingly, we encounter the use of striking terminology in the correspondence between Werefkin and the German Jewish poet, artist, and writer Else Lasker-Schüler (1869–1945), where the concept of a "Blaue Reiterreiterin" (Blue Rider/Woman Rider) was introduced. Notwithstanding her divorce from the publisher and dealer Herwarth Walden in 1912, Lasker-Schüler developed a creative exchange with Franz Marc and other members of the Blaue Reiter.[28] In

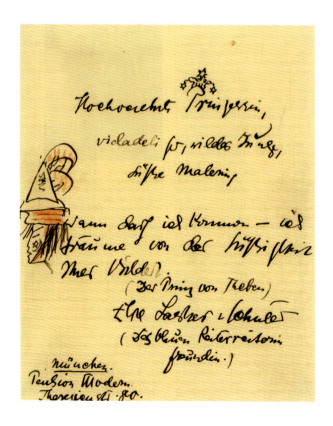

57 *Letter by Else Lasker-Schüler to Marianne Werefkin (Blaue Reiterreiterin)*, 1913, pen, ink, and crayon on paper, 16.5 × 13.5 cm, private collection

1913, in correspondence with Werefkin, the poet hailed the artist as both "vieladeliger, wilder Junge" (noble, wild lad) and "süsse Malerin" (sweet woman painter) (fig. 57). This conjunction and disjunction of values and gender-crossing was as typical of the poet's style of addressing her female colleagues as it was of her own fictional self-naming (fig. 58). She signed herself "Der Prinz von Theben" (The Prince of Thebes) and this is accompanied in the margin by her self-portrait, adorned with cosmic symbols and an exotic, plumed hat.[29] Finally, below her name she termed herself "Des blauen Reiterreiterin Freundin" (the woman friend of the Blue Rider/Woman Rider), suggesting the collocation of the rider and horsewoman.

The fluidity of gendered authorship, as conveyed in the above, interpolates in well-worn narratives of the Blaue Reiter as well as providing an emancipating precedent for the woman artist in poststructuralist terms. Historically speaking, though, it allows some insight as to how Werefkin's persona and oeuvre could attract the adulation not only of a network of creative women but also of male artists and critics. This is notwithstanding the fact that Werefkin's and Jawlensky's works were neither featured in the two Blaue Reiter exhibitions that were held in Munich nor in its Berlin venue in March 1912, which launched Herwarth Walden's Sturm Gallery.[30] But, certainly, by the summer of 1912, they participated at the *Sturm* premises, alongside Münter, Kandinsky, Marc, and Albert Bloch, in the exhibition *Deutsche Expressionisten: Zurückgestellte Bilder des Sonderbundes Köln* (German Expressionists: Deferred Pictures from the Sonderbund Cologne).[31] In addition, their works were included in various group shows in Munich: in *Die Kunst für Alle*, the well-known reviewer Maximilian Karl Rohe focused exclusively on Werefkin's works as the most original within an exhibition that was held at the gallery of the dealers Paul Ferdinand Schmidt and Max Dietzel.[32] In August 1913, in his catalog essay for the Neuer Kunstsalon Hans Goltz at the Odeonsplatz in Munich, the critic and art historian Wilhelm Hausenstein celebrated her works within the context of Expressionism.[33]

One may well ask why such deference and affiliation was accorded to Werefkin and not Münter, whose efforts were so crucial to the formation of the Blaue Reiter? What of the case of Maria Marc, whose "double marginalization" with regard to patriarchal society and the group

58 Anonymous, *Else Lasker-Schüler as Fakir from Thebes*, frontispiece from her novel *Mein Herz* (Munich: Bachmair, 1912), photograph, Else Lasker-Schüler Archive, the National Library of Israel, Jerusalem

occludes material on aesthetic debates, not to mention the flourishing—albeit sporadic—of her own artistic talents?[34] This chapter explores the positions of Werefkin and Münter in relation to the Blaue Reiter, its art world, and avant-garde practices. While their works do not easily conform to paradigms of autonomy and spiritual abstraction, they shared a concern for painterly figuration in their handling of city/country themes, issues of which, as elucidated in the chapter on Modersohn-Becker, were fiercely debated in the cultural politics of the period. Linked to a variation of agrarian romanticism, their rural subject matter can be set against a backdrop of the familiar category of *scènes et types*, much promoted by popular photography, postcards, and travel literature in the colonial period.[35]

While visiting family in America between 1898 and 1900, Münter's acquisition of the most up-to-date model

of a Kodak Eastman (No. 2) camera on her twenty-second birthday gave rise to a substantial portfolio of more than four hundred photographs, the trope of travel informing her photographic practice.[36] In 1901, in Munich, she documented the spectacle of non-European cultures in the *Völkerschau* (Colonial Exhibition) in candid photographs that subverted expectations of the primitive "Other."[37] Furthermore, as has been observed of her shots of wealthy, self-confident black Africans in the Maghreb during her and Kandinsky's visit to Tunis in 1905, Münter countered stereotypes that represented them only as beggars, laborers, or entertainers in the stock images.[38] Hence, her photographs offer instructive examples of a departure from the ethnographic link in Orientalist discourses of consumable alterity.

Her interests were more versatile in catering for different constituencies in the art market. In the pre- and mid-war years, as expanded in forthcoming chapters, the dealer Walden invited women artists to participate in *Sturm* exhibitions and to contribute graphics and drawings to the weekly publication of the journal *Der Sturm*.[39] Münter's flair for draftsmanship and printmaking meant that she was the first of many women practitioners to have woodcuts commissioned by Walden; in January 1913, he arranged a *Sturm* retrospective of her wider oeuvre in Berlin. Werefkin met Walden in October 1912; thereafter she provided him with an introduction to the impresario Sergei Diaghilev, who was visiting Berlin to direct a performance of the famous Ballets Russes.[40] Werefkin's unpublished correspondence with the dealer couple reveals that they remained her agents during her extended visit to Lithuania in 1914 and subsequent emigration to Switzerland.

Before considering why Munich was such an attractive artistic center for Russian artists and how their interaction engendered a sense of community and social cohesion, it is appropriate to consider Werefkin's early career. Of concern here are the discourses surrounding gendered artistic identity in late nineteenth-century Russia, her relocation to Munich, secessionist aspirations, and transnational idealization of the premodern amid modernity's predictable foray into the rural. Thereafter, the chapter introduces Münter's early formation, and discrete sections focus on the group's Murnau interlude, the exhibition of the Blaue Reiter, and *Sturm* connection.

Werefkin: From Russia to Munich (ca. 1886–1909)

A unique characteristic of German Expressionism in Munich is the high concentration of Russian émigré artists who participated in its formation, and in this respect Werefkin's origins are just as relevant to such considerations as those of her male colleagues. In addition to her early oeuvre, Werefkin's corpus of writings is indispensable to charting her intellectual formation: of particular interest are her unpublished reading lists, which date from 1889 onward. Therein she meticulously documented her bibliography in chronological order, including current edition dates and page references of the publications.[41] Art historian Laima Laučkaitė-Surgailienė's discovery of correspondence with members of Werefkin's family and Jawlensky is also invaluable.[42] In particular, the artist's letters from her period of return to Lithuania between December 1909 and the spring of 1910 disclose a great deal about her expatriate identity and nostalgia for a privileged youth in Russia and in outposts of the empire.

From a feminist perspective, and vital to understanding Werefkin in light of her construction of an artistic persona, is her journal *Lettres à un Inconnu* (Letters to an Unknown, 1901–5).[43] Written in French, the preferred language of elite circles in czarist Russia, it escapes strict definition as memoir, soliloquy, or manifesto and remained unpublished during her lifetime.[44] In an epistolary format that addressed her inner alter ego, the journal reveals her theoretical aspirations toward an expressive and non-mimetic art of the future. Yet the tone of narration over the three volumes (1901–2, 1903–4, 1904–5) is progressively nuanced, from first to third person, and embraces Werefkin's wider internationalist and political concerns. These involve her experiences in the Parisian art world and critique of Russia's imperial aggression under Czar Nicholas II, who reigned between 1894 and 1917. The third volume of the journal illuminates her despair during the Russo-Japanese War in 1904 and abortive Russian Revolution of 1905, indicating how fervently Werefkin kept abreast of events in her homeland while living abroad.

In Russia there were more social and professional outlets for women artists, and they gained access to academic training almost thirty years earlier than in Germany.[45] Born

59 Marianne Werefkin, *Portrait of Mother* (Elisabeth von Werefkin), 1886, oil on canvas, 64 × 54 cm, location unknown

into aristocracy in Tula, south of Moscow, well known as the birthplace of Tolstoy, Werefkin had the benefit of both private and academic tuition. However, the fact that her mother, Elisabeth Daragan (1834–85), was a painter of portraits and icons for iconostases in Eastern Orthodox churches alerts us to the more complex lineage of Werefkin's development. The authors P. D. Ouspensky and Vladimir Lossky sum up the liturgical meanings of icon painting as impinging "on our consciousness by means of the outer senses, presenting to us the same supra-sensible reality in 'aesthetic' expressions."[46] As we will see, such ontological reasoning served as the basis of Werefkin's theoretical arguments regarding figural abstraction.[47]

In both word and paint, she honored her mother as a role model, who offered her professional direction, feminist inclinations, and vital energy. As Werefkin recollected in

her journal, "She [Mama] said that her most beautiful legacy was my art, she left me a little money so that I did not have to experience the master in the man."[48] Fascinatingly, in her *Portrait of Mother* (1886; fig. 59), a posthumous tribute to Elisabeth, who died the previous year, Werefkin adapted the colors and conventions of traditional Russian icons to a somber portrayal of the woman in Spanish attire. The portrait represents a dynamic cultural exchange between East and West: while the cinnabar-red shades enliven the lacy black mantilla, the yellow-gold ground transmits little warmth, and a deathly silence pervades the image akin to the meditative function of icon viewing.

In her journal entries, Werefkin was no less reflective about the supportive role of her father, Vladimir Nikolaevich Verefkin (1821–96). Due to his military career as an infantry commander general, the family was transferred

to several garrisons across the Russian Empire, including Vitebsk in Russia, Vilnius in Lithuania, Lublin in Poland, Moscow, and St. Petersburg. In a photograph of Werefkin riding a horse (1890; fig. 60), she is shown on the estate Gut Blagodat (Paradise), near the town Utena, in the Kovno (now Kaunas) guberniya (province) of Lithuania, a generous gift from Czar Alexander II to her father in 1879. The family spent summers there and it was the locus of one of Werefkin's studios, the other being in St. Petersburg. That urban and rural debates informed her interludes on the estate can be gauged from photographs of her studio and the interior décor.

Locally derived artisanal detail is apparent in the decorative architectural wood carvings within the pediment and acroteria of the pitched roof on the left-hand side of the vintage photograph (fig. 61). In the interior, a selection of hand-carved furniture, oriental decorative textiles, and patterned wall coverings contrast with Werefkin's large painting of her sister-in-law in Dutch costume on the left (fig. 62). In late nineteenth-century Russia, there was a major trend to institutionalize permanent ethnographic displays and this was echoed in the domestic tastes of the landed gentry, upper-middle classes, and intelligentsia.[49] Instructively, the Werefkin family had contact with the

Abramtsevo colony north of Moscow, which fostered the preservation of folk art as well as encouraging its revival among contemporary artists.

Pioneering in this regard was Elena Polenova's (1850–98) management of the carpentry workshops from 1884 onward, an engagement that grew out of her close friendship with Elisaveta Mamontova, wife of Abramtsevo's patron, the industrialist Savva Mamontov.[50] As a frontrunner of the Russian Arts and Crafts movement, Polenova received commissions for furniture from Werefkin's mother, examples of which accompanied the artist to Munich (fig. 63). This decorated and gilded limewood cabinet shows that Polenova's designs were sensitive reworkings of folk art and design, the patterns and painted relief carving encased within a new rustic style.[51]

As has been argued, ethnographic knowledge helped in the perception, understanding, and also shaping of imperial cultural diversity.[52] Werefkin's painting *Girl in Russian Costume* (ca. 1883–88; fig. 64) signals a definitive fascination for the bright-colored fabrics of the folk costume reserved for young Lithuanian women (the red emphasizing fertility).[53] While there is an intrigue with the detail of the headdress, emblazoned with symbolic bird imagery, jewelry, and embroidered patterns of the fabric, Werefkin's

60 Anonymous, *Marianne Werefkin on Horse*, ca. 1890, photograph, PSM Privatstiftung Schloßmuseum Murnau

61 Anonymous, *Studio of Marianne Werefkin on the Blagodat Estate*, 1879, photograph, PSM Privatstiftung Schloßmuseum Murnau

62 Anonymous, *Interior of Marianne Werefkin's Studio on Blagodat Estate*, ca. 1890, photograph, PSM Privatstiftung Schloßmuseum Murnau

63 Elena Dimitrieva Polenova, *Sideboard Cupboard*, ca. 1880, carved and painted wood, from former collection of Marianne Werefkin, 59 × 52.5 × 27.5 cm, private collection

painterly technique signals her acquaintance with a wide tradition of Western figural art. Evidently, she benefited from private tuition with the prominent realist Ilya Repin (1844–1930). As a leading figure in the Peredvizhniki (Society of Traveling Artists), which was founded in 1870 as the first independent artistic organization in imperial Russia, Repin spent time in Paris and admired Manet's portraiture in particular.[54]

Yet Repin's concern for the common people and their physical labor certainly made his protégée more aware of the discrepancies between her privileged existence and the world beyond the gates of the Blagodat estate. The Russification of Lithuania, which intensified under the counter-reformist tyranny of Czar Alexander III (1881–94), resulted in the persecution of Catholic and non-Russian populations, in increased anti-Semitism, and suppression of educational autonomy.[55] Werefkin's portrayal of ethnic types stems from the early 1890s when she attended the Imperial Academy of Arts in St. Petersburg and sought

out local models during her sojourns in Lithuania. Only a faded photograph remains of her lost or destroyed painting *The Jewish Day Laborer* (ca. 1890–95; fig. 65). Notwithstanding the impoverished status of the model, Werefkin's characterization preserves his dignity and subjecthood and is comparable to the portraits of Hasidic men shown in cabinet cards from contemporary Jewish photographic studios in the Kovno province.[56] Perhaps Hasidic, rather than traditional Orthodox Jews, secular Zionists, or socialists, were more identifiable by their codes of dress, beard, and sideburns (payot), markers that could descend into misguided conceptions of "authenticity."[57] In the hands of Werefkin, though, her style had broadened and become much less devoted to exotic coloration and detail; tonal values unify the composition and evoke the monumentality of Rembrandt's *Portrait of an Old Jew* (1654), as found in the Hermitage collection.[58] After viewing her painting, Repin used superlatives when comparing the smiling Lithuanian in a cap to "a Velasquez work" and, in 1892, Werefkin

64 Marianne Werefkin, *Girl in Russian Costume*, ca. 1883–88, oil on canvas, 43 × 79 cm, private collection

65 Marianne Werefkin, *The Jewish Day Laborer*, ca. 1890–95, oil on canvas, location unknown

exhibited this or a similar painting in the twentieth exhibition of the Peredvizhniki in St. Petersburg.[59]

Clearly, for Werefkin, in focusing on portraiture, the issue of what to paint was unproblematic, but the matter of "how to paint" was critical. In 1888, due to a hunting accident, her painter's hand was injured and her thumb and index finger crippled. Although she attempted to draw with her left hand, she retrained her right hand to apply the medium by gripping the base of the brush within her fist. This manner of painting can be gauged from her *Self-Portrait in Sailor Blouse* (1893; fig. 66), an honest confrontation with her professional identity as an artist, brazen in her pose with hand on hip, and brushes ready for action.

Instructively, if we examine the unfinished self-portrait in a photograph of her and Jawlensky in the St. Petersburg studio (fig. 67), then we can ascertain that Werefkin painted alla prima, incorporating drawing as she developed the work, the area of greatest irresolution being in the portrayal of her hands.[60]

Although seated in the foreground, Jawlensky's position in the photograph is subordinate to Werefkin's mentor-like perusal of his painting, which dwells on a more caricatured depiction of an elderly Jew, momentarily disturbed from prayer. In 1892 Werefkin had met Jawlensky through Repin; their relationship was serious, and Jawlensky was invited to Blagodat, where he encountered

models appropriate to the realist directions of their pedagogy.[61] Yet, consistent with a social milieu that included the Russian poets Zinaida Hippius and her husband Dmitry Merezhkowsky, Werefkin embraced French literary symbolism. As one can ascertain from the reading lists, her bibliography was diverse and ranged from the realism of Honoré Balzac to the esotericism of Joséphin Péladan and the criminal anthropology of Cesare Lombroso.[62] In this regard, one can understand her and Jawlensky's agitation to further their studies abroad, and this became a reality for Werefkin when her father died in 1896 and she inherited a pension, the proviso being that she remained single. As to why Munich was chosen above Paris, the Bavarian city held many attractions as a place to study art.

The Munich milieu was critical to the ambience in which incipient emancipation, progressive modernism, and the international (or foreign) fulminated against the local and the conservative. In 1892, Munich superseded Berlin in establishing the Secession, an artists' group independent from academic and traditionally linked professional circles.[63] Various nationalities were represented at the Munich Secession exhibitions, and Russians, such as Isaak

Levitan, who became a member in 1897, shared contemporary tendencies to work *en plein air* and to affect a marked departure from the realism that had infiltrated academic practice in St. Petersburg. The suburb Schwabing, home to the Munich Art Academy and the university, became the hub of the so-called Russian colony.[64] Remarkably, in 1895, whereas 965 Russian citizens were documented in Bavaria, by 1910 the number had quadrupled to 4,116, half of whom lived in Munich.[65] Werefkin and Jawlensky were among a group, all friends from St. Petersburg, who arrived in 1896 and were a welcome addition to the city's international art community. A photograph from 1897, set in her Giselastraße apartment (fig. 68), shows Werefkin feted by her Russian compatriots Dimitry Kardowsky, Jawlensky, Igor Grabar, and the renowned Slovenian teacher Anton Ažbé.

While her colleagues enrolled in Ažbé's private art school, Werefkin's first decade in Munich was devoted to her support of Jawlensky's career. In 1897, she founded the St. Lukas Brotherhood, an informal salon that was held at her residence; Gustav Pauli, director of the Bremen Kunsthalle, wrote tellingly of her role in the setting wherein "[a]ll the questions concerning art and literature, ancient

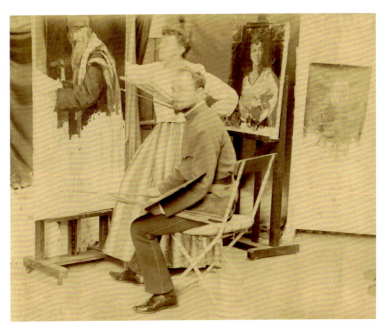

66　Marianne Werefkin, *Self-Portrait in Sailor Blouse*, 1893, oil on canvas, 69 × 73 cm, Museo Comunale d'Arte Moderna, Ascona, FMW 0-0-1

67　Anonymous, *Marianne Werefkin and Alexej Jawlensky in St. Petersburg Studio*, ca. 1893, photograph, PSM Privatstiftung Schloßmuseum Murnau

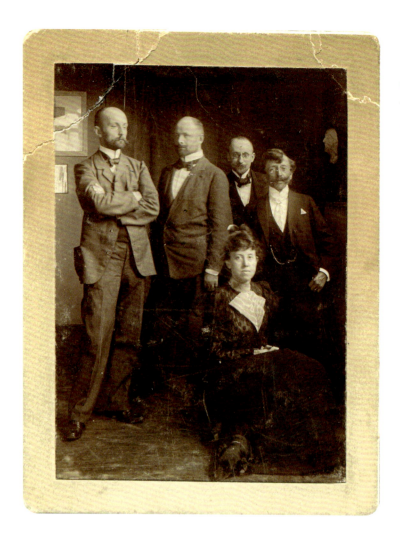

or modern, were debated with an unusual passion and as much spirit."[66] Indeed, a cultural shift toward the pursuit of an expressive art can be detected in Werefkin's reading, which included Henri Lichtenberger's book *La Philosophie de Nietzsche* (1898), an introduction based on close analysis of the visionary character of the German philosopher.[67] Prior to Nietzsche's death in August 1900, she had read his *Die Geburt der Tragödie* (The Birth of Tragedy, 1872), and its authorial subjectivity and promotion of the instinctual in the arts infused the substance of Werefkin's writings.[68]

Yet, like her compatriots, Werefkin's reception of Nietzsche was conditioned by his distinctive appeal to Russian religious philosophers in the Silver Age. In his *Lectures on Godmanhood* (1880), Vladimir Solovyov adapted Nietzsche's *Übermensch* to the quest for a new religious consciousness and reformulation of Christianity.[69] Accordingly, man was the unique intermediary to affect

the synthesis between the world and God. Closely allied to this dialectic was Solovyov's utopian belief in Eros, which had both its physical and heavenly coordinates, heterosexual love being suggestive of a future state of androgynism as a model for spiritual regeneration.[70] For Werefkin, these notions of Eros—the divine in earthly love—were important to the phenomenon of intimate, creative partnership, but such utopianism was not matched by her more errant and intuitive partner. Jawlensky's cohabitation with their Russian housemaid Helena Nesnakomoff (1881–1965) and the birth of their son Andreas in 1902 greatly complicated the household.[71]

Werefkin's *Lettres à un Inconnu* need to be viewed against a background of this domestic turmoil, and its writing is the result of her deep sense of loss of ideal partnership. Within its pages she addressed an imaginary recipient and articulated this inward turn as follows:

To console me I invented you, the unknown, and lis-
tening to you I felt more than ever what was missing
from me. Life is done now. There is no more return
and if it [life] was to start again it would still be the
austere life of mine that I would have chosen. I will
never deny the beauty that is in me, because it is the
only true one.[72]

In this quotation, although Werefkin grieves the loss of
a pleasurable "life," she shows a Nietzschean preference
for the pain and struggle of inner existential striving. The
splitting of the subject was calculated to transgress the
hierarchical bonds of the traditional male/female divide.[73]
As she claimed in the final sections of the journal: "I am
neither man nor woman—I am I."[74]

In establishing her aura as a prophetic voice, Werefkin
distinguished her agency from the practitioner, Jawlen-
sky. This she noted at a time of reconciliation, perhaps
subsequent to the birth of Andreas, that the experienced
anxieties were distant, and they were back in the calm of
their parallel labor: "Work begins again, for him brush in
hand, for me in the tension of my whole being toward the
proposed goal . . . And now I take the pen to resume our
chats."[75] Meditation, confession, dreams, and a healthy dose
of self-interest propelled the woman artist forward and
served as the basis of a symbolist-inspired Weltanschau-
ung; so, she proclaimed:

> Artistic creation is not limited to making paintings,
> pieces of music . . . or poetry. It is all creative thought,
> every thought that brings into the life of a world that
> we do not know things that we have never seen. It
> is like those rays coming to us from invisible stars,
> bringing the light of a luminous center that we may
> never see.[76]

Here Werefkin asserts the interdisciplinary manifestations
of the creative process as a cosmological event, as bringing
into existence a light from afar, the harnessing of the invis-
ible through contemplation. Characteristic of Neoplatonic
idealism, true reality resides in the extraterrestrial, whereas
in this world we try to catch glimpses of it.[77]

The mystical conception of nature's role in the uni-
verse and her visits to Paris via Normandy in 1903 and

Brittany in 1906 predisposed Werefkin toward the Pont-
Aven school and French Synthetist aesthetic theory. In a
discussion of Gauguin's Tahitian works, a week prior to the
opening of the notable Fauve exhibition at the Salon d'Au-
tomne, she reflected on a central feature of this approach to
painting, observing that, "[c]olor directly influences relief.
A body high in color always is flat compared to one mod-
eled in white and black."[78] Favoring the compositional unity
of color relationships to that of drawing and modeling, she
continued:

> It is established in aesthetics that a colorist is usually
> a poor draftsman. One should say that the drawing
> of the colorist must necessarily be different from the
> one who only sees in chiaroscuro, black and white.
> In color, so as not to deviate into the realm of the
> impossible, one must keep to organic form, that is
> the limits of the object, and still, there are many cases
> when this very limit must be discarded so that the
> coloristic impression can act with its full force.[79]

In other words, the artist can forego volume and linear
configuration to achieve an orchestration of colorful
sensations. Five years prior to Kandinsky's completion of
his manuscript for the publication *Über das Geistige in
der Kunst*, Werefkin argued forcefully for the autonomy
of the formal elements in favor of an emotional language
of color.[80]

Interestingly, in 1906, after almost a decade-long
sabbatical from painting, her resumption coincided with
the cessation of the *Lettres à un Inconnu*: as Dorothy Price
has suggested, the writing process not only excised the
agonies of Jawlensky's betrayal but also served as a vehicle
to develop Werefkin's own artistic ideas.[81] This raises
the question as to whether her ensuing practice was as
vanguard as her aesthetic theory. Werefkin's numerous,
small-scale sketchbooks reveal that they were a laboratory
of experimentation, offering sequences of tantalizing ges-
tural drawings as well as compositional motifs in gouache,
blocked out in unusual color combinations and variegated
washes. Therein, she pursued themes of modernity derived
from the extremes of social entertainment, from sophisti-
cated salon, ballroom, and soirée interiors to scenes from
popular culture—the circus, cabaret, and low life.[82] As

69 Marianne Werefkin, *Sketches I and II towards "The Stone Quarry,"*
1907, pencil, ink, watercolor, 7.8 × 12 cm, Museo Comunale d'Arte
Moderna, Ascona, FMW 50-5-678-b26: 4–5

70 Marianne Werefkin, *The Stone Quarry*, 1907, tempera on board,
50 × 71 cm, private collection

in the case of Modersohn-Becker, within the context of the early twentieth century, the role of the flaneuse was a possibility in observing the spectacle engendered by urban capitalism.

Yet urban modernity was merely part of Werefkin's interests and studies, for one of her earliest Bavarian landscapes in Murnau (1907; fig. 69) discloses a heightened degree of abstraction in the creative process. Unlike her completed works, which are rarely dated or signed, many of the sketches are accompanied by notations of time, place, and a system of mnemonics to trigger visual memory. Relatively new to the landscape genre, Werefkin initially produced an in situ pencil drawing with Russian inscriptions and black ink additions, presumably overlaid in the studio.[83] Thereafter, she subsumed the landscape elements into a flattened composition of blue washes, irregular blotches, and a smudge of orange. However, in the painting *The Stone Quarry* (1907; fig. 70), she restored the motifs, albeit distilled, of the receding telephone poles, wires, and steep, pink-tinted road. These features, as well as the introduction of a laborer hunched over a wheelbarrow, his vermillion cap echoing the color of the stone crusher in the pit, strike dissonant notes of modernity in the otherwise sublime mountainous setting.[84] Evidently, while Werefkin sustained her links to the Peredvizhniki concern for the common people, she looked to Munch, Van Gogh, and the Japanese woodcut for the bird's-eye perspective, cloisonné linearity, and dramatization of the content.[85]

When she resumed painting, Werefkin revised her understanding of what constituted high art and abandoned the earthy tonalities of oil painting on canvas. Like other Russian artists in her circle—such as Grabar, Kardowsky, and Kandinsky—she researched the potential of diverse mediums to achieve an impact of great freshness and purity.[86] Preferring to use the saturation of colors and the quicker drying processes of a mixed technique, she achieved a translucency even in the impasto-like, directional flecks of the facture. Within the limited flexibility of gouache and tempera, the crafting of the work is more layered, stylistically speaking, an enigmatic sensation arising from the unusual color combinations of blues, pinks, reds, and greens. Certainly, at this juncture, we can observe that Werefkin's avant-garde strategies match those outlined by Griselda Pollock, albeit in another context, which include

a *reference* to contemporary practice, *deference* of the latest developments, and *difference* from current aesthetics and criticism in the bid for "modern" art.[87]

Werefkin's internationalist credentials were strengthened via personal contact with the Nabis Jan Verkade and Paul Sérusier, who visited Jawlensky's studio in Munich during 1907. Moreover, renewed association with Paris-based Russian émigrés of the World of Art group—in particular, the impresario Sergei Diaghilev—sharpened her awareness of expatriate identity.[88] As part of a subculture that was both communal and enlightened, she disparaged her nation's role in the Russo-Japanese War, declaring her hatred not for the enemy but "against all those quiet Germans, English, French, who themselves speak and understand only the narrow interest, that of profit."[89] When hearing of events that led to the 1905 Revolution, Werefkin excitedly wrote, "Convulsed Russia is giving birth to a new regime," but soon she recorded her despair over the cruel suppression of the march on *Bloody Sunday*: "Today there is only one indignant cry throughout the city [Munich]. People gathered on the street corners to read the dispatches, the shopkeepers and the salons all shudder with horror at what is happening in Petersburg."[90]

It is arguable whether the term cosmopolitanism suitably encompasses Werefkin's experiences of modernity and the trajectories between Munich, Paris, and St. Petersburg. Her status goes beyond the cocktail of habits, customs, and fashion that are identified with Western city lifestyles and projected onto the female body. Certainly, metropolitan accoutrements became part of her social identity, as Münter's *Portrait of Marianne Werefkin* (1909; fig. 71) demonstrates. Painted in Murnau, it negotiated the spectacle of an urbane woman's sojourn in the Bavarian alpine town, as Münter recalled in an undated note: "I painted the Werefkina in 1909 before the yellow base of my house. She was a bombastic appearance, self-confident, domineering, richly dressed, with a hat like a carriage wheel, on which all kinds of things had place."[91]

Typical of her style of writing, Münter had strong recollections of visual data—of color, character, and objects—that amplified her presence. Hence, we are in no doubt that Werefkin's demeanor transmitted a role more consistent with a *Weltbürger* or "citizen of the world," instrumental in forging alternative sociocultural communities previously

considered male business.[92] In early 1909, we are unsurprised to learn how pivotal she and Münter were to the formation of the NKVM and the group's utopian aims. By that time, Werefkin and Jawlensky's contact with Kandinsky and Münter had matured into collaboration and, as witnessed in the above-mentioned portrait, the younger woman artist demonstrated a technical command and fluency with codes of expressive emphasis that are as risk-taking as Fauvist painting. Prior to a comparison of relevant works, the section below explores Münter's route toward avant-garde practice via aspects of her early training, travels, and creative partnership with Kandinsky.

Münter's Early Formation (1898–1909)

Whereas the large retrospective exhibition of Münter's works in 1992 already brought into question the role traditionally assigned to her as a mere companion or muse, her ban on the publication of her writings until fifty years after her death stalled academic scrutiny of their theoretical implications.[93] Abridged versions of her correspondence and journals have since been published, and this counteracts the narratives, which assume that the apparent lack of written testimony is sufficient evidence of Münter's supposed simplicity of character and naïveté of style.[94] Her second partner, the art historian Johannes Eichner (1886–1958), was partially responsible for this dubious elision, which he defined in opposition to Kandinsky's intellectual and spiritual contribution to the origins of modern art.[95] Münter herself contributed to this legend by relaying Kandinsky's comments on her talent to Eichner: "You are hopeless as a pupil—it is impossible to teach you anything. You can only do what has grown within you. You have everything [instinctively] by nature. What I can do for you is to protect and cultivate your talent so that nothing false creeps in."[96] Since Expressionist theory emphasizes the values of the "untutored," the "spontaneous," and the "natural," it is difficult to extricate women artists' agency from the metaphoric associations of their gender in cultural practice.

Hence, these features of Münter's reception have to be assessed critically in relation not only to her writings but also to her creative processes, involving drawing, photography, graphic production, and painting.

Unlike Werefkin, Münter's training specialized in draftsmanship, and the existence of innumerable sketchbooks from all periods attest to her graphic aptitude and systematic reliance on preliminary studies for her final paintings.[97] Born in Berlin and resettled in Herford, Münter received her schooling in Koblenz; in 1897, she pursued her first drawing lessons in Düsseldorf in the studio of the painter Ernst Bosch and, thereafter, in the classes of Willy Spatz. But her comfortable middle-class, Prussian, and Protestant background belied the family's close links to the United States.[98] Since her father left an inheritance to the children, which was administered by her brother Carl, Münter shared none of the pressures that compelled other *höhere Töchter* to find employment as governesses and teachers.

Between 1898 and 1900, Münter and her sister Emmy went on an extended tour of North America to visit relatives of their deceased parents. In many ways this was a pilgrimage for Münter, given that she cherished her mother's tales of her upbringing in Texas and early married life in Tennessee, before the couple returned to Germany in 1864. If Münter inherited a pioneering spirit from her mother in refusing to conform to the decorum of *haute bourgeois* society, she also valued the stories of her father's radical idealism, which resulted in his political exile in America before the 1848 revolution in Germany.[99] Hence, as in the case of Werefkin's critique of czarist imperialism from abroad, Münter found an emancipatory space in the "Wild West" to develop a questioning approach toward Wilhelmine patriarchy.

Admittedly, in a photograph of Münter, we find her elegantly dressed and mounted sidesaddle on the horse "Brown Jug" in Guion, Texas (1900; fig. 72): young women were expected to retain modesty even when attending gatherings far from all comforts. Yet she later reminisced about the liberation she felt in the "unending nature" of Texas and of her intrigue at the comic spectacle of "Pferdebrechen," the bridling of previously untamed colts.[100] Her photographs of this period reveal her efforts to frame the "endless" landscape and to thematize the daily lives, work, and

72 Emmy Münter, *Gabriele Münter on "Brown Jug,"* Guion, Texas,
March 25, 1900, photograph, Gabriele Münter- und Johannes
Eichner-Stiftung, Munich, Inv.-No. 3549

73 Gabriele Münter, *Double Side of Photograph Album from the
America Journey*, ca. 1900, Gabriele Münter- und Johannes
Eichner-Stiftung, Munich

leisure activities of her relatives. So, too, she paid deference
to the local townsfolk in shots that included African Amer-
ican women at a fair in Marshall, Texas, in their Sunday
outfits. In her study of Münter's travels in America, the art
historian Ann Bible deploys notions of "dailiness," rather
than the "everyday," to apply to this form of representation,
one that is constructed rather than merely intuited.[101] As
in the case of diary writing, Münter attached captions and
inserted dates in her photographic albums (fig. 73), and
this custom lends itself to a feminist interpretation of the
genres of life-writing.[102]

Importantly, the German American experience
opened a lens on gendered practices as a form of self-
ethnology and inscription; here one can seize on the infer-
ences in Münter's remarkable photograph *Votive Tree with
Dolls and Other Objects* (1899; fig. 74), an atavist-like shrine
possibly created by the women and children of the Plain-
view homestead. Comprised of dangling toys, memorabilia,
kitsch souvenirs, mirrors, fabrics, and family photographs,

the arrangement perhaps introduced Münter to the rituals
of staging subjective and collective memory through the
placement and juxtaposition of eclectic objects in the
domestic interior. In bridging the gap between the past and
present, the photograph intervenes in the development of
the assemblage, which accrues meaning and is subject to
alteration over time. Hence, on an epistemological level,
photography as praxis and medium held consequences for
Münter's artistic development.[103] As is argued elsewhere,
not only did the repetition and sequential handling of
themes and motifs first manifest themselves in Münter's
North American photographs but the "photographic gaze"
had an enduring impact on her painted oeuvre.[104] Inter-
estingly, unlike the previous model of Kodak camera, the
viewfinder of the No. 2 Brownie was integral and enabled
landscape or portrait orientation.

On her return to Germany, while her preference
would have been to enroll in an art academy, from May
1901, Münter attended the "Ladies' Academy" of the
Münchner Künstlerinnenverein. There her routine of
instruction included drawing the partially clad nude and
painting character heads and landscapes. Based at the
Pension Bellevue in Schwabing, she was joined by the
Hamburg-born art student, poet, and feminist Margarete
Susman, who introduced her to the Wolfskehl circle of lit-
erary and theatrical reform. Inevitably, Münter encountered

Jugendstil, which, as we have seen, was prevalent in Munich. The movement rebelled against historicism and in its initial phase promoted an organic and lyrical interpretation of nature in landscape painting and ornamental graphics on folklore and fairy-tale themes. In 1897, support from wealthy industrialists and the aristocracy led to the founding of the Vereinigte Werkstätten für Kunst und Handwerk (United Workshops for Arts and Handicrafts) in Munich, which allowed for the spread of Jugendstil to architecture and the applied arts. Indeed, in 1902, Münter attended a course in woodcutting technique run by the graphic artists Ernst Neumann and Heinrich Wolff, well

known for their poster designs for the cabaret group Elf Scharfrichter (Eleven Executioners) and title sheets of the journal *Simplicissimus*.[105]

Furthermore, by January 1902 she had enrolled in the newly established Phalanx Schule, which was founded by Kandinsky and the sculptor Wilhelm Hüsgen according to these interdisciplinary principles. As shown in a photograph of that year (fig. 75), women predominated as art students in the informal studio environment, the Russian Olga Meerson (1877–1929) and Emmy Dresler (1880–1962) seated to the left of Münter and, to her right, Maria Giesler (1877–1970). Münter retained connections with them, with

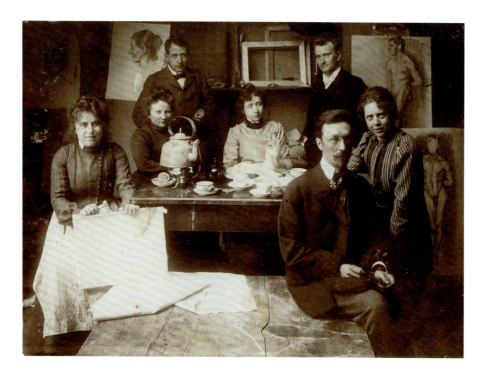

75 Anonymous, *Wassily Kandinsky's Phalanx Class*, Munich, 1902, photograph (Gabriele Münter in the center, Wassily Kandinsky front right), Gabriele Münter- und Johannes Eichner-Stiftung, Inv.-No. 2031

Meerson in Paris in 1906, with Strakosch-Giesler, as she was known by then, and Dresler in theosophist circles in Berlin and Munich from 1908 onward. In this photo, all four are shown attending an evening life-drawing class, which was conducted by Kandinsky, who is shown seated in the foreground.

Yet Münter also benefited from her pursuit of land-scape painting *en plein air* on excursions to the Bavarian countryside under Kandinsky's tutelage. As she reported to Edouard Roditi, on these occasions she painted a number of small-scale canvas boards in a pastose, palette-knife technique that Kandinsky had taught her.[106] Although he had separated from his wife Anja Semjakina, social convention dictated that Kandinsky and Münter main-tain decorum in Munich, reserving their cohabitation for extended visits abroad. This peripatetic mode of existence, which continued until 1908, was dictated by personal reasons. However, travel had a significant effect on their art, Münter in particular seeking out the opportunity to explore modern artistic identity.

In November 1906, during a period of estrangement from Kandinsky, who remained in Sèvres, she rented a room in Paris, no. 58 rue Madame, located in the house where Michael Stein—the brother of the famous writer

and collector Gertrude Stein—lived with his wife Sarah.[107] Münter would have had access to their large collection of Fauve paintings and, indeed, may have attended one of the Saturday salons held in the joint residence of Leo and Gertrude nearby in rue de Fleurus. Instructively, the Stein siblings purchased Matisse's painting *Woman with a Hat* (1905) on the last day of its scandal-provoking display in the Fauve exhibition at the Salon d'Automne in 1905.[108] But, in any case, Münter was actively engaged in pursuing motifs of urban modernity and in attending exhibitions.[109]

By mid-1907, apart from her paintings, she had produced ten sketchbooks of more than four hundred and fifty pages and twenty-five graphics, eight of which were portraits cut from linoleum sheets, an industrial material that had been invented in England in the mid-nineteenth century.[110] Used as a surrogate for wood, marble, or carpets, linoleum also displaced traditional woodblocks in avant-garde experimentation, and critics had difficulty in seizing on the differences between the two. Münter's portrait *Kandinsky* (fig. 76) was the first result of her exploration of this medium in Paris; as in her other portraits, she set the crisp, bold silhouette against a background that identified the sitter with a sphere of his/her activity. In this case, she used simplified, organic shapes—possibly of landscape

origin—delineated by contour, a synthesizing mode much discussed in contemporary artistic circles.

A major retrospective exhibition of Gauguin's works, including the woodcuts from the artist's book *Noa Noa*, attracted great attention at the Salon d'Automne of 1906. Interestingly, her linocut *Kandinsky* was exhibited in 1907 along with four other portraits at the Salon d'Automne, Münter submitting seven further examples to the same venue in 1908. Her contribution to the latter exhibition was favorably reviewed in the symbolist magazine *Les Tendances Nouvelles*, which also reproduced her graphics in 1909.[111] She had found a place in the Paris art world and thereafter strove to secure a niche in the competitive market economy of late imperial Germany.

While she and Kandinsky resided in Berlin, between September 1907 and April 1908, Münter prepared for her solo exhibition at the Kunstsalon Lenoble in Cologne; this included an impressive eighty paintings: landscape studies from Rapallo and the Paris period. Thereafter, the Kunstsalon Lenoble devoted an exhibition exclusively to her print production, which traveled to Friedrich Cohen's bookstore in Bonn. These works revealed her interest in themes of childhood and were inspired in particular by close observation of her niece Friedel (Elfriede) Schroeter's

76 Gabriele Münter, *Kandinsky*, 1906, color linocut on Japan paper, 25 × 18.5 cm, Städtische Galerie im Lenbachhaus und Kunstbau, Munich, Gabriele Münter Stiftung 1957, Inv.-No. GMS 795

77 Gabriele Münter, *Anthony and Company*, 1908, Playthings No. 2, color linocut on Japan paper, 16 × 22.8 cm, Städtische Galerie im Lenbachhaus und Kunstbau, Munich, Gabriele Münter Stiftung, 1957, Inv.-No. GMS 877

upbringing and formative experiences.[112] Münter conceived of a graphic series of five colored prints, entitled *Playthings*, which was aimed not only at delighting Friedel but also various constituencies within the expanding market for print culture.[113] Clearly, she had developed considerable expertise in wood- and linocuts, and no doubt the critic had these prints in mind—such as *Tünnes [Anthony] and Company* (1908; fig. 77)—when he commented:

> Gabriele Münter's nursery pictures are very entertaining in the grotesqueness of the drawn figures and situations. They also have a certain charm of originality. Individuals recall the painted comic wooden figures with which the humorous-naïve Munich Kasperle theaters, very well known in southern Germany, delight people. To be praised is the clean, well-shaded print of these rapidly created woodcuts, the prints of which are done by hand without the aid of the press.[114]

Here, the anonymous reviewer seized on the ability of this odd composition of toys and domestic items to conjure a form of German regionalism—the Kasper hand-puppet tradition popularized in Bavaria since the late eighteenth century. The print medium could contain the nonornamental incisiveness of Münter's experimental drawing and conform to the current demand for authenticity and hand-printed craftsmanship. However, the technical radicalism of her paintings, as well as those of her male colleagues in the NKVM, attracted much opprobrium.

Although we are aware that Münter's Paris sojourn had acquainted her with Synthetist aesthetic theory, she wrote in her diary of the epochal Murnau visit of 1908. Once she and Kandinsky had resettled in Munich, and following their excursions to the Staffel Lake near the town of Murnau, they shared the information with their colleagues, the artist couple Werefkin and Jawlensky. After taking their advice, the latter invited Kandinsky and Münter to join them in mid-August at the guesthouse Griesbräu. This initiated a period of interaction that involved their testing of the limits of painting in the landscape genre, as the artists sought to negotiate paths between a Matisse-linked modernism and the communal, artisanal aesthetics of folk art.[115]

The Murnau Effect

In late nineteenth-century Germany, as in Russia and Scandinavia, the institutional display of folk material culture was spurred by the new disciplines of ethnography and anthropology. In Munich, the Wittelsbach king Maximilian II founded the Bavarian National Museum in 1855; not only did it house their private collections of European art and culture but it was also dedicated to displays of religious cribs and folk art. Certainly, by 1904, both Kandinsky and Münter would have been alerted to the newly launched, folk-decorated interiors that were designed by Franz Zell (1866–1961). In Upper Bavaria, tallying with the more conservative interests of Jugendstil reform, völkisch aspirations to preserve *Heimatkunst* (regional arts and crafts) gathered momentum; architects redesigned towns and museum interiors for novel installations of wood-carved furniture, religious carvings, and *Hinterglasbilder*.[116] Key to the ethnographic impulse was the notion of "salvage," a term used by art historian Roger Benjamin to connote the desire to protect such ways of life from the march of modern civilization.[117] In a similar vein, in her anthropological survey of religious belief and the private consumer of Catholic Bavarian *Hinterglasbilder*, Helena Lepovitz observes that the decline of glass painting in the face of superior competition from chromolithography was rooted in the historical development of the urban graphic arts industry.[118]

In the case of the Oberammergau Museum, between 1904 and 1910, Zell was commissioned to install the collection of the wealthy publisher and entrepreneur Guido Lang (1865–1921). Importantly, as can be assessed from a vintage photograph (fig. 78), Zell's methodology was purely historicist and inventive, the priority being that the arrangement of the artifacts and domestic products should evoke the naturalness and piety of agrarian romanticism.[119] Münter's and Kandinsky's collecting habits and display of folk art retain a simulacrum of this attitude; issues of authenticity and provenance were subsidiary to the visceral appeal of the objects. They purchased reproductions and copies that were readily available from the tourist market in the Auer Dult (fig. 79), a popular fair in a suburb of Munich that they frequented.[120]

78 Anonymous, *Installation of Peasant Bedroom*, ca. 1910, photograph, Oberammergau Museum

79 Anonymous, *Madonna Figure from the Auer Dult*, nineteenth century, carved and painted limewood, 23 cm (height), from the collection of Gabriele Münter, Schloßmuseum Murnau, Murnau, Inv.-No. 3339

Located in the south Bavarian Alps, Murnau was a market town with a predominantly farming community of Catholic disposition. Being close to Oberammergau, celebrated for its Passion plays, Murnau was also sought out as a tourist destination, easily reached by train from Munich. That the architectural cohesion of the town was the result of recent modernization, conducted under the direction of the architect Emanuel von Seidl (1856–1919), was of little consequence to this group of artists. The foursome explored similar motifs, views from the guesthouse windows and, from August 1909 onward, the outlook over the town from Münter's property, known as the "Russian House," which she purchased that year.[121] Beyond the cultivated lowlands, the environs offered the expanse of the Murnau wetlands, the largest living marshes in southern Germany. Bordered by woodlands and the range of Bavarian Alps, the vivid panorama was compelling, as was the quality of light peculiar to the region in exposing the planar divisions between these different components.

How did the regional culture and landscape contribute to Münter's new approach toward painting? In her

diary, she testified to her departure from an Impressionist mode of depicting nature, "to feeling the content of things—abstracting—conveying an extract" and referred chiefly to Jawlensky, who "passed on what he had experienced and learned—talked about 'synthesis.'"[122] As the most conversant with the French avant-garde, Jawlensky adopted the term "synthesis" to apply to a radical simplification of form and color, bound by line, so as to avoid anecdotal content and strengthen the autonomous qualities of the work of art.[123] Encouraged by Jawlensky's example, both Kandinsky and Münter gave up the palette knife in favor of shorthaired brushes and unprimed strawboards.

Through Jawlensky, as well, Münter was inspired by the technique of *Hinterglasmalerei*, and she pursued lessons with local glass painter Heinrich Rambold (1872–1953), who was active at the time. In a later statement, she claimed precedence for her actions: "I was the first in Murnau—as far as I know—who took glass panes and also made something . . . I was entranced by the technique and kept telling Kandinsky about it, to stimulate him about it too—until he too began and then made many glass paintings."[124] To familiarize herself with the craft, Münter initially copied traditional examples and responded to its souvenir implications by inventing quasi-religious, *völkisch* themes. This can be seen in the glass painting *Peasant Woman with Children* (fig. 80), in which the family is set against a typical motif of the town—the crenelated, medieval gable of the Murnau castle. Instructively, Münter

80 Gabriele Münter, *Peasant Woman with Children*, 1909/10, glass painting, Städtische Galerie im Lenbachhaus und Kunstbau, Munich, Gabriele Münter Stiftung 1957, Inv.-No. GMS 733

81 Gabriele Münter, *Landscape with a Hut in the Sunset*, 1908, oil on board, 33 × 40.8 cm, oil on cardboard, Kunstsammlungen Chemnitz-Museum Gunzenhauser, Eigentum der Stiftung Gunzenhauser, Inv.-No. GUN-M-0003

never exhibited her *Hinterglasbilder* and, in her study of the artist couple, Bibiana Obler has shown that Münter and Kandinsky were fully conversant with theoretical debates regarding kitsch as well as the threat of the decorative to the "psychic purity" of fine art.[125]

What Münter gleaned from the lessons in glass painting was the rote that linear configuration had to be applied first on the reverse of the pane before the daubing of color. Increasingly, she transposed this separation of the formal elements—line and color—into her oil painting; whereas at times she reinforced the drawing with overpainted dark contour, on other occasions she allowed colors to mask drawing and exist independently as flattened, irregular planes. With their unusual palette of primary and complementary hues—blue and yellow, red and green—with pink for an evocative, crepuscular effect, the diverse surfaces and facture of her Murnau vistas are nonetheless bound together by a strong sense of composition, as in *Landscape with a Hut in the Sunset* (1908; fig. 81).

Comparable to Werefkin, yet in their inimitable ways, Münter was well aware of her avant-garde strategies; her small-scale oils on board served as an increasing stimulus to achieve a bold painterly style. Indeed, in late 1910, in her correspondence with Kandinsky, while he was on a return visit to Moscow, she imparted her strivings:

> I'm glad about the way you praise my works—& I believe I have grasped something in the lines (& in color too). In my case it is largely or nearly always a smooth flow of the lines—parallel—harmony—in your case it's the opposite, the lines collide & intersect in your work. This landscape I did today is like the ones Jawl. [ensky] has painted (or perhaps how he used to, not any more) but as I see it Jawl's are always cruder—coarser—& naked color & form.[126]

On this occasion and, paradoxically, at some distance from each other, creative partnership appeared rewarding for the woman avant-gardist. Münter neatly articulated her progress in terms of a harmonic interplay of line, color, and form; in accordance with the formula outlined by Griselda Pollock, Münter *referred* and paid *deference* to her male colleagues as well as signaling *difference* from them.

If the colliding and intersecting lines provoked dissonance in her viewing of Kandinsky's landscape painting, then Münter found Jawlensky's works unfinished and impetuous. In her interview with Roditi, Münter defended Werefkin's best and most original pictures from the less theoretical Jawlensky, who was labeled "a devotee of the *touche de peinture* of the French Fauvists, rather than an innovator."[127] Notwithstanding Münter's negative assessment of Jawlensky, Werefkin held his painterly talents in great esteem to the degree that she transcribed and/or composed a glowing letter in French on his behalf—subsequently entitled *Glaubensbekenntnis* (Credo, ca. 1908)—for an unknown recipient.[128] Werefkin's approach toward landscape painting was certainly inventive in her portrayal of the burdened silhouettes of washerwomen or factory workers in the sunset-lit darkness of nature.[129] Whether in the vicinity of Murnau at Oberau or, in summer 1912, in Oberstdorf, the highest market town in the South Bavarian Alps, she sought out motifs that harnessed her Russian training in the Wanderers' school to convey social commentary: the alienation of labor in prewar regional townscapes.[130] Yet Werefkin's unpopulated landscapes increasingly abandoned local color and site specificity to evince an internal vision of mystery and drama.

In the tempera on board *Red City* (1909; fig. 82), based on in situ color sketches from April and May of that year, the ruins of a town, including that of a church, are portrayed in fiery red.[131] They assume flat, cut-out shapes, like gravestones, set against the purple blues of the ground. The black limbs of the burned-out trees animate the composition and connect the apocalyptic wasteland with the icy mountainscape beyond. As in the case of Münter, the technique of glass painting may have encouraged Werefkin to endorse the quasi-geometry of the edifices, although her interests lay in an evocative orchestration of the latter in relation to the glistening tones of the romantic, sublime setting.[132] That both artists were working from memory is apparent, however toward different ends: Münter domesticated the landscape by including a hut and seasonal agricultural referents but the overall composition was resolved through a modernist lens. Different conclusions can be drawn in their handling of portraiture.

Both artists painted the same woman, Rosalia Leiss (figs. 83 and 84), the mother of their landlady Frau Schönach, with whom they lodged in the Pfarrstraße

82 Marianne Werefkin,
Red City, 1909,
tempera on cardboard,
74 × 115 cm, private
collection

during the foursome's second sojourn in Murnau, between May and June 1909. Since the late nineteenth century, the influx of tourists into rural Bavaria provided villagers with an ideal new source of subsidiary income and the possibility of forging their own modern identity.[133] Leiss, however, was of an older generation and part of an agriculturist tradition. In both works, she is portrayed in a peasant costume and set against a neutral background, the stylization of the features and vivid paint application resonating with the ongoing vogue in Germany for the works of Van Gogh.[134] The sitter was also featured in one of Münter's photographs of Murnau (fig. 85).[135] In addition to the "characteristic type" of native inhabitant, the composition includes a "scenic" architectural setting and figure, shown lurking in a doorway, that allude to images—*scènes et types*—promoted in contemporary travelogues and commercial photography in the period.

When compared to the photograph, it is evident that the portrait of the *Woman from Murnau* involves a discrepancy of the viewing point, indicating that Münter probably used the photograph interchangeably with sketches for her departure. Clearly, she also had in mind the synthesizing features of *Hinterglasbilder*. These different creative processes partake of the discourses of travel and the expanding tourist economy of the locale, and we detect how Münter's misinformed quest for *Natur* (rural authenticity) simultaneously bears levels of association with the

modern, the foreign, and the regional. Notwithstanding its painterly qualities, Werefkin's portrait, in its frontal pose and summarily cut-off composition, retains a commitment to expressive realism; the piercing blue eyes and leatherlike skin of the elderly woman conflict with the floral ornamentation on the folk headdress, which is so deftly integrated in Münter's facture. Compared to the latter's sitter, who is shown glancing sideways, Werefkin's individualized portrait meets the spectator's gaze, encroaches on their space, and disrupts the containment of the format.

Within a year, Werefkin's ideas regarding an emotional art—the mystical and nonmimetic values of representation—were foregrounded in her practice. In her *Lettres à un Inconnu*, we read how she favored the primacy of saturated color over and above the use of modeling, and we can observe such preferences in her *Self-Portrait* (1910; fig. 86), undoubtedly one of the most important of the Expressionist period.[136] It radiates the intensity and restlessness of her personality. She chose to depict herself theatrically, sporting a fitted hat with flower, the startling color of her eyes being painted with the equally dramatic red pigment. Renewed contact with the paintings of Van Gogh, at the Kunstsalon Zimmermann in 1908 and Brakl's gallery in 1909, led Werefkin to adopt the three-quarter-view pose and swirling gestural brushstrokes surrounding the head. The inclusion of a symbolic light source on the right-hand side of her self-portrait points to her inspirational role

83 Gabriele Münter, *Woman from Murnau (Rosalia Leiß)*, 1909, oil on cardboard, 92 × 64.8 cm, permanent loan from Ernst von Siemens Kunststiftung, Munich, and the PSM Privatstiftung Schloßmuseum Murnau, Murnau, Inv.-No. 11070

84 Marianne Werefkin, *Rosalia Leiß*, 1908/9, tempera on cardboard, 64 × 50 cm, permanent loan from PSM Privatstiftung, Schloßmuseum Murnau, Murnau

85 Gabriele Münter, *Farmer's Wife from Murnau*, 1909, photograph, Gabriele Münter- und Johannes Eichner-Stiftung, Munich

and serves as a riposte to the stylish bombast portrayed in Münter's *Portrait of Marianne Werefkin* (see fig. 71).

In her painting, Werefkin extolled the visionary role of the woman artist, who had no need to masquerade her womanliness in order to hide the possession of masculinity.[137] The appropriation of the masculine was the vehicle through which she was able to explore the autonomy of artistic formation.[138] As one of several works that arose following a visit to Kovno in Lithuania, where her brother Peter was governor of the guberniya, the *Self-Portrait* was indicative of Werefkin's resurrection, not of the lessons of Repin but those of her mother's example in icon painting. Typical of émigré experience on returning to their roots, her correspondence with Jawlensky between December 1909 and April 1910 discloses how the realities she encountered in the Pale conflicted with her memories. Werefkin yearned "for everything that is sweet and good,

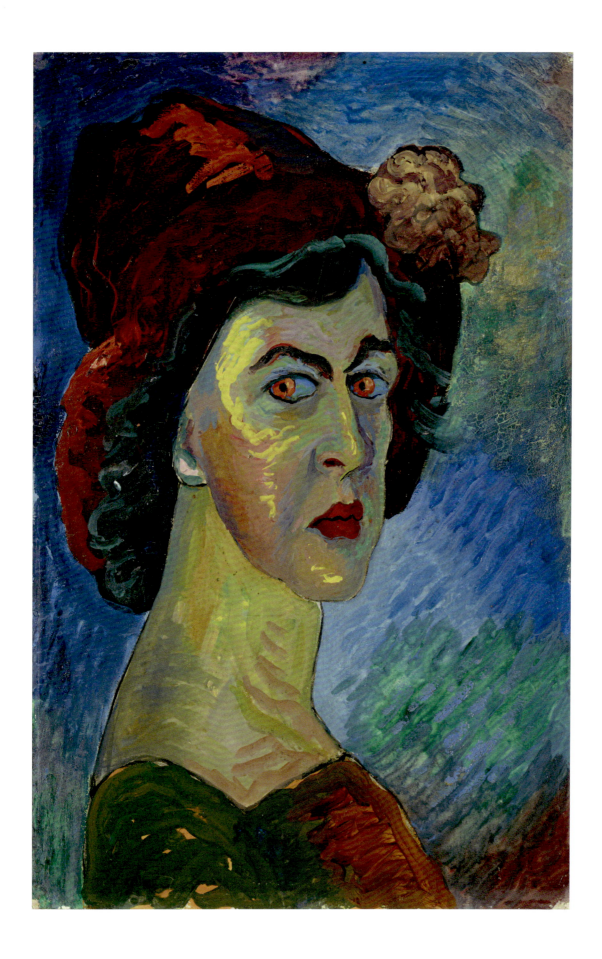

which is called Russian life"—that which was absent from a city in which the vernacular was mainly Polish or broken Russian.[139] Indeed, she recalled that only escape into a church—"Dark, empty. Lights flickering before icons"—provided succor. In Kovno, she stated, "Something terrible, terrible lies over everything," and yet it was a "treasure-trove for artists."

Werefkin's self-portrait draws sustenance from the dialectic between her Russian origins and embrace of the West at a key moment in her life and professional career: the commemoration of her fiftieth birthday on September 11, 1910. Franz Marc, who entered the circle of the NKVM in autumn of the same year, wrote informatively to Maria Franck about his encounters with Werefkin:

> Miss Werefkin said to Helmut [Macke] recently about Nauen's large painting: the Germans frequently make the mistake of taking light as color, while color is totally different and has, in general, nothing to do with light viz. illumination. I keep thinking of this observation, it is very profound and, I believe, has hit the nail on the head.[140]

In this febrile exchange of formal ideas, Werefkin's Russian status and theoretical observations were valued among the German members of the association.[141] Although the portrayal of the self-image would seem to be one of the most solitary acts of the creative process, the artist as model, the portrait evinces the most complex relationship between private and public life.[142] In this instance, it is noteworthy that Werefkin exhibited the work as one of eight paintings contributed to the third exhibition of the NKVM, which opened at the Modern Gallery of the dealer Heinrich Thannhauser on December 18, 1911.[143]

Concurrent with this event, the editors of the Blaue Reiter held their initiating exhibition in three rooms of the skylighted hall on the second floor above.[144] In view of the haste in which they had to arrange this, the name was adopted from the project of the almanac. Tellingly, if

not for Münter's photographic interventions, we would have no visual documentation of the installation of this landmark exhibition. From the layout of the first room (fig. 87), we can see that Münter attempted to take in as much as the shutter would allow within a single shot, from Delaunay's pre-Orphist painting of Paris (*La Ville No. 1*) on the right to Kandinsky's much-disputed *Composition V* (1911) viewed through the doorway. Although devoted to an eschatological theme and subtitled *Auferstehung* (Resurrection), the flow and flux of the dematerialized surface bewildered commentators who considered that "a picture without object is meaningless."[145]

Of the six paintings Münter contributed to the exhibition, *Dark Still Life (Secret)* (1911)—its frame just visible on the left-hand side of the photograph—demonstrated a profound and distinct engagement with the group's ideology of spiritual and artistic renewal via the "primitivism" of folk art.[146] The seriality of such works and their raising of the issues of the material and spiritual realms are considered below, as is Münter's and Werefkin's negotiation of the art world and their introduction to the dealer couple Herwarth and Nell Walden.

Münter and the Exhibition of the Blaue Reiter (1911–12)

On October 30, 1910, following a summer in Murnau, Münter returned to their residence in Ainmillerstraße 36, Munich. While she regretted Kandinsky's absence in Moscow, she wrote joyfully about seeing familiar objects again: their paintings on the wall and other hangings. Münter anticipated the many still life compositions waiting to be done: "It's so beautiful here," she stated, "with the flowers! And the table with the seventeen madonnas!"[147] The pleasures associated with the apartment interior were accompanied by constant rearrangement of their collections—as though a work of art in progress. A week hence, after painting all afternoon, she reported her dissatisfaction: "Am putting a lighter colored cloth on the table to get a different picture."[148] Indeed, her photograph in Munich of the side table of carved Madonna figurines and seasonal floral arrangement, set against the wall of *Hinterglasbilder* (1913; fig. 88), is constitutive of notions of "dailiness" in framing the site as a model of female aesthetic sensitivity as well as the departure for future scenarios.

From a comparison with the photograph, it is evident that most of the objects portrayed in Münter's *Dark Still Life (Secret)* (fig. 89) derive from their collection of Catholic folk art. However, the painting's inconsistent lighting effects and spatial ambiguities pose questions that exceed issues of "dailiness."[149] In many respects the need to decipher its shadowy mysteries and glowing highlights are reminiscent of the autochthonous qualities conveyed in her Texan family's assemblage, as shown in the early photograph *Votive Tree with Dolls and Other Objects* (see fig. 74). In one of her scattered notations for Eichner, Münter relayed the origins of *Dark Still Life (Secret)* as the result of intense moments of reflection:

> Once in the Ainmillerstraße in my study, I stood after breakfast and watched the smoke from the cigarette. There was a still life on the table against the wall of the Madonna figurines, glass pictures, the ceramic goblet I hand-painted and the red darning egg, dark, deep, like a lament. I took the large canvas quickly, made it . . . black and painted the picture. When it was complete and I looked up, it seemed good to me—so I said "Gosh." But it was not a lament, it was a secret. Maybe it came from the black?[150]

Münter, in her creative reimagining of the phenomenal experience, developed the faculty of what modernist author Virginia Woolf (1882–1941) termed "scene making," a way of marking the past and proof of its reality.[151] In Woolf's late autobiographical writings, which were published

88 Gabriele Münter, *Hinterglasbilder Wall in the Kandinsky and Münter Residence, Ainmillerstraße 36, Munich*, 1913, photograph, Gabriele Münter- und Johannes Eichner-Stiftung, Munich, Inv.-No. 2188

89 Gabriele Münter, *Dark Still Life (Secret)*, 1911, oil on canvas,
78.5 × 100.5 cm, Städtische Galerie im Lenbachhaus und Kunstbau,
Munich, Gabriele Münter Stiftung 1957, Inv.-No. FH 294

posthumously, she articulated the sketch as a fragment of
"being," a sudden recollection of the visual and semantic
"shock," in contrast to the mainly unconscious moments of
"non-being" (washing or bookbinding) that are portrayed
in the act of writing.[152] Pertinently, she raised the issue
of feminine agency as a geography of the possible.[153] In
Münter's correspondence, reports on her artistic progress
were similarly embedded within mundane or routine ob-
servations. Yet the ecstatic moments formed the scaffolding
of her many studies and revisions: she worked assiduously,
often producing one or more large-format pictures in a

single day, the apparent spontaneity belying the earnestness
of her mission.[154]

Clearly this style of still life painting and its seriality
were important for her artistic identity within the newly
established group. The curator and art historian Barnaby
Wright argues that, unlike Marc's and Kandinsky's desire
to produce paintings that could connect directly with
a spiritual realm, Münter's concern was to emphasize
the aspect of spiritual contemplation itself through the
representation of actual devotional artifacts.[155] In allowing
for a metaphysical component to these compositions, it is
feasible that her pre-1914 encounter with Theosophy was
of greater significance than previously recognized. Indeed,
as will be shown, new evidence points to Münter's fasci-
nation with Rudolf Steiner's ideas during her Swedish
period.

It was in Berlin, at the Architektenhaus on March 26, 1908, that the artist couple attended Steiner's lecture "Sonne, Mond und Sterne" (Sun, Moon and Stars).[156] Münter would have been drawn to his thoughts on Goethe as the preeminent natural scientist, who emphasized the role of the "artistic imagination" in intuiting the spiritual beyond physical light.[157] A former co-student of Münter's—Maria Strakosch-Giesler—from the Phalanx Schule introduced them to these circles.[158] Between 1909 and 1914, they sustained these esoteric interests as Steiner initiated his own annual cycle of mystery dramas in Munich.[159] Münter renewed contact with another of her former colleagues, Emmy Dresler, who not only contributed four works to the first exhibition of the NKVM but also became a dedicated stage-set painter for Steiner's theatrical works.[160] Informatively, Dresler's copy of Steiner's nine lectures, which were delivered in Munich in August 1909, can be found in Münter's former library.[161]

His handbook *Theosophie: Einführung in Übersinnliche Welterkenntnis und Menschenbestimmung* (Theosophy: An Introduction to the Spiritual Processes in Human Life and in the Cosmos, 1908) also resides therein.[162] It contains underlining and marginalia in Kandinsky's hand, yet Steiner's philosophical monism also provides clues to Münter's intellectual framework. As the theosophist wrote, "And there in truth *all* reality is one; since the lower reality and the higher spiritual reality are merely two sides of one and the same fundamental unity of being."[163] Here, in a general sense, we can find corroboration for Münter's immense respect for figuration as embodying the potential to represent "higher truths." As we read in the aforementioned account of the evolution of her painting *Dark Still Life (Secret)*, she was stunned and surprised by the outcome and the secretive depths that the artistic imagination could expose beyond the visual experience.

At its inception, then, the milieu of the Blaue Reiter was conducive to the possibility of a Blaue Reiterreiterin: Münter claimed a space for feminine agency and found the freedom to negotiate the territory between figuration and abstraction, the material and the spiritual realms notwithstanding the incipient threat of Marc's and Kandinsky's doubling of masculine creativity. She, as with Werefkin, further benefited from access to the machinations of the art world, and the section below traces their networking and interaction with the dealer couple Herwarth and Nell Walden.

Münter and Werefkin: The *Sturm* Connection

Following the success of the Berlin venue of the Blaue Reiter exhibition, Münter was introduced to Herwarth Walden via Kandinsky. In October 1912, during the hanging of the *Sturm* Futurist exhibition in Munich and accompanied by the gallerist Hans Goltz, Walden visited Münter's studio. He was so impressed with the color in her paintings—particularly the warmth of the yellows—that he offered her a solo exhibition, so Münter communicated to Kandinsky, who was in Odessa at the time.[164] No doubt Walden shared Kandinsky's admiration of Münter's painterly talents as well as her inspired engagement with the Blaue Reiter ethos of *Ursprünglichkeit* (originality) to be found in old German prints, Bavarian folk art, and child art.

Not long thereafter, we find the first of five woodcuts that Walden commissioned from Münter for title pages of issues of *Der Sturm*, which were lined up to promote her solo exhibition.[165] These were printed on covers of the journal between November 1912 and May 1913 (fig. 90). As encountered in the study of Kollwitz, the carved woodcut enjoyed a conscious revival in Germany and was claimed by cultural commentators as a quintessentially German art.[166] Starkly composed, but with an intimacy absent from other contributions of graphic work (by Kirchner or Kokoschka, for instance) to Walden's publication, Münter's prints drew on motifs derived from her paintings of rural Murnau and urbane scenes of Munich. Yet, in the latter, such as *Construction Work* (1912; fig. 91), which portrays a scene of workmen in contemporary dress loading a cart on a building site, notions of modernity are complicated by her economic use of line and shape: these evoke the inspiration of *Hinterglasbilder* and the immediacy of children's expression. As outlined above, Münter's portrayal of toys and the child's world was as typical of the "restricted" domestic genre of women's art as it was part of the European avant-gardes' wider fascination with primitivism.

At first sight, it may seem that Münter's *Sturm* retrospective, which was held in Berlin in January 1913, assisted in advancing her career. A portion traveled to

Copenhagen, with other works going to Munich, Frankfurt, Dresden, and Stuttgart. Certainly, the well-known Berlin-based collector and supporter of the Blaue Reiter, Bernhard Koehler, offered Walden 400 marks for the gouache *Garden Concert* (1911–12).[167] However, this was well below Münter's asking price; hence, the dealer proposed to deduct 10 percent (rather than the usual 20 percent) agent's fees for the transaction.[168] On another occasion, so as to alleviate what he termed the ongoing financial crisis, Walden encouraged her to join his Verein für Kunst (Art Association), which was celebrating the tenth year of its founding.[169] This would no doubt assist in arousing the membership's interest in her. The following month, presumably in response to Münter's inquiries regarding sales, Walden provided a report on her touring exhibition and related expenses, entreating her "not to believe that I do less for your collection than for others."[170] Treading warily, he advised her that, in his experience, the difficulty lies in not having a catalog of her works with negatives, which he could distribute to dealers unfamiliar with artists he represented.

Although her comparatively fluid compositional arrangements were a source of high regard for Kandinsky, they became the departure for his writing on the purely intuitive, gendered, and national directions of her art.[171] While he was at pains to distinguish her genuine female talent from feminine coquettishness, so Obler notes, Kandinsky's essays failed to do justice to the intellectualism of her project.[172] Complications arose, too, with Marc when Walden invited Münter to participate in the Erster Deutscher Herbstsalon (First German Autumn Salon) in Berlin.[173] As an international exhibition that featured the works of ninety artists from fourteen countries, it represented the chef d'oeuvre of Walden's efforts to homogenize distinctive European groups, such as Cubism and Futurism, under the banner of Expressionism.[174]

On this occasion, Marc, who held a curatorial role and assisted Walden with the hang, initially rejected three of her submissions, including the large-scale interior scene *Man in Chair (Paul Klee)* (1913; fig. 92). On a social level, not all the protagonists of the Blaue Reiter were consistently supportive of Münter, and this can be ascertained

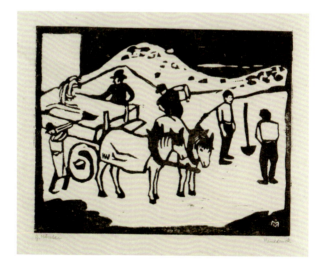

90 Title page with reproduction of *Construction Work* by Gabriele Münter, *Der Sturm* 3, no. 136/137 (November 1912): 209

91 Gabriele Münter, *Construction Work*, 1912, woodcut on Japan paper, 16.9 × 29.2 cm, Städtische Galerie im Lenbachhaus und Kunstbau, Munich, Gabriele Münter Stiftung 1957, Inv.-No. GMS 893

from the correspondence between Marc and August Macke and their respective wives, Maria and Lisbeth.[175] However, in this instance, Marc was explicit in his aesthetic judgment of her painting:

> What I have against it is that it looks *unfinished* to me, unequal in its parts; some of it is modeled, some inertly flat, some full of deep sentiment, some too naturalistic as, for example, the left doorknob and the like . . . now this picture expressly requires, in its total expression and its size, a victorious, not partial, overcoming of *matter*.[176]

Marc's critique reveals the discriminatory and gendered discourses of spirit/matter so prominent in *Sturm* circles.[177] It also points to Münter's efforts to retain her artistic integrity within the Blaue Reiter group; after 1912, her pace of work slackened and was characterized by restlessness when compared to the breakthrough of 1908.[178] Her portrait of Paul Klee is typical of her caricatured representations of male colleagues, who are wedged into the picture plane and compete with both domestic and rarefied objects for the viewer's attention. Yet Münter's adoption of local color and variegated facture signal an ongoing search for creative expression via the means of resemblance rather than spiri-

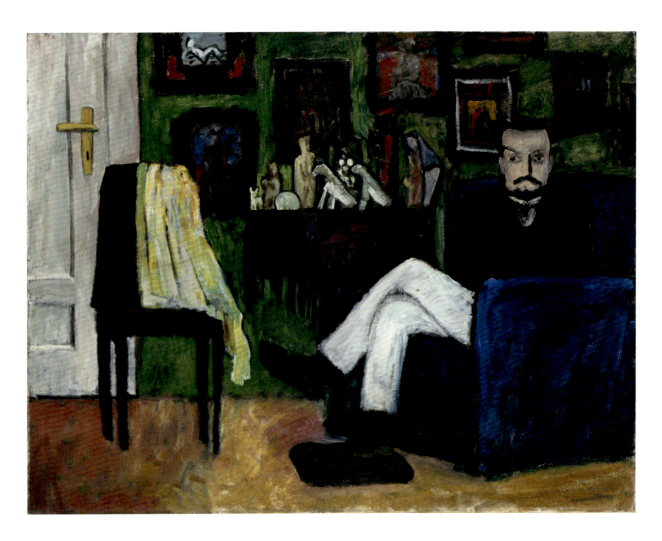

92 Gabriele Münter, *Man in Chair (Paul Klee)*, 1913, oil on canvas, 95 × 125.5 cm, Bayerische Staatsgemäldesammlungen, Pinakothek der Moderne, Munich, Inv.-No. 11227

93 Gabriele Münter, *Black Mask with Pink*, 1912, oil on canvas, 60.4 × 49 cm, Gabriele Münter- und Johannes Eichner-Stiftung, Munich, Inv.-No. 5114

tualizing abstraction. The placing of an evaluative distance between the material and spiritual realms can be confirmed when examining another of the six works listed in the Herbstsalon catalog.[179]

In the still life *Black Mask with Pink* (1912; fig. 93), Münter's arrangement of the black mask, gloves, and pink costume-like motifs conjure up notions of carnival and the Bavarian *Fasching* (festival) that take place before Lent.[180] In this way it represents a profane counterpart to the sacred religious traditions of the region as well as engaging in the formal contrasts between the decorative sweet coloration, exuberant pleats, and jarring, vacant stare of the black mask-cum-memento mori. Within the category of a lesser

genre, Münter's subversive use of the carnivalesque makes as profound a statement on life and death issues as the major canvases and apocalyptic themes of Kandinsky and Marc at the time.[181] Fascinatingly, Walden chose to illustrate this painting in the catalog in addition to reproducing a *Sturm* postcard thereof, advertising Münter's name through the circulation of an image that set an unusual tone in her still life oeuvre.

Werefkin was also invited to contribute paintings to the Herbstsalon and, of the three titles listed, *Autumn Idyll* (ca. 1910; fig. 94) was illustrated in the catalog and advertised as a *Sturm* postcard.[182] Located in the foreground of a soaring mountain range with fiery-colored conifers in

94 Marianne Werefkin, *Autumn Idyll*, ca. 1910, tempera on paper mounted on cardboard, 78 × 60 cm, Museo Comunale d'Arte Moderna, Ascona, FMW 0-0-19

the middle distance, a Bavarian peasant couple and baby are shown secluded on a precipice. On first examination the painting appears sentimental, almost kitsch-like, in Werefkin's nostalgic favoring of the premodern harmony of völkisch life (and iconography of the Holy Family is evoked). But, unlike turn-of-the-century souvenir postcards, which acted as mediators of modernity in bringing together a totality of that which was physically and socially fragmented, this painting is disruptive of such a unity.[183] The group's organic relationship to the setting is destabilized by the looming forces of nature.

The rupture between the lyrical and mystical values in Werefkin's works was seized upon by art historian and critic Wilhelm Hausenstein. In his catalog essay "Die Neue Kunst" (The New Art) for a 1913 exhibition, he termed her paintings as quite dualistic, "utterly romantic and eccentric to the point of being religious."[184] Well known for his promotion of Russian artists in general and Kandinsky in particular, Hausenstein favored the metaphysical referents of her works; differing from Marxist philosophy, he believed in the possibility of a new religiosity or spirituality, which would be the natural outcome of a "properly

95 Marianne Werefkin, *Early Spring*, ca. 1910, tempera on paper mounted on cardboard, 55.6 × 73.3 cm, Mead Art Museum at Amherst College, gift of Thomas P. Whitney (Class of 1937), Inv.-No. AC 2001.84

understood socialism."[185] He grouped her works within the newest trends in painting, a result of "inner intuition" rather than a response to the surfaces of phenomena: "incarnations of psychological extremes, inner tensions, and disasters."[186] Hausenstein's theories on the collectivism and futurity of Expressionism as the coming into being of "die Malerei der anderen Seite" (the painting of the other side) are revealed in this significant essay and certainly favor a position for Werefkin consistent with the scope of a Blaue Reiterreiterin.[187]

In November 1913, Werefkin returned to her brother's residence in Vilnius with the intention of separating from Jawlensky permanently. During her absence from Germany, Walden showcased her paintings alongside those of Jacoba van Heemskerck and Arthur Segal.[188] In the wake of the Herbstsalon, this exhibition testified not only to the honorific Expressionist status conferred on both women practitioners, whether of Russian or Dutch origin, but also to the heterogeneous directions offered within the ambit of the Blaue Reiter. Whereas Van Heemskerck exhibited twenty-one of her most recent works that embraced spiritual abstraction, Werefkin's display of twenty-two paintings was retrospective in focusing on painterly figuration from 1909 onward. Fascinatingly, in paintings such as *Early Spring* (ca. 1910; fig. 95), she invested the motifs common to her Murnau interlude with transnational and transcultural resonances.[189] Here we find the Lithuanian variant of the cross in the countryside—a roofed, wayside

96 Marianne Werefkin, *La Révolution*, 1916–17, tempera on paper mounted on cardboard, 48 × 64 cm, private collection

shrine—favored by the artist Mikalojus Čiurlionis (1875–1911), in addition to the inclusion of an allegorical figure of an elderly man wearing a skull-like mask.[190] Hence, there is merit to the claim that Werefkin was strongly aware of the importance of local ethnicities to modern Lithuanian painting.[191] Other titles listed in the *Sturm* catalog, such as *Winter in Lithuania*, disclose that her thoughts and ambitions were already projected to a future elsewhere.[192] Indeed, in correspondence with Nell Walden, Werefkin requested that, on closure of the exhibition in Berlin, the works come directly to Vilnius to be exhibited in a spring exhibition of the Society of Artists.[193]

In a conference on April 22, 1914, she delivered a little-known lecture to this society, "Talk on the Symbol, the Sign, and Its Significance in Mystical Art," in which she spoke with collegiality of the multivalent positions—between abstraction and figuration—within the Blaue Reiter:

> Many of my friends . . . talk directly the language of primary symbols, for example, Kandinsky in painting or Schönberg in music and they are right, perhaps even more than I am. But my closest friends and I . . . believe only in the example of it [life]. That is why we do not renounce it, we do not escape from it, but we love it, it and its forms; we compel it to serve our faith . . . My friends and I we form a unity.[194]

As a citizen of the world, Werefkin had no hesitancy in asserting her role within avant-garde Expressionist culture, and such fortitude served her well during the turbulent years of the First World War. The expatriate, unlike the exile, has the choice of voluntarily living in an alien country but, in the case of Werefkin, her return to Munich in late July 1914 coincided with Germany's declaration of war against Russia. In inquiring about paintings that were being sent to the dealer d'Audretsch in The Hague (she and Jawlensky had the same 20 percent commission arrangement with the *Sturm*), she wrote to Walden of their swift departure from Germany and experiences in Saint-Prex:

> You can imagine how sad it is about our art and we need help here. We left Munich immediately on August 3 for Switzerland, everything was so unexpected for us that we had to live months and months without works and without painting material. It was exasperating. Fortunately, we were supported by friends from German Switzerland.[195]

After the Russian Revolution in 1917, moreover, Werefkin was denied the czarist pension that she had inherited, and repatriation no longer seemed an option.[196]

The painting *La Révolution* (1917–20; fig. 96) reveals her creative response to the seismic contemporary events that brought an end to the three-hundred-year-old Romanov dynasty and the empire over which it ruled. While the work is reminiscent of Delacroix's *Liberty Leading the People* (1830), Werefkin's message is distant from the liberal republicanism favored by early nineteenth-century French anti-Royalists. Indeed, the assault is led by a woman rider in red who, shown astride her blue horse, bears the flag not of the Bolsheviks but of an image of Christ. The red flag is borne aloft by an anonymous and defeated enemy dressed in black. Werefkin includes another springing blue horse on the right-hand side of the painting, a denouement, on a metaphoric level, to the epic battle in which the victory of the spirit/art supersedes that of the people, monarch, or nation. The dramatic, Futurist-inspired composition, symbolic use of coloration, and strain of mystical Orthodoxy identified in her pre-1914 works were strengthened in her later oeuvre. In 1918, their move to the artists' and literary colony in Ascona provided a favorable intellectual and

spiritual haven. However, her separation from Jawlensky was made final with his return to Wiesbaden and marriage to Helena in 1921.

This study has maintained that not only did the Blaue Reiter's broad church and internationalism harbor the potential for staging more complex notions of gendered identity and exchange, but it also offered a forum for women artists' creative rivalry with one another. Yet the ambivalent reception of Münter, both within her immediate circle and in critical reviews, worked against the anchorage of her career in Germany, a set of circumstances that was not enhanced by the outbreak of war on August 1, 1914, and her speedy departure to Switzerland with Kandinsky. In chapter 5, I explore Münter's emigration to Sweden and the consequences that this held for her development after her final meeting with Kandinsky in 1916. Münter was independent-minded, and in the face of war euphoria in 1914, she sustained a commitment to pacifist beliefs. Critical to her success, I argue, was not only the support of the Waldens but also her tenacious intellectual and creative strength to endure the joint traumas of voluntary exile and loss of partnership during wartime.

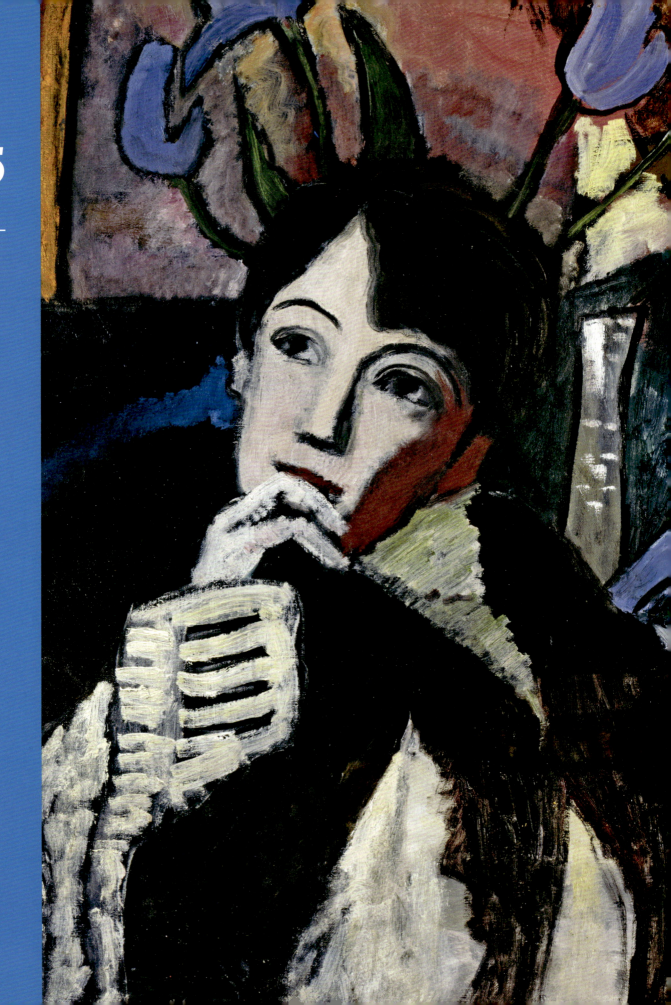

5

EUROPEANISM AND NEUTRALITY AS ACTIVE INTERVENTION

Gabriele Münter, *Sturmkünstlerin*, and Swedish Expressionism (1915–20)

Founded by the German Jewish pianist, writer, and art-dealing publisher Herwarth Walden, the *Sturm* has rightfully been termed an enterprise.[1] In March 1910, Walden and his wife, the poet and artist Else Lasker-Schüler, initiated the journal *Der Sturm: Wochenschrift für Kultur und die Künste* (The Storm: Weekly for Culture and the Arts), which, in its long history until 1932, uncompromisingly promoted modernism in literature, artistic theory, and the visual arts.[2] This formed the linchpin for the launch of the Sturm Gallery in 1912, a publishing house, a bookshop, an art school (from 1916), and a theatrical workshop.[3] A Verein für Kunst (Art Association), which Walden founded in 1903, continued under the auspices of the *Sturm*. Until 1919, the year that his lucrative interwar business slowed down and art prices started to increase due to inflation, the name Walden was synonymous with success. Indeed, the *Sturm* empire was retrospectively called a "kulturelles Gesamtkunstwerk" (cultural total work of art), a narrative that was sustained through omission of Walden's less successful years in the 1920s.[4] Yet, as will become clear, it is problematic to claim that the interdisciplinary interests of the *Sturm*, with its emphasis on "spiritual originality" and "liberal internationalism," were able to dismantle the entrenched patriarchy and "hurrah-patriotism" of the German Empire.[5]

It is generally accepted that prior to his divorce from Lasker-Schüler in 1912, Walden was courting his future second wife, Nell Roslund (fig. 97), whom he met in Landskrona in south Sweden. Roslund was introduced to Walden by his sister Gertrud Schlasberg, who also resided in Landskrona. As a musician, talented linguist, and (soon to be) aspiring artist, Nell Walden became implicated in the *Sturm* administration, dealership, and collecting; the couple's frequent trips to Scandinavia were not limited to family visits as they sought out venues in which to exhibit and display their wares. In March 1912, the launch of the Sturm Gallery as the third venue of the Blaue Reiter exhibition held tremendous significance for the marketing of the group in general and Gabriele Münter (fig. 98) in particular. In January 1913, as her agent, Walden arranged her solo exhibition and, by summer 1914, a traveling exhibition of the Blaue Reiter group visited Trondheim in Norway and then Gothenburg in Sweden.[6] However, on August 1, 1914, with Germany's declaration of war on Russia, the Blaue Reiter circle was in disarray as the Russian nationals had to leave Munich speedily. Once again, Nell Walden's contacts in Sweden were to prove invaluable to individuals in the group.

On August 6, Kandinsky and Münter traveled to Goldach in Switzerland, where they remained until November 25, the couple parting ways when Kandinsky returned to Moscow and Münter to Munich. Due to military restrictions on postal communication

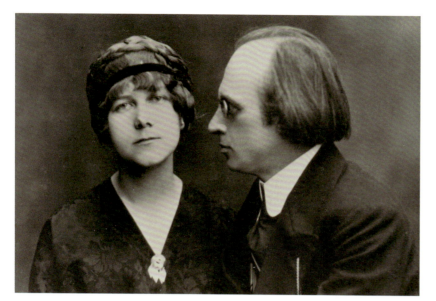

97 Anonymous, *Herwarth and Nell Walden*, 1916, photograph from the photo album of Nell Walden, Handschriftenabteilung, Staatsbibliothek Preußischer Kulturbesitz, Berlin, Sign: Hdschr. 118 (no page reference)

98 Henry B. Goodwin, *Gabriele Münter*, 1917, Sturm artist postcard, Gabriele Münter- und Johannes Eichner-Stiftung, Munich, Inv.-No. 3281

between enemy countries, Nell Walden arranged with her brother-in-law in Stockholm, Knut Ljunggren, to exchange Münter's and Kandinsky's correspondence.[7] Since its defeat in the Napoleonic Wars, Sweden had adopted an official policy of neutrality and retreated to its core. Its strategic location and maritime links made it an accessible destination from the Baltic nations, and it retained good relations with Germany. Indeed, due to the perceived regional threat from Russia with its stranglehold on Finland, Sweden strengthened its cultural ties with Germany.[8] In 1914, conservative forces defeated the liberal government and King Gustav V invited Hjalmar Hammarskjöld to become prime minister. A professor of international law and chief Swedish delegate at The Hague Peace Conference (1907), Hammarskjöld pursued a policy of strict neutrality during the war, which included trading with Germany in violation of the British blockade.

Initially, the economy prospered, as did the buoyancy of the Swedish art market, and Münter left for Stockholm—via Copenhagen—in mid-July 1915 in order to reunite with Kandinsky.[9] In 1916 they effected a brief reconciliation there and, although their correspondence was fraught with recriminations and bitterness, Münter hoped to marry Kandinsky. However, as early as February 1917, he married the younger woman Nina Andreyevskaya in Moscow, of which Münter remained unaware until her return to Germany in 1920. Notwithstanding this private turmoil and her reluctance to forego the surname Münter-Kandinsky, a title seemingly indispensable to her social and professional persona, she managed to establish a viable circle of colleagues and friends. In particular, her association with the Swedish Expressionists, who were championed by the artist couple Isaac Grünewald and Sigrid Hjertén, proved to be rewarding. In November 1917, as a consequence of the downward spiral of Sweden's economy in the continuing trade wars, Münter moved to Copenhagen where she forged transnational and cultural connections through *Sturm*'s agency.[10] Yet the Scandinavia/Berlin axis was strengthened by other economic and political factors. Whereas, in September 1914, Walden informed Münter, who was in Switzerland at the time, that "all exhibitions are of course completely dead," matters took a different turn during the war.[11]

As Kate Winskell has shown, it was as agents on the payroll of the Deutsches Auswärtiges Amt (German Foreign Office) that the *Sturm* enterprise could operate so

successfully in neutral Sweden, Copenhagen, Holland, and Switzerland.[12] This phenomenon can be viewed within the geopolitical culture of the early twentieth century, in which there were shifts in the equilibrium between land and sea power in international and strategic relations.[13] Walden's promotion of the international avant-garde as a disguise for national propaganda secured his continuous success both at home and abroad in a war-restricted economy. His connection to the Zentralstelle für Auslandsdienst (Central Office of the Foreign Service), a collaboration that, among other privileges, gave him permission to import works of Swedish artists, for example, and export exhibitions of Expressionist art under the pretext of German identity as being culturally progressive.[14] This was considered necessary in the face of vehement worldwide anti-German press campaigns and the ever-increasing list of trade embargos to and from the country.

Importantly, Nell Walden was pivotal to the task of translating German propaganda for Swedish newspapers. Walden's personal assistant during 1915, Sophie van Leer (1892–1953), a Dutch Jewish woman poet and future participant in the Munich Räterepublik (Council Republic), was also responsible for translations into Dutch (fig. 99).[15] Hence, it is difficult to sustain arguments that proclaim the *Sturm*'s program as exclusively vested in aesthetic autonomy. Particularly after the outbreak of the First World War, Walden's dealings with officialdom render his promotion of Expressionism as strongly linked to debates regarding nationalism and internationalism, culture and politics, and this was no different for the artists he represented.

That this phenomenon of so-called black or secretive propaganda was more extensive than otherwise admitted in the historiography has been sedulously researched by the cultural historian Hubert van den Berg.[16] As he has shown, the policy makers of *Kulturpropaganda* (cultural propaganda) were not limited to traditionalists but also encompassed liberal representatives.[17] Whether out of expediency, opportunism, or both, on occasions Walden's writing becomes rhetorical and gendered, as in his editorial "Das Hohelied des Preußentums" (The Song of Songs of Prussianism) of January 1916. Therein, at the outset, he declares his Swedish wife Nell Walden an honorary Prussian while singing the praises of militarism, albeit in the name of a superior creativity.[18] Granted, this is less

patronizing than his Americanized nickname for her ("Baby") and gives credence to Nell Walden's reminiscences, in which she considered herself a *Gefährtin und Kampfgenossin* (partner and comrade in arms) in the battle for the new art.[19] Yet, in reality, through her translations of press cuttings and journalism, she was a major financial backer and decision maker.[20] In the case of their private collection, which was originally advertised as "Sammlung Herwarth Walden," Nell rightfully protested that, since she spent her own earnings on this, it should be "Sammlung Walden."[21] When they divorced in 1924, the entire collection was seceded to her.

Against this backdrop, this chapter traces Münter's post-1914 role as *Sturmkünstlerin* (*Sturm* woman artist), her relationship to the circle, and her interaction with the exhibition world in Scandinavia. Although her correspondence

99 Anonymous, *Nell Walden and Sophie van Leer*, ca. 1915, photograph from the photo album of Nell Walden, Handschriftenabteilung, Staatsbibliothek Preußischer Kulturbesitz, Berlin, Sign: Hdschr. 118, Bl. 13v unten

with the dealer couple is helpful, her communications are formal and mostly dedicated to the subject of Kandinsky's finances. Even during his final absence in Moscow, she was proactive in her efforts to reduce Walden's commission—from 20 percent down to 15 percent—on sales of their works.[22] This is telling of her status in their creative partnership; yet the aim of this study is to uncover Münter's agency and networking among women practitioners and a wider modernist milieu. Whatever the drawbacks of pre-emancipation Sweden, the context of neutrality and more open attitude toward women and sexuality must have been liberating. At this time, her subject matter and figuration drew close to the Swedish woman Expressionist Sigrid Hjertén, who had trained in Matisse's studio. In their singular ways, Münter and Hjertén appropriated and transgressed the discourses of male avant-garde practice and produced strongly feminized works that raise issues of the embodiment and psychology of women's experience.

If we refer to methodological arguments laid out in chapter 1, Lu Märten's contention that the socialization of the woman artist would have an impact on traditional forms of women's erotic life is compelling. Moreover, that this would give rise to new configurations of womanhood is pertinent to both artists' representations. Yet for Hjertén, as wife and mother, and Münter, as single and foreign, there was the constant need to negotiate the sociosymbolic contract.[23] In late 1917, before leaving Stockholm, Münter entered the following in her women's calendar: "I lived in the country of prophets—now I have become a *Weltkind* (worldling)."[24] It may be surprising to us that Münter drew on Goethe's satirical 1774 poem "Diner zu Koblenz" (Dinner in Koblenz) in which he characterized his philosophy as a dynamic between the material and theological.[25] However, her concurrent sketchbook contains quotations from the writings of Rudolf Steiner who, as a former editor of Goethe's scientific works, was deeply influenced by the German Romantic poet and writer.

Münter's statement further attests to the expanding physical and psychological boundaries of her émigré identity and distance traveled from Kandinsky's prophetic voice. No doubt her transition to a more fluid form of internationalism involved a crisis of the self and, although mainly discussed in relation to Kandinsky's oeuvre in Stockholm, there is sufficient evidence to suggest that

Münter took careful heed of their interchange with the psychiatrist Poul Bjerre. Not only was Bjerre a keen pacifist and believer in neutrality as a form of active political intervention, he was also a supporter of contemporary art with a deep interest in the psychic functions of the creative process between the poles of figuration and abstraction.[26] Prior to considering these issues, however, let us explore Münter's encounters in Scandinavia, which brought her into contact with a cosmopolitan circle of artists, just as at home in Paris as in Stockholm or Copenhagen.

Amid Swedish Expressionists and Women Modernists

In comparison to the decentered, albeit crucial, role that Münter played in the Blaue Reiter, her emigration to Stockholm offered new opportunities for cultural exchange, in particular with women practitioners who shared similar modernist aspirations. Between 1890 and 1920, as in Germany, Swedish women artists became increasingly visible in the public sphere. They had had access to academic training since the 1860s and, even if not directly active in feminist or socialist circles, were attuned to a milieu in which social, economic, and sexual reform was publicly addressed.[27] In comparison to Paris, Stockholm was a small city, and the cultural elite were well acquainted; assimilated Jews were never ghettoized in Sweden, and they became prominent members of this circle, as witnessed in the emergence in the 1890s of major women painters like Hanna Hirsch (1864–1940) and Eva Bonnier (1857–1909), who were daughters of the proprietors of major publishing houses.[28]

The processes of democratization were sped up once the Socialdemokratiska Arbetarpartiet (Social Democratic Workers' Party) won the second chamber election in 1907. At this time, questions relating to prostitution, free love, contraception, and abortion were especially lively in the face of the so-called contraceptive law, which prohibited related propaganda and was debated in the *Riksdag* (parliament) in 1910.[29] Comparable to Germany, notions of maternalism were rife across the political divide and forms of *kvinnokultur* (women's culture) were advocated; this was prevalent in the less radical, although no less influential, views of the Swedish women's rights' advocate and

writer Ellen Key, who was based in Stockholm from 1880 onward.[30] Yet Sweden neither followed Norway in 1913 nor Denmark in 1915 in nationally enfranchising women, but joined Austria, Luxembourg, Great Britain (partial enfranchisement), the Netherlands, and Germany in doing so by 1919 (women participated in the election of 1921).[31]

Indeed, a conservative attitude was apparent in the policies of vanguard associations; formed in 1909 De unga (The Young Ones), for instance, only permitted male membership. Clearly the route for modern women artists was to form their own exhibiting and support group and, in 1910, they did just that in founding the Svenska Konstnärinnors Förening (Swedish Women Artists' Association).[32] They also sought out the cosmopolitan and liberating ambience of private studio tuition in Paris, Munich, or Düsseldorf. In the case of Sigrid Hjertén (1885–1948), who was raised in Sundsvall, a northern city known for its timber industry, she initially trained to become an art teacher in Stockholm at the Advanced School for Arts and Crafts and worked drawing cartoons for woven tapestries for the craft company Giöbels. In 1909, Hjertén chose to further her art education in Paris and forego plans to specialize in tapestry weaving in England.[33] As a resident of Paris until 1911, her experiences at the Académie Matisse were both formative and enduring.[34]

According to Carl Palme, one of her colleagues, Matisse praised Hjertén's works highly, even inquiring on one occasion whether she had previously studied the nude and, if so, where.[35] There is little reason to doubt Palme's word since in a well-known ink drawing (see fig. 7) by the chronicler Arvid Fougstedt, based on his and other Scandinavian artists' sojourn at the Académie Matisse in 1910, we find visual confirmation of the difficulty women artists faced in combining artistic excellence with femininity. Standing in front of Hjertén's painting of a nude model, Matisse is depicted extolling its virtues to the group of astonished and attentive male students.

Hjertén moreover gained fluency with Matisse's aesthetic theories, as contained in his 1908 treatise "Notes of a Painter," and while still in Paris, she published the essay "Modern och österländsk konst" (Modern and Oriental Art) in a leading Swedish newspaper.[36] Therein, she declared that "the same characteristics that we admire in the Chinese and Persians are to be found in a Cézanne

or a van Gogh. These particular characteristics . . . can be reduced to elementary laws." Just as Matisse's interest in textiles and Eastern art charged his visual imagination, so Hjertén seized upon the reciprocal interplay between figures and ground as found in Persian artifacts.[37] Evidently, her training in the applied arts prepared her for contemporary debates on the importance of "primitive" and oriental ornamentation to modern painting.

Hjertén's relationship with the painter Isaac Grünewald intensified in Paris, and they married on their return to Stockholm. She was one of a sizable proportion of Swedish women who were expecting or had children at the time of their marriage.[38] Indicative of her commitment to her career, however, is the fact that she published a biography of Cézanne in November 1911, just two days prior to the birth of her son Iván.[39] The only woman artist to exhibit with the group De åtta (The Eight), Hjertén's public debut placed her in close association with the core of French-influenced former pupils of Matisse.[40] Their first exhibition was held at the Salon Joël between May and July 1912, and newspaper headlines labeled them "Svenska expressionister" (Swedish Expressionists),[41] an adaptation from Matisse's usage of the term "expression."[42] Intrigued by notions of modernity, the artist couple gained prominence in this group and exhibited paintings of the city, entertainment, interiors of the studio, family, and social life, all of which were portrayed in a technically radical manner.[43]

Although they had critical support, it comes as no surprise that their work was disparaged in the conservative press. Whereas Hjertén's status as a woman artist was prejudicially undermined, Grünewald's Jewish identity marked him out as different, and in reviewing this exhibition, the critic Ossian Elgström was one of the first to transform the designation "Expressionists" into "Express-zionists."[44] Just as in Germany, where Carl Vinnen's recent *Ein Protest Deutscher Künstler* denounced museums' acquisition of the foreign and the modern, so critical reception in Sweden considered modernism and the art market an attack on the social and national body. It is important to note that a psychological interpretation of nation, style, and character was common to both the supporters and detractors of contemporary art in Sweden. As will be seen, this was no less apparent in the critical reception of Gabriele Münter's works.

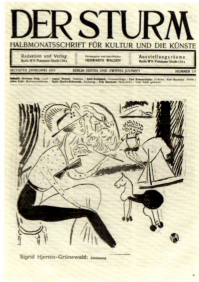

100 Sigrid Hjertén, *Self-Portrait*, 1914, oil on
canvas, 115 × 89 cm, Malmö Konstmuseum,
Malmö

101 Title page, *Der Sturm* 6, no. 7/8
(July 1915): 209

By the time she made contact with Hjertén and
Grünewald, they had emerged as part of a broader
subculture of Expressionism, brought to international
prominence following the group exhibition *Schwedische
Expressionisten*, which was held in May 1915 at Walden's
Sturm Gallery in Berlin.[45] In that year, adapted from her
painting *Self-Portrait* (1914; fig. 100), Hjertén's ink draw-
ing was reproduced on the cover of the July issue of the
journal *Der Sturm* (fig. 101). As the focus of a sophisticated
avant-garde milieu, she portrayed herself in a fashion-
able outfit: plumed hat, delicate spotted blouse, red bow,
emphasized waistband, and long fitted skirt. These features
of Hjertén's femininity are consistent with her appearance

in contemporary photographs (fig. 102) and point to the
performative strategies adopted by the couple, particularly
in the studio.

However, in the painting, while the formal conven-
tions of the contrasting red and blue-green colors, dec-
orative linearity, and insistence on the two-dimensional
surface reveal a debt to Matisse, Hjertén's self-image is
a disquieting one. The figure is portrayed in an uncom-
fortable position; the masklike face, with downcast eyes,
is perched awkwardly on the narrow neck and is forcibly
contained within the dominating curved line of the back
and elongated limbs. The act of painting is depicted uncon-
vincingly as the paintbrush is held in an elegantly posed

102 Anonymous, *Sigrid Hjertén Drawing in the Apartment on Katarinavägen*, Stockholm, 1913, photograph, Sundsvalls Museum, SuM-foto 018243

hand that dabbles with an unseen canvas. Within the studio interior, her son and his wooden horse are shown and, in the arched format at the rear, we find one of her husband's preparatory paintings for the decoration of the wedding room of the Stockholm Law Courts—a scheme that never came to fruition. Evidently Hjertén's turn to self-portraiture negotiated the challenging identities of her various roles as artist, wife, and mother.

From a sociological viewpoint, Hjertén's numerous portrayals of her son reveal much about the effects of birth control on family life and of the upbringing of the single child. Consistent with the advice of intellectuals, such as Ellen Key in her book *Barnets århundrade* (The Century

of the Children), which was published in 1900, education and encouragement of the child's individual and creative talents were critical to promoting a form of "spiritual motherhood," women's contribution to national reform.[46] Certainly, Hjertén's cosmopolitanism is distant from this model, but in paintings included in the *Sturm* exhibition, she imbues the rituals of play and Iván's favorite objects with talismanic significance. She also delights in attempting to view the external world through the untainted "eye of the child," which is conveyed at its most radical in her painting *Iván at the Window* (1914; fig. 103). This work draws on her experience of Matisse's single-color interiors to heighten the effect of the cityscape through the window

103 Sigrid Hjertén, *Iván at the Window*, 1915, oil on canvas, 58 × 43 cm, image courtesy of Bukowskis Auction, Stockholm

104 Isaac Grünewald, *The Red Curtain*, 1915, oil on canvas, 199 × 89 cm, Åmells Fine Art Dealer, Stockholm

with its saturated colors (yellow and red) of the freight on the quay, alongside the toylike crane and barge.[47] The experience of the city serves as a vehicle to explore the autonomy of picture formation and is simultaneously nourished by and from the spaces of femininity.

Interestingly, of Grünewald's paintings exhibited in Berlin, *The Red Curtain* (1915; fig. 104) is less subversive technically speaking but no less intriguing for that.[48] The domestic scene is used as a site for the display of modern female identity, his younger sister Dora serving as the model. Yet the contemplative mood of the interior is disrupted by the steep perspectival view of Stockholm through the window, which seizes on the priapic spires of the Gamla stan (Old Town) surmounted by a hovering, orb-like sun.

In August 1915, Münter's first encounter with Hjertén and Grünewald was at the *konsthandel* (art gallery) of Carl Gummeson on the Strandvägen, a venue where most

makes the Grünew[ald]'s strong is that they believe in their precepts—and talent."[49] If we examine the final *Portrait of Thyra Wallin* (1915; fig. 105), it becomes clear that Münter jettisoned her previous stylizing draftsmanship and integrated line in the unexpectedly lightened palette and facture. Amid this testimony of formal transition, low self-esteem, and the ongoing absence of Kandinsky, it is understandable that Münter viewed the Hjertén/Grünewald creative partnership in idealized terms.

Nevertheless, according to another of her colleagues, the woman artist Lilly Rydström (1891–1957), Münter "brought together the scattered youth of the avant-garde" at her pension in Stureplan and organized invitations to tea, which occasioned relaxed, yet profound, discussions on art: "There one could find together Hilding Linnqvist, Helge Lundholm, Hugo Scholander, John Jon-And, and his wife Agnes Cleve, and myself."[50] Between 1912 and 1914, all except Linnqvist had studied at the private Académie de la Palette in Paris at a juncture when Henri Le Fauconnier had taken over as director and André Dunoyer de Segonzac was one of the instructors.[51] At the end of September 1915, Münter participated in a debut exhibition with Rydström at Gummeson's, Walden having sent nineteen of her works from Berlin in the interim.[52] Indeed, Münter's swiftness in introducing herself to this *Sturm* contact took Walden by surprise, as he wrote, "I hear from Stockholm that your paintings are now on show at Gummeson's after all. Is that correct?"[53] It seems that Münter selected a few representative Murnau landscapes and still life paintings for display, which were encouragingly received. The well-disposed critic August Brunius of the *Svenska Dagbladet* (Swedish Daily Paper) found the German a more robust and modern woman artist than Rydström. The exhibition of Münter's works may have been chaotically arranged, he stated, but they were "painterly in substance and weight, which can be felt immediately."[54] Rydström's landscapes, although based on the outlying Swedish archipelago, were recognizable as French inspired, her nude bathers evoking a timeless idyll consistent with Le Fauconnier's take on Cézanne.[55]

Of greatest urgency for Münter was her negotiation with Walden and Gummeson in organizing separate exhibitions for her and Kandinsky to coincide with his long-awaited visit from Moscow. Between December 1915

of Walden's *Sturm* artists were exhibited. Subsequent to this, she frequented the artist couple's apartment on the Katarinavägen, which overlooked the *Slussen* (lock) on the outskirts of the Old Town, and met up with them socially at the Grand Hotel or Opera Café. At a time when she reported to be struggling on preparatory studies for a portrait of a new friend, the artist and stenographer Thyra Wallin (1882–1963), Münter noted in her diary: "I have no standpoint—no faith to profess, no precepts. What

133 Europeanism and Neutrality

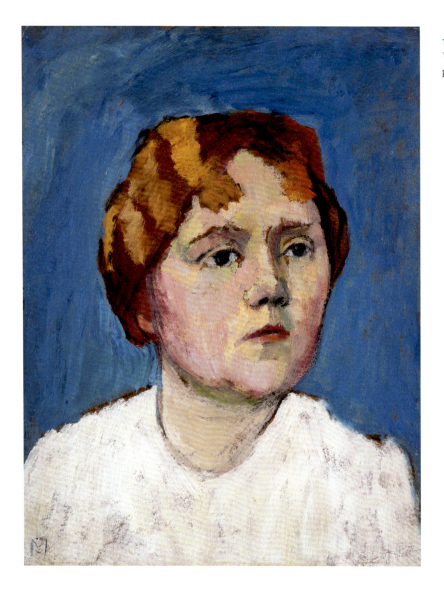

105 Gabriele Münter, *Portrait of Thyra Wallin*, ca. 1915, oil on board, 40.1 × 30.9 cm, private collection

and March 1916, his sojourn in Stockholm represented both a climax in their joint reception and watershed in their relationship (fig. 106). Kandinsky's exhibition opened at Gummeson's on February 1; importantly, his list of works included not only key abstract compositions from the Munich period but also fairy-tale and Biedermeier scenes—watercolor, pencil, and ink drawings—known as "bagatelles," which he commenced in Stockholm.[56] As evinced from festivities after the launch of the exhibition, Kandinsky's reintroduction of figuration was debated with interest at one of the artist couple's visits to the peace activist and psychiatrist Poul Bjerre.

In June 1915, prior to leaving Berlin for Scandinavia,

Münter arranged a formal introduction to Bjerre when she met up with Erich Gutkind and his wife Lucie in Potsdam.[57] As with Bjerre and Kandinsky, Gutkind was a member of the Blut Bund or Forte Kreis, which he founded with the Dutch educator and social reformer Frederik van Eeden in June 1914. This international network of men aimed to lead mankind out of the wilderness of materialism and warmongering.[58] That Münter, too, shared pacifist beliefs can be gauged from her mid-war correspondence with Maria Marc. Therein we learn that Münter was reading widely and had posted her friend a copy of the journal *Neue Wege* (New Paths), a well-known Zurich-based publication espousing religious and socialist

pacifism.[59] She further recommended similar literature arising from publishers in neutral Switzerland, among them *Blätter für Zwischenstaatliche Organisation* (Journal for Interstate Organization), which, in 1915, distributed *Ergänzungshefte zur Friedenswarte* (Supplementary Issues to Peacekeeping).[60]

In his professional capacity as a psychiatrist, Bjerre was responsible for introducing Freudian theory into Sweden, but he was intrigued by *Psykosyntes* (psychosynthesis), which was closer to Carl Jung's use of active techniques to stimulate the psychic functions. On the occasion of an invited social gathering, Kandinsky was questioned regarding his thoughts during the creative process between representation and abstraction.[61] Although Kandinsky was reportedly unresponsive, it was Bjerre's contention that the artist's abstract works were the result of a form of self-therapy, a compensatory release from his over-rationalizing theories.[62] We will have reason to return to Bjerre's political and aesthetic theories in relation to Münter; suffice it to add at this juncture that, formulated in the 1910s and in the publication *Död och förnyelse* (Death and Renewal, 1919), his language is less that of psychoanalysis than Nietzsche—a romantic paean to the healing power of (inner) nature as a guide to spiritual renewal and wholeness.[63] Within this natural system, dreams and their interpretation were likened to the creations of artists, which facilitated the complete synthesis of the patient's personality.[64] No doubt it was in relation to similar discussions that Kandinsky presented Bjerre with a small watercolor that included the figures of the psychiatrist and a rider in a dreamlike, Swedish rural setting with lake and house.[65]

Münter's exhibition, which ran between March 1 and 16, included twenty-six major Munich and Murnau canvases—interiors, landscapes, portraits—drawings and graphics. Inevitably, comparisons were drawn with Kandinsky, and distinctions between painterly figuration and abstraction were high on the list of reviewers' concerns. The critic Karl Asplund preferred her works to Kandinsky's explosive abstractions, seizing upon "Münter's clever attempt to combine the exclusive color art of her husband" with early European forms.[66] However, Gregor Paulsson, an art historian and critic who was part of a network in support of the Swedish Expressionists, saw her as a very radical painter, but her proud temperament, which

he determined was a classic element of Prussian culture (Münter was born in Berlin), held the consequences of limiting her radicalism.[67]

Since Münter mainly exhibited her pre-1914 oeuvre, such a response is unsurprising; apart from a few in situ landscapes and portraits on board, her output was limited and only gained momentum well into 1916. Furthermore, Kandinsky's publication in the Swedish language of a previously penned essay, in which he introduced Münter to a German rather than an international audience, served to reiterate the importance of national schools in framing the qualities of the individual artist.[68] Entitled *Om Konstnären* (On the Artist), the text distinguished between the

106 *Kandinsky and Münter in Stockholm*, 1916, photograph, Nordiska Kompaniet, Stockholm

107 Gabriele Münter, *Wall Hanging at the Liljevalchs Konsthall*, 1917, photograph, Gabriele Münter- und Johannes Eichner-Stiftung, Munich

108 Gabriele Münter, *Portrait of a Child* (Iván Grünewald), 1916, oil on canvas, 45.5 × 38.5 cm, Städtische Galerie im Lenbachhaus und Kunstbau, Munich, Gabriele Münter Stiftung 1957, Inv.-No. GMS 669

creative and the virtuoso artist, Münter clearly belonging to the former category in which drawing and color stemmed from an inner rather than external stimulus.[69] According to Kandinsky, this intuitive process of creating art had its genealogy in the finest epochs of German art, such as folk art, music, and poetry, and testified to Münter's authenticity. This tribute, fragments of which were published in her subsequent companion's—the art historian Johannes Eichner—mid-twentieth-century monograph on the artist couple, set a standard in the historiography on Münter and perpetuated her reception as a naive artist in the German manner.[70] Hence, it is important to ferret out those occasions when her works escaped inscription within purely national terms, albeit that they retained pejorative gendered associations.

Beyond Kandinsky

If we fast-forward to January 1917 and to an installation of her works in the Liljevalchs Konsthall, a recently built gallery on the Djurgården island for the display of contemporary art, then one gains insight into the shifts in her practice and allegiances while in Stockholm. The exhibition was a joint initiative and tour de force of the Swedish Women's Artists' Association and the Vereinigung Bildender Künstlerinnen Österreichs (Association of Austrian Women Artists), the latter also founded in 1910. Along with Hjertén and the painter Malin Gyllenstierna (1866–1936), who had trained under André Lhote in Paris, Münter was invited to exhibit in a shared gallery space to which she contributed thirty-one of her most recent works. The wall hanging (fig. 107) reveals the predominance of portraits over still life, interior scenes, and landscape painting, which testifies to her close social and professional interaction with Hjertén and Grünewald. Indeed, *Portrait of a Child* (1916; fig. 108), one of Münter's first oil paintings in Stockholm, depicts Iván, their five-year-old son.[71] As stated earlier, Münter's interest in portraying children was aligned with the Blaue Reiter ethos and fascination with child art. His wide-eyed face and impetuous gestures are brought close to the picture plane by means of a variegated rich impasto that contrasts with the shimmering washes of the ground. Content-wise and formally, Münter's representation of Iván signals her ease in accommodating the Swed-

ish followers of Matisse, an experience surely rekindling memories of her own Paris sojourn in 1907.

Of further note in the installation is the large-scale canvas known as *Music* (1916; fig. 109), which is derived from preparatory sketches of a musical performance in a private household, amid the siblings of the aforementioned Thyra Wallin.[72] In this work, distinct from the interiors of either Murnau or Schwabing, Münter portrays a scene of middle-class hospitality. Since the late nineteenth century in Sweden, new family rituals were invented and, among these, music-making around the piano served an important role in cultivating social cohesion.[73] Münter seizes on the contemplative absorption of the performers—a dark-suited violinist in the center and rear view of the pianist to the right—and listener, who is seated on the left. This triangulation of the composition in relation to the viewer is not uncommon in her works, as witnessed in *Man in Chair (Paul Klee)* (1913; see fig. 92), where strategically placed objects, a chair with a robe on the left and Bavarian votive figurines in the center, compete with the sitter for our attention. In the painting *Music*, floral arrangements, from the tall vase placed on the foreground brocade tablecloth to those in the light-filled interior beyond, direct us to the spaces between and around the protagonists and furniture.

As has been observed of this period, temporality plays an important role as subject (as in *The Watchmaker Shop*, 1916), and object, with the inclusion of wall clocks, diaries, and photographs as signifiers of literal time and memories of the past.[74] Commentators interpret these objects, the self-contained figures, and enclosed spaces as symptomatic of Münter's emotional isolation. However, it is evident that her preoccupations also lay in formal concerns; in one of the sketches for the composition, Münter links the coordinates of space and time, the visual and the aural, by noting thereon, "Blumenheim mit Musik" (Flower[-filled] home with music).[75] In negotiating the musicality of painting, she makes the links tangible via expressive counterpoise of the everyday and the cyclical (seasonal flowers); large swathes of the painting are in complex, cool shades of mixed pinks, yellow greens, yellows, and grays, with strong accents for the blue of the Swedish flag above the pianist or red of the clock and book on the table.

The contrast of pastel and saturated colors, sparse application of paint, and lyrical use of line forego

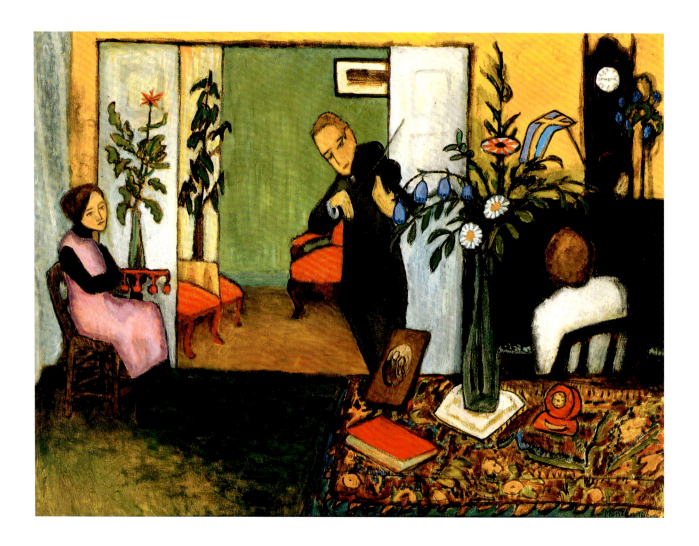

109 Gabriele Münter, *Music*, 1916, oil on canvas, 90 × 114 cm, private collection

Kandinsky's synesthetic theories of abstraction and point to Münter's links with her Swedish colleagues. Hjertén submitted ten works, including the major canvas *Studio Interior* (1916; fig. 110).[76] In this salon-like gathering, her son Iván acts as intercessor and directs the spectator to typologies of avant-garde male and female identity. In the foreground we find the dandyish, violet-clad figure of Nils Dardel and an unidentified femme fatale dressed in black, whose sinuous curves dominate the composition. Sharply reduced in scale in the rear, but just as intense in the choice of discordant colors, Hjertén depicts other male members of the Swedish Expressionist group, Einar Jolin in conversation with her husband Grünewald, an unanimated woman seated between them. An exotic gypsy mother and child, the subject of an independent canvas in the exhibition, is portrayed within a vignette, a reminder possibly of

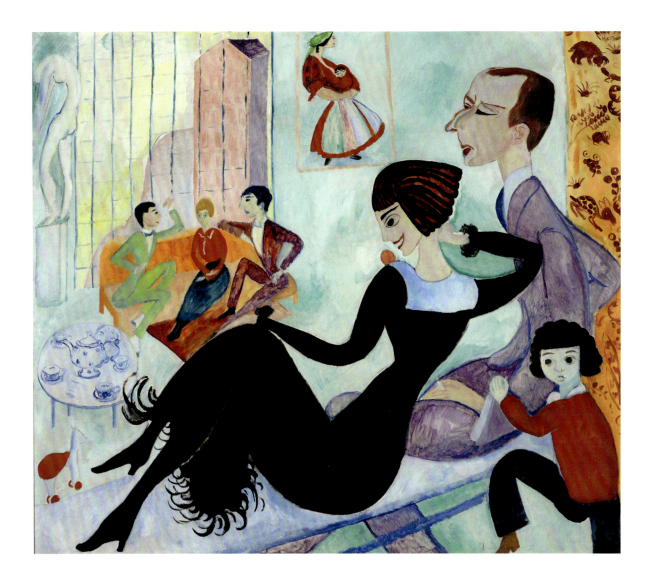

110 Sigrid Hjertén, *Studio Interior*, 1916, oil on canvas, 176 × 204 cm, Moderna Museet, Stockholm

natural motherhood within this spectacle of what would be deemed "decadence" among hostile critics.[77]

Indeed, Hans Sax, a reviewer of the *Stockholms Dagblad*, seized on the impact of the installation in cynical terms, associating modern art with malformation and degeneracy:

> In an area adjacent to the Austrian exhibition room the wives Hjertén-Grünewald and Münter-Candinsky [*sic*] had the walls decorated with parts of legs and deformed human bodies, with dancing and whimsically shaped people, as well as Cubo-Futurist orgies and clashes of color, with, to the undersigned, in any case, entirely hidden values of beauty. The room is for those who believe they comprehend more than others![78]

No doubt this critique included Gyllenstierna's exhibits, such as *Chords* (1916; fig. 111), which is a dynamic Cubist rendering of a nude holding a guitar and sheet of music.[79] In a more abstracted manner than Münter's *Music*, Gyllenstierna deploys contrasts of the complementary colors blue and orange and red and green, and uses fluctuating planes to evoke tonalities of sound. Notwithstanding these nuances in avant-garde practice, of importance to assessing Münter's position is that, while referred to as Kandinsky's wife, she was adjudicated in relation to other modernist women artists. Their works defied the more traditional

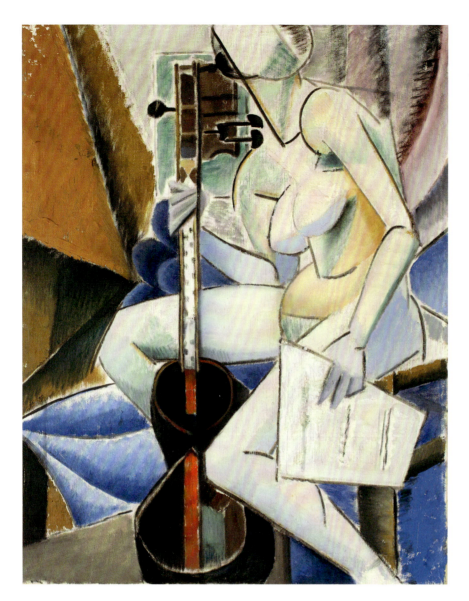

111 Malin Gyllenstierna, *Chords*, 1916, oil on canvas, 81.5 × 60 cm, image courtesy of Bukowskis Auction, Stockholm

submissions and were thereby negatively associated with concepts of degeneracy, the decorative, and the foreign.[80]

Both the lyrical use of line and evocative treatment of the ground seeped into Münter's graphics as well. In the etching *At the Lock in Stockholm* (1916; fig. 112), she appears to have been inspired by the view out of Hjertén's and Grünewald's window of their combined studio and residence. In comparison to the unadorned planar contrasts of her pre-1914 linocut or woodcut technique, Münter's print is atmospheric as she unites the waterways of Lake Mälaren with the open sea by means of curvilinear lines of smoke and cloud. As with Hjertén, Münter flattens the aerial landscape and includes toylike boats and stick figures of passersby on the quay in the middle ground.

The cityscape is simultaneously distanced conceptually but placed within hand's reach by virtue of its treatment. It is as if control of these public spaces could be made more palpable by viewing them from the private sphere.

It is also within the domestic spaces of femininity that Münter utilizes the iteration of line and textures to achieve an unexpected form of intimacy with the sitters. Her etching *Mother and Son* (1916; fig. 113) derives from sketches made on visits to the Wissler artist couple, who were based in Mariefred, a quaint town southwest of Stockholm. Berta Wissler (1866–1952), better known as Bess, and her sculptor husband Anders, were pioneers in Sweden of Japanese-inspired ceramics that evoke the organic shapes and semimatte running glazes of Art

112 Gabriele Münter, *At the Lock in Stockholm*, 1916, etching, no. 5 out of 10, 7.4 × 9.9 cm, Städtische Galerie im Lenbachhaus und Kunstbau, Munich, Gabriele Münter Stiftung 1957, Inv.-No. GMS 918

113 Gabriele Münter, *Mother and Son*, 1916, etching, no. 10 out of 10, 10.3 × 3.6 cm, with kind permission of Ketterer Kunst GmbH und Co. KG

114 Sigrid Hjertén, *Mother and Child*, ca. 1916, etching, 25 × 19.5 cm, private collection, Stockholm

Nouveau. In Münter's print we can detect an interest in the repeat pattern of local textiles as well as a delicacy of line found in Japanese prints. Interestingly, following Hjertén's Berlin exposure, she, too, produced cycles of graphics—three linocuts and seven etchings—in response both to Walden's staging of a *Sturm* exhibition of prints in Stockholm (December 1917) and her acquaintance with German Expressionist print culture.[81] If we compare Hjertén's etching *Mother and Child* (ca. 1916; fig. 114) with Münter's, we notice similar mannered poses and elongated figures, although Hjertén's use of the intaglio medium is

sketchier and more pictorial. Their works also differ in the compositional arrangement; Münter's narrow format and setting strengthen the unity of the coupling, as their facial features are echoed, their arms are interlinked, and the mother's elegant hand cups the chin of the youth.

That notions of the maternal and heredity were of relevance to Münter is conveyed in her diary, *Beichte und Anklage* (Confession and Complaint), which she completed in the mid-1920s. Therein, she recorded some bitter memories of her interaction with Bess Wissler: "Mrs Wissler stated she was over 40 years old when she had the boy. She said I would have still time to do so—and my feelings! The youth squandered, missed life—maybe it is yet to come."[82] In this account, Münter exposed her personal sensitivities to being childless at a critical stage of a woman's fertile years (she turned thirty-nine on February 19, 1916). However, it is important to consider Münter's portrayal of women beyond the issues of the maternal. Tellingly, her wider oeuvre bears testimony to creative engagement with the images, contemplative moods, cropped hairstyles,

and fashionable dress of early twentieth-century mature womanhood.

"A Woman of International Living"

In May 1917, Münter exhibited a recently completed series of paintings in the Nya konstgalleriet (The New Art Gallery), which was launched in 1915 on the Strandvägen —a mere block away from Gummeson's—by the Italian Futurist Arturo Ciacelli (1883–1966). He had studied in Paris under Robert Delaunay and, through his marriage to the Swedish painter Elsa Ström (1876–1952), later moved to Stockholm. As an art dealer, he specialized in the French avant-garde but also tried to spread the Futurist word via lectures, cabarets, and the editing of a single issue of a journal, *Ny konst* (New Art).[83] No doubt he had the *Sturm* model in mind, but the competition was fierce, and in a letter to Münter in May 1916, Walden accused Ciacelli of being a false Futurist, copyist, and defrauder.[84]

Nevertheless, such strongly held views did not prevent

115 Gabriele Münter, *Exhibition in Ciacelli's Nya Konstgalleriet*, Stockholm, 1917, photograph, Gabriele Münter- und Johannes Eichner-Stiftung, Munich

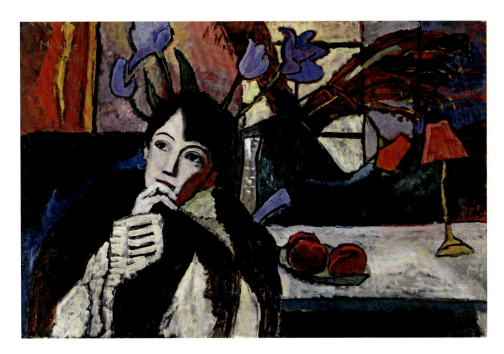

Münter from liaising with both dealers. Her exhibition was partnered with the Swedish artist Georg Pauli (1855–1935), who was the husband of the academically trained portraitist Hanna Hirsch. Münter must have been aware of this connection and, in particular, of Hirsch's full-length portraits of female colleagues in a style close to French realism but with an interest in the optical flicker of an Impressionist brushstroke.[85] Although Pauli was a moderate Cubist, he was responsible for the founding of *flamman* (Flame, 1917–21), one of the most prominent of Swedish avant-garde magazines. With its precedents in Walden's *Der Sturm* and Amédée Ozenfant's *l'Elan* (1915–16), the transnational referents of *flamman* were established from the outset. In the first issue Pauli declared that the journal was "an attempt to give the young and promising in modern art a mouthpiece before a Swedish audience . . . The

modernisms will be attended to: expressionism, cubism, futurism, simultaneism et al. and totalism!"[86]

Pauli's use of the term "totalism" to apply to a synthesis of the various modernist tendencies was well publicized before his and Münter's joint exhibition. As can be ascertained from a photograph of the installation of her works (fig. 115), Münter's larger canvases, based on women in interiors, reveal her current aspirations toward a form of European Expressionism, the referents of which will be explored in the final section. They were painted in quick succession following a more straightforward rendering of a *Portrait of Miss Gertrude Holz* (1917).[87] The work *Reflection* (1917; fig. 116)—originally entitled *Det förflutna* (The Past)—shows the model crowned with heavenly colored spring tulips. A more naturalistic study (fig. 117), sketched two days prior to the painting, indicates that the blooms

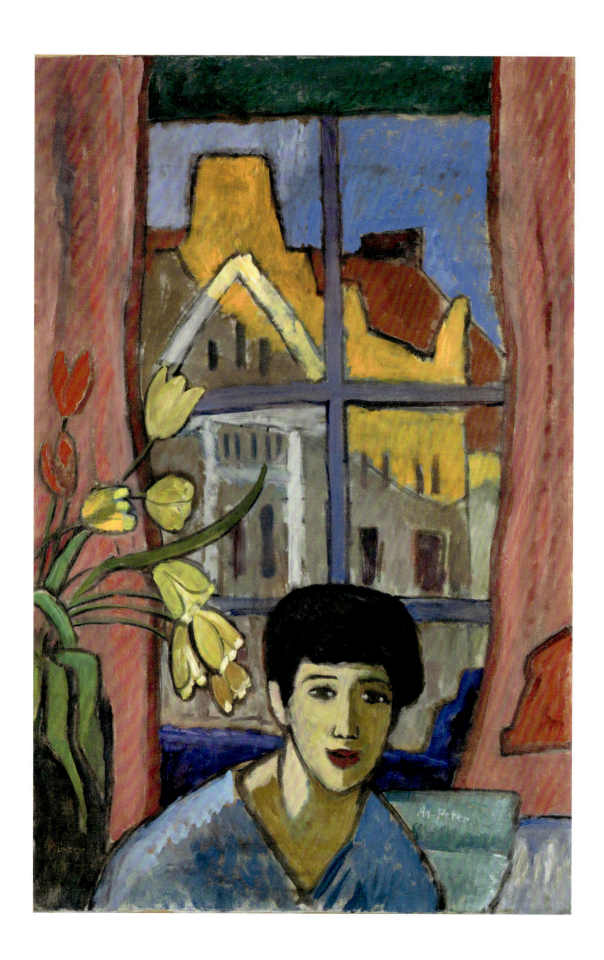

118 Gabriele Münter, *Future*, 1917, oil on canvas, 100.5 × 66.5 cm, Cleveland Museum of Art, gift of Mr. and Mrs. Frank E. Taplin, Jr., 1992.96

119 Gabriele Münter, notations and sketch for *Future*, 1917, Sketchbook Kon 46/48, 24–25, Gabriele Münter- und Johannes Eichner-Stiftung, Munich

arise from a vase to the rear of the model's head, their organic and rhythmic contours connecting ornamentally with the corn sheaf behind and Cézannesque apples to the right. Not present in the study, a spindly lamp is added to the painting, and its red shade balances the compositional use of color; complementary red/green accents and yellow light from the window tinge the shadows of the interior.

Located opposite *Reflection* was the painting *Future* (1917; fig. 118), and they were paired by having the same catalog reference (number 5). Both works utilize the figure and setting to suggest abstract themes of reverie and meditation, on the one hand, and anticipation on the other. Additional works, entitled *Sjuk* (Sick), with their melancholic associations, conjure the seriality and themes of Edvard Munch's installations—such as his *Frieze of Life* (1893–99). Münter was certainly mindful of the Norwegian artist's psychologically charged figural compositions in her pre-1914 Munich oeuvre.[88]

On first examination it may seem that the artist embeds meaning in an allegory of linear temporality by virtue of the titles "The Past" and "Future"; in comparison to the stasis and predominant focus on the half-length figure and still life in *Reflection*, the painting *Future* reveals a more upright woman set against the sunlit outer world through the window. As Eichner informs us about its iconography, the model had received a telegram from her betrothed in St. Petersburg and this filled her with hopes for the future.[89] An inscription to the right of the figure "An Peter" (to Peter) in an open, blue-green book plays on this innuendo. There is no reason to doubt Eichner's account since, in notes accompanying one of Münter's sketches for the composition (fig. 119), the word "Telegramm" heads an itemization of the contents and its color scheme.[90]

Yet Münter's series shares neither in the pessimistic determinism of Munch's cycles of life, love, and death nor

in his typologies of womanhood as pubescent innocents, lustful sirens, or elderly, barren women.[91] As distinct from nineteenth-century philosophical and evolutionary monism, Münter's images proclaim their identity as "new women"; dress, hairstyle, and content-wise, they embody the processes of thought and intellectual creativity usually reserved for portraits of men. The model for these works was a young Jewish woman, Gertrude Holz, who had spent time traveling with the artist in Lapland and along the west coast of Norway the previous year. There Münter sketched the inhabitants and studied local folk art, and in a photograph taken at the time (fig. 120), Holz is shown holding a wooden knife decorated with Lapland carving. Little else is known of her other than Johannes Eichner's observation that Holz was "Eine Dame des internationalen Leben" (a

120 Gabriele Münter, *Gertrude Holz* (on left), North Sweden, July 1916, photograph, Gabriele Münter- und Johannes Eichner-Stiftung, Munich

woman of international living).[92] In this case the charge of internationalism and cosmopolitanism usually linked with Jewish urban identity was viewed in positive terms, particularly in light of Münter's admiration of Holz.

But, as always with Münter, the ostensible content gives way to a more profound statement. How else can one articulate the impact on the viewer of the compelling portrayal of Holz in *Reflection*, wherein the relief-like, pensive face with upward and sideways glance is poised at the apex of a ruggedly painted black-and-white shawl. Münter advances all aspects of the canvas productively toward a space-defying metaphysics, and as a consequence, the experience of temporality is cursive rather than sequential. In common with the Swedish Expressionists, Münter was familiar with the ideas of the philosopher Henri Bergson, as propounded in his essay "Introduction à la Métaphysique" (1903), a German translation of which resides in her estate.[93] Therein Bergson's suggestion that durational flux can best be understood through intuition was held sacrosanct among the followers of Matisse: indeed, Matisse had famously claimed, "I am unable to distinguish between the feeling I have about life and my way of translating it."[94]

Entries in Münter's sketchbooks from this period reveal the complex textures of her émigré identity, affiliations, and differences. Notwithstanding the radical disruptions of German life and culture at the time, her quotations from the writings of Rudolf Steiner indicate that prewar concerns were just as much a product of her agency as her adaptation to the new milieu. In the main, she refers to Steiner's ideas contained in his four lectures, "Der Menschliche und der Kosmische Gedanke" (Human and Cosmic Thought), which were delivered in Berlin on January 20–23, 1914. On one page, she transcribed a diagram from his third lecture (fig. 121), detailing the twelve possible Weltanschauungen (worldviews) of the mind of man; these correspond to the signs of the zodiac and are laid out in a circle, ranging clockwise, from Materialism, via Realism, to Spiritualism, Idealism, and so on.[95] Importantly, in his approach toward Phenomenalism, Steiner considered Intuitionism to be the third and highest mode of cognition, ahead of Theism on the one hand and Naturalism on the other: "A man who seeks for the best, guided by his intuitions—he is like the intuitive poet whose soul is stirred by the mild silvery glance of the moon to sing its

121 Rudolf Steiner, diagram from the third lecture of *Der Menschliche und der Kosmische Gedanke* (Berlin, January 22, 1914), Rudolf Steiner Online Archive, 4th ed., 2010, 42 http://anthroposophie.byu.edu/vortraege/151.pdf

praises." [96] It is via such means that spiritual reality might be apprehended.

Steiner's arguments are far from being a closed system. In fact, in another entry, Münter copied a paragraph from the fourth lecture in which he questioned the very notion of universal thought: "The worst enemies of truth are worldviews that are exclusive and strive after finality; the conceptions of those who want to frame a couple of thoughts and suppose that with them they can dare to build up a world-edifice. The world is boundless, both qualitatively and quantitatively!" [97] For the anthroposophist, then, if one is a seeker then one never stops seeking and, comparable to Bergson, Steiner's concept of the world is characterized by movement, creativity, and constant change. Just how appropriate this lecture is to an understanding of the iconography and theoretical coordinates of Münter's series of paintings is conveyed in Steiner's exhortation at the head of the concluding paragraph: "Meditate sometimes on the idea: 'I think my thoughts—And I am a thought which is thought by the hierarchies of the cosmos.'" [98]

The contention that the individual person's thoughts were embedded in a greater, albeit fluctuating, cosmic process could serve as a rationalization for Münter's tenacious

commitment to figuration, nature, and the world of objects. If we think back to Kandinsky's Stockholm visit and of his reluctance to respond to Bjerre's probing questions about the creative process and spiritual abstraction, then we can suggest that Münter's series of meditative women were an admirable riposte on her position. The interiority of the figures is characterized by a powerful physical presence of the subject and manual energy of the artist, a self-reflexive embodiment of Lu Märten's aspirations for the modern *Künstlerin*. As we have seen in chapter 1, Märten's utopian notions were predicated not on outdated historical and scientific legacies of women's essential nature but on psychological and intellectual experiences that were constantly in process—the socialized body.

That Münter took momentary pleasure in this synthesis of her inner and outer personality can be ascertained from the fact that she requested a *Sturm* postcard of herself and had a studio portrait (see fig. 98) made in Stockholm by the Munich-born photographer Henry B. Goodwin (1879–1931). This served as her main professional photograph for many years thereafter. [99] Goodwin was Sweden's foremost pictorialist photographer, who was noted for his studies of female celebrity; in another photograph of Münter (fig. 122), the transformation of her image is made visible—from the more formally dressed companion of Kandinsky (see fig. 106) to stylishly aware cosmopolitan.

In her correspondence with Walden, too, she took issue with his selection of her exhibits, grouped with those of Paul Klee and the Swedish artist Gösta Adrian-Nilsson, for a December 1917 exhibition in the Sturm Gallery in Berlin. [100] She wrote of the importance for critics to see new works and complained that Walden had chosen an exhibition from old material that "zum alten Sturm-Stamm gehöre" (belong to the old Sturm strain). [101] Clearly, Münter was thinking of a future as an internationally recognized artist beyond her *Sturm* affiliations and German identity.

"We Europeans"

Instructively, the dynamics between nationalism and internationalism were aired in Poul Bjerre's writings, some of which are held in the library of the Münter estate. In particular, one can trace a faint pencil line in the margin of her copy of his *Läsdrama* (reading drama) in three acts,

which was delivered at a *Fredenskongressen* (peace congress) in 1916. The markup occurs at a juncture where the protagonists—the crestfallen Harzburg and optimistic Fabian Block—enter into a dialogue on the fate of Europeanism.[102] Whereas Block viewed this concept as a beautiful memory that would evolve triumphant after the struggles of the war, Harzburg considered it an illusion, and that the war was only a preamble to a European pandemonium: "'We Europeans,' name not the word, dear friend, it is only to demolish both your and my life's bitterest memory."[103] These earnest considerations on Europe's destiny must be measured against the relentless toll of the war; perusal of Münter's correspondence with the former circle of the Blaue Reiter endorses the observation that nostalgia was a hollow experience for those who were separated from partners or had lost husbands, brothers, or sons on the front. In the months following the death of Franz Marc at the Battle of Verdun on March 4, 1916, Maria Marc wrote pitifully of her grief, "And death is nothing terrible for me anymore, since I have lost Franz in this life."[104]

Hence, the breakthrough that we perceive in Münter's artistic career must be accompanied by acknowledgment of her vulnerability on a private and existential front. In the pen and ink drawing *Ich bin deutsch* (I am German, 1917), she confided intense feelings of isolation in her sketchbook.[105] Customarily most economic and decisive in her draftsmanship, here she scored and underscored the shape of her face and the questioning line of her brow, differentiating the abject mood of the self-portrait from her recent oil paintings of women in interiors. Her experiences of alienation can be attributed to various factors: paramount among these was the loss of contact with Kandinsky and concern for his safety during the October Revolution. Due to the volatile political climate in Russia, her enemy identity and, of course, Kandinsky's intransigent silence, she was unable to join him, and the title of the self-portrait draws attention to the limitations of her national origins at the height of Germany's pariah status.

By 1917 in Sweden, there were heightened political tensions between Left and Right as a consequence of Swedish foreign policy. The country faced a devastating economic crisis both on an industrial and commercial front; Britain would not compromise on their blockade policy and the Swedes insisted on neutrality and continuing trade with Germany. Rampant inflation and shortages led to Hammarskjöld's resignation in March and the Conservative government was replaced in the September elections by a Liberal and Social Democrat coalition. However, there was no immediate resolution to the economic conditions, and it was only in May 1918 that a trade agreement with the Entente ended Sweden's isolation.[106] Aware of Münter's financial constraints and search for rent-free accommodation in exchange for art lessons, Walden had offered her a month in Berlin during which she could teach a master class in the newly established Sturm-Kunstschule (Sturm School of Art).[107] Yet the artist availed herself neither of this opportunity nor of Nell Walden's warm entreaties to return to live in Berlin. Conversant with everyday life in Scandinavia, Nell Walden observed that it was becoming more and more difficult abroad as the neutral countries endured scarcities of food and came to mistrust foreigners.[108]

In November 1917, soon after this communication, Münter chose to move to Copenhagen, no doubt in order to linger in neutral territory until she had heard from Kandinsky. She was not alone in seeking haven there since the wartime economy was less austere in the Danish capital, and constitutional reform, such as the enfranchisement of women in 1915, was still pursued. Since Denmark shared its southernmost border with Germany, the country adapted its neutrality to German needs and, indeed, the minority ethnic Danes in North Schleswig (now Denmark's South Jutland County) were recruited to serve the kaiser and the Imperial German Army.[109] Nevertheless, this policy was implemented by a radically liberal government whose sympathies, as well as those of King Christian X and the cultural elite, lay with the Allied forces.[110] Hence, as commentators note, there was a disjuncture between political reality and cultural discourse: Copenhagen became the destination of artists from the Nordic countries, many of whom were Paris-trained and sought out modern artistic idioms.[111]

Clearly, Walden saw potential in this widening of the geopolitical horizon, and in October 1917, he organized a group exhibition in Copenhagen entitled *Der Sturm Kunstnere* (Der Sturm Artists). This was held at the Edderkoppen (The Spider), an artists' cabaret, and included the works of Münter, Feininger, Kandinsky, Klee, Kokoschka,

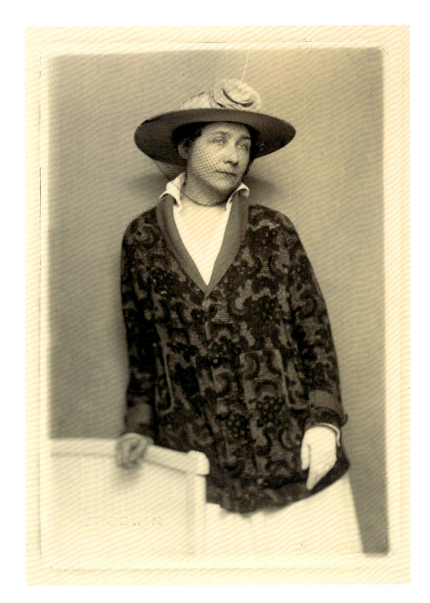

and Marc. Moreover, as late as December 1918, with the benefit of his arrangement with the German Central Office for Foreign Services, Walden secured a major exhibition, *International Kunst: Ekspressionister og Kubister* (International Art: Expressionists and Cubists), which, as stated by the German ambassador to Denmark, aspired to promote the German case by having an "international feel and will prove to the Danes that we are free of political sympathies or aversions within the art world."[112]

However, the exhibition, which was held at the private gallery of the modern art dealer Georg Kleis, failed to convince the Danish press of its internationalism and instead raised fierce anti-German sentiment.[113] Given this framework, it is understandable that Münter continued to predispose herself toward French-inspired modernism. Following a scandalous anti-Semitic press campaign against Isaac Grünewald in Stockholm, due to what reviewers termed his foreign style and profiteering, he and Hjertén exhibited and spent some time in Denmark.[114] Tellingly, in an unpublished article that was written in Swedish and destined for publication in the *Dagens Nyheter* (Today's News), Münter deemed it necessary to defend the artist couple from the media onslaught and stated: "We can still be happy to have Grünewald and

123 Gabriele Münter, *Exhibition Wall: Den Frie Udstilling Copenhagen*, March 1918, photograph, Gabriele Münter- und Johannes Eichner-Stiftung, Munich

Hjertén—full of life, talented followers of Matisse. He often with oriental sweetness and virtuoso refinery, she with harsher, cold Nordic, and naïve features."[115]

Münter's defense makes for a compelling inversion of the gender roles as well as for the reshaping of our understanding of the national referents of Expressionism. Whereas both artists were seized upon as being inspired by Matisse, Grünewald's style was linked to a warm and feminine exoticism (a reference perhaps, as well, to his Jewish origins) and Hjertén's to a more psychologically taut, transnational form of expression. Due to the presence of many Nordic artists in Copenhagen's art scene during

the war, the forging of a new art was accompanied by the emergence of an interconnected cultural identity between the various northern nations.[116] Hence, and fascinatingly so, Münter's usage of the terms "followers of Matisse" and "Nordic" to apply to Swedish artists is not unprecedented in the construction of the European coordinates of Expressionism. In light of these findings, it is interesting to gauge Münter's output at the time.

In March 1918, she contributed more than a hundred works to the annual spring show, *Den Frie Udstilling* (The Free Exhibition)—paintings, drawings, etchings, reverse glass paintings—ranging from a selection of German works that were sent by Walden to examples of her Swedish and Danish oeuvre. This can be ascertained from her photograph of a section of the wall hanging (fig. 123) in which one can identify a couple of Murnau landscapes in the lower register of the installation. Evidently, the artist

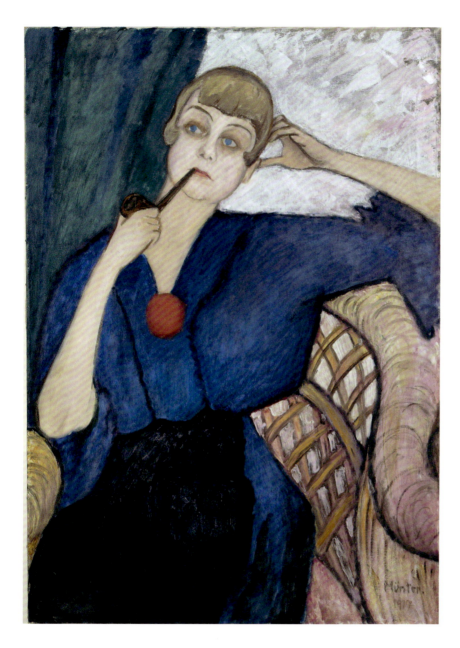

124 Gabriele Münter, *Portrait of Anna Roslund*, 1917, oil on canvas, 94 × 68 cm, New Walk Museum, Leicester

attempted to subsist by securing commissions for portraits, charging the amount of two hundred kroner for two to four sittings (witness the preponderance of portrait studies in the upper register of the hanging).[117] Not included in the photograph, however, is a key exhibit, *Portrait of Anna Roslund* (1917; fig. 124), which continued the theme of meditative women in interiors but as the departure for a commissioned work.[118] This could be one of the earliest undertaken in Copenhagen, the location and date (Koph. 27 Nov.) being inscribed on one of the preparatory sketches.[119] Once again, the network of contacts supplied by Nell Walden had proved invaluable, as Anna (1891–1945)

was the youngest sister of the Roslund family; she was a trained musician and writer who later married the Danish painter Carl Trier Aagaard (1890–1961). Münter apparently boarded with her on arrival in Copenhagen, and the author's book of poetry *Den fattiges glädje* (The Joy of the Poor, 1915) remains in Münter's library.

The sketches and painting document the fashion for women in bohemian circles of the day to adopt the assertive masculinity of smoking as a sign of independence from convention.[120] From her sketches, Münter selected the potent, frontal, cut-off composition, authorizing the image of the pipe-smoking *garçonne* (epitomized by the bob

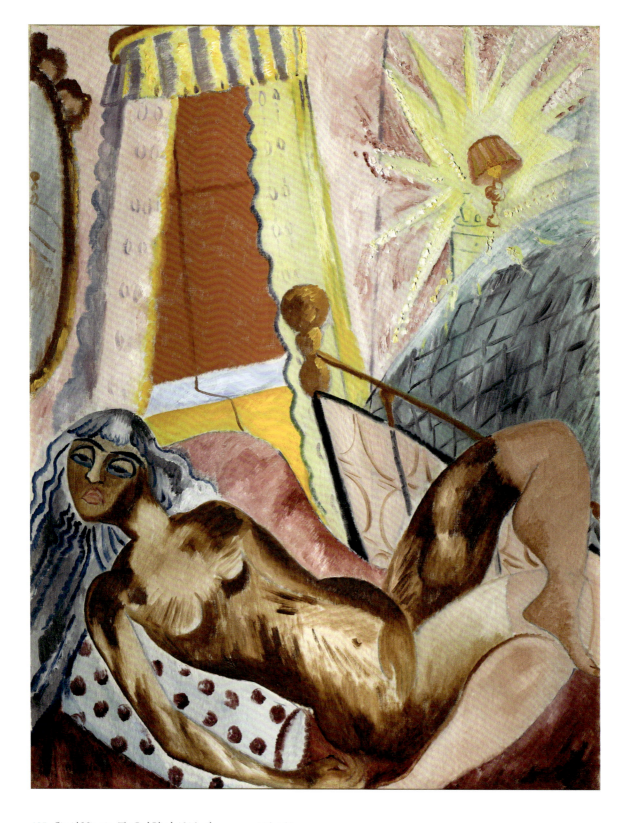

125 Sigrid Hjertén, *The Red Blind*, 1916, oil on canvas, 116 × 89 cm, Moderna Museet, Stockholm

haircut) with the ability for creative fantasy. Maintaining the economic linearity of her drawing technique, Münter defined broadly painted areas, subtly contrasting the jagged angularity of the clothing with the sinuous curves of Roslund's neck and limbs. Characteristic of the coloration of this period, it is local and reduced to tones of black, white, blue, and blue green. Used for emphasis, the ice-blue eyes and simplified large red brooch function as dramatic highlights, set against the textured brushstrokes of the background and wicker chair. Of all of Münter's works, this is closest to what she attributes to Hjertén's cool, naive, and Nordic take on Matisse. But, if anything, this is truer of Münter's rather than Hjertén's canvases at the time.

In the *Expressionistutställningen* (Expressionist Exhibition), which was held at the Liljevalchs Konsthall in Stockholm in May 1918, Hjertén's works were discordant color-wise and provocative in different ways. *The Red Blind* (1916; fig. 125), for instance, parodies the tradition of the painting of the nude female body, the unexpected disproportion and deformity raising issues of ambivalent desire, eroticism, and sexuality. The splayed-out figure and the spokes of artificial light radiating from the lamp invite comparison with the work of the schizophrenic Swedish artist Ernst Josephson (1851–1906), examples of which Hjertén had the opportunity to study closely.[121] Overall, however, one can agree that both artists' portrayal of women, whether clothed or unclothed, subvert the mastering and controlling gaze of male avant-garde practice.

While the bravura displayed in Münter's works belies the biographical events of her life at the time, one has to acknowledge that her output was deeply affected by the downturn in the art market after 1918.[122] The Danish economy, like that of the other European neutrals, was in a precarious state as Denmark could not supply Germany as it had in the past.[123] Instructively, during 1919, Münter's activities extended to an attempt to establish a school of drawing and painting on the Baltic island of Bornholm.[124] In February 1920, her return to Germany predated the Easter dismissal of Denmark's Social Liberal government and brief constitutional crisis regarding the curtailment of monarchical interventions in the parliamentary democracy. Initially based in Berlin and thereafter in Munich, she faced the immense transformations brought about by the end of empire and the founding of the semipresidential representative democracy of the Weimar Republic. As we have seen in chapter 3 on Kollwitz, the concordant changes in the art world were accompanied by the questioning of Expressionism's role as an effective voice for societal and revolutionary change.

Münter's epistolary contact with Walden dwindled and their relationship was under considerable strain as she sought (but was denied) access to his correspondence with Kandinsky. But, in any case, the *Sturm*'s dealership was far from solvent in the inflationary cycle of the early Weimar economy. As her agents, Herwarth and Nell Walden had proved vital to Münter's engagement in an international art world and to her networking with the Swedish Expressionists and avant-garde milieu in Denmark. As an émigré in neutral Scandinavia, she could give free reign to her antiwar sentiments and was able to question the traditions of national belonging and gender identity. Thereby, her works of this period bring forth not only richness to our understanding of the transnational and cultural boundaries of Expressionism but also insight into her theoretical commitment to expressive figuration. Regretfully, it was only through an intermediary—the painter Ludwig Baehr—that Münter learned of Kandinsky's whereabouts, marriage, and incipient return from Moscow to teach in the Bauhaus.[125]

During the 1920s, a bitter legal dispute continued over Münter's possession of Kandinsky's early oeuvre, which she saw as moral rather than material recompense for the humiliation she had suffered.[126] Following her solo exhibition at Thannhauser's in Munich in December 1920, it was a decade before she commenced exhibiting again. Indeed, in 1926, after attending a lecture on the biography of Paula Modersohn-Becker, Münter compellingly identified with the fate of the posthumously famous woman Expressionist. However, Münter pondered thoughtfully: "But, how much is up to me, how much to the external circumstances and opportunities, to the people around me?"[127] Certainly, she perceived herself within this matrilineal genealogy, but emancipation, while legislated, was far from guaranteeing Münter a similar recognition of her own contribution to the interiority and embodiment of early feminist practice.

THE GENDER AND GEOPOLITICS OF NEUTRALITY

Jacoba van Heemskerck, the *Sturm* Circle, and Spiritual Abstraction (1913–23)

Dutch-born Jacoba van Heemskerck (1876–1923; fig. 126) was a prolific and well-feted woman artist, one of the few to emerge as a major abstractionist in the second decade of the twentieth century, yet she still goes unmentioned in major narratives of this phenomenon.[1] Her interaction with avant-garde groups in Paris, The Hague, Domburg, and Berlin between 1911 and 1923 secured familiarity with the fundamental tenets of early modernism; the prominence of the Netherlands and its artists' colonies in this cultural exchange belies claims of provincialism in relation to the metropolitan artistic centers.[2] If Gabriele Münter's relationship with Herwarth and Nell Walden secured a modicum of professional identity in the turmoil of mid-war geopolitics, then it was a significant and career-making move for Van Heemskerck. In 1914, Walden became her exclusive agent and, notwithstanding the political crisis and its explosion into war across Europe, the artist and her patron Marie Tak van Poortvliet (1871–1936; fig. 127) exchanged visits with the dealers. Of course, this has everything to do with the geopolitics of Holland's neutrality and Walden's connections to the Zentralstelle für Auslandsdienst (Central Office of the Foreign Service), as outlined in chapter 5. Throughout the war, Van Heemskerck sustained her loyalty to the Berlin dealer, actively sought out pro-German contacts, and translated cuttings from Dutch newspapers to assist in Walden's cultural propaganda for the Foreign Service.[3]

In contrast to Germany and Wilhelm II's belligerent expansionism, the constitutional monarchy in the Netherlands had a benign profile, and Queen Wilhelmina reigned from 1898 until 1948. Between 1913 and 1918, the parliamentary democracy was led by progressive Liberals and their prime minister, Pieter Adrian Cort van der Linden, who successfully maintained neutrality and ushered in universal suffrage with women gaining the vote in 1919.[4] However, although celebrated as part of the Dutch national psyche and central to its foreign policy, neutrality cannot be equated with pacifism; The Hague Peace Conference of 1907 and London Declaration of 1909 offered standards of behavior for neutrals and combatants alike.[5] In wartime, neutrality had to be protected, and the Dutch armed forces took on the roles of defense, deterrence, and upholding regulations, which included being subject to the British naval blockade that monitored trade with Germany.

As is evident from an overview of Van Heemskerck's correspondence, these limitations meant that there were domestic shortages in general and inflationary prices on art materials in particular. Diplomacy was at the basis of their observance of the embargo, notwithstanding the fact that many Dutch loathed the idea of an alliance with Britain after the Boer War

126 Anonymous, *Jacoba van Heemskerck*, 1915, photograph from the photo album of Nell Walden, Handschriftenabteilung, Staatsbibliothek Preußischer Kulturbesitz, Berlin, Sign. Hdschr. 121, Bl 82v

127 Anonymous, *Marie Tak van Poortvliet*, photograph from the photo album of Nell Walden, Handschriftenabteilung, Staatsbibliothek Preußischer Kulturbesitz, Berlin, Sign. Hdschr. 121, Bl 82v

(1899–1901), a conflict that fomented profound pro-Afrikaner (and anti-British) sentiments in Germany as well.[6] It is arguable that, beyond gaining an outlet for her works in Germany, the reasons above and the geostrategic position of Holland, flanked by Wilhelmine Germany on the eastern border and an invaded Belgium to the south, allows for some understanding of Van Heemskerck's vacillating political stance in her exchanges with the Waldens. Indeed, particularly when compared to Münter's consistent support of pacifism, Van Heemskerck's socialist credentials receded as her language became bellicose in Germany's favor.

Unlike Münter's correspondence with the couple then, Van Heemskerck's epistolary exchanges, although incomplete, are illuminating concerning her context; among other matters, they reveal her membership in the Anthroposophist Society in 1915 and bewildering criticism of French and Dutch artists.[7] There are differences of tone in their communication as well, as Van Heemskerck was confident and assertive about her goals and personal artistic direction. Of equal significance is the contribution of patrons of European contemporary art in neutral Holland, who were inspired by the German model via the circulation of specialist art journals and an expansion

of dealership. Since 1912, artists and collectors had been exposed to Walden's organization of exhibitions in the Netherlands. Instructively, in the writer and art critic Friedrich Huebner's (1886–1964) postwar volume on the private collections of modern art in Holland, we learn of collectors' trendsetting purchases in comparison to public museums and institutions.[8] In addition to patronizing Dutch modern artists, both male and female, Tak van Poortvliet acquired works by Le Fauconnier and Léger as well as Kandinsky's *Lyrical* (1911) and Marc's *The Sheep* (1913–14), indicating that her collection of contemporary art was one of the most progressive of its period.[9] The well-known Jewish collector Willem Beffie (1880–1950) is also relevant to Huebner's arguments, insofar as Beffie was an avid collector of contemporary art who also sought out Van Heemskerck's works.[10]

This chapter explores the ways in which Van Heemskerck was drawn into the realms of the *Sturm* circle and German Expressionism, and traces the importance of her interaction with the Waldens and her reception in Germany. Whereas Münter's figural style and composition drew closer to the works of the Swedish followers of Matisse, Van Heemskerck became critical of both French and Dutch modernism as she embraced spiritual abstraction in various media (be it oil on canvas, woodcut, stained glass, or mosaic) and the implications of the Gesamtkunstwerk (total work of art). Various concepts of the synthesis of the arts flourished in late eighteenth- and nineteenth-century Romanticism as well as in Richard Wagner's theories on operatic reform. In the early twentieth century, debates on the unity of art and life were common to Jugendstil, and Expressionists prided themselves on what was termed the *Doppelbegabung* (double talent), the ability to be just as adept in painting as in creating poetry, theatrical composition, or stage design. As a writer, musician, composer, and editor of *Der Sturm*, Herwarth encouraged an interdisciplinary approach, and we learn of Nell's endeavors to become a serious artist in her own right in addition to her roles as a translator, journalist, poet, and collector. Unsurprisingly, the journal served as an outlet for architectural theory as well; Bruno Taut's (1880–1938) essay "Eine Notwendigkeit" (A Necessity) was published therein and was purportedly the first manifesto of Expressionist architecture in calling on fellow architects to pursue

the course of contemporary painters.[11] As will be seen, Van Heemskerck was apprised of these developments, in addition to receiving highly positive critical reviews from a colleague of Taut's, the architectural historian and theorist Adolf Behne.

Throughout the First World War, Van Heemskerck engaged with the Dutch landscape and marine genres, which, as we are aware, are culturally, politically, and gender-laden forms, particularly at a time of empire-driven warfare; international trade was disrupted and the Netherlands was dependent on imports of raw materials from her colonies in the Dutch East Indies (Indonesia).[12] While Van Heemskerck positioned herself in relation to traditional Dutch painting, she shared her male colleagues' interests in the pseudoscientific strands of modern theosophist and anthroposophical thought. The feminist art historian Jane Beckett has written cogently on Dutch male avant-gardists' mid-war efforts to cleanse and purify rural landscape through geometry, making it safe for urban eyes.[13] Utopian in aspiration, such abstraction of form, line, and color sublimated outdated metaphoric oppositions of masculinity and femininity. As will be seen, however, Van Heemskerck's abstraction manipulated these tropes and allowed for a feminizing curve to nuance the geometrical elements. Due to the artist's reticence on a theoretical front, it is helpful to draw on the explanatory potential of Tak van Poortvliet's writings, on her essays published in the anthroposophical monthly *Het nieuwe Leven* (New Life, 1919–20), and on her biography of Van Heemskerck, which commemorated the artist's premature death in 1923.[14]

Between The Hague and Berlin

As the daughter of a retired naval officer and well-known seascape painter, Jacob Eduard van Heemskerck van Beest (1828–1894), Van Heemskerck's initial instruction took place in his studio. Thereafter, between 1897 and 1900, she studied painting at The Hague Academy, which had started separate classes for female students already in 1872.[15] Evidence of her formative tuition can be found in small-scale character portraits, such as the colored crayon and watercolor drawing *A Woman from Huizen* (1900; fig. 128), which reveal a forceful command of realism and interest in regional detail. In her configuration of the

128 Jacoba van Heemskerck, *A Woman from Huizen*, 1900, colored crayon and watercolor on paper, 36.5 × 32 cm, private collection

wizened face, we detect Van Heemskerck's deep respect for the inhabitants of this agricultural and fishing village, purported to be the locale of the earliest stone houses in Holland. Under the tuition of Ferdinand Hart Nibbrig in Laren between 1901 and 1903, moreover, she was to realize the potential of the lithographic medium for disseminating images of a "primitive" *Urvolk* to a wider audience.

Between 1904 and 1905, her experiences in Paris at the Académie Carrière were liberating, not only from the evidence that Eugène Carrière left talented students to their own devices but also from her association with like-minded women artists.[16] Indeed, she exhibited in February and March 1904 in the women-only salons of the Union des Femmes Peintres et Sculpteurs in the Grand Palais. As has been shown, the union was founded in 1881 as a forum for debate and mutual support in the campaign for the

professionalization of women in art.[17] The social benefits of her interaction with women came to the fore on her return to Holland. The youngest of six children, Van Heemskerck had lived with her older sister Lucie since their mother's death in 1901. Above all, however, it was her close friendship and companionship with the collector and publicist of modern art Marie Tak van Poortvliet that gave the artist the security to pursue her chosen career, particularly in the face of persistent ill health. While we have little anecdotal evidence relating to their private relationship, both women remained unmarried and dedicated to each other as well as to their respective paths.

Five years older than Jacoba, Marie had attended the same High School for Girls in The Hague. Although they both descended from an upper-middle-class and titled background, Tak van Poortvliet's Zeeland-born

129 *Villa Loverendale, Domburg* (architect J. J. van Nieukerken), 1905–8, postcard, private collection

father was prosperous and served as the minister of home affairs between 1891 and 1894. His death in 1904 left his daughter independently wealthy; she was generous to Van Heemskerck and had a private studio designed for her in the gardens of the Villa Loverendale in Domburg (fig. 129), where the friends retreated for the summers.[18] During the 1890s, comparable to the founding of artists' colonies in rural France and Germany, the coastal town of Domburg and its environs also hosted artistic communities, who sought out a simpler lifestyle and authentic subject matter. Born in Indonesia, Jan Toorop (1858–1928), who had trained in Amsterdam and practiced in Brussels, emerged as a major portraitist of local people as well as an interpreter of "the Zeeland light" in landscapes focusing on the dunes, forests, and beaches. He invested these themes with a mystical form of nature symbolism, deploying not only Neo-Impressionist pointillism but also whiplash contours inspired by Art Nouveau and Javanese motifs. One also cannot overestimate the importance of the large exhibition of Van Gogh's French works, which was held at the Stedelijk Museum in Amsterdam in the summer of 1905.

This exhibition was equally instructive for Piet Mondrian (1872–1944) who, in 1908, was a guest at the Villa Loverendale in Domburg. During this summer he sketched the apple tree in the garden as the departure for his notable painting *Evening (Red Tree)* (1908–10; fig. 130). In his expressive handling of the work's planarity, nonnaturalistic color, and divisionism, Mondrian loosened the ties with the quotidian, even though one can vaguely identify the vertical railings that surrounded the villa. No doubt Tak van Poortvliet recognized the painting's significance as she purchased it for her private collection in 1910. In that year, too, Van Heemskerck and Mondrian worked together outdoors in Domburg, sketching similar motifs.[19] In her painting *Two Trees* (1910; fig. 131), Van Heemskerck shows her radical experimentation with Luminism as she contrasted pastel and saturated colors. For her, the pointillist brushstrokes became a visible microstructure—a deliberate interplay between horizontal blocks above the horizon and vertical facture in the foreground—the composition forming a shallow stage for the organic silhouettes of tree trunks and foliage.

As with Mondrian, Van Heemskerck contributed works to the Salon des Indépendants between 1911 and 1914, coming into contact with the Montparnasse group of Cubists: Gleizes, Metzinger, Le Fauconnier, Delaunay, and Léger. Between 1911 and 1913, she also exhibited annually with the Moderne Kunstkring in Amsterdam, which promoted cultural exchange with Paris. By late 1912, Walden had organized traveling exhibitions of the Futurists at the galleries Roos in Amsterdam and Oldenzeel in Rotterdam, and a large show of eighty-six works by Kandinsky at the latter venue. Given Walden's role in the internationalization of the art market, it is understandable how, in 1913,

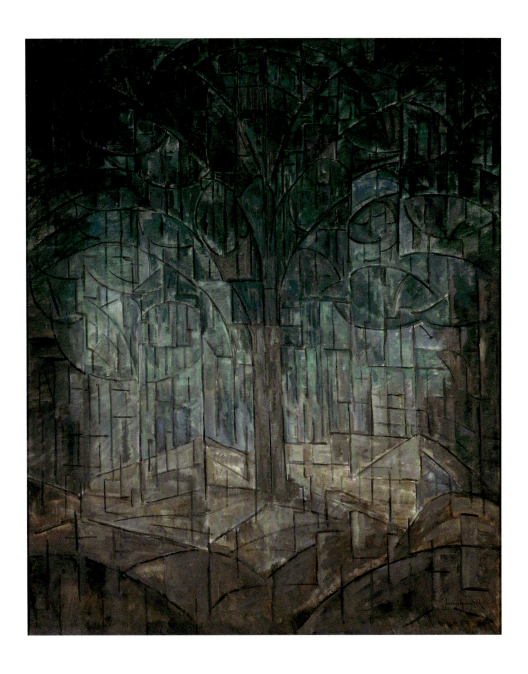

Van Heemskerck was invited to contribute to the Erster Deutscher Herbstsalon in Berlin.[20] As we have seen in the cases of Münter and Werefkin, this exhibition revealed Walden's efforts to incorporate distinctive European groups, such as Cubism and Futurism, under the banner of Expressionism. For Van Heemskerck, who also viewed the exhibition, it was a watershed experience. Of the four paintings she contributed, the oil on canvas *Composition No. 6* (1913; fig. 132), with its range of austere tonalities and transparent faceting, is representative of her Cubist-inspired language. While looking to Paris and Henri Le Fauconnier, Van Heemskerck was equally taken with

Mondrian's 1912 Domburg landscapes, as she invested the iconology of the tree and woodland path with the mystical significance of Gothic church interiors.

In March 1914, at the twenty-third *Sturm* exhibition in Berlin, which was held jointly with Werefkin and Arthur Segal, Van Heemskerck's oeuvre underwent stylistic diversification. Among twenty-one of her works contributed to the installation, *Composition* (1914; fig. 133) declared her affinities with the Blaue Reiter group in general and Kandinsky's apocalyptic works in particular. In its dimensions and appearance as a cosmic landscape, we are reminded of Kandinsky's *Composition 6* (1913), which was prominently displayed at the Herbstsalon.[21] Here, Van Heemskerck freed contour from its form-defining function and experimented with saturated effects of primary and complementary colors, astral-like shapes revolving around a central

source of light. However, as we will see, this liberation of the palette was just as applicable to the distilled architectonic qualities of her concurrent series of sailing boats, sea, mountains, and trees, which were produced contiguous with her abstract inventions. Prior to exploring these tendencies, it is important to examine Van Heemskerck's role in relation to the Dutch avant-garde, the reasons that led her to seek out Walden's exclusive agency, and to offer her vocal support for Germany with the onset of war.

Eve and Declaration of War

Given the departure from her Cubist phase, it is interesting to note that, during 1914, in her correspondence with Walden, Van Heemskerck affirmed her identification with the *Sturm* and distance from artists in France and Holland.

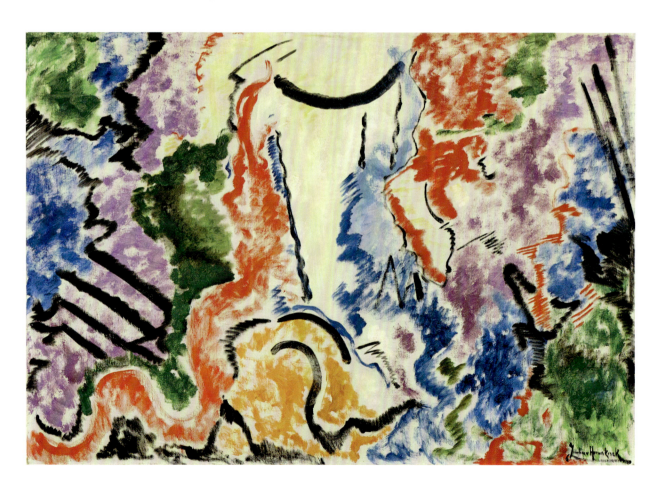

133 Jacoba van Heemskerck, *Composition*, 1914, oil on canvas, 75 × 108.8 cm, Kunstmuseum, The Hague

As she wrote:

> I think it is much better if I only exhibit when you
> are in charge: you know which works go well together
> and I don't find the independent exhibitions are for
> us anymore; I don't understand why Kandinsky is ex-
> hibiting [with others] in Amsterdam at the moment,
> it is much better if we [*Sturm* artists] keep ourselves
> apart. Do you also think it is better if I don't exhibit
> in the Moderne Kunstkring in Amsterdam? I was
> in Paris at Le Fauconnier's; and, really, I have to say
> his work is not at all to my taste anymore . . . No,
> for once I really hope to get started with some sales
> and then you must take the right percentages for all
> your efforts; I don't want to take part in any other
> exhibitions.[22]

Indeed, it is inferred from her subsequent letter that
Walden agreed with Van Heemskerck's withdrawal from
independent group exhibitions.[23] Testimony to the fact that
he became her exclusive agent followed the Walden couple's
visit to Domburg in July 1914; Van Heemskerck commu-
nicated that the notable Amsterdam collector Willem Bef-
fie, who already had the works of Le Fauconnier, Chagall,
Marc, Kandinsky, Münter, Werefkin, and Jawlensky in his
collection, visited her studio in order to purchase paintings,
but she advised him in no uncertain terms that Walden
was organizing everything.[24]

Van Heemskerck's preference for *Sturm* affiliation
is understandable. On the one hand, with the exception
of Mondrian, she felt marginalized in male avant-garde
circles, and this was not without justification. Already, in
1910, in her participation in the exhibitions of the Society
of St. Lucas at the Stedelijk Museum in Amsterdam, the
Luminist Jan Sluijters revealed his prejudices in having his
works installed alongside women artists. As he commu-
nicated to a colleague, he would appreciate being hung
"in Piet's [Mondrian's] company, but now the room is so
intensely ruined by work from their friends and girlfriends,
that I should be ashamed to be there . . . not between that
kind of young female teachers who want to be different."[25]
On the other hand, Van Heemskerck sustained her contact
with women artists and served as treasurer for the Sub-
Committee of the Visual Arts, which helped organize the

feminist-inspired centenary exposition *De Vrouw, 1813–1913*
(The Woman, 1813–1913). Yet the works she submitted—
two character portraits and three Cubist compositions—
appealed to different constituencies.[26]

The exposition celebrated women's contribution to
the nation and its colonies since the ousting of the French
in 1813. In this spectacle, which was held at Meerhuizen in
Amsterdam and attended by Queen Wilhelmina, the visual
arts were one of numerous categories—housekeeping,
suffrage, hygiene, sport, and women's labor—deemed
worthy of display.[27] The graphic artist and illustrator
Wilhelmina Drupsteen (1880–1966), whose winning
poster design *Paars en Groen* (Purple and Green) was also
used as the cover of the exhibition catalog (fig. 134), found
her clients in the women's movement and other related
social causes. Chosen for its legibility, the poster's title and
imagery show her acquaintance with suffragette visual and
material culture, the colors purple (dignity), white (purity),
and green (hope) having been adopted in Britain by the
Women's Social and Political Union for banners, rosettes,
and flags.[28] A lithe, reform-clad woman and child, accom-
panied by domestic virtues of spinning and embroidery,
replace the iconology of the Vitruvian male as the center
of a measurable world. Her arms are shown held aloft, not
circumscribed by a geometric circle within a square but
contained by a mellifluous tree trunk and branches, which
form a vessel for universal womanhood against the skyline
of Amsterdam.

Notwithstanding Drupsteen's propensity for the
allegorical, her choice of motifs, engendering of color,
composition, and ornament had its basis in formal prin-
ciples of art and design that are relevant to considerations
of Van Heemskerck's abstraction, as will be discussed
below.[29] For, on August 1, 1914, Germany's declaration of
war against Russia was a major blow to the artist. In the
days building up to this, she nurtured hopes for peace, as
she wrote to Walden: "Today there was very sad news in
the newspaper . . . I never thought there would be a great
war: it will be awful for all industry and for art. It is such a
shame the Socialists do not have more power to encourage
a general strike; if that were to occur the war would not
happen but we will have to wait and see."[30] Here we find
that Van Heemskerck's views accord with the Sociaal-
Democratische Partij (Socialist Democratic Party), which

134 Cover of exhibition catalog, *De Vrouw 1813–1913* (Meerhuizen, 1913), featuring Wilhelmina Drupsteen's design, *Paars en Groen* (Purple and Green)

was renowned for its antimilitaristic opinions. Moreover, it supported the aims of the Samenwerkende Arbeidersvereenigingen (Associations of Organized Workers), which were established in August 1914 to organize the various radical socialist and anarchist unions in decrying militarism as the scourge of both capitalist and imperialist regimes.[31]

Two months hence, however, while the artist affirmed her support for Dutch neutrality, she endorsed the "wonderful" news that the war bonds had raised 4.2 billion marks, "the unity of the German people is so great that they will win through." She continued:

> The artists are all working so little, now there are also a few Dutch here from Paris but it is terrible how little energy they have; always the same thing, the moderns have fallen asleep in France, and all [are] so anti-Germany it is ridiculous. Our art must progress with and through Germany. We have you to thank

for everything and I have much more faith in you than in all of Paris. In the end we'll see who's right, whether me or a Dutch artist from Paris. It is so stupid to mix a war with art.[32]

In spite of her plea for the autonomy of art from war in the final sentence, the artist's tone is strident in pitting nation against nation and, what is more, artist against artist. Unsurprisingly, in 1916, notwithstanding the presence of many Belgian refugees, she expressed her support for the ongoing German offensive at Verdun. Such was her identification with Germany that Van Heemskerck reported feeling "so un-Dutch" as she witnessed the mood in Holland—in the face of spiraling costs and the ongoing British blockade—veer toward the Triple Entente.[33]

On an artistic front, she promoted Walden's dealership on a financial level while forging a niche for her own production. Interestingly, then, in October 1914, at a time when the exhibition world was in severe difficulty,

135 Jacoba van Heemskerck, "Originalholzschnitt," *Der Sturm* 5, no. 23/24 (March 1, 1915): 140

she offered Walden a portfolio of six woodcuts free of charge as a *Sturm* publication for its Verein für Kunst (Art Association). In that the distribution of graphic works was part of the attraction of paying a membership fee, Van Heemskerck suggested the following:

> You told me in Domburg that you have around forty or fifty members; so, if I make seventy-five prints of each woodcut[,] then you could make up seventy-five portfolios in Berlin and would only have to pay for the portfolios. Since I find the paper so expensive to buy, Fräulein Tak will pay for the paper and I will do the printing by hand[,] then you can sell any extra portfolios and keep the proceeds for your publishing company. Please say absolutely if this would help you.[34]

Whereas a comparable project matured in April 1915, the citation above discloses her emboldened approach and the symbolic economy of the gift in facilitating her career. Furthermore, Van Heemskerck was apprised of this method of dissemination and the values attached to hand-printed graphics among collectors of modern art. From her correspondence, we gain insight into her aesthetic preference for producing woodcuts, which, as we have seen in the case of Kollwitz, became a nationally loaded and Expressionist medium in the early decades of the twentieth century. Indeed, there was a great deal of cultural affinity between

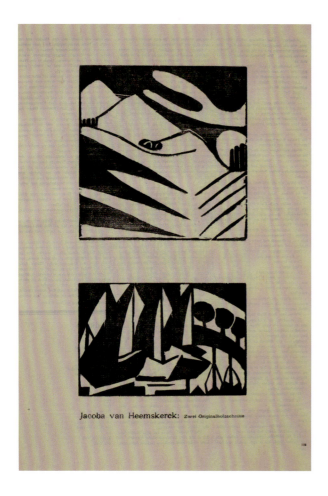

136 Jacoba van Heemskerck, "Zwei Originalholzschnitte," *Der Sturm* 5, no. 15/16 (November 1, 1914): 105

the German and Dutch in relation to wood symbolism: the nation's name derives from the words "Holt Land" (Forest Land) and most of the mythological deities and sacred attributes of oak trees, springs, and wooded groves were of Germanic origin.

Van Heemskerck's preferences were for carving a hard wood of uniform surface, and she specifically ordered pear-tree woodblocks from a German supplier in Berlin due to current shortages in Holland.[35] Her original woodcut prints of landscape motifs, which were published in *Der Sturm* (figs. 135 and 136), show a vital interplay of positive and negative space, of flattened, abstract shapes, or lines. Rather than engaging with the authenticity of the medium, the exposed wood of the block is smoothed so as to reduce imprints of the arboreal grain.[36] This isn't any less

Expressionist, though, and the technique and process of woodcutting in itself encouraged her move toward expressive abstraction.

As we see in a series of thumbnail preparatory drawings in black ink that she sent to Walden in 1915, she distills her artistic language (figs. 137a and b). Here, as in her woodcuts, we find that Van Heemskerck pares down the composition into a few lines and planes, using shorthand text to denote line, color, and object, as in *Zeichnung 14*, where she states, "black lines on colored paper, above total black planes, lines of trees and mountains."[37] Significantly, by this time she had abandoned giving titles to her drawings and paintings, preferring to allocate numbers or the musical term "composition." In December 1914, in a lecture entitled "Deutsche Expressionisten" (German Expressionists), which was delivered at the twenty-ninth *Sturm* exhibition in which Van Heemskerck participated, the architectural historian and theorist Adolf Behne, who was clearly indebted to Wilhelm Worringer, proclaimed "the builders, the sculptors, the painters, and the draftsmen of the Gothic" as Expressionists.[38] Therein he found it possible to list Van Heemskerck, along with Kokoschka, Marc, and Mense, as the rightful heirs to the Gothics.

To Behne, who contributed reviews and cultural criticism to *Der Sturm*, it was not merely Van Heemskerck's forest and tree motifs that evoked the Gothic style but also her move beyond Cubism, which was consistent with his theories on the purity of artistic expression as an evolving organism. Quoting from the German biologist Jakob von Uexküll (1864–1944), who was noted for his research on the *Umwelt* (environment) of living species, Behne asserted that the first responsibility of the artist is "to exclude from the creative process anything that could impede the growth of colors, forms, and lines."[39] As in the case of the Russian nationals beforehand, Van Heemskerck had become an honorary German Expressionist! Indeed, while on army service in the Oranienburg Hospital in Berlin, Behne mounted five of her works on paper on the wall of his room.[40]

In turn, Van Heemskerck was quick to order a copy of his first book, *Zur Neuen Kunst* (Toward New Art), which was published by *Der Sturm* in 1915 and featured one of her woodcuts on the frontispiece.[41] Therein Behne promoted Expressionism as the new art, declaring the

137a and b Jacoba van Heemskerck, *Six Sketches*, pen and ink, from letter to Herwarth Walden, April 9, 1915, sheets 88/89, Sturm-Archiv Herwarth Walden, Handschriftenabteilung, Staatsbibliothek Preußischer Kulturbesitz, Berlin

freedom of artistic laws from the visible world.[42] He also referred to Van Heemskerck in the same breath as Marc and Nolde in defending them from hostile criticism.[43] However, of importance to the forthcoming discussion is the observation that Behne's concepts of Expressionist spiritual abstraction embraced not only Kandinsky's art of "inner necessity" as cosmic flux but also the measured and "sachlich" qualities attributed to the architecture of Bruno Taut and Adolf Loos.[44] In building up to the conclusion of his treatise, it is telling that Behne seized on the seemingly disparate theoretical coordinates of his inquiry—notions of classic art formulated by Heinrich Wölfflin as well as Nietzschean aesthetic striving.[45]

The "Imperious Brush" and Architectonic Abstraction

In a photograph of Van Heemskerck in her studio in 1915 (fig. 138), she is shown seated with palette and brushes in hand against a backdrop of her works, testimony to her professional status and practice. As Tak van Poortvliet noted in her biography, after Van Heemskerck's Paris years, "it was a period of intense labor and of struggle to pursue her aim, especially for a woman it is far from easy to be a pioneer."[46] Certainly, the photograph registers her demure presence in relation to the immense physical undertaking and technical radicalism of her canvases; to her rear, the large-scale *Painting No. 25* (1915) on the easel deploys various figural and landscape motifs from the Zeeland region while the work balanced on the floor in the center, *Painting No. 21* (1915), is a far more formalized rendering of a harbor scene into a repetition of inverted triangular sails, colors,

and diagonals.[47] Clearly, these were also considered major works by her dealers and were acquired by Nell Walden for her personal collection.

In *Painting No. 25* (fig. 139), the vertical railings and trees, adapted from the perimeter of the Loverendale Villa, both demarcate and fragment a tumultuous landscape of waves, dunes, squat huts, and mountains. Her use of the complementary colors yellow and purple and red and green strengthen the two-dimensional surface, as does the broad handling of the medium. Whereas Van Heemskerck evokes Gauguin's Breton landscapes (she visited Brittany in May 1914), she differences the ethnicity and locale of the procession of women, who are dressed in typical Walcheren costume—vivid red capes and white hoods. Here, too, although she challenges the Russo-Bavarian folk-art origins of Kandinsky's apocalyptic compositions, she adopts his use of the "imperious brush."[48]

In his autobiographical essay "Rückblicke" (Reminiscences, 1913), Kandinsky deployed the control over the female body as a colonial metaphor for his encounter with the bare canvas. Thus, he wrote:

> I learnt to struggle with the canvas, to recognize it as an entity opposed to my wishes and to force it to submit to those wishes. At first, it stands there like a pure, chaste maiden, with clear gaze and heavenly joy—this pure canvas that is itself as beautiful as a picture. And then comes the imperious brush, conquering it gradually, first here, then there, employing all its native energy, like a European colonist who with axe, spade, saw penetrates the virgin jungle where no human foot has trod, bending it to conform to his will.[49]

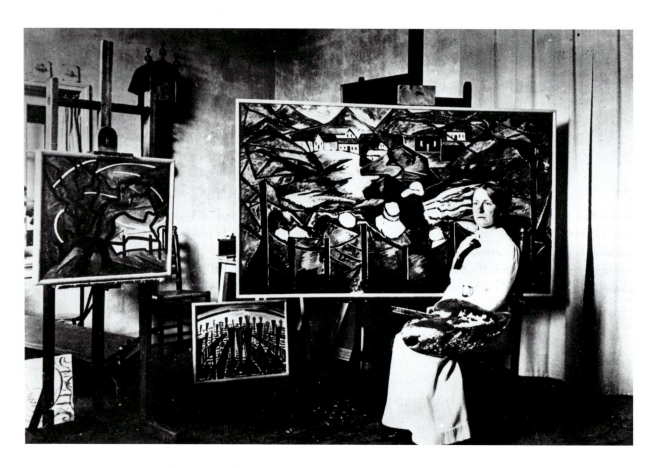

138 Anonymous, *Jacoba van Heemskerck in Her Studio*, 1915, photograph, Collection RKD—Netherlands Institute for Art History, The Hague

139 Jacoba van Heemskerck, *Bild no. 25 (Painting no. 25)*, 1915, oil on canvas, 112.7 × 192.9 cm, Kunstmuseum, The Hague

Typical of sexual fantasy, this passage seeks not only to summon imaginary objects of desire but also to stage its primal mise-en-scène in no uncertain terms.[50] Understandably, Van Heemskerck was less inclined to communicate her ideas in phallocentric terms, and when invited to deliver a lecture on modern art to the Anthroposophist Society in The Hague (March 13, 1916), she proposed to read extracts from Kandinsky's *Über das Geistige in der Kunst* and Behne's *Zur Neuen Kunst*. Yet she claimed to have different views on the whole: "As you know," she wrote to Walden, "I always find it easier to paint my principles."[51] Her emphasis on the intuitive approach to painting can be gauged from Van Heemskerck's handling of the medium, which bears evidence of her manual activity and gestural "struggle" to control the painting.[52] Such observations complicate not only simple gendered equations between the active (masculine), colonizing painter and the passive (feminine) canvas in early modernism but also straightforward readings of

the Dutch rural landscape as a "picturesque" genre.

Some of Van Heemskerck's seascapes raise a further set of related issues since they go beyond the implications of regatta-like scenes. In *Painting No. 18* (1915; fig. 140), which was originally in Tak van Poortvliet's private collection, we recognize that, wittingly or unwittingly, the artist was working within a genre that enjoyed national status in Dutch painting. The motifs are formalized into opposing forces of upturned and inverted equilateral triangles that appear to represent the stern of the boats. These are set within a repetition of horizontal lines for water, which, together with the black vertical masts and white sails, recede against a mountain range and glowing sunrise.

Given the model of transgenerational pedagogy, it is not too far-fetched to compare it with a work by her late father, which was acquired by the Rijksmuseum in 1895, a maritime seascape that portrays *The Dutch, English, French, and American Squadrons in Japanese Waters* (1864; fig. 141). There is a striking similarity in the compositional lineup of the fleets in the two paintings and in the scaffolding of masts, sails, and pennants. While her father's painting depicts the naval battle in the Shimonoseki Strait, which

140 Jacoba van Heemskerck, *Bild no. 18 (Painting no. 18)*, 1915, oil on canvas, 87.7 × 77.2 cm, Kunstmuseum, The Hague

141 Jacob E. van Heemskerck van Beest, *Dutch, English, French, and American Squadrons in Japanese Waters*, 1864, oil on canvas, 80 × 49.1 cm, Rijksmuseum, Amsterdam

destroyed the Chōshū Domain's ability to wage war on the Western powers, Van Heemskerck's abstraction—albeit that she uses vivid national colors (red, white, blue)—foregoes direct associations with contemporary marine warfare. Interestingly, though, she was fully informed of the blockade's impact and, in April 1915, attributed the sinking of the neutral Dutch steamer *Katwijk* by a German U-boat torpedo to a "misunderstanding."[53] This was contrary to the fact that the incident provoked outrage in the Netherlands and helped turn Dutch public opinion against Germany.

How, then, are we to interpret the artist's restructuring of nature and motifs in terms of a strident interplay of triangles, verticals, horizontals, zigzag, and curvilinear shapes? Between 1914 and 1915, Van Heemskerck regularly visited the harbor town of Veere, not far from Domburg, where she was drawn to sketching the sailing boats.[54] The marine genre was also of significance to Mondrian, who concurrently produced his *Pier and Ocean* series in Domburg. Therein he reduced the inspiration of the seascape to a rhythmic interaction of so-called plus and minus signs. The art historian Michael White characterizes Mondrian's war years in the Netherlands as just as much a transition between Cubism and abstract art as a shift between two sets of ideas: the theosophical explanation of natural phenomena and the fully fledged theory of Neoplasticism.[55] We are more familiar with Mondrian's theories on the mystical reordering of nature through a set of binary and gendered oppositions (male/female, spirit/matter, vertical/horizontal), which he publicized in twelve installments of "De Nieuwe Beelding in de Schilderkunst" (The New Plastic in Painting) in the first issues of *De Stijl* (1917–18). But it was not until 1919 and his return to Paris that he produced the first paradigmatic Neoplastic paintings; in the later 1920s Mondrian extended these theories to encompass various realms of human life.

In the case of Van Heemskerck, the journey from Cubism to abstract art followed a similar, albeit more hybrid, route. Art historian Jacqueline van Paaschen reveals how Van Heemskerck's membership in Masonic lodges in Amsterdam and The Hague from 1910 onward acquainted her with a repertoire of transcendental imagery and color symbolism.[56] Added to this was the move from a theosophical to an anthroposophical epistemological outlook.

Following the Theosophical Congress in Munich in 1907, Rudolf Steiner lectured in The Hague and imparted his brand of thought, which was based less on the "divine wisdom" of the Eastern masters than on the mysteries of the Christian West. Hence, by the time Van Heemskerck joined the Theosophical Society in The Hague in 1910, it had forged close ties with the German section.[57] In 1915, Van Heemskerck and Tak van Poortvliet became members of Steiner's breakaway Anthroposophist Society, which had moved its headquarters from Munich to Dornach in Switzerland during the war.[58] The artist was no doubt taken with Steiner's emphasis on the dialectic between intuitive creativity and a contemplative envisioning of the natural world in his search for a "spiritual science." However, it is through Tak van Poortvliet's writings on art that we can speculate on Van Heemskerck's theoretical preoccupations. Her patron was actively involved in promoting Steiner and served for a time as chair of The Hague Anthroposophical Society, which, founded in 1916, was considered an extension of the German branch.[59]

In a series of essays entitled "Het begrijpen van nieuwe schilderkunst" (Understanding New Painting), which she published in the monthly anthroposophist periodical *Het nieuwe Leven* (New Life, 1919–20), Tak van Poortvliet asserted that all gradations and nuances in the work of art arise from the spiritual life and are motivated by feelings. Those driven by the intellect are synonymous with a cold, materialistic view of the world. Seemingly critical of Mondrian, Tak van Poortvliet claimed that horizontal and vertical lines are not the pure expression of opposites, but that the emotional value of all the possibilities that lie in between are at the core of its aesthetics:

How are we to account for the various effects that the horizontal and vertical line have on us: the first gives us a sense of calm, of uniformity: trapped in the second is striving. If such a vertical line is interrupted by a horizontal, we take it to be an obstacle. From this example, it is also shown that . . . her character is different depending on the position in which they occur [in relation] to other lines. The straight line imposes a positive character, the curve is more compliant, the zigzag line raises a character of striving, that involves struggle, with passion. The triangle with the

apex pointing upwards, it is our image of a search for the spiritual, which is above us; with the top down, he makes us powerless to rise to something higher, as sinking into the material.[60]

From this vivid argument regarding the grammar of line and geometry, we recognize familiar occultist, theosophical, and anthroposophical tropes: the spiritual and material coordinates of vertical and horizontal lines, up- and down-turned triangles. However, Tak van Poortvliet introduces the dynamism of curved and zigzag lines and the relational interplay between the different variables in order to align it with expressive and symbolic effects. In place of a mechanistic interpretation of the binary opposites, she substitutes a multivalent and feminized take on the compositional elements that are simultaneously abstracted from the visible world. Consistent with mid-war discourses in the historiography of German Expressionism, Tak van Poortvliet favored intuitionist theories over and above the rationalist and masculine schema that could be found in *De Stijl*.

Yet, in assessing the impact of Van Heemskerck's works on the viewer, the critic Behne proclaimed their aesthetic autonomy from issues of gender. His views thereon can be found in Walden's Danish-language journal *Nutiden* (The Future), a venture that was subsidized by the Zentralstelle für Auslandsdienst and several well-to-do Danes who were sympathetic to Germany.[61] As Behne stated, "In the works of Jacoba van Heemskerck one sees neither male nor female, one simply sees art: an art that has evolved and rises higher and higher. Severe forms, nothing superfluous, nothing dead. In stark wonderful colors these works of art stand in front of us."[62] For Behne, Van Heemskerck's forceful abstraction matched his theories on artistic expression as an evolving and spiritual organism, which lay beyond inscriptions of gendered authorship. Other commentators in *Sturm* literary circles—the Expressionist Adolf Knoblauch (1882–1951), for instance—responded to the poetic resonances of her marine works. Between 1914 and 1917, Knoblauch contributed poetry to *Der Sturm* that veered away from Behne's formalist aesthetic. Knoblauch's early poems are antibourgeois and reveal his socialist identification with the proletariat and critique of modern industrialization.[63] His poem "Deutsche Hafenstadt" (German Harbor City, 1915), which appeared in the same issue

of *Der Sturm* as one of Van Heemskerck's woodcuts, was dedicated to her.[64] Based on the harbor in Hamburg, the city in which he was born, his poem visualizes the departure of steamers, moving quietly seaward in "wondrous restlessness," as a counterpoint to the "dreary harbor," with its tired workers returning with difficulty along "old winding streets to high-gabled, narrow houses."[65] Clearly, Van Heemskerck's spiritual abstraction, albeit grounded in her Zeeland locale, offered a vital and suggestive apotheosis of spirit over matter that appealed to nuanced constituencies in the war-weary circles of the *Sturm*.

That Van Heemskerck benefited as well from this intriguing form of cultural exchange can be gauged from her pedagogic experience in running master classes for the Sturm-Kunstschule in Berlin in the summer of 1916, her experimentation with theatrical composition and stage design, and, last but not least, involvement with glass painting. This led her to embrace aspects of the art and life project of Expressionism. Prior to examining this phenomenon, however, it is appropriate to outline the geopolitical and gender implications of a notable *Sturm* exhibition, which was held at the Kunstzalen d'Audretsch in The Hague in 1916 (fig. 142a). Importantly, Nell Walden launched her career as an abstractionist at this venue, her experimentation closely relating to her poetry and interest in the display of art and design in an interior setting. It was via this exhibition, too, that Van Heemskerck gained recognition in Holland; indeed, the architect Jan W. Buijs (1889–1961) and medical student Willem Zeylmans van Emmichoven (1893–1961) became crucial to the artist's development in the postwar years.[66]

They were all active in anthroposophical circles, and Zeylmans enthusiastically promoted Van Heemskerck in a manuscript entitled "De geestelijke richting in de nieuwe schilderkunst" (The Spiritual Direction of the New Art, 1917). Seizing on color as being the major factor of her works, Zeylmans asserted: "Each color raises a spiritual value . . . whether of conflict or harmony."[67] Indebted to the theories of Goethe and Steiner, he attributed emotional values to the different colors: red is the color of violence; green, that of harmony in nature; yellow is symbolic of restless searching; blue is the color of thoughtfulness, and so on. Interestingly, during 1918, Van Heemskerck and Zeylmans attempted to give a scientific foundation to these

142a Catalog cover, *Der Sturm Ständige Kunstausstellung: Expressionisten Kubisten* (The Hague: Kunstzalen d'Audretsch, 1916)

142b *Expressionisten Kubisten*, list of "Ausgestellte Künstler" (exhibited artists), 3

subjective interpretations, and they undertook a series of controlled experiments on children in Domburg in order to investigate the emotional effects of different colors, the results of which were published in 1923, the year of Van Heemskerck's death.[68] Evidently, such theoretical considerations were relevant to the "spiritual glow" that the artist sought to achieve in her architectural commissions for stained-glass windows in the private and public spheres.

Nell Walden, Abstraction, and the Performative Expressionist Interior

In 1913 the dealer Herman d'Audretsch (1872–1966) established his gallery in the center of The Hague in the Hooge Wal area, not too distant from the Noordeinde Paleis (North-end Palace). His dealership was dedicated both to recognized Hague-born artists and members of the rising avant-garde. As her correspondence discloses,

Van Heemskerck was responsible for liaising directly with d'Audretsch on Walden's behalf and in arranging details of the exhibition. This extended to securing works from the Czech Cubist Otakar Kubin (1883–1969), who was Paris-based during the war and "not German-friendly," according to Van Heemskerck.[69] Otherwise, as one can ascertain from the list of exhibitors in the catalog (fig. 142b), Walden gathered an international array of *Sturm* artists (from Germany, Sweden, Austria, Czechoslovakia, Russia, Switzerland, and Holland) under the title *Expressionisten Kubisten*; either their works must have remained accessible or were left in his keeping during the war.

Walden's idealist philosophical position remained consistent, as he declared in his lecture at the launch of the exhibition: "The artist paints what he sees with his innermost senses, the expression, the expression of its essence."[70] Moreover, in a mystical and utopian vein, he instructed the viewer to, "Believe in the art and it will be resurrected

before your own eyes."[71] Albeit through official sanction from Germany, the *Sturm* offered a redemptive message and was significant to a positive reception of what was conventionally interpreted as "enemy" tendencies (Russian and French) under the rubric of Expressionism.

What is more, in a rare moment of serendipity in Germany's cultural propaganda, the paintings of Van Heemskerck, Münter, Hjertén, and Nell Walden were included amid male artists. It is fascinating, although not unexpected during the First World War, how the *Sturm* facilitated women artists' emergence in this transnational dynamic between war-based and neutral economies. Van Heemskerck's list of exhibits comprised a tour de force of eleven paintings, all dating from the year 1915.[72] This rivaled those of the male exhibitors, among them ten of Franz Marc's major canvases, poignant reminders of his tragic death at the Battle of Verdun a mere two weeks

143 Nell Walden, *Mary and Child Jesus with Crown*, 1914, glass painting, 19 × 14 cm, Nell Walden Collection, Landskrona Museum, Landskrona

prior to the opening of the exhibition.[73] Three of Münter's 1912 works that she had lodged with Walden were shown, as was a painting by Hjertén that was drawn from the *Schwedische Expressionisten* exhibition in Berlin of 1915.[74]

Via her interaction with Münter and Kandinsky, Nell Walden had experimented with *Hinterglasmalerei* in emulation of the Blaue Reiter's practice and reverence for Bavarian reverse glass painting. Nell's mission as a collector emerged in the prewar years as she made the decision to purchase small-scale works from each *Sturm* exhibition, and she was in correspondence with Münter, requesting a work in exchange for a Japanese woodcut.[75] During 1914, while visiting Kandinsky and Münter in Murnau, we learn of the dealer couple's encounter with the Krotz collection of *Hinterglasbilder* and of Nell's impulse to attempt the medium.[76] This she did on her return to Berlin, and her initial works, such as *Mary and Child Jesus with Crown* (1914; fig. 143), quote directly from religious examples in exploring the motifs and technique. That such an activity served as a means of forging avant-garde communal identity in emulation of a völkisch artisanal past is clear from Nell's report that both Kandinsky and Klee approved of her experiments.

While her collection of traditional Swedish folk art also became the departure for her artistic practice, as in the glass painting *Salome* (1915; fig. 144), she was inspired by Kandinsky's metaphysical ideas and synesthetic color theories and committed herself to untitled nonfigural compositions. In 1916, this direction was reinforced when she enrolled in Sturm-Kunstschule classes under the leadership of Rudolf Bauer, Lothar Schreyer, and Georg Muche; she made her public debut at d'Audretsch with two adventurous works that reveal her foray into the world of lyrical abstraction.[77] Seriality is implicit in the juxtaposition of *Painting 1* (1915; fig. 145) and *Painting 2* (1915; fig. 146), in which the unbounded, dynamic shapes echo one another. While there are slight variations and omissions of detail in the second painting, the overall impact is of a rhythmic musicality of floating shapes, hatched repetition of colored line, and opaque and translucent washes. These features, in addition to their organic associations, prepare us for Nell Walden's interdisciplinary exploration of painting and poetry, as well her concerns for notions of the Gesamtkunstwerk.

144 Nell Walden, *Salome: After an Old Swedish Motif*, 1915, glass painting, Kunstmuseum Bern

was reproduced and disseminated in a postcard format.[80]

Whereas the furnishing is typically middle class, the Chagall canvases declare their modernist allegiance and frame the seated couple's connective gaze.[81] Notwithstanding the vagaries in the historiography that proclaim Herwarth as sole actor in the *Sturm* enterprise, scholarship suggests otherwise, and here we detect mutuality and recognition of Nell's endeavors in the partnership.[82] Interestingly, Walden dedicated his first novel, *Das Buch der Menschenliebe* (The Book of Philanthropy, 1916), to Nell, idealizing (and idolizing) her Scandinavian features: "Sweet woman in blonde light, Child of my love, Form to me [and] art."[83] While he objectifies and infantilizes her status, the dedication is couched in terminology consistent with Nietzschean aesthetic theory. Similarly, Nell's poetry, which she published concurrently in *Der Sturm* under the pseudonym Marja Enid, revolved around neo-Romantic cyclical themes of nature, love, and art, as in the poem "An Dich" (To You): "Silver dew lies on my heart / Rosy it dreams of you."[84] Characteristic of Expressionist poetic formation, colors are twinned with strong emotional sensations of desire but can act also as substantives, resonant with visual and tactile symbolic associations.

Such experimentation is intensified in her poem "Tod-Frühling 1916" (Death-Spring, 1916), which dwells on themes of seasonal change in highly abstracted and conflicting terms:

> Red rips blue
> In yellow, pale light
> of the hesitant spring:
> Blue beats red
> Dripping of blood
> Rings out to the sky,
> Bites in earth,
> Frost-hard.[85]

In this single-stanza poem, the interaction of primary colors is given agency and, in an indexical manner, evokes the mythological allegory of Hades's abduction of Persephone and her reemergence from the wintery underworld in the "pale light of the hesitant spring." The portentous date of 1916 and references to violence are akin to the *Wortkunst* (word/image) theories of the *Sturm* poet August Stramm

Of assistance in examining the dissolution of the boundaries between art and life is her construction of an identity as an artist and collector in relation to the display of her works in the urban interior: a comparison of photographic material roughly ten years apart offers testimony to this evolving phenomenon. It has been convincingly argued that a photograph of the dealer couple in the dining room of their apartment (fig. 147) discloses the performative function of their collection.[78] By 1916, the Sturm Gallery and offices were located adjacent to their private residence in Potsdamer Straße 134A.[79] Yet the domestic realm served a similar function to the commercial spaces in being orientated toward a semiprivate, invited audience. It is paradoxical that, given wartime restrictions, the photograph corresponds to the most lucrative period of the *Sturm* and

FACING PAGE LEFT

145 Nell Walden, *Bild 1* (Painting 1), 1915, oil on panel, 81× 28 cm, Nell Walden Collection, Landskrona Museum, Landskrona.

FACING PAGE RIGHT

146 Nell Walden, *Bild 2* (Painting 2), 1915, oil on panel, 81 × 28 cm, Nell Walden Collection, Landskrona Museum, Landskrona

147 Anonymous, *Herwarth and Nell Walden in the Dining Room of Their Apartment in Potsdamer Straße 134A*, 1916, photograph from the photo album of Nell Walden, Handschriftenabteilung, Staatsbibliothek Preußischer Kulturbesitz, Berlin, Sign. Hdschr. 118, Bl. 13r unten

(1874–1915).[86] As a reservist, who was called into active duty with the outbreak of the First World War, his mid-war poetry pared down language to its basics, as in the closing sequence of the poem "Krieg" (War): "Time gives birth / Exhaustion / Borne / Of death."[87] Its technical radicalism and antiheroic stance on war subject matter attracted satirical reviews, and Herwarth Walden was drawn into a loyal defense of Stramm's poetry, particularly in view of the latter's untimely death on the eastern front on September 1, 1915.[88]

Consistent with Expressionist notions of the *Doppelbegabung*, Nell Walden explored these themes in her paintings as well. Although the present location of the work *Todfrühling* (ca. 1916; fig. 148) is unknown, we can assess the dynamic interplay of abstract colors and shapes from a print, which was published in a later issue of *Der Sturm*.[89] However, its impact in reproduction is sanitized when compared to the agitated and visceral effects of the

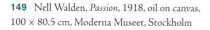

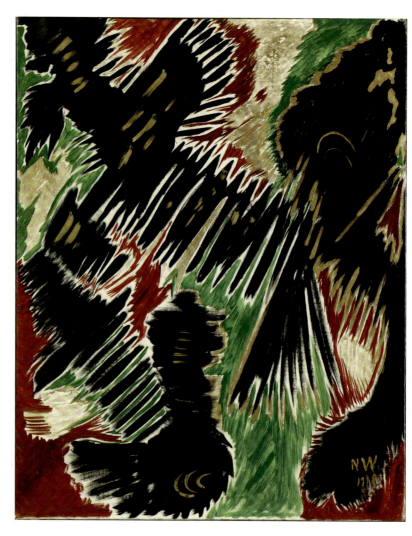

148 Nell Walden, *Todfrühling*, 1916, colored print, *Der Sturm* 12, no. 8 (August 5, 1921): 145

149 Nell Walden, *Passion*, 1918, oil on canvas, 100 × 80.5 cm, Moderna Museet, Stockholm

medium in the companion piece *Passion* (1918; fig. 149). By means of the iteration of gestural, zigzag brushstrokes, diagonal composition, and intensity of the complementary colors red and green, she engaged in the antidecorative and instinctual coordinates of the Dionysian *Rausch* (frenzy). By hyperbolizing the *Sturm* Expressionist aesthetic, Nell Walden claimed both intuitive feeling and the autonomous manipulation of the material for the woman artist. Interestingly, subsequent to her divorce from Herwarth, these two paintings were given pride of place in the display of Nell's oeuvre in the living room of her apartment in Rankestraße 34. This can be ascertained from a later photograph (fig. 150) wherein the two large abstract canvases can be located above eye-level and on either side of the door frame; adjacent to them and toward the roundel, one

can view her glass paintings, which etherealize and dissolve form and space.

The photograph also shows that she had altered her appearance and no longer conformed to the image of a "sweet woman in blonde light"; her sophisticated presence and gaze are directed firmly toward the camera lens. Evidently, she successfully negotiated the dialectic between subjective agency and the commercialized, media world of Weimar Germany by commissioning the photograph from the firm Atlantic Photo-Co.[90] So, too, she had abandoned her coiled braids and now sported a stylish "Bubikopf" (bob haircut); her garments are deceptively loose fitting as they underscore her trim, lanky figure beneath the restless fabric design. Fashion and performativity play their role in advancing a type of horror vacui in the interior, since

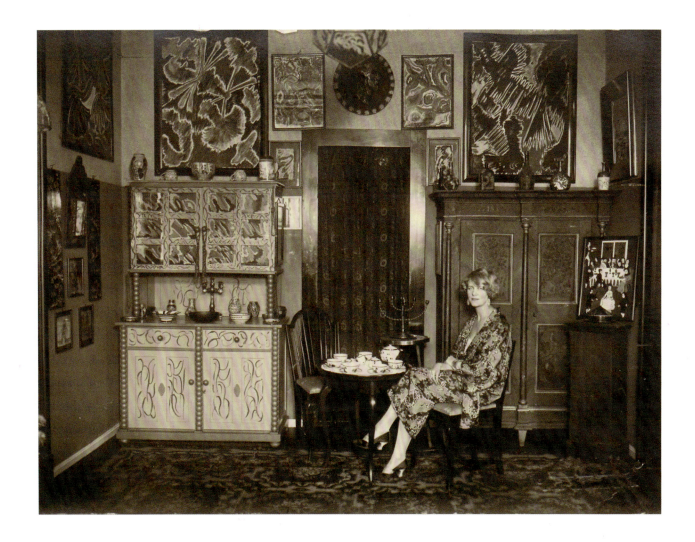

asymmetrical, organic design is also applied to the painted furniture. The artist syncopates and promotes her oeuvre in a way that reinvents the experience of the Expressionist living room as one of dissonance and assault on the eye of the beholder. Instructively, in a companion photograph (fig. 151), in which Nell Walden is portrayed with a cigarette in hand, she is ensconced within her collection of ethnographic artifacts. Not unlike the institutional housing of non-European art in the late nineteenth and early twentieth centuries, the stacked, ceiling-high installation—bereft of taxonomy—swamps the onlooker in addition to disclosing the syncretic tastes of Western modernist practice.[91] Clearly Nell Walden's engagement in notions of the Gesamtkunstwerk paralleled the growth of her private collection as well as stimulating her ideas on the impactful and embodied viewing experience of the installation.

150 Atlantic Photo-Co., *Nell Walden in Her Apartment at Rankestraße 34 with Her Own Works on the Wall*, year unknown, photograph from the photo album of Nell Walden, Handschriftenabteilung, Staatsbibliothek Preußischer Kulturbesitz, Berlin, Sign. Hdschr., 121, Bl. 81r

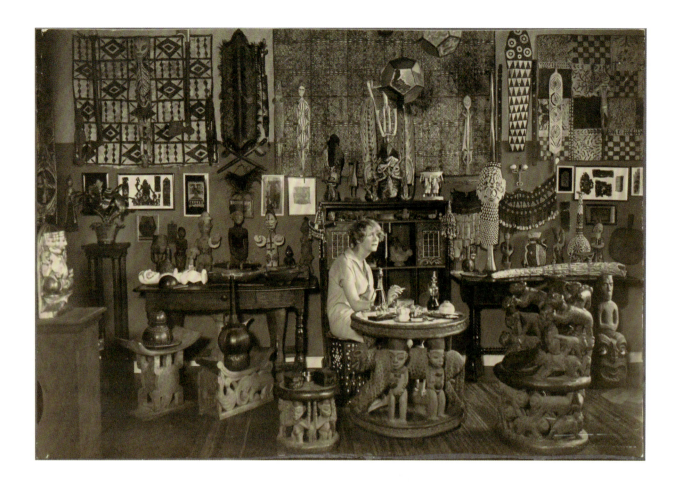

151 Atlantic Photo-Co., *Nell Walden Seated in Her Apartment at Rank-estraße 34 with Her Ethnographic Collection*, year unknown, photograph from the photo album of Nell Walden, Handschriftenabteilung, Staats-bibliothek Preußischer Kulturbesitz, Berlin, Sign: Hdschr. 121, Bl. 81r

Van Heemskerck and the *Einheitskunstwerk* (Unified Artwork)

Although inspired by her dealings with the *Sturm* circle, Van Heemskerck's route through the intertextual discourses of Expressionism arose from different circumstances and also gestated over the war period. Already in November 1914, she wrote to Herwarth Walden:

> I am working a lot and thinking a great deal[;] I would so like to try painting on glass; if you ever speak to Mr. Taut on the telephone, please ask him if there are any transparent colors with which one can paint directly on the glass because with normal oil paints it is not transparent and firing is so difficult:

one gets the effect of old stained-glass windows and I would like to have a new technique that the artist can use directly on glass just like on canvas. If one wants the colors to have a real spiritual glow, then there will come a time when oil paints and canvas won't be appropriate anymore. You and your wife know my work so well, you will understand my intentions and how I feel.[92]

Here she reveals not only her acquaintance with the architect Bruno Taut but also awareness of his *Glashaus* (Glass Pavilion), a temporary structure that was on display in Cologne at *Die Deutsche Werkbundausstellung* (The German Werkbund Exhibition) prior to the outbreak of war. The rhombic, domed building was uniquely experimental and included, amid other multisensory experiences, backlit stained-glass fenestration with inlaid commissioned artworks in the apse-like space of the lower level.[93] As in the Gothic cathedral, Taut believed that an architectural sensibility—what he termed the *Aufbauen* (construction)—lay at the basis of the new art.[94]

Nonetheless, Van Heemskerck's efforts to achieve a luminosity of color so necessary to her mystical concepts proved elusive and, as we learn from the passage above and her patron Tak van Poortvliet, the artist installed a firing oven in her studio so as to experiment with the technique of painted glass.[95] Beyond her innovational approach toward the medium and support ("there will come a time when oil paints and canvas won't be appropriate"), she ascribed to the architect's utopian ideals of evolving a vital culture from a new environment. Moreover, she valued the writings of the anarchist and fantasist author Paul Scheerbart (1863–1915), whose aphoristic poetry was emblazoned on the external lintel of Taut's *Glashaus*. Indeed, having read Scheerbart's book *Glasarchitektur* (Glass Architecture), she reported it "superb" in her correspondence with Walden.[96] In this treatise, Scheerbart advised that the only way to remove the enclosed spaces in which we live was to allow light through "the greatest possible number of walls that are made entirely of glass—colored glass. The new environment that we shall thus create must bring with it a new culture."[97]

With these principles in mind, in spring 1918, she embarked on a more professional venture so as to attract commissions from German architects. She informed Walden:

> I like to make studies for certain windows; one can then also think of the rooms for which one designs. Do you know any modern architects? They could then design rooms for glass windows. I would then get window frames and make my drafts; for different rooms also different main colors in the windows, for example, different tonalities for study rooms, hall etc. And so, we could have exhibitions together in the *Sturm*.[98]

Such ideas on collaboration, room-specific color schemes, and joint exhibitions illustrate how closely she identified with foremost theorists, including Behne, who sought to reform architecture from an externally driven Impressionist to an inner-driven Expressionist approach.[99] As the architectural historian Kai Gutschow argues, in place of a Wagnerian Gesamtkunstwerk that synthesized the discrete arts, Behne sought an *Einheitskunstwerk* (unified artwork)

that achieved a new art form through a common inner motivation and artistic principles.[100] Tellingly, having read Wagner's *Das Kunstwerk der Zukunft* (The Artwork of the Future), Van Heemskerck concluded: "How rapidly times change that in thirty years [*sic*] such ideas are completely outdated."[101]

These utopian aspirations for cultural renewal via architecture, the most public of all the arts, must be viewed within a context of political extremis; increasing losses were sustained by the German army notwithstanding numerous spring offensives at Ypres. In late May 1918, American entry into the armed conflict reenergized the Allied war effort and the November mutiny of sailors at the ports of Kiel and Wilhelmshaven led to Bolshevist-style uprisings in major German cities. Socialist and worker agitation spread to Holland and achieved important concessions regarding the length of the working week.[102] "It is a great but terrible time," Van Heemskerck wrote in light of these events as well as of Kaiser Wilhelm's abdication and flight to Holland on November 10.[103] As observed in chapter 3 on Kollwitz, post–November Revolution developments in Expressionist theory were dedicated to the reform of the imperial art institutions; in December 1918, under the auspices of the Arbeitsrat für Kunst, Taut published his leaflet "Ein Architektur-Programm" (A Program for Architecture), which proclaimed that there "will be no frontiers between the applied arts and sculpture and painting. Everything will be one thing: architecture[—]the direct carrier of the spiritual forces."[104]

Interestingly, then, in October 1919, Van Heemskerck exhibited ten of her studies for stained glass at the Sturm Gallery alongside the second-generation Expressionist Johannes Molzahn (1892–1968), who was active in the Arbeitsrat.[105] A supporter of the Spartacist League, Molzahn was involved in revolutionary politics, and two of his mainly abstract works included in the exhibition directly referenced the murders of Karl Liebknecht and Rosa Luxemburg by the Freikorps in January 1919.[106] His paintings conjured somewhat Futurist sensations, with arrows, scrolls, and colored circles radiating from diagonal axes at the centers of paintings.[107]

Moreover, the exhibition catalog reissued his emotionally charged essay, "Das Manifest des Absoluten

Expressionismus" (The Manifesto of Absolute Expressionism), which was originally published in *Der Sturm*.[108] In mystical terms, Molzahn announced the emergence of a new eternal order in the aftermath of destruction, and he wrote that an artist's work should echo the pulsating energies of the universe. Typical of *Sturm* aesthetic theory, this creative process was underpinned by gendered rhetoric but in overtly violent terms, the maternal elements succumbing to the "new man" ("We sing the magnificence of the male giant—who cuts through space like an arrow"), her bloody death fueling the eternal order.[109]

Within the valences of postwar Expressionism, Van Heemskerck endorsed her commitment to spiritual abstraction and aesthetic disinterest in politics, as is evident in her comments to Walden: "Titles are so offensively

romantic, and now one will have at any time hundreds of Springs, Summers, Trees to Liebknechts, Eberts, and so on. Color and line, above all, has its own different language that will not be fixed in titles."[110] Hence, she found a niche in the interdisciplinary concerns of architectural reform. In two of her exhibited designs, which show the thematic and stylistic variations common to her oeuvre, she set homogeneous areas of unmixed colors into the tectonics of linear-bound planes and frame. It is possible to discern a red tree in the *Design for a Stained-Glass Window No. 19* (fig. 152) in which the twisting branches become one with a format of violet and a cool blue. The curvilinear, organic shapes differ from the overall geometric arrangement in the *Design for a Stained-Glass Window No. 17* (fig. 153). Here, both composition and construction are unified as the abstracted facets

152 Jacoba van Heemskerck, *Design for a Stained-Glass Window No. 19*, 1919, watercolor and inks on cardboard, 132 × 99.5 cm, Berlinische Galerie, Landesmuseum für Moderne Kunst, Fotografie und Architektur, Berlin

153 Jacoba van Heemskerck, *Design for a Stained-Glass Window No. 17*, 1919, watercolor and inks on paper, 105 × 77 cm, Berlinische Galerie, Landesmuseum für Moderne Kunst, Fotografie und Architektur, Berlin

154 Jacoba van Heemskerck, *Composition after Design for a Stained-Glass Window No. 17*, ca. 1920, stained glass in lead, 98.5 × 70 cm, Kunstmuseum, The Hague

155 Jacoba van Heemskerck, *Design for the Stained-Glass Fenestration in the Hall of the Villa Wulffraat, Wassenaar*, photograph in *Jaarboek Nederlandische Ambachts en Nijverheidskunst*, 1921, fig. 57

of nautical motifs—harbor, bridge, and sailboats—are regimented into an oblong frame that contains nine panels of equal dimension. The design is jewel-like in appearance, drawing on the spectrum of a six-part color circle in catering for its eventual function as a stained-glass window connecting inner space to cosmic light.

Yet, in order to achieve modern rather than traditional effects, Van Heemskerck no longer experimented on her own but deployed the services of the firm Puhl & Wagner in Berlin, the workshops of which were acquired by the businessman Gottfried Heinersdorff in 1914.[111] Herwarth Walden assisted her with this introduction, and Van Heemskerck personally visited the premises while in Berlin for the opening of her exhibition in October 1919.[112] Heinersdorff's (1883–1941) role was critical to the Expressionists' rejuvenation of stained-glass and mosaic production for domestic and public environments.[113] Importantly,

too, his workshops had developed methods whereby a wide range of color effects of the glass window was additionally supported by the material used. In contrast to the diffused transparency of cathedral glass, it was a blown material, in which streaks and bubbles caused numerous refractions that increased the brightness of the colors.[114]

Such luminous effects are apparent in the two above-mentioned designs, which were produced in the workshops of Puhl & Wagner and were the result of private commissions: *Window No. 19* (see fig. 152) from her patron Tak van Poortvliet and *Composition after Design for a Stained-Glass Window No. 17* (fig. 154) from the Dutch architect Jan Buijs, with whom Van Heemskerck collaborated on a domestic residence, the Villa Wulffraat, located in Wassenaar, a prosperous suburb near The Hague.[115] However, her other designs for stained glass were realized locally in the studios of Johannes Willem Gips, a member of the Haagse

156 Jacoba van Heemskerck, *Panel for Door of Hall Window, Villa Wulffraat, Wassenaar*, 1920, stained glass in lead, 166.5 × 68.5 cm, Kunstmuseum, The Hague

157 Jacoba van Heemskerck, *Fanlight of Hall Window, Villa Wulffraat, Wassenaar*, 1920, stained glass in lead, 39.5 × 90 cm, Kunstmuseum, The Hague

say again: deep ultramarine blue or green, and then a richly colored runner. And, what comes down in the hall on the floor? There could be a large or several small colorful rugs. Anything . . . to get a whole.[116]

Although the colored fenestration has long since been dismantled, a photograph of the design is available for the window that she discusses above: an entire north-facing wall made up of four stained-glass panels with fanlights above (fig. 155). It is a highly complex construction of both architectonic and curvilinear leaded strips that resolves into a dynamic composition of a bridge and coastal setting. From extant originals for the right-hand door (fig. 156) and fanlight (fig. 157), one can recognize the motifs and gauge the stunning impact of the unusual color scheme of purple, green, and ultramarine that Tak van Poortvliet reported as creating a "general concert of light."[117]

Indeed, in the quotation above, Van Heemskerck suggested aesthetic preparation for the viewer's journey as they surmounted the staircase, entered the hall on the first-floor level, and encountered the color effects of the stained-glass wall. How these spaces are experienced and felt through kinetic motion rather than stationary vision is pertinent to a phenomenon that the architectural historian Christopher Long has identified in relation to the "new space" in

Kunstkring, and equally patronized for his skills by Theo van Doesburg. Not only was this a more pragmatic arrangement but it also signaled that Van Heemskerck's rich transnational experiences were being brought to bear on her Dutch professional milieu and contacts.

Undoubtedly, in correspondence with Buijs regarding the commissions for the Villa Wulffraat, Van Heemskerck drew on her knowledge of the *Einheitskunstwerk*—the role of the architecture in coordinating the stained-glass windows, color scheme, and floor coverings:

> Now I have already thought of the immense color effects that the window will make and it will certainly work powerfully, [but] must be carried by strong colors in the hall; otherwise, it is too isolated. The paint in the staircase, for example, can receive a *strong* color and not oak; that would not be too dull? To

Viennese modern architecture.[118] Here Van Heemskerck's ideas partake of the shift from the surface to the interior and of the consequent emphasis on the psychophysiological experience of *Raumgestaltung* (spatial creation) in early avant-garde architecture.[119]

Buijs, for his part, had trained at the Delft Technical College as an architectural engineer, a typical career path for civil servants who eventually served in the colonies. Commissioned in 1920, the Villa Wulffraat was his first domestic undertaking and, whereas organic flourishes enliven the gabled roofing on the facade and side vestibule, the ground plan of the two-storied house retains more conventional spaces balanced around a central core.[120] However, the nonextant interior decoration was a different matter, and a grainy photograph of the dining room reveals the legacies of Jugendstil design, ornament, and the whiplash curve, Van Heemskerck having been commissioned to create the decorative sideboard panel in asbestos to accompany the furnishings. But it is her windows in the Villa Wulffraat that constitute one of the few instances in the Netherlands of glass painting relating to German Expressionism in an architectural setting. Thereafter, Van Heemskerck's designs for stained glass were mainly Constructivist and accorded with internationalist tendencies in Dutch architecture; she gained national prominence in commissions that she received for the three-storied stairwell of the Marinierskazerne (Marine Offices) in Amsterdam, among others.[121]

By 1920 Van Heemskerck had broken the exclusiveness of her contract with Walden, and their correspondence diminished accordingly. In the postwar climate, differences had emerged not least in the economic spheres in which the Netherlands experienced a brief financial boom with the resumption of international trade and the rise of multinational companies.[122] Walden was financially overextended and many first-line Expressionists curtailed their relationship with the Sturm Gallery in favor of the art promoter I. B. Neumann, who was the owner of the Graphisches Kabinett in Berlin.[123] Whereas Walden switched his political allegiances to the Kommunistische Partei Deutschlands (Communist Party of Germany; KPD) after 1919, Van Heemskerck intensified her activities in the anthroposophist movement in response to Rudolf Steiner's international call for collective unity. Indeed, she is listed as a member of the Netherlands Committee in Tak van Poortvliet's translation from the German of Steiner's open letter "An das Deutsche Volk und an die Kulturwelt" (An Appeal to the German Nation and to the Civilized World, March 1919).[124] Therein Steiner exhorted the German people to examine the reasons for their ruinous present and attend to the spiritual needs of a future generation. As an appendix to his treatise *Die Kernpunkte der Sozialen Frage* (The Renewal of the Social Organism), Steiner's concept of a threefold society, in which the economic, cultural, and political domains would enjoy relative autonomy within the social organism, served as the departure for Tak van Poortvliet's philanthropy.[125] These ideas underpinned her subsequent founding of the Cultural Community of Loverendale in Domburg, which became pivotal to the history of biodynamic agriculture.[126]

But the war years proved central to Van Heemskerck's forceful deployment of her creative energies and contribution to German Expressionism. Indeed, this period seemed to intensify her ability to be productive; Behne phrased this succinctly when he cited an extract from one of her letters in his essay "Der Krieg und die Künstlerische Produktion" (The War and Artistic Production, 1915). While he argued that during wartime many found the surrender to creativity heartless and egoistic, there were exceptions to the rule: "Very instructive was a letter from the Dutch woman painter Jacoba van Heemskerck, saying: 'It is a terrible but also a tremendous time. Personally, it is so important for my art to live now . . . At this time, you have to think a lot and work a lot, in nature there is now so much creativity.'"[127] Behne added that it is hardly paradoxical to say that the war can have a stimulating effect on the art of neighboring nations, who are not involved in the bloodshed, rather than on their own. In the Netherlands, the geopolitics of neutrality offered unique, egalitarian conditions in which *Sturm* representation could facilitate Van Heemskerck's transnational success as a woman avant-gardist.

From her prewar apocalyptic, cosmic landscapes to her architectonic seascapes and graphics, her spiritual abstraction found favor in the androcentric milieu of the *Sturm* as well as with Nell Walden. Such was the latter's patronage of Van Heemskerck that they entered into correspondence regarding the need for an interior space to house her works,

a discussion that presaged Nell's performative and Expressionist installations of her private collection in the 1920s.[128] Not unsurprisingly, then, the catalog of the Sammlung Walden (Walden Collection) bore the logo of one of Van Heemskerck's woodcuts as a vignette on the title page.[129] In her role as a practitioner, Nell Walden's largely unknown abstractions reveal how the woman artist could deploy the *Sturm* aesthetic of autonomy for heightened emotional effect and break new ground in exploring the dialogue between image and text. Stemming from similar discourses on the interrelationship of the arts, Van Heemskerck's mutual intrigue with glass painting steered her toward the futurity of architecture's spiritual potential in uniting fine art, the applied arts, and design. In their different ways, both artists addressed the fluidity of the Expressionist project and dealt with the psychophysiological impact and interiority of the viewing experience.

However, Tak van Poortvliet's contribution as "significant other" sustained and articulated the feminist implications of Van Heemskerck's engagement in the public sphere. Following the artist's death from coronary disease on August 3, 1923, her patron's initiative secured *Sturm* commemorative exhibitions in Germany and Holland, as well as the issuing of a Sturm-Bilderbuch in her honor.[130] Clearly, the anthroposophist movement served as an emancipative agent for both protagonists, although Tak van Poortvliet's move to Dornach in 1930 meant a retreat from secular life. After her death in 1936, her private collection of European modernism and Van Heemskerck's oeuvre were placed in the national domain, but it was not until the early 1980s, coincident with the second wave of feminism, that the artist's substantial achievements were recuperated.[131]

THE FORMATION OF THE MODERN WOMAN PATRON, COLLECTOR, AND DEALER

From Brücke to Second-Generation Expressionism

> In the year 1893 I moved to Hamburg. Stimulation, which I received there, through the lecture cycles held on behalf of the upper school board, in particular through the work of the directors Brinckmann and Lichtwark, self-instruction and travel caused me to dedicate myself to the study of the history of art.

For Rosa Schapire (1874–1954; fig. 158), one of the first women to pursue the art-historical profession, Hamburg's museums played a key pedagogic role in heightening her awareness of the visual arts and in triggering her own commitment to the discipline. As she explained in the citation above from her *Lebenslauf*, due to the lack of appropriate schooling in Brody in Poland, she immigrated to Hamburg at the age of nineteen so as to prepare for university entrance.[1] Her undergraduate degree was pursued in Bern and her PhD research was conducted in Heidelberg.[2] Schapire's journey from Central Europe to Germany and the career she forged as a freelance art historian, patron, and collector of Expressionism is a moving and inspirational tale that traverses the first half of the twentieth century.

From her base in Hamburg, it encompasses her support of the Künstlergruppe Brücke, her ardent civic activities during the First World War, and her prolific reviewing and promotion of a second generation of Expressionists in the Weimar period. Sadly, it also testifies to her bitter experiences in the Third Reich; as a consequence of her Jewish identity, feminism, and socialist politics, her professional life was severely curtailed and her daily existence threatened. To add to this, in 1937 she was listed as one of the twenty-five *Kritiker der Systemzeit* (critics of the [Weimar] system) at the infamous *Entartete Kunst* exhibition.[3] On August 18, 1939, with a visa for America awaiting her in Britain, she traveled to London, where she remained in exile due to the outbreak of the Second World War.

Equally fascinating are the achievements and fate of one of Weimar Germany's most well-known modern art dealers Johanna Ey (1864–1947; fig. 159), customarily known as "Mutter Ey" (Mother Egg). A few biographic details serve to illustrate her tenacious will to succeed in her chosen path. She was born Johanna Stocken, the daughter of humble Catholic parents. Her father was a weaver in the market village of Wickrath, near Mönchengladbach. In 1890, she married brewer manager Robert Ey and apparently bore him twelve children, only four of whom survived.[4] In 1910, following her divorce, Ey established a bakery café in

158 Anonymous, *Otto Neurath, Anna Schapire and Dr. Rosa Schapire*, ca. 1904, photograph, Nachlass Otto and Marie Neurath, Österreichische Nationalbibliothek, Handschriftensammlung, Vienna

dealership traced the shift from Expressionism to Neue Sachlichkeit—she represented Otto Dix during his Düsseldorf sojourn—and embraced internationalism through her purchase of the works of Cologne-born Surrealist Max Ernst. In 1925, with the departure of Wollheim and Dix to Berlin, the atmosphere in the gallery was less buoyant, and by the late 1920s sales dwindled as a consequence of the downturn in the world economy. Due to municipal initiatives and support from the local art scene, Ey was able to move premises in 1930. However, the combination of chronic debt and the invasiveness of National Socialist cultural policies regarding "degenerate art" meant that she was evicted therefrom on April 6, 1934. German literary historian Michael Hausmann argues that her memoirs of 1936, written at a time of severe ideological and social constraint, are characteristic of a state of "inner emigration" and ambition to publish the material for a post-Nazi audience.[5]

Whatever the differences in their background, upbringing, or class, Schapire and Ey shared a passion for the vitalism of Expressionist avant-garde culture. Ey was sharp-witted and apprised of developments in the art world. Indeed, in 1919, while in Berlin for the marriage of her son, she attended the second exhibition of Das Junge Rheinland at the Kronprinzenpalais (Crown Prince's Palace). On August 4, 1919, one week before the Weimar Constitution was signed into law, the Galerie der Lebenden (The Gallery of Living Artists) opened in the Kronprinzenpalais, a neoclassical building that had previously been a residence for the German emperor's family. After the dissolution of the monarchy, the palace became a possession of the Free State of Prussia and was initially given to the Nationalgalerie to house its drawing collection. Instead, the director Ludwig Justi devoted the spaces to a new concept of an "unfolding" culture that displayed "today's flourishing types of artistic endeavor, which one calls by the slogans Impressionism and Expressionism."[6] Expressionism had come of age and was deemed institutionally acceptable. Consolidating the political inflections of the First World War, it was also regarded as a distinctly German rather than an imported phenomenon.

In the account of her visit to the Kronprinzenpalais, Ey found that the works of Christian Rohlfs and Heinrich Nauen were of greater interest to her than those of the realist Hans Thoma, which affirmed her predilection for

the historic district of Düsseldorf, which was frequented by members of the nearby Art Academy. At this stage, she allowed students and staff to leave their works with her for sale. This practice was interrupted by the First World War, but Ey eventually found a location at Hindenburgwall 11, with double shop windows, which she named "Neue Kunst Frau Ey" in 1919 (see fig. 8).

Through her personal contact with modern artists, the gallery became the locus for members of the secessionist association Das Junge Rheinland (The Young Rhineland), formed in February 1919, as well as the dissident group Der Aktivistenbund 1919 (The Activist League), founded by Gert Wollheim and Otto Pankok. Hence, Ey's

159 Anonymous, *Johanna Ey*, ca. 1913, photograph, silver gelatin on paper pasted on card, Stadtmuseum Landeshauptstadt Düsseldorf, Inv.-No: SMD.F 87

modern figural manifestations.[7] From this brief outline of the formative experiences of Schapire and Ey during the late Wilhelmine and early Weimar period, we can ascertain that the audience for vanguard art was not confined to the male viewer. The art historian Carol Duncan argued that Expressionist renderings and objectification of the female body merely gratified the artist's desire for instinctual freedom and male dominance.[8] By extension, the male collector's acquisition and display of such works endorsed myths of the nature/culture divide, an ideology perpetuated with the compliance and passivity of those (in this case, his wife) whom it oppressed.[9] Such theorization tallies with the implications of the "male gaze," a term initiated by film and cultural historian Laura Mulvey.[10] Most discourse about the gaze, as Margaret Olin observes, concerns pleasure and knowledge, yet it generally places both of these within

the command of power, manipulation, and desire.[11] Since the early 1980s, though, concomitant with debates regarding the nuances in gendered spectatorship, research has revealed that women collectors' agency was far from docile.

Notions of the performative are relevant to psychoanalytical theory in general and feminist art-historical inquiry in particular. In theorizing the female spectator, film and media historian Mary Ann Doane seized on the importance of "masquerade."[12] Doane cited British psychoanalyst Joan Riviere's essay of 1929, "Womanliness as a Masquerade," wherein she contended that women display the mask of "masculinity" (knowledge and skill) as a game, acknowledging that this is something they do not genuinely possess.[13] Equally, nonetheless, she considered "womanliness" in female identity as a mask and protective mechanism in concealing what they allegedly lack in patriarchal society. Consistent with the methodology in earlier chapters, I have taken on board Judith Butler's poststructuralist response to Riviere, that no essential femininity or masculinity exists but that gender is constructed and performative.[14]

In an interview published in 1992, Butler explored how fantasy could function as a means of escape from, and resistance to, sex-based gender constraints. This is not to say that fantasy is free of social relations and power, but Butler maintains that its process "orchestrates and shatters relations of power."[15] Via these means, the female gaze could be a productive instrument of knowledge as well as a mode of institutional critique. Schapire not only contributed to Expressionist theory but also set a precedent in destabilizing the male preserve of the art-historical discipline. In the case of Ey, she discerned the tendentious value of antiwar imagery and deployed confrontational marketing techniques in invading the masculine realm of art dealership.

Expressionism corresponded with the height of feminist-inspired activities, which had been at an intense pitch for roughly a quarter of a century, achieving emancipation in 1919. As has been argued, in its intersection with the thrust of the women's movement, German colonialism provided an "emancipatory space" for women in their questioning of Wilhelmine patriarchy.[16] Yet, Schapire, a socialist in favor of sexual liberation, rebuked bourgeois feminists' notions of the maternal as perpetuating imperialist tenets: "When Europe finally becomes too limited for the women's

state," she contended, "what prevents women from crossing the ocean, starting colonies, and transferring their 'motherly feeling' to the natives, who have not yet been lured by Europe's courtesy?"[17] From her viewpoint, feminists had to jettison all forms of colonial paternalism and maternalism. Already attuned to the art and life paradigms of Jugendstil, Schapire responded to Expressionism's denunciation of academic hierarchies and conventions in favor of organic communalism and what is known broadly as "modernist primitivism."[18]

Together with other women in her circle who patronized the Brücke, she engaged with the artworks, and commissioned jewelry and interior design in this vein. As was the case with many German Jews during the Wilhelmine and Weimar periods, Schapire's involvement in collecting and patronage was seen as a means of shaping modernity.[19] So, too, she was subject to malicious tropes regarding Jewish character and physiognomy, which were deeply embedded in German society at all levels. Incorporating such perspectives, this chapter argues that the gender divide of spectatorship was bridged through various sociological models that arose from different initiatives. These mechanisms facilitated women's emergence into the public sphere and served to acculturate them. I examine the Brücke's enlisting of patrons and the coincidence of such endeavors with the formation of the Frauenklub (Women's Club) in locally formed networks in Hamburg and Jena.

Subsections of this chapter build on previous scholarship in devoting attention to Schapire's interaction with the Warburg circle and her articulation of Expressionist theory as it arose from her interest in Nolde and Schmidt-Rottluff. As mentioned above, Hausmann's doctoral research on Ey's life and writings allow for greater understanding of her sponsorship of Dix and Wollheim in Düsseldorf. As the subject of countless portraits by male artists, Schapire and Ey are representative icons of the Expressionist period and merit this focus in case studies. Beforehand, however, it is important to lay out the approaches of the so-called new type of gallery director in catering to the expansion of viewing constituencies.[20] Their strategies held implications for modern female identity as producers, spectators, and/or elite consumers, embracing the realms of both high and low art in constructing their private and public personae.

The Arts of Beholding, Performative Viewing, and Collecting

By the turn of the century, it was clear from the rapid development of public museums in Germany that various tensions would arise between insular state bureaucracies and the outward-looking aspirations of a new generation of directors. Concordant with the rise of the bourgeoisie in German society, these establishments were founded around the collections of private bequests or propagated by voluntary associations known as the Kunstvereine.[21] As this phenomenon was fairly widespread in the major and regional centers of Germany, consideration of the directors of three differently formed institutions in Berlin, Hagen, and Hamburg illuminates how their activities and publications impinged on the promotion and collection of Expressionism and the implications that this held for women.

In the metropolis Berlin, the founding of a national museum of modern art was spurred by the donation of a private collection by the banker and consul Joachim Heinrich Wilhelm Wagener to Emperor Wilhelm I in 1861. Completed in 1876, the Nationalgalerie was imbued with the significance of the recent unification of Germany of 1871, and dedicated to the display of German art. The controversial Austrian-born, Swiss-raised Hugo von Tschudi (1851–1911), who studied law in Vienna but turned to art history, became director of the Berlin Nationalgalerie between 1896 and 1908. In consultation with the gallery dealer Paul Cassirer and secessionist artist Max Liebermann, Tschudi systematically enriched the collection with the works of nineteenth-century French realists and Impressionists.[22] Although these were largely acquired through bequests and donations from Tschudi's circle of Jewish patrons, such actions led to open confrontation with Wilhelm II, who cherished notions of an idealized national culture. Tschudi's position in Berlin was made untenable, and he subsequently accepted an offer to head the Bavarian State Museums in Munich, from 1909 until his untimely death in 1911.

The publicity surrounding the "Tschudi affair" and his championing of both foreign and modern art underscores the dynamism of the museum director in interacting with patrons, dealers, and artists.[23] Moreover, in communicating his ideas on the functions of the modern director and

collector, Tschudi's writings resonate with features of early modernist theory:

> This new gallery director of the twentieth century now also steps side by side with a new type of collector. As the one supervises and restores, so the other builds up. Not according to art-historical points of view, and also not with those specific collector's passions . . . but with the excited abandon of the spirited art lover, who . . . seizes quickly there, where his artistic feelings become transposed into strong vibrations.[24]

This extract, a form of neo-Kantian testament, highlights the importance of the emotions in aesthetic experience, but frames that recognition within a cognitivist essence of human feelings through art.[25] Thereby, in selecting works of art, outmoded taxonomies of national or chronological boundaries were irrelevant. However, it would be a misrepresentation to label this approach as purely "formalist." As was made clear in his lecture "Kunst und Publikum" (1899), the context for Tschudi's theoretical departure was based on a rejection of official history painting in favor of the immediacy of Impressionist subject matter.[26] Unlike the directors Karl Ernst Osthaus in Hagen or Alfred Lichtwark in Hamburg, Tschudi maintained an elitist viewpoint in asserting that modern art was beyond the sensibility of the masses.[27] His legacies testified to the attempt to define national heritage in accordance with a nonparochial, contemporary living tradition that prioritized the role of emotional feelings and visual experience in the building of collections. Instructively, in 1912, in a review of Karl Scheffler's new guide to the Nationalgalerie, Rosa Schapire commended Tschudi's directorship as a moment of pride for the national collection.[28]

Of all three discussed, the case of Karl Ernst Osthaus (1874–1921) is rather unique since, as founder, owner, and director of the Folkwang Museum in Hagen between 1898 and 1919, he was responsible for an unusual degree of public patronage with private funds. Imbued with the ideas of Nietzsche and Wagner, Osthaus's völkisch ideology extended to the choice of the museum's name, "Folkwang," which designated a place for tribal assemblies in Norse mythology and referred to the Hall of Freya, the goddess

160 Gertrud Osthaus, *Paul Cézanne in Aix-en-Provence*, April 13, 1906, photograph, Bildarchiv Foto Marburg

of love, beauty, sex, death, and war.[29] Osthaus came from a wealthy background; his father owned a bank in Hagen and the family was well connected with industrialists and businessmen.[30] After inheriting 65 million marks from his maternal grandparents, Osthaus was able to fulfill his ambition of bringing modern visual culture to the Ruhr.

His wife, Gertrud Osthaus (née Colsman, 1880–1975), whom he married in 1899, assisted in acquiring artworks, pursuing contacts with artists, and managing the museum.[31] Although not formally trained, her photographic skills were accomplished and served to document the collection until a professional photographer, Käthe Bernstein (1892–1987), was employed in 1917: this implies that museum photography became an expanding niche for women in the field and signaled their creative presence behind the camera.[32] Gertrud's repertoire featured unique examples of what Karl later termed *Aufnahme der Begegnung* (recording the encounter) with key modern artists, as in the poignant shot of the wizened Cézanne in Aix-en-Provence on April 13, 1906 (fig. 160), six months prior

to his death in October of the same year.[33] In her prolific correspondence, Gertrud admitted to the challenges of photographing modern paintings with limited means (in black and white) and inexpensive apparatus. So, she wrote to Ada Nolde, "The difficult thing about pictures, and certainly especially of your Emil's paintings, is to bring out the right tonal values. There, one has to try and study. A good yellow slide of mine, mounted behind the lens, helped a lot. Finally, I also got Gauguin in his tonal values."[34] Gertrud's writing for a broader audience further revealed her endeavors to come to grips with the transformations in viewing experience that arose from the changes wrought by architectural and museum reform.

Whereas the Berlin-based architect Carl Gérard completed the exterior of the Folkwang Museum in an eclectic, historicist style (fig. 161), in 1900 Osthaus turned to the Belgian architect and designer Henry van de Velde (1863–1957) to craft the interior of the museum around the collection of modern European and non-Western art. A notable supporter of the Applied Arts movement, Van de Velde played a crucial role in disseminating Jugendstil and the principles of the Gesamtkunstwerk in Germany. He was a committed internationalist, and it has been suggested that he tempered the less salubrious features of Osthaus's affiliation with right-wing, anti-Semitic groups, which stemmed from his student career.[35] As with Van de Velde, Osthaus was taken with the principles of *Lebensreform*, of reuniting art and craft in improving the environment of a modern industrial society. Such values were of enduring significance to his dedication to the display of the decorative arts and to his ongoing involvement in the Deutscher Werkbund (German Works Union). Osthaus played a decisive role in making the Folkwang Museum the starting venue for the traveling exhibitions of the Deutsches Museum für Kunst in Handel und Gewerbe (German Museum for Art in Commerce and Trade).[36]

In planning the interior spaces of the Folkwang, Van de Velde broke with the narratives of nineteenth-century German museology, which was dedicated to housing chronological sequences of national schools. He supplanted these with a dynamic interpretation of the architectural elements, including a rhythmic iteration of motifs, color, and ornament; the resultant spatial fusion broke down the barriers between exhibits of various origins.[37] On

161 Carl Gérard, *Folkwang Museum Exterior*, Hagen, ca. 1902–12, photograph, Osthaus Museum, Hagen, photographer unknown

162 Henry van de Velde, *Folkwang Museum*, Hagen, entrance hall with fountain by Minne and paintings by Gauguin and Matisse, ca. 1910, Bildarchiv Foto Marburg

163 Henry van de Velde, *Gown for Gertrud Osthaus*, ca. 1902, Foto Marburg

164 Henry van de Velde, *Hohenhof*, Hagen, 1906–8, ladies' salon with furniture arranged around Édouard Vuillard's painting *Promenade in the Vineyard* (1900), Bildarchiv Foto Marburg

the landing of the first floor, the Belgian Georg Minne's circular, white marble fountain, surrounded by sculpted kneeling youths (fig. 162), reflected colored light from the stained-glass skylight above. To this was added the colorful tones of paintings by Gauguin and Matisse, which were hung in the arched niches, producing a complex sensorium for the individual viewer. As outlined in chapter 6, the shift from the surface to the interior space—*Raumgestaltung*—characterized the psychophysiological experience of early avant-garde domestic architecture. Here this was transposed into the public realm; instructively, so as to amplify the theme of the Gesamtkunstwerk, Osthaus commissioned Van de Velde to design a music room and auditorium for theatrical performance and dance.

By 1908, Van de Velde had also completed the private residence Hohenhof for the Osthaus family, in which the architect controlled both the external and internal detailing of the plan. Therein, the domestic space served a performative function in catering to the social ambiance of a stream of visitors, artists, performers, dealers, and literati. Van de Velde was responsible for designing not only Gertrud Osthaus's fashionable reform outfits (fig. 163), but also her

personal *Frauenzimmer* (women's salon), which contained elegantly curved furniture, a woman's desk, and a piano. Paramount to the "intimate modernism" of the room (fig. 164), as architectural historian Katherine Kuenzli terms it, was Van de Velde's securing of the Nabi Édouard Vuillard's sumptuous landscape *Promenade in the Vineyard* (1900).[38] Originally commissioned to decorate another Parisian residence, the painting's dappled effects and sinuous linear elements served as the departure for the interior decoration. Kuenzli argues that in creating a contemplative space for women's socializing, art viewing, music making, and writing, Van de Velde blurred the gender boundaries of the Folkwang project; yet, Osthaus maintained his masculine authority as the director of the museum.[39]

Through his capacity as a patron and collector, Osthaus was of notable importance to the promotion of Expressionism.[40] While his collection of modern French works was also purchased through art dealers such as Paul Cassirer, Osthaus soon became directly involved in patronizing contemporary German art.[41] He first bought a painting from Emil Nolde in 1906 and was a source of continuous encouragement to the artist during times of

165 Anonymous, *View of Installation in the Folkwang Museum*, Hagen, ca. 1920–21, photograph, South Sea Island figurines with paintings by Emil Nolde and Lasar Segall in the center, Bildarchiv Foto Marburg

extreme difficulty.[42] As a consequence of Nolde's interaction with the Brücke artists in Dresden, the group held major exhibitions at the Folkwang in late 1907 and 1910. Importantly, one of the unique features of Osthaus's approach, his installation of modern art juxtaposed with the art of Africa and Oceania, was of seminal importance to the "primitivist" reorientation of the group.[43] A contemporaneous photograph of Nolde's and Lasar Segall's paintings, abutted by figural sculpture from the imperial protectorate of German New Guinea (fig. 165), is a vivid demonstration of this principle.[44] Whereas the origin of these objects denoted the power relations of German colonial rule in the South Pacific between 1885 and 1914, their "exoticism" was deemed in a positive light and worthy of emulation among members of the avant-garde.[45]

In 1913, in an essay published in the *Kölnische Zeitung*,

Gertrud Osthaus formulated the viewer's experience of the architectural design in the Folkwang Museum: "By a well-balanced organization and sequence of the spaces, by the rhythmic [arrangement] of their relationships and colors, an almost imperceptible, but by no means lifeless, atmosphere is created, in which every work of art can freely unfold its powers."[46] According to her analysis, the vitalized spatiality enhanced the autonomous function of the artwork. In connection with the "harmonious contrast" between world cultures and modern art, she observed that the beholder's gaze slides from one to another, the one perhaps more deeply exciting the other. She continued:

> The fact that the groups of the newest painting and sculpture, the Expressionists, represented above all by Matisse and Nolde, are joined by the demonic works of African culture now seems almost self-evident. After all, these artists, as a result of some strange psychic relationship, took inspiration and sometimes even means of expression from those far-off gloomy regions.[47]

166 Milly Steger, *Four Female Nude Figures*, 1911, limestone, facade, Municipal Theater, Hagen

167 Milly Steger, *Head of a Woman*, 1912, portal relief, sandstone, 110 cm high, Karl-Ernst-Osthaus Museum, Hagen

Seizing on the pedagogic values of African art, Gertrud Osthaus evoked the theories of art historian Wilhelm Worringer, who argued that the "urge to abstraction" as a psychological need was consistent with a more "primitive," spiritual worldview.[48] Her interests were characteristic of other women patrons and collectors whose aesthetic tastes moved beyond the intimate modernism of Jugendstil in favor of the attack on the senses of Expressionist technical and formal radicalism.

The director Osthaus appeared unperturbed by the stylistic pluralism of early Expressionism and invited the NKVM and Blaue Reiter to exhibit, acquiring works by Kandinsky and Alexej Jawlensky for his permanent collection by 1912. Evidence abounds, as well, of the inclusion of women practitioners within this arena. Through their interest in handmade craft, Gertrud and Karl promoted the finely woven rugs and pillows made by Ada Nolde, based on her husband's designs.[49] Moreover, between 1910 and 1918, the Expressionist sculptor Milly Steger (1880–1941) was associated with the Folkwang Museum, executing commissions in Hagen and working in the artists' colony at Hohenhof, the director's mansion.[50] In 1911, a nationwide controversy ensued from the placement of her monumental sculpture—four colossal female nudes—on

the facade of the Hagen Municipal Theater (fig. 166). Carved from limestone, the pillar-like, frontal figures were attacked as "obscene," the production of architectural sculpture and nudity being considered the preserve of male privilege.[51] Another of her works, a high-relief portal sculpture in sandstone of a woman's head, surmounted the central arch of the entrance to the Folkwang Museum (fig. 167). Given the head's archaized and powerful features, it is understandable how critical reception came to invest Steger with qualities usually attributed to male sculptors, that of technical skill, inventiveness, and, of course, "masculine" strength.[52]

A frequent visitor to the Folkwang, following a presentation of her poetry on March 16, 1913, Else Lasker-Schüler was intrigued with the Hohenhof circle of artists and beguiled by Gertrud Osthaus's patronage.[53] No stranger to adopting the male guise for the purposes of literary creative autonomy, Lasker-Schüler dedicated a poem to Steger that highlighted the transgressive masquerade of the sculptor as a "lady Gulliver" (Jonathan Swift's hero):

> Sometimes this lady Gulliver carves
> Adam from matchsticks—and behind his
> back—his wife
> Then she laughs like an apple;
> A rascally look in the steel-blue eye.[54]

Interpreted in light of Old Testament symbolism and the creation of Adam and Eve, the poem elicits the Promethean energy of the woman sculptor, who partakes of the knowledge of good and evil as well as appropriating the male gaze ("a rascally look").[55]

In April 1916, as a tribute to Lasker-Schüler's *Doppelbegabung* (double talent), eighty-five of her drawings, watercolors, and three books were exhibited at the Folkwang. These were twinned with the paintings and woodcuts of Jacoba van Heemskerck, secured from the Dutch artist's dealer Herwarth Walden in Berlin. By then, Van Heemskerck was already a well-known quantity, a forceful representative of spiritual abstraction in mid-war Germany and the neutral countries. One wonders how Lasker-Schüler's drawings and illustrations, mostly inclusive of text, fared within the context of Expressionism and the museum's holdings.[56] For her, the element of fantasy operated on various levels and was a serious part of her literary and artistic strategies. Through mythmaking—her childhood reminiscences and claim that she was born in Thebes and not Wuppertal—Lasker-Schüler expanded the possibilities of her persona beyond her expected role as a woman in bourgeois German Jewish society. This rich dialectic between the autobiographic or local and the Orient signifies what Donna Heizer has termed Lasker-Schüler's "Oriental performance space," in which the "Oriental" is invested with passion, bravery, and the ability to produce great art.[57]

Included in the exhibition was the work *Die Jüdischen*

Häuptlinge: Die wilden Juden (Jewish Chiefs: The Wild Jews, 1913; fig. 168), drawn on velum in inks and crayon.[58] The title typified her yearning to return to an ancient, original Jewish culture. As in the case of other intellectuals in her circle, Lasker-Schüler located authenticity in an amalgam of ancient Egypt, Old Testament, and Middle Eastern exoticism.[59] In her inventive use of line, especially the graphic precision of the profiles in serial formation, she explored the interplay between negative and positive space, which is endorsed by the lacelike delicacy of colored linear formation therein.[60] One anonymous reviewer of her works valorized "the whole sensuality of the Orient, the dreamy Bacchanal" that is expressed with very economical means.[61]

Certainly, the poet's drawings linked to the wider discourses of the Folkwang collection of European modernism and south global art, yet their ostensible Jewish content subverted the ideological framework of Osthaus's program to spur national regeneration. His pronouncements resonate with völkisch sentiments: "Today, culture is not a question of class, it is a question of a people (Volksfrage)."[62] However, in attempting to foster and develop the civic virtues of regional and industrial communities, Osthaus was pivotal to the decentralization of Prussian dominance in cultural matters and, wittingly, he upheld the importance of women's performative creativity and viewing. Being privately financed, the Folkwang Museum could well ignore the ramifications of the so-called Tschudi affair that waged in Berlin or the conservative tastes of a wealthy mercantile class in Hamburg.[63]

In 1871, this Hanseatic League city joined the Reich as a federated state, with control over its own local political structure and economy and over social and cultural policy. Nonetheless, the stimulation of cultural life was not the concern of the governing senate but was left to the efforts of local arts administrators and private individuals. In this case, the function of leading figures—such as Alfred Lichtwark (1852–1914), director of the Hamburger Kunsthalle between 1896 and 1914, and Justus Brinckmann (1843–1915), director of the Museum für Kunst und Gewerbe (Museum of Applied Arts) between 1877 and 1915—was critical to the dissemination of ideas regarding cultural reform. The relative political and economic autonomy of Hamburg, induced by liberal doctrines of free enterprise

168 Else Lasker-Schüler, *Die Jüdischen Häuptlinge (Die wilden Juden)* (Jewish Chiefs: The Wild Jews), 1913, ink and crayon on velum, 14 × 18 cm, Eigentum der Else Lasker-Schüler-Gesellschaft, Wuppertal

and laissez-faire, resulted in the forceful presence of a thriving business community.[64] Indeed, the Kunsthalle itself was founded in the mid-nineteenth century on the initiative of the local Kunstverein and subsequently donated as a gift to the state.[65]

Lichtwark wanted to instill civic pride and to harness the energies of the affluent middle class, thereby dedicating himself to the task of reforming and educating a literate bourgeois audience in the value of the visual arts for everyday life. At the core of this project was the Enlightenment concept of Bildung, which Lichtwark developed in the article "Selbsterziehung" (Educating Oneself, 1896). Here he zealously advised adults to take art into their own home

and to respond to it with the senses: "Treat it as a friend at your hearth and in constant communion with it to expand your own sensitivity, increase and strengthen your ability to recognize and appreciate art."[66]

To this effect he revived the term and concept "dilettante," purging it of its pejorative, amateur connotations, a reevaluation that was argued in his essay "Wege und Ziele des Dilettantismus" (Paths and Goals of Dilettantism).[67] In 1893, he founded the Gesellschaft Hamburgischer Kunstfreunde (Society of Hamburg's Patrons of Fine Art), a group of charitable and influential citizens whose tasks included curating exhibitions and commissioning and fostering the local arts.[68] In that original graphics were financially accessible for middle-class consumption, Lichtwark recommended that these would serve as an important means to self-improvement, a process that would spiritually benefit the broader community and ultimately the nation.[69] By 1911, Lichtwark's agenda was summarized

in the discourse "Der Sammler" (The Collector) in which he stated that the bourgeoisie should model themselves on the nobility of the eighteenth century. Collecting should involve the elements of patronage and aesthetic self-education through the *Gymnastik der Sammeltätigkeit* (the gymnastic of collecting activity).[70]

In these debates regarding the importance of the visual arts to the everyday life of the cultured civilian, we encounter several hallmarks of the "public sphere," as laid out by Jürgen Habermas.[71] Notwithstanding the fact that Habermas's usage of the classical liberal model was limited to the late eighteenth and early nineteenth centuries, in the early twentieth-century administration and promotion of modern art in Hamburg, we can detect features of what he termed the "democratic bourgeois public sphere." Discourse was generated within the private domain and circulated through family-based salons and voluntary societies within civil society. Furthermore, at a time when adult suffrage excluded women—indeed, it was only in 1908 that an Imperial Law of Association permitted women's attendance of political meetings—Lichtwark openly encouraged women's participation in the Gesellschaft Hamburgischer Kunstfreunde, female membership far outnumbering the male (thirty-eight women to twenty men).[72]

These women rallied to his support during a major scandal of 1896, when Lichtwark was attacked as "unpatriotic" in conservative quarters of the Hamburger Kunstverein for his support of local artists such as Ernst Eitner.[73] In correspondence with her future husband, the notable art historian Aby Warburg, Mary Hertz, who was an artist and active in the Gesellschaft from its inception, defended Lichtwark and the new artistic tendencies.[74] In many ways this is understandable given the cruel feminization of early modernism in the Hamburg press, where a caricature entitled "Moderne Kunstmalerei" (Modern Artistic Painting), was represented as an unattractive elderly woman seated before a mirror, applying blush to her cheek.[75] The suggestion is that just as the ugliness of the older woman is repulsive to the male beholder, so, too, is modern painting.[76] Female spectators' intervention within this hegemony of "looking" was timely indeed.

Although Lichtwark was neither a staunch supporter of Expressionism nor of women's rights, his contribution toward establishing the discursive framework of the modern patron was of paramount importance within his lifetime. Like Tschudi, he stressed the values of empirical response to the work of art, however, the difference being that Lichtwark considered "aesthetic sensitivity" to be a matter of education and not class. Accordingly, while cultivating an informed "taste" among adults, he also laid the foundation for the reform of school education.[77] As we have seen in the case of Schapire, her experience of his lectures, organized by the upper-school board, spurred her interest in the visual arts. This involvement was not limited to single professional women; Luise Schiefler (1865–1967), wife of the district judge and collector of contemporary art Gustav Schiefler, actively engaged in promoting avant-garde artists. Upper-middle-class women's complex interaction with public life was therefore not sudden but contingent on the gradual embourgeoisement of culture and institutional reform that gathered pace during the nineteenth century. Let us now consider the role of the Frauenklub (Women's Club) as an arena where novel psychological experiences of modern subjectivity extended beyond the frame of the patriarchal, conjugal family. This section begins in the midst of a prominent corpus of male artists, who established an avant-garde group in Dresden but who sought out supporters and collectors further afield in the regional centers of Germany.

Women Networking

In the absence of arrangements with commercial galleries, the formation of communal artists' groups dedicated to self-sponsorship and the securing of alternative exhibiting venues is best exemplified by the Künstlergruppe Brücke. As architectural students in Dresden, Ernst Ludwig Kirchner, Erich Heckel, Karl Schmidt-Rottluff, and Fritz Bleyl banded together in 1905 both in order to promote shared aesthetic ideals and to create a viable studio existence. While their manifesto declared their commitment to the new epoch, to authenticity of approach in rejecting academic practice, they nonetheless recognized the need for reaching like-minded spectators. Thus, their words proclaimed: "With faith in progress and in a new generation of creators and appreciators, we call together all youth."[78] With such aims in mind, they recruited so-called passive members who, in return for a subscription (which started

169a and b Ernst Ludwig Kirchner, *The List of Passive Members of the Künstlergruppe Brücke*, 1906–10, woodcuts reproduced in the catalog of the *Brücke-Ausstellung* (Dresden: Galerie Arnold, 1910), Yale University Library, call no. 2008 1786

at twelve marks and later increased to twenty-five marks), received a membership card, an annual portfolio of prints, and an annual report. Invariably, these members remained long-standing patrons of the individual artists well after the Brücke disbanded in Berlin in 1913.

Whether or not the manifesto was intended to bridge the gender divide is debatable. Instructively, the majority of the passive members of the Brücke community recorded by 1910 were based in Hamburg, where networking among supporters was well entrenched. Of these, the district judge

Gustav Schiefler (1857–1935) was one of the earliest to be listed. In 1893 he became secretary of the Gesellschaft Hamburgischer Kunstfreunde, and his dedication served to set Lichtwark's ideas in motion.[79] Together with his wife Luise, Schiefler's home became a venue for cultural evenings, the so-called Schiefler-Abende, establishing a forum in which patrons, artists, writers, and performers could mingle. In a similar manner, he first met Emil Nolde in 1906 and was enlisted by Schmidt-Rottluff to promote the Brücke in the same year. Far from being a "passive" member,

Schiefler's friendly interest extended to preparing catalogs of the graphics of Nolde and Kirchner.[80]

Closer scrutiny of the membership (figs. 169a and b) reveals that eleven of the passive members based in Hamburg were women.[81] Not all the individuals fulfilled the "call to all youth," however, and ranged from the wives of the professional upper-middle class (Martha Rauert, 1869–1958, wife of the lawyer Paul Rauert) to practitioners (Minya Diez-Dührkoop, 1873–1929, the photographer). Single, professional women were also listed, such as Elsa Hopf (1875–1943), who had qualified in the United States and was one of the first women to practice as a dental surgeon in Germany. By 1910, together with her younger Jewish colleague Clara Goldschmidt (1886–1934), they set up a dental surgery in the Hamburger Esplanade. As feminists and lesbians, they flouted bourgeois conventions and became avid collectors of the Brücke after they were recruited by Schapire.[82] These observations signal that the residue of traditional salon-derived patronage was accompanied by the significant discourses of the demand for political equality and the role of the empowered female consumer.[83] Generally, those women involved in circles of patronage were active in groups raising awareness of feminist issues. Hence, the founding of women's clubs in regional centers with strong connections to the Allgemeiner Deutscher Frauenverein (General German Women's Association) contributed to the development of the modern woman patron and networking among its members.

In emulation of its London parallel, the German Lyceum Club was founded in Berlin in 1905.[84] The organization was dedicated to the assembly of professional women, not only to find a haven from the city but also to engage in intellectual and social activities within the urban context. As the architectural historian Despina Stratigakos has shown in this regard, the emphasis was on civic-mindedness and on consolidating influence in the public sphere, where women could learn to think democratically and access the language of diplomacy and statesmanship.[85] By 1912, the *Monatszeitschrift für das Gesamte Frauenleben unserer Zeit* (Monthly Magazine for the Entire Women's Life in Our Time) announced the existence of a cartel of eighteen women's clubs throughout Germany, with nearly eight thousand members.[86] However, listings in the

Jahrbuch der Frauenbewegung (Yearbook of the Women's Movement) of 1914 reveal that the women's clubs in Berlin and Hamburg, among others, preferred to maintain their independence from the cartel.[87]

In Hamburg, one of the future passive members of the Brücke, the notable art collector Bertha Rohlsen, established and became chair of the Frauenklub at the Antoine-Feillschehaus (Neuer Jungfernstieg 10) in 1906.[88] She was assisted in this endeavor by Ida Dehmel, of Jewish origin and a well-known supporter of the vote for women.[89] Having separated from her first husband in Berlin, Ida subsequently met the poet Richard Dehmel, and they led an unconventional bohemian existence before their marriage and move to Hamburg in 1901. Responding to a letter of invitation from Luise Schiefler, Ida Dehmel endorsed the need for a local Frauenklub:

> At one time I was asked and agreed to join the Berlin Lyceum-Club; this I leant toward although I never was in Berlin without [Richard] Dehmel. I consider such a club in Hamburg so necessary and beneficial in our foundation for the dignified improvement ("aufbesserungswürdigen") of Hamburg ladies, and I for my part have so often felt the absence of a really conducive social space in Hamburg, that I with the fullest conviction will not only participate but will even become a social member of the club.[90]

Clearly, the aim was to "elevate" the cultural and spiritual aspirations of bourgeois women by organizing literary events, recitals, exhibitions, and lectures—in that winter of 1906, one by Elizabeth Förster-Nietzsche. In the same year, exhibitions of both fine and applied art were organized, and Luise Schiefler delivered an informal lecture based on two of Emil Nolde's graphics drawn from their collection, which were circulated among the attendants for their perusal.[91] Comparable to men's clubs, here was a semi-private space that nonetheless functioned as a venue for the espousal of very public concerns, the promotion of core features of Bildung. Open to members all day, the club was a remarkable success, popular among upper-middle-class housewives, who paid an annual membership fee of thirty marks, as well as professional women, who contributed ten marks per annum.

Yet Dehmel noticed that the leveling achieved within such a community lent itself to prejudice, as she conveyed in a letter to her niece Marianne Neumaier in 1907. Apparently, the wife of a senator left the club so as not to risk sitting next to a modest teacher. Ida considered that this defeated its purpose and commented:

> When you think that the majority of women barely come out of the circle in which they were born, or in which they found their husband, so you can calculate yourself what a break this means for them now suddenly to become acquainted with dozens of women from totally other circles, and to hear their opinions . . . I have absolutely the feeling that the clubhouse is my house, the young women, the housewives, the committee ladies, all this is my disposition, and I am convinced that the other ladies feel likewise.[92]

Here Dehmel exhibits her critical distance in theorizing the makeup of the social group, the limitations of women confined to the domestic sphere, and her aspirations for them to overcome these barriers. It is noticeable, however, that her list of participants in the Frauenklub excludes proletarian women. In 1910, such prejudicial attitudes were sufficiently obvious to lead to the founding of a concurrent Hamburgischer Frauenklub association in Büschstraße dedicated to the interests of working women.[93] Evidently, the role of the Frauenklub, while conceived in relation to broader progressive feminist concerns, nonetheless referenced the constraining class and gender politics of Wilhelmine bourgeois society.

Ida Dehmel herself suitably represents this complex makeup of modern female identity in transition. As shown in the photograph of the Dehmel couple seated in the living room of their Parkstraße residence in the village of

170 Anonymous, *Richard and Ida Dehmel in the Living Room of Their Blankenese Residence, Hamburg*, 1905, photograph, private collection, Hamburg

Blankenese on the Elbe (fig. 170), the interior rejects the clutter of historicism, the chairs and bookcase evincing clear silhouettes and simplified contours consistent with the naturalizing elements of Jugendstil. Clearly, in having the furniture hand-built for their house, Dehmel followed the inspiration of architect designers such as Peter Behrens and Henry van de Velde. In this posed photograph, Richard's command of the domestic space is made explicit. While he is shown possibly reading poetry aloud, Ida is portrayed with hands in her lap, her gaze directed toward her partner. Functioning as listener or muse, her presence is essential to the omniscient power of male creativity, the design of her reform outfit furthermore betraying the hand of her husband.[94]

While assuming a subordinate position in her marriage, she nonetheless called for women to participate in modernizing politics and national renewal, and her subscription to notions of *Lebensreform* catered to her positive reception of Brücke artists. By 1910, under the auspices of Schapire, Ida Dehmel's correspondence with Schmidt-Rottluff was initiated when she received from him a vividly drawn postcard of a woman on the beach at Dangast.[95] Subsequently, she commissioned the artist to design a letterhead for Richard, as Schmidt-Rottluff had been inspired by his encounter with the couple and thereafter maintained a keen interest in Dehmel's poetry. While Ida Dehmel's tastes were transformed from Jugendstil to Expressionism via the networking of the Frauenklub, in the postwar years her activities were dedicated to establishing national and regional professional outlets for women artists as well as to the preservation of her husband's literary estate.[96]

The success of the Frauenklub in cultivating women's patronage of contemporary art, its nexus with feminism, and the rise of female consumerism can be gauged from Kirchner's interaction with the Jena milieu. Exhibitions of Brücke works at the Kunstverein Jena in February 1911, and Kirchner's contact with the philosopher Eberhard Grisebach and the art historian and archaeologist Botho Graef, secured a network of supporters and patrons in this university town.[97] Irene Eucken, wife of Rudolf Eucken, a Nobel Prize winner in 1908 and professor of philosophy at Jena University, was among a group of women who were active in the Gesellschaft der Kunstfreunde von Jena und Weimar (Society of Art Friends of Jena and Weimar). Already

in 1906, as secretary of the society, she was responsible for recruiting Ferdinand Hodler for the commission of the patriotic fresco *The Departure of the German Students in the War of Liberty against Napoleon* (1813). She was also taken sufficiently with Kirchner's works, viewed in solo exhibitions in Jena from early 1914 onward, to commission a painting of herself and her daughter Ida in the Euckens' music room, which captures a vital moment of contemporary social cohesion within the privacy of a cultured upper-middle-class domestic setting.[98] Appropriately, in his *Lebenserinnerungen* (Memoirs, 1921), Rudolf Eucken characterized his family's close ties with the art world as "a microcosm of the spiritual life."[99]

However, Irene Eucken was not only an astute businesswoman who had her own *Stickstube* (needlework salon), but she also exhibited her wares at the Kunstverein Jena along with Ada Nolde in 1910. Her professionalization of the Kunstgewerbe and connections with feminist organizations can be found in her sponsorship of a fashion show of her designs for the Bremer Frauenklub in 1916 (founded in 1908). Here she commissioned Kirchner to produce three color woodcut prints for her catalog (figs. 171 and 172). Indeed, he had taken this on at a time of intense psychological suffering after his military service, communicating as much in letters to Gustav Schiefler.[100]

Eucken's introduction ("Zur Einführung") to the catalog of fashion-ware has the impact of a manifesto in stating the following:

> For some years in Germany, we have been striving after an independent existence of fashion . . . To put striving into practice, however, we require now urgently the strong cooperation of creative artists. They must give us new forms and colors. They must teach us the application of our highly developed art and crafts, thus really portable, new dress models develop. Now, in my embroidery studio, some skillful artists will have the opportunity to bring their ideas to completion.[101]

Her sentiments demonstrate that awareness and sponsorship of modernist manifestations in Germany extended beyond the realms of fine art production to embrace the commercial. This in itself was not uncommon in view of

171 Ernst Ludwig Kirchner, *Title Page of Catalog for Exhibition of Dresses from the Needlework Salon of Mrs. Eucken*, 1916, color woodcut on paper, 17.3 × 11.5 cm, Los Angeles County Museum of Art, the Robert Gore Rifkind Center for German Expressionist Studies, Los Angeles, M.82.288.136a–c

172 Ernst Ludwig Kirchner, *Woman with Dog*, 1916, color woodcut on paper, 17.1 × 11.7 cm, Los Angeles County Museum of Art, the Robert Gore Rifkind Center for German Expressionist Studies, Los Angeles, M.82.288.136b

the aspirations of Jugendstil at the turn of the century and what we have seen of Osthaus's efforts to inspire contemporary artists to engage in trade and the applied arts. Interestingly, in Berlin, Kirchner and Pechstein had attempted to extend their involvement in tutoring the decorative arts when launching their Institut Moderner Unterricht in Malerei in November 1911. Kirchner's and Heckel's contribution of decorative work to the chapel at the Sonderbund exhibition in Cologne in 1912 has been charted elsewhere, as has Kirchner's foray into the world of commerce through commissions for the Cologne Werkbund exhibition in 1914.[102] Yet Eucken's words resonate with a Nietzschean-derived emphasis on the importance of eter-

nal striving for personal expression and of her centrality to the enterprise: her attempt to promote originality and authenticity in modern German fashion through reference to a contemporary and vital artistic practice.

The setting of Eucken's fashion show in a Frauenklub poses the question as to whether Kirchner's woodcuts responded to the challenge of giving voice to the conjunction between avant-garde art, fashion, and feminism. In his scholarly essay, "Ernst Kirchner's Streetwalkers: Art, Luxury, and Morality in Berlin, 1913–16," art historian Sherwin Simmons demonstrates how Kirchner's interests in fashion and advertising infused his major paintings of prostitutes in metropolitan Berlin. However, transposed to

173a and b Anonymous, *Irene Eucken Modeling Her Own Designs*, ca. 1900, photographs, Thüringer Universitäts- und Landesbibliothek Jena, Nachlass Rudolf Eucken III/5

the context of an elite woman's club and the limitations of a commission, Kirchner was confronted with experiences distinct from what he considered his true vocation.[103] Certainly, photographs of Eucken modeling her own designs give us some insight into Kirchner's departure (figs. 173a and b).[104] On the rear of the photos, Eucken noted in pencil that these were designs for "Strassenkleider," clothing for the everyday, made from what we would consider rather extravagant materials (black moiré-patterned taffeta, black tulle, and feathers).[105] In his prints, Kirchner preserved the clipped-in waist and overall balance of verticals and curves; indeed, his attention to abstract ornament is consistent with Eucken's rich, silk-embroidered textures and unusual

accessories on the hat. Typical of his woodcut technique at the time, the angular striations reference both African art and German medieval sources, investing the compositions with an overall somber and mysterious mood arguably different from the streetwalkers.

Whether in Hamburg, Jena, or Bremen, the Frauenklub facilitated women's acculturation at a crucial moment for the positive reception of the Künstlergruppe Brücke in regional cities. In her study of provincial modernity and the Hamburg context, the historian Jennifer Jenkins illuminates how local institutions and voluntary associations were spurred to reinvent cultural traditions.[106] Although the Frauenklub is unmentioned in her study, the evidence suggests that their formation and outcome were implicated in the circuitous development of structural change. Schapire's activities as an art historian, critic, patron, and collector similarly reveal a self-conscious resoluteness about her role in modern life. In the following section, I trace how her

networking and art criticism in Hamburg helped to establish Nolde's Expressionist credentials, a relationship that proved brief, nonetheless. Schapire's lifelong promotion of Schmidt-Rottluff—as painter, sculptor, printmaker, and designer—testified to a deep understanding of his creative development. This led to a unique assemblage of his oeuvre in Schapire's private residence, which defined not only her identity, social, and cultural status, but also advanced her theories on Expressionism as a dialogical engagement with the art object.

Schapire's Expressionism

That Rosa Schapire managed to sustain her indefatigable energy as a freelance art historian in Hamburg was an impressive achievement. She was well equipped to brave her outsider status through her upbringing, feminist, and socialist beliefs. Born into an upper-middle-class Jewish family in Brody, Galicia—her father established a savings bank—she was the second youngest of five daughters.[107] Schapire's parents provided their daughters with a rich cultural milieu that encouraged independence; their secular private schooling and aptitude for languages facilitated their emigration beyond the bounds of the area.[108] After obtaining her *Abitur* in Hamburg, Schapire pursued an undergraduate degree in Bern; while there, she published the essay "Ein Wort zur Frauenemanzipation" (A Word on Women's Emancipation), which was devoted to the theme of sexual politics.[109]

Therein, she was critical of Laura Marholm (1854–1928), the Latvian-born feminist who was representative of a type of bourgeois feminism that advanced a separate domain for womanhood based on motherly instincts, "if not in the flesh, then the mind and soul."[110] Fiercely anticapitalist, Schapire promoted socialism as the remedy to the so-called women's question. Only in such a state, she contended, was it possible for both sexes to become comrades in confronting the future.[111] Schapire never married and she retained a strong commitment to socialist utopianism, one that was founded upon intellectual and artistic endeavor.

Following the official admission of women to pursue art-historical studies at Heidelberg University, Schapire conducted doctoral research there under Henry Thode

(1857–1920).[112] Although her thesis was devoted to the eighteenth-century Frankfurt landscapist Johann Morgenstern, her interests thereafter turned to promoting contemporary German art. Clearly, she had managed to keep her distance from the conservative views of Thode who, as a Romanticist and lover of Wagner's music, had labeled French modernism and the "cabal" around Max Liebermann as inimical to the national interest.[113] Schapire returned to Hamburg and, during 1905, sought advice from Aby Warburg (1866–1929) about possible outcomes for her thesis and an itinerary for traveling in Italy.[114] By late 1907, she was the only female member of the local committee of the International Congress of the History of Art, which held its meeting in Darmstadt. Interestingly, in reporting from this event, Warburg's correspondence with his wife Mary reveals that he considered Schapire to be "naive" and her behavior "strange" and "affected," the latter remark often repeated in this elite group.[115] As was necessary in a male-dominated discipline, perhaps Schapire stood her ground in a performative manner and this upset the status quo.[116] Yet her writing shared a mutual position with the Hamburg school.

The art historian Emily Levine has made a study of the German Jewish circle of Warburg, Ernst Cassirer, and Erwin Panofsky.[117] She stresses the importance of the ideas of Hermann Cohen (1852–1918), a leading exponent of neo-Kantianism in Marburg, to their epistemological framework. Cohen honed in on Kant's observation that in our knowledge of the world, the mind does not conform to objects but rather objects conform to the mind.[118] Whatever the drawbacks to this philosophy, as Levine elucidates, by incorporating both subject and object in a coherent system, Kant claimed to have bridged the great divide between empiricist and idealist philosophy. As will be shown, this synthesis underpins Schapire's reviews of the works of both Nolde and Schmidt-Rottluff, and renders them invaluable to the historiographic emergence of Expressionist theory.

Her introduction to the work of the Brücke artists probably occurred at the evening gathering of the Frauenklub when Luise Schiefler circulated two of Nolde's woodcuts among the attendants. Between February 1906 and November 1907, Nolde was an active member of the Brücke, and Schapire was recruited to its circle of patrons. In July 1907, Nolde held his first major exhibition

174 Emil Nolde, *Winter*, 1907, oil on canvas, 75 × 88 cm, Ada- und
Emil Nolde-Stiftung, Neukirchen, Wvz. Urban 200

of paintings and drawings at the Commeter Gallery, a
long-established dealership in the center of Hamburg.
He was delighted with a review that Schapire wrote of
his works, as he conveyed to Gustav Schiefler: "A quiet,
almost childlike naturalness is my own and I treasure it as
my dearest asset. That Fräul[ein] Sch[apire] immediately
perceived this touched me so warmly."[119] Nevertheless, on
perusing Schapire's article, one of the first to concentrate
solely on the forty-year-old, unknown artist, we encounter
a narrative that portrays Nolde as a keen strategist rather
than an untrained genius.

In these years, Nolde was in search of his own style
of painting, and he competed with his younger col-
leagues in the Brücke. As with them, color was his main
expressive medium, and he was drawn to the French
Post-Impressionists, in particular Van Gogh. According
to Schapire, though, unlike the latter, who strove to bring
together line and color and develop them simultaneously,
"the painter Nolde strives and achieves quite different
effects than the draftsman . . . color, pure, glowing, lumi-
nous color is the secret of his pictures. They are of dazzling
brightness, form is expressed through color."[120] One of the
exhibits she cited in this analysis was the landscape *Winter*
(fig. 174), which Nolde painted in Jena in early 1907. At
that time, he was visiting his patrons Hans and Nelly Fehr
in Cospeda, who subsidized the artist's rent in a nearby

apartment.[121] We can agree with Schapire that it is a work of "intense luminosity," comprised of bold, variegated brushwork, which "envelops people and things and takes on its own life."[122] Indeed, alongside a concurrent sketch that he included in a letter to his wife, Nolde wrote, "That's what my new picture looks like. A man goes uphill in the dim light in the snow and mud. The mood is wet and cold. The colors are blue-green-purple."[123] Underpinning Nolde's technical radicalism lay his theoretical experimentation with unusual complementary color combinations to achieve a tactile *Stimmung* (mood).

We have to remind ourselves that Schapire was writing at a time when the terminological apparatus of Expressionist criticism was far from routine. Of course, her methodology had its basis in *Geistesgeschichte* (cultural or intellectual history of ideas), as she stated: "Every age with a strong artistic drive has its own characteristic expressive formula . . . Impressionism, like any art form, leads to convention."[124] Her task was to introduce an audience, schooled in Lichtwark's promotion of French, German, and Scandinavian Impressionism, to a new, strenuous type of viewing. In contrast to the optical mixture that occurs in looking at Impressionist painting, in Nolde's work, "[t]he process of transformation that the object undergoes through the artist's psyche becomes tangibly distinct. It is a fast and feverish creativity, certainly neither easy nor happy. Blood and sweat stick to the work."[125] Here the opposition between *Eindruck* (impression) and *Ausdruck* (expression) is made clear; rather than conveying mere optical sensation, the cognitive dissonance of the artwork arose via the mental image of the object. It is understandable why Nolde was so appreciative of her efforts when he welcomed Schapire to her membership of the Brücke.[126]

In the interim, Nolde kept her informed of his experimentation with different types of graphic processes, and Schapire was no less diligent when it came to encouraging these.[127] According to Ada Nolde, the "extraordinarily intelligent" Schapire visited them in Berlin in December 1907 and was arranging a chronological exhibition of Nolde's graphics, at which she would also deliver a lecture.[128] An article published for a Swiss audience devoted attention to his etchings, woodcuts, and lithography in which she explored how Nolde perhaps achieved even more direct effects than in his painting, thanks to the black-and-white medium that rendered the creative process more swiftly.[129] Nevertheless, after March 1908, epistolary contact between Schapire and Nolde came to a sudden halt.

Having left the Brücke and joined the Berlin Secession between 1908 and 1910, Nolde's paintings received fierce critical reception and this exacerbated his feelings of alienation and victimhood.[130] His final letter to Schapire makes for uncomfortable reading as Nolde wrote of his dedication to the struggle of initiating a second period of great German art—the first obviously being the age of Grünewald, Holbein, and Dürer.[131] From his arrogant, national emphasis, we detect a hardening of Nolde's intolerance toward Jewish protagonists in the art world. This viewpoint is consolidated in the second volume of his autobiography, published in 1934 at a watershed moment in his support of Nazism, wherein Nolde openly proclaimed that the breakdown in the relationship with Schapire was due to his anti-Semitic prejudices: "The fast-growing friendship between her and us soon collapsed again. Only ashes remain. Gone with the wind. In art it was my first conscious encounter with a person different from me . . . Jews have a lot of intelligence and spirituality, but little soul and little creative talent."[132] The acceptability of stereotypes of Jewishness in cultural discourse was not a sudden phenomenon, however, but stemmed from centuries-held attitudes and perceptions of their outsider status in German society.[133] Moreover, during the First World War, spurious propaganda questioned the loyalties of the almost 100,000 German Jews who wore the uniform of the imperial army.[134]

In establishing Schapire's patronage of Schmidt-Rottluff, the research is unfortunately hampered by the fact that they destroyed their correspondence—from the years 1908 until 1939—due to surveillance in the Third Reich.[135] Gerhard Wietek's publications are the most helpful in documenting their relationship, particularly after their encounter in Dangast in 1908.[136] A resort in lower Saxony on the North Sea, Dangast became a favored summer retreat for Schmidt-Rottluff and Heckel between the years 1907 and 1912. While not an artists' colony in the sense of Worpswede, it was within easy reach of Oldenburg, the regional capital where they exhibited graphics as members of the local Künstlerbund.[137] The talented woman artist Emma Ritter (1878–1972), a native of this

city, recalled working alongside Schmidt-Rottluff in Dangast, producing hand-printed woodcuts.[138] She listed his other activities as well: the painting of postcards, carving of woodblocks, and small objects. It is worth recalling that the architectural training of members of the Brücke at the Dresden Technical University offered a wide range of courses, which included interior design, in addition to the historical and practical aspects of the applied arts.[139]

Schapire, too, was committed to the art-historical value of material culture and to its display for a wider public, having established contact with Justus Brinckmann, director of the Museum für Kunst und Gewerbe in Hamburg, as well as his assistant at the time, Max Sauerlandt.[140] A postcard that Schmidt-Rottluff sent to Schapire, *Preparatory Study for a Pillow Slip* (fig. 175), alerts us to his engagement with rugged Jugendstil-like design for the domestic environment and of his patron's interest therein.[141] In 1909, as a gift for her thirty-fifth birthday, he presented her with a carved and incised wooden box bearing a comparable symmetrical and curvilinear composition with painted relief (fig. 176). He sought out the basic form of the box from Wilhelm Voge (1879–1970), a Dangast-based cabinetmaker, who was also responsible for providing the artist with wooden frames to carve in relief for his paintings.[142]

In 1911, at a time when the Brücke still nurtured the idea of group identity, a large solo exhibition of Schmidt-Rottluff's oil paintings, watercolors, lithographs, and drawings was launched at the Commeter Gallery in Hamburg; on this occasion Schapire delivered a lecture that attracted interest, albeit skeptical of her keen endorsement of the artist.[143] In the same year, he exhibited fifteen of his carved wooden boxes at the same venue; Schapire reviewed both exhibitions, summarizing her thoughts as follows: "It is not the imitation of nature that is sought but the mystery is revealed, which hides behind the seemingly inanimate matter . . . This art stirs up deep concealments."[144] Schapire's idealist reading of his oeuvre was consistent but her excitement lay in his applied art, and she was one of the first patrons to encourage Schmidt-Rottluff's engagement in this practice. She admired the *ausdrucksvolle* linear elements in his carved boxes, which reminded her of peasant art, particularly of painted wooden sculpture from Peru or Mexico.[145] We can be sure that she was well aware of Worringer's *Abstraktion und Einfühlung* (Abstraction and Empathy, 1908) in endorsing the psychic uneasiness conveyed by the brutal, elemental mysticism of the ornament, yet Schapire always accompanied such concepts with firm analysis of the gestalt experience. According to her, notwithstanding the strength of the cubic form, the richness of the colored planes altered the shapes of the boxes, introducing new laws of their relationship to the whole, which, Schapire stated, could only be detected by the cultivated eye.[146]

175 Karl Schmidt-Rottluff, *Postcard Containing Preparatory Study for a Pillow Slip*, September 9, 1909, inks and brush on paper, 9 × 14 cm, SHMH-Altonaer Museum, Hamburg, Inv.-No. 1963–270e (formerly in possession of Dr. Rosa Schapire)

176 Karl Schmidt-Rottluff, *Ornamental Four-Sided Wood-Carved Box*, 1909, wood-carved relief on brown background with black, white, and red color, 14 × 27 × 22 cm, Lentos Kunstmuseum, Linz (formerly in possession of Dr. Rosa Schapire)

177 Karl Schmidt-Rottluff, *Wooden Chest with Incised Abstract Planes*, 1912, painted wood (green, white, yellow, blue), 54 × 98 × 57 cm (depth), private collection (formerly in collection of Dr. Elsa Hopf)

Sharing similar aesthetic values, her close friend Elsa Hopf purchased an example from the exhibition.[147] Moreover, almost a decade before the artist designed the furniture for Schapire's apartment, Hopf commissioned Schmidt-Rottluff to produce a wooden chest (fig. 177), which reveals a remarkable economy of means, bold abstraction, and coloration, anticipating his Cubist orientation in 1912. Given the limitations of space in his temporary studio in Kleine Johannisstraße 6, Hamburg, Schmidt-Rottluff had the chest built by the cabinetmaker, collector, and interior designer Jack Goldschmidt (1892–1979) and this piece is one of the earliest outcomes of their collaboration. The artist's irregularly shaped, beaten metal jewelry was equally in demand, becoming integral to Schapire's distinctive and unpretentious attire, as well as to Luise Schiefler's, following Schmidt-Rottluff's exhibiting of his gold ware at the Cologne Sonderbund exhibition in 1912.[148]

For Schapire, as well as for other women patrons in the Frauenklub circle, Schmidt-Rottluff's designing of letterheads and envelope insignias (figs. 178–81) invested the rituals of letter writing with ceremony and destiny, marking their command of language and planning for the future. Importantly, his woodcut for the Brücke "passive membership" cards (fig. 182) bore the signature of the patron within the artifact, symptomatic thereby of both difference and belonging to a sociological subculture. His portrayal of the female nude typified the Brücke celebration of *Freikörperkultur* (nudism) and objectification of the woman's body as passive and natural; the angular stylization relates to the painted relief carving as found in the collection of house beams from the Palau Islands in the Dresden Ethnographic Museum.[149] Produced from three separate wooden blocks, the prints reveal traces of the grain and highlight the importance of the Oceanic prototype as the departure for Schmidt-Rottluff's early woodcuts.

From 1912 onward, as witnessed in the installation program of the Folkwang Museum in Hagen, the connections between "avant-garde" modernism and primitivism were made explicit. An important catalyst for Schmidt-Rottluff was the Hamburg-based art historian and poet Wilhelm Niemeyer (1873–1929), who had visited Paris in late 1911 and become an important conduit for the reception of Cubism in Germany. Schmidt-Rottluff's knowledge of African art and Cubism came to a climax in a series of monumental woodcut portraits, as in *The Portrait of R. S.* (fig. 183), made prior to Schmidt-Rottluff's call-up for army

178 Karl Schmidt-Rottluff, *Letterhead Design for Rosa Schapire*, 1912, woodcut on paper, 16.8 × 12.4 cm, Prints, Drawings, and Painting Collection, Victoria and Albert Museum, London (formerly in collection of Dr. Rosa Schapire)

180 Karl Schmidt-Rottluff, *Seals for Envelopes for Dr. Elsa Hopf*, 1912, woodcut on paper, 3.8 cm diameter, Prints, Drawings, and Painting Collection, Victoria and Albert Museum, London (formerly in collection of Dr. Rosa Schapire)

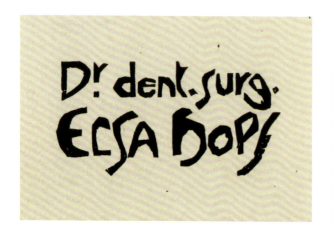

179 Karl Schmidt-Rottluff, *Visiting Card for Dr. Elsa Hopf*, 1912, woodcut on paper, 6.6 × 13.5 cm, Prints, Drawings and Painting Collection, Victoria and Albert Museum, London (formerly in collection of Dr. Rosa Schapire)

181 Karl Schmidt-Rottluff, *Seals for Envelopes for Martha Rauert*, 1912, woodcut on paper, 3.8 cm diameter, Prints, Drawings, and Painting Collection, Victoria and Albert Museum, London (formerly in collection of Dr. Rosa Schapire)

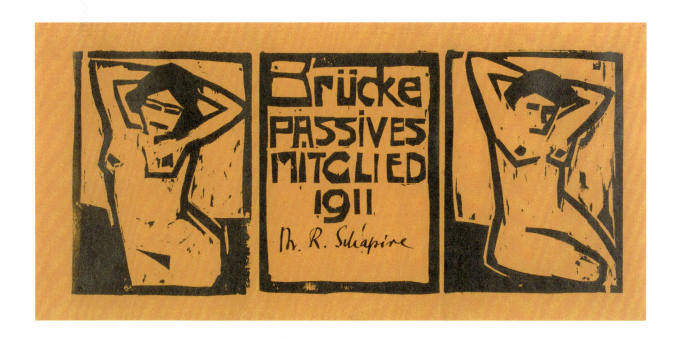

182 Karl Schmidt-Rottluff, *Brücke Passive Membership Card for Dr. Rosa Schapire*, 1911, woodcut printed on orange-tone paper, 21.3 × 44.5 cm, Prints, Drawings, and Painting Collection, Victoria and Albert Museum, London (formerly in collection of Dr. Rosa Schapire)

service in May 1915. One of the seven oil paintings from Schapire's collection, *Woman with a Bag* (fig. 184), also originated from this period.[150] Both works testify to the impact of African sculpture in the proportionally enlarged heads, the extended cheeks, and the attenuated noses common to West African masks. Whereas the volumetric effects are translated into two-dimensional terms in each example, the angular facets and deep striations in the woodcut forge an austere portrait of Schapire, which, as Robin Reisenfeld notes, registers the ambivalences of their society in including physiognomic traits of the "hooked nose."[151] Just as the image of the modern Jewish woman patron as racially "Other" is heightened by the "primitivist" reference, so in the painting the masked head transforms the fashionable European woman, bearing up-to-date accessories, into a figure of melancholic alterity.

In March 1915, in a letter to a former Brücke patron Ernst Beyersdorff, Schmidt-Rottluff wrote convincingly of his aesthetic credo before he was stationed in Russia: "The war has literally swept everything away from me—everything seems dull and I suddenly see things in their terrible violence. I have never made the art that was a beautiful stimulus to the eye . . . and I realize fundamentally that you have to resort to even stronger forms, so strong that they can withstand the force of such peoples' madness."[152] Recollecting her acquisition of the painting *Woman with a Bag*, Schapire considered it to represent, "in its tragic expression and dark colors one of the most impressive documents of the misery of the war."[153]

Schapire's publications and her civic activities during wartime sustained a commitment to internationalism; indeed, as we have seen, she was critical of Paul Fechter's efforts to harness Expressionism to the "metaphysical necessity of the German people."[154] In 1916, along with Ida Dehmel, Schapire cofounded the Frauenbund zur Förderung Deutscher Bildenden Kunst (Women's Society for the Advancement of German Art), which sponsored contemporary art in Hamburg.[155] While working within the framework of patriarchal institutions, and due to the privations of war and a reduction in purchasing budgets of galleries and museums, Schapire considered it essential for the Frauenbund to donate works as gifts to the state. This was necessary so as to protect the freedom of artistic creativity from both officialdom and the general public who, strengthened by the political situation, would censor acquisitions that exhibited foreign influences.[156] Thereby,

the Nietzschean ideal of cultural renewal could be achieved through constant reference to a living, creative tradition.[157]

Evidently, Schapire considered it urgent to mitigate the reactionary forces in cultural politics and, indeed, we learn from art historian Aya Soika that Schmidt-Rottluff, like many of his peers, was not immune to anti-Semitic views. So, he declared, in an undated letter to Niemeyer, that the Jews, "who have the money," and the Social Democrats, "who have none," were a "new danger in the country."[158] Soon after his recruitment, however, his chauvinism was mollified as he discovered common ground with the enemy's soldiers. He wrote to Curt Hermann, "If I hang around in Russia for a long time, all my patriotism and German pride run the risk of being shattered—I really like the Russian landscape with its great Slavic dreaminess."[159] From September 1916, while he was stationed at the

183 Karl Schmidt-Rottluff, *Portrait of R. S. (Rosa Schapire)*, 1915, woodcut on paper, 61 × 47 cm, Lentos Kunstmuseum, Linz (formerly in collection of Dr. Rosa Schapire)

184 Karl Schmidt-Rottluff, *Woman with a Bag*, 1915, oil on canvas, 95.2 × 87.3 cm, Tate Gallery, London (presented by Dr. Rosa Schapire in 1950)

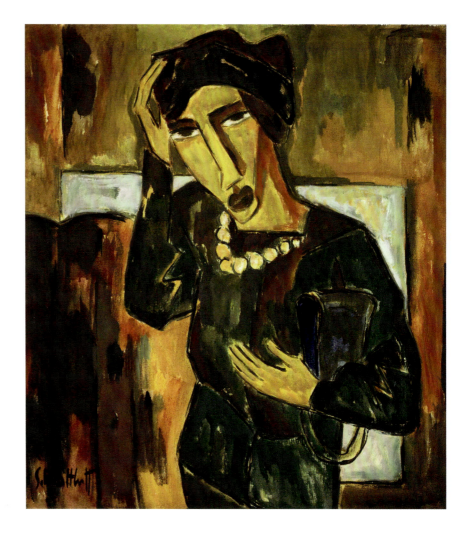

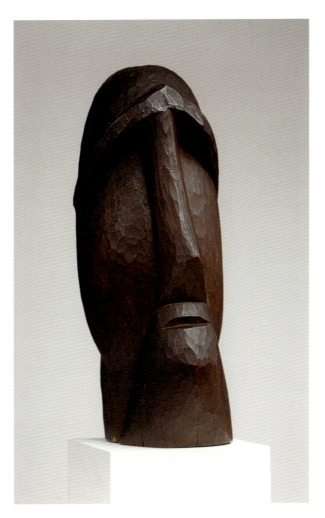

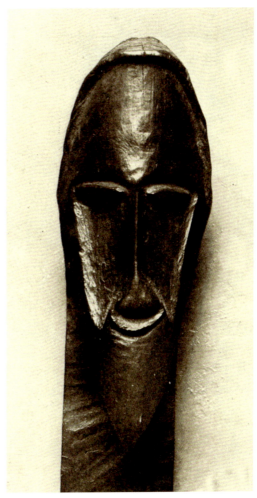

185 Karl Schmidt-Rottluff, *Male Head*, 1917, poplar wood, originally painted red and overpainted with brown, 34.9 × 13.3 × 16.5 cm, Tate Gallery, London (formerly in collection of Dr. Rosa Schapire)

186 *Nigerian (?) Wooden Head*, illustration 4, in Carl Einstein, *Negerplastik* (Leipzig: Verlag der Weissen Bücher, 1915), 34

censor's staff office in Kovno, Lithuania, Schmidt-Rottluff found a particular affinity with the local peasant culture, and he experimented with three-dimensional wooden sculpture. Concurrently, Schapire's acquaintance with and review of Carl Einstein's book *Negerplastik* (Negro Sculpture) introduced Schmidt-Rottluff to the views of this influential cultural commentator, and many of the illustrations in this book inspired the artist's carvings.[160]

A case in point is his imposing *Male Head* (fig. 185),

one of eight sculptures that Schapire acquired for her collection. It obviously relates to the photograph of a *Nigerian (?) Wooden Head* (fig. 186), as reproduced in Einstein's book; both works share a bulbous chin and thickened neck that maintain the girth of the tree trunk into the head.[161] Schmidt-Rottluff's primordial form, exposing blatant chisel marks, its eyes closed beneath a heavy brow, has a brooding presence, albeit that it was originally stained an alarming red color before being overpainted in brown.[162]

The importance of Einstein's book for the Expressionist generation has been well rehearsed in the literature and the origins and characteristics of the photographic material sedulously traced.[163] Schapire was equally taken with the reproductions; according to her review, they exhibited the high quality of African sculpture, masks, and everyday objects normally hidden in ethnographic collections and

187 Emil Maetzel, cover design for the catalog of the *First Exhibition of the Hamburg Secession*, 1919, electrotype from 1919 woodcut on card, 18.5 × 14 cm, Warburg-Haus-Archiv Hamburger Kunst/Archive of Art in Hamburg

was challenged by the formation of Kräfte (Forces) in 1919, a branch of the Berlin Novembergruppe, and by the group known as the Hamburg Secession. Schapire joined the Secession as a literary member and dedicated herself to cultivating the "newest Expressionist art." Emil Maetzel (1877–1955) and Dorothea Maetzel-Johannsen (1886–1930), a prominent artist couple in the Secession, were thoroughly versed in Expressionist primitivism and in the use of the woodcut as a medium to promote the exhibitions of the group (fig. 187).[165] In the intervening years, the Hamburger Kunsthalle had cautiously pursued new purchases, such as the acquisition of Franz Marc's *Mandrill* (1913) in 1918, which generated intense public controversy. These were nonetheless prominently displayed in a hall of Expressionist works.[166] The completion of the new section of the Kunsthalle, started in 1911 under Lichtwark, was opened to the public in 1919. Gustav Pauli, the director since 1914, commissioned second-generation Expressionists—members of the Hamburg Secession—to decorate the interior.[167] Here we do discover that Warburg and Schapire shared an important commitment to German Expressionism in their support of Pauli, who recruited both art historians to his cause.[168] Schapire also favorably reviewed Pauli's monograph on Modersohn-Becker and indicated that her own manuscript on the "creatively talented woman" would be published in the autumn, a project that never matured, however.[169]

Assisted by the media explosion of the early Weimar period, Schapire acted as coeditor and contributor to two Expressionist broadsheets featuring original prints, literature, and reviews—*Die Rote Erde* (The Red Earth; fig. 188) and *Kündung* (Announcement; fig. 189).[170] In both cases, Schmidt-Rottluff was commissioned to create the title pages, and his inventive "Wortbild" woodcuts attempted to preserve the integrity of the artifact, notwithstanding the implications of the print run.[171] As with the other former Brücke artists Pechstein and Heckel, Schmidt-Rottluff served on the executive committee of the Arbeitsrat für Kunst, founded in Berlin in November 1918. Sharing in the messianic fervor for the arts and institutional reform, Schmidt-Rottluff responded to a questionnaire that was distributed by the Arbeitsrat, endorsing the call for the dissolution of the academies.[172] He argued for the freedom of the artist in a socialist state and, harking back to his

only appreciated by a small circle of people, who saw in them the departure for a great modern art. But she was extremely critical of the author's formalist methodology: "Since only a few Benin pieces are dated, Einstein refrains from classifying things historically, he does not determine the sculptures according to their locality . . . On the whole, the author, 'trying to testify about African sculpture, appears rather hopeless.'"[164] Schapire recognized Einstein's book as steeped in the aesthetics of European avant-gardism and, with postcolonial foresight, criticized the ahistorical foundation of his project.

In Hamburg, in the wake of the November Revolution of 1918, a purely advisory body, the Künstlerrat, was formed to provide the city council with suggestions for assisting artists. The largely conservative Kunstverein

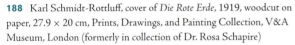

188 Karl Schmidt-Rottluff, cover of *Die Rote Erde*, 1919, woodcut on paper, 27.9 × 20 cm, Prints, Drawings, and Painting Collection, V&A Museum, London (formerly in collection of Dr. Rosa Schapire)

189 Karl Schmidt-Rottluff, cover of *Kündung*, 1920, woodcut printed in red on wove paper, 30.8 × 23.8, Los Angeles County Museum of Art, the Robert Gore Rifkind Center for German Expressionist Studies, purchased with funds provided by Anna Bing Arnold, Museum Associates Acquisition Fund, and deaccession funds, Los Angeles, 83.1.1059a

architectural training, devised an "Ideal Project," a "construction of a town in the mountains" that would cater to a new Christian community. Within this context of spiritual utopianism, Schapire published an essay in *Die Rote Erde* on Schmidt-Rottluff's religious woodcuts, a series devoted to the "Life of Christ," which was published in a portfolio of nine sheets by Kurt Wolff (fig. 190) at the end of the war.[173] This essay offers further insight into Schapire's distinctive and idealistic Expressionist critique.

Schmidt-Rottluff turned to biblical subject matter while still based in Kovno at a time of extreme war weariness, the most potent example of the series being *Christ* (fig. 191), a woodcut of Christ's head with the year 1918 emblazoned on his brow. Drawing on the transnational appeal of the Russian icon tradition and an amalgam of

African and Gothic referents, Schmidt-Rottluff portrayed Christ's face with one eye open, the other closed, directed toward inner vision.[174] Image and text are deployed to address a vital question to the viewer: "Did not Christ appear to you?" Yet, to Schapire, neither the artist's bitter war experiences nor his theological admonitions were relevant to the ecstatic millenarianism generated by the portfolio. In powerful black-and-white planar woodcuts, as in *Christ and Judas* (fig. 192), the meaning was distilled and transmitted in the confrontation of large single heads: "Judas purses his lips for the kiss, while Christ, with wide[-]open all perceiving eyes, calmly takes his fate unto himself."[175]

The narrative's transcendence above earthly suffering was a mark of their revelatory and true artistic quality, a

190 Karl Schmidt-Rottluff, *Nine Woodcuts*, title page, 1918, woodcut on wove paper, 35 × 50 cm, Los Angeles County Museum of Art, the Robert Gore Rifkind Center for German Expressionist Studies, Los Angeles, M.82.288.269

191 Karl Schmidt-Rottluff, *Christ*, 1918, woodcut on wove paper, 35 × 50 cm, Los Angeles County Museum of Art, the Robert Gore Rifkind Center for German Expressionist Studies, Los Angeles, M.82.288.270

192 Karl Schmidt-Rottluff, *Christ and Judas*, 1918, woodcut on wove paper, 39.7 × 50 cm, Los Angeles County Museum of Art, the Robert Gore Rifkind Center for German Expressionist Studies, Los Angeles, M.82.288.266

193a *Dr. Rosa Schapire's Living Room, Osterbekstraße 43, Hamburg*, with furniture by Schmidt-Rottluff (1921) and his painting, *Women with a Bag* (1915), after 1924, photograph, Nachlass Olga Zuntz, London

193b *Dr. Rosa Schapire's Living Room, Osterbekstraße 43, Hamburg*, detail of table, after 1924, photograph, Nachlass Olga Zuntz, London

characteristic that Schapire linked to the aesthetic ideas of Jewish philosopher Martin Buber (1878–1965).[176] She quoted the following from his essay "Leistung und Dasein" (Performance and Existence): "According to a beautiful saying of Buber's, quality in the work of art only ensures admission into the 'outer circle'; in the 'inner' [circle], however, 'are the works that have shaped the meaning of the world.'"[177] As one of his early pieces, written in 1914, Buber's essay appeared in a collection entitled *Ereignisse und Begegnungen* (Events and Encounters, 1917).[178] Offering a foretaste of postmodern decentering of the author, Buber was keen to emphasize that a work of art should not be assessed according to artistic intention or morality but by its qualities; indeed, he stated, "in its inner becoming, control and decision only fall upon the artist, who is worthy of his work."[179] In a seminal biography of Buber, Maurice Friedman observes that it is in this volume of essays that we find the link between Buber's philosophy of realization and his philosophy of dialogue, the move between the passive experience of the senses and recognition of the irreducible incarnation of the spirit.[180]

Schapire's concept of Expressionism, as with Buber's embrace of the dialogical, was deeply indebted to Cohen's brand of neo-Kantianism and the belief that history progresses toward an ideal goal. Her contention that "through the power of ecstasy, the door was opened to the Third Reich" should not be interpreted in any pre-Nazi sense but as affirmation of a third realm that was seen as both "deeply human and shaped as divine."[181] Such adulation of Schmidt-Rottluff's woodcuts was accompanied by Schapire's steady acquisition of his graphic oeuvre of more than six hundred sheets (by 1939), as well as by her publication of a catalogue raisonné, which remains in use until this day.[182] In 1921, as her patterns of collecting escalated, she commissioned Schmidt-Rottluff to design her apartment as a total entity.[183] Views of the living-room interior (figs. 193a and b; fig. 194) in Osterbekstraße 43, in the Barmbek district of Hamburg, testify to the integration

194 *Dr. Rosa Schapire's Living Room, Osterbekstraße 43, Hamburg,* with furniture by Schmidt-Rottluff (1921), assorted sculpture and carved reliefs, after 1924, photograph, Nachlass Olga Zuntz, London

of art and life, and to the aesthetic unity of applied and fine art, whether sculpture, relief, or easel art.

The furniture was designed by Schmidt-Rottluff and executed in the workshops of Goldschmidt in Hamburg. Their shapes were simple and geometric, controlling the organic configuration appropriated from various primitive sources and the strident coloration of yellow, brown, and ultramarine blue.[184] The walls were painted in green distemper and the woodwork of the windows and doors in

black. It is not difficult to see how important the utopian setting was to Schapire's core of existence, feminism, and patronage.[185] Yet she was not immune to having photographs of the interior made up as postcards to circulate among friends and acquaintances, her colleague from Berlin, Olga Zuntz, having assisted in the photography.[186]

Particularly during the Weimar years, when suffrage was extended and women explored a modern, self-determined identity, Schapire must have presented a problematic and commanding image, which male artists in her circle had to negotiate. Schmidt-Rottluff's *Portrait of Rosa Schapire* (fig. 195) dates from her attendance of a social gathering in the summer of 1919 in Hohwacht, on the Baltic coast, soon after Schmidt-Rottluff's marriage to

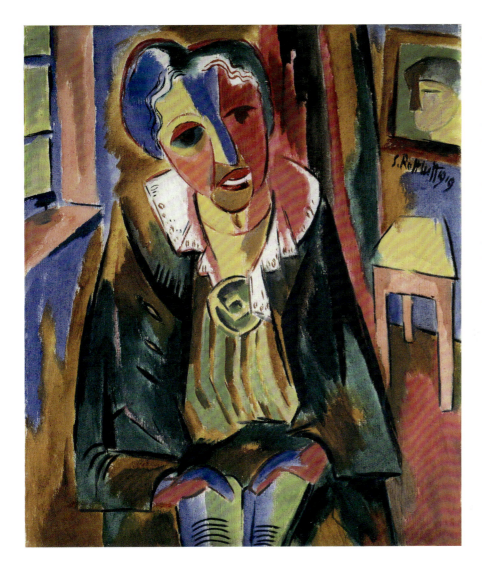

195 Karl Schmidt-Rottluff, *Portrait of Rosa Schapire*, 1919, oil on canvas, 100.6 × 87.3 cm, Tate Gallery, London (formerly in collection of Dr. Rosa Schapire)

196 Anonymous, *Karl Schmidt-Rottluff, Emy Frisch, Rosa Schapire, and Gertrud Schmidt*, Hohwacht, 1919, photograph, *Karl Schmidt-Rottluff: Ausstellungen zum 100. Geburtstag des Künstlers* (Berlin: Brücke Museum, 1984)

197 Karl Schmidt-Rottluff, *Round Metal Brooch with Quadratic Ornamental Design*, 1910, beaten metal, diameter 6.9 cm, Lentos Kunstmuseum, Linz (formerly in the collection of Dr. Rosa Schapire)

the photographer Emy Frisch. A concurrent photograph (fig. 196) shows Schapire with Frisch (in the center), along with Gertrud Schmidt, the artist's sister, on the right. In the portrait, Schapire is portrayed wearing the same outfit with a blouse and lace collar as featured in the photograph; she also wears a beaten metal brooch (fig. 197) with a central quadratic ornament made by Schmidt-Rottluff.[187] On the figure's knees, an open book is depicted, evidence of the woman's intellectual pursuits. Her taste as both patron and adviser are acknowledged in the proportionally enlarged masklike face of the sitter, who is set against the backdrop of one of Schmidt-Rottluff's works. The coloration—reds and ochre to green and blue—is equally saturated in the rear and enhances the frontal position of the figure. While the painting stereotypes Schapire's Jewish identity, it pays homage to her benevolence and dignity with which she assumed the mantle most often worn by male collectors and critics.

At this juncture, it is instructive to consider how the dealer Johanna Ey was portrayed in the Düsseldorf milieu. While an assessment of Schapire's career has been long overdue, it is clear that accounts of her role have escaped the realms of mythical categorization. This is not the case with Ey, a fact that prompted Anna Klapheck, one of Ey's earliest biographers, to caution against mystification of the dealer's contribution: "The legend speaks of 'Mutter Ey' and legends are stronger than history. Johanna Ey was certainly a motherly person, taking all to heart that sought for her help . . . however, she was, fundamentally[,] a rebel, a fighter on the barricades, a despiser of comfort."[188] With her specialist knowledge of the archival holdings in the Stadtmuseum Düsseldorf, the art historian and curator Annette Baumeister's publication of an edition of Ey's collected writings serves to demystify Ey's celebrity status in the media, in addition to anchoring her dealership within the cultural politics of the Rhenish art world.[189]

Neue Kunst Frau Ey

In contrast to the phenomenon of the *Neue Frau*, Schapire and Johanna Ey were representatives, albeit dissimilar, of an earlier generation who transcended the confines of domesticity and marriage to invade the spaces of male culture.[190] They achieved this in rather different ways. Not

198 Otto Dix, *Portrait of the Art-Dealer Johanna Ey*, 1924, oil on canvas, 61.3 × 96 cm, Kunstsammlung Nordrhein Westfalen, Düsseldorf

unlike her male colleagues, Schapire's qualifications and upper-middle-class cosmopolitanism served to anchor her interaction with the public as part of the individual's commitment to civic responsibility, an evocation of progressive modernity espoused since the Enlightenment. Assuming a more confrontational stance, Ey's activities exuded a foray into male commercial dominance. One could interpret her almost exclusive patronage of male artists as veiled complicity in the existing structures of power relations. However, the risks Ey took in promoting certain artists, such as Gert Wollheim (1894–1974) and Otto Dix (1891–1969), provide a fascinating opportunity to examine the performativity of gender roles.

In the early 1920s, Dix's images of women generally conveyed a desire for and fear of femininity.[191] His *Portrait of Johanna Ey* (fig. 198), painted in 1924 during his sojourn in Düsseldorf, catalogs both his dependence on and admiration for the dealer. Ey commissioned this work after having successfully sold Dix's double portrait, *My Parents I*, to the Wallraf-Richartz-Museum in Cologne.[192] Certainly, the monolithic treatment of the body fetishizes the figure, but Dix retrieves the image from the mythologized zone, the universal realm of "Mutter," by according the sixty-year-old woman a frank and shrewd disposition. Attention is focused on the detailed, if unflattering, portrayal of the head and hands, the alert eyes, emphasized by spectacles, firmly engaging the viewer. Indeed, imperial connotations are suggested by pronounced emphasis on the coronet (a reference to Ey's love of things Spanish) and the baroque splendor of the monumental architectural setting and billowing swathe of drapery.[193]

Just as artists needed to engage with the implications of modernity—an urban-based, commodified existence—so, too, dealers faced urgent commercial considerations. In 1919, Ey's search for appropriate gallery premises led her to a shop in the Hindenburgwall with two display windows, Neue Kunst Frau Ey (see fig. 8). Although she operated within a confined community of participants, her broader impact was less reserved than Schapire's.

In the early Weimar period in Düsseldorf, both official and professional organizers of artistic activity seized the opportunity to liberate themselves from the paternalism of Prussian administration. In certain instances, this resulted in conflicts between factions who sought to engender a provincial Rhenish identity and those who wished to evoke the spirit of the Cologne Sonderbund exhibition of 1912, which encompassed both the regional and the international in a most effective manner. From this viewpoint the formation of the group Das Junge Rheinland in 1919 was considered to be conservatively "evolutionary" rather than "revolutionary."[194]

Ey appears to have been at the center of these debates, as her initial entry into dealership involved the sponsorship of traditionalists and her gallery offered a meeting point for the older generation of artists and younger radicals. Several commentators argue that Ey preferred the company of men, considering them to be her comrades. Indeed, beyond her daughters Elisabeth and Maria, Ey is said to have had little time for women in general—models, wives, girlfriends, or women artists.[195] Trude Brück (1902–92), an artist colleague of Gert Wollheim, reported being asked not to visit the gallery too often, as her presence detracted from Ey's sphere of influence.[196] Nonetheless, on a subsequent occasion, Brück vividly recalled that her controversial etching *The War Blind* (1922) was included in a window installation dedicated to antiwar and pacifist sentiments. It was accompanied by a label in her own handwriting, "Cursed shall be the war! Damn the work of the weapons!"[197] In the same year, one of Wollheim's paintings was confiscated from the window and he was taken to the High Court by the Men's Association for Combating Public Indecency; the trial took place under a storm of publicity, but he was subsequently acquitted and the painting returned.[198]

Ey's adoption of confrontational tactics to attract a clientele is one of the most intriguing aspects of her dealership. Seizing on the modernity implicit in glass-fronted shops, she seduced the public gaze by allowing artists to display controversial works in the windows of her gallery. Furthermore, the dealer encouraged the notion of spectacle by sponsoring practitioners who attracted official scandal. Otto Pankok and Wollheim were lured to Düsseldorf to join a group of left-wing, dissident war veterans known as the Aktivistenbund. In the wake of the Rosa Luxemburg

and Karl Liebknecht assassinations, the group dedicated themselves to political art in the form of graphic production, declaring the bankruptcy of bourgeois formalism. Both artists had been severely wounded on the front, and their antiwar statement precipitated their move.

When Wollheim's triptych *The Wounded Man* (1919; fig. 199), of which only the central panel with its tormented, lacerated figure remains, was included in an exhibition of new purchases at the Düsseldorf Kunsthalle in February 1920, public protest forced its removal.[199] Whatever events transpired, the triptych, with its compelling image of penetration and castration in the soldier's body armor, found its way into one of the most intimate spaces of Ey's private realm, above the bed in her bedroom.[200] In 1936, Ey reminisced about her attraction to and fear of viewing the work:

> It is my favorite picture . . . *The Wounded Man* hung on a large wall, and since my bed was underneath, I hardly ventured into it. I smelled the blood; I felt the pain myself and slept on the ground. I thought the painting had killed me. So, 3 nights passed. Then I made a curtain to draw across the picture and was reassured to look at it from time to time until I was strong enough to endure it.[201]

Ey's visceral response to the painting reveals that she was not protected from the traumatic impact of the war; she worked for the Military Clothing Services, a euphemism for removing redeemable buttons and clasps from the blood-soaked, cast-off clothing of dead and wounded soldiers.[202] Evidently, she had her own living nightmares to exorcize, including the fact that both her sons Paul and Hermann served in the German navy.

It would appear that the dealer favored a more *sachlich* interpretation of war imagery and encouraged Wollheim to generate further paintings with pacifist sentiments, such as *The Condemned Man* of 1921.[203] Dix was also prompted to complete his unfinished painting *The Trench* once he joined Johanna Ey's circle in 1923. The work itself attracted notoriety, endorsing the observation that in the highly competitive art market during the great inflation of the early twenties, public or professional scandal could secure artist's careers.[204] The politicized nature of war themes

199 Gert Wollheim, *The Wounded Man*, April 1919, oil on wood, 156 × 158 cm, private collection, Berlin

200 Anonymous, *Barricade-Battle at the Ey-Wall*, Düsseldorf, December 24, 1919, as published in *Das Stachelschwein* no. 4 (1925)

admirably lent itself to this procedure and, significantly, Dix's Berlin dealer and publisher at this time, Karl Nierendorf, commissioned the artist to produce the print portfolio *Der Krieg*.[205]

A photograph of December 24, 1919, *Barrikadenkampf auf dem Düsseldorfer Ey-Wall* (Barricade-battle at the Ey-wall in Düsseldorf) (fig. 200) functions as a display of avant-garde transgressive behavior, while a painting by Max Ernst (*Lime-Preparation from Bones*) serves as a protective barrier. The ritualistic enactment also refers to past and current political conflicts within the ideological structures of the early Weimar Republic; above the barricade Karl Schwesig aims a revolver at the viewer while Wollheim is

adorned with a swastika. Interestingly, this photograph preceded the right-wing Kapp Putsch (March 1920) in Berlin by three months and its subsequent publication in the satirist Hans Reimann's journal *Das Stachelschwein* (The Porcupine) testifies to its ongoing relevance to cultural politics.[206] The inferences of rebellion and deviancy are more self-evident when the inner sanctum (fig. 201) of Ey's gallery is compared to that of Alfred Flechtheim's (1878–1937), another notable dealer in the fashionable district of Düsseldorf. Behind the group of Ey, her daughter Maria and the artist Schwesig, is Wollheim's sober *Self-Portrait in a Garret* (1924), unframed sketches to the left and right and informally hung paintings that contrast with Flechtheim's

201 Anonymous, *Interior of "Neue Kunst Frau Ey,"* Johanna Ey, Karl Schwesig, and Maria Ey with Gert Wollheim's painting *Self-Portrait in a Garret* (1924) displayed in the rear, photograph, Stadtmuseum Landeshauptstadt Düsseldorf

more elitist aspirations and sponsorship of international modernism.[207]

While Ey was purported to be unfamiliar with bookkeeping, her correspondence reveals a firm control of financial matters.[208] She adopted a simple yet unprofitable means of existence, subtracting a third of the percentage off group exhibition sales.[209] The front rooms of her shop contained primarily commission items with fixed prices and percentages; some insight as to the stylistic range of these works can be gauged from a photograph of the interior around 1919 (fig. 202). As shown in figure 201, the rear rooms of her gallery housed her private collection without listed prices or private agreements with artists.

Whether their works were hung or not, Ey did not charge artists, and her dealership was based on this latitude. One can trace the resourcefulness of her transactions in her published autobiography, *Das Rote Malkästle* (1930); in response to a theft of works, Ey received a gift from the respected academic artist Eduard von Gebhardt, which she sold for 7,000 marks.[210] This enabled her to buy new works from Dix; she also purchased a Madonna from Von Gebhart and sold it for 4,500 marks, so as to finance paintings from Wollheim, Pankok, and Conrad Felixmüller, and graphics from Emil Nolde.

Her contribution to public life was recognized in 1927 on the occasion of her sixty-fifth birthday when she

202 Anonymous, *Johanna Ey and Her Daughter in "Neue Kunst Frau Ey,"* Hindenburgwall 11, ca. 1919, photograph, Stadtmuseum Landeshaupstadt Düsseldorf

was congratulated by both the mayor of the city (Robert Lehr) and the director of the academy (Walter Kaesbach). Having achieved institutional acceptance, Ey's image was popularized in the media as the all-embracing, nurturing "Mutter."[211] Yet this was a misleading interpretation of her activities, since it is clear that her strategies were consistent with the transgressive actions of her metaphoric sons.[212] Although Ey was not a practitioner, a less monolithic view of what constitutes avant-gardism allows for a more fruitful exploration of her dealership as a useful inroad to exploring women's cultural interaction in Weimar Germany.

In the post-Depression years, between 1931 and 1932, a traveling exhibition of her collection was arranged to boost sales. This visited Cologne, Königsberg, Mannheim, and Wiesbaden and was meant to be shown at the World Exhibition in Chicago.[213] With the seizure of "degenerate" works from her collection by the newly imposed Nazi administration in Düsseldorf in 1934, her livelihood became even more precarious.[214] During his visit to Germany between 1936 and 1937, the renowned Irish playwright and novelist Samuel Beckett (1906–89) was a firsthand witness to the treatment meted out to so-called decadent art.[215] On October 30, 1936, during Beckett's stay in Hamburg, a precedent was established when Bernhard Rust, minister of Science, Education, and National Culture, ordered the closure of the modern section of the Kronprinzenpalais in Berlin.[216] The Entartete Kunst Aktion, as it was deemed, did not arrive in Hamburg until the first half of July 1937, and as Beckett traveled around Germany, he diarized the ongoing seizures.[217]

While in Hamburg, Beckett reported on an intriguing visit to Schapire's apartment. It appeared to him like a

shrine to Schmidt-Rottluff: "cigarette boxes, ash trays, table covers, cushions, bedspreads. All carved or designed or worked from designs by S.R."[218] After relaying the impact of the Gesamtkunstwerk, Beckett was then drawn to one of the paintings, a *Frauenkopf* (woman's head), with red hair streaming back, long nose and "lip lifted in a dribble of bitter cultivation," before realizing that it was a portrait of Schapire herself. Perhaps the closest to Beckett's graphic description is Schmidt-Rottluff's *Portrait of Rosa Schapire* (see fig. 195), which externalized the "decadent" characteristics of Jewishness that were considered so threatening to national coherence. However, it was an identity that Schapire claimed with great pride throughout her life and with defiance in the late thirties in Germany; as she conveyed to Beckett when she remarked with due satire that she was "fortunate not [to be] of pure Aryan descent," and therefore could neither publish nor give public lectures.[219]

James Knowlson, Beckett's biographer, informs us that it was during the writer's discussion with Schapire that he found himself drawn into restating his own criterion of true and authentic art: "the art (picture) that is a prayer sets up a prayer, releases prayer in the onlooker, i.e., *Priest*: Lord have mercy on us. *People*: Christ have mercy upon us."[220] While such a dialogical approach was apparently central to Beckett's view of art at the time, it is rarely associated with him, yet his eloquent testimony resonates with knowledge of Schapire's Expressionism as the reciprocal interaction between presence and universality when beholding the artwork. Contrasting with Schapire's singular devotion and theoretical contribution to Expressionism, Ey's inventive strategies were committed to the principle of nonclosure. In his quest to devote a "monument in words" to the dealer, Cologne-born and well-known author Heinrich Böll (1917–85) seized on these attributes; Ey was quite prepared to deal in academic works if this financed her less profitable sponsorship of new art.[221] Favoring the late Expressionist style of Wollheim's paintings did not preclude her from remaining Max Ernst's only dealer in Germany until 1928, well into the Surrealist period.[222] Unlike Schapire, she received little formal education and was seemingly neither interested in the broader issues of women's rights nor in the promotion of women artists, yet her very assumption of non-difference permitted her to forge a space in the public sphere without which male

avant-garde activity in Düsseldorf would be unthinkable.

Ey's performative role in the urban arena differed from that of Rosy Fischer (1869–1926) who, after her husband's death in 1922, decided to become a dealer and promoter of *Neuzeitliche Kunst* (Modern Art) from the privacy of her residence in Mendelsohnstraße, Frankfurt am Main.[223] Set against a background of the spiraling inflation at the time, this was as much a feature of economic necessity as a desire to explore a modern, self-determined identity. The Fischers held a particular fascination for the works of Kirchner, whose paintings dominated the interior, their modernity being made all the more explicit by their contrast with the middle-class domestic setting.

Between 1916 and 1922, the Fischer couple assembled an incomparable collection of more than five hundred Expressionist works, including major paintings, sculpture, works on paper, and graphics. Due to the hyperinflation of 1923 and the subsequent revaluation of the mark, trade in the Galerie Fischer dwindled. On behalf of the Städtisches Museum für Kunst und Gewerbe in Halle, Max Sauerlandt negotiated for the purchase of twenty-four works in exchange for a life annuity for Rosy Fischer.[224] The Halle acquisition was greeted with immense approval, an indication of the degree to which Expressionism had made inroads into public collections since its inception.[225]

As Vernon Lidtke has commented, this convergence led to an alliance of cultural modernism with more traditional notions of German patriotism.[226] Whereas the Expressionist movement started out as a marginalized experience of semiprivate viewing among select patrons, it was now recognized as a mainstream and organic development of modernism, and women were fundamental to its production, positive reception, and marketing. Unlike the fate of most private and public collections of Expressionism during the Third Reich, at least half of the Fischer collection was salvaged and kept intact by their son Ernst Fischer, who immigrated to the United States in 1934.[227] The Fischers' activities, as representative of the climax of Jewish participation in the project of modernity, serve to highlight the extremely fragile and short-lived path of this renaissance.[228]

Epilogue

This book has charted women Expressionists in Germany within the theme—from empire to emancipation—and investigated their divergent responses to the dramatic historical events and political changes in the early twentieth century. The chronology embraced the period from around 1890 until 1924, and while the study was context-bound, considerations of the fulmination of Expressionism during the 1920s, its defamation in the Third Reich and its afterlife in exile certainly arose in its narration.

In the multivalent strands of the period, known variously as "The End of Expressionism" or "Post-Expressionism," Lu Märten emerged as a potent commentator.[1] This was particularly so in her embrace of the German Communist Party (KPD), support of *Proletkult* (proletarian culture), and unorthodox theoretical position. In contrast to the KPD art critic Gertrud Alexander, for instance, Märten favorably reviewed the Erste Internationale Dada-Messe (First International Dada Fair) in the pages of the party newspaper *Die Rote Fahne* (The Red Flag).[2] Fascinated by practices in Russian Constructivism and the Bauhaus, Märten distilled her ideas on historical materialism in relation to the arts.

In her book *Wesen und Veränderung der Formen/Künste* (Essence and Transformation of Forms/Arts), which was published in 1924, Märten developed the notion of the *Werkstatt* (workshop) as a utopian concept.[3] According to her Marxist critique, the origin of forms must be sought in the work and technics, in production. This brief summary belies the sophistication of Märten's arguments, but, evidently, her concept of arts/forms as instruments of class struggle and as anchored in the "science of the material" was critical to the revolutionary milieu of the 1920s. Clearly, Märten's political sympathies were anathema to the policies of the Third Reich, and given that many of her books were marked as "un-German" and destroyed in the student book burnings of May 11, 1933, she was unable to publish until after the Second World War.

Kollwitz, for her part, along with Albert Einstein, Maxim Gorky, Grosz, and Upton Sinclair, joined the nonpartisan Internationale Arbeiterhilfe (Workers International Relief, IAH), an organization initiated by Willi Munzenberg in 1921. A communist deputy to the Reichstag, Munzenberg aimed to generate public awareness in order to alleviate famine in Russia and, equally so, in Germany in 1923. Continuing to challenge her creative practice in adopting the method of transfer lithography, Kollwitz designed some of her most forceful and immediately recognizable posters, *Help Russia*, *The Survivors*, and *Bread!*[4]

By September 1925, we can observe in Kollwitz's diary entry her delight that she was recognized, albeit that she found celebrity status rather irksome:

> A petering out of my name would probably depress me very much. My sighing and moaning about the burdens of being well-known are a bit of coy talk ... Pampered as I am now, I would find it hard if the concept "Käthe Kollwitz" ceased to exist, if the name did not mean respect and recognition. How horrible it must be for artists who work without reaction.[5]

As we notice, success did not prevent Kollwitz from empathizing with colleagues who were less feted in the public sphere. Pertinent to her situation were the changes brought about by the Dawes Plan in 1924 and the revaluation of the mark, which ushered in a period of relative economic stability after years of hyperinflation.[6]

Indeed, Kollwitz revealed her excitement about the prospect of receiving 1,000 marks for her involvement in a cycle of documentary films, *Schaffende Hände* (Creating Hands, 1926), directed by Hans Cürlis.[7] While open toward the medium of the *Kulturfilm*, Kollwitz reevaluated her aesthetic criteria and maintained that artistic tradition was essential to the realization of an inner concept. In this respect, she cited the views of literary and cultural critic Hermann Bahr as being appropriate.[8] Bahr, as we recall, published the book *Expressionismus* during the First World War as a paean to intuitive creativity and unmediated expression. Yet, in the 1920s, he rediscovered the nineteenth-century novelist and painter Adalbert Stifter (1805–68), whose works were presented as worthy of

comparison with the late Goethe's revival of the classical heritage.[9]

Arising out of the inclusion of her works in an exhibition in Moscow of revolutionary artists from the West in 1926, Kollwitz was brought to the attention of Anatoly Lunacharski, the Soviet People's Commissar for Culture, who favored her graphic interpretation of *Tendenzkunst* (art with a political message).[10] The following year, not only did Kollwitz visit Moscow with a German delegation to celebrate the tenth anniversary of the October Revolution, but she was also honored with an exhibition at the Prussian Academy of Art on the occasion of her sixtieth birthday. In 1928, sixty of her prints were exhibited in a commemorative solo exhibition at the Moscow State Museum of Fine Arts. Against a backdrop of the Great Depression, Kollwitz was at the zenith of her fame and was recognized in Germany, Soviet Russia, and, increasingly, in America. Fortuitously for Kollwitz's legacy, after the bankruptcy of the Dresden art dealer Emil Richter in 1931, Alexander von der Becke in Berlin was entrusted with the publication of her graphic works.

By June 1932, having dedicated more than twelve years to projects relating to the memorialization of her son Peter, Kollwitz's sober, kneeling figures, *Mourning Parents*, carved in granite by August Rhades and Fritz Diederich after her plaster originals, were exhibited in the atrium of the Nationalgalerie in Berlin. These were subsequently installed in the war cemetery in Roggevelde in Belgium. Fascinatingly, the director Ludwig Justi arranged for a concurrent exhibition of the artist's plaster sculptures for this monument in the Kronprinzenpalais, a privilege rarely shared by other women artists.[11] Responsible for the institutionalization of Expressionism in the national consciousness, Justi was an immediate target for dismissal on political grounds following the National Socialist takeover of power on January 30, 1933.[12] In February of that year, Kollwitz supported another urgent appeal of the left-wing parties for unity in the last free elections on March 5. As a consequence of such resistance, along with Heinrich Mann, she was obliged to resign from her position at the Prussian Academy. While Kollwitz was able to maintain her studio there until mid-January 1934, her works were consistently removed from public display thereafter.

Clearly, had Kollwitz not resigned, she would have

been expelled under the provisions of the Law of Restoration of the Professional Civil Services, which was passed on April 7, 1933. While affecting Communists and political oppenents, the Restoration Law was aimed at the dismissal of non-Aryans from positions in the civil service, from teachers and lawyers to doctors, and proved to be a crucial turning point in the history of German Jewry. Lasker-Schüler, who was awarded the esteemed Kleist literary prize in 1932, feared for her safety and future as an author. On April 19, 1933, she emigrated to Zurich and, subsequent to two short visits to Palestine, remained in exile there from April 1939 onward. Due to the Restoration Law, Schapire found that she was was unable to publish and was confined to lecturing in the private sphere.[13]

A member of her circle and former patron of the Brücke, the dentist Clara Goldschmidt, was no longer allowed to practice, and she committed suicide in January 1934. In his memoirs, her brother Moses, a doctor who emigrated to Brazil in 1939, wrote that her "mental energies were not strong enough to counter the propaganda of the Hitler government with sufficient internal resistance."[14] But perhaps this explanation oversimplifies the reasons for her actions, given the findings of Darcy Buerkle's publication on *Charlotte Salomon and an Archive of Suicide*.[15] In exposing the extremely high incidence of Jewish women and suicide in the Weimar era, Buerkle revealed the deep legacy of convergences between gender, anti-Semitism, and trauma, particularly in relation to the historiographic omission of lesbian desire.[16] For seventy-two-year-old Ida Dehmel, who was loath to leave the Richard Dehmel house in Hamburg after the outbreak of the Second World War, the choice was bleak. In a letter to Marie Stern, Ida recorded the details of the rounding up and deportation of Hamburg's Jews; her fear of the same fate led her to commit suicide by an overdose of sleeping tablets on September 29, 1942.[17]

When addressing a meeting of the National Socialist Women's Organization at the Nuremberg Rally on September 7, 1934, Adolf Hitler reclaimed women's role as a mere complement to man in the fight for the Volk and future of the Third Reich:

The feeling and, above all, the nature of woman has always acted throughout the ages as a supplement to the intellect of man . . . The catchword "Women's

Liberation" is merely a phrase invented by the Jewish intellect, and its contents are marked by the same spirit. The German woman will never need to emancipate herself in an age supportive of German life. She possessed what Nature gave her automatically as an asset to maintain and preserve.[18]

From Hitler's speech we are under no illusion that feminists and Jewish women constituted a threat not only to the body politic but also to the survival of the pure race. Yet how did independent and liberated German women artists, previously deemed Expressionist, negotiate this characterization of their gender as well as the regressive artistic policies of the National Socialists?

The answers to this are complex and variations occur in view of the speedy coordination of the political, economic, social, and cultural institutions known as *Gleichschaltung*. Indeed, for Münter, the changes in administration offered a brief period of respite. Notwithstanding her turn to Neue Sachlichkeit, her experience of the 1920s was particularly bleak.[19] On her return to Murnau in 1931, and through the encouragement of her companion Johannes Eichner, she became more commercially orientated. In his writings, Eichner steadily reinvented her artistic identity as völkisch and promoted the "simple nature" of her works that "akin to that of folk art seems awkward and yet expresses essentials."[20] By 1934, apart from initiating a traveling retrospective of fifty of her paintings, which started in Bremen, Eichner had emboldened Münter to become a member of the newly formed Reichskammer der bildenden Künste (National Chamber of Visual Arts).[21] Moreover, she concentrated on subjects that appealed to the regime and participated with two paintings in the 1936 traveling exhibition *Die Strassen Adolf Hitlers in der Kunst* (The Streets of Adolf Hitler in Art). Isabelle Jansen has shown that these works were lodged with the art dealer Erna Hanfstaengl in Munich, and it was via this route that they were submitted to the jury and accepted.[22] An older sister of the German American businessman Ernst, who fraternized with the Nazis, Erna was rumored to have been romantically linked with Hitler in the early 1920s.

Interestingly, Münter's exhibiting opportunities gathered pace in early 1937, and on the occasion of her sixtieth birthday, she was honored with an exhibition in Herford, the location of her early upbringing. In March, the Munich Kunstverein showed a selection of her paintings that included exhibits from the Blaue Reiter and *Sturm* period. A run-in with the *Gauleiter* (regional party leader) Adolf Wagner did not prevent these works from traveling to the Galerie Fritz Valentien in Stuttgart, a well-known outlet supportive of modernism, where they were exhibited alongside those of Schlemmer and Macke. As distinct from Munich, which was considered the Hauptstadt der Bewegung (the capital of the Nazi movement), Stuttgart proved to be an amenable sojourn for Münter amid avantgardists, such as Ida Kerkovius and Willi Baumeister. No sales resulted from this exhibition, however, and testimony to the fact that Münter found it necessary to differentiate her practice for an official audience can be gauged from her correspondence with Eichner. In May, she suggested titles that would prove suitable to the jury selecting works for the *Große Deutsche Kunstausstellung* (Great German Art Exhibition, GDK), which was launched at the opening of the Haus der Deutschen Kunst (House of German Art) on July 18, 1937. One of these, *Jochberg*, no doubt a Tyrolean setting, she opined, was "a German, German landscape."[23] Ultimately, of the four paintings that Eichner submitted on her behalf, none were accepted for display.

In the first half of July 1937, Joseph Goebbels commissioned the president of the Reich Chamber for the Visual Arts, Adolf Ziegler, with the task known as the Entartete Kunst Aktion (Degenerate Art Action), the Nazi campaign to confiscate artworks that were deemed "degenerate." Consequently, around eleven hundred artworks from thirty museums were chosen and ordered to Munich. Roughly six hundred of these were denounced in the *Entartete Kunst* exhibition, which was launched on July 19, 1937. Since Münter's works were not held in public collections, her oeuvre escaped being categorized as "degenerate." The sculptor Milly Steger had six works on paper and two sculptures removed in this initial drive.[24] Nevertheless, her plaster seated nude, *Musing Woman* (ca. 1937), was featured in the official GDK. Art historian Nina Lübbren suggests that perhaps Steger's already classicizing style could be accommodated within the new framework of expectation.[25] As with Münter, though, Steger joined the Reichskammer der bildenden Künste in 1937, and her decision to exhibit in the GDK involved personal agency.

Lasker-Schüler's works on paper were confiscated from the Kronprinzenpalais collection under the above-mentioned commission and the Gesetz über Einziehung von Erzeugnissen entartete Kunst (Law on the Confiscation of Products of Degenerate Art), decreed on May 31, 1938.[26] Jonathan Petropoulos has illuminated how this statute sanctioned the disposal of modern art in state collections through specified dealers, who traded them for foreign currency.[27] Under this provision, many of Modersohn-Becker's and Kollwitz's works were seized and stored in the Depot in Schloß Niederschönhausen so as to attract international exchange.[28] However, by the late 1930s, the distinctions between private and public property were steadily eroded as artworks were appropriated from Jews by the Gestapo at a fraction of their value, initially as a response to emigration and then as part of a more extensive Aryanization of business assets and holdings.[29] Particularly after the persecution of the Jews in the Kristallnacht (Night of Broken Glass) pogrom of November 9, 1938, the pressure to cede possessions at minimal rates was rampant among prospective exiles. As was shown, Schapire's most valued belongings, amounting to eighty-six items, could not accompany her to England and were confiscated from storage in Hamburg by the Gestapo. These were auctioned by the Customs bailiffs on January 30–31, 1941, for the total sum of 1,384.30 marks.[30]

Approached by the Kunsthalle Basel already in 1932, Nell Walden was indeed farsighted to have moved her entire private collection there for safekeeping.[31] We saw the photographs of its installation in her Berlin residence (see figs. 150 and 151), which dated from the Weimar period at the time of her second marriage to the German Jewish physician Hans Heimann (1864–1942). The couple separated in 1933 on political grounds, since Walden reclaimed her Swedish citizenship and emigrated to Switzerland, hoping to reunite with her husband in Ascona; Heimann, however, did not survive the Holocaust.[32] It is understandable, therefore, why the human consequences of the defamation of Expressionism and modern art underlay witness accounts of the *Entartete Kunst* exhibition in the Hofgarten in Munich.

In 1938, and while in exile, the art historian and critic Peter Thoene, a pseudonym for the Serbian Jew Oto Bihalji-Merin (1904–93), wrote the following thereof:

Walking through the fantastic rooms of the Exhibition of "Degenerate Art," opened in July 1937, we read the complete history of German art in the past century. The walls turn to documents, the martyred creatures of art speak out, since the age, obedient to the voice of power[,] is dumb. True, it is a ghostly company: expressionistic and cubistic shapes, the forms of Futurism, moving and caught in movement; pictures of horror and protest which have arisen out of the great Death of the War . . . the superreal dream world of those who have tried to record the unconscious and subconscious of their time.[33]

The tone of the passage reveals that the viewing experience was traumatic for the author.[34] He used anthropomorphic terminology to describe the exhibits: the works were "martyred creatures" and acted as "documents" to the stranglehold of authoritarianism over national, civil, and cultural life in Germany. Their temporary installation, relentless amassing, mocking quotes, irregular hanging, and labeling as overpriced commodities, spoke volumes about the perpetrators.

We detect as well the psychoanalytical coordinates of Thoene's aesthetic theories: the function of creativity as eliciting the subconscious and unconscious horrors of the First World War and contemporary atrocities.[35] For the generation of art students in the 1930s, whose training was purged of modernist influence, the *Entartete Kunst* exhibition could function as a primer in the Expressionist Gesamtkunstwerk as resistance. Such is the argument of various scholars in negotiating the German Jewish artist Charlotte Salomon's (1917–43) mammoth undertaking in *Life? Or Theater? A Song-Play* (1941–42).[36] Created in the South of France prior to her deportation and murder in Auschwitz, the gouache drawings and paintings amounted to 1,325 pages, the earliest 220 of which were accompanied by semitransparent paper overlays containing text. Salomon used the Expressionist conventions of word, image,

MARIE-LOUISE VON MOTESICZKY ARCHIVE GALLERY

204 *The Marie-Louise von Motesiczky Archive Gallery*, 2019, Tate Britain, London

and musical references strategically, not only to subvert Nazi propaganda but also to stage the subjective narratives of her autobiography, family history of mental illness, and fraught psychological condition in exile. Griselda Pollock does due justice to these challenging variables in the publication *Charlotte Salomon and the Theatre of Memory*, which sheds light on refugees' collective experience of statelessness in Nazi-occupied Europe, as well as dealing with new evidence of sexual abuse in Salomon's private life.[37] Constituted as such, the artwork bears the burden of history, the darkest in living memory—of the artist's gender and Jewish identity.

The afterlife of Expressionism shares in the gravity of historical memory no more so than in exile. The Viennese-born artist Marie-Louise von Motesiczky (1906–96) and her mother left Austria the day after the Anschluß, March 13, 1938, for the Netherlands. Her brother Karl (1904–43), a psychoanalyst, who remained in Vienna and helped other Jews to escape, corresponded with Marie-Louise about the family's existential crisis: "In general I think the following solution has crystallized: you and mother will stay abroad for the winter . . . I will continue to study until my first doctoral viva and then go to America."[38] While Karl was arrested in July 1942 and

deported to Auschwitz, where he subsequently perished from typhus, in the abovementioned letter he communicated some nuggets of therapeutic advice to his sister and mother: "Maybe it is a requirement for inner luck—at least in these times—to really make sacrifices and to change oneself, to really experience a 'death and rebirth' situation. You will say: from your point of view this is right, but not from mine."

Whereas Karl was dubious as to whether his sister would respond to this advice, it would seem that the trope "death and rebirth" was internalized during her exile in London, from February 1939 onward. Art historians are in general agreement that Motesiczky's *Self-Portrait in Green* (1942; fig. 203) represents a move away from the *sachlich* style of her mentor, Max Beckmann.[39] In the late 1920s, Motesiczky had spent a year in his master class at the Städelschule in Frankfurt am Main, and he continued to be an unfailing source of encouragement to her.[40] The self-portrait is frontal and the head fills the entire format so that there are no distractions from the mutability of the face. It is painted in subtle, searching colors, which allow the gesturally drawn outlines to emerge beneath the pentimenti. A daring use of green for the hair and underpainting contrasts with red highlights on the eyelids and slightly open mouth. Yet this painterly and Expressionist language is interpreted as *apres gardé* and as an attempt to recoup the early development of her *haute bourgeois* cultural milieu with symbolic resonance.[41] I would argue differently, however.

In the 1960s, Motesiczky recounted her memories of Beckmann's pedagogy and reported how he fueled her ambition by comparing her with Modersohn-Becker, "the best woman painter in Germany—well, you have every chance of succeeding her."[42] As shown in the second chapter, it was in 1927 that, funded by Ludwig Roselius, the first museum dedicated to the work of a female artist—the Paula Modersohn-Becker Museum—was launched in Böttcherstraße in Bremen, a site that was designed by Hoetger (see fig. 29). No doubt Beckmann was familiar at the time with the publicity in the specialist press that admitted Modersohn-Becker to the realms of the canonic. Yet it is Motesiczky's mature works in exile—her self-portraits, portraits, allegories, and still life painting—that reclaim the political imperative and impart a knowledge of

women Expressionists' pre-emancipative endeavors to gain entry into the public sphere.

Tellingly, it was only when Motesiczky was in her eighties that she received recognition.[43] After her death, due to a remarkably efficient charitable trust administering her works and papers, Motesiczky's émigré origins and the shaping of British visual culture were honored in the founding of the Marie-Louise von Motesiczky Archive Gallery at Tate Britain (fig. 204). However, such commemoration is the exception rather than the rule. Over a century ago, on the cusp of emancipation, Lu Märten offered us a nonhierarchical evaluation of what it means to be a "woman artist." These aspirations are still a work in progress, and the task of making visible the remarkable depth and legacies of women's manifold cultural practices still remains.

Acknowledgments

This book has evolved over many years since the publication of the Phaidon/Rizzoli edition of *Women Expressionists* in 1988. The earlier study introduced a range of women artists with the realization that there were inevitable links, networking, and cultural exchanges to be forged in a major tome. In gathering the material and formulating the themes, research for the book could not have been undertaken without institutional funding, access to archival resources, and the inspiration of numerous colleagues in Germany, Sweden, Holland, America, and Britain.

In the early 1990s Annegret Hoberg, curator of the Blaue Reiter Collection and Kubin-Archiv at the Städtische Galerie im Lenbachhaus und Kunstbau in Munich, was instrumental in encouraging my research on Gabriele Münter. Encounters with Ilse Holzinger in the Gabriele Münter- und Johannes Eichner-Stiftung were memorable, and her guidance through the holdings proved vital over the years. My interaction with Isabelle Jansen, present curator of the Stiftung, remains equally productive, and I acknowledge her gracious assistance with retrieving material from Münter's sketchbooks and the artist's personal library. Brigitte Salmen, curator of the Privatstiftung Schloßmuseum Murnau, was forthcoming in her advice regarding their collection of Münter's works and photographs from the Marianne von Werefkin Fotoarchiv.

In 1999, I conducted extensive primary research in the Fondazione Marianne Werefkin at the Museo Comunale d'Arte Moderna in Ascona, with the permission of the then director Efrem Beretta. I thank the current conservatrice, Michela Zuconni-Poncini, for her help in aligning my references with the archive's updated catalog system. Of significance to the resurgent growth in Werefkin studies was the exhibition *Marianne Werefkin: Vom Blauen Reiter zum Großen Bären*, which was held at the Paula Modersohn-Becker Museum in Bremen in 2014. I thank Isabel Wünsche and Tanya Malycheva for their invitation both to view this exhibition and to participate in the associated conference *Crossing Borders: Marianne Werefkin and the Cosmopolitan Women Artists in Her Circle.*

In 2000, an academic exchange program enabled me to conduct in-house and out-of-house research at the Moderna Museet in Stockholm. I thank Cecilia Widenheim, curator of Swedish and Nordic Art, for the opportunity to consolidate material on Sigrid Hjertén. Subsequent collaborations with Birgitta Flensburg and Katarina Borgh Bertorp benefited from this research. I am delighted to retain contact with Allan, Rakel, and Rebekah Grünewald, descendants of Hjertén and Isaac Grünewald. Birthe Wibrandt, curator of the Landskrona Museum, was unstinting in her support with the holdings of the Nell Walden Estate. In the Netherlands, Jacqueline van Paaschen, who is writing a biography on the patron Marie Tak van Poortvliet, found the time to advise me regarding Jacoba van Heemskerck's works in private collections.

My initial appointment as the Bosch Lecturer in German Twentieth-Century Art at the Courtauld Institute of Art in London arose from the foresight of former director Michael Kauffmann, who recognized the need to encompass German modernism in the courses on offer. At an early stage, I established contact with Frances Carey, who was deputy keeper of the Prints and Drawings Department at the British Museum. I am indebted to her for numerous invitations to participate in gallery talks and symposia that spurred the concerns of my book. Sean Rainbird, then senior curator at the Tate, was equally well disposed toward my research on the artist couple Kandinsky and Münter. I value the intercollegiality of various scholars: Christian Weikop for involving me in Die Brücke Centenary International Conference (University of Sussex, 2005); Dorothy Price for her ongoing support and creative endeavors in relation to the Blue Rider Centenary Symposium (Tate Modern, 2011); Nina Lübbren for our inspiring conversations; Aya Soika and Burcu Dogramaci for their generous response to my queries.

I have also benefited immensely from many American colleagues whose publications and feedback have helped further my project. I am thankful for the introduction to Reinhold Heller and value the occasions on which we were able to exchange ideas at conferences. Timothy Benson, curator of the Robert Gore Rifkind Center for German

Expressionist Studies at the Los Angeles County Museum, has been a consistent supporter of my research. In August 1995, the trustees of the Robert Gore Rifkind Foundation approved my application to be a Rifkind Scholar-in-Residence, which involved an in-depth study of women Expressionists. I still refer to the notes arising from my stint at the center, an unparalleled collection of rare periodicals, original works on paper, and primary documentation. I had the good fortune, at the time, to meet up with the late Robert Gore Rifkind and am especially grateful to Stephanie Barron for encouraging my inquiry into the supporters and collectors of Expressionism.

In the context of the College Art Association and its affiliated society, the Historians of German, Scandinavian, and Central European Art, I appreciate the collegiality and scholarship of James van Dyke, Keith Holz, Ricki Long, Marsha Morton, Françoise Forster-Hahn, Barbara McCloskey, Diane Radycki, and Sherwin Simmons. At CAA conferences and other venues, I strategically presented research toward the methodological basis and development of the chapters in this book. In 2003, I contributed the paper "Lu Märten, the Textuality of Time, and the Professionalization of the Woman Artist" to the HGSCEA-sponsored session, "Models of the Visual in Germany and Central Europe, 1800–2000," which was held in New York. I thank Frederic Schwartz for organizing and chairing this panel. So, too, in the case of my interaction with Adrienne Kochman, chair of the session "Feminism and Modernity in Central Europe," in Dallas, 2008, I gained from both her input and the discussion arising out of my paper "Paula Modersohn-Becker: The National, Regional and the Modern."

Seminal to my exploration of the gendered considerations of print culture was the invitation to a Private Scholars Day in New York in 2011 that was devised by Starr Figura, curator of the Prints and Drawings Department at MoMA. This accompanied her major exhibition *German Expressionism: The Graphic Impulse* and resulted in a colloquium "Disseminating Expressionism: The Role of Prints, 1905–1924." The themes of my presentation, "Between Authenticity and the Multiple: Käthe Kollwitz, Graphic Dissemination, and Dealership," owe much to the dialogical process of the workshop, alongside in situ viewing and group discussion of the installations.

Lecturing at the Courtauld was an absolute privilege, particularly when one considers the institution's origins in the 1930s and its role in nurturing the art-historical discipline as a self-sufficient member of the humanities. I thank the respective directors for their support, especially Deborah Swallow, who deserves special mention. I learned much from my colleagues in the Modern and Contemporary Section and was fortunate to co-teach and supervise with Chris Green, Sarah Wilson, Caroline Arscott, Mignon Nixon, Julian Stallabrass, and, in the latter years, Gavin Parkinson, Klara Kemp-Welch, and John Milner. I thank Robin Schuldenfrei for the invitations to present research material to her postgraduates. In 2005, Ernst Vegelin and Barnaby Wright were pivotal to the success of the exhibition *Gabriele Münter: The Search for Expression, 1906–1916*, held in the Courtauld Gallery.

I am grateful to the Courtauld Institute of Art Research Committee for funds allocated toward travel expenses. My sincerest appreciation goes to the Courtauld picture researcher Karin Kyburz, whose expertise and professionalism made the process of securing images and permissions for this book a veritable learning experience. For these costs, I acknowledge the generous grant of the Marie-Louise von Motesiczky Charitable Trust and thank the chair Frances Carey and trustees for their consideration. Additional support for these expenses came from the AKO Foundation, and I convey my gratitude to the chief executive Philip Lawford and the trustees. Behind the scenes, Laura Palmer was of considerable help, as was Alexandra Mitchell in the Accounts Office.

This book also represents a fulfillment of the teaching experiences I had at the Courtauld and of how gratifying it was to have contact with such talented students. I have been energized by the postgraduates who I supervised; many have maintained their contact as friends and colleagues. In this regard, I greatly value the sincere and ongoing interest of Glenn Sujo, and appreciate my interaction with Nicolai Tangen, Lucy Wasensteiner, Kerry Greaves, and Leonie Beiersdorf. I could not have done without the rigorous feedback and assistance of Ines Schlenker, whose checking of manuscript drafts and genuine concern were irreplaceable. Amid Niccola Shearman's busy academic schedule, she found the time to read through several chapters and respond with constructive criticism. I thank other

former doctoral students—Isabel Boldry, Anna Müller-Haerlin, and Anke Daemgen—for their assistance.

I am also indebted to Michelle Komie, publisher in art and architecture at Princeton University Press, for her sustained encouragement, as well as Kenneth Guay, the art publications coordinator. At all times the senior production manager Sara Lerner, copyeditor Cathy Slovensky, and art and illustrated books production manager Steven Sears were forthcoming and highly professional. Finally, work on this book has made exceptional demands on my husband, Bernard, who is my most enthusiastic supporter and sounding board. As he is prone to tell others, he has learned more about art history vicariously than he bargained for. Without his guidance in computer technology, my progress on this book would not have been possible. I am immensely proud of my sons, Elijah and Gabriel, and of their respective spouses, Estelle and Nicola. My granddaughters Eliana, Aurelia, Naomi, and grandson Raphael continue to surprise me with their creativity and avid responses to viewing art. Notwithstanding the distances that separate us, my older sisters, the music teacher Rhona Metrikin and neuroscientist Gina Geffen, have served as inspirational role models. I dedicate this book to the memory of our dear parents, Hilda and Teddy Ruch, who encouraged their daughters to strive for self-fulfillment responsibly.

Notes

Chapter 1. Women Artists, Expressionist Avant-Garde Culture, and the Public Sphere

1 Anton Lindner, "Eine Phänomenale Malerin oder Was Bleibt von der Worpsweder Kunst Übrig?," *Neue Hamburger Zeitung*, July 3, 1914.

2 Karl Scheffler, "Neue Bücher," *Kunst und Künstler* 19 (1921): 332

3 Karl Scheffler, "Berlin," *Kunst und Künstler* 7 (1909): 427.

4 Ingrid von der Dollen, *Malerinnen im 20. Jahrhundert: Bildkunst der "Verschollenen Generation": Geburtsjahrgänge 1890–1910* (Munich: Hirmer, 2000).

5 For arguments on the "polyvocality of the modern period" and the observation that women artists found a voice within the varied languages of modernism, see Marsha Meskimmon, *We Weren't Modern Enough: Women Artists and the Limits of German Modernism* (London: I. B. Tauris, 1999), 3.

6 Von der Dollen's inquiry was a response to Rainer Zimmermann's *Die Kunst der Verschollenen Generation: Deutsche Malerei des Expressiven Realismus von 1925–1975* (Düsseldorf: Econ, 1980), which listed biographies of 195 male artists and only nine women.

7 See Hildegard Reinhardt, "Olga Oppenheimer (1886–1941): Malerin und Graphikerin," in *Rheinische Expressionistinnen*, ed. Anke Münster (Bonn: Verein August Macke Haus, 1993), 113–23.

8 Stephanie Barron, ed., *"Degenerate Art": The Fate of the Avant-Garde in Nazi Germany* (Los Angeles: Los Angeles County Museum of Art, 1991), 64; Marion Ackermann, "Paula Modersohn-Becker und München," in *Paula Modersohn-Becker, 1876–1907: Retrospektive*, ed. Helmut Friedel (Munich: Hirmer, 1997), 21–22.

9 See Uwe Fleckner, ed., *Angriff auf die Avantgarde: Kunst und Kunstpolitik im Nationalsozialismus* (Berlin: Akademie, 2007), 199.

10 Richard J. Evans cautions against teleogical thinking in "From Hitler to Bismarck: 'Third Reich' and Kaiserreich in Recent Historiography," in *Rethinking German History: Nineteenth-Century Germany and the Origins of the Third Reich*, ed. Richard J. Evans (London: Allen & Unwin, 1987), 55–93.

11 Trude Brück (1902–92), who was associated with the Düsseldorf circle of artists Das Junge Rheinland, suffered great trauma after almost all her works were destroyed in the bombing of Munich in 1943. She never resumed painting and turned her attention to restoration. Annette Baumeister, "Trude Brück," in Münster, *Rheinische Expressionistinnen*, 60–71; Von der Dollen, *Malerinnen im 20. Jahrhundert*, 292.

12 Though more interested in German contemporary artistic identity, Fechter devoted chapters to Cubism and Futurism. Paul Fechter, *Der Expressionismus* (Munich: Piper, 1914).

13 See Stephanie Barron, ed., *German Expressionism: The Second Generation, 1915–1925* (Munich: Prestel, 1988).

14 Alessandra Comini, "Gender or Genius? The Women Artists of German Expressionism," in *Feminism and Art History: Questioning the Litany*, ed. Norma Broude and Mary D. Garrard (New York: Harper & Row, 1982), 289.

15 See, in particular, Ulrike Stelzl, "'Die Zweite Stimme im Orchester': Aspekte zum Bild der Künstlerin in der Kunstgeschichtsschreibung," in *Künstlerinnen International, 1877–1977* (Berlin: Schloß Charlottenburg, 1977). The first volume published by the group of women art historians was Cordula Bischoff and Brigitte Dinger et al., eds., *FrauenKunstGeschichte: Zur Korrektur des Herrschenden Blicks* (Gießen: Anabas, 1984).

16 Renate Berger, *Malerinnen auf dem Weg ins 20. Jahrhundert: Kunstgeschichte als Sozialgeschichte* (Cologne: DuMont, 1982); Renate Berger, ed., *Und Ich Sehe Nichts, Nichts als die Malerei: Autobiographische Texte von Künstlerinnen des 18.–20. Jahrhunderts* (Frankfurt am Main: Fischer Taschenbuch Verlag, 1987).

17 Shulamith Behr, *Women Expressionists* (Oxford: Phaidon, 1988).

18 Dietmar Fuhrmann and Carola Muysers, eds., *Profession ohne Tradition: 125 Jahre Verein Berliner Künstlerinnen* (Berlin: Kupfergraben, 1992).

19 Münster, *Rheinische Expressionistinnen*; and *Der Blaue Reiter und das Neue Bild: Von der Neuen Künstlervereinigung München zum Blauen Reiter*, ed. Helmut Friedel and Annegret Hoberg (Munich: Prestel, 1999); Birgit Gatermann, *Künstlerinnen der Hamburger Sezession, 1919–1933: Alma del Banco, Dorothea Maetzel-Johannsen, Alexandra Povorina, Anita Rée, Gretchen Wohlwill* (Hamburg: Patriotische Gesellschaft, 1988).

20 *Gabriele Münter, 1877–1962: Retrospektive*, ed. Helmut Friedel and Annegret Hoberg (Munich: Städtische Galerie im Lenbachhaus, 1992).

21 Alexandra von dem Knesebeck, *Käthe Kollwitz: Werkverzeichnis der Graphik*, 2 vols. (Bern: Kornfeld, 2002); hereafter KN.

22 *Käthe Kollwitz*, ed. Elizabeth Prelinger (New Haven, CT: Yale University Press, 1992); Reinhold Heller, *Gabriele Münter: The Years of Expressionism, 1903–1920* (Munich: Prestel, 1997); Diane Radycki, *Paula Modersohn-Becker: The First Modern Woman Artist* (New Haven, CT: Yale University Press, 2013).

23 Gisela Kleine, *Gabriele Münter und Wassily Kandinsky: Biographie eines Paares* (Frankfurt am Main: Insel, 1994); Bibiana K. Obler, *Intimate Collaborations: Kandinsky & Münter, Arp & Tauber* (New Haven, CT: Yale University Press, 2014).

24 Barbara D. Wright, "Intimate Strangers: Women in German Expressionism," in *A Companion to the Literature of German Expressionism*, ed. Neil H. Donahue (Rochester, NY: Camden House, 2005), 291.

25 Judith Butler, *Bodies that Matter: On the Discursive Limits of "Sex"* (New York: Routledge, 1995), 16.

26 Ron Manheim effectively raises these issues in his essay "Die Rolle der Künstlerin im Rheinischen Expressionismus: Vergleichende Betrachtungen und Perspektiven der Forschung," in Münster, *Rheinische Expressionistinnen*, 43–57.

27 Konrad Jarausch, ed., *The Transformation of Higher Learning, 1860–1930: Expansion, Diversification, Social Opening, and Professionalization in England, Germany, Russia, and the United States* (Stuttgart: Klett-Cotta, 1983), 34; Hans-Joachim Hahn, *Education and Society in Germany* (Oxford: Berg, 1998), 32–41.

28 For coverage of women's education, see James C. Albisetti, *Schooling German Girls and Women: Secondary and Higher Education in the Nineteenth Century* (Princeton, NJ: Princeton University Press, 1988).

29 See Ilse Brehmer, ed., *Lehrerinnen: Zur Geschichte eines Frauenberufes* (Munich: Urban und Schwarzenberg, 1980), 81. Albisetti indicates that, as late as 1899, more than a quarter of the women teachers in Germany found employment as governesses. James C. Albisetti, "Women and the Professions in Imperial Germany," in *German Women in the Eighteenth and Nineteenth Centuries*, ed. Ruth-Ellen Joeres and Mary Jo Maynes (Bloomington: Indiana University Press, 1986), 97.

30 An exemplary outline of training, professional, and social organizations for German women artists can be found in Cornelia Matz, *Die Organisationsgeschichte der Künstlerinnen in Deutschland von 1867 bis 1933* (PhD diss., University of Tübingen, 2000). Extensive material on the Munich Künstlerinnenverein can be found in Yvette Deseyve, *Der Künstlerinnen-Verein München e.V. und Seine Damen-Akademie: Eine Studie zur Ausbildungssituation von Künstlerinnen im Späten 19. und Frühen 20. Jahrhundert* (Munich: Herbert Utz, 2005).

31 Henni Lehmann, *Das Kunst-Studium der Frauen: Ein Vortrag von Henni Lehmann* (Darmstadt: Koch, 1914), 11–12.

32 For an expansive treatment of the Frauenkunstverband, see Matz, *Organisationsgeschichte der Künstlerinnen*, 148–79.

33 Eugenie Kaufmann, "Die Malerin und die Bildhauerin," in *Das Frauenbuch*, ed. Eugenie von Soden (Stuttgart: Franckh, 1913), 211–22. The statistics were drawn from *Dresslers Kunstjahrbuch* from the years 1909 and 1911.

34 Lehmann, *Kunst-Studium der Frauen*, 1–2.

35 Lehmann, *Kunst-Studium der Frauen*, 19.

36 Having relocated to Berlin from Munich in 1901, Corinth reported on the success of the painting school, which he stated was also a means of improving his own skills. See Lovis Corinth, *Selbstbiographie* (1926), ed. Renate Hartleb (Leipzig: Kiepenheuer, 1993), 147.

37 Claudia Schmalhofer, *Die Kgl. Kunstgewerbeschule München (1868–1918): Ihr Einfluss auf die Ausbildung der Zeichenlehrerinnen* (Munich: Herbert Utz, 2005); Monika Scharff, *Ausbildungsmöglichkeiten für Künstlerinnen im Deutschen Kaiserreich: Beispiel Hamburg* (MA diss., University of Hamburg, 1989), 140.

38 Gerhard Leistner, ed., *Ida Kerkovius (1879–1970): Gemälde, Pastelle, Aquarelle, Zeichnungen, Teppiche: Retrospektive* (Regensburg: Stiftung Ostdeutsche Galerie, 2001), 16–17.

39 For an in-depth account of women's access to the academies, see Anne-Kathrin Herber, *Frauen an Deutschen Kunstakademien im 20. Jahrhundert: Ausbildungsmöglichkeiten für Künstlerinnen ab 1919 unter Besonderer Berücksichtigung der Süddeutschen Kunstakademien* (PhD diss., University of Heidelberg, 2009).

40 The city's symbol originates from its founding father, the knight and noble Albert the Bear, who wrested Berlin back from a Polish-backed Slavic prince in 1157. See Alexandra Richie, *Faust's Metropolis: A History of Berlin* (New York: Carroll and Graf, 1998), 18–19.

41 See listings of the jury in "Rundschau: Die Nächsten Ausstellungen der Sezession," *Der Cicerone* 5 (1913): 214–15.

42 Peter Zankl, "Das Malweib," *Simplicissimus* 12, no. 31 (October 28, 1907): 484.

43 Bruno Paul, "Malweiber," *Simplicissimus* 6, no. 15 (1901): 117.

44 Karl Scheffler, *Die Frau und die Kunst* (Berlin: Bard, 1908), 92.

45 Scheffler, *Frau und die Kunst*, 27–28. Translation after Heller, *Gabriele Münter*, 46.

46 From 1895, the sexologist Magnus Hirschfeld campaigned against Paragraph 175, the law in Germany's penal code against male homosexuality. He publicized his views on the rights of what he termed the "Third Sex" in periodicals, such as *Annals of Sexual Intermediacy* (1900–1923). See Anton Kaes, Martin Jay, and Edward Dimendberg, eds., *The Weimar Republic Sourcebook* (Berkeley: University of California Press, 1994), 693. Citing Morel and Lombroso for the derivation of the term, Max Nordau characterized "stigmata" as brandmarks that betrayed degeneracy either as physical deformity or mental aberration. See Max Nordau, *Degeneration*, 2nd ed. (New York: Appleton, 1895), 17–18.

47 For further elucidation of the *Mannweib*, see Adrienne Kochmann, "Ambiguity of Home: Identity and Reminiscence in Marianne Werefkin's *Return Home*, c. 1909," *Nineteenth-Century Art Worldwide* 5, no. 1 (Spring 2006): 7, http://www.19thc-artworldwide.org/spring06/52-spring06/spring06article/171-ambiguity-of-home-identity-and-reminiscence-in-marianne-werefkins-return-home-c-1909.

48 Marianne Werefkin, *Lettres à un Inconnu*, vol. 3 (October 30, 1905), 257. Fondazione Marianne Werefkin (hereafter FMW), Museo Comunale d'Arte Moderna, Ascona.

49 See Jacques Derrida, "La Différance," in *Marges de la philosophie* (Paris: Editions de Minuit, 1972). Translated in Jacques Derrida, *A Derrida Reader: Between the Blinds*, ed. Peggy Kamuf (New York: Harvester Wheatsheaf, 1991), 59–79.

50 Max Nordau, *Entartung* (Berlin: Dunckler, 1892–93).

51 Nordau, *Degeneration*, unpaginated dedication. Lombroso's *Genio e follia* (*Genius and Insanity*, 1863) was one of the principal sources of inspiration for Nordau's *Degeneration*.

52 The literature on the derivations and meanings of Expressionism is extensive. Later contributions to the field argue with the findings of Donald E. Gordon's pivotal article, "On the Origin of the Word 'Expressionism,'" *Journal of the Warburg and Courtauld Institute* 29 (1966): 368–85. See Marit Werenskiold, *The Concept of Expressionism: Origin and Metamorphoses* (Oslo: Universitetsforlaget, 1984) and Ron Manheim, "Expressionismus: Zur Entstehung eines Kunsthistorischen Stil-und Periodenbegriffes," *Zeitschrift für Kunstgeschichte* 49, no. 1 (1986): 73–91.

53 Lovis Corinth (?), "Vorwort," in *Katalog der XXII: Ausstellung der Berliner Secession* (Berlin: Ausstellungshaus am Kurfürstendamm, 1911), 11.

54 Further commentary on the nationalistic discourses, in which the "optical passivity" of French Impressionism was invested with notions of the feminine, can be found in Magdalena Bushart, "Changing Times, Changing Styles: Wilhelm Worringer and the Art of His Epoch," in *Invisible Cathedrals: The Expressionist Art History of Wilhelm Worringer*, ed. Neil H. Donahue (University Park: Pennsylvania State University Press, 1995), 69–85. For its earlier appearance in French art criticism, consult Tamar Garb, "Impressionism as a 'Feminine' Art," in *Modernity and Modernism: French Painting in the Nineteenth Century*, ed. Francis Frascina et al. (New Haven, CT: Yale University Press, 1993), 280–89.

55 See Gabriel P. Weisberg and Jane Becker, eds., *Overcoming All Obstacles: The Women of the Académie Julian* (New York: Dahesh Museum of Art, 1999), 15–67; Peter Kropmanns and Carina Schäfer, "Private Akademien und Ateliers im Paris der Jahrhundertwende," in *Die Große Inspiration: Deutsche Künstler in der Académie Matisse*, part 3 (Ahlen: Kunstmuseum, 2004), 25–39.

56 André Theuriet, ed., *Le Journal de Marie Bashkirtseff*, 2 vols. (Paris: G. Charpentier, 1887); Marie Bashkirtseff, *The Journal of Marie*

Bashkirtseff, ed. Rozsika Parker and Griselda Pollock (London: Virago, 1985).

57 See H [Henriette] M [Mendelssohn], "Pariser Studientage: Kollegialischer Ratgeber für Malerinnen und solche, die es werden wollen," *Die Kunst für Alle* 12 (February 15, 1897): 150–53.

58 Henri Matisse, "Notes d'un Peintre," *La Grande Revue* (December 1908).

59 Henri Matisse, "Notizen eines Malers," *Kunst und Künstler* (May 1909): 335–47, trans. Greta Moll; Sigrid Hjertén, "Modern och österländsk konst," *Svenska Dagbladet* (February 24, 1911).

60 Henri Matisse, "Notes of a Painter," 1908, ed. and trans. Jack D. Flam, *Matisse on Art* (Berkeley: University of California Press, 1995), 38.

61 Fechter, *Expressionismus*, 28–29.

62 Worringer formulated psychological typologies of style from the artistic forms of the past (primitive, Oriental, classical, and Gothic). Wilhelm Worringer, *Formprobleme der Gotik* (Munich: Piper, 1911); English edition: *Form in Gothic*, ed. Herbert Read (New York: Tiranti, 1957).

63 Rosa Schapire, review of *Der Expressionismus*, by Paul Fechter, *Zeitschrift für Bücherfreunde* NF 6, no. 1 (1914): 243.

64 See Charles W. Haxthausen, "A Critical Illusion: 'Expressionism' in the Writings of Wilhelm Hausenstein," in *The Ideological Crisis of Expressionism: The Literary and Artistic German War Colony in Belgium, 1914–1918*, ed. Rainer Rumold and O. K. Werckmeister (New York: Columbia University Press, 1990), 178–79.

65 Wilhelm Hausenstein, *Die Bildende Kunst der Gegenwart* (Stuttgart: Deutsche Verlags-Anstalt, 1914), 302–3. Also see Joan Weinstein, "Wilhelm Hausenstein, the Leftist Promotion of Expressionism, and the First World War," in Rumold and Werckmeister, *The Ideological Crisis of Expressionism*, 198.

66 Wilhelm Hausenstein, "Die Neue Kunst: Zur Naturgeschichte der Kritik," *Neue Kunst* (Munich: Hans Goltz, 1913), 16–17.

67 For this viewpoint see, for instance, Bernd Küsters, "Einleitung," in *Malerinnen des XX. Jahrhunderts*, ed. Bernd Küsters (Bremen: Donat Verlag, 1995), 8.

68 Gabriele Münter to Wassily Kandinsky, November 6, 1912, in *Wassily Kandinsky und Gabriele Münter in Murnau und Kochel, 1902–1914: Briefe und Erinnerungen*, ed. Annegret Hoberg (Munich: Prestel, 1994), 139.

69 Gabriele Münter, Manuscript, 1917, Gabriele Münter- und Johannes Eichner-Stiftung (hereafter GMJES), as cited in Anders Wahlgren, *Sigrid & Isaac* (Stockholm: Prisma, 2007), 119.

70 Jacoba van Heemskerck to Herwarth Walden, January 23, 1915, Sturm-Archiv Herwarth Walden, Handschriftenabteilung, Staatsbibliothek Preußischer Kulturbesitz Berlin (hereafter SBPK), Acc. MS1026.106: Blatt 49/50.

71 Carl Vinnen, "Quousque Tandem," in Carl Vinnen, ed., *Ein Protest Deutscher Künstler* (Jena: Eugen Diederichs, 1911), 2–16.

72 Alfred Walter Heymel, ed., *Kampf um die Kunst: Die Antwort auf den Protest Deutscher Künstler* (Munich: Piper, 1911).

73 See Peter Paret, *The Berlin Secession: Modernism and Its Enemies in Imperial Germany* (Cambridge, MA: Belknap, 1980), 189.

74 The intense period of economic expansion is pinpointed to the years around 1893–1913. Volker R. Berghahn, *Economy, Society and Culture of Imperial Germany, 1870–1914* (Oxford: Berghahn, 1994), 15–17.

75 Shulamith Behr, "Anatomy of the Woman as Collector and Dealer in the Weimar Period: Rosa Schapire and Johanna Ey," in *Visions of the "Neue Frau": Women and the Visual Arts in Weimar Germany*, ed. Marsha Meskimmon and Shearer West (Aldershot: Scolar Press, 1995), 96–107.

76 Haxthausen, "Critical Illusion," 172.

77 Peter Bürger, *Theory of the Avant-Garde* (1974; Minneapolis: University of Minnesota Press, 1984).

78 Susan Rubin Suleiman, *Subversive Intent: Gender, Politics and the Avant-Garde* (Cambridge, MA: Harvard University Press, 1990).

79 Griselda Pollock, *Avant-Garde Gambits, 1888–1893: Gender and the Colour of Art History* (London: Thames and Hudson, 1993).

80 Pollock, *Avant-Garde Gambits*, 20n16, 74. See Sigmund Freud, *Totem and Taboo: Some Points of Agreement between the Mental Lives of Savages and Neurotics*, trans. James Strachey (London: Routledge, 1919), 153: "An event such as the primal elimination of the father by the company of his sons must inevitably have left ineradicable traces in the history of humanity."

81 For the social conditions of identifying an artistic avant-garde, see Reinhold Heller, "'Das Schwarze Ferkel' and the Institution of an Avant-Garde in Berlin, 1892–1895," in *Künstlerischer Austausch: Artistic Exchange. Akten des XXVIII. Internationalen Kongresses für Kunstgeschichte*, ed. Thomas W. Gaehtgens (Berlin: Akademie, 1993), 3:509.

82 See Dorothy Rowe, *Representing Berlin: Sexuality and the City in Imperial and Weimar Germany* (Aldershot: Ashgate, 2003), 63–80; Georg Simmel, "Die Großstädte und das Geistesleben," in *Die Großstadt: Vorträge und Aufsätze zur Städteausstellung* (Dresden: v. Zahn & Jaensch, 1903), 185–206; "Weibliche Kultur," *Neue Deutsche Rundschau (Freie Bühne)* 13, no. 5 (1902): 504–15; "Das Relative und das Absolute im Geschlechter-Problem," *Frauen-Zukunft* 2, nos. 1/3 (June 1911): 157–72; 2: 1/4 (July 1911): 253–65.

83 For coverage of Märten's early formation and relationship with the Social Democratic Party of Germany (SPD), see Chryssoula Kambas, *Die Werkstatt als Utopie: Lu Märtens Literarische Arbeit und Formästhetik seit 1900* (Tübingen: Max Niemeyer, 1988).

84 Lu Märten, *Die Künstlerin* (Munich: Albert Langen, 1914). Copies of this and the 1919 edition are no longer extant. For the facsimile edition, consult Lu Märten, *Die Künstlerin*, ed. Chryssoula Kambas (Bielefeld: Aisthesis, 2001).

85 Märten, *Künstlerin*, 41.

86 Märten, *Künstlerin*, 40.

87 Märten, *Künstlerin*, 44.

88 Georg Simmel, *Über Soziale Differenzierung: Soziologische und Psychologische Untersuchungen* (Leipzig: Duncker & Humblot, 1890).

89 See Harry Liebersohn, *Fate and Utopia in German Sociology, 1870–1923* (Cambridge, MA: MIT Press, 1988), 140.

90 Märten, *Künstlerin*, 36.

91 Märten, *Künstlerin*, 36.

92 Märten, *Künstlerin*, 52–55.

93 Märten, *Künstlerin*, 35.

94 Linda Nochlin, "Why Have There Been No Great Women Artists?," in *Women, Art and Power and Other Essays* (1971; New York: Harper & Row, 1988), 145–78.

95 Ann Taylor Allen's research reveals that present-day feminist historians, discomforted by late nineteenth- and early twentieth-century glorifications of motherhood, viewed the phenomenon as concessions to patriarchy and labeled it as such. See Ann Taylor Allen, "Feminism and Motherhood in Germany and in International Perspective, 1800–1914," in *Gender and Germanness: Cultural Production of Nation*, ed. Patricia Herminghouse and Magda Mueller (Oxford: Berghahn, 1997), 113–28.

96 See Belinda Davis, "Reconsidering Habermas, Gender and the Public Sphere: The Case of Wilhelmine Germany," in *Society, Culture, and the*

State in Germany, 1870–1930, ed. Geoff Eley (Ann Arbor: University of Michigan Press, 1996), 402–3.

97 Jürgen Habermas, *The Structural Transformation of the Public Sphere: An Enquiry into a Category of Bourgeois Society*, trans. Thomas Burger with Frederick Lawrence (Cambridge, MA: MIT Press, 1989).

98 Geoff Eley, "Nations, Publics, and Political Cultures: Placing Habermas in the Nineteenth Century," in *Habermas and the Public Sphere*, ed. Craig Calhoun (Cambridge, MA: MIT Press, 1992), 292.

99 Nancy Fraser, for instance, argues that gendered identity is lived out in all arenas of life and that, via the exchange medium of power, the "public sphere" or space of political participation, debate, and opinion formation is connected to the state administrative system. See Nancy Fraser, "What's Critical about Critical Theory? The Case of Habermas and Gender," in *Feminism as Critique*, ed. Seyla Benhabib and Drucilla Cornell (Minneapolis: University of Minnesota Press, 1987), 31–55.

100 Jürgen Habermas, "Further Reflections on the Public Sphere," in Calhoun, *Habermas and the Public Sphere*, 428.

101 Margarete Susman, "Wandlungen der Frau," *Die Neue Rundschau* 44 (1933): 105–24.

102 For a critical biography and translation of this essay, see Barbara Hahn, "Margarete Susman," Jewish Women's Archive, https://jwa.org/encyclopedia/article/susman-margarete.

103 David Blackbourn and Richard J. Evans, eds., *The German Bourgeoisie: Essays on the Social History of the German Middle Class from the Late Eighteenth Century to the Early Twentieth Century* (Abingdon: Routledge, 1991), 9.

104 Despina Stratigakos illuminates the discourse of "Bad Shoppers: The Role of Women Consumers" in her essay "Women and the Werkbund: Gender Politics and German Design Reform, 1907–14," *JSAH* 62, no. 4 (December 2003): 491–511.

105 Anke Daemgen, *The Neue Secession in Berlin, 1910–14: An Artists' Association in the Rise of Expressionism* (PhD diss., University of London, 2001), 90.

106 Jennifer Louise Jenkins, *Provincial Modernity: Culture, Politics, and Local Identity in Hamburg, 1885–1914* (PhD diss., University of Michigan, 1997), 3.

107 Benedict Anderson, *Imagined Communities: Reflections on the Origin and Spread of Nationalism*, rev. ed. (New York: Verso, 1991), 36.

108 Anthony D. Smith, *Nationalism and Modernism: A Critical Survey of Recent Theories of Nations and Nationalism* (London: Routledge, 1998), 139.

109 Joy Dixon, *Divine Feminine: Theosophy and Feminism in England* (Baltimore: Johns Hopkins University Press, 2003), 93.

110 Dixon, *Divine Feminine*, 79.

111 On February 10, 1889, the theosophical movement was founded in Stockholm at the private home of Gustav Zander (1835–1920), physician and originator of medico-mechanic gymnastics. By 1891, the Svenska Teosofika Samfundet (Swedish Theosophical Society) was organized as a subsection of the European movement. See Einar Petander, "Theosophy in Sweden," in *Western Esotericism in Scandinavia*, ed. Henrik Bogdan and Olav Hammer (Leiden: Brill, 2016), 578–86.

112 For further scholarship, see Anna Maria Bernitz, "Hilma af Klint and the New Art of Seeing," in *A Cultural History of the Avant-Garde in the Nordic Countries, 1900–1925*, ed. Hubert van den Berg et al. (Amsterdam: Rodopi, 2012), 587–97; Iris Müller-Westermann, ed., *Hilma af Klint: A Pioneer of Abstraction* (Stockholm: Moderna Museet; Ostfildern: Hatje Cantz, 2013).

113 Rudolf Steiner, *Die Philosophie der Freiheit: Grundzüge einer*

Modernen Weltanschauung (Hamburg: Severus, 2014), 305.

114 Most biographies of Rudolf Steiner are hagiographical, but for a critical survey, see Katharina Brandt and Olav Hammer, "Rudolf Steiner and Theosophy," in *Handbook of the Theosophical Current*, ed. Olav Hammer and Mikael Rothstein (Leiden: Brill, 2013), 113–33.

115 See Marie Savitch, *Marie Steiner-von Sivers: Fellow Worker with Rudolf Steiner* (London: Rudolf Steiner Press, 1967), 60–76.

116 For a summary of the structures of the feminist movement in Germany during this period, see Richard J. Evans, "Liberalism and Society: The Feminist Movement and Social Change," in Evans, *Rethinking German History*, 221–47.

117 Taylor Allen, "Feminism and Motherhood," 120.

118 Ann Taylor Allen, "German Radical Feminism and Eugenics, 1900–1918," *German Studies Review* 9 (February 1988): 31–56.

119 See Marion A. Kaplan, *Die Jüdische Frauenbewegung in Deutschland: Organisation und Ziele des Jüdischen Frauenbundes, 1904–1938* (Hamburg: Hans Christian Verlag, 1981), 20–21.

120 Marion A. Kaplan, *The Making of the Jewish Middle Class: Women, Family, and Identity in Imperial Germany* (New York: Oxford University Press, 1991), 8, 134.

121 Kaplan, *Making of the Jewish Middle Class*, 138.

122 Kathinka von Rosen, "Gegen die Frauenrechtlerinnen," *Hammer: Parteilose Zeitschrift für Nationales Leben* 12, no. 256 (1913): 96, as cited by Maya Fassmann, "Jüdinnen in der deutschen Frauenbewegung, 1865–1919," in *Zur Geschichte der Jüdischen Frau in Deutschland*, ed. Julius Carlebach (Berlin: Metropol, 1993), 147.

123 See the incisive chapter "Women in the First World War," in Helen Boak, *Women in the Weimar Republic* (Manchester: Manchester University Press, 2013), 13–62.

124 Isabel Wünsche, ed., *The Routledge Companion to Expressionism in a Transnational Context* (Abingdon: Routledge, 2019).

125 Hermann Bahr, *Expressionismus* (Munich: Delphin Verlag, 1916).

126 Rosalind Krauss, *The Originality of the Avant-Garde and Other Modernist Myths* (Cambridge, MA: MIT Press, 1986), 170.

127 As cited by Kollwitz in her diary, May 13, 1917. Käthe Kollwitz, *Die Tagebücher*, ed. Jutta Bohnke-Kollwitz (Berlin: Siedler, 1989), 315–16.

128 Pollock, *Avant-Garde Gambits*, 20. I thank Matthew Potter (professor of art history and design, University of Northumbria) for his helpful advice in this regard.

129 Lasker-Schüler letter to Werefkin, 1913, pen, ink, and crayon on paper, 16.5 × 13.5 cm, private collection. See Shulamith Behr, "The Dynamics of Gendered Artistic Identity and Creativity in the Blaue Reiter," in *German Expressionism: Der Blaue Reiter and Its Legacies*, ed. Dorothy Price (Manchester: Manchester University Press, 2020), 43–46.

130 Rudolf Steiner, *Der Menschliche und der Kosmische Gedanke: Vier Vorträge Gehalten in Berlin vom 20. bis 23. Januar 1914* (Berlin: Philosophisch-Anthroposophischer Verlag, 1949).

131 Jane Beckett, "In the Bleaching Fields: Gender, Landscape and Modernity in the Netherlands, 1880–1920," in *Gendering Landscape Art*, ed. Steven Adams and Anna Gruetzner Robins (Manchester: Manchester University Press, 2000), 61–75.

132 Adolf Behne, *Zur Neuen Kunst*, Sturm-Bücher VII, 2nd ed. (Berlin: Der Sturm, 1917), 24–28.

133 In 1926, along with other anthroposophists, Marie Tak van Poortvliet set up the public limited company Cultuurmaatschappij Loverendale to sponsor Biodynamic Agriculture on her landholdings in the Zeeland and Brabant regions. See Jacqueline van Paaschen, *Biography*

Joanna Maria Tak van Poortvliet (1871–1936), Biografie Instituut, University of Groningen (rug.nl).

134 Jennifer Jenkins, *Provincial Modernity: Local Culture and Liberal Politics in Fin-de-Siècle Hamburg* (Ithaca: Cornell University Press, 2002).

135 Judith Butler, *Gender Trouble: Feminism and the Subversion of Identity* (1990; Abingdon: Routledge, 2007), 68–73.

136 Frau K. E. Osthaus, "Das Museum Folkwang in Hagen," *Kölnische Zeitung* 908 (August 10, 1913): 2, as quoted in Rainer Stamm, "Strömen und Wollen unserer Zeit: Die Sammlerin Gertrud Osthaus," in *Kunstsammlerinnen: Peggy Guggenheim bis Ingvild Goetz*, ed. Dorothee Wimmer, Christina Feilchenfeldt, and Stephanie Tasch (Berlin: Reimer Verlag, 2009), 91; and Katherine Kuenzli, "The 'Primitive' and the Modern in the Blaue Reiter Almanac and the Folkwang Museum," in Price, *German Expressionism*, 58–59.

137 Emily J. Levine, *Dreamland of Humanities: Warburg, Cassirer, Panofsky, and the Hamburg School* (Chicago: University of Chicago Press, 2013).

138 Rosa Schapire, "Schmidt-Rottluffs religiöse Holzschnitte," *Die Rote Erde* 1, no. 6 (November 1919): 186–88.

139 Johanna Ey, "Erinnerungen der Johanna Ey" (1936), in Annette Baumeister, *Treffpunkt "Neue Kunst": Erinnerungen der Johanna Ey* (Düsseldorf: Droste, 1999), 55–83.

140 Sigmund Freud, "The Unconscious," 1915, in *The Standard Edition of the Complete Psychological Works of Sigmund Freud*, trans. James Strachey in collaboration with Anna Freud (London: Hogarth Press and Institute of Psycho-Analysis, 1953–74), 14:159–215.

141 Peter Galison, "Blacked-out Spaces: Freud, Censorship, and the Re-territorialization of Mind," *British Journal for the History of Science* 45, no. 2 (June 2012): 245–46; https://doi.org/10.1017/S000708741200009X.

142 Freud, "The Unconscious," in *The Standard Edition of the Complete Psychological Works of Sigmund Freud*, 14:172–73.

Chapter 2. The Canonizing of Paula Modersohn-Becker: Embodying the Subject and the Feminization of Expressionism

1 Lindner, "Eine Phänomenale Malerin."

2 Lindner, "Eine Phänomenale Malerin."

3 For a discussion of the genealogy of this concept, see Christine Battersby, *Gender and Genius: Toward Feminist Aesthetics* (London: Women's Press, 1989).

4 Otto Weininger, *Sex and Character* (Geschlecht und Charakter: Eine Prinzipielle Untersuchung, 1903), authorized translation from the 6th German ed. (London: Heinemann, 1910), 189.

5 Modersohn-Becker attended the Cézanne and Gauguin retrospectives, which ran at the Salon d'Automne in 1906 (Letter to Rainer Maria Rilke, April 5, 1907). Paula Modersohn-Becker, *The Letters and Journals*, ed. Günter Busch and Liselotte von Reinken (New York: Taplinger, 1983), 418, 531.

6 Emil Löhnberg, "Paula Modersohn," *Die Aktion* 8, nos. 9–10 (March 9, 1918): 127.

7 See commentary in Günter Busch and Wolfgang Werner, eds., *Paula Modersohn-Becker, 1876–1907: Werkverzeichnis der Gemälde* (Munich: Hirmer, 1998), 2:586.

8 Günter Busch, "Einführung in das Werk von Paula Modersohn-Becker," in Busch and Werner, *Paula Modersohn-Becker 1*, 25.

9 Von Hohenzollern and Schuster, *Von Manet bis van Gogh*, 130.

A comprehensive account of this reception can be found in Walter Feilchenfeldt, *Vincent van Gogh and Paul Cassirer Berlin: The Reception of van Gogh in Germany from 1901 to 1914* (Zwolle: Uitgverij Waanders, 1988).

10 For further discussion of this, consult Patricia G. Berman, "The Invention of History: Julius Meier-Graefe, German Modernism, and the Genealogy of Genius," in *Imagining Modern German Culture, 1889–1910*, ed. Françoise Forster-Hahn (Washington, DC: National Gallery of Art, 1996), 91–105.

11 Letter to Otto Modersohn from Paris, June 30, 1906, in Modersohn-Becker, *Letters and Journals*, 404.

12 In 1899, Gustav Pauli, director of the Bremen Kunsthalle, arranged the exhibition of three Worpswede-based women artists—*Studien von Paula Becker, Marie Bock und Clara Westhoff*. This was severely disparaged by the sixty-year-old critic Artur Fitger in his review, "Aus der Kunsthalle," *Weser-Zeitung* (Bremen) (December 20, 1899). At the same venue, four of her paintings were included in an exhibition devoted to the artists of Worpswede in November 1906. In 1907, the same exhibition traveled to the Galerie Gurlitt in Berlin, and at the Kunst- und Kunstgewerbehaus in Worpswede, one still life was included in an exhibition of Worpswede artists.

13 Curt Stoermer, "Ausstellungen," *Der Cicerone* 5, no. 16 (August 1913): 593.

14 Gustav Pauli, "Paula Modersohn-Becker," in vol. 1 of *Das Neue Bild*, ed. Carl Georg Heise (Leipzig: Kurt Wolff Verlag, 1919).

15 See Otto Karl Werckmeister, *The Making of Paul Klee's Career, 1914–1920* (Chicago: University of Chicago Press, 1984), 35–36, 86–88; Shulamith Behr, "Supporters and Collectors of Expressionism," in *German Expressionism: Art and Society*, ed. Stephanie Barron and Wolfgang-Dieter Dube (Milan: Bompiani, 1997), 52.

16 Letter to Martha Vogeler, May 21, 1906, in Modersohn-Becker, *Letters and Journals*, 400–401.

17 Letters to Bernhard Hoetger, April 27 and May 5, 1906, in Modersohn-Becker, *Letters and Journals*, 393.

18 See Dörte Zbikowski, "Die Sammlung Rauert in Ihrer Zeit," in *Nolde, Schmidt-Rottluff und Ihre Freunde: Die Sammlung Martha und Paul Rauert Hamburg, 1905–1958*, ed. Eva Caspers, Wolfgang Henze et al. (Hamburg: Ernst Barlach Haus, 1999), 60–63.

19 This exhibition occurred in October 1920. Nineteen of Modersohn-Becker's works were included with those of James Ensor and applied art from Tibet. For further commentary on the exhibition catalog, see Diane Josephine Radycki, *Paula Modersohn-Becker: The Gendered Discourse in Modernism* (PhD diss., Harvard University, 1993), 103–4.

20 Editorial comment in Modersohn-Becker, *Letters and Journals*, 512–13.

21 For further commentary on this journal, see Lutz Windhöfel, *Paul Westheim und Das Kunstblatt: Eine Zeitschrift und Ihr Herausgeber in der Weimarer Republik* (Cologne: Böhlau, 1995).

22 P. E. Küppers, "Paula Modersohn (In Memoriam)," *Das Kunstblatt* 2, no. 2 (1918): 65–68. Evidence of positive critical reception abounds prior to 1920, contrary to conclusions drawn by Gregor Langfeld in "Paula Modersohn-Becker in den Niederlanden," in *Paula Modersohn-Becker*, ed. Jisca Bijlsma, Sigrid Kullmann, and Thea Wieteler (Rotterdam: Chabot Museum, 2006), 38.

23 Küppers, "Paula Modersohn," 66.

24 Journal entry, February 20, 1903, in Modersohn-Becker, *Letters and Journals*, 299.

25 Journal entry, February 25, 1903, in Modersohn-Becker, *Letters and Journals*, 300.

26 Küppers, "Paula Modersohn," 68; see Rainer Stamm, ed., *Paula Modersohn-Becker und die Ägyptischen Mumienportraits* (Bremen: Paula Modersohn-Becker Museum, 2007), 22.

27 Küppers, "Paula Modersohn," 68.

28 Paula Becker-Modersohn, "Briefe und Tagebuchblätter," *Güldenkammer* 3, nos. 4–8 (January–May 1913). For the history of the journal, see Christel Rademaeker, "Bücher aus der Böttcherstraße," in *Projekt Böttcherstraße*, ed. Hans Tallasch (Delmenhorst: Aschenbeck/Holstein, 2002), 281–82.

29 See Sophie Dorothea Gallwitz, "Zum Kampf der Künstlerinnen," *Die Frau* 14, no. 3 (December 1906): 173–77.

30 Paula Modersohn-Becker, *Eine Künstlerin: Briefe und Tagebuchblätter* (Hanover: Kestner Gesellschaft, 1917). In 1919, Franz Leuwer, Bremen, published a second edition, and the Kurt Wolff Verlag, Leipzig, produced an expanded publication in 1920. Gallwitz served as editor for all multiple printings.

31 Preface in Modersohn-Becker, *Letters and Journals*, trans. Arthur S. Wensinger and Carole Clew Hoey, vii. For a scholarly review of the letters and journals, see Ellen C. Oppler, *Woman's Art Journal* 5, no. 2 (Autumn 1984–Winter 1985): 48–50.

32 In citing Rosalind Coward and John Ellis, *Language and Materialism: Developments in Semiology and the Theory of the Subject* (London: Routledge, 1977), 80–81, the feminist German literature historian Leslie Adelson seizes on Lacan's and Kristeva's notion of *positionality* in the signifying practice. This is not to be confused with immutable fixity of position of the language-using subject (Lacan calls this the symbolic) but of the subject in relation to contradictory outside and ideological articulations (155). From this we understand the constructed nature of the human subject. See Leslie Adelson, *Making Bodies, Making History: Feminism and German Identity* (Lincoln: University of Nebraska Press, 1993), 16–17.

33 Pauli, "Paula Modersohn-Becker," 11.

34 The diaries of this Ukrainian-born painter, who studied in the studio of the Académie Julian in Paris, were translated from the French into the German. See *Tagebuch der Maria Bashkirtseff*, trans. Lothar Schmidt, 2 vols. (Breslau: L. Frankenstein, 1897). Journal entry, November 15, 1898, in Modersohn-Becker, *Letters and Journals*, 115.

35 See Gill Perry, "Paula Modersohn-Becker," in *Dictionary of Women Artists*, ed. Delia Gaze (London: Fitzroy Dearborn, 1997), 966, and Mara R. Witzling, ed., *Voicing Our Visions: Writings by Women Artists* (London: Women's Press, 1991), 187–92.

36 Catherine Russell, *Experimental Ethnography* (Durham, NC: Duke University Press, 1999), 276.

37 Modersohn-Becker, *Letters and Journals*, 16.

38 Letter to her parents from Berlin, January 10, 1897, in Modersohn-Becker, *Letters and Journals*, 64.

39 Adelson prefers to call these "moments in social process." Adelson, *Making Bodies*, 9.

40 For information on Becker's family background and upbringing in Dresden, including her mother's aristocratic genealogy, see *Paula Modersohn-Becker: Von Dresden Her*, ed. Gabriele Werner (Dresden: Galerie Neue Meister, Staatliche Kunstsammlungen, 2003).

41 A reconstruction of Becker's artistic experiences in London is contained in Radycki, *Gendered Discourse*, 139–48.

42 Letter from Woldemar Becker to his wife, July 3, 1896, in Modersohn-Becker, *Letters and Journals*, 60–61.

43 Letter to her father, August 7, 1892, in Modersohn-Becker, *Letters and Journals*, 21.

44 Karen Lang, "Monumental Unease: Monuments and the Making of National Identity in Germany," in Forster-Hahn, *Imagining Modern German Culture*, 284.

45 Letter to her father, May 18, 1896, in Modersohn-Becker, *Letters and Journals*, 60.

46 For discussion of this phenomenon, see Eric Hobsbawm, "Mass Producing Traditions: Europe, 1870–1914," in *The Invention of Tradition*, ed. Eric Hobsbawm and Terence Ranger (Cambridge: Cambridge University Press, 1983), 263–307.

47 Letter to Paula from her father, February 20, 1898, in Modersohn-Becker, *Letters and Journals*, 96.

48 Geoff Eley, "Introduction 1," in *Society, Culture, and the State in Germany, 1870–1930*, ed. Geoff Eley (Ann Arbor: University of Michigan Press, 1996), 12.

49 Letter to her parents from Berlin, March–April 1898, in Modersohn-Becker, *Letters and Journals*, 97. On February 5, 1892, the foundation of the Vereinigung der XI (Association of the Eleven) by Max Liebermann constituted one of the first reactions to artists' dissatisfaction with the available possibilities and policies of exhibitions in Berlin.

50 Letter to her parents, November 7, 1897, in Modersohn-Becker, *Letters and Journals*, 83.

51 Letter to her father, January 10, 1897, in Modersohn-Becker, *Letters and Journals*, 65. Surprisingly, then, it was her father who encouraged broader consideration of women's rights. Letter from her father, January 26, 1897, in Modersohn-Becker, *Letters and Journals*, 67.

52 Letter to her parents from Berlin, January 10, 1897, in Modersohn-Becker, *Letters and Journals*, 64–65.

53 A survey of the interaction between Scandinavian women artists and Germany can be found in Marit Lange, "Malerinnen und Maler in Karlsruhe, Berlin und München," in *Wahlverwandtschaft: Skandinavien und Deutschland, 1800 bis 1914*, ed. Bernd Henningsen and Janine Klein et al. (Berlin: Deutsches Museum, 1999), 324–39.

54 Letter to her parents from Berlin, March 5, 1897, in Modersohn-Becker, *Letters and Journals*, 71.

55 Letter to her parents from Berlin, October 28, 1897, in Modersohn-Becker, *Letters and Journals*, 82.

56 Letter to her parents, October 28, 1897, in Modersohn-Becker, *Letters and Journals*, 82.

57 Letter to her aunt Cora von Bültzingslöwen from Worpswede, September 7, 1898, in Modersohn-Becker, *Letters and Journals*, 107–8.

58 Letter to her parents from Lilleon, July 3, 1898, in Modersohn-Becker, *Letters and Journals*, 106–7. Becker was already reading Jacobsen's six stories at the time and was pleased to receive the novels as gifts from her parents.

59 This is discussed in greater detail in Gill Perry, "'The Ascent to Nature': Some Metaphors of 'Nature' in Early Expressionist Art," in *Expressionism Reassessed*, ed. Shulamith Behr and David Fanning (Manchester: Manchester University Press, 1993), 53–64.

60 For a discussion of class, gender, and citizenship, see Kathleen Canning, "Key Words in German Gender History," *Central European History* 37, no. 2 (2004): 225–44 (239).

61 Julius Langbehn, *Rembrandt als Erzieher (Von einem Deutschen)* (1890; Leipzig: Hirschfeld, 1925), 203–4.

62 For further discussion, see Geoff Eley, "German History and the Contradictions of Modernity: The Bourgeoisie, the State and the Mastery of Reform," in *Society, Culture, and the State in Germany, 1870–1930*, ed. Geoff Eley (Ann Arbor: University of Michigan Press, 1996), 99.

63 In 1884, under Bismarck's chancellorship, Germany commenced the annexation of colonial territory. Theoretically speaking, however, Bismarck never accepted the term "Kolonie," which he associated pejoratively with its French derivation, preferring instead the euphemism *Schutzgebiet* or protectorate. Harry R. Rudin, *Germans in the Cameroons, 1884–1914: A Case Study in Modern Imperialism* (London: Jonathan Cape, 1938), 39.

64 See Nina Lübbren, *Rural Artists' Colonies in Europe, 1870–1910* (Manchester: Manchester University Press, 2001), 135–36.

65 Here, Lübbren effectively argues that the later painters who arrived in Worpswede, such as Becker and Ottilie Reyländer, "did not need a period of acclimatization because the schemata for 'Worpswede' were already in place for them to utilize." Lübbren, *Rural Artists' Colonies in Europe*, 124.

66 In its intersection with the thrust of the women's movement, German colonialism is interpreted as providing an "emancipatory space" for women in their critique of Wilhelmine patriarchy. See Russell A. Berman, *Enlightenment or Empire: Colonial Discourse in German Culture* (Lincoln: University of Nebraska Press, 1998), 171–202.

67 Lübbren, *Rural Artists' Colonies*, 27, 40–63.

68 Letter to her parents from Worpswede, November 25, 1898, in Modersohn-Becker, *Letters and Journals*, 116.

69 On the subject of white women's activism in Germany's colonial movement, see Lora Wildenthal, *German Women for Empire, 1884–1945* (Durham, NC: Duke University Press, 2001); Marcia Klotz, *White Women and the Dark Continent: Gender and Sexuality in German Colonial Discourse from the Sentimental Novel to the Fascist Film* (PhD diss., Stanford University, 1995).

70 Entry in journal in Worpswede, December 16, 1898, in Modersohn-Becker, *Letters and Journals*, 120.

71 Entry in journal in Worpswede, November 11, 1898, in Modersohn-Becker, *Letters and Journals*, 113.

72 For her attempts at the fairy-tale genre, undated entry in her journal, see Modersohn-Becker, *Letters and Journals*, 114–15.

73 A Jungian interpretation of Modersohn-Becker's representation of women can be found in Kimberley Allen-Kattus, *Paula Modersohn-Becker and the Archetype of the Great Mother* (PhD diss., University of Michigan, 1997).

74 For instance, see the discussion of Mackensen's programmatic work *Sermon on the Moor* (Worpswede), 1895, 235 × 376 cm, Historisches Museum Hannover, in Lübbren, *Rural Artists' Colonies*, 123–25.

75 From Otto Modersohn's journal, September 26, 1903, in Modersohn-Becker, *Letters and Journals*, 324.

76 The Munich academician Franz von Lenbach was responsible for selecting the works. His portraits of Wilhelm II were placed alongside the works of Adolph von Menzel and the secessionists Walter Leistikow and Max Liebermann. For further details, see Françoise Forster-Hahn, "Constructing New Histories: Nationalism and Modernity in the Display of Art," in Forster-Hahn, *Imagining Modern German Culture*, 77.

77 Letter to Otto and Helene Modersohn, beginning of May 1900, in Modersohn-Becker, *Letters and Journals*, 185.

78 Letter to her parents, March 3, 1900, and editorial comment, in Modersohn-Becker, *Letters and Journals*, 171, 475–76.

79 Letter to her brother from Paris, April 26, 1900, in Modersohn-Becker, *Letters and Journals*, 182. In his essay, "Eine Neue Welt: Paula Modersohn-Becker und Sanne Bruinier," in *Paula Modersohn-Becker* (Rotterdam: Chabot Museum, 2006), 23–34, Rainer Stamm gives a fascinating account of foreign women artists' experiences as students at the Académie Colarossi, which Becker attended until June 1900.

80 Design for *Die Jugend*, 1899, watercolor, 26.5 × 20.3 cm; Design for *La Ferme* cigarettes, 1900, watercolor and ink, 13.3 × 16.9 cm, both in the Kunsthalle Bremen.

81 Eric Torgersen, *Dear Friend: Rainer Maria Rilke and Paula Modersohn-Becker* (Evanston, IL: Northwestern University Press, 1998).

82 Rainer Maria Rilke and Ellen Key, *Briefwechsel*, ed. Theodor Fiedler (Frankfurt am Main: Insel, 1993), 249–55; Rainer Maria Rilke, review of "Das Jahrhundert des Kindes," *Bremer Tageblatt und General Anzeigern* 6, no. 32 (June 8, 1902): 254. Key's text, *Barnets århundrade* (1900), was translated into German in 1902 (Berlin: S. Fischer).

83 Rainer Maria Rilke, *Worpswede: Fritz Mackenson, Otto Modersohn, Fritz Overbeck, Hans am Ende, Heinrich Vogeler* (Bielefeld: Velhagen & Klasing, 1903).

84 See Torgersen, *Dear Friend*, 130, quoting from a transcription in the Worpswede Archive.

85 Sigmund Freud, *Three Essays on Sexuality* (1905), trans. and ed. James Strachey (London: Hogarth Press, 1962), 41.

86 Letter to Rainer Maria Rilke, November 12, 1900, in Modersohn-Becker, *Letters and Journals*, 207 (these were presumably the childhood drawings by the painter Ottilie Reyländer from whom Becker inherited the studio). For commentary on the mistranslation of this from the German, see Marcel Franciscono, "Paul Klee and Children's Art," in *Discovering Child Art: Essays on Childhood, Primitivism, and Modernism*, ed. Jonathan Fineberg (Princeton, NJ: Princeton University Press, 1998), 96, 118n12.

87 Letter to Rainer Maria Rilke, January 23, 1901, in Modersohn-Becker, *Letters and Journals*, 236; see also Torgersen, *Dear Friend*, 102–3. Rilke expressed regret that, apart from a sketch of a Worpswede landscape, he had seen very little of her work. Letter to Paula Becker, January 24, 1901, in Rainer Maria Rilke, *Briefe und Tagebücher aus der Frühzeit, 1899 bis 1902*, ed. Ruth Sieber-Rilke and Carl Sieber (Leipzig: Insel, 1931), 98.

88 *Die Konfirmandin*, ca. 1903, charcoal on paper, 35.5 × 16 cm, private collection, bought by present owner from Frau Hausinger in 1938. According to the latter, the drawing derived from the collection of the Folkwang Museum, Essen, which had to dispose of it as "Entartete Kunst." This information is confirmed and correlates with the drawing *Braut* EK 3862: Beschlagnahmeinventar "Entartete Kunst": Datenbank, Freie Universität, Berlin.

89 Rainer Maria Rilke, *The Book of Images* (*Das Buch der Bilder*), trans. Edward Snow (San Francisco: North Point Press, 1991), 49 (the first edition of forty-five poems was published in July 1902; the second edition, to which Rilke added thirty-seven new poems, was published in December 1906).

90 For an informative discussion of the notion of the *Kindweib* (child-woman) at the turn of the century, see Alessandra Comini, "Toys in Freud's Attic: Torment and Taboo in the Child and Adolescent Themes of Vienna's Image-Makers," in *Picturing Children: Constructions of Childhood between Rousseau and Freud*, ed. Marylin R. Brown (Aldershot: Routledge, 2002), 167–88.

91 Rilke, *Book of Images*, xiv.

92 Letter to Otto Modersohn from Paris, March 2, 1903. By virtue of his position as secretary to Rodin, Rilke provided her with an introduction to the sculptor. Modersohn-Becker, *Letters and Journals*, 303.

93 The drawing is related to the image of Martha Vogeler in the painting *Brustbild eines Mädchens mit Schleier*, ca. 1901, mixed media on board, 38 × 49.7 cm, private collection, Munich. Busch and Werner, *Paula Modersohn-Becker*, 163.

94 Letter to Otto Modersohn from Paris, March 3, 1903, in Modersohn-Becker, *Letters and Journals*, 305.

95 *Brustbild einer Alten Frau mit Kind*, 1905, mixed media on board, 64.5 × 40 cm, Kestner Gesellschaft, Hanover.

96 From Otto Modersohn's journal, December 11, 1905, in Modersohn-Becker, *Letters and Journals*, 377.

97 Letter to Karl von der Heydt from Meudon, January 16, 1906, in Rainer Maria Rilke, *Briefe, 1902–6*, ed. Ruth Sieber-Rilke and Carl Sieber (Leipzig: Insel, 1929), 29.

98 Letter to Milly Becker from Worpswede, April 15, 1904, in Modersohn-Becker, *Letters and Journals*, 331.

99 See Torgersen, *Dear Friend*, 179. For Modersohn-Becker's affair with the economist Werner Sombart, see Radycki, *Paula Modersohn-Becker: The First Modern Woman Artist*, 141–42.

100 This observation was raised in an abstract by Christina Urie (Brigham Young University), "Paula Modersohn-Becker's Experience with the Modernity of the Metropolis" (paper presented at the German Studies Graduate Student Conference, University of Wisconsin, Madison, September 10, 2002).

101 Letter to Otto Modersohn from Paris, March 19, 1906, in Modersohn-Becker, *Letters and Journals*, 388. On the notion of the flâneuse, see Janet Wolff, "The Invisible *Flâneuse*: Women and the Literature of Modernity," in *Feminine Sentences: Essays on Women and Culture* (Cambridge: Polity Press, 1990), 47.

102 Letter to Martha Vogeler from Paris, May 21, 1906, in Modersohn-Becker, *Letters and Journals*, 401.

103 In her theorization of the aesthetics of liminal performance, Susan Broadhurst describes the limen as "a space which holds a possibility of potential form structures, conjectures, and desires." Susan Broadhurst, *Liminal Acts: A Critical Overview of Contemporary Performance and Theory* (London: Cassell, 1999), 12.

104 For further amplification on this, consult Brian O'Doherty, *Inside the White Cube: The Ideology of the Gallery Space* (1976; Berkeley: University of California Press, 1999), 35–64.

105 Radycki raises the implications of the artist's use of her maiden name ("P. B.") for the signature, as well as the historiographic mishandling of the title. See Radycki, *Paula Modersohn-Becker: The First Modern Woman Artist*, 150–52.

106 For material on Vuillard, consult Susan Sidlauskas, "Psyche and Sympathy: Staging Interiority in the Early Modern Home," in *Not at Home: The Suppression of Domesticity in Modern Art and Architecture*, ed. Christopher Reed (London: Thames and Hudson, 1996), 74.

107 Carol Duncan, "Virility and Domination in Early Twentieth-Century Vanguard Painting," in Broude and Garrard, *Feminism and Art History*, 302.

108 Christa Murken-Altrogge points to the religious iconographic sources and metaphoric meanings of the self-portrait. Christa Murken-Altrogge, *Paula Modersohn-Becker* (Cologne: DuMont, 1991), 114.

109 Herma Becker to her mother, May 26, 1906, in Modersohn-Becker, *Letters and Journals*, 402.

110 Torgersen, *Dear Friend*, 195.

111 Letter to Paula from her mother, February 5, 1906, in Modersohn-Becker, *Letters and Journals*, 382. Paula's thirtieth birthday was on February 8, 1906.

112 Rosemary Betterton, "Mother Figures: The Maternal Nude in the Work of Käthe Kollwitz and Paula Modersohn-Becker," in *Generations and Geographies in the Visual Arts: Feminist Readings*, ed. Griselda Pollock (London: Routledge, 1996), 30–32.

113 Letter to her parents from Paris, February 8, 1900, in Modersohn-Becker, *Letters and Journals*, 165; Torgersen, *Dear Friend*, 198–203, discusses the context of Modersohn-Becker's *Portrait of Rainer Maria Rilke*, 1906 (mixed medium on board, 32.3 × 25.4 cm, Ludwig Roselius Collection, Böttcherstraße, Bremen), which was painted between May 13 and June 2, 1906.

114 Letter to Clara Rilke-Westhoff, May 29, 1906, in Rilke, *Briefe 1902–6*, 274.

115 Caroline Arscott and Katie Scott, eds., *Manifestations of Venus: Art and Sexuality* (Manchester: Manchester University Press, 2000), 7.

116 In her handbook of health for women at the fin de siècle, Anna Fischer-Dückelmann (1856–1917), one of the first women to graduate in medicine in Zurich in 1896, stands in a long medical tradition of associating female health, beauty, and fertility as prerequisites for the improvement of the race. Anna Fischer-Dückelmann, *Die Frau als Hausärztin: Ein Ärztliches Nachschlagebuch der Gesundheitspflege und Heilkunde in der Familie* (1901; Stuttgart: Sueddeutsches Verlags-Institut, 1905). See also Sander Gilman, *Health and Illness: Images of Difference* (London: Reaktion Books, 1995), 58–59.

117 Letter with drawings for Frau Becker's birthday, November 3, 1905, in Modersohn-Becker, *Letters and Journals*, 373.

118 Letter to Clara Rilke-Westhoff, June 1, 1906, in Rilke, *Briefe 1902–6*, 276.

119 Karl Scheffler, "Paula Modersohn-Becker," *Kunst und Künstler* 19 (1921): 332.

120 Scheffler, "Paula Modersohn-Becker," 332.

121 Lübbren, *Rural Artists' Colonies in Europe*, 57–58.

122 For the text of this poem and an in-depth consideration of its referents (it was written in November 1908, a year after Modersohn-Becker's death), see Torgersen, *Dear Friend*, 1–10, 261–67.

123 Gustav Pauli, "Ausstellung in der Kunsthalle," *Bremer Nachrichten* (November 11, 1906), as cited in Modersohn-Becker, *Letters and Journals*, 412.

124 For instance, while Monet's painting *Camille* (1866) was purchased at the end of 1908 for 50,000 marks, Modersohn-Becker's *Still Life with Sunflower and Hollyhocks* (1907) was purchased for 500 marks. See Wulf Herzogenrath, "Paula Modersohn-Becker und Gustav Pauli: Der Kampf um Paula Modersohn-Becker als Vorspann zum 'Protest Deutscher Künstler' 1911," in Friedel, *Paula Modersohn-Becker*, 47–62.

125 Herzogenrath, "Paula Modersohn-Becker und Gustav Pauli," in Friedel, *Paula Modersohn-Becker*, 52–53, citing Gustav Pauli, "Zweierlei Kunst," *Bremer Nachrichten* (December 13, 1908) and the response by the Bremen-based pastor Friedrich Steudel, *Das Blaubuch* 4, no. 2 (January 1909): 43–45 and no. 3:70–75.

126 Carl Vinnen, "Quousque Tandem," 2–16.

127 Carl Vinnen, "Quousque Tandem," 6–7.

128 Lindner, "Eine Phänomenale Malerin."

129 Ludwig Bäumer, "Lovis Corinths 'Aufruf an die Jugend, für die Deutsche Kunst': Eine Entgegnung," *Die Aktion* 4 (February 21, 1914): 161–64.

130 Bäumer, "Lovis Corinths 'Aufruf,'" 163.

131 For a wealth of evidence regarding Modersohn-Becker's cosmopolitan experiences, see *Paula Modersohn-Becker und die Kunst in Paris um 1900: Von Cézanne bis Picasso*, ed. Anne Buschoff and Wulf Herzogenrath (Bremen: Kunsthalle, 2007).

132 Hermann Bahr, *Expressionismus*, 36–37.

133 Bahr, *Expressionismus*, 68–75. Bahr explicitly acknowledges the

inspiration of both Alois Riegl (1858–1905) and Wilhelm Worringer (1881–1965).

134 Bahr, *Expressionismus*, 75. For further commentary on Expressionist theory and the "perception of the new," see Anke Daemgen, *The Neue Secession in Berlin, 1910–14: An Artists' Association in the Rise of Expressionism* (PhD diss., University of London, 2001), 263–65.

135 Joan Weinstein, "Expressionism in War and Revolution," in *German Expressionism: Art and Society*, ed. Stephanie Barron and Wolf-Dieter Dube (Venice: Palazzo Grassi, 1997), 38.

136 Bahr, *Expressionismus*, 110.

137 Löhnberg, "Paula Modersohn," 128.

138 C. E. Uphoff, "Paula Modersohn," *Der Cicerone* 11, no. 17 (1919): 538–39.

139 *Die Aktion* 8, no. 13–14 (April 6, 1918).

140 Apart from attending classes with Martin Brandenburg at the Levin-Funcke Studio, Stern studied with Fritz Mackensen. See Karel Schoeman, *Irma Stern: The Early Years, 1894–1933* (Cape Town: South African Library, 1994), 46–47.

141 Irma Stern, *The Eternal Child*, 1916, oil on board, 72.5 × 42 cm, Rupert Museum, Stellenbosch.

142 Rosa Schapire, "Paula Modersohn-Becker," *Kunstchronik und Kunstmarkt* 54, no. 41 (July 25, 1919): 866.

143 See Fritz Malcomess and Eva Neuroth, "Marie von Malachowski," in *Rheinische Expressionistinnen*, ed. Münster, 102, 108.

144 See Arn Strohmeyer, *Parsifal in Bremen: Richard Wagner, Ludwig Roselius und die Böttcherstraße* (Weimar: Verlag und Datenbank für Geisteswissenschaften, 2002), 168, citing Adolf Hitler, "Rede auf dem Nüremberger Parteitag," September 9, 1936.

145 Lisa Tickner, "Mediating Generation: The Mother-Daughter Plot," in *Women Artists at the Millenium*, ed. Carol Armstrong and Catherine de Zegher (Cambridge, MA: MIT Press, 2006), 91–92.

Chapter 3. Käthe Kollwitz, the Expressionist Milieu, and the Making of Her Career

1 See Alessandra Comini, "Gender or Genius?," in Broude and Garrard, *Feminism and Art History*, 273–77.

2 The Cologne Sonderbund exhibition was a spectacular event that included the works of Edvard Munch, Vincent van Gogh, the German group Brücke, and a range of new art drawn from various countries. Magdalena Bushart discusses the national, regional, and international implications of this exhibition in *Der Geist der Gotik und die Expressionistische Kunst* (Munich: Silke Schreiber, 1990), 100–103.

3 Interestingly, an exhibition was dedicated to the theme of their outsider status: see Sebastian Giesen, ed., *Einzelgänger: Käthe Kollwitz, Ernst Barlach, Eugeen van Mieghem* (Leuven: Davidsfonds, 2003).

4 Consult, in particular, the essay "Khōra" in Jacques Derrida, *On the Name*, ed. Thomas Dutoit, trans. Ian McLeod (Palo Alto, CA: Stanford University Press, 1995), 89–127, in which the proper noun and its associations are discussed. Here khōraic metonymy supersedes the singularity offered by the logos.

5 For studies that consider Kollwitz's remarkable artistic skills in relation to the social content, see Louis Marchesano, ed., *Käthe Kollwitz: Prints, Process, Politics* (Los Angeles: Getty Research, 2019); Jonathan Watkins, ed., *Portrait of the Artist: Käthe Kollwitz* (Birmingham: Ikon Gallery and British Museum, 2017); Elizabeth Prelinger, "Kollwitz Reconsidered," in Prelinger, *Kollwitz*, 13–88.

6 For the most pertinent contributions to this inquiry, consult Erika

Hartmann, "Käthe Kollwitz: Mutter mit Totem Kind," *Jahrbuch der Psychoanalyse: Beiträge zur Theorie, Praxis und Geschichte* 45 (2002): 88–120; Rosemary Betterton, "Mother Figures: The Maternal Nude in the Work of Käthe Kollwitz and Paula Modersohn-Becker," in *An Intimate Distance: Women, Artists and the Body* (London: Routledge, 1996), 20–45. An early feminist intervention in the field can be found in Martha Kearns, *Käthe Kollwitz: Woman and Artist* (New York: Feminist Press at the City University, 1976).

7 Hildegard Bachert examines "The Collecting of Art of Käthe Kollwitz: A Survey of Collections, Collectors, and Public Response in Germany and the United States," in Prelinger, *Kollwitz*, 117–35. Jay A. Clarke contributes to Kollwitz studies by reframing the artist in a critical context rather than a biographical one, retaining, however, the shifting lenses of gender and politics. See her essays, "Käthe Kollwitz and the Critics," in *Käthe Kollwitz: The Art of Compassion*, ed. Brenda Rix (Toronto: Art Gallery of Ontario, 2003), 43–62; "Kollwitz, Gender, Biography, and Social Activism," in Marchesano, *Kollwitz*, 40–56.

8 In introducing an abridged publication of her writings, her eldest son Hans revealed that, already in 1922, following his request, Kollwitz presented him with written material pertaining to her childhood, professional, and married life. She was not against a personalized account of her life, but not by her, preferring Hans to publish a book, "Meine Eltern" (My Parents), after her death. While this never matured, the timing was of significance to the decision to do justice not only to her own achievements but also those of her husband Karl, a committed socialist and medical practitioner whom she married in 1891. See Käthe Kollwitz, *Tagebuchblätter und Briefe*, ed. Hans Kollwitz (Berlin: Gebr. Mann, 1948), 7–16.

9 Alice Miller, "Käthe Kollwitz: A Mother's Dead Little Angels and Her Daughter's Activist Art," in *The Untouched Key: Tracing Childhood Trauma in Creativity and Destructiveness* (New York: Anchor Books, 1991), 19–35.

10 Marcus Moseley writes effectively on the distinctions between memoir and autobiography in the introductory chapter "Autobiography: The Elusive Subject" in his book *Being for Myself Alone: Origins of Jewish Autobiography* (Palo Alto, CA: Stanford University Press, 2006), 1–17.

11 Published in 1989, the complete diaries cover the years from 1908 until 1943. During Allied bombing of Berlin, Kollwitz fled to the house of sculptor Margareta Böning in Nordhausen am Harz. On November 23, 1943, Kollwitz's property on Weissenburger Strasse 25 was destroyed. While Hans had saved all her letters and artistic works dating from prior to 1908, his house in Lichtenrade was subsequently destroyed. Käthe Kollwitz, *Die Tagebücher*, ed. Jutta Bohnke-Kollwitz (Berlin: Siedler, 1989), 8–9.

12 Kollwitz, *Tagebücher*, 716–35.

13 As has been explained in relation to narratives of the Werkbund, theoretical statements from the 1920s represent the "solutions to problems . . . whose full complexity is to a certain extent repressed in the finality of these formulations." See Frederic J. Schwartz, *The Werkbund: Design Theory and Mass Culture before the First World War* (New Haven, CT: Yale University Press, 1996), 5–6.

14 Kollwitz, *Tagebücher*, 718, 729.

15 Kollwitz, *Tagebücher*, 735.

16 Alexandra von dem Knesebeck, *Käthe Kollwitz: Die Prägenden Jahre* (Petersberg: Michael Imhof, 1998), 17.

17 The Anti-Socialist Law was passed in the Reichstag under Bismarck on October 21, 1878, and only abrogated on October 1, 1890. With its repeal, the name of the SAPD changed to the Sozialdemokratische

Partei Deutschlands (Social Democratic Party of Germany, SPD). See Alexandra von dem Knesebeck, "Die Bedeutung von Zolas Roman *Germinal* für den Zyklus *Ein Weberaufstand* von Käthe Kollwitz," *Kunstgeschichte* 52, no. 3 (1989): 404.

18 Letter to Max Lehrs, August 29, 1901, in Käthe Kollwitz, *Briefe der Freundschaft und Begegnungen*, ed. Hans Kollwitz (Munich: Paul List, 1966), 23.

19 "Rückblick auf Frühere Zeit," 1941, in Kollwitz, *Tagebücher*, 736.

20 See Jutta Bohnke-Kollwitz, ed., "Introduction," in *Käthe Kollwitz: Briefe an den Sohn, 1904 bis 1945* (Berlin: Siedler, 1992), 13.

21 "Rückblick auf Frühere Zeit," 1941, in Kollwitz, *Tagebücher*, 737. Max Klinger (1857–1920), *Ein Leben*, 15 plates, 4 editions: 1884, (1884), 1891, 1898; see *Graphic Works of Max Klinger*, introduction and notes by J. Kirk T. Varnadoe with Elizabeth Streicher (New York: Dover, 1977), 81–83, pls. 29–36.

22 See the illuminating chapter "The Life and Death of the Lost Woman" in Richard J. Evans, *Tales from the German Underworld: Crime and Punishment in the Nineteenth Century* (New Haven, CT: Yale University Press, 1998), 166–212.

23 "Rückblick auf Frühere Zeit," 1941, in Kollwitz, *Tagebücher*, 736; Emil Neide (1843–1908), *Am Ort der Tat (die Auffindung der Leiche eines Ermordeten)*, 1884, oil on canvas, 111 × 183 cm, destroyed, formerly in Berlin, Öffentliche Sammlung, Staatliche Museen, Nationalgalerie Berlin. *Die Lebensmüden*, 1885, formerly Preußische Akademie der Künste.

24 *Die Lebensmüden* was exhibited at the 1886 Berlin Jubilee Exhibition in the new National Exhibition Palace by the Lehrter Bahnhof and was received with great acclaim. See Ludwig Kaemmerer, *Kaethe Kollwitz: Griffelkunst und Weltanschauung* (Dresden: Emil Richter, 1923), 28.

25 Evans, *Tales from the German Underworld*, 169.

26 See Robin Lenman, *Artists and Society in Germany, 1850–1914* (Manchester: Manchester University Press, 1997), 79–80.

27 Lenman, *Artists and Society in Germany*, 108–11.

28 See Ludwig Herterich, *Johanna Stegen, die Heldin von Lüneburg, 2. April 1813*, 1887, oil on canvas, 338 × 262 cm, now in Museum Behnhaus Drägerhaus, Lübeck, *Illustrierter Katalog der III. Internationalen Kunstausstellung (Münchener Jubiläumsausstellung)* (Munich: Glaspalast, 1888), no. 1227, 49–50.

29 Käthe Kollwitz, "Rückblick auf Frühere Zeit," 1941, in Kollwitz, *Tagebücher*, 738.

30 Beate Bonus-Jeep, *Sechzig Jahre Freundschaft mit Käthe Kollwitz* (Bremen: Schünemann, 1963), 15.

31 Yvette Deseyve, *Der Künstlerinnen-Verein München*, 76–77.

32 "Rückblick auf Frühere Zeit," 1941, in Kollwitz, *Tagebücher*, 738–39.

33 Georg Jacob Wolf, *Die Münchnerin: Kultur- und Sittenbilder aus dem Alten und Neuen München* (Munich: Franz Hanfstaengl, 1924), 218.

34 Kaemmerer, *Kaethe Kollwitz*, 130.

35 Johann Jakob Bachofen, *Das Mutterrecht: Eine Untersuchung über die Gynaikokratie der Alten Welt nach Ihrer Religiösen und Rechtlichen Natur (Mother Right: A Study of the Religious and Juridical Aspects of Matriarchy in the Ancient World)* (Stuttgart: Krais and Hoffmann, 1861).

36 August Bebel, *Woman under Socialism* (1879), trans. Daniel de Leon from the 33rd ed. (New York: New York Labor News Press, 1904), 332–33. For the historiography, see Caroline A. Foley, "Review: August Bebel, *Die Frau und der Sozialismus*," *Economic Journal* 4, 13 (1894): 90–93.

37 Letters to Paul Hey from Königsberg, September 22, 1889, February 26, 1891. Kollwitz, *Briefe der Freundschaft*, 15, 19. For an exemplary

study of the journal *Die Kunst für Alle* and its discourses, see Beth Irwin Lewis, *Art for All: The Collision of Modern Art and the Public in Late-Nineteenth Century Germany* (Princeton, NJ: Princeton University Press, 2003).

38 Letter to Paul Hey from Königsberg, September 23, 1890, in Kollwitz, *Briefe der Freundschaft*, 19.

39 Bonus-Jeep, *Sechzig Jahre Freundschaft*, 28–32. Walter Benjamin suitably dealt with the implications of photographic technology, "freeing the hand" from executing the more mundane processes of copying works of art, in the essay "The Work of Art in the Age of Its Technological Reproducibility. Second Version," in *The Work of Art in the Age of Its Technological Reproducibility and Other Writings on Media*, ed. Michael William Jennings and Brigid Doherty (Cambridge, MA: Belknap, 2008), 24.

40 Letter to Paul Hey from Königsberg, February 26, 1891, in Kollwitz, *Briefe der Freundschaft*, 20.

41 In 1883, the German Sickness Insurance Act obliged all German artisans and industrial workers to join sickness insurance funds; visits to a doctor were required in order to claim any support from their insurance. See Gunnar Stollberg, "Health and Illness in German Workers' Autobiographies from the Nineteenth and Early Twentieth Centuries," *Society for the Social History of Medicine* 6, no. 2 (1993): 270.

42 For an incisive account of the cultural politics, consult Marsha Morton, "*Malerei und Zeichnung*: The History and Context of Max Klinger's Guide to the Arts," *Zeitschrift für Kunstgeschichte* 58, no. 4 (1995): 542–69, as well as the major tome Marsha Morton, *Max Klinger and Wilhelmine Culture: On the Threshold of German Modernism* (Abingdon: Routledge, 2014).

43 *Max Klinger: Painting and Drawing*, ed. Jonathan Watkins, trans. Fiona Elliott and Christopher Croft (Birmingham, UK: Ikon Gallery, 2005), 19–20; Gotthold Ephraim Lessing, *Laokoon oder Über die Grenzen der Malerei und Poesie* (1766), in *Sämtliche Schriften*, ed. Karl Lachmann (Stuttgart: Göschen, 1886–1924), 9, 1–177.

44 Morton, "*Malerei und Zeichnung*," 549, citing Max Klinger, *Malerei und Zeichnung, Tagebuchaufzeichnungen und Briefe*, ed. Anneliese Hübscher (Leipzig: Reclam, 1985), 39–43; Watkins, *Max Klinger*, 23–26.

45 As Morton has suggested, in arguing against Impressionism on the one hand and academic historicism on the other, Klinger aligned himself with a more conservative, yet cosmopolitan, agenda for painting. See Morton, "*Malerei und Zeichnung*," 569.

46 For a discussion of the gendered distinctions between high and low, see Andreas Huyssen, "Mass Culture as Woman: Modernism's Other," in *After the Great Divide: Modernism, Mass Culture, Postmodernism* (Bloomington: Indiana University Press, 1986), 44–62.

47 German Romantic aesthetic theory rejuvenated the polarities between line and color, line considered an unmediated expression of the (male) intellect, color—emotive and physical—aligned with the feminine. For a discussion of gender and the aesthetics of line versus color, see Jay A. Clarke, *The Construction of Artistic Identity in Turn-of-the-Century Berlin: The Prints of Klinger, Kollwitz, and Liebermann* (PhD diss., Brown University, 1999), 144–57. In the French context, Charles Blanc's theories further endorsed "drawing as the masculine side of art"; see *The Grammar of Painting and Engraving* (1867), trans. Kate Newell Doggett (Chicago: Griggs, 1874), 468, as cited in Morton, "*Malerei und Zeichnung*," 563n87.

48 Max Lehrs, "Käthe Kollwitz," *Die Graphischen Künste* 26 (1903): 56, as reproduced in *Die Kollwitz-Sammlung des Dresdner*

Kupferstich-Kabinettes: Graphik und Zeichnungen, 1890–1912, ed. Werner Schmidt (Cologne: Käthe Kollwitz Museum Köln, 1988), 198.

49 "Erinnerungen," 1923, 725, in Kollwitz, *Tagebücher*.

50 Clarke discusses the transformation from reproductive to original printmaking in Berlin and its implications for authorship in her thesis *The Construction of Artistic Identity*, 13–71.

51 Letter to Paul Hey from Königsberg, September 22, 1889, in Kollwitz, *Briefe der Freundschaft*, 17. Adolph Rosenberg, "Max Klingers Federzeichnungen und Radierungen," *Chronik* 1, no. 3 (1888): 26, cited in Morton, *Malerei und Zeichnung*, 565–66n101. Kollwitz acknowledged the importance of Klinger in an early letter to the director of the Dresden Kupferstichkabinett, Max Lehrs, on August 19, 1901, in Kollwitz, *Briefe der Freundschaft*, 23.

52 On Kollwitz's beginnings as a printmaker, consult Von dem Knesebeck, *Die Prägenden Jahre*, 88–117.

53 Albrecht Dürer, *Self-Portrait in Fur Coat*, 1500, oil on panel, 67 × 49 cm, Alte Pinakothek, Munich.

54 See Joseph Koerner, *The Moment of Self-Portraiture in German Renaissance Art* (Chicago: University of Chicago Press, 1996), 53.

55 An illuminating discussion of the iconography and transformation of the motifs of "hand and head" can be found in Peter Springer, *Hand and Head: Ernst Ludwig Kirchner's Self-Portrait as Soldier* (Berkeley: University of California Press, 2002), 100–108.

56 See Betterton, "Mother Figures," 32–33; 199n19. No doubt this is the *Self-Portrait* (1892) referred to by Kearns in *Woman and Artist*, 64.

57 As we have seen, Langbehn's *Rembrandt als Erzieher*, which went through thirty-nine editions almost immediately, was highly influential in this regard.

58 For the responses to the so-called Munch affair, see Peter Paret, *The Berlin Secession: Modernism and Its Enemies in Imperial Germany* (Cambridge, MA: Belknap, 1980), 50–56.

59 Ludwig Pietsch, "Die Freie Berliner Kunstausstellung," *Vossische Zeitung* (1893), cited in Jay A. Clarke, "Beyond Biography: Käthe Kollwitz and the Critics," in Rix, *Käthe Kollwitz*, 45.

60 For a comprehensive account of the sources and the topicality of Social Democrat agitation for the improvement of current-day Silesian weavers' conditions, consult Von dem Knesebeck, *Die Prägenden Jahre*, 118–205.

61 Von dem Knesebeck argues for a materialist rather than a metaphysical interpretation of the final etching, *Aus vielen Wunden blutest du, o Volk*, the title of which modifies a well-known refrain from Wilhelm Zimmermann's book *Der Große Deutsche Bauernkrieg* (Stuttgart: Dettinger, 1841–43). Von dem Knesebeck, "Die Bedeutung von Zolas Roman *Germinal*," 407; *Die Prägenden Jahre*, 173–92.

62 Nordau, *Degeneration*, 497; Paret, *Berlin Secession*, 21–24.

63 Clarke, "Käthe Kollwitz and the Critics," in Rix, *Käthe Kollwitz*, 49.

64 Julius Elias, "Die Freie Berliner Kunstausstellung," *Die Nation* 10, no. 43 (1893): 673.

65 Lehrs, "Käthe Kollwitz," 56, in Schmidt, *Die Kollwitz-Sammlung des Dresdner Kupferstich-Kabinettes*, 198. For updated archival material on Kollwitz's interaction with Lehrs, see *Käthe Kollwitz in Dresden*, ed. Petra Kühlmann-Hodick and Agnes Matthias (Dresden: Staatliche Kunstsammlungen Dresden Kupferstich-Kabinett/Paul Holberton, 2017).

66 In the winter of 1901–2, the Berlin Secession began to hold regular exhibitions for graphic art, in addition to their annual summer shows. The exhibitions, entitled *Schwarz-Weiss Ausstellungen* (Black-and-White Exhibitions), included sketches, watercolors, graphics, and sculpture.

67 "Vorwort," in *Katalog der Vierten Kunstausstellung der Berliner Secession: Zeichnende Künste* (Berlin: Paul Cassirer, 1901), 7–8.

68 See Frances S. Connelly, "Poetic Monsters and Natural Hieroglyphics: The Precocious Primitivism of Philipp Otto Runge," *Art Journal* 52, no. 2 (Summer 1993): 31–39.

69 Lu Märten, "Käthe Kollwitz," *Die Frau: Monatsschrift für das Gesamte Frauenleben Unserer Zeit* 10 (February 1903): 290–92.

70 This finding is endorsed in Stefana Lefko's consideration of the journal in the Weimar period in, "Truly Womanly and Truly German: Women's Rights and National Identity in *Die Frau*," in Herminghouse and Mueller, *Gender and Germanness*, 129–44.

71 Märten, "Käthe Kollwitz," 291. For these images, see KN, vol. 1, 46 I: VI; 51 III: V.

72 Under the auspices of Fräulein Margarethe Hörnerbach, director of the Berliner Künstlerinnenschule, Kollwitz was invited to give classes in graphic techniques and drawing between 1898 and 1903.

73 Lu Märten, "Die Künstlerischen Momente der Arbeit in Alter und Neuer Zeit," in *Die Zeit* 11, no. 51 (September 17, 1903): 801. *Die Zeit* was a weekly publication of Friedrich Naumann's National Social Party. While his efforts to unite the liberal bourgeoisie under the banner of democracy and empire waned with the dissolution of the National Social Union in 1903, Märten maintained contact with him and the Hilfe Verlag, notwithstanding her membership of the SPD.

74 Märten, "Käthe Kollwitz," 292.

75 See Reinhart Koselleck, *Futures Past: On the Semantics of Historical Time*, trans. Keith Tribe (Cambridge, MA: MIT Press, 1985), 47–49.

76 Very little is known about Plehn's artistic practice or her training as an art historian. For a brief outline of her publications, see Käthe Kollwitz's obituary for Plehn in *Sozialistische Monatshefte* 24 (March 12, 1918): 272. Also see Darcy C. Buerkle, "Käthe Kollwitz and 'Boasting Virility' at Smith College's Museum of Art," in *Käthe Kollwitz and the Women of War: Femininity, Identity, and Art during World Wars I and II*, ed. Claire C. Whitner (New Haven, CT: Yale University Press, 2016), 35–38.

77 Anna L. Plehn, "Die Neuen Radierungen von Käthe Kollwitz," *Die Frau: Monatsschrift für das Gesamte Frauenleben Unserer Zeit* 11, no. 4 (January 1904): 237.

78 Wilhelm Zimmermann, *Allgemeine Geschichte des großen deutschen Bauernkrieges* (Stuttgart: Dettinger, 1841–43).

79 Von dem Knesebeck, *Kollwitz: Werkverzeichnis der Graphik*, vol. 1, 70 I–XIII.

80 Otto Nagel and Werner Tim, eds., *Käthe Kollwitz: Die Handzeichnungen* (Stuttgart: Kohlhammer, 1980), 252; hereafter NT.

81 *Katalog der Achten Kunstausstellung der Berliner Secession: Zeichnende Künste* (Berlin: Paul Cassirer, 1903), 24, no. 345, *Bauernkrieg* (Blatt 4), Radierung.

82 Plehn, "Die Neuen Radierungen von Käthe Kollwitz," 234. For an explanatory account of the installation of Kollwitz's works in the eighth exhibition of the Berlin Secession, consult Alexandra von dem Knesebeck, "'Der Volkskrieg Dieser Zeit hatte auch Seine Heldinnen': Zum Frauenbild der Frühen Graphikfolgen," in *Käthe Kollwitz: Das Bild der Frau*, ed. Jutta Hülsewig-Johnen (Bielefeld: Kerber, 1999), 65.

83 In May 1904, after competing with thirty-six other artists, Kollwitz secured a commission from the Verbindung für historische Kunst (Society for Historical Art) to complete the *Bauernkriegzyklus* as a *Vereinsgabe* for its membership. This contained seven impressions: *The Plowers*, *Raped*, *Sharpening the Scythe*, *Outbreak*, *Arming in a Vault*, *Battlefield*, and *The Prisoners*.

84 *Katalog der Achten Kunstausstellung der Berliner Secession: Zeichnende Künste*, 24, no. 346, *Totes Kind*, Radierung. For an account of the historical status of the German print, consult Robin Reisenfeld, *The German Print Portfolio, 1890–1930: Serials for the Private Sphere* (London: Sotheby's, 1992).

85 A discussion of Kollwitz's use of graphic techniques can be found in Frances Carey and Anthony Griffiths, *The Print in Germany, 1880–1933: The Age of Expressionism* (London: British Museum, 1984), 65–66; Prelinger, "Kollwitz Reconsidered," 42; and Natascha Kirchner, "Processes, Practices, Techniques," in Marchesano, *Kollwitz*, 57–73.

86 Angela Moorjani, "Käthe Kollwitz on Sacrifice, Mourning, and Reparation: An Essay in Psychoaesthetics," *MLN* 101, no. 5 (December 1986): 1110–134; Angela Moorjani, *The Aesthetics of Loss and Lessness* (New York: St. Martin's Press, 1992), 107–22 (113). Moorjani deploys Melanie Klein's psychoanalytical theory, in particular, from her 1935 article "A Contribution to the Psychogenesis of Manic-Depressive States," in which Klein links her work on mourning and sublimation to Freud's and Karl Abraham's concept of introjection and incorporation of the lost object. See Melanie Klein, *Love, Guilt and Reparation and Other Works, 1921–1945* (London: Hogarth Press, 1975), 262–89. Hartmann, "Mutter mit Totem Kind," 112–13, reads this image in a similar manner.

87 Evidently, as Klein argues, abnormal mourning, whether destructive oral fantasies, on the one hand, or idealizing (manic) ones, on the other, blocks the regenerative processes of sublimation. Moorjani, "Käthe Kollwitz on Sacrifice," 1116–17.

88 Plehn, "Die Neuen Radierungen von Käthe Kollwitz," 235.

89 See Betterton, "Mother Figures," 44, who argues that "loss of a child" for Kollwitz in this context stood for the artist's ongoing fear of losing her own creative identity.

90 Plehn, "Die Neuen Radierungen von Käthe Kollwitz," 237–38.

91 See, for instance, A. L. Plehn, "Käthe Kollwitz," *Die Kunst für Alle* (1901–2), 227–30; Anna Plehn, "Bildende Kunst," *Sozialistische Monatshefte* 5 (1904): 419; "Handzeichnungen bei Cassirer," *Sozialistische Monatshefte* 8 (1908): 522. Published monthly from 1895 onward, this newspaper was edited by Joseph Bloch, husband of Helena Freudenheim-Bloch, Königsberg-born friend of Kollwitz. The *Sozialistische Monatshefte* had close ties with the SPD but was not officially attached to a party-political organization.

92 In the *Sozialistische Monatshefte*, reports on the women's movement, provided until 1908 by the socialist Henriette Fürth (1861–1938), were anchored in the taxonomies of *Öffentliches Leben* (public life), alongside the *Wissenschaften* (sciences), "Kunst," and "Kultur." Roger Fletcher outlines the importance of the newspaper's critique of foreign policy in "Revisionism and Wilhelmine Imperialism," *Journal of Contemporary History* 23, no. 3 (July 1988): 347–66.

93 *Simplicissimus* was founded in 1896 by Albert Langen, who collaborated with the caricaturist Thomas Theodor Heine. See Ann Taylor Allen, *Satire and Society in Wilhelmine Germany: Kladderadatsch and Simplicissimus, 1890–1914* (Lexington: University Press of Kentucky, 1984).

94 *Simplicissimus* (November 1, 1909): 516.

95 Kollwitz, *Tagebücher*, September 19, 1908, 41–43. In writing about her models, Kollwitz considered alcohol addiction the most damaging to family life and, as with social hygienists, viewed this as inhibiting healthy reproduction. For the distinctions in the broader field of eugenics between race hygiene (biology and reproduction) and social hygiene, see Paul Weindling, *Health, Race, and German Politics between National Unity and Nazis, 1870–1945* (Cambridge: Cambridge University Press, 1993), 11–154.

96 *Simplicissimus* (November 1, 1909): 515. For an account of the feminization of the textile industry's workforce and transition from home to factory, see Kathleen Canning, *Languages of Labor and Gender: Female Factory Work in Germany, 1850–1914* (Ithaca: Cornell University Press, 1996).

97 The medical referents in Kollwitz's works are discussed in Hildegard Schubert, *Käthe Kollwitz (1867–1945): Medizinisch Wichtige Darstellungen in Ihrem Werk, Kölner Medizinhistorische Beiträge* 56 (Cologne: University of Cologne, 1991).

98 Kollwitz, *Tagebücher*, September 28, 1909, 57. Kollwitz records donating a sketch of a *Mother and Child* to the Mutterschutzbund; also, her diary entry on May 8, 1910 (68) details her attendance of the Generalversammlung des Mutterschutzbundes. For critical consideration, see Canning, *Languages of Labor and Gender*, 207, and Ann Taylor Allen, *Feminism and Motherhood in Germany, 1800–1914* (New Brunswick, NJ: Rutgers University Press, 1991).

99 Ernst Gombrich, "Ritualised Gesture and Expression in Art," in *The Image and the Eye* (Oxford: Phaidon, 1986), 63–77. Gombrich offers three categories for the different kinds of expressive signage—symptom, symbol, and the graphological.

100 Hans W. Singer, *Käthe Kollwitz* (Esslingen: Paul Neff, 1908).

101 Singer, *Käthe Kollwitz*, 46.

102 See Immanuel Kant, *Critique of Judgement* (1790), trans. Werner S. Pluhar (Indianapolis: Hackett, 1987), 39, 158–59.

103 Kollwitz, *Tagebücher*, October 6, 1909, 56. Kollwitz states that she was reading Dilthey's essay on Novalis. This was contained in the volume *Das Erlebnis und die Dichtung* (Leipzig: Teubner, 1905). Wilhelm Dilthey's (1833–1911) neo-Kantian critique of the natural sciences proclaimed an oscillating relationship between inner and outer, subjectivity and objectivity. See Stanley Corngold, "Dilthey's Poetics of Force," in *The Fate of the Self: German Writers and French Theory* (Durham, NC: Duke University Press, 1994), 55–94.

104 Max Liebermann, "Zehn Jahre Sezession" (1908), in *Die Phantasie in der Malerei: Schriften und Reden*, ed. Günter Busch (Frankfurt am Main: Fischer, 1978), 179, cited by Paret, *Berlin Secession*, 167.

105 Karen Lang, "Response: The Far in the Near," *Art Bulletin* 89, no. 1 (March 2007): 26–34.

106 See *Katalog der Einundzwanzigsten Ausstellung der Berliner Secession: Zeichnende Künste* (Berlin: Ausstellungshaus am Kurfürstendamm, 1910), 9–11.

107 Trude Freibus, "Berlin Sezession, 1910–1911," *Sozialistische Monatshefte* 3 (1911): 216.

108 For discussion of the graphic process in this work, see Frances Carey and Max Egremont, "Tod und Frau," in Watkins, *Käthe Kollwitz*, cat. no. 25, 108.

109 See Otto Rank (1884–1939), "Der Doppelgänger," *Imago: Zeitschrift für Anwendung der Psychoanalyse auf die Geisteswissenschaften* 3 (1914): 97–164; *The Double: A Psychoanalytic Study*, trans. and ed. Harry Tucker (Chapel Hill: University of North Carolina Press, 1977), 57: "A series of folkloric investigations has shown without any doubt that primitive man considered his mysterious double, his shadow, to be an actual spiritual being."

110 In 1913, along with the future psychoanalyst Ernst Simmel and socialist practitioner Ignaz Zadek, Käthe's husband, Karl, established the Sozialdemokratischer Ärzteverein (Association of Social Democratic Doctors). In 1920, after Freud proposed the creation of institutions or

outpatient clinics where treatment was free, Simmel, together with Max Eitington, founded the Berlin Poliklinik. See Elizabeth Ann Danto, "The Berlin Poliklinik: Psychoanalytic Innovation in Weimar Germany," *Journal of the American Psychoanalytical Association* 47 (1999): 1269–92.

111 In 1909 Gertrud (née Prengel, 1883–1932) and Heinrich Goesch (1880–1930) met Otto Gross in Ascona. By that time Gross (1877–1920) lived in Munich and Ascona, where he had an important influence on many of the Expressionist writers and artists. See Emanuel Hurwitz, "Otto Gross: Von der Psychoanalyse zum Paradies," in *Monte Verità: Berg der Wahrheit*, ed. Harald Szeemann (Milan: Electa Editrice, 1980), 107–16.

112 For illustrations of the *Sekreta*, consult Otto Nagel and Werner Tim, eds., *Käthe Kollwitz: Die Handzeichnungen* (Stuttgart: Kohlhammer, 1980), 561–63. Also see Jutta Bohnke-Kollwitz, editorial comment, in Kollwitz, *Tagebücher*, 757; November 30, 1909, 62; April 10, 1910, 64.

113 Kollwitz, *Tagebücher*, April 10, 1910, 65.

114 In 1905, Hugo Heller (1870–1923), Hungarian by birth, founded his own bookshop, Hugo Heller und Cie., comprising a publishing house, an art gallery, and a reception hall. He first met Freud, presumably in 1902, at the start of the midweek social meetings of the Vienna Psychoanalytical Association. Freud lectured at the bookshop in 1907 and, by 1912, Heller founded *Imago: Zeitschrift für die Anwendung der Psychoanalyse auf die Geisteswissenschaften*, the third periodical of which he published under the editorial direction of Freud. It introduced an interdisciplinary approach to psychoanalysis, the original title being *Eros and Psyche*, which was soon changed to *Imago* after a novel by Carl Spitteler (1845–1924).

115 For an illuminating discussion of the hydraulic model, see Mark Hansen, *Embodying Technesis: Technology beyond Writing* (Ann Arbor: University of Michigan Press, 2000), 6, 158–62.

116 Here Kollwitz's diagnosis tallies with Freud's discussion of "object finding" in "The Transformations of Puberty," in Sigmund Freud, "Three Essays on the Theory of Sexuality" (ca. 1905), in *The Standard Edition of the Complete Psychological Works of Sigmund Freud*, ed. James Strachey (London: Vintage, 2001), 7:222–25.

117 Kollwitz, *Tagebücher*, January 20, 1911, 97.

118 Käthe Kollwitz, "Rodin," *Sozialistische Monatshefte* 24 (1917): 1226–27.

119 Founded in 1868, the Académie Julian was the first to offer women training comparable to the official École des Beaux-Arts, which did not accept women until 1897. Kollwitz would have been aware of Marie Bashkirtseff's attendance in the early 1880s. After an initial trial of mixed classes, male and female students were separated. See Gabriel P. Weisberg, "The Women of the Académie Julian: The Power of Professional Emulation," in *Overcoming All Obstacles: The Women of the Académie Julian*, ed. Gabriel P. Weisberg and Jane Becker (New York: Dahesh Museum of Art, 1999), 15–67; Peter Kropmanns and Carina Schäfer, "Private Akademien und Ateliers im Paris der Jahrhundertwende," in *Die Große Inspiration: Deutsche Künstler in der Académie Matisse*, part 3 (Ahlen: Kunstmuseum, 2004), 25–39.

120 For an account of Rodin's works in public collections in Germany prior to 1914, see Von Hohenzollern and Schuster, *Manet bis van Gogh*, 188–91, 282–85, 379–81.

121 "Rückblick auf Frühere Zeit" (1941), in Kollwitz, *Tagebücher*, 742. For panoramic vintage photographs of the interior of the Rodin Museum at Meudon, see Albert E. Elsen, *In Rodin's Studio: A Photographic Record of Sculpture in the Making* (Oxford: Phaidon, 1980).

122 For contextual analysis of Adolf Hildebrand's *Das Problem der Form in der Bildenden Kunst* (Strasbourg: Heitz & Mündel, 1893), see Erich Ranfft, *Adolf von Hildebrand's Problem der Form and His "Front" against August Rodin* (MA diss., University of Michigan, 1992).

123 See Erich Rannft, "Reproduced Sculpture of German Expressionism: Living Objects, Theatrics of Display, and Practical Options," in *Sculpture and Its Reproductions*, ed. Anthony Hughes and Erich Rannft (London: Reaktion, 1997), 128.

124 A critical discussion of Rodin's reception can be found in Alex Potts, *The Sculptural Imagination: Figurative, Modernist, Minimalist* (New Haven, CT: Yale University Press, 2001), 74–101.

125 Georg Simmel, "Die Kunst Rodins und das Bewegungsmotiv in der Plastik," in *Nord und Süd: Eine Deutsche Monatsschrift* 129, no. 33 (May 1909): 189–96; reprinted in Georg Simmel, *Gesamtausgabe 12: Aufsätze und Abhandlungen, 1909–1918*, ed. Rüdiger Kramme and Angela Rammstedt (Frankfurt am Main: Suhrkamp, 2001), 1:28.

126 Simmel, "Die Kunst Rodins," in *Gesamtausgabe*, 31.

127 See Nagel and Tim, *Die Handzeichnungen*, 343–50, and Kollwitz's letter to Hanna Löhnberg (née Mendel), July 29, 1919, in Kollwitz, *Briefe der Freundschaft*, 30–31, where she advises the young student that drawing from the nude in motion goes hand in hand with the faithful study of nature, facilitating the rapid seizure of the essence of an appearance.

128 Simmel, "Die Kunst Rodins," in *Gesamtausgabe*, 32.

129 See Patricia G. Berman, *Modern Hieroglyphs: Gestural Drawing and the European Vanguard, 1900–1918* (Wellesley, MA: Davis Museum and Cultural Center, 1995), 14; 28–29.

130 Berman, *Modern Hieroglyphs*, 17. As independent works, gestural drawings were largely associated with the work of Rodin (1840–1917). Practiced initially as an aid to his sculpture, Rodin's drawings became ends in themselves by 1900 and were exhibited widely in Germany, Düsseldorf, Leipzig, Weimar, and Berlin in 1904. See Alain Beausire, *Quand Rodin Exposait* (Paris: Éditions du Musée Rodin, 1988). Usually dated to around 1908, Kollwitz's turn to sculpture followed her visit to Florence and Rome in 1907 as a consequence of receiving the Villa Romana Prize, a scholarship founded in honor of Max Klinger's fiftieth birthday. See Werner Timm, "Protokoll zum Plastischen Werk von Käthe Kollwitz," in Herwig Guratzsch, *Käthe Kollwitz: Druckgraphik, Handzeichnungen, Plastik* (Ostfildern: Hatje Cantz, 1992), 29–52.

131 See Annette Seeler, *Käthe Kollwitz: Die Plastik Werkverzeichnis Onlinekatalog*, ed. Käthe Kollwitz Museum Köln (Cologne: Hirmer, 2016), no. 13IA:74, stand-mai-2016.pdfx (kollwitz.de).

132 For a critical discussion of the act of sculptural viewing experience, see Sebastian Zeidler, "Totality against a Subject: Carl Einstein's *Negerplastik*," *October* 107 (Winter 2004): 20–46.

133 Max Jungnickel, "Käthe Kollwitz," *Die Aktion* 1, no. 19 (June 26, 1911): 587–89.

134 Ernst Cohn-Wiener, "Revolutionskunst," *Die Aktion* 1, no. 24 (July 31, 1911): 752–54. Cohn-Wiener (1882–1941) was primarily an Islamic specialist. He studied art history, archaeology, and philosophy at the universities of Berlin and Heidelberg, receiving his doctorate in 1907.

135 Ernst Cohn-Wiener, *Die Entwicklungsgeschichte der Stile in der Bildenden Kunst* [The History of the Development of Style in the Fine Arts] (Leipzig: Teubner, 1910), 1:2–3.

136 Cohn-Wiener, "Revolutionskunst," 752–54.

137 See Daemgen, *The Neue Secession in Berlin, 1910–14*.

138 Kollwitz, *Tagebücher*, April, 1910, 67.

139 Vinnen, *Protest Deutscher Künstler*, 19.

140 Vinnen, *Protest Deutscher Künstler*, 8.

141 The official "salons" were held annually after 1876 and became known as the Grosse Berliner Kunstausstellung from 1893 onward. These took place in the Landesausstellungspalast near the Lehrter Bahnhof.

142 Käthe Kollwitz, *Briefe an den Sohn, 1904 bis 1945*, ed. Bohnke-Kollwitz, May 20, 1911, 30.

143 Uwe Fleckner, ed., *Jenseits der Grenzen: Französische und Deutsche Kunst vom Ancien Regime bis zur Gegenwart; Thomas W. Gaehtgens zum 60. Geburtstag* (Cologne: DuMont, 2000), 3:6. Baudelaire conceived of German artistic production more as a result of intellectual activity than a "translation of visual and artistic perceptions," a conception that was formed through a parallel drawn with German philosophy. See Charles Baudelaire, "Philosophic Art" (1868), in *The Painter of Modern Life and Other Essays*, trans. and ed. Jonathan Mayne (London: Phaidon, 1964), 204.

144 See Alexandre Kostka and Françoise Lucbert, eds., *Distanz und Aneignung: Kunstbeziehungen zwischen Deutschland und Frankreich, 1870–1945* (Berlin: Akademie, 2004), 32–34. As revealed in this volume, the fascination for German culture in France in the last two decades of the nineteenth century was on the whole conditioned by philosophy and music rather than the visual arts. The ideas of Kant, Hegel, Schopenhauer, Nietzsche, or Wagner had been well diffused through translations and made accessible to the French public.

145 Paret, *Berlin Secession*, 188–89.

146 A journal providing a calendar of artistic events, *Die Werkstatt der Kunst* 10, no. 48 (September 24, 1911): 663, reported that "Die erste Vereinsgabe der Vereinigung besteht in einer Originalradierung des Mitglieds Käthe Kollwitz."

147 Daemgen, *Neue Secession Berlin*, 316, citing *Kunstchronik* 23, no. 2 (October 20, 1911): col. 27–28.

148 Letter to Hans, February 2, 1913, in Käthe Kollwitz, *Tagebuchblätter*, 78.

149 Paret, *Berlin Secession*, 230–31.

150 Kollwitz, *Tagebücher*, 802. However, as Bohnke-Kollwitz observes, on a comparative level, Kollwitz's sale of a good signed graphic for no more than 30 marks in 1911 could not approach Max Liebermann's sale of an oil *Self-Portrait* for 12,000 marks in 1912 (27).

151 Roy Porter provides historical usage of the term "hysteria" in the essay "The Body and the Mind, the Doctor and the Patient: Negotiating Hysteria," in *Hysteria beyond Freud*, ed. Sander L. Gilman et al. (Berkeley: University of California Press, 1993), 225–85.

152 Sigmund Freud, "Zeitgemäßes über Krieg und Tod" (1915), translated as "Thoughts for the Times on War and Death," in Freud, *Standard Edition*, 14:275–300.

153 Kollwitz, *Tagebücher*, April 27, 1915, 184.

154 Letter from Kollwitz to Märten, April 13, 1916. Handschriftenabteilung Staatsbibliothek Berlin Lu Märten, Autogr. 1 1015–4.

155 Hausenstein, *Die Bildende Kunst*, 276.

156 Hausenstein, *Die Bildende Kunst*, 20.

157 Kollwitz, *Tagebücher*, February 15, 1915, 183.

158 Kollwitz, *Tagebücher*, "Goethe als Befreier I," November 3, 1916, 284–85; "Goethe als Befreier II," November 8, 1916, 285–86; "Goethe über Politik," December 1916, 289–90.

159 Dora Apel perhaps overlooks the nuances of revolutionary pacifism in focusing on Kollwitz's postwar pacifism and labeling it "Social Democratic." Apel concludes that Kollwitz's representations of the home front cast women into the role of "working-class feminine passivity." See

her essay "'Heroes' and 'Whores': The Politics of Gender in Weimar Antiwar Imagery," *Art Bulletin* 79, no. 3 (1997): 366–83.

160 Kollwitz, *Tagebücher*, February 1, 1917, 298.

161 Max Deri, "Käthe Kollwitz," in *Kaethe Kollwitz Sonder-Ausstellung zu Ihrem Fünfzigsten Geburtstag* (Berlin: Paul Cassirer, 1917), 1.

162 Max Deri, "Käthe Kollwitz," 3.

163 Letter from Kollwitz to Dr. Fritz Koenig, February 19, 1918, Special Collection, the Getty Center for the Arts and Humanities, Los Angeles.

164 For this terminology, see Pierre Bourdieu, "The Market of Symbolic Goods," *Poetics* 14 (1985): 13–44. "Cultural capital" exists in various forms and includes dispositions as well as habits acquired in the socialization process. "Social capital" is the sum of the actual and potential resources that can be mobilized through membership in social networks.

165 Letter from Kollwitz to Dr. Fritz Koenig, February 14, 1918, Special Collection, the Getty Center for the Arts and Humanities, Los Angeles.

166 See Thierry de Duve, "When Form Has Become Attitude—and Beyond," in *The Artist and the Academy: Issues in Fine Art Education and the Wider Cultural Context*, ed. Nicholas de Ville and Stephen Foster (Southampton: John Hansard Gallery, 1996), 23–40.

167 Von dem Knesebeck, *Käthe Kollwitz: Werkverzeichnis der Graphik*, 1:24.

168 Benjamin, "Technological Reproducibility," 24.

169 Rosalind Krauss, *The Originality of the Avant-Garde and Other Modernist Myths* (Cambridge, MA: MIT Press, 1986), 170.

170 See Bruno Taut, *Ein Architektur-Programm*, 1st ed. (Berlin: Arbeitsrat für Kunst, 1918), trans. Michael Bullock, in *Programs and Manifestos on Twentieth-Century Architecture*, ed. Ulrich Conrads (Cambridge, MA: MIT Press, 1971), 41–43, cited in *Expressionist Utopias: Paradise, Metropolis, Architectural Fantasy*, ed. Timothy O. Benson (Los Angeles: Los Angeles County Museum of Art, 1993), 279.

171 Peter was born in 1896 and died on October 22, 1914, on the western front at Dixmuiden in Flanders, ten days after Kollwitz had last seen him. Kollwitz's first mention of a "Denkmal" was recorded in her diary on December 9, 1914, and she originally conceived of it placed on the Schildhornhöhen in West Berlin, with a view of the Havel (January 1, 1915). Kollwitz, *Tagebücher*, 178, 181. See Regina Schulte, "Käthe Kollwitz's Sacrifice," *History Workshop Journal* 41 (1996): 193–221.

172 For discussion of this exhibition, consult Joan Weinstein, *The End of Expressionism: Art and the November Revolution in Germany, 1918–19* (Chicago: University of Chicago Press, 1990), 70–76.

173 Kollwitz, *Tagebücher*, March 26, 1919, 415–16.

174 Consult Weinstein, *End of Expressionism*.

175 Kollwitz, *Tagebücher*, May 9, 1919, 421.

176 Maud Lavin, *Cut with the Kitchen Knife: Weimar Photomontages of Hannah Höch* (New Haven, CT: Yale University Press, 1995), 31.

177 See Schubert, *Medizinisch Wichtige Darstellungen*, 93–95.

178 Kollwitz, *Tagebücher*, June 25, 1920, 476. Instructively, from 1919, the large annual exhibitions organized by the academy catered for plural tendencies and included works of members of the conservative professional association, the Verein der Berliner Künstler, as well as those of the Freie Secession and Novembergruppe.

179 For the Expressionist and national referents of the woodcut medium, see Christian Weikop, "Karl Schmidt-Rottluffs Arborealer Expressionismus," in *Rosa: Eigenartig Grün; Rosa Schapire und die Expressionisten*, ed. Sabine Schulze (Hamburg: Museum für Kunst und Gewerbe, 2009), 188–215.

180 For an in-depth analysis of this cycle, see Claire C. Whitner, "Käthe

Kollwitz and the *Krieg* Cycle: The Genesis, Creation, and Legacy of an Iconic Print Series," in Whitner, *Käthe Kollwitz and the Women of War*, 101–11.

181 Von dem Knesebeck, *Käthe Kollwitz: Werkverzeichnis der Graphik*, 2:515.

182 Kollwitz, *Tagebücher*, May 13, 1917, 315–16.

183 As argued in Max Wertheimer, "Untersuchungslehre von der Gestalt II," *Psychologische Forschung* 4 (1923): 301–50.

184 Letter from Martin Heidegger to Elizabeth Blockmann (1919), as cited in Koral Ward, *Augenblick: The Concept of the "Decisive Moment" in Nineteenth- and Twentieth-Century Western Philosophy* (Aldershot: Ashgate, 2008), 105. This is comparable to what Heidegger would call "a high-tension moment" of experience. In 1919, following his return from the front, Heidegger wrote in his correspondence that "being" in these moments makes itself clear to us primordially through basic intuition, before theorizing and discourse take over.

185 Sigmund Freud (1920), "Beyond the Pleasure Principle," *Standard Edition*, 18:14–15.

186 This is underscored in the chapter "Modernism and Mass Culture in the Visual Arts," in Thomas Crow, *Modern Art in the Common Culture* (New Haven, CT: Yale University Press, 1996), 3–38.

Chapter 4. Female Avant-Garde Identity and Creativity in the Blaue Reiter: The Possibility of a "Blaue Reiterreiterin"

1 Gustav Pauli, *Erinnerungen aus Sieben Jahrzehnten* (Tübingen: Wunderlich, 1936), 264–66.

2 See Bernd Fäthke, *Marianne Werefkin: Gemälde und Skizzen* (Wiesbaden: Städtisches Museum, 1980); Anne Mochon, *Gabriele Münter: Between Munich and Murnau* (Cambridge, MA: Busch-Reisinger Museum, 1980); Bernd Fäthke, *Marianne Werefkin: Leben und Werk, 1860–1938* (Ascona: Museo Comunale D'Arte Moderna, 1988); Sabine Windecker, *Gabriele Münter: Eine Künstlerin aus dem Kreis des "Blauen Reiter"* (Berlin: Reimer, 1991); Friedel and Hoberg, *Gabriele Münter, 1877–1962: Retrospektive*; Heller, *Gabriele Münter*; Hoberg and Friedel, *Der Blaue Reiter und das Neue Bild*; Bernd Fäthke, *Marianne Werefkin* (Munich: Hirmer, 2001); *Gabriele Münter: The Search for Expression, 1906–1916* (London: Courtauld Institute of Art, 2005); *Marianne Werefkin: Vom Blauen Reiter zum Großen Bären* (Bietigheim-Bissingen / Bremen: Städtische Galerie Bietigheim-Bissingen / Paula Modersohn-Becker Museum, 2014); *Gabriele Münter, 1877–1962: Painting to the Point*, ed. Isabelle Jansen and Matthias Mühling (Munich: Städtische Galerie im Lenbachhaus und Kunstbau, 2017).

3 See Gisela Kleine, *Gabriele Münter und Wassily Kandinsky*; Hoberg, *Wassily Kandinsky and Gabriele Münter*; Shulamith Behr, "Kandinsky, Münter and Creative Partnership," in *Kandinsky: The Path to Abstraction, 1900–1921*, ed. Hartwig Fischer and Sean Rainbird (London: Tate Publishing, 2006), 77–100, 213–14; Obler, *Intimate Collaborations: Kandinsky & Münter, Arp & Tauber*; Roger Benjamin with Cristina Ashjian, "Kandinsky and Münter in Tunisia," in *Kandinsky and Klee in Tunisia* (Oakland: University of California Press, 2015), 17–94.

4 Such strategies are outlined in Pollock, *Avant-Garde Gambits*, 12–15.

5 This contrasts dramatically with the proliferation of exhibitions and accompanying catalogs on the interaction of male artists in this community. See *August Macke and Franz Marc: An Artist Friendship*, ed. Volker Adolphs and Annegret Hoberg (Ostfildern: Hatje Cantz, 2014); *Klee and Kandinsky: Neighbours, Friends, Rivals*, ed. Michael Baumgartner, Annegret Hoberg, Christine Hopfengart (Munich: Prestel, 2015).

6 Pollock, *Avant-Garde Gambits*, 20, 74n16.

7 Otto Fischer, *Das Neue Bild* (Munich: Delphin, 1912).

8 Wassily Kandinsky, *Über das Geistige in der Kunst* (Munich: Piper, 1912).

9 For coverage of the impact of Fischer's book, see Hans Wille, "'Das Neue Bild' von Otto Fischer," in Hoberg and Friedel, *Der Blaue Reiter und Das Neue Bild*, 321–28.

10 Marc married a colleague of Franck's, Maria Schnür, in 1906, ostensibly as an honorable gesture to give her illegitimate son a name. Although Marc separated from Schnür in 1908, it was only in 1911 that he was issued with a divorce that enabled him to marry Maria Franck. They traveled to London for this and were subsequently married in accordance with German law in 1913. See Annegret Hoberg, *Maria Marc: Leben und Werk, 1876–1955* (Munich: Städtische Galerie im Lenbachhaus, 1995), 13–27; Brigitte Salmen, *Maria Marc: Im Kreis des "Blauen Reiter"* (Murnau: Schloßmuseum Murnau, 2004).

11 Bernd Fäthke, *Elisabeth I. Epstein* (Wolfsburg: Kunstverein Wolfsburg, 1990); Hildegard Reinhardt, "Elisabeth Epstein: Moscow–Munich–Paris–Geneva: Waystations of a Painter and Mediator of the French-German Cultural Transfer," in *Marianne Werefkin and the Women Artists in Her Circle*, ed. Tanya Malycheva and Isabel Wünsche (Leiden: Brill; Boston: Rodopi, 2017), 165–74.

12 For an outline of the women artists in the NKVM, see Tanya Malycheva, "Grenzüberschreitungen: Die Kosmopolitischen Künstlerinnen im Umfeld Marianne Werefkins," *Marianne Werefkin: Vom Blauen Reiter zum Großen Bären*, 168–91.

13 Hoberg, *Wassily Kandinsky und Gabriele Münter*; Klaus Lankheit, ed., *Wassily Kandinsky und Franz Marc: Briefwechsel* (Munich: Piper, 1983).

14 *Erste Ausstellung der Redaktion "Der Blaue Reiter"* (Munich: Moderne Galerie Heinrich Thannhauser, December 18, 1911–January 1, 1912); italics in the original.

15 *Die Zweite Ausstellung der Redaktion "Der Blaue Reiter": Schwarz-Weiss* (Munich: Kunsthandlung Hans Goltz, February 12–April 1912).

16 Wassily Kandinsky, "Über die Formfrage," in *Der Blaue Reiter*, ed. Wassily Kandinsky and Franz Marc (1912), documentary edition, ed. Klaus Lankheit (Munich: Piper, 1984), 132–88.

17 On the themes of the "feminine," "natural," and "primivist ideology" in the postwar reception of Münter, see Windecker, *Gabriele Münter*.

18 Janet Wolff, "The Feminine in Modern Art: Benjamin, Simmel and the Gender of Modernity," *Theory, Culture & Society* 17, no. 6 (2000): 33–53.

19 See Perry, "The Ascent to Nature," in Behr and Fanning, *Expressionism Reassessed*, 53–58, and Friedrich Nietzsche, *Twilight of the Idols or How to Philosophize with a Hammer* (1889), trans. Duncan Large (Oxford: Oxford University Press, 1998), 9:48–49, 9:73–74.

20 For the gendered implications of the domestic aesthetic in interior design as an alternative form of modernism, see Christopher Reed, *Bloomsbury Rooms: Modernism, Subculture, and Domesticity* (New Haven, CT: Yale University Press, 2004). Katherine M. Kuenzli advances Reed's findings but argues that Nabi painting transgresses spatial and gender categories in *The Nabis and Intimate Modernism: Painting and the Decorative at the Fin-de-Siècle* (Abingdon: Routledge, 2017).

21 Kandinsky trained as an ethnographer in Moscow before deciding to pursue a professional career as an artist in Munich in 1896. See Peg Weiss, *Kandinsky and Old Russia: The Artist as Ethnographer and Shaman* (New Haven, CT: Yale University Press, 1995).

22 Wassily Kandinsky, "Reminiscences," in *Complete Writings*, ed. Kenneth Lindsay and Peter Vergo (London: Faber, 1982), 368–69.

"Rückblicke" was published as part of a retrospective album of his essays in *Kandinsky, 1901–1913* (Berlin: Sturm, 1913).

23 See Comini, "Gender or Genius?," in Broude and Garrard, *Feminism and Art History*, 283–84.

24 Wassily Kandinsky, "Der Blaue Reiter Rückblick," *Das Kunstblatt* 14 (1930): 57–60.

25 For recent consideration of this theme, see Marta Ruiz del Árbol, "The Rider and the Dream: The Relationship between Franz Marc and Wassily Kandinsky through the Works They Exchanged," in *Kandinsky, Marc, and Der Blaue Reiter*, ed. Ulf Küster (Basel: Fondation Beyeler, 2016), 158–62.

26 See Joseph L. Koerner, *The Moment of Self-Portraiture in German Renaissance Art* (Chicago: Chicago University Press, 1993), 426–34.

27 Johanna Werckmeister, "'Blaue Reiter' im Damensattel: Rezeptionsraster für eine Künstlerin," *Kritische Berichte* 17, no. 1 (1989): 70–77. For a social history of sidesaddle and cross saddle and its relationship to women's emancipation, see Susanna Forrest, *If Wishes Were Horses: A Memoir of Equine Obsession* (London: Atlantic Books, 2012).

28 See Ricarda Dick, ed., *Else Lasker-Schüler—Franz Marc: Eine Freundschaft in Briefen und Bildern* (Munich: Prestel, 2012).

29 For amplification, see Shulamith Behr, "Performing the Wo/man: The 'Interplay' between Marianne Werefkin and Else Lasker-Schüler," in Malycheva and Wünsche, *Marianne Werefkin*, 92–105.

30 *Erste Ausstellung: Der Blaue Reiter, Franz Flaum, Oskar Kokoschka, Expressionisten* (Berlin: Der Sturm, March 12–May 10, 1912).

31 *Deutsche Expressionisten: Zurückgestellte Bilder des Sonderbundes Köln* (Berlin: Der Sturm, June 16–end July 1912).

32 Maximilian Karl Rohe, "München," *Die Kunst für Alle* 28, no. 12 (March 15, 1913): 286.

33 Wilhelm Hausenstein, "Die Neue Kunst: Zur Naturgeschichte der Kritik" (Munich: Hans Goltz, August–September 1913), 16.

34 Shulamith Behr, "Comparative Issues of Marginality: The Case of Maria Marc," *Women's Art Magazine* 69 (April/May 1996): 18–20.

35 For further commentary on this category, consult Cristina Maria Ashjian, *Representing "Scènes et Types": Wassily Kandinsky in Tunisia, 1904–1905* (PhD diss., Northwestern University, 2001).

36 See *Gabriele Münter: Die Reise nach Amerika, Die Photographien, 1899–1900*, ed. Helmut Friedel (Munich: Schirmer/Mosel and Gabriele Münter- und Johannes Eichner-Stiftung, 2006).

37 See Jansen and Mühling, *Gabriele Münter*, 176–77: Gabriele Münter, *Völkerschau: München*, 1901, six photographs, 8.9 × 8.9 cm, Gabriele Münter- und Johannes Eichner-Stiftung, Munich, Inv.-No. 3000–3005.

38 Benjamin with Ashjian, *Kandinsky and Klee*, 30.

39 For overviews, see Karla Bilang, *Frauen im Sturm: Künstlerinnen der Moderne* (Berlin: Aviva, 2013); *STURM-FRAUEN: Künstlerinnen der Avant-Garde in Berlin, 1910–1932*, ed. Ingrid Pfeiffer and Max Hollein (Frankfurt am Main: Schirn Kunsthalle, 2015).

40 Letter from Werefkin to Walden, Sturm-Archiv Herwarth Walden, SBPK, Blatt 3/4 [1912].

41 There are two Lektürehefte (reading notebooks) in the Fondazione Marianne Werefkin, Museo Comunale d'Arte di Ascona (hereafter FMW). For the holdings of the FMW, see Maria Folini, *Marianne Werefkin, 1860–1938* (Ascona: Museo Comunale d'Arte Moderna, 2016), 148–61.

42 The letters were kept at Werefkin's family estate, Blagodat, in Lithuania until the outbreak of the Second World War and are now maintained in the Pyotr Verefkin Fond, Manuscript Department, Lithuanian National Martynas Mažvydas Library in Vilnius. See

the various publications of Laima Laučkaitė-Surgailienė, "Marianna Verefkina: Zhizn' v iskusstve," *Vilnius* 2 (1992): 92–104; 3 (1992): 126–37; "Reisen nach Litauen," in *Marianne von Werefkin: Oeuvres Peintes, 1907–1936*, ed. Nicola Brögmann (Gingin: Fondation Neumann, 1996), 93–101; "Der Unbekannte Briefnachlaß der Malerin Marianne Werefkin," in *Marianne Werefkin: Die Farbe Beisst mich ans Herz*, ed. Barbara Weidle (Bonn: August Macke Haus, 1999), 58–71; *Ekpresionizmo raitelė Mariana Veriovkina* (Vilnius: Kultūros, filosofijos ir meno Institutas, 2007); "Women Artists of Marianne Werefkin's Circle: Sisters or Rivals? The Case of Vera Abegg-Verefkine," in Malycheva and Wünsche, *Marianne Werefkin*, 80–91; Kochmann, "Ambiguity of Home."

43 See Mara R. Witzling, ed., "Marianne Werefkin: *Lettres à un Inconnu*, 1901–1905," in *Voicing Our Visions: Writings by Women Artists* (London: Women's Press, 1992), 132–46; Dorothy Price, "'Between Us Sleeps Our Child—Art': Creativity, Identity, and the Maternal in the Works of Marianne von Werefkin and Her Contemporaries," in Malycheva and Wünsche, *Marianne Werefkin*, 106–22.

44 All cited extracts are from the archival material: Marianne Werefkin, *Lettres à un Inconnu*, 1901–5, FMW. There are abridged translations in German in Clemens Weiler, ed., *Marianne Werefkin: Briefe an einen Unbekannten, 1901–1905* (Cologne: DuMont Schauburg, 1960) and a more substantive transcription in Gabrielle Dufour-Kowalska, ed., *Marianne Werefkin: Lettres à un Inconnu: Aux sources de l'expressionisme* (Paris: Klincksieck, 1999).

45 By the mid-nineteenth century, monitoring access to the Academy of Fine Arts became available to women, as higher education came within their reach. In 1891 the academy admitted the first class of women to be eligible for the title of "Artist." See Wendy R. Salmond, "Training and Professionalism: Russia," in *Dictionary of Women Artists*, ed. Delia Gaze (London: Fitzroy Dearborn, 1997), 115–21.

46 Léonide Ouspensky and Vladimir Lossky, *The Meaning of Icons*, trans. G.E.H. Palmer and E. Kadloubovsky (New York: St. Vladimir's Seminary Press, 1982), 22.

47 For the Platonic and Neoplatonic in Russian religious philosophy in the early twentieth century, see Clemena Antonova, *Space, Time, and Presence in the Icon: Seeing the World with the Eyes of God* (Abingdon: Routledge, 2016), 17.

48 Marianne Werefkin, *Lettres à un Inconnu*, vol. 1 (1901–2), 251, FMW.

49 In 1895, the ethnographic department was founded as part of the Russian Museum in St. Petersburg and officially came into being in 1902; it focused on the presentation of primarily Slavic tribes of the Russian Empire. See Roland Cvetkovski, "Empire Complex: Arrangements in the Russian Ethnographic Museum, 1910," in *An Empire of Others: Creating Ethnographic Knowledge in Imperial Russia and the USSR*, ed. Roland Cvetkovski and Alexis Hofmeister (Budapest: Central University Press, 2014), 211–52.

50 The railway tycoon Savva Mamontov (1841–1918) and his wife Elisaveta Grigorievna (1847–1908) bought the estate in 1870 and cherished the intellectual legacy of its former owner, the writer Sergei Aksakov. See Eleanora Paston, "The Abramtsevo Circle: Founding Principles and Aesthetic Directions," in *From Realism to the Silver Age: New Studies in Russian Artistic Culture*, ed. Rosalind P. Blakesley and Margaret Samu (De Kalb: Northern Illinois University Press, 2014), 59–78.

51 For a wider consideration of Polenova, see Natalia Murray, ed., *A Russian Fairytale: The Art and Craft of Elena Polenova* (Guildford: Watts Gallery, 2014).

52 According to Roland Cvetkovski, the emergence of a national idea in the nineteenth century and the all-Russian census of 1897 (listing 130 nationalities and identifying as many as 260 different languages) led to the continuous involvement of the imperial state in ethnographic differentiation on that level. See Cvetkovski, "Introduction," in *An Empire of Others*, 3–4.

53 Between 1884 and 1887, under the auspices of the Russian Academy of Arts and Sciences in St. Petersburg, Kovno-born ethnographer Eduardas Volteris (1856–1941) was commissioned to conduct expeditions in Lithuania with the view to collecting sets of traditional costume, which were later presented to the Museum of Moscow. See http://postilla.mch.mii.lt/Paprociai/kostiumai.en.htm.

54 See Rosalind P. Blakesley, *Russia and the Arts: The Age of Tolstoy and Tchaikovsky* (London: National Portrait Gallery, 2016), 43–47.

55 Glenn E. Curtis, ed., *Russia: A Country Study* (Washington, DC: Library of Congress, 1998), 37.

56 Hasidism, a movement of mysticism and revivalism, emerged in the Ukraine in the middle of the eighteenth century and spread rapidly through Eastern Europe. Cabinet cards were popular in the second half of the nineteenth century until around 1910. The proliferation of Jewish photographic studios in Lithuania and the paucity of research thereon are observed in Michael Berkowitz, "Photography as Jewish Space," in *Space and Spatiality in Modern German-Jewish History*, ed. Simone Lässig and Miriam Rürup (New York: Berghahn, 2017), 255.

57 As Louis Jacobs observed, by the late nineteenth century most Jews in the Pale of the Settlement were urbanized, highly differentiated, and stratified—culturally, economically, and politically. See Louis Jacobs, "The Jewish Tradition," in *The World's Religious Traditions: Current Perspectives in Religious Studies*, ed. Frank Whaling (London: Bloomsbury, 2016), 83–84.

58 In 1781, the Hermitage acquired Flemish and Dutch painting, including Rembrandt's *Portrait of an Old Jew*, 1654 (oil on canvas, 109 × 85 cm), from the Count Baudouin collection in Paris.

59 Letter from Repin to Werefkin, October 18, 1891, as cited in Fäthke, *Marianne Werefkin* (2001), 32.

60 Alexej (Alexi) Jawlensky, the son of a colonel, was born in 1864 in Torrzhok, Russia. When he was ten, his family moved to Moscow. Following family tradition, he attended cadet and military school and became a lieutenant in the Samogita Infantry-Grenadier's Regiment, based in Moscow. During this period, he frequented the Tretyakov Gallery in Moscow and began to paint. In 1889, Jawlensky transferred to a regiment in St. Petersburg so that he could attend classes at the Royal Academy of Art and study with Ilya Repin, which is where he met Werefkin.

61 For extant examples of these works, see Maria Jawlensky and Angelica Jawlensky, eds., *Alexej von Jawlensky: Catalogue Raisonné of the Oil Paintings*, vol. 1, 1890–1914 (London: Sotheby's, 1991), nos. 3–5.

62 See Lektüreheft, FMW 22L-3-563 (1893–94): Péladan, *Comment on devient fée* (1891) and *Comment on deviant mage* (1893), Lombroso, *L'homme criminel* (1891); FMW 27L-2-587: Balzac, *Le recherche de l'absolu* (1894), and so on.

63 For amplification thereon, consult Maria Makela, *The Munich Secession: Art and Artists in Turn-of-the-Century Munich* (Princeton, NJ: Princeton University Press, 1990).

64 Adrienne Kochman, "Russian Émigré Artists and Political Opposition in Fin-de-Siècle Munich," *Emporia State Research Studies* 45, no. 1 (2009): 6–26.

65 Vivian Endicott Barnett, "Russian Artists in Munich and the Russian Participation in the Blaue Reiter," in *Russian Modernism: Cross-currents of German and Russian Art, 1907–1917*, ed. Konstantin Akinsha (Munich: Prestel and Neue Galerie, 2015), 62.

66 Pauli, *Erinnerungen*, 264.

67 Lektüreheft, FMW 22L-4-564 (1900). Alsace-born Henri Lichtenberger (1864–1941) was a professor of foreign languages at the university in Nancy at the time, and he interviewed Elisabeth Förster-Nietzsche in person for the book *La Philosophie de Nietzsche* (Paris: Alcan, 1898).

68 Lektüreheft, FMW 22L-4-564 (1900).

69 See Nel Grillaert, *What the God-Seekers Found in Nietzsche: The Reception of Nietzsche's Übermensch by the Philosophers of the Russian Religious Renaissance* (Leiden: Brill; Boston: Rodopi, 2008).

70 In the influential Russian philosopher Vladimir Solovyov's (1853–1900) text *Smysl liubui* (The Meaning of Love, 1892–94), sexual love was associated with Judeo-Christian imagery of the creation of man, "not as one separate part [gender] of the human being but as a true unity of his male and female sides." See Vladimir Solovyov, *The Meaning of Love*, intro. Owen Barfield (Felton: Lindisfarne Books, 1985); Anna Lisa Crone, *Eros and Creativity in Russian Religious Renewal: The Philosophers and the Freudians* (Leiden: Brill, 2010), 27–31.

71 Listed as in the employ of Werefkin, Nesnakomoff had no legal documentation of her own, and this situation remained unresolved until 1921, at a time when Jawlensky and Werefkin's relationship ended in Ascona. See Fäthke, *Marianne Werefkin* (2001), 32–35.

72 Werefkin, *Lettres*, vol. 1 (1901–2), 57, FMW.

73 In the Wilhelmine period, whether lesbian or not, many professional women poets and artists forayed into a field traditionally monopolized by men. This led to them being given the pejorative label *Mannweib* (man-woman) to denote their being neither man nor woman but members of a third sex; they were thought to have gone against nature, shirking their responsibility as wives and mothers. See Kochman, "Ambiguity of Home," 10.

74 Werefkin, *Lettres*, vol. 3 (October 30, 1905), 257, FMW.

75 Werefkin, *Lettres*, vol. 1, "Minuit 1902," 35, FMW.

76 Werefkin, *Lettres*, vol. 1 (1902), 135, FMW.

77 For the importance of Russian symbolism, see Jelena Hahl-Koch, *Marianne Werefkin und der Russische Symbolismus: Studien zur Ästhetik und Kunsttheorie* (Munich: Otto Sagner, 1967); John E. Bowlt, "Things That Are Not: Marianne Werefkin and the Condition of Silence," in Blakesley and Samu, *From Realism to the Silver Age*, 201–8.

78 Werefkin, *Lettres*, vol. 3 (September 12, 1905), 187, FMW. On December 10, 1904, Werefkin mentioned having seen Gauguin's painting *Riders on the Beach in Tahiti* in the collection of Felix von Rath (1866–1905). See Dufour-Kowalska, *Marianne Werefkin*, 149.

79 Werefkin, *Lettres*, vol. 3 (September 12, 1905), 188–89, FMW.

80 Although the treatise was published in 1912, Kandinsky's manuscript was complete by February 10, 1910; see Kleine, *Gabriele Münter und Wassily Kandinsky*, 356.

81 Price, "'Between Us Sleeps Our Child—Art,'" in Malycheva and Wünsche, *Marianne Werefkin*, 116.

82 For the full list of sketchbooks, consult Folini, *Marianne Werefkin*, 157–61.

83 The inscriptions are Cyrillic directives for color and/or weather conditions.

84 See also Bernd Fäthke, "Marianne Werefkin—'Des Blauen Reiterreiterin,'" in *Marianne Werefkin: Vom Blauen Reiter zum Großen Bären*, 36–37.

85 Further discussion of Munch's impact can be found in Fäthke, *Marianne Werefkin* (2001), 88–92; on Munch's exhibitions in Germany, consult *Munch und Deutschland* (Munich: Kunsthalle der Hypo-Kulturstiftung, 1994).

86 See Rudolf H. Wackernagel, "'Watercolor with "Oil" . . . , Oil with "Watercolor," and so on': On Kandinsky's Studio and His Painting Techniques," in *Vasily Kandinsky: A Colorful Life*, ed. Vivian Endicott Barnett and Helmut Friedel (Munich: Städtische Galerie im Lenbachhaus, 1996), 547–68.

87 Pollock, *Avant-Garde Gambits*, 12–15.

88 In 1906, this led to the acceptance of nine of Jawlensky's paintings for the major survey of Russian art at the Salon d'Automne. His works are listed under the name "Alexei Yavlensky" in *Exposition de l'Art Russe* (Paris: Salon d'Automne, 1906), nos. 735–44: Études (Bretagne), 138.

89 Werefkin, *Lettres*, vol. 3 (1904), 279, FMW.

90 Werefkin, *Lettres*, vol. 3 (January 22, 1905), 70–72, FMW.

91 Friedel and Hoberg, *Gabriele Münter*, 264, cat. no. 63.

92 As Ulrike Vieten has pointed out, there are key differences in the social positions attached to the terms *Weltbürger*, which implies upper-middle-class social mobility, and *Kosmopolit*, which was laden with anti-Semitic signifiers of rootlessness and bisexuality at the turn of the nineteenth and early twentieth centuries. Ulrike M. Vieten, *Gender and Cosmopolitanism in Europe: A Feminist Perspective* (Farnham: Ashgate, 2013), 7–11.

93 See Hans K. Roethel and J. K. Benjamin, *Wassily Kandinsky: Catalogue Raisonné of the Oil Paintings*, vol. 1, 1900–1915 (London: Sotheby's, 1982), 20.

94 For the reception history of Münter, see Windecker, *Gabriele Münter*.

95 Johannes Eichner, *Kandinsky und Gabriele Münter: Von Ursprüngen Moderner Kunst* (Munich: Bruckmann, 1957), 22, 282. Münter and Eichner first met in Berlin in 1927 and developed their lives together from 1929 until his death in 1958.

96 Eichner, *Kandinsky und Gabriele Münter*, 38.

97 The Gabriele Münter- und Johannes Eichner-Stiftung in the Städtische Galerie im Lenbachhaus und Kunstbau München (hereafter GMJES) houses the artist's estate. The American output includes seven sketchbooks, some of which contain drawings prior to her travels; around fifty individual sketches; four hundred photographs; a photograph album of around ninety images; pocket calendars for each of the years of her travels; and reminiscences from her upbringing and travels. In addition, her library contains books belonging to her parents.

98 For an extended discussion, see Heller, *Gabriele Münter*, 40–44.

99 "Gabrièle Münter," in Edouard Roditi, *Dialogues on Art* (Santa Barbara, CA: Ross Erikson, 1980), 135.

100 Gabriele Münter, "Erinnerungen an Amerika," 1959, typed manuscript, GMJES, as cited in Friedel, *Gabriele Münter: Die Reise nach Amerika*, 220.

101 Ann Vollmann Bible, *Cakewalking into Representation: Gabriele Münter's America Travels (1898–1900) and Art of Dailiness* (PhD diss., Massachusetts Institute of Technology, 2008), 33–35.

102 Bible, *Cakewalking into Representation*, 33–35. Among other theorists, Bible refers to Rebecca Hogan, "Engendered Autobiographies: The Diary as a Feminine Form," in *Autobiography and Questions of Gender*, ed. Shirley Neuman (London: Routledge, 1991), 95.

103 See Daniel Oggenfus, "Kamera und Verfahrenstechnik der Amerika-Photographien Gabriele Münters," and Ulrich Pohlmann, "Die Fragilität des Augenblicks: Gabriele Münters Photographien der USA-Reise im Spiegel der zeitgenössischen (Moment) Photographie," in Friedel,

Gabriele Münter: Die Reise nach Amerika, 189–202; 203–15.

104 Isabelle Jansen, "Visual Delight," in Jansen and Mühling, *Gabriele Münter*, 16–19.

105 Christina Schüler, "Nachahmung oder Autonomie? Überlegungen zur Frühen Druckgraphik und Drucktechnik Gabriele Münters," in *Gabriele Münter: Das Druckgraphische Werk*, ed. Helmut Friedel (Munich: Prestel, 2000), 28.

106 Roditi, "Gabrièle Münter," 167.

107 See Hilary Spurling, *Matisse the Master: A Life of Henri Matisse* (New York: Knopf, 2005), 17–18.

108 Jansen and Mühling, *Gabriele Münter*, 100–101; Henri Matisse, *Woman with a Hat*, 1905, oil on canvas, 81 × 60 cm, San Francisco Museum of Modern Art.

109 See Shulamith Behr, "Beyond the Muse: Gabriele Münter as *Expressionistin*," in *Gabriele Münter: The Search for Expression*, 55–56.

110 Isabelle Jansen, "Gabriele Münter in Paris, 1906–1907," in Friedel, *Gabriele Münter: Das Druckgraphische Werk*, 43.

111 *Les Tendances Nouvelles* 3, no. 39 (November, 1908): 835.

112 In 1907, Elfriede was the four-year-old daughter of Münter's sister, Emmy (1869–1946), who married Georg Schroeter (1869–1943), a chemistry professor, in 1901. See Gisela Kleine, *Gabriele Münter und die Kinderwelt* (Frankfurt am Main: Insel, 1997), 11–33, 63–67.

113 Kleine, *Gabriele Münter und die Kinderwelt*, 34–48; Friedel, *Gabriele Münter: Das Druckgraphische Werk*, 118–26.

114 *Der Bonner Generalanzeiger* (June 16, 1908), as cited in Friedel, *Gabriele Münter: Das Druckgraphische Werk*, 120.

115 See Brigitte Salmen, ed., *Marianne von Werefkin in Murnau: Kunst und Theorie, Vorbilder und Künstlerfreunde* (Murnau: Schloßmuseum Murnau, 2002); Brigitte Salmen, ed., *1908/2008: Vor 100 Jahren: Kandinsky, Münter, Jawlensky, Werefkin in Murnau* (Murnau: Schloßmuseum Murnau, 2008).

116 See Constanze Werner, "'Vor allem wies mir die Volkskunst den Weg': Gabriele Münter im Kontext von Volkskunst als Inspiration, Sammelgegenstand und Stil," in *Gabriele Münter und die Volkskunst* (Murnau: Schloßmuseum Murnau, 2017), 10–24.

117 Benjamin, *Kandinsky and Klee in Tunisia*, 25.

118 Helena Waddy Lepovitz, *Images of Faith: Expressionism, Catholic Folk Art and the Industrial Revolution* (Athens: University of Georgia Press, 1991), 145–46.

119 Werner, "'Vor allem wies mir die Volkskunst den Weg,'" in *Gabriele Münter und die Volkskunst*, 18.

120 Nina Gockerell, "'Und der Tisch mit den 17 Madonnen . . .': Gabriele Münter und Ihre Volkskunstsammlung," in *Gabriele Münter und die Volkskunst*, 59–61.

121 Münter acquired the house in Kottmülleralle in Murnau August 21, 1909. See Sandra Uhrig, "'. . . deine Glasbilder u. einiges andre zu dem ich ein besonderes Verhältnis hatte': Gabriele Münter und die Volkskunst im Spiegel ihrer Lebensstationen," in *Gabriele Münter und die Volkskunst*, 69.

122 Münter, Diary, 1911, in Hoberg, *Wassily Kandinsky and Gabriele Münter*, 45–46.

123 The term "synthesis" became a rhetorical catchword in Kandinsky's formulation of the program for the catalog of the first exhibition of the NKVM in 1909, wherein he proclaimed their search "for artistic forms . . . that must be freed from everything incidental, in order to bring only what is necessary to express strongly—in short, the pursuit of artistic synthesis." Wassily Kandinsky, "Vorwort," in *Neue Künstlervereinigung München* (Munich: Moderne Galerie, 1909).

124 Gabriele Münter, "Aufzeichnung," February 10, 1933, as cited in *Gabriele Münter, 1877–1962*, ed. Hans Lautenbacher (Munich: Städtische Galerie im Lenbachhaus, 1962), no page ref.

125 Obler, *Intimate Collaborations*, 31–44.

126 Letter from Münter to Kandinsky, November 25, 1910, in Hoberg, *Wassily Kandinsky and Gabriele Münter*, 89.

127 Roditi, "Gabrièle Münter," 146.

128 Fäthke, *Marianne Werefkin* (2001), 115–17.

129 For consideration of the washerwoman motif, see Kochmann, "Ambiguity of Home."

130 For discussion of the Oberstdorf sojourn and the painting *Factory Town/The Way Home*, 1912, tempera on board, 69.5 × 83 cm, FMW, Museo Comunale D'Arte Ascona, see Behr, "Performing the Wo/man," in Malycheva and Wünsche, *Marianne Werefkin*, 100–101.

131 For the sketches toward *Red City*, see Fäthke, *Marianne Werefkin* (2001), 142.

132 For an account of Werefkin's lost glass paintings, see Fäthke, *Marianne Werefkin* (2001), 130–31.

133 Lepovitz, *Images of Faith*, 152.

134 For an account of this intercultural exchange, see Timothy O. Benson, ed., *Expressionism in Germany and France: From Van Gogh to Kandinsky* (Munich: Prestel, 2014).

135 See Annegret Hoberg, *Gabriele Münter* (Munich: Prestel, 2003), 18–19.

136 Fäthke, *Marianne Werefkin* (2001), 149.

137 See Joan Rivière, "Womanliness as a Masquerade," *International Journal of Psychoanalysis* 10 (1929): 303–13, in *Formations of Fantasy*, ed. Victor Burgin, James Donald, and Cora Kaplan (Abingdon: Routledge, 1986), 38.

138 This was discussed by Mara Witzling in an unpublished paper, "My Beautiful, My Unique, Myself, My Muse: Werefkin's 'Inconnu' and Women Artists' Appropriation of Artistic Authority," College Art Association, 1993.

139 See Kochmann, "Ambiguity of Home," 4, for translation of the Werefkin letter to Jawlensky, 1910, RS Fond 19–1458, 17–18; 27–28, Lithuanian National Martynas Mažvydas Library, Vilnius.

140 Letter from Marc to Franck, December 8, 1910, in *Der Blaue Reiter: Dokumente einer Geistigen Bewegung*, ed. Andreas Hüneke (Leipzig: Reclam, 1991), 37.

141 It is important to add here that Marc arrived at a mystical, symbolic, and gendered interpretation of the primary and complementary colors and communicated his theories to Macke just four days thereafter. Letter from Marc to Macke, December 12, 1910, in August Macke and Franz Marc, *Briefwechsel* (Cologne: Du Mont, 1964), 27–30.

142 For a discussion of women artists' negotiation of self-portraiture, see Shulamith Behr, "Die Arbeit am Eigenen Bild: Das Selbstporträt bei Gabriele Münter," in Friedel and Hoberg, *Gabriele Münter*, 85–91.

143 *Neue Künstlervereinigung München, III. Ausstellung* (Munich: Moderne Galerie Heinrich Thannhauser, 1911–12), 12, no. 52 "Porträt."

144 Hoberg and Friedel, *Der Blaue Reiter und das Neue Bild*, 50.

145 Fischer, *Neue Bild*, 15.

146 *Die Erste Ausstellung der Redaktion: Der Blaue Reiter* (Munich: Moderne Galerie Heinrich Thannhauser, 1911–12), 6, no. 35.

147 Letter from Münter to Kandinsky, October 30, 1910, in Hoberg, *Kandinsky und Münter*, 76.

148 Letter from Münter to Kandinsky, November 8, 1910, in Hoberg, *Kandinsky und Münter*, 83.

149 Bibiana Obler cites Henri Bergson's ideas in *Time and Free Will* (1889) as relevant to Kandinsky's and Münter's intellectual framework, in which past experiences are linked to the present. She contrasts their distinctive approaches and relates Münter's animation of still life objects to the vital materialist theories of feminists, such as Elizabeth Grosz and Jane Bennett. See Obler, *Intimate Collaborations*, 85–87, 104–5.

150 Hoberg, *Gabriele Münter* (2003), 23.

151 Virginia Woolf, "A Sketch of the Past," in *Moments of Being*, ed. Jeanne Schulkind, 2nd ed. (London: Hogarth Press, 1985), 142.

152 Woolf, "Sketch of the Past," 70–72.

153 Ana Clara Birrento, "Virginia Woolf: Moments of Being," in *Virginia Woolf: Three Centenary Celebrations*, ed. Luisa Flora and Maria Cândida Zamith (Porto: Universidade do Porto, 2007), 62.

154 Letter from Münter to Kandinsky, December 8, 1910, in Hoberg, *Kandinsky and Münter*, 97.

155 Barnaby Wright, "Catalogue," in *Gabriele Münter: The Search for Expression*, 106.

156 Sixten Ringbom, *The Sounding Cosmos: A Study in the Spiritualism of Kandinsky and the Genesis of Abstract Art* (Åbo: Åbo Akademi, 1970), 37–39.

157 Rudolf Steiner, "Sonne Mond und Sterne," Berlin, March 26, 1908, Rudolf Steiner Online Archive, http://anthroposophie.byu.edu, http://anthroposophie.byu.edu/vortraege/056_11.pdf, 4. Auflage 2010, 8.

158 Kleine, *Münter und Kandinsky*, 297–302.

159 Ronald Templeton, "Wassily Kandinsky und Rudolf Steiner," *Das Goetheanum* 63, no. 23 (June 3, 1984): 179, refers to Kandinsky having attended all the mystery dramas.

160 Hoberg and Friedel, *Der Blaue Reiter und das Neue Bild*, 376.

161 Rudolf Steiner, *Der Orient im Lichte des Occidents: Die Kinder des Lucifer und Brüder Christi*, 9 Vorträge (Munich, August 23–31, 1909). Literaturbestand aus dem Nachlaß von Gabriele Münter, GMJES, Munich, 5. This copy contains a receipt that it was presented to Emmy Dresler by Marie von Sivers, May 3, 1911.

162 Literaturbestand aus dem Nachlaß von Gabriele Münter, GMJES, Munich, 5.

163 Rudolf Steiner, *Theosophie: Einführung in Übersinnliche Welterkenntnis und Menschenbestimmung* (1908; Dornach: Rudolf-Steiner-Verlag, 1987), 9, https://archive.org/details/rudolf-steiner-ga-009.

164 Letter from Münter to Kandinsky, October 28, 1912, in Hoberg, *Wassily Kandinsky and Gabriele Münter*, 136.

165 Friedel, *Gabriele Münter: Das Druckgraphische Werk*, 136–45.

166 Thorough coverage of this topic may be found in Robin Reisenfeld, *Cultural Identity and Artistic Practice: The Revival of the German Woodcut* (PhD diss., University of Chicago, 1993).

167 *Gartenkonzert* (1911–12), gouache, 28.6 × 37.7 cm, GMJES, Munich, is listed as no. 67 in "Gabriele Münter Kollektive Ausstellung 1904–1913," Faltblatt, *Elfte Ausstellung* (Berlin: Der Sturm, 1913).

168 Letter from Herwarth Walden to Münter, January 18, 1913, in Karla Bilang, ed., *Kandinsky, Münter, Walden: Briefe und Schriften, 1912–1914* (Bern: Benteli, 2012), 45.

169 Letter from Herwarth Walden to Münter, May 27, 1913, in Bilang, *Kandinsky, Münter, Walden*, 73.

170 Letter from Herwarth Walden to Münter, June 11, 1913, in Bilang, *Kandinsky, Münter, Walden*, 77.

171 Kandinsky wrote the text "Der Künstler und sein Spiegelbild" (The Artist and His Mirror Image) in honor of Münter's solo exhibition of eighty-four paintings, which was organized by Walden in Berlin in January 1913. It was intended to serve as the catalog introduction, with

further plans to incorporate it in a book of his essays (*Kleine Schriften*), neither of which came to fruition. An excerpt was published anonymously when Münter's retrospective moved to the Kunstsalon Dietzel in Munich in April 1913. See A. M., "Aus dem Münchner Kunstleben," *Vossische Zeitung*, morning edition (April 20, 1913). Reinhold Heller considered this text and its variations in an unpublished paper, "A Non-Male German Talent: Gabriele Münter's Work Perceived through Vassily Kandinsky's Eyes," which was contributed to the conference *From Expressionism to Exile: German-speaking Women Practitioners and the Public Sphere* (Courtauld Institute of Art, London, July 1, 2005).

172 Obler, *Intimate Collaborations*, 98.

173 Letter from Herwarth Walden to Münter, May 8, 1913, in Bilang, *Kandinsky, Münter, Walden*, 66.

174 For detailed handling, consult Mario-Andreas von Lüttichau, "Erster Deutscher Herbstsalon," in *Stationen der Moderne: Die Bedeutenden Kunstausstellungen des 20. Jahrhunderts in Deutschland*, ed. Eva Züchner (Berlin: Berlinische Galerie, 1988), 131–53.

175 August Macke and Franz Marc, *Briefwechsel* (Cologne: Du Mont, 1964), 113–15.

176 Letter from Marc to Münter, July 23, 1913, in *Wassily Kandinsky, Franz Marc: Briefwechsel; Mit Briefen von und an Gabriele Münter und Maria Marc*, ed. Klaus Lankheit (Munich: Piper, 1983), 234.

177 In the gendered rhetoric of the journal *Der Sturm*, the victory of masculine "spirit" over female "matter" emerged as a dominant aesthetic discourse. See Barbara D. Wright, "'New Man,' Eternal Woman: Expressionist Responses to German Feminism," *German Quarterly* 60, no. 4 (Fall 1987): 582–83; Barbara D. Wright, "Intimate Strangers," in Donahue, *A Companion to the Literature of German Expressionism*, 291.

178 This is interpreted as an expression of personal and artistic crisis by Reinhold Heller, "Innenräume: Erlebnis, Erinnerung und Synthese in der Kunst Gabriele Münters," in Friedel and Hoberg, *Gabriele Münter*, 61.

179 *Erster Deutscher Herbstsalon*, Katalog der Ausstellung (Berlin: Der Sturm, 1913), nos. 297–302, 26.

180 Barnaby Wright, "Catalogue," in *Gabriele Münter: The Search for Expression*, 108.

181 Among their works submitted to the Herbstsalon was Kandinsky's programmatic *Composition VI (Deluge)*, 1913, oil on canvas, 195 × 300 cm, State Hermitage Museum, St. Petersburg, and Franz Marc's similarly scaled *Tierschicksale (Fate of the Animals)*, 1913, oil on canvas, 196 × 266 cm, Kunstmuseum, Basel. See *Erster Deutscher Herbstsalon*, no. 181, 20, and no. 271, 25.

182 *Erster Deutscher Herbstsalon*, nos. 348–50, 30.

183 The introduction of the photographic negative allowed for the emergence of new genres of postcards. See David Prochaska and Jordana Mendelson, eds., *Postcards: Ephemeral Histories of Modernity* (Philadelphia: Pennsylvania University Press, 2010), xii.

184 Hausenstein, "Die Neue Kunst," 16.

185 Hausenstein, *Die Bildende Kunst*, 261, as cited in Haxthausen, "A Critical Illusion," in Rumold and Werckmeister, *The Ideological Crisis of Expressionism*, 180.

186 Hausenstein, "Die Neue Kunst," 17.

187 Hausenstein, "Die Neue Kunst," 5, 9. Clearly, the reference to "die andere Seite" is a play on the title and substance of Alfred Kubin's *Die Andere Seite: Ein Phantasischer Roman* (Munich: Georg Müller, 1909), a dreamlike odyssey into unknown worlds of the subconscious.

188 *Dreiundzwanzigste Ausstellung: Jacoba van Heemskerck, Arthur Segal, Marianne von Werefkin* (Berlin: Der Sturm, 1914).

189 *Dreiundzwanzigste Ausstellung*, no. 44: "Vorfrühling."

190 Laima Laučkaitė-Surgailienė, "M. K. Čiurlionis and Marianne von Werefkin: Their Paths and Watersheds," *Lituanus* (*Lithuanian Quarterly Journal of Arts and Sciences*) 49, no. 4 (Winter 2003), http://www.lituanus.org/2003/03_4_03.htm.

191 Annekathrin Merges-Knoth, "'Ich sehe in allem hier mich selbst': Marianne Werefkin und Litauen," in Weidle, *Marianne Werefkin*, 76–88.

192 *Dreiundzwanzigste Ausstellung*, no. 55: "Winter in Litauen."

193 Letter from Werefkin to Nell Walden, Wilna, February 3, 1914, Sturm-Archiv Herwarth Walden, SBPK, Blatt 5/6.

194 Marianne Werefkin, *Vilenskij vestnik* no. 3234 (1914), trans. Dufour-Kowalska, "Causerie sur le symbole, le signe et sa signification dans l'art mystique," in Dufour-Kowalska, *Marianne Werefkin*, 175–82; English trans. Isabel Boldry.

195 Letter from Werefkin to Herwarth Walden from Saint-Prex, May 28, 1915, Sturm-Archiv Herwarth Walden, SBPK, Blatt 12.

196 Interestingly, Werefkin never received Swiss citizenship, but she obtained a Nansen Passport for Stateless Persons, so-named posthumously after the famous Norwegian polar explorer and philanthropist Fridtjof Nansen, who was appointed High Commissioner for Refugees by the League of Nations in 1922.

Chapter 5. Europeanism and Neutrality as Active Intervention: Gabriele Münter, *Sturmkünstlerin*, and Swedish Expressionism (1915–20)

A portion of this chapter already appeared, in altered form, in Shulamith Behr, "Gabriele Münter and the 1917 Exhibition of the Föreningen Svenska Konstnärinnor and Vereinigung Bildende Künstlerinnen Österreichs," in *Modern Women Artists in the Nordic Countries, 1900–1916*, ed. Kerry Greaves (New York: Routledge, 2021), 66–71.

1 Formerly known as George Lewin, Walden changed his name at the turn of the twentieth century, apparently on the advice of the poet and artist Else Lasker-Schüler, whom he married in 1903. The name was inspired by the New England transcendentalist and naturist Henry David Thoreau (1817–62), whose book *Walden or, Life in the Woods* (1865) was translated into German in 1897. See Sigrid Bauschinger, *Else Lasker-Schüler: Eine Biographie* (Göttingen: Suhrkamp, 2006), 85–86.

2 Between April 1913 and 1916 *Der Sturm* was published twice a month, from 1917 to 1929 monthly, and irregularly between 1930 and 1932.

3 For a sustained and creative examination of Walden's multisensory aesthetic theories in relation to their origins and impact, see Jenny Anger, *Four Metaphors of Modernism: From Der Sturm to the Société Anonyme* (Minneapolis: University of Minnesota Press, 2018).

4 Beatrix Nobis, "'Expressionismus ist ein Kampfwort . . .': Ein Idealistischer Revolutionär; Herwarth Walden und der 'Sturm,'" *Avantgarde und Publikum: Zur Rezeption Avantgardistischer Kunst in Deutschland, 1905–1933*, ed. Heinrike Junge (Cologne: Böhlau, 1992), 321–22.

5 Nobis, "'Expressionismus ist ein Kampfwort,'" in Junge, *Avantgarde und Publikum*, 321.

6 Bengt Lärkner, "'Humbug' or 'Genius'? When Kandinsky Came to Sweden," in *New Perspectives on Kandinsky* (Malmö: Malmö Konsthall, 1990), 28.

7 Vivian Endicott Barnett, *Kandinsky in Sweden* (Malmö: Malmö Konsthall, 1989), 12–14.

8 See Marion C. Siney, "Swedish Neutrality and the Economic Warfare in World War I," *Conspectus of History* 1, no. 2 (1975): 13–28.

9 See Andrea Kollnitz, "Promoting the Young: Interactions between the Avant-Garde and the Swedish Art Market," in Van den Berg, *A Cultural History of the Avant-Garde in the Nordic Countries*, 275–90.

10 Annika Öhrner, "'Ich Lebte im Prophetenland—Jetzt bin ich Weltkind Geworden': Gabriele Münter in Skandinavien, 1915–1920," in Friedel and Hoberg, *Gabriele Münter*, 77.

11 Letter from Herwarth Walden to Münter, Berlin, September 24, 1914, in Bilang, *Kandinsky, Münter, Walden*, 169.

12 Kate Winskell, "The Art of Propaganda: Herwarth Walden and 'Der Sturm,' 1914–1919," *Art History* 18, no. 3 (September 1995): 315–44.

13 The British geographer Halford Mackinder (1861–1947), director of the London School of Economics, developed the notion of geopolitics in the essay "The Geopolitical Pivot of History," *Geographic Journal* 23 (1904): 421–37. The essay argued that the era of sea power was coming to an end and that land-based powers were in the ascendant, and, in particular, that whoever controlled the heartland of "Euro-Asia" would control the world.

14 For a focused study of the Zentralstelle für Auslandsdienst, see Jürgen Wilke, "Deutsche Auslandspropaganda im Ersten Weltkrieg: Die Zentralstelle für Auslandsdienst," in *Der Erste Weltkrieg als Kommunikationsereignis*, ed. Siegfried Quandt (Gießen: Justus-Liebig-Universität, 1993), 95–157.

15 See A. H. Huussen, Jr., ed., *Sophie van Leer, Een Expressionistische Dichteres: Leven en Werk, 1892–1953* (Haren-Gn: Knoop, 1997).

16 Hubert van den Berg, "The Autonomous Arts as Black Propaganda: On a Secretive Chapter of 'German Foreign Relations' in the Netherlands and Other Neighbouring Countries during the First World War," in *The Autonomy of Literature at the Fins de Siècles (1900 and 2000)*, ed. Gilles Dorleijn and Altes Korthals (Leuven: Peeters, 2007), 70–119.

17 Van den Berg, "The Autonomous Arts," in Dorleijn and Korthals, *Autonomy of Literature*, 105–11.

18 Herwarth Walden, "Das Hohelied des Preußentums," *Der Sturm* 6, nos. 19–20 (January 1, 1916): 110–11.

19 Nell Walden, "Aus meinen Erinnerungen an Herwarth Walden und die 'Sturmzeit,'" in *Der Sturm: Ein Erinnerungsbuch an Herwarth Walden und die Künstler aus dem Sturmkreis*, ed. Nell Walden and Lothar Schreyer (Baden-Baden: Woldemar Klein, 1954), 9.

20 Nell Walden, *Herwarth Walden: Ein Lebensbild* (Berlin: Florian, 1963), 21–23. For an account of "Nell Walden als Fixpunkt," see Maaike Moniek van Rijn, *Bildende Künstlerinnen im Berliner "Sturm" der 1910er Jahre* (PhD diss., Eberhard Karls Universität Tübingen, 2013), 103–8; Maaike van Rijn, "Nell Walden i Der Sturm: Berlin 1910-tal," in *Nell Walden & Der Sturm* (Stockholm: Carlsson, 2015), 207–20.

21 Walden, *Herwarth Walden*, 23.

22 Münter to Herwarth Walden, Stockholm, May 15, 1916, in Bilang, *Kandinsky, Münter, Walden*, 169–70. In 1926, out of financial need, Walden presented the greater part of his epistolary estate to the Preußischer Staatsbibliothek, Berlin, now in the Handschriftenabteilung, Staatsbibliothek Preußischer Kulturbesitz Berlin (hereafter SBPK). Known as "The Sturm-Archiv Herwarth Walden," Münter's correspondence can be found therein. The original handwritten and typewritten letters from Herwarth and Nell Walden to Münter from 1912 to 1924 are preserved in the Gabriele Münter- und Johannes Eichner-Stiftung, Städtische Galerie im Lenbachhaus und Kunstbau, Munich (hereafter GMJES). As the volume edited by Karla Bilang is incomplete, it is necessary to consult the secondary literature. See Annegret Hoberg, "Sigrid Hjertén und Gabriele Münter," in *Sigrid Hjertén: Wegbereiterin des Schwedischen Expressionismus / Sigrid Hjertén: Pioneer of Swedish*

Expressionism (Munich: Städtische Galerie im Lenbachhaus, 1999), 43–58; Annegret Hoberg, "Gabriele Münter, STURM-Künstlerin in München, Berlin und Skandinavien," in *STURM-FRAUEN: Künstlerinnen der Avant-Garde in Berlin, 1910–1932*, ed. Ingrid Pfeiffer and Max Hollein (Frankfurt am Main: Schirn Kunsthalle, 2015), 228–33; 376–77.

23 For the "socio-symbolic contract," consult Julia Kristeva, "Women's Time," trans. Alice Jardine and Harry Blake, *Signs: Journal of Women in Culture and Society* 7, no. 11 (1981): 28; originally published as "Le Temps de Femmes," *Cahiers de Recherché de Sciences des Textes et Documents* 34/44, no. 5 (Winter 1979): 5–19.

24 Gabriele Münter, Damenkalender, 1917, GMJES, as cited in Öhrner, "Gabriele Münter in Skandinavien," Friedel and Hoberg, *Gabriele Münter*, 67.

25 Johann Wolfgang von Goethe, *Gedichte* (Munich: Beck, 1981), 90. For the biblical referents (Luke 24:13) of Goethe's poem, which arose out of his travels with Johann Bernhard Basedow and Johann Kasper Lavater, see Gudrun Schury, *Ich Weltkind: Gabriele Münter; Die Biographie* (Berlin: Aufbau, 2012), 16–18.

26 See Poul Bjerre, *Krigs Betraktelser: Varför Tyskland Måste Segra och Varför Tyskland Icke Får Segra; Neutraliteten som Aktiv Insats: Det Stora Offret* (1916a) (War Reflections: Why Germany Will Win and Why Germany Cannot Win; Neutrality as Active Intervention: The Great Sacrifice), Literaturbestand aus dem Nachlaß von Gabriele Münter, GMJES, 1.

27 Charlotte Christensen, "Training and Professionalism: Nordic Countries," in Gaze, *Dictionary of Women Artists*, 112. As early as 1864 a section for women was established at the Royal Academy of Fine Arts in Stockholm, with eighteen students in attendance in its first year.

28 See Michelle Facos, *Nationalism and the Nordic Imagination: Swedish Art of the 1890s* (Berkeley: University of California Press, 1998), 13.

29 For a comprehensive account of these debates, consult Hjördis Levin, *Masken Uti i Rosen: Nymalthusianism och Födelsekontroll i Sverige, 1880–1910* (Stockholm: Stehag, 1994), 475.

30 Shulamith Behr, "Differencing Modernism: Swedish Women Artists in Early Twentieth-Century Avant-Garde Culture," in *Utopia and Reality: Modernity in Sweden, 1900–1960*, ed. Cecilia Widenheim and Eva Rudberg (New Haven, CT: Yale University Press, 2002), 108–21.

31 See Bonnie S. Anderson and Judith P. Zinsser, *A History of Their Own: Women in Europe from Prehistory to the Present* (New York: Harper & Row, 1989), 2:200.

32 Christensen, "Training and Professionalism," in Gaze, *Dictionary of Women Artists*, 114.

33 Katarina Borgh Bertorp, "Sigrid Hjertén: Erbin Matisses aus dem Hohen Norden / Sigrid Hjertén: Heir of Matisse from the Far North," in *Sigrid Hjertén: Wegbereiterin*, 17–18.

34 See Anders Wahlgren, "Konstnärsliv i Paris," in *Paris Tur och Retur: Svenska och Norska Matisseelever* (Kristinehamn: Kristinehamns Konstmuseum, 2007), 38; Shulamith Behr, "Académie Matisse and Its Relevance in the Life and Work of Sigrid Hjertén," in Van den Berg, *A Cultural History of the Nordic Avant-Garde*, 149–64.

35 Carl Palme, *Sigrid Hjertén* (Stockholm: Bonniers, 1936), 8.

36 Sigrid Hjertén, "Modern och Österländsk Konst," *Svenska Dagbladet* (February 24, 1911).

37 Matisse came from a family with a weaving background in Bohain, in northeastern France. For the impact of this on his works, see Ann Dumas, "Beginnings in Bohain," in *Matisse, His Art and His Textiles:*

The Fabric of Dreams (London: Royal Academy of Arts, 2007), 75.

38 Apparently, this was as high as one-third of Swedish women. See Neil Kent, *The Soul of the North: A Social, Architectural and Cultural History of the Nordic Countries* (London: Reaktion, 2000), 112.

39 Sigrid Hjertén, "Paul Cézanne: Något om hans Lif och Verk," *Svenska Dagbladet* (November 24, 1911).

40 Apart from Hjertén and Grünewald, the group De åtta included former Matisse students Leander Engström, Einar Jolin, and Nils von Dardel. Other members of the group were Tor Bjurström and Gösta Sandels. Albert Hoffsten left the group and was replaced by August Lundberg, whose work was not included in the first exhibition.

41 As in R. Sz., "Svenska Expressionister," *Aftonbladet* (May 17, 1912).

42 Henri Matisse, "Notes of a Painter" (1908), in Flam, *Matisse on Art*, 37. On the adaptation of Matisse's term, see Werenskiold, *The Concept of Expressionism*, 101.

43 For a consideration of their artistic partnership, see Shulamith Behr, "Modernity, Family and Fashion: Performative Strategies and the Artist Couple Sigrid Hjertén and Isaac Grünewald," in *Sigrid Hjertén och Isaac Grünewald: Modernismens Pionjärer* (Norrköping: Norrköpings Konstmuseum, 2002), 13–26.

44 Ossian Elgström, *Sondags-Nisse* (1912): 21, as cited in Lars M. Andersson, *En Jude är En Jude är En Jude: Representationer av "Jude" i Svensk Skämpress Omkring, 1900–1930* (Lund: Nordic Academic Press, 2000), 377.

45 For full coverage of this exhibition, see the dual-language catalog *Schwedische Avantgarde und der Sturm in Berlin/Svenskt Avantgarde och der Sturm I Berlin* (Osnabrück: Museums- und Kunstverein Osnabrück, 2000).

46 Ellen Key, *Barnets århundrade* (Stockholm: Albert Bonniers, 1900).

47 *Schwedische Expressionisten: Katalog der 32. Sturm Ausstellung* (Berlin: Der Sturm, April/May 1915), no. 25: "Der Knabe am Fenster."

48 *Schwedische Expressionisten*, no. 12: "Die Rote Gardine."

49 Gabriele Münter, Manuscript, October 29, 1915, GMJES, as cited in Hoberg, "Sigrid Hjertén und Gabriele Münter," in *Sigrid Hjertén: Wegbereiterin*, 51.

50 Lilly Rydström-Wickelberg, "Gabriele Münter," *Konstrevy* 28, nos. 4–5 (1952): 216, as cited in Kleine, *Gabriele Münter und Wassily Kandinsky*, 466.

51 For the circle of artists, consult Folke Lalander, *Gabriele Münters Svenska Vänner: Agnes Cleve, Isaac Grünewald, Malin Gyllenstierna, Sigrid Hjertén, John Jon-And, Tyra Kleen, Hilding Linnqvist, Carl Palme, Lilly Rydström, Nell Walden* (Stockholm: Liljevalchs Konsthall, 1993).

52 Öhrner, "Gabriele Münter in Skandinavien," in Friedel and Hoberg, *Gabriele Münter*, 83n16.

53 Letter from Herwarth Walden to Münter, November 11, 1915, GMJES, as cited in Barnett, *Kandinsky in Sweden*, 23.

54 August Brunius, "Från Nya Konstutställningar: Svensk, Fransk och Tysk Konst," *Svenska Dagbladet* (October 19, 1915), as cited in Öhrner, "Gabriele Münter in Skandinavien," in Friedel and Hoberg, *Gabriele Münter*, 70.

55 On Le Fauconnier, see David Cottington, "'Ce beau pays l'avenir': Cubism, Nationalism and the Landscape of Modernity in France," in *Framing France: The Representation of Landscape in France, 1870–1914*, ed. Richard Thompson (Manchester: Manchester University Press, 1998), 208–10.

56 Barnett, *Kandinsky in Sweden*, 29–66.

57 Barnett, *Kandinsky in Sweden*, 46n37, 49. Gutkind was in touch with Bjerre and would have given Münter a letter of introduction, although Barnett confirms that there is no documentary evidence to suggest that Münter was a patient of Bjerre.

58 See Shulamith Behr, "Wassily Kandinsky and Dmitrije Mitrinovic: Pan-Christian Universalism and the Yearbook 'Toward the Mankind of the Future through Aryan Europe,'" *Oxford Art Journal* 15, no. 1 (1992): 81–88.

59 Postcard, Maria Marc to Münter, June 18, 1915, in *Wassily Kandinsky, Franz Marc: Briefwechsel*, 276.

60 Letter from Münter to Maria Marc, June 30, 1915, in *Wassily Kandinsky, Franz Marc: Briefwechsel*, 277.

61 Poul Bjerre, Notebook, Handskriftssektionen, Kungliga Biblioteket, Stockholm, 126–28, as cited in Barnett, *Kandinsky and Sweden*, 41.

62 Kleine, *Münter und Kandinsky*, 475.

63 Poul Bjerre, *Död och Förnyelse* (Stockholm: Segerbrandska, 1919). See Petteri Pietikäinen, *Neurosis and Modernity: The Age of Nervousness in Sweden* (Leiden: Brill, 2007), 199.

64 Poul Bjerre, *Drömmarnas Helande Kraft: Språkligt Bearbetad Utgåva av Drömmarnas Naturliga System* (Stockholm: Bonniers, 1933). See Erik Berggren, *The Psychology of Confession* (Leiden: Brill, 1975), 199–200.

65 Barnett, *Kandinsky in Sweden*, 41–42. Kandinsky, *Watercolor for Poul Bjerre*, March 1916, watercolor and India ink on paper, 22.3 × 33.4 cm, private collection.

66 Karl Asplund, *Dagens Nyheter* (March 8, 1916), as cited in Öhrner, "Gabriele Münter in Skandinavien," in Friedel and Hoberg, *Gabriele Münter*, 71.

67 Gregor Paulsson, *Stockholm Dagblad* (March 13, 1916), as cited in Öhrner, "Gabriele Münter in Skandinavien," in Friedel and Hoberg, *Gabriele Münter*, 71.

68 As imparted in chapter 4, Kandinsky had initially written the text in honor of Münter's solo exhibition of eighty-four paintings, which was organized by Walden in Berlin in January 1913.

69 Wassily Kandinsky, *Om Konstnären* (Stockholm: Gummesons Konsthandel, 1916). For an English translation and discussion of its relationship to the manuscript in German, *Über den Künstler* (1916, GMJES), consult Barnett, *Kandinsky and Sweden*, 58–64.

70 Johannes Eichner, *Kandinsky und Münter*, 174–75.

71 Listed in the exhibition catalog *Föreningen Svenska Konstnärinnor och Vereinigung Bildende Künstlerinnen Österreichs: Januari-Februari 1917* (Stockholm: Liljevalchs Konsthall), 50, no. 352: "Barn."

72 Indeed, the painting was originally listed in the catalog as no. 323: "Syskonen W." (Siblings W[allin]), *Föreningen Svenska Konstnärinnor och Vereinigung Bildende Künstlerinnen Österreichs*, 49.

73 Kent, *Soul of the North*, 90, citing Eric Johanneson, "Den Helige Familjen: Om Borgerlig Familjekult under 1800-talet," in *Den Utsatta Familjen*, ed. Hans Norman (Stockholm: L. T., 1983), 31–32.

74 See Sarah H. Gregg, "Gabriele Münter and Sweden: Interlude and Separation," *Arts Magazine* 55 (May 1981): 116–19.

75 Gabriele Münter, *Skizzenbuch Kon 46/46*, July 1, 1916, 41–45, GMJES, Hoberg and Öhrner, "Katalog," in *Gabriele Münter*, 279, no. 150.

76 Listed in the catalog as no. 211, "Ateljéinterior," *Föreningen Svenska Konstnärinnor och Vereinigung Bildende Künstlerinnen Österreichs*, 33.

77 Listed in the catalog as no. 206, "Zigernerska," *Föreningen Svenska Konstnärinnor och Vereinigung Bildende Künstlerinnen Österreichs*, 33.

78 Hans Sax, "Svenska och Österrikiska Konstnärinnorna," *Stockholms Dagblad* (February 20, 1917).

79 Listed in the catalog as no. 220, "Akkord," *Föreningen Svenska Konstnärinnor och Vereinigung Bildende Künstlerinnen Österreichs*, 34.

80 For a positive critical review of the women modernists, see August Brunius, "De kvinnlige konstnaren," *Svenska Dagbladet* (January 27, 1917), as cited in Shulamith Behr, "Gabriele Münter and the 1917 Exhibition of the Föreningen Svenska Konstnärinnor and Vereinigung Bildende Künstlerinnen Österreichs," in Greaves, *Modern Women Artists in the Nordic Countries, 1900–1916*, 72.

81 See Kleine, *Münter und Kandinsky*, 755n75.

82 Gabriele Münter, *Beichte und Anklage*, 1925 (GMJES), as cited in Kleine, *Münter und Kandinsky*, 495–96.

83 Mats Jannson, "Crossing Borders: Modernism in Sweden and the Swedish-Speaking Part of Finland," in *The Oxford Critical and Cultural History of Modernist Magazines: Europe, 1880–1940*, vol. 3, ed. Peter Brooker, Sascha Bru, Andrew Thacker, and Christian Weikop (Oxford: Oxford University Press, 2013), 668.

84 Letter from Herwarth Walden to Münter, May 13, 1916, GMJES, as cited in Annika Öhrner, "Delaunay and Stockholm," in *O Circulo Delaunay / The Delaunay Circle*, ed. Ana Vasconcelos e Melo (Lisbon: Fundação Calouste Gulbenkian, 2015), 237.

85 By 1910, Hirsch's works were collected by the Nationalmuseum in Stockholm. See Margareta Gynning, "Hanna Pauli," in *Svenskt Biografiskt Lexicon* (Stockholm, 1994), 28:746–49.

86 Georg Pauli, *flamman* 1, no. 1 (January 1917), as cited in Claes-Göran Holmberg, *flamman*, in Van den Berg, *A Cultural History of the Avant-Garde*, 382–83.

87 Gabriele Münter, *Bildnis Frl. Gertrude Holz* (Portrait of Miss Gertude Holz), 1917, oil on canvas, 75 × 58.3 cm, GMJES, was signed and dated "Münter 14.III.17"; *Sinnende* (Reflection): "Münter 31.III.1917"; *Zukunft* (Future): "Münter 8.IV.17"; *Krank* (Sick): "Münter 19.IV.17."

88 Gabriele Münter, *Krank* (Sick), 1917, oil on canvas, 78 × 84 cm, private collection.

89 Eichner, *Kandinsky und Gabriele Münter*, 177.

90 Gabriele Münter, *Skizzenbuch*, Kon 46/48, 24–25, 1917, GMJES.

91 Kristie Jayne, "The Cultural Roots of Edvard Munch's Images of Women," *Woman's Art Journal* 10, no. 1 (1989), 28–34.

92 Eichner, *Kandinsky und Gabriele Münter*, 177.

93 Henri Bergson, *Einführung in die Metaphysik* (Jena: Diederichs, 1912). Literaturbestand aus dem Nachlaß von Gabriele Münter, GMJES, 1.

94 Henri Matisse, "Notes of a Painter," in Flam, *Matisse on Art*, 38. See Martina Padberg, "Matisse als Lehrer: Originalität und Intuition in der Künstlerausbildung," in *Die Große Inspiration: Deutsche Künstler in der Académie Matisse*, 41–42.

95 Gabriele Münter, *Skizzenbuch*, Kon 46/48, 108, 1917, GMJES. In the notes below and on the left, Münter summarized the course of Steiner's lecture, which focused on the seven overarching *Stimmungen* (moods) of the soul—gnosis, logicism, voluntarism, empiricism, mysticism, transcendentalism, and occultism. On the right-hand side, she connected a couple of these to Steiner's characterization of well-known philosophers, logicism to Hegel and Fichte, voluntarism to Schopenhauer.

96 Rudolf Steiner, "Der Menschliche und der Kosmische Gedanke: Vier Vorträge Gehalten in Berlin vom 20. bis 23. Januar 1914," Rudolf Steiner Online Archive, 4th ed., 2010, 53, http://anthroposophie.byu.edu/vortraege/151.pdf.

97 "Steiner 4 Vortr. S. 15. Die schlimmsten Feinde der Wahrheit sind die abgeschlossenen oder nach Abschluss trachtenden Weltanschauungen, die ein paar Gedanken hinzimmern wollen und glauben, ein Weltgebäude mit ein paar Gedanken aufbauen zu dürfen. Die

Welt ist ein Unendliches, qualitativ und quantitativ!" Gabriele Münter, *Skizzenbuch*, Kon 46/48, 56, 1917, GMJES.

98 Rudolf Steiner, "Der Menschliche und der Kosmische Gedanke," 73, http://anthroposophie.byu.edu/vortraege/151.pdf.

99 Hoberg, "Gabriele Münter, STURM-Künstlerin in München, Berlin und Skandinavien," in Pfeiffer and Hollein, *STURM-FRAUEN*, 231, 377.

100 This was the fifty-eighth exhibition. For a chronological list of exhibitions, see Volker Pirsich, "Ausstellungen der Galerie DER STURM 1912–1919," in *DER STURM im Berlin der Zehner Jahre*, ed. Barbara Alms and Wiebke Steinmetz (Bremen: Städtische Galerie Dehmenhorst, 2000), 257–70.

101 Letter from Münter to Herwarth Walden, January 2, 1918 (GMJES), as cited in Kleine, *Münter und Kandinsky*, 480.

102 Poul Bjerre, *Fredenskongressen: Läsdrama i Tre Akter* (1916) (Peace Congress: Read Drama in Three Acts), 81. Literaturbestand aus dem Nachlaß von Gabriele Münter, GMJES, 1.

103 Bjerre, *Fredenskongressen*, 81.

104 Letter from Maria Marc to Münter, July 15, 1916, in *Wassily Kandinsky, Franz Marc: Briefwechsel*, 281.

105 Gabriele Münter, *Ich bin Deutsch*, 1917, pen and ink, sketchbook, Gabriele Münter- und Johannes Eichner-Stiftung, Munich. For an illustration, see Behr, "Die Arbeit am Eigenen Bild," in Friedel and Hoberg, *Gabriele Münter*, fig. 6, 88.

106 See Steven Koblik, "Wartime Diplomacy and the Democratization of Sweden in September–October 1917," *Journal of Modern History* 41, no. 1 (March 1969): 29–45.

107 Letter from Herwarth Walden to Münter, August 3, 1916, GMJES, as cited in Öhrner, "Gabriele Münter in Skandinavien," in Friedel and Hoberg, *Gabriele Münter*, 78.

108 Letter from Nell Walden to Münter, November 14, 1917, GMJES, as cited in Kleine, *Münter und Kandinsky*, 497.

109 See Claus Bundgård Christensen, "Fighting for the Kaiser: The Danish Minority in the German Army, 1914–1918," in *Scandinavia in the First World War: Studies in the War Experience of the Northern Neutrals*, ed. Claes Ahlund (Lund: Nordic Academic Press, 2012), 277–78.

110 See Dorthe Aagesen, "Art Metropolis for a Day: Copenhagen during World War 1," in Van den Berg, *A Cultural History of the Avant-Garde*, 299–322. For an account of the delicate balancing act that Denmark pursued—allowing trade through to Germany and exporting foodstuffs to Britain—consult Bo Lidegaard, "Walking the Line, 1914–1918," in *A Short History of Denmark in the 20th Century* (Copenhagen: Nordisk, 2009), 64–73.

111 Aagesen, "Art Metropolis for a Day," in Van den Berg, *A Cultural History of the Avant-Garde*, 307.

112 Winskell, "The Art of Propaganda," 342. The exhibition started in Düsseldorf, traveled to Hamburg, Jena, Stettin, Breslau, and went to Copenhagen in December 1918. See Barbara Alms, "DER STURM: Corporate Identity für die Internationale Avantgarde," in Alms and Steinmetz, *Der Sturm in Berlin der Zehner Jahre*, 32.

113 Aagesen, "Art Metropolis for a Day," in Van den Berg, *A Cultural History of the Avant-Garde*, 317–20.

114 On this polemic and the purchase of Grünewald's painting *Portrait of the Poetess Ulla Bjerne* (1916, oil on canvas, 211 × 421 cm, Moderna Museet, Stockholm) by the Nationalmuseum, see Wahlgren, *Sigrid und Isaac*, 105–20.

115 Gabriele Münter, Manuscript, 1917 (GMJES), as quoted in Wahlgren, *Sigrid & Isaac*, 119.

116 Aagesen, "Art Metropolis for a Day," in Van den Berg, *A Cultural History of the Avant-Garde*, 312–16.

117 Kleine, *Münter und Kandinsky*, 500.

118 *Den Frie Udstilling* (Copenhagen, 1918), no. 100, *Froken A. R. (Miss A[nna] R[oslund])*.

119 For discussion of the related preparatory sketches in Münter's sketchbook, 1917–18 (GMS 1134), consult Shulamith Behr, "Gabriele Münter, Portrait of Anna Aagaard," *National Arts Collection Fund Review* (London, 1992), 56–59.

120 See Dolores Mitchell, "The 'New Woman' as Prometheus," *Woman's Art Journal* 12, no. 1 (Spring/Summer 1991): 3–9.

121 Grünewald had at least seven drawings and one watercolor by Josephson in his collection. For further discussion of this painting, consult Behr, "Académie Matisse and Its Relevance in the Life and Work of Sigrid Hjertén," in Van den Berg, *A Cultural History of the Avant-Garde*, 158–59.

122 Aagesen, "Art Metropolis for a Day," in Van den Berg, *A Cultural History of the Avant-Garde*, 320–21.

123 Eric W. Osborne, *Britain's Economic Blockade of Germany, 1914–1919* (London: Frank Cass, 2004), 179.

124 Öhrner, "Gabriele Münter in Skandinavien," in Friedel and Hoberg, *Gabriele Münter*, 78.

125 See Kleine, *Münter und Kandinsky*, 504–16.

126 Helmut Friedel and Marion Ackermann, "A Colorful Life: The History of the Collection of Vasily Kandinsky's Work in the Lenbachhaus," in *Vasily Kandinsky: A Colorful Life*, ed. Helmut Friedel (Munich: Städtische Galerie im Lenbachhaus; Cologne: Du Mont, 1995), 15–31.

127 Gabriele Münter, "Tagebucheintragung," August 20, 1926 (GMJES), as quoted in Kleine, *Münter und Kandinsky*, 531.

Chapter 6. The Gender and Geopolitics of Neutrality: Jacoba van Heemskerck, the *Sturm* Circle, and Spiritual Abstraction (1913–23)

1 Van Heemskerck was not included in the much-feted exhibition and catalog *Inventing Abstraction, 1910–1925: How a Radical Idea Changed Modern Art*, ed. Leah Dickerman (New York: Museum of Modern Art, 2012).

2 For an account of interwar considerations, see Ute Schürings, "Provincie zoekt metropol: Die reputatie van Berlijn in de Nederlandse literatuur van het interbellum," in Frits Boterman, ed., *Nederland en Duitsland in het interbellum i wisselwerking en contacten* (Hilversum: Uitgeverij Verloren, 2003), 69–86.

3 Winskell, "The Art of Propaganda," 328–30. For more recent scholarship on the Waldens' official activities during the First World War in relation to Van Heemsckerck, see Hubert van den Berg, "'. . . Wir Müssen mit und durch Deutschland in unserer Kunst Weiterkommen': Jacoba van Heemskerck und das Geheimdienstliche 'Nachrichtenbüro Der Sturm,'" in *Laboratorium Vielseitigkeit: Zur Literatur der Weimarer Republik*, ed. Petra Josting and Walter Fähnders (Bieleveld: Aisthesis, 2005), 67–87.

4 Blanca Rodriguez Ruiz and Ruth Rubio-Marín, eds., *The Struggle for Female Suffrage in Europe: Voting to Become Citizens* (Leiden: Brill, 2012), 176.

5 Maartje M. Abbenhuis, *The Art of Staying Neutral: The Netherlands in the First World War, 1914–1918* (Amsterdam: Amsterdam University Press, 2006), 18–19.

6 Abbenhuis, *The Art of Staying Neutral*, 28.

7 Signatur: Sturm-Archiv I, Heemskerck, Jacoba van, Handschriftenabteilung, SBPK, Berlin. Whereas Jacoba van Heemskerck's correspondence amounts to 257 items (inclusive of post-cards) to Herwarth Walden, his portion of the correspondence is lost. There is only one letter from Nell Walden to Van Heemskerck, but their correspondence must have been quite comprehensive as there are eleven letters written to Nell. There are nineteen letters and two postcards from Marie Tak van Poortvliet to Herwarth. Translations are from the original German in the Sturm-Archiv in consultation with the publication A. H. Huussen Jr., ed., *Brieven van Jacoba van Heemskerck en Marie Tak van Poortvliet aan Herwarth en Nell Walden en anderen, 1911–1923* (Haren: Cahiers uit het Noorden X, 2006). Since 2020, the correspondence has been placed online: Kalliope | Verbundkatalog für Archiv- und archivähnliche Bestände und nationales Nachweisinstrument für Nachlässe und Autographen (kalliope-verbund.info).

8 Friedrich M. Huebner, *Moderne Kunst in den Privatsammlungen Europas, Vol.1: Holland* (Leipzig: Klinkhardt and Biermann, 1922), 9–16.

9 Huebner, *Moderne Kunst*, 79–83; Wassily Kandinsky, *Lyrical*, 1911, oil on canvas, 94 × 130 cm; Franz Marc, *The Sheep*, 1913–14, oil on canvas, 54.5 × 77 cm. Both paintings were acquired at the Sturm exhibition held at the gallery d'Audretsch in The Hague March 17–April 16, 1916. These are held in the Museum Boijmans van Beuningen, Rotterdam, and were part of the Marie Tak van Poortvliet Bequest in 1936.

10 Huebner, *Moderne Kunst*, 62–66. For updated research on Beffie, consult Huibert Schijf and Edward van Voolen, eds., *Gedurfd Versamelen van Chagall tot Mondriaan* (Amsterdam: Joodshistorisch Museum, 2010).

11 Bruno Taut, "Eine Notwendigkeit," *Der Sturm* 4, no. 196–97 (February 1914): 174–75.

12 Keetie E. Sluyterman, *Dutch Enterprise in the 20th Century: Business Strategies in Small Open Country* (Abingdon: Routledge, 2013), 248–49.

13 Beckett, "In the Bleaching Fields: Gender, Landscape and Modernity in the Netherlands, 1880–1920," in Adams and Gruetzner, *Gendering Landscape Art*, 61–75.

14 Marie Tak van Poortvliet, *Jacoba van Heemskerck*, Sturm-Bilderbuch VII (Berlin: Der Sturm, 1924), 6–17.

15 Rosella M. Huber-Spanier, "Training and Professionalism: The Netherlands," in Gaze, *Dictionary of Women Artists*, 1:108–11.

16 See A. H. Huussen, Jr., and J.F.A. van Paaschen-Louwerse, *Jacoba van Heemskerck van Beest, 1876–1923: Schilderes uit roeping* (Zwolle: Waanders Uitgevers, 2005), 13, quoting Robert Bantens, *Eugène Carrière: The Symbol of Creation* (New York: Kent Fine Art, 1990), 44.

17 Tamar Garb, "Revising the Revisionists: The Formation of the *Union des Femmes Peintres et Sculpteurs*," *Art Journal* 48, no. 1 (Spring 1989): 63–70.

18 In 1905, Tak van Poortvliet purchased property adjacent to the Badhotel and commissioned the villa from the Hague-born architect J. J. van Nieukerken, who was responsible for both the local Badhotel and Badpaviljoen (bathing pavilion). Villa Loverendale was completed in 1908 and the studio, designed by Pieter Janse, was in use by 1912.

19 Huussen and Van Paaschen-Louwerse, *Jacoba van Heemskerck*, 35.

20 Robin Lenman, "The Internationalisation of the Berlin Art Market 1910–1920 and the Role of Herwarth Walden," in Gaehtgen's, *Künstlerischer Austausch*, 535–42.

21 Wassily Kandinsky, *Composition 6 (Deluge)*, 1913, oil on canvas, 195 × 300 cm, Hermitage Museum, St. Petersburg.

22 Letter from Van Heemskerck to Herwarth Walden, June 1, 1914, Sheets 5/6, SBPK; Huussen, *Brieven*, 13–14.

23 Letter from Van Heemskerck to Herwarth Walden, June 12, 1914, Sheets 7/8, SBPK; Huussen, *Brieven*, 14–15.

24 Letter from Van Heemskerck to Herwarth Walden, July 21, 1914, Sheets 13/14, SBPK; Huussen, *Brieven*, 16–17.

25 Letter from Jan Sluijters to Kees Spoor, 1910, in Lily van Ginneken, "Amice addio: Kunstenaars-brieven aan Cornelis Spoor," *Algemeen Handelsblad* Supplement (December 27, 1969): 13, quoted in Huussen and Van Paaschen-Louwerse, *Jacoba van Heemskerck*, 33.

26 Huussen and Van Paaschen-Louwerse, *Jacoba van Heemskerck*, 206n245.

27 See Jane Beckett, "Engendering the Spaces of Modernity: The Women's Exhibition, Amsterdam 1913," in *Women Artists and Decorative Arts, 1880–1935: The Gender of Ornament*, ed. Bridget Elliott and Janice Helland (Aldershot: Palgrave, 2003), 155–75.

28 Elizabeth Crawford, *The Women's Suffrage Movement: A Reference Guide, 1886–1928* (Abingdon: Routledge, 2001), 136–37.

29 Between 1900 and 1902, Wilhelmina Cornelia Drupsteen trained at the National School of Applied Arts in Amsterdam and, between 1902 and 1906, at the State Academy of Art.

30 Letter from Van Heemskerck to Herwarth Walden, July 30, 1914, Sheets 16/17, SBPK; Huussen, *Brieven*, 18.

31 Abbenhuis, *The Art of Staying Neutral*, 225.

32 Letter from Van Heemskerck to Herwarth Walden, September 25, 1914, Sheets 23/24, SBPK; Huussen, *Brieven*, 21.

33 Letter from Van Heemskerck to Herwarth Walden, April 13, 1916, Sheet 201, SBPK; Huussen, *Brieven*, 94.

34 Letter from Van Heemskerck to Herwarth Walden, October 23, 1914, Sheets 31/32, SBPK; Huussen, *Brieven*, 24.

35 As listed therein, the supplier was Leopold Hess, Genthiner Straße 29, Berlin W/35. Letter, Van Heemskerck to Herwarth Walden, November 5, 1914, Sheets 35/36, SBPK; Huussen, *Brieven*, 26.

36 For illustrations of the woodblocks, see Herbert Henkels, *Jacoba van Heemskerck, 1876–1923: Kunstenares van het expressionisme* (The Hague: Haags Gemeentemuseum, 1982), 87.

37 Letter from Van Heemskerck to Herwarth Walden, April 9, 1915, Sheets 88/89, SBPK; Huussen, *Brieven*, 247–48.

38 Adolf Behne, "Deutsche Expressionisten," *Der Sturm* 5, nos. 17–18 (December 1, 1914): 114–15. For Behne's formation as a cultural critic, see Kai Konstanz Gutschow, *The Culture of Criticism: Adolf Behne and the Development of Modern Architecture in Germany, 1910–1914* (PhD diss., Columbia University, 2005).

39 Behne, "Deutsche Expressionisten," 114.

40 Huussen and Van Paaschen-Louwerse, *Jacoba van Heemskerck*, 111.

41 Letter from Van Heemskerck to Herwarth Walden, December 19, 1914, Sheets 47/48, SBPK; Huussen, *Brieven*, 30.

42 Adolf Behne, *Zur Neuen Kunst*, Sturm-Bücher VII, 2nd ed. (Berlin: Der Sturm, 1917), 9.

43 Behne, *Zur Neuen Kunst*, 14.

44 Behne, *Zur Neuen Kunst*, 22, 27–28.

45 Behne, *Zur Neuen Kunst*, 27, 32.

46 Tak van Poortvliet, *Jacoba van Heemskerck*, 1924, 10.

47 Jacoba van Heemskerck, *Bild 21*, 1915, oil on canvas, 54.5 × 63 cm, Kunstmuseum Bern, formerly in the collection of Nell Walden.

48 Further implications of the term "imperious brush" in relation to Kandinsky's oeuvre are discussed in Shulamith Behr, "Veiling Venus: Gender and Painterly Abstraction in Early German Modernism," in *Manifestations of Venus: Art and Sexuality*, ed. Caroline Arscott and Katie Scott (Manchester: Manchester University Press, 2000), 132–35.

49 Wassily Kandinsky, "Rückblicke" (1913), in Vergo and Lindsay, *Complete Writings*, 373.

50 See Victor Burgin, "Fantasy," in *Feminism and Psychoanalysis: A Critical Dictionary*, ed. Elizabeth Wright (Oxford: Blackwell, 1992), 85.

51 Letter from Van Heemskerck to Herwarth Walden, February 28, 1916, Sheets 174/175, SBPK; Huussen, *Brieven*, 82.

52 Her views are more consistent with the then popular philosophical ideals of Bergson, with their basis in the role of intuition and the élan vital. Henri Bergson, *L'Évolution créatrice* (Paris: Alcan, 1907); *Creative Evolution*, trans. Arthur Mitchell (New York: Henry Holt, 1911).

53 Letter from Van Heemskerck to Herwarth Walden, April 1915, Sheets 86/87, SBPK; Huussen, *Brieven*, 45.

54 Jacqueline van Paaschen, "A Litany for the Dead: Sailing Boats," in *Jacoba van Heemskerck: Truly Modern*, ed. Luisa Pauline Fink, Sebastian Möllers, et al. (Munich: Hirmer, 2021), 50.

55 For this context, see Michael White, *De Stijl and Dutch Modernism* (Manchester: Manchester University Press, 2003), 22; Jacqueline van Paaschen, *Mondriaan en Steiner: Wegen Naar Nieuwe Beelding* (Uitgeverij: Komma, 2017).

56 See Van Paaschen, "A Litany for the Dead: Sailing Boats," in Fink and Möllers, *Jacoba van Heemskerck*, 49.

57 On July 9, 1892, De Nederlandsche Theosophische Vereeniging (The Netherlands Theosophical Society, NTV) was founded in Amsterdam. De Theosophische Vereeniging, Nederlandsche Afdeling (Theosophical Society, Netherlands Section, TVNA) was founded in The Hague on February 17, 1897, and on March 30, 1897, was granted a lodge charter.

58 Letter from Van Heemskerck to Marie Steiner-von Sivers, April 21, 1915, Rudolf Steiner Archiv, Dornach, as quoted in Huussen, *Brieven*, 214.

59 Founded on January 1, 1916, it was entitled the Anthroposophische Gesellschaft, Afdeeling Den Haag der Anthroposophische Vereeniging te Berlijn and received royal confirmation on February 14, 1916. See Huussen and Van Paaschen-Louwerse, *Jacoba van Heemskerck*, 106.

60 Marie Tak van Poortvliet, "Het begrijpen van nieuwe schilderkunst" [1–4], *Het nieuwe Leven* 5 (1919–20): 118–23, 143–48, 186–92, 237–42, quoted in Henkels, *Jacoba van Heemskerck*, 38.

61 Walden's journal *Nutiden* was launched in June 1915. See Winskell, "The Art of Propaganda," 323.

62 Adolf Behne, *Nutiden* (November 16, 1915), quoted in Huussen and Van Paaschen-Louwerse, *Jacoba van Heemskerck*, 109.

63 See Volker Pirsich, "Adolf Knoblauch zum 100. Geburtstag am 25. Mai 1982: Adolf Knoblauch und sein Verhältnis zum 'Sturm' Herwarth Waldens," *Auskunft Mitteilungsblatt Hamburger Bibliotheken* 1/82, no. 2 (1982): 83–103.

64 Adolf Knoblauch, "Frühe Gedichte," *Der Sturm* 6, no. 15–16 (November 1, 1915): 89–95. The dedication of Knoblauch's poem "Deutsche Hafenstadt" to Van Heemskerck can be found in his correspondence with Walden (February 16, 1916), as quoted in Huussen and Van Paaschen-Louwerse, *Jacoba van Heemskerck*, 112.

65 "Dampfer nach den atlantischen Freistaaten / mit goldglänzenden Namen auf den Stirnen / sie bewegen sich leise in der wundersamen Unrast. / Die von See herandrängt / Die Stahlschrauben am Rücken / spannen die riesigen Flügel hoch / . . . Die müden Werker gehen schwer in den alten krummen Gassen, / zu den hochgieblich schmalen Häusern, / zu den seltsamen Türen. / In der schweigenden Hafenöde / brennen an

den Schiffsmasten tote spärliche Laternen." Knoblauch, "Frühe Gedichte," 92–93.

66 For an account of Zeylmans's interaction with Tak van Poortvliet and Van Heemskerck, see Emanuel Zeylmans, *Willem Zeylmans van Emmichoven, an Inspiration for Anthroposophy: A Biography* (Forest Row: Temple Lodge, 2002), 42–57.

67 Henkels, *Jacoba van Heemskerck*, 32.

68 Willem Zeylmans van Emmichoven, *De werking de kleuren op het gevoel* (MA diss., University of Amsterdam, 1923).

69 Letter from Van Heemskerck to Herwarth Walden, February 7, 1916, Sheets 160/61, SBPK; Huussen, *Brieven*, 75.

70 Herwarth Walden, "Vortrag zur Eröffnung der Sturm-Ausstellung," *Der Sturm* 7, no. 1 (April 15, 1916): 5.

71 Walden, "Vortrag zur Eröffnung der Sturm-Ausstellung," 4.

72 *Expressionisten Kubisten: Der Sturm Ständige Kunstausstellung* (Den Haag: Kunstzalen d'Audretsch, March 17–April 16, 1916), nos. 12–22:6–7.

73 *Expressionisten Kubisten*, nos. 45–55:8.

74 *Expressionisten Kubisten*, nos. 64–66:9, Gabriele Münter, "Lampe mit Kerze gelb," "Schwarze Maske mit rosa," "Blaue Blume"; no. 23:7, Sigrid Hjertén-Grünewald, "Mädchen im Schatten" (exhibited as "Im Schatten," *Schwedische Expressionisten, Katalog der 32. Sturm Ausstellung*, no. 24:3).

75 Letter from Nell Walden to Münter and Kandinsky, October 30, 1913, in Bilang, *Kandinsky, Münter, Walden*, 122.

76 Nell Walden, "Aus meinen Erinnerungen an Herwarth Walden und die 'Sturmzeit,'" 34–35.

77 *Expressionisten Kubisten*, nos. 67–68:9: "Bild 1," "Bild 2."

78 Jessica Sjöholm Skrubbe, "The Most Effective Propaganda Stunt?," in *Nell Walden & Der Sturm* (Halmstad: Mjellby Konstmuseum and Carlsson, 2015), 41–68.

79 In January 1914 the Waldens relocated their private residence to Potsdamer Straße 134A. At the end of May 1914, the Sturm Gallery moved from Königin Augusta Straße to the same address in Potsdamer Straße.

80 Jessica Sjöholm Skrubbe, "Modernism Diffracted: Picture Postcards from the Sturm Gallery and the Walden Collection in Berlin," in *The Aesthetics of Matter: Modernism, the Avant-Garde, and Material Exchange*, ed. Sarah Posman et al. (Berlin: De Gruyter, 2013), 17–28.

81 The two works by Marc Chagall, *Half-Past Three* (The Poet), 1911, oil on canvas, 195.9 × 144.8 cm, Philadelphia Museum of Art, and *The Flying Carriage*, 1913, oil on canvas, 106.7 × 120.1 cm, Solomon R. Guggenheim Museum, New York, were probably acquired in June 1914. For further information on their subsequent provenance, see Franz Meyer, *Marc Chagall: Life and Works* (New York: Harry N. Abrams, 1967), 315–16.

82 Skrubbe, "The Most Effective Propaganda Stunt?," in *Nell Walden & Der Sturm*, 49–51.

83 "Die süsse Frau im Blondschein / Du Kind mir meiner Liebe / Gestalt mir, Kunst." Herwarth Walden, "Nell Walden," in *Das Buch der Menschenliebe* (Berlin: Sturm, 1916), dedication.

84 "Silbertau liegt um mein Herz / Rosig träumt es von Dir." Marja Enid [Nell Walden], "An Dich," *Der Sturm* 7, no. 3 (June 15, 1916): 30.

85 "Rot reißt Blau / Im gelben, fahlen Licht / des zagen Frühlings: / Blau schlägt Rot / Tropfendes Blut / Gellt zum Himmel, / Beißt in Erde, / Frost-hart," Nell Walden, "Tod-Frühling 1916," in *In Roten Schuhen Tanzt sich die Sonne zu Tode: Lyrik Expressionistischer Dichterinnen*, ed. Hartmut Vollmer (Hamburg: Igel, 2014), 36.

86 For further consideration of August Stramm and his relationship to the Sturm circle, see Wolfgang Emmerich, "'. . . Das Einzige Allessagende Wort': Die Lebens- und Sprach-Stürme des August Stramm," in Pfeiffer and Hollein, *DER STURM im Berlin der Zehner Jahre*, 53–61.

87 "Die Zeit gebärt / Erschöpfung / Jüngt / Der Tod," August Stramm, "Krieg," in "Gedichte," *Der Sturm* 6, nos. 3–4 (May 1, 1915): 15.

88 See Herwarth Walden, "Die Mücke," *Der Sturm* 6, no. 17–18 (December 1, 1915): 98–99.

89 Nell Walden, "Todfrühling," colored print, *Der Sturm* 12, no. 8 (August 5, 1921): 145.

90 This firm was active in Berlin in the 1920s and 1930s. See Skrubbe, "The Most Effective Propaganda Stunt?," in *Nell Walden & Der Sturm*, 61.

91 The shift in Nell Walden's collecting habits and embrace of artifacts from Africa, Oceania, and Asia was already listed in the seventeenth catalog of the *Sammlung Walden Berlin: Gemälde/Zeichnungen/Plastiken* (Berlin: Der Sturm, 1919), 15–16, nos. 364–400, SBPK. The growth of this collection and installation dates to the period between 1926 and 1932 at the time of her marriage to the German Jewish physician Hans Heimann (1864–1942). See Andreas Schlothauer, "Nell Walden: Die Erste Sammlerin Außereuropäischer Kunst?," *Kunst und Kontext* 1 (2014): 50–55.

92 Letter from Van Heemskerck to Herwarth Walden, November 11, 1914, Sheets 37/37, SBPK; Huussen, *Brieven*, 27.

93 See Kai K. Gutschow, "From Object to Installation in Bruno Taut's Exhibit Pavilions," *Journal of Architectural Education* 59, no. 4 (May 2006): 63–70.

94 Taut, "Eine Notwendigkeit," 174.

95 Tak van Poortvliet, *Jacoba van Heemskerck*, 15.

96 Letter from Van Heemskerck to Herwarth Walden, June 12, 1914, Sheets 7/8, SBPK; Huussen, *Brieven*, 15.

97 Paul Scheerbart, *Glasarchitekur* (Berlin: Der Sturm, 1914); mit einem Nachwort zur Neuausgabe von Mechthild Rausch (Berlin: Gebrüder Mann, 2000), 13.

98 Letter from Van Heemskerck to Herwarth Walden, April 8, 1918, Sheet 338, SBPK; Huussen, *Brieven*, 157.

99 Behne, *Zur Neuen Kunst*, 24–28.

100 Gutschow, "From Object to Installation in Bruno Taut's Exhibit Pavilions," 66–67.

101 Letter from Van Heemskerck to Herwarth Walden, September 19, 1916, Sheets 257/8, SBPK; Huussen, *Brieven*, 115. Clearly, Richard Wagner's *Das Kunstwerk der Zukunft* (Leipzig: Otto Wigand, 1849) was published much earlier.

102 Sluyterman, *Dutch Enterprise in the 20th Century*, 87–88.

103 Letter from Van Heemskerck to Herwarth Walden, November 12, 1918, Sheet 347, SBPK; Huussen, *Brieven*, 163.

104 See Bruno Taut, *A Program for Architecture* (Berlin, 1918), trans. Michael Bullock, *Programs and Manifestoes in 20th Century Architecture*, ed. Ulrich Conrads (Cambridge, MA: MIT Press, 1971), 41.

105 *Der Sturm 79. Ausstellung: Johannes Molzahn, Jacoba van Heemskerck* (Berlin: Galerie Der Sturm, 1919).

106 *Der Sturm 79. Ausstellung*, no. 1: "Der Idee. Bewegung. Kampf. Dir—Karl Liebknecht"; no. 13: "Frauenmord."

107 See Rose-Carol Washton Long, "Expressionism, Abstraction, and the Search for Utopia in Germany," in *The Spiritual in Art: Abstract Painting, 1890–1985*, ed. Maurice Tuchman (Los Angeles: Los Angeles County Museum of Art, 1986), 209; Stephanie Barron, "Introduction," in *German Expressionism, 1915–1925: The Second Generation* (Los Angeles: Los Angeles County Museum, 1988), 35–36.

108 Johannes Molzahn, "Das Manifest des Absoluten Expressionismus,"

Der Sturm 10, no. 6 (September 15, 1919): 90–92.

109 Johannes Molzahn, "Das Manifest des Absoluten Expressionismus," 91.

110 Letter from Van Heemserck to Herwarth Walden, January 14, 1920, Sheet 377, SBPK; Huussen, *Brieven*, 179.

111 See Dorit Köhler, "Firmengeschichte: Gottfried Heinersdorff als Geschäftsmann," in *Farblicht: Kunst und Künstler im Wirkungskreis des Glasmalers Gottfried Heinersdorff (1883–1994)* (Ahlen: Kunstmuseum Ahlen and Ardenkuverlag, 2001), 59–80.

112 The correspondence between Herwarth Walden and Gottfried Heinersdorff, dating from October 20, 1919, until December 29, 1919, can be found in the archives of the Berlinische Galerie, Landesmuseum für Moderne Kunst, Fotografie, und Architektur 216.1.1–216.1.5; 6/H18/III/1/1–1/5.

113 For further consideration of Heinersdorff's interaction with key Expressionists, see Dagmar Schmidt, "Expressionistische und Konstruktive Tendenzen in der Profanen Glasbildkunst," in *Farblicht: Kunst und Künstler im Wirkungskreis des Glasmalers Gottfried Heinersdorff*, 15–41.

114 See Gabriele Struck, "Jacoba van Heemsckerck," in *Wände aus Farbigen Glas: Das Archiv der Vereinigten Werkstätten für Mosaik und Glasmalerei Puhl & Wagner, Gottfried Heinersdorff* (Berlin: Berlinische Galerie, 1989), 43–44.

115 Both stained-glass windows are in the collection of the Kunstmuseum Den Haag: *Window No. 19*, 1920, stained glass in lead, 101 × 74.5 cm, legacy of Marie Tak van Poortvliet.

116 Letter from Van Heemserck to Jan Buijs, April 28, 1920, Archief Buijs, Nederlands Documentatiecentrum voor de Bouwkunst te Amsterdam, as quoted in Chris Rehorst, "Jacoba van Heemsckerck en lr. Jan W. E. Buijs: Twee glas-in-loodramen in het huis Wulffraat te Wassenaar," *Nederlands kunsthistorisch jaarboek* 31 (1981): 551.

117 Tak van Poortvliet, *Jacoba van Heemsckerck*, 15.

118 Christopher Long, *The New Space: Movement and Experience in Viennese Modern Architecture* (New Haven, CT: Yale University Press, 2017).

119 For discussion of the theoretical sources, see Long, *The New Space*, 1–11.

120 For the ground plan, consult Rehorst, "Jacoba van Heemsckerck en lr. Jan W. E. Buijs," 549.

121 See Huussen and Van Paaschen-Louwerse, *Jacoba van Heemsckerck*, 189–94.

122 Sluyterman, *Dutch Enterprise in the 20th Century*, 77–78.

123 Weinstein, *The End of Expressionism*, 48–49.

124 Rudolf Steiner, "An het Deutsche volk en aan de overige mensch-heid," in *De kern van het sociale vraagstuk in de levensvoorwaarden voor het heden en de toekomst*, trans. Marie Tak van Poortvliet (Utrecht: De Haan, 1919), 122. For a facsimile copy, see Huussen, *Brieven*, 260–68.

125 Jacqueline van Paaschen-Louwerse, "Johanna Maria Tak van Poortvliet," *Biographien, Kulturimpuls*, https://biographien.kulturimpuls .org/detail.php?&id=687.

126 In 1926, Tak van Poortvliet founded this organic commune with Zeylmans and Ehrenfried Pfeiffer (1899–1961), a German soil scientist, who worked in the private research laboratory at the Goetheanum in Dornach after Steiner's death in 1925. Marie Tak van Poortvliet, "Loverendale" (1934–36), manuscript of eleven pages, http://www .archieven.nl.

127 Adolf Behne, "Der Krieg und die Künstlerische Produktion," *Die Umschau* (1915): 270–71.

128 See letter from Van Heemserck to Nell Walden, February 28, 1915, Sheet 63–64, SBPK; Huussen, *Brieven*, 36–37, and Nell Walden's response to Van Heemserck, February/March, 1915, Sheet 6, SBPK; Huussen, *Brieven*, 207.

129 Catalog of the *Sammlung Walden: Gemälde/Zeichnungen/Plastiken* (Berlin: Der Sturm, 1917).

130 *Der Sturm Hundertneunundzwanzigste Ausstellung: Jacoba van Heemsckerck Gedächtnis Ausstellung* (Berlin: Der Sturm, March 1924); Tak van Poortvliet, *Jacoba van Heemsckerck*, 1924.

131 In 1936, the Marie Tak van Poortvliet Bequest was distributed to the Museum Boijmans van Beuningen, Rotterdam (mainly her collection of European modernism), and the Kunstmuseum, The Hague (Jacoba van Heemsckerck).

Chapter 7. The Formation of the Modern Woman Patron, Collector, and Dealer: From Brücke to Second-Generation Expressionism

Sections of chapter 7 appeared in a different form in Shulamith Behr, "Künstlergruppe Brücke and the Public Sphere: Bridging the Gender Divide," in *New Perspectives on Brücke Expressionism: Bridging History*, ed. Christian Weikop (New York: Routledge, 2011), 99–123.

1 Rosa Schapire, *Johann Ludwig Ernst Morgenstern* (PhD diss., Karl Ruprecht University, Heidelberg, 1904), 49.

2 For the ascertainable facts regarding her undergraduate and art-historical training, see Burcu Dogramaci and Günther Sandner, "Rosa und Anna Schapire: Eine Intellektuelle Doppelbiografie," in *Rosa und Anna Schapire: Sozialwissenschaft, Kunstgeschichte und Feminismus um 1900*, ed. Burcu Dogramaci and Günther Sandner (Berlin: Aviva, 2017), 17–18.

3 "Die Systemzeit" was a pejorative National Socialist term used for the constitutional democracy of the Weimar period. For a full list of the critics whose names were displayed on the wall of the Haus der Deutschen Kunst in Munich during the *Entartete Kunst* exhibition in 1937, see Peter Klaus Schuster, ed., *Die "Kunstadt" München 1937: Nationalsozialismus und "Entartete Kunst"* (Munich: Prestel, 1987), 173.

4 The surviving offspring included an illegitimate child, Maria, who was conceived with Robert Ey prior to their marriage; Maria was raised by Johanna's sister in Brussels. See Sandra Labs, *Johanna Ey und die Avantgarde der Düsseldorfer Kunstszene* (Hamburg: Diplomica, 2012), 14.

5 Michael Hausmann, *Johanna Ey: A Critical Reappraisal* (PhD diss., University of Birmingham, 2010), 4. Hausmann consulted the type-script, dictated to Hedwig Mommertz, available in the Stadtmuseum Düsseldorf archive. The "Erinnerungen der Johanna Ey" are published in edited form in Annette Baumeister, *Treffpunkt "Neue Kunst": Erinnerungen der Johanna Ey* (Düsseldorf: Droste, 1999), 55–83.

6 Ludwig Justi, "Vorwort zum Verzeichnis der Gemälde und Bildwerke in der National-Galerie zur Berlin" (Berlin, 1921), as quoted in Annegret Janda and Jörn Grabowski, *Kunst in Deutschland 1905–1937: Die Verlorende Sammlung der Nationalgalerie im Ehemaligen Kronprinzen-Palais; Dokumentation* (Berlin: Staatliche Museen zu Berlin, 1992), 12.

7 Ey, "Erinnerungen," in Baumeister, *Treffpunkt*, 74.

8 Carol Duncan, "Virility and Domination in Early Twentieth-Century Vanguard Painting," in Broude and Garrard, *Feminism and Art History*, 293–313.

9 Duncan, "Virility and Domination," in Broude and Garrard, *Feminism and Art History*, 312–13.

10 Laura Mulvey, "Visual Pleasure and Narrative Cinema," *Screen* 16, no. 3 (Autumn 1975): 6–18.

11 Margaret Olin, "The Gaze," in *Critical Terms for Art History*, ed. Robert S. Nelson and Richard Shiff (Chicago: University of Chicago Press, 1996), 209.

12 Mary Ann Doane, "Film and the Masquerade: Theorizing the Female Spectator," *Screen* 23, nos. 3/4 (September/October 1982): 74–88.

13 Joan Riviere, "Womanliness as a Masquerade" (1929), in Burgin, Donald, and Kaplan, *Formations of Fantasy*, 45–61.

14 Judith Butler, *Gender Trouble: Feminism and the Subversion of Identity* (1990; Abingdon: Routledge, 2007), 68–73.

15 Judith Butler, "The Body You Want: Liz Kotz Interviews Judith Butler," *Artforum* 31, no. 3 (November 1992): 87.

16 See Berman, *Enlightenment or Empire*, 171–202.

17 Rosa Schapire, "Ein Wort zur Frauenemanzipation," *Sozialistische Monatshefte* 1 (1897): 515.

18 The literature on "modernist primitivism" is vast, starting with Robert Goldwater's use of the term in *Primitivism in Modern Painting* (New York: Harper & Row, 1938) and its uncritical adoption in William Rubin and Kirk Varnedoe, eds., "*Primitivism" in Twentieth Century Art: Affinities of the Tribal and the Modern* (New York: Museum of Modern Art, 1984). For the critical response to this exhibition, see Hal Foster, "The 'Primitive' Unconscious of Modern Art or White Skin Black Masks," *October* 34 (Autumn 1985): 45–70.

19 See George L. Mosse, "Jewish Emancipation between 'Bildung' and Respectability," in *The Jewish Response to German Culture: From the Enlightenment to the Second World War*, ed. Jehuda Reinharz and Walter Schatzberg (Hanover, NH: Brandeis University Press, 1986), 1–16.

20 Hugo von Tschudi, "Introduction," in *Die Sammlung des Kgl. Rates Marczell von Nemes: Budapest* (Munich: Alte Pinakothek, 1911), reprinted in *Gesammelte Schriften zur neueren Kunst von Hugo von Tschudi*, ed. Ernst Schwedeler-Meyer (Munich: Bruckmann, 1912), 228.

21 Walter Grasskamp outlines this phenomenon in his essay, "Die Einbürgerung der Kunst: Korporative Kunstförderung im 19. Jahrhundert," in *Sammler, Stifter und Museen: Kunstförderung in Deutschland im 19. und 20. Jahrhundert*, ed. Ekkehard Mai and Peter Paret (Cologne: Böhlau, 1993), 104–13. For an analysis of German historical methodology in this regard, see Maiken Umbach, *German Cities and Bourgeois Modernism, 1890–1924* (Oxford: Oxford University Press, 2009), 1–26.

22 Peter-Klaus Schuster, "Hugo von Tschudi und der Kampf um die Moderne," in Von Hohenzollern and Schuster, *Von Manet bis Van Gogh*, 21–40.

23 See Peter Paret, "The Tschudi Affair," in the *Journal of Modern History* 53, no. 4 (December 1981): 589–618. This essay is updated in Peter Paret, "Die Tschudi-Affäre," in Von Hohenzollern and Schuster, *Manet bis Van Gogh*, 396–401.

24 Tschudi, "Introduction," in *Die Sammlung des Kgl. Rates Marczell von Nemes*, in Schwedeler-Meyer, *Gesammelte Schriften*, 228.

25 On the strength of the relationship between *Empfindungsgefühl* (emotional feeling) and *ästhetischen Gefühl* (aesthetic emotion), see the writing of the Marburg School, neo-Kantian philosopher Hermann Cohen, *Ästhetik des Reinen Gefühls* (Berlin: Bruno Cassirer, 1912), 1:150–51.

26 See Thomas W. Gaehtgens, "Tschudi's Impressionismusverständnis: Historienmalerei als Darstellung Erlebten Lebens," in Von Hohenzollern and Schuster, *Manet bis Van Gogh*, 360–63.

27 Gaehtgens, "Tschudi's Impressionismusverständnis," 362, quoting

Hugo von Tschudi, "Kunst und Publikum," 1899, in Schwedeler-Meyer, *Gesammelte Schriften*, 75.

28 Rosa Schapire, review of *Die Nationalgalerie zu Berlin: Ein Kritischer Führer*, by Karl Scheffler, *Monatshefte für Kunstwissenschaft* 5, no. 12 (1912): 533.

29 Umbach, *German Cities*, 123.

30 See Carmen Luise Stonge, *Karl Ernst Osthaus: The Folkwang Museum and the Dissemination of International Modernism* (PhD diss., City University of New York, 1993).

31 Rainer Stamm, "Strömen und Wollen unserer Zeit: Die Sammlerin Gertrud Osthaus," in *Kunstsammlerinnen: Peggy Guggenheim bis Ingvild Goetz*, ed. Dorothee Wimmer, Christina Feilchenfeldt, and Stephanie Tasch (Berlin: Reimer Verlag, 2009), 85–97.

32 Rainer Stamm, "Von der 'Photographien und Diapositivzentrale des Deutschen Museums für Kunst in Handel und Gewerbe' zum Karl Ernst Osthaus-Bildarchiv (1910–1933)," in Rainer Stamm, *Der Folkwang Verlag: Auf dem Weg zu einem Imaginären Museum* (Frankfurt am Main: Buchhändler Vereinigung, 1999), 108.

33 Karl Ernst Osthaus, "Cézanne," *Das Feuer* (1920–21), 81–85, in *Reden und Schriften: Folkwang, Werkbund, Arbeitsrat*, ed. Rainer Stamm (Cologne: König, 2002), 176–78, as quoted in Stamm, "Strömen und Wollen," in Wimmer, *Kunstsammlerinnen*, 88.

34 Letter from Gertrud Osthaus to Ada Nolde, August 26, 1916, in *Emil und Ada Nolde—Karl Ernst und Gertrud Osthaus: Briefwechsel*, ed. Herta Hesse-Frielinghaus (Bonn: Bouvier, 1985), 147.

35 Stonge, *Karl Ernst Osthaus*, 78–100.

36 For an exploration of Osthaus in relation to the Deutscher Werkbund (founded in 1907) and the Deutsches Museum für Kunst in Handel und Gewerbe (cofounded by Osthaus and the Werkbund in 1909), see the exhibition catalogs *Der Westdeutsche Impuls, 1900–1914: Kunst und Umweltgestaltung im Industriegebiet; Die Deutsche Werkbund-Ausstellung Cöln, 1914* (Cologne: Kölnischer Kunstverein, 1984); *Das Schöne und der Alltag: Die Anfänge Modernen Designs, 1900–1914*; and *Deutsches Museum für Kunst in Handel und Gewerbe*, ed. Michael Fehr, Sabine Röder, and Gerhard Störk (Cologne: Wienand, 1997).

37 See Katherine Kuenzli, "The Birth of the Modernist Art Museum: The Folkwang as Gesamtkunstwerk," *Journal of the Society of Architectural Historians* 72, no. 4 (December 2013): 505–10.

38 Kuenzli, *The Nabis and Intimate Modernism*, 220–21.

39 Katherine M. Kuenzli, *Henry van de Velde: Designing Modernism* (New Haven, CT: Yale University Press, 2019), 55.

40 For the list of acquisitions and provenance of the collection, see Herta Hesse-Frielinghaus, "Folkwang 1. Teil," in *Karl Ernst Osthaus: Leben und Werk*, ed. Herta Hesse-Frielinghaus et al. (Recklinghausen: Aurel Bongers, 1971), 192–241.

41 For his purchase of modern French paintings, see Andres Lepik, "Die Zurückführung der Kunst ins Leben: Karl Ernst Osthaus und das Museum Folkwang," in Von Hohenzollern and Schuster, *Von Manet bis Van Gogh*, 302–7.

42 Martin Urban, *Emil Nolde: Catalogue Raisonné of the Oil Paintings, 1895–1914* (London: Sotheby's, 1987), 27. After Osthaus's death in 1921, the city of Hagen was unwilling to keep the collection intact, as stipulated in his will. As a consequence, the city of Essen raised the 15 million marks required, and the new Folkwang Museum opened on October 29, 1922. The collection was dismantled after 1933, however.

43 Stonge, *Karl Ernst Osthaus*, 114, 116; Jill Lloyd, *German Expressionism: Primitivism and Modernity* (New Haven, CT: Yale University Press, 1991), 8–12.

44 The first and third pieces from left to right originated from New Ireland, the former New Mecklenburg in the Bismarck Archipelago, which belonged to the imperial protectorate of German New Guinea. In 1915, Franz Wiesener, serving as imperial police chief to the colonial administration and on home leave in his native Hagen, presented the objects to Karl Ernst Osthaus on the recommendation of Ada and Emil Nolde. For "Emil Nolde in Neuguinea (1913–14)," see Cristoph Otterbeck, *Europa Verlassen: Künstlerreisen am Begin des 20. Jahrhunderts* (Vienna: Böhlau, 2007), 220–37.

45 As cultural historian Hal Foster observed of this process, albeit in the context of the 1984 MoMA exhibition *"Primitivism" in the Twentieth Century: Affinity of the Tribal and the Modern*, "Here then, Primitivism emerges as fetishistic discourse, a recognition and disavowal of difference." The differences of race, culture, and color, perceived as a threat, are fetishized away and incorporated within the realm of the same. Foster, "The 'Primitive' Unconscious," 46.

46 Frau K. E. Osthaus, "Das Museum Folkwang in Hagen," *Kölnische Zeitung* 908 (August 10, 1913): 2, as quoted in Stamm, "Strömen und Wollen," in Wimmer, *Kunstsammlerinnen*, 91.

47 Frau K. E. Osthaus, "Das Museum Folkwang," as quoted in Stamm, "Strömen und Wollen," in Wimmer, *Kunstsammlerinnen*, 92.

48 See Worringer, *Abstraktion und Einfühlung*, 18–19.

49 Stonge, *Karl Ernst Osthaus*, 204–5.

50 See Magdalena Bushart, "Der Formsinn des Weibes: Bildhauerinnen in den Zwanziger und Dreißiger Jahren," in Fuhrmann and Muysers, *Profession ohne Tradition*, 135–50. Birgit Schulte, "Milly Steger: Stadtbildhauerin von Hagen," in *Hagener Impuls* 9 (September 1994): 27–36.

51 Carmen Stonge, "Women and the Folkwang: Ida Gerhardi, Milly Steger, and Maria Slavona," *Woman's Art Journal* 15, no. 1 (Spring/Summer 1994): 5–6.

52 Hans Hildebrandt, "Milly Steger," *Das Kunstblatt* 2, no. 12 (December 1918): 372, as quoted in Erich Ranfft, "German Women Sculptors, 1918–1936: Gender Differences and Status," in Meskimmon and West, *Visions of the Neue Frau*, 52.

53 See Rainer Stamm, "'Ihre und meine Freundschaftlichen und Diplomatischen Beziehungen': Else Lasker-Schüler und das Folkwang-Museum," in *Wirkendes Wort: Deutsche Sprache und Literatur in Forschung und Lehre* 46, no. 3 (December 1996): 379–92.

54 Else Lasker-Schüler, "Milly Steger," in *Gesammelte Gedichte* (Leipzig: Verlag der Weißen Bücher, 1917), 200. For translation of the poem and discussion of its symbolism, see Sherwin Simmons, "Expressionism in the Discourse of Fashion," in *Fashion Theory* 4, no. 1 (2000): 69–70.

55 Consult, as well, Birgit Schulte, "Zwischen Theben und Hagen: Else Lasker-Schülers Begegnung mit Karl Ernst Osthaus, Milly Steger und Christian Rohlfs," in *Hagener Impuls* 11 (June 1995): 7–15.

56 For consideration of Lasker-Schüler in an art-historical context, see Astrid Schmetterling, "'Das ist Direkt ein Diebstahl an den Kunsthistorikern': Else Lasker-Schülers Bildnerisches Werk im Kunsthistorischen Kontext," in *Else Lasker-Schüler: Die Bilder*, ed. Ricarda Dick (Frankfurt am Main: Suhrkamp, 2010), 161–93.

57 Donna K. Heizer, *Jewish-German Identity in the Orientalist Literature of Else Lasker-Schüler, Friedrich Wolf and Franz Werfel* (Columbia: Camden House, 1996), 37–38.

58 See "Werkverzeichnis," in Dick, *Else Lasker-Schüler: Die Bilder*, no. 12, 200.

59 In 1907, Lasker-Schüler attended a seminar on Oriental languages run by the lecturer Hamed Waly at the University of Berlin and approached him to translate passages from *Nächte Tino von Bagdads* into Arabic for a reading session. See Ricarda Dick, "Else Lasker-Schüler als Künstlerin," in *Else Lasker-Schüler: Die Bilder*, 124.

60 For consideration of Else Lasker-Schüler's draftsmanship, see Ricarda Dick, "Else Lasker-Schülers Entwicklung zur Zeichnerin," in *Der Sturm: Zentrum der Avante Garde*, vol. 2, ed. Andrea von Hülsen-Esch and Gerhard Finckh (Wuppertal: Von der Heydt Museum, 2012), 86–100.

61 Anonymous, *Westfalische Tageblatt* (April 27, 1916), as quoted in Stamm, "Else Lasker-Schüler und das Folkwang-Museum," 383.

62 Karl Ernst Osthaus, "Der Folkwang in Hagen" (Lecture, September 21, 1903), in *Die Museen als Volksbildungsstätten, Ergebnisse der 12. Konferenz der Centralstelle für Arbeiter-Wohlfahrtseinrichtungen*, Schriften der Centralstelle für Arbeiter-Wohlfahrtseinrichtungen, no. 25 (Berlin, 1904): 58–61, as quoted in Monika Lahme-Schlenger, "Karl Ernst Osthaus," in *Avantgarde und Publikum: Zur Rezeption Avant-Gardistischer Kunst in Deutschland, 1905–1933*, ed. Henrike Junge (Cologne: Böhlau, 1992), 228.

63 In the summer of 1916, following Gertrud Osthaus's health cure at the sanatorium of Oskar Kohnstamm in Königstein im Taunus, her marriage to Karl broke down. In 1919, given Karl's deteriorating ill health, the writer and philosopher Ernst Fuhrmann took charge of the Hagen collection. See Rainer Stamm, "'Ein Versuch Phantastischen Ausmaßes': Ernst Fuhrmann—Schriftsteller, Verleger, Biosoph und Bildreggiseur," in *Deutschsprachige Exilliteratur seit 1933*, vol. 3, part 5, ed. John M. Spalek, Konrad Feilchenfeldt, and Sandra H. Hawrylchak (Zurich: De Gruyter Saur, 2005), 72–92.

64 See Richard J. Evans, "Family and Class in the Hamburg Grand Bourgeoisie, 1815–1914," in Blackbourn and Evans, *The German Bourgeoisie*, 117–19.

65 See "Introduction," in *Katalog der Meister des 19. Jahrhunderts in der Hamburger Kunsthalle*, ed. Eva Maria Krafft and Carl-Wolfgang Schumann (Hamburg: Hamburg Kunsthalle, 1969). The Kunsthalle was founded in 1846 around the bequest of P. Delaroche and was initially called the "Öffentliche Städtische Gemäldegalerie."

66 Alfred Lichtwark, "Selbsterziehung," *Pan* 2, no. 4 (1896–97): 302, as cited in Reinhold Heller, *Stark Impressions: Graphic Production in Germany, 1918–1933* (Evanston, IL: Mary and Leigh Block Gallery, Northwestern University, 1993), 10.

67 Alfred Lichtwark, "Wege und Ziele des Dilettantismus" (1894), in *Die Grundlagen der Künstlerischen Bildung: Studien aus den Vorträgen an der Kunsthalle* (Berlin: Bruno Cassirer, 1918). See Clive Ashwin, *Drawing and Education in German-Speaking Europe, 1800–1900* (Ann Arbor: UMI Research Press, 1981), 148–49.

68 For details of the Gesellschaft Hamburger Kunstfreunde, see Carolyn Kay, *Art and the German Bourgeoisie: Alfred Lichtwark and Modern Painting in Hamburg, 1886–1914* (Toronto: University of Toronto Press, 2002), 100–16.

69 Alfred Lichtwark, "Glitza-Blätter," in *IV. Jahresausstellung der Gesellschaft Hamburgischer Kunstfreunde* (Hamburg: Gesellschaft der Hamburgischer Kunstfreunde, 1898): 17, as quoted in Henrike Junge, "Alfred Lichtwark und die 'Gymnastik der Sammeltätigkeit,'" in Mai and Paret, *Sammler, Stifter und Museen*, 205.

70 Alfred Lichtwark, "Der Sammler," *Kunst und Künstler* 10 (1911–12): 288, as quoted in Junge, *Avantgarde und Publikum*, 204.

71 Habermas, *Structural Transformation of the Public Sphere*.

72 Sabina Ghandchi, *Die Hamburger Künstlerin Mary Warburg, geb. Hertz: Werkliste 1–4* (MA diss., University of Hamburg, 1986), 12.

73 Further comment on the scandal can be found in Kay, *Art and the German Bourgeoisie*, 70–99.

74 The correspondence between Mary Hertz and Aby Warburg can be found in the archive of the Warburg Institute, University of London (WIA). See WIA GC/26676: April 1, 1896, for Hertz's comments on the Lichtwark scandal, her participation in the so-called dilettante exhibitions of 1895 and 1896 and design of a poster for the latter. For an illustration, see Bärbel Hedinger and Michael Diers, eds., *Mary Warburg: Porträt einer Künstlerin, Leben/Werk* (Munich: Hirmer, 2020), 431.

75 For illustration, see Carolyn Kay, *Art and the German Bourgeoisie*, Pl. 20: Anon. "Moderne Kunstmalerei," *Hamburger Freie Presse* (March 15, 1896).

76 Kay, *Art and the German Bourgeoisie*, 87.

77 Clive Ashwin, *Drawing and Education in German-Speaking Europe* (Ann Arbor: UMI Research Press, 1981), 146–48.

78 Ernst Ludwig Kirchner, *Programm der Künstlergruppe Brücke*, 1906, woodcut, 15.1 × 7.5 cm, Drawing and Prints Department, Museum of Modern Art, New York.

79 See Indina Kampf, "Gustav Schiefler (1857–1935): Der Programmatische Dilettant," in Junge, *Avantgarde und Publikum*, 291–97.

80 Gustav Schiefler, *Das Graphische Werk Emil Noldes bis 1910* (Berlin: Julius Bard, 1911); *Das Graphische Werk von Emil Nolde, 1910–1925* (Berlin: Euphorian, 1927); *Die Graphik Ernst Ludwig Kirchners bis 1924* (Berlin: Euphorian, 1926).

81 See Kirchner, *List of Passive Members*, 1906–10, woodcuts from the catalog of the Brücke exhibition in Galerie Arnold, Dresden, 1910. For the list of names of women members and biographies, consult Indina Woesthoff, "Verzeichnis der Passiven Mitglieder der Künstlergruppe Brücke 1906–1911," in *Die Brücke in Dresden, 1905–1911*, ed. Birgit Dalbajewa and Ulrich Bischoff (Cologne: König, 2001), 338–47.

82 For the available biographic detail on Hopf and Goldschmidt, see Traute Hoffmann, *Der Erste Deutsche ZONTA-Club: Auf den Spuren Außergewöhnlicher Frauen* (Hamburg: Dölling and Galitz, 2006), 126–31.

83 See Ute Frevert, *Women in German History: From Bourgeois Emancipation to Sexual Liberation* (Oxford: Berg, 1989), 54–58. The salon of the late eighteenth century was a typically middle-class institution that bridged the schism between the private and the public, the bourgeoisie and the aristocracy; Barbara Hahn, "Encounters at the Margins: Jewish Salons around 1900," in *Berlin Metropolis: Jews and the New Culture, 1890–1918*, ed. Emily D. Bilski (Berkeley: University of California Press, 2000), 188–207.

84 For the origins, architecture, and aims of the Lyceum Club, see Despina Stratigakos, *A Woman's Berlin: Building the Modern City* (Minneapolis: Minnesota University Press, 2008), 17–51.

85 Despina Stratigakos, "A Woman's Berlin: How Female Patrons and Architects in Imperial Germany Re-Gendered the City," in *Embodied Utopias: Gender, Social Change and the Modern Metropolis*, ed. Amy Bingaman, Lise Sanders, and Rebecca Zorach (Abingdon: Routledge, 2002), 142–47.

86 Helene Lange and Gertrud Bäumer, "Das Kartell der Frauenklubs," *Monatszeitschrift für das Gesamte Frauenleben unserer Zeit* (November 1912): 120.

87 "Die Deutschen Frauenklubs," *Jahrbuch der Frauenbewegung* (1914): 94.

88 Gustav Schiefler, *Eine Hamburgische Kulturgeschichte 1890–1920* (Hamburg: Verein für Hamburgische Geschichte, 1985): 300–301. Bertha Rohlsen (née Rauert) was the older sister of the collector Paul Rauert and widow of the businessman consul Gustav Rohlsen.

89 Like her sister Alice Bensheimer, Ida Dehmel was a fervent supporter of women's suffrage, joining the ranks of various pressure groups in the early twentieth century and serving as chief editor, from 1912 to 1916, of the monthly report *Frau und Staat*, issued by the Deutsche Vereinigung für Frauenstimmrecht (German Union for Women's Right to Vote). Her political affiliations were somewhat conservative, however, and she was a member of the National Liberal Party. For further information regarding Dehmel's role in feminism, art, and politics, see Shulamith Behr, "Ida Dehmel," in *Jewish Women: A Comprehensive Historical Encyclopaedia*, ed. Paula E. Hyman and Dalia Ofer (Jerusalem: Shalvi, 2007), CD-ROM and Jewish Women's Archive, https://jwa.org/encyclopedia/article/dehmel-ida.

90 Letter from Ida Dehmel to Bertha Rohlsen, filed under 1908/3:27, but addressed and dated Bingen am Rhein, July 8, 1906. Nachlaß Gustav Schiefler, Staats- und Universitätsbibliothek Hamburg.

91 Hans Platte and Luise Schiefler, *Gustav Schiefler: Aus den Erinnerungen von Luise Schiefler* (Hamburg: Hans Christians, 1965), 28–29.

92 Letter from Ida Dehmel to Emmi Marianne Neumeier, March 15, 1907, quoted in Elisabeth Höpker-Herberg, *Ida Dehmel, 1870–1942* (Hamburg: Staats- und Universitätsbibliothek Hamburg, 1970), 59–60.

93 Helmut Stubbe-da Luz, *Die Stadtmütter: Ida Dehmel, Emma Ender, Margarete Treuge* (Hamburg: Verein für Hamburgische Geschichte, 1994), 20–21.

94 Well known for her elegance and exotic beauty, Ida modeled Richard's designs for women's clothing, photographs of which were published. See Richard Dehmel, "Reformkleidung," *Berliner Illustrirte Zeitung*, August 13, 1908.

95 *Am Strand gehende Frau mit Hut*, 1910, wax crayon postcard, 9 × 14 cm, DA Staats- und Universitätsbibliothek Hamburg, illustrated in Gerhard Wietek, *Schmidt-Rottluff: Oldenburger Jahre 1907–1912* (Mainz: Philipp von Zabern, 1994), 169, 430 (script on the rear in the hand of Rosa Schapire, who was in Dangast at the time).

96 In 1926, Dehmel founded the Gemeinschaft Deutscher und Österreichischer Künstlerinnenvereine aller Kunstgattungen (Community of German and Austrian Women Artists' Associations of All Artistic Genres, GEDOK), which is active to this day. See Margarete Sorg and Margarete Sorg-Rose, eds., *Kontrapunkt GEDOK gestern–heute: Dokumentation der GEDOK RHEIN-MAIN-TAUNUS zum 50. Todesjahr der GEDOK-Gründerin Ida Dehmel (1870–1942)* (Mainz: Biebrich, 1992).

97 For the context, see Volker Wahl, *Jena als Kunst-Stadt: Begenungen mit der Modernen Kunst in der Thüringischen Universitätsstadt zwischen 1900 und 1933* (Leipzig: Seemann, 1988).

98 Kirchner, *Musikzimmer II* (Musik Room II, 1915), oil on canvas, 121.5 × 91.3 cm, Landesmuseum, Hanover.

99 Rudolf Eucken, *Lebenserinnerungen: Ein Stück Deutschen Lebens* (Leipzig: Koehler, 1921), 118, as quoted in Uwe Dathe and Nils Goldschmidt, "Wie der Vater, so der Sohn? Neuere erkenntnisse zu Walter Euckens Leben und Werk anhand des Nachlasses von Rudolf Eucken in Jena," in *Freiburger Diskussionspapiere zur Ordnungsökonomik* (Freiburg: Walter Eucken Institut, August 3, 2005), 8.

100 Letters from Ernst Ludwig Kirchner to Gustav Schiefler, dated September 22 and October 19, 1916, in *Briefwechsel, 1910–1935/1938*, ed. Wolfgang Henze (Stuttgart: Belser, 1990), 80–83. For further detail on Kirchner's morphine addiction, see Aya Soika, "Ernst Ludwig Kirchner," in *Weltenbruch: Die Künstler der Brücke im Ersten Weltkrieg,*

1914–1918, ed. Magdalena M. Moeller (Berlin: Brücke-Museum, 2014), 76–77.

101 Irene Eucken, "Zur Einführung," in *Ausstellung von Kleidern aus der Stickstube von Frau Eucken* (Bremen: Bremer Frauenklub von 1908, 1916).

102 See Sherwin Simmons, "Ernst Kirchner's Streetwalkers: Art, Luxury, and Immorality in Berlin, 1913–16," *Art Bulletin* (March 2000): 117–48, and Jill Lloyd, *German Expressionism: Primitivism and Modernity* (New Haven, CT: Yale University Press, 1991), 134–37.

103 Simmons, "Ernst Kirchner's Streetwalkers," 140, citing Kirchner's letter to Schiefler, October 19, 1916, in *Briefwechsel*, 82–83.

104 For further photographs, consult Brunhild Neuland, "Irene Eucken—vom Salon Eucken zum Eucken-Haus," in *Entwurf und Wirklichkeit: Frauen in Jena, 1900 bis 1933*, ed. Gisela Horn (Jena: Hain, 2001), 219–33.

105 The photographs are held in the Thüringer Universitäts- und Landesbibliothek Jena, Nachlass Rudolf Eucken III/5. I thank the librarian of the historical collections, Uwe Dathe, for the digitization of the transcriptions on the rear.

106 Jenkins, *Provincial Modernity*, 2003.

107 For the family's upbringing in Galicia, see Börries Kuzmany, "Das Intellektuelle und Wirtschaftliche Umfeld der Famile Schapire in Brody," in Dogramaci and Sandner, *Rosa und Anna Schapire*, 38–67.

108 Rosa's younger sister Anna (1877–1911), who studied in Vienna and Berlin, graduated in 1906 with a doctorate in economics from Bern University. Like Rosa, Anna was a gifted linguist and was thoroughly committed to socialist and feminist causes. In 1907 she married her colleague, the social scientist Otto Neurath (1882–1945), and they enjoyed a fruitful academic collaboration until her death in childbirth, her son Paul surviving her.

109 Rosa Schapire, "Ein Wort zur Frauenemanzipation," 510–17.

110 Laura Marholm, *The Psychology of Woman*, trans. Georgia A. Etchison (London: Grant Richards, 1899), 289.

111 Schapire, "Ein Wort zur Frauenemanzipation," 511.

112 From 1900, women could audit lessons as *Gasthörerin* (guest students). See Dogramaci and Sandner, *Rosa und Anna Schapire*, 18.

113 For an outline of Thode's pedagogy and cultural politics, see Christian Welzbacher, *Edwin Redslob: Biografie eines Unverbesserlichen Idealisten* (Berlin: Matthes & Seitz, 2009), 44–60.

114 Letter from Schapire to Warburg, March 22, 1905, WIA GC/1854.

115 Letter from Aby Warburg to Mary Warburg, September 27, 1907, WIA GC/31906.

116 On the roles of the wives Mary Warburg and Toni Cassirer (1883–1961) in this circle of male art historians, see Levine, *Dreamland*, 40–42; 101–4.

117 Levine, *Dreamland*, 111.

118 See Immanuel Kant, *Critique of Pure Reason* (1781; London: Henry G. Bohn, 1885), trans. J.M.D. Meiklejohn, 126; Levine, *Dreamland*, 111.

119 Letter from Nolde to Schiefler, July 26, 1907, in *Emil Nolde: Briefe* (Hamburg: Furche, 1967), 58.

120 Rosa Schapire, "Emil Nolde," *Hamburg Zeitschrift für Heimat und Fremde* 16, no. 2 (June 1907): 769.

121 Born in St. Gallen, the jurist Hans Fehr (1874–1961) took drawing lessons with Nolde when the artist (then known as Emil Hansen) taught at the St. Gallen Kunstgewerbeschule (1892–97). Between 1906 and 1912, Fehr was a professor of jurisprudence at the university in Jena, and he lived nearby in Cospeda.

122 Schapire, "Emil Nolde," 769.

123 Letter from Emil Nolde to Ada Nolde, March 1, 1907, Archive Nolde-Stiftung Seebüll, as quoted and translated from Danish in Andreas Fluck, "Emil Nolde in Jena und Cospeda, 1907/08," in *Weimar-Jena: Die Grosse Stadt* 3/4 (2010): 238–40.

124 Schapire, "Emil Nolde," 767.

125 Schapire, "Emil Nolde," 767.

126 Letter from Nolde to Schapire, July 26, 1907, in *Emil Nolde: Briefe*, 59.

127 Letters from Nolde to Schapire, November 12/17, 1907, in *Emil Nolde: Briefe*, 65–67.

128 Letter from Ada Nolde to Hans Fehr, December 29, 1907, Getty Research Library, Special Collections 2004.M.34.

129 Rosa Schapire, "Emil Nolde," *Die Schweiz: Schweizerische Illustrierte Zeitschrift* 12 (1908): 246.

130 See letter from Nolde to Schapire, March 11, 1908, in *Emil Nolde: Briefe*, 70–72.

131 Letter from Nolde to Schapire, March 20, 1908, in *Emil Nolde: Briefe*, 73–74.

132 Emil Nolde, *Jahre der Kämpfe* (Berlin: Rembrandt, 1934), 101–2.

133 See Robin Reisenfeld, "Collecting and Collective Memory: Jewish Patronage of German Expressionist Art and Modern Jewish Identity," in *Jewish Identity in Modern Art History*, ed. Catherine M. Soussloff (Berkeley: University of California Press, 1999), 117.

134 For the waves of anti-Semitism in the military establishment, see Tim Grady, *A Deadly Legacy: German Jews and the Great War* (New Haven, CT: Yale University Press, 2017), 136–42.

135 In a letter to Agnes Holthusen, January 26, 1951, Schapire stated that this was a "cruel necessity" to protect their safety. Nachlaß Agnes Holthusen, Archiv für Bildende Kunst, Germanisches Nationalmuseum, Nürnberg. Agnes Weizsäcker (1896–1990), who married the radiologist Hermann Holthusen, was an art historian who was Hamburg-based through the Second World War. While the two women met in 1929, the bulk of the letters from Schapire date from 1945–54.

136 Gerhard Wietek, "Dr phil Rosa Schapire," *Jahrbuch der Hamburger Kunstsammlungen* 9 (1964): 115–60; *Schmidt-Rottluff: Oldenburger Jahre, 1907–1912* (Oldenburg: P. Von Zabern, 1995); *Schmidt-Rottluff: Plastik und Kunsthandwerk Werkverzeichnis* (Munich: Hirmer, 2001).

137 See Andreas Hüneke, "Die Dangaster Jahre der 'Brücke' Maler, 1907–1912," in *"Brücke": Expressionisten in Dangast*, ed. Franz-Radziwill-Gesellschaft (Cologne: Hermann Krause, 2002), 14.

138 Emma Ritter, "Dangaster Erinnerungen" (1946), as quoted in Gerhard Wietek, "Emma Ritter und ihr Verhältnis zur Malerei des Deutschen Expressionismus," *Oldenburger Jahrbuch* 58 (1959): part 1:4.

139 See Peter Lasko, "The Student Years of the Brücke and Their Teachers," *Art History* 20, no. 1 (December 2003): 61–99; Christian Weikop, "The Arts and Crafts Education of the Brücke: Expressions of Craft and Creativity," *Journal of Modern Craft* 1, no. 1 (March 2008): 77–99.

140 For a comprehensive survey, see Rüdiger Joppien, "Max Sauerlandt und Rosa Schapire," in Schulze, *Rosa. Eigenartig Grün*, 146–85.

141 At least seventy-seven of Schmidt-Rottluff's postcards remained in Schapire's collection. See Gerd Presler, *"Brücke"an Dr Rosa Schapire* (Mannheim: Städtische Kunsthalle Mannheim, 1990); Gerhard Wietek, *Karl Schmidt-Rottluff: Zeichnungen auf Postkarten* (Cologne: Wienand, 2010).

142 Wietek, *Schmidt-Rottluff: Plastik und Kunsthandwerk*, 364–70.

143 See Dennis Hoffmann, "Die Sonntags-Matinee bei Commeter," *Hamburger Zeitung* (January 9, 1911).

144 Rosa Schapire, "Zu Schmidt-Rottluffs Ausstellung bei Commeter," *Der Hamburger* 1, no. 12 (1911): 268.

145 Schapire, "Zu Schmidt-Rottluffs Ausstellung," 267.

146 Schapire, "Zu Schmidt-Rottluffs Ausstellung," 267–78.

147 Karl Schmidt-Rottluff, *Ornamental Four-sided Wooden Box with Incised Designs*, 1911, painted lime wood (blue, red, and white), 12 × 24 × 13.7 cm (depth), formerly in the collection of Elsa Hopf, Schleswig-Holsteinisches Landesmuseum, Sammlung Gerlinger, Wietek, *Schmidt-Rottluff: Plastik und Kunsthandwerk*, no. 239, 348.

148 Karl Schmidt-Rottluff, *Gold Bracelet of Six Sections*, 1911–12, beaten gold, 21 × 3 cm, formerly in collection of Luise Schiefler, Museum für Kunst und Gewerbe, Hamburg. Wietek, *Schmidt-Rottluff: Plastik und Kunsthandwerk*, no. 432, 491.

149 For the impact of the Palau roof beams on Schmidt-Rottluff's relief carving and woodcuts in 1911, see Lloyd, *German Expressionism*, 70.

150 In a letter to the Tate Gallery, Schapire stated that it came straight from his studio in Berlin and was painted, "in autumn 1915, a few weeks before he had to do his military duty and go to the Front in Russia." However, Schmidt-Rottluff was already on the Russian front in autumn and only received leave over Christmas 1915. Letter from Rosa Schapire to Mr. Hollon, January 6, 1951, Tate Gallery Archive TG4/2/929/2. For her period in exile, see Shulamith Behr, "Dr Rosa Schapire: Art Historian and Critic in Exile," in *Keine Klage über England? Deutsche und Österreichische Exilfahrungen in Großbritannien, 1933–1945*, ed. Charmian Brinson et al. (Munich: Iudicium, 1998), 215–23.

151 Reisenfeld, "Collecting and Collective Memory," in Soussloff, *Jewish Identity*, 120.

152 Schmidt-Rottluff to Ernst Beyersdorf, ca. March 1915, Nachlass Gerhard Wietek, Landesmuseum für Kunst und Kulturgeschichte Oldenburg, as quoted in Aya Soika, "Karl Schmidt-Rottluff," in *Weltenbruch: Die Künstler der Brücke im Ersten Weltkrieg, 1914–1918*, ed. Magdalena M. Moeller (Munich: Prestel, 2014), 156.

153 Letter from Rosa Schapire to Mr. Hollon, January 6, 1951, Tate Gallery Archive TG4/2/929/2.

154 Schapire, review of *Der Expressionismus*, by Paul Fechter, *Zeitschrift für Bücherfreunde*, 243.

155 Rosa Schapire, "Der Frauenbund zur Förderung Deutscher Bildenden Kunst," *Neue Blätter für Kunst und Dichtung* 2 (November 1919): 166–67.

156 Rosa Schapire, "Der Frauenbund zur Förderung Deutscher Bildenden Kunst," *Die Literarische Gesellschaft* 4 (1918): 204–6.

157 Schapire, "Der Frauenbund" (1918): 205.

158 Letter from Karl Schmidt-Rottluff to Wilhelm Niemeyer, presumed date: August/September 1914, Nachlass Gerhard Wietek, Landesmuseum für Kunst und Kulturgeschichte Oldenburg, as quoted in Soika, "Karl Schmidt-Rottluff," in *Weltenbruch*, 156n20.

159 Schmidt-Rottluff, field postcard to Curt Herrmann, July 4, 1915, "Dokumentation zu Leben und Werk," in *Karl Schmidt-Rottluff: Retrospektiv*, ed. Gustav Thiem (Munich: Städtsche Galerie im Lenbachhaus München, 1989), 86, as quoted in Soika, "Schmidt-Rottluff," in *Weltenbruch*, 159–60n36.

160 Rosa Schapire, review of *Negerplastik*, by Carl Einstein, *Zeitschrift für Bücherfreunde* NF 7, no. 1 (1915): 243.

161 See Carl Einstein, *Negerplastik* (1915; Leipzig: Kurt Wolff, 1920), no. 4, 34.

162 Wietek, *Schmidt-Rottluff: Plastik und Kunsthandwerk*, no. 38, 311.

163 See Zoë S. Strother, "Looking for Africa in Carl Einstein's *Negerplastik*," *African Arts* 46, no. 4 (Winter 2013): 8–21; Sebastian Zeidler, *Form as Revolt: Carl Einstein and the Ground of Modern Art* (Ithaca: Cornell University Press, 2016).

164 Schapire, "Rezension: Carl Einstein," 243.

165 For detailed information on the artist couple, see Maike Bruhns, *Kunst in der Krise: Künstlerlexicon Hamburg, 1933–1945* (Hamburg: Dölling und Galitz, 2001), 2:275–80.

166 See Roland Jaeger and Cornelius Steckner, eds., *Zinnober: Kunstszene Hamburg, 1919–1933* (Hamburg: Szene, 1983), 32–33.

167 See Peter W. Guenther, "A Survey of Artists' Groups: Their Rise, Rhetoric and Demise," in *German Expressionism, 1915–1925: The Second Generation*, ed. Stephanie Barron (Munich: Prestel, 1988), 108–10.

168 See letter from Gustav Pauli to Warburg, December 12, 1917, WIA GC/7865. For Warburg's engagement in the Hamburg cultural sphere, see Mark A. Russell, *Between Tradition and Modernity: Aby Warburg and the Public Purposes of Art in Hamburg, 1896–1918* (New York: Berghahn, 2007), 211.

169 Rosa Schapire, "Paula Modersohn-Becker," 866.

170 *Die Rote Erde* was coedited with Karl Lorenz between 1919 and 1920, *Kündung* with Wilhelm Niemeyer between 1920 and 1921.

171 For coverage of the publications and print run, see Timothy O. Benson, "Kiel and Hamburg: Radical 'Bilderbürgertum,'" in Brooker et al., eds., *The Oxford Critical and Cultural History of Modernist Magazines*, 3:905–24.

172 *JA! Stimmen des Arbeitsrates für Kunst* (Charlottenburg [Berlin]: Verlag der Photographischen Gesellschaft, 1919), 7–8, 90–91, 96–97, as quoted in *German Expressionism: Documents from the End of the Wilhelmine Empire to the Rise of National Socialism*, ed. Rose-Carol Washton Long (New York: G. K. Hall, 1993), 208–9.

173 Rosa Schapire, "Schmidt-Rottluffs religiöse Holzschnitte," *Die Rote Erde* 1, no. 6 (November 1919): 186–88.

174 Stephan von Wiese, "Expressionistische Verkündigung: Bemerkungen zu Schmidt Rottluffs religiösen Holzschnitten," in *Karl Schmidt-Rottluff: Retrospektive*, ed. Gunther Thiem and Armin Zweite (Munich: Prestel, 1989), 42–48.

175 Schapire, "Schmidt-Rottluffs religiöse Holzschnitte," 187; also see translated excerpts in Washton Long, *German Expressionism*, 150. For the epistemological framework of gestalt psychology and its implications for the German woodcut, see Niccola Shearman, *Weimar in Black and White: The Woodcut in the Work of Ernst Barlach and Lyonel Feininger in Germany, 1918–1927* (PhD diss., University of London, 2017).

176 See Robin Reisenfeld, "Catalogue Entry 122," in *"Brücke": German Expressionist Prints from the Granvil and Marcia Specks Collection*, ed. Reinhold Heller (Evanston, IL: Gallery, 1988), 300–301.

177 Schapire, "Schmidt-Rottluffs religiöse Holzschnitte," 187.

178 Martin Buber, "Leistung und Dasein," in *Ereignisse und Begegnungen* (Leipzig: Insel, 1917), 75–76.

179 Buber, "Leistung und Dasein," 75–76.

180 Maurice S. Friedman, *Martin Buber: The Life of Dialogue*, 4th ed. (1955; Abingdon: Routledge, 2002), 56–57.

181 Schapire, "Schmidt-Rottluffs religiöse Holzschnitte," 187. For a discussion of Cohen's brand of neo-Kantianism lending substance to the German Jewish search for a "Third Force" (beyond capitalism and Marxism) in German life, see Levine, *Dreamland*, 116, quoting George Mosse, in *Germans and Jews: The Right, the Left, and the Search for a Third Force in Pre-Nazi Germany* (Detroit: Wayne State University Press, 1987), 179–82.

182 Rosa Schapire, *Karl Schmidt-Rottluffs Graphisches Werk bis 1923* (Berlin: Euphorion, 1924).

183 Comparatively speaking, her patronage of the second-generation Expressionist Franz Radziwill (1895–1983) was less intense and of shorter duration. It lasted from 1919 until mid-1924, when his style moved toward New Objectivity and he altered his professional network due to suspicion of both Jewish dealers and cosmopolitanism. See James A. van Dyke, *Franz Radziwill and the Contradictions of German Art History, 1919–1945* (Ann Arbor: University of Michigan Press, 2011), 32–34, 46–50.

184 Schapire stored the possessions that could not accompany her to England in a depot at the Hamburg harbor; the table and four chairs were among eighty-six items confiscated by the Gestapo and auctioned by the Customs bailiffs, January 30/31, 1941. For a list and valuations in the court records, see Wietek, *Schmidt-Rottluff: Plastik und Kunsthandwerk*, 161.

185 For a similar conclusion, see Leonie Beiersdorf, "'—das Leben und Arbeit einen sind': Gelebte Utopia bei Ernst Ludwig Kirchner und Rosa Schapire," in *Gesamtkunstwerk Expressionismus: Kunst, Film, Literatur, Theater, Tanz und Architektur, 1905 bis 1925*, ed. Ralf Beil and Claudia Dillmann (Stuttgart: Hatje Cantz, 2010), 68–74.

186 Wietek, "Dr phil Rosa Schapire," 132.

187 Wietek, *Schmidt-Rottluff: Plastik und Kunsthandwerk*, no. 358, 443.

188 Anna Klapheck, *Mutter Ey: Eine Düsseldorfer Künstlerlegende*, 4th ed. (1958; Düsseldorf: Droste, 1984), 8.

189 Baumeister, *Erinnerungen der Johanna Ey*.

190 Ute Frevert, *Women in German History: From Bourgeois Emancipation to Sexual Liberation* (Oxford: Berg, 1989), 201. Frevert observes that while relations between the sexes were freer in public life in Weimar Germany, this was true mainly for young people.

191 For an incisive account of Dix's images of women, consult Beth Irwin Lewis, "*Lustmord*: Inside the Windows of the Metropolis," in *Berlin: Culture and Metropolis*, ed. Charles Haxthausen and Heidrun Suhr (Minneapolis: University of Minnesota Press, 1990), 111–40.

192 Johanna Ey, "Erinnerungen 1936," in Baumeister, *Erinnerungen der Johanna Ey*, 79. Otto Dix, *Meine Eltern I*, 1921, oil on canvas, 101 × 115 cm, Öffentliche Kunstsammlung Basel.

193 See Johanna Ey, "Meine Spanische Reise 1927," in Baumeister, *Erinnerungen der Johanna Ey*, 84–111.

194 Ulrich Krempel, *Am Anfang "Das Junge Rheinland": Zur Kunst und Zeitgeschichte einer Region, 1918–1945* (Düsseldorf: Claassen, 1985), 8–9.

195 Peter Barth, *Johanna Ey und Ihr Künstlerkreis* (Düsseldorf: Galerie Remmert und Barth, 1984), 16.

196 Barth, *Johanna Ey*, 16, quoting from the exhibition catalog *Trude Brück* (Düsseldorf: Stadtmuseum, 1958), no page reference.

197 Letter from Trude Brück to Stadtmuseum Düsseldorf, March 16, 1992, as quoted in Annette Baumeister, "Trude Brück," in *Rheinische Expressionistinnen*, 62.

198 Johanna Ey, "Das Rote Malkästle: *Frau Ey schreibt Biographie*," *Das Kunstblatt* 14 (1930): 76–85, reprinted in Baumeister, *Erinnerungen der Johanna Ey*, 219–22. For a photograph of Wollheim's lost or destroyed painting *Ein Stück Festland passiert unter Wehender Flagge von Omega*, date, medium, and scale unknown, see Stephan von Wiese, ed., *Gert Wollheim: Phantast und Rebell* (Bonn: Verein August Macke Haus, 2000), 24.

199 The triptych was painted in Remels, East Friesland, where Wollheim and Pankok were hoping to establish an artists' colony.

200 Klaus Theweleit, *Male Fantasies* (Minneapolis: University of Minnesota Press, 1987), 1:76–79, employs the metaphor of the soldier's "body armor" to connote the impact of military codes of behavior on male subjectivity. Ey, "*Das Rote Malkästle*," in Baumeister, *Erinnerungen der Johanna Ey*, 216–17. For the context of the representations of the war wounded, see Dorothy Price, "A 'Prosthetic Economy': Representing the 'Kriegskrüppel' in the Weimar Republic," in *Weimar's Others: Art History, Alterity and Regionalism in Inter-War Germany*, ed. Dorothy Price; and Camilla Smith, *Art History* 42, no. 4 (September 2019): 751–79.

201 Ey, "Erinnerungen 1936," in Baumeister, *Erinnerungen der Johanna Ey*, 76.

202 Ey, "*Das Rote Malkästle*," in Baumeister, *Erinnerungen der Johanna Ey*, 211–12.

203 Barron, *German Expressionism, 1915–1925*, fig. 9, 87. Gert Wollheim, *The Condemned Man*, 1921, oil on canvas, 123 × 99 cm, private collection.

204 See Wolfgang Schröck-Schmidt, "Der Schicksalweg der *Schützengraben*," in *Otto Dix zum 100. Geburtstag, 1891–1991*, ed. Wulf Herzogenrath and Johann-Karl Schmidt (Albstadt: Städtische Galerie Albstadt, 1991), 159–64. Otto Dix, *Schützengraben*, 1920–23, oil on canvas, 227 cm × 250 cm, lost or destroyed.

205 Wulf Herzogenrath, "Die Mappe Der Krieg, 1923–24," in *Otto Dix zum 100. Geburtstag*, 167–75.

206 Hans Reimann (1889–1969), novelist, playwright, and cabaret director, published *Das Stachelschwein* between 1924 and 1929. For the possible relevance of this photograph to Dix, see James van Dyke, "Otto Dix's *Streetbattle* and the Limits of Satire in Düsseldorf, 1928," *Oxford Art Journal* 32, no. 1 (2009): 39–45.

207 See *Alfred Flechtheim: Sammler, Kunsthändler, Verleger*, ed. Hans Albert Peters and Stephan von Wiese (Düsseldorf: Kunstmuseum Düsseldorf, 1987), 163.

208 Krempel, *Am Anfang "Das Junge Rheinland*," 123–26.

209 Barth, *Johanna Ey*, 44.

210 Ey, "*Das Rote Malkästle*," in Baumeister, *Erinnerungen der Johanna Ey*, 219.

211 Klapheck, *Mutter Ey*, 56–57, and illustration "Mutter Ey: Die Meistgemalte Frau Deutschlands," *Berliner Illustrirte* (August 23, 1930).

212 Beyond the frame of combative sexual politics, although mostly devoted to Surrealism as exemplary of the modern male erotic imagination, Susan Suleiman maintains that one cannot be too constrained by definitions of the avant-garde. In her terms, "avant-garde" stands for that which is transgressive of discursive norms and ideological structures, a definition that is appropriate for Johanna Ey's sponsorship of iconoclasm. See Suleiman, *Subversive Intent*, 11–12, 145.

213 Barth, *Johanna Ey*, 58–59.

214 Barth, *Johanna Ey*, 60–69; Barbara Lepper, "Die 'Machtergreifung': Aus den Gestapo-Akten in Düsseldorf," in Krempel, *Am Anfang "Das Junge Rheinland*," 113–17.

215 James Knowlson, *Damned to Fame: The Life of Samuel Beckett* (London: Bloomsbury, 1997), 238.

216 Jonathan Petropoulos, *Art as Politics in the Third Reich* (Chapel Hill: University of North Carolina Press, 1996), 61.

217 For the Entartete Kunst Aktion, see Petropoulos, *Art as Politics*, 54–60.

218 Beckett, unpublished German diaries, notebook 2, November 14, 1936, as quoted in Knowlson, *Damned to Fame*, 237.

219 Beckett, unpublished German diaries, notebook 2, November 15, 1936, as quoted in Knowlson, *Damned to Fame*, 239.

220 Beckett, unpublished German diaries, notebook 2, November 15, 1936, as quoted in Knowlson, *Damned to Fame*, 237.

221 Heinrich Böll, "Mutter Ey: Versuch eines Denkmal in Worten," in *Aufsätze, Kritiken, Reden* (Cologne: Kiepenhauer & Witsch, 1960), 71.

222 Krempel, *Am Anfang "Das Junge Rheinland,"* 13–14.

223 For detailed coverage, see Georg Heuberger, ed., *Expressionismus und Exil: Die Sammlung Ludwig und Rosy Fischer* (Munich: Prestel, 1990).

224 For an account of Sauerlandt's support of Expressionism and museology, see Andreas Hüneke, "Von der Verantwordung des Museumdirektors-Max Sauerlandt," in Junge, *Avant-Garde und Publikum*, 261–68.

225 For an account of the reception, see Cordula Frohwein, "Die Sammlung Rosy und Ludwig Fischer in Frankfurt am Main," in Junge, *Avant-Garde und Publikum*, 75.

226 Vernon L. Lidtke, "Museen und die Zeitgenössische Kunst in der Weimarer Republik," in Mai and Paret, *Sammler, Stifter und Museen*, 233–34.

227 Cordula Frohwein, "Schicksal der Sammlung Fischer," in Heuberger, *Expressionismus und Exil*, 116–19.

228 This context is elaborated in Peter Paret, "Bemerkungen zu dem Thema: Jüdische Kunstsammler, Stifter und Kunsthändler," in Mai and Paret, *Sammler, Stifter und Museen*, 171–85.

Epilogue

1 Weinstein, *The End of Expressionism*; Dennis Crockett, *German Post-Expressionism: The Art of Disorder, 1918–1924* (University Park: Pennsylvania State University Press, 1999).

2 Lu Märten, "Geschichte, Satyre, Dada und Weiteres I/II," in *Rote Fahne* nos. 163/164 (August 22, 1920; August 24, 1920). For further commentary, consult the authoritative text by Chryssoula Kambas, *Die Werkstatt als Utopie: Lu Märtens Literarische Arbeit und Formästhetik seit 1900* (Tübingen: Max Niemeyer, 1988), 138–45.

3 Lu Märten, *Wesen und Veränderung der Formen/Künste: Resultate Historisch-Materialischer Untersuchungen* (Frankfurt am Main: Der Taifun-Verlag, 1924), 208–10. Reprint in Lu Märten, *Formen für den Alltag: Schriften, Aufsätze, Vorträge*, ed. Rainhard May (Dresden: VEB Verlag der Kunst, 1982), 105–8.

4 See Crockett, *German Post-Expressionism*, 56–61.

5 Kollwitz, *Tagebücher*, September 13, 1925, 602.

6 See Eberhard Kolb, *The Weimar Republic*, trans. P. S. Falla (1988; London: Routledge, 2001), 60–72.

7 Trained as an art historian, Hans Cürlis (1889–1982) founded the Institut für Kulturforschung (Institute for Cultural Research) in Berlin in June 1919. From 1922 until 1933 he produced the film cycle *Schaffende Hände* in which he filmed various artists at work, focusing on the hands of the creator. Kollwitz was the only woman out of fifteen artists included in the cycle. See Reiner Ziegler, *Kunst und Architektur im Kulturfilm, 1919–1945*, ed. Europäisches Medienforum (Stuttgart: Konstanz, 2003), 35–46.

8 Kollwitz, *Tagebücher*, November 1, 1925, 604.

9 See Hermann Bahr, "Stifter," in *Die Neue Rundschau* 33, no. 1 (1922): 470–87.

10 For Kollwitz's interpretation of *Tendenzkunst* and critical reception, see Louis Marchesano and Natascha Kirchner, "Artistic Quality and Politics in the Early Reception of Kollwitz's Prints," in Marchesano, *Käthe Kollwitz*, 23–32.

11 Kollwitz, *Tagebücher*, June 4, 1932, 661; 908.

12 Justi was relieved of his position at the end of June 1933. See Janda and Jörn Grabowski, *Kunst in Deutschland, 1905–1937*, 107.

13 Prior to 1933, apart from public lectures and translations, Schapire taught art and literary courses at the Hamburger Volkshochschule. See Hoffmann, *Der Erste Deutsche ZONTA-Club*, 34.

14 Moses Goldschmidt, *Mein Leben als Juden in Deutschland, 1873–1939* (Hamburg: Ellert and Richter, 2014), 61.

15 Darcy C. Buerkle, *Nothing Happened: Charlotte Salomon and an Archive of Suicide* (Ann Arbor: University of Michigan Press, 2013).

16 Buerkle, *Nothing Happened*, 209. Regarding "lesbian desire," see Camilla Smith, "Sex Sells! Wolfgang Gurlitt, Erotic Print Culture and Women Artists in the Weimar Republic," in Price and Smith, *Weimar's Others*, 781–806.

17 Ida Dehmel letter to Marie Stern, October 25, 1941, as cited in Höpker-Herberg, *Ida Dehmel*, 78.

18 Adolf Hitler, "Speech to the Meeting of the National Socialist Women's Organization," Nuremberg, September 7, 1934, in *The Third Reich Sourcebook*, ed. Anson Rabinbach and Sander L. Gilman (Berkeley: University of California Press, 2013), 311–13.

19 See Isabelle Jansen, "Eine Neue Sehweise? Gabriele Münter und die Neue Gegenständlichkeit der Zwanzigerjahre," in Jansen and Mühling, *Gabriele Münter*, 200–204.

20 Johannes Eichner, *Murnauer Tagblatt* (September 28, 1931), as quoted in Kleine, *Münter and Kandinsky*, 602.

21 Kleine, *Münter and Kandinsky*, 595.

22 Isabelle Jansen, "Das Ungeheur frißt u. läßt fallen," in Jansen and Mühling, *Gabriele Münter*, 216–18.

23 Letter from Münter to Eichner, May 27, 1937, as quoted in Kleine, *Münter and Kandinsky*, 627.

24 Nina Lübbren, "Authority and Ambiguity: Three Sculptors in National Socialist Germany," in *Art and Resistance in Germany*, ed. Deborah Ascher Barnstone and Elizabeth Otto (London: Bloomsbury, 2018), 70–71.

25 Lübbren, "Authority and Ambiguity," in Barnstone and Otto, *Art and Resistance*, 72–73.

26 "Entartete Kunst" Datenbank, Freie Universität Berlin: Lasker-Schüler, Else. For details of Ludwig Justi's purchase from Lasker-Schüler of twenty-eight of Franz Marc's letters and twenty-three of her drawings in 1919–20, the confiscations during 1937 and fortuitous exchange of these for German Romantic paintings from the collection of Sofie and Emanuel Fohn (based in Rome), see Betty Falkenberg, *Else Lasker-Schüler: A Life* (Jefferson, NC: McFarland, 2003), 90.

27 Jonathan Petropoulos, *The Faustian Bargain: The Art World in Nazi Germany* (London: Penguin Press, 2000), 85.

28 "Entartete Kunst" Datenbank, Freie Universität Berlin: Modersohn-Becker, Paula; Kollwitz, Käthe.

29 Petropoulos, *The Faustian Bargain*, 26–27.

30 For a list and valuations in the court records, see Wietek, *Schmidt-Rottluff: Plastik und Kunsthandwerk*, 161.

31 See Lucy Wasensteiner, "The Nell Walden Collection at Twentieth Century German Art," in *The Twentieth Century German Art Exhibition: Answering Degenerate Art* (Abingdon: Routledge, 2019).

32 Hans Heimann was deported from Berlin on October 3, 1942, to Theresienstadt and died there on October 9, 1942. See Yad Vashem, the Central Database of Shoah Victims' Names: https://yvng.yadvashem.org/nameDetails.html?language=en&itemId=11518098&ind=1.

33 Peter Thoene, *Modern German Art* (Harmondsworth: Penguin, 1938), 41.

34 For an account of "traumatic viewing," see Reesa Greenberg, "The Aesthetics of Trauma: Five Installations of Charlotte Salomon's *Life?*

Or Theater?," in *Reading Charlotte Salomon*, ed. Michael P. Steinberg and Monica Bohm-Duchen (Ithaca: Cornell University Press, 2006), 160–64.

35 As Thoene wrote, "Never before have generations of artists been placed beyond the pale of the law, nor a whole epoch of art as such proscribed and its representatives threatened with sterilisation because their palettes did not function to the liking of the ruling powers." Thoene, *Modern German Art*, 42.

36 For the most recent, see Ariela Friedman, "Charlotte Salomon, Degenerate Art, and Modernism as Resistance," *Journal of Modern Literature* 41, no. 1 (Fall 2017): 3–18.

37 Griselda Pollock, *Charlotte Salomon and the Theatre of Memory* (New Haven, CT: Yale University Press, 2018).

38 Letter from Karl von Motesiczky to Marie-Louise von Motesiczky, April 2, 1938. Tate Gallery Archive, London, 20129/1/1/195/21, trans. Ines Schlenker.

39 Ines Schlenker, *Marie-Louise von Motesiczky, 1906–1996: A Catalogue Raisonné of the Paintings* (Manchester: Hudson Hills Press), 153; Jill Lloyd, *The Undiscovered Expressionist: A Life of Marie-Louise von Motesiczky* (New Haven, CT: Yale University Press, 2007), 118.

40 Schlenker, *Marie-Louise von Motesiczky*, 27.

41 David Cohen, "Marie-Louise von Motesiczky," *Modern Painters* 7, no. 2 (Summer 1994): 93–95.

42 Marie-Louise von Motesiczky, "Max Beckmann als Lehrer: Erinnerungen einer Schülerin des Malers," in *Frankfurter Algemeine Zeitung* (January 11, 1964); "Max Beckmann as Teacher," in *Artscribe* no. 47 (July/August 1984): 52.

43 As Julie Johnson has demonstrated, women artists' erasure from history is more common. See Julie M. Johnson, *The Memory Factory: The Forgotten Women Artists of Vienna, 1900* (West Lafayette: Purdue University Press, 2012), 180–81.

Index

Page numbers in italics indicate images.

A

Aagaard, Carl Trier, 151

Abitur (diploma), 4, 207

Abschied (Farewell) (Kollwitz), 72, *73*

Abstraktion und Einfühlung (Abstraction and Empathy) (Worringer), 210

Académie Carrière (Paris), 158

Académie Colarossi (Paris), 10, 249n79

Académie de la Palette (Paris), 133

Académie Julian (Paris), 10, 52, 72

Académie Matisse (Paris), 129

Adelson, Leslie, 248n32

Adrian-Nilsson, Gösta, 147

Advanced School for Arts and Crafts (Stockholm), 129

African sculpture, 213, 215–216, *215*

Die Aktion (journal), 51, 52, *52*, 74

Der Aktivistenbund 1919 (The Activist League), 190, 224

Albisetti, James C., 244n29

Alexander, Gertrud, 231

Alexander II, Czar, 92

Alexander III, Czar, 93

Allen, Ann Taylor, 245n95

Allgemeiner Deutscher Frauenverein (General German Women's Association), 4, 19, 202

Allgemeiner Österreichischer Frauenverein (General Austrian Women's Association), 19

am Ende, Hans, 38

"An das Deutsche Volk und an die Kulturwelt" (An Appeal to the German Nation and to the Civilized World) (Steiner), 186

"An Dich" (To You) (N. Walden), 175

Anderson, Benedict, 18

Andreyevskaya, Nina, 126

Annals of Sexual Intermediacy (journal), 244n46

Anthroposophical Society, 19, 156, 169, 171–172

anthroposophy: Heemskerck and, 19, 156, 169, 171, 172–173, 186, 187; Tak van Poortvliet and, 19, 157, 171–172, 186, 187, 246–247n133; theosophy and, 18–19. *See also* Steiner, Rudolf

Anti-Kriegs-Museum (Anti-War Museum) (Berlin), 83

anti-Semitism: First World War and, 209; Grünewald and, 149; Münter and, 12; Nazi regime and, 232; E. Nolde and, 209; K. E. Osthaus and, 194; Schapire and, 192, 209, 232, 234; Schmidt-Rottluff and, 214

Anti-Socialist Law (1878), 251–252n17

Apel, Dora, 256n159

Applied Arts movement, 194

Arbeitsrat für Kunst (Working Council for Art) (Berlin), 79, 181, 216–217

architecture and architectural theory: Behne and, 157, 166–167, 181; I. Dehmel and, 204; Folkwang Museum (Hagen) and, 194–197, *194–195*; Heemskerck and, 180–186; Künstlergruppe Brücke (Artists' Group Bridge) and, 210; Schmidt-Rottluff and, 216–217; *Der Sturm* (journal) and, 157; Taut and, 79, 157, 167, 180–181

"Ein Architektur-Programm" (A Program for Architecture) (Taut), 79, 181

Art Nouveau, 140–141, 159. *See also* Jugendstil

Arts and Crafts movement, 32, 92

Asplund, Karl, 135

Association of the Eleven (Vereinigung der XI), 36

At the Lock in Stockholm (Münter), 140, *141*

Atlantic Photo-Co., 178–179, *179–180*

De åtta (The Eight), 129

d'Audretsch, Herman, 123, 172, 173–174

Auer Dult fair (Munich), 106

Aufruhr (Uprising) (Kollwitz), 65–66

Auge des Geistes (the eye of the spirit, or the soul), 51

Auge des Leibes (the eye of the body), 51

Ausbildung (professional training), 4–5

Ausdruck (expression), 209

Ausdruckskunst (expressive art), 33

Austria: women artists in, 137, 272n96; women's rights in, 19, 129

"Die Auswanderer" (The Emigrants) (Freiligrath), 57

authorship, 78

Autumn Idyll (Werefkin), 119–121, *120*

Avant-Garde Gambits, 1888–1893 (Pollock), 13

Ažbé, Anton, 95, *96*

B

Bachofen, Johann Jakob, 60

Baehr, Ludwig, 153

Bahr, Hermann, 51, 231–232

Ballets Russes, 90

Balzac, Honoré, 72, 95

Barbizon school, 37

Barlach, Ernst, 3, 55, 80

Barnets århundrade (The Century of the Children) (Key), 43, 131

Bashkirtseff, Marie, 10, 35, 39, 255n119

Bauck, Jeanna, 37–38

Baudelaire, Charles, 256n143

Bauer, Rudolf, 174

Bauernkriegzyklus (Peasants' War Cycle) (Kollwitz), 66–67

Bauhaus, 153, 231

Baumeister, Annette, 222

Picasso, Pablo, 10

Pictures of Family Life on November 3, 1905 (Modersohn-Becker), 48, *50*

Pietà (Michelangelo), 67

Pietsch, Ludwig, 63

Pisano, Giovanni, 67–68

Playthings (Münter), 106

Plehn, Anna, 18, 66–68

Pohle, Carla, 86

pointillism, 159

Polenova, Elena, 92, *93*

Pollock, Griselda, 13, 85, 99, 109, 236

Pont-Aven school, 97

Poppy Field (van Gogh), 50

Portrait of a Child (Münter), *136*, 137

Portrait of a Young Woman (AD 120–130), *34*

Portrait of an Old Jew (Rembrandt), 93

Portrait of Anna Roslund (Münter), 151–153, *151*

Portrait of Marianne Werefkin (Münter), 99–101, *100*, 111

Portrait of Miss Gertrude Holz (Münter), 143

Portrait of Mother (Werefkin), 91, *91*

Portrait of R. S. (Schmidt-Rottluff), 211–213, *214*

Portrait of Rosa Schapire (Schmidt-Rottluff), 220–222, *221*, 229

Portrait of the Art-Dealer Johanna Ey (Dix), 222, *223*

Portrait of Thyra Wallin (Münter), 133, *134*

positionality, 35

Post-Expressionism (End of Expressionism), 231

Post-Impressionism, 208

post-modernist theory, 78

Prelinger, Elizabeth, 4

Prengel, Gertrud, 70

Preparatory Study for a Pillow Slip (Schmidt-Rottluff), 210, *210*

Pre-Raphaelites, 42

Price, Dorothy, 97

primitivism: Hamburg Secession and, 216; Kollwitz and, 73–74; Künstlergruppe Brücke (Artists' Group Bridge) and, 196, 211–213; Modersohn-Becker and, 45, 49; Schapire and, 192. *See also* folk art

print-capitalism, 18

printmaking: Kollwitz and, 55, 61–68, *67*, 80–83; Münter and, 103, 105–106, *106*, 116, 140–141, *141*; N. Walden and, 177–178, *178*. *See also* woodcut

Das Problem der Form in der Bildenden Kunst (The Problem of Form in Painting and Sculpture) (Hildebrand), 72

Proletkult (proletarian culture), 231

Promenade in the Vineyard (Vuillard), 195, *195*

prostitution, 58–59, 205

Ein Protest Deutscher Künstler (Vinnen), 12, 50–51, 74–75, 129

Prussia: Jews in, 20; women's education in, 4, 20, 57; women's rights in, 36–37, 38. *See also* Berlin

Prussian Academy of Arts (Berlin), 79, *80*, 232

Prussian Law of Association (1908), 38

psychoanalysis: Bjerre and, 135; on child development, 83; First World War and, 76; Kollwitz and, 55–57, 70–72; Thoene and, 234. *See also* Freud, Sigmund

Psykosyntes (psychosynthesis), 135

public sphere, concept of, 15, 200

Puhl & Wagner, 184

Puy, Jean, 10

R

Radiervereine (etching societies), 61

Radycki, Diane, 4, 45–47

Radziwill, Franz, 275n183

Rambold, Heinrich, 107

Rank, Otto, 70

Rauert, Bertha (née Rohlsen), 202

Rauert, Martha, 33, 202, *212*

Rauert, Paul, 33, 202, 272n88

Raumgestaltung (spatial creation), 186, 195

The Red Blind (Hjertén), *152*, 153

Red City (Werefkin), 109, *110*

The Red Curtain (Grünewald), 132–133, *133*

Reflection (Münter), 143–145, *143*, 146

Reichskammer der bildenden Künste (Reich Chamber of Visual Arts), 233

Reimann, Hans, 226

Reisenfeld, Robin, 213

Rembrandt, 37, 38, 62–63; *Portrait of an Old Jew*, 93

Rembrandt als Erzieher (Langbehn), 38

Remels, 275n199

Repin, Ilya, 93–95, 111

"Requiem for a Friend" (Rilke), 49

La Révolution (Werefkin), *122*, 123

Reyländer, Ottilie, 39, 249n65, 249n86

Rhades, August, 232

Richter, Emil, 80, 232

Richter-Berlin, Heinrich, 74, 79

Riegl, Alois, 250–251n133

Rijksmuseum (Amsterdam), 169–171

Rilke, Clara (née Westhoff), 39, 42, 44, 247n12

Rilke, Rainer Maria, 31, 35, 42–44, 47–48, 49

Ritter, Emma, 209–210

Riviere, Joan, 191

Rodin, Auguste, 43, 45, 72–74, 78; *The Kiss*, 73–74

Roditi, Edouard, 104, 109

Rohe, Maximilian Karl, 89

Rohlfs, Christian, 190–191

Rohlsen, Bertha (née Rauert), 202

Rohlsen, Gustav, 272n88

Roos Gallery (Amsterdam), 159

Rosalia Leiß (Werefkin), *111*

Photo Credits

National Library of Medicine, Bethesda, Maryland (fig. 50)

Nationalgalerie, Staatliche Museen zu Berlin, Berlin, Photo: bpk / Nationalgalerie, SMB / Jörg P. Anders (fig. 49)

New Walk Museum, Leicester, Image: Leicester City Council (fig. 124)

Oberammergau Museum (fig. 78)

Österreichische Nationalbibliothek, Handschriftensammlung, Vienna © ÖNB (fig. 158)

Osthaus Museum Hagen, Fotograf: Unbekannt (fig. 161)

Paula Modersohn-Becker-Stiftung, Bremen, Image courtesy Paula Modersohn-Becker-Stiftung, Bremen (figs. 12, 16, 18, 20, 22, 23, 24, 27); Photo: Karl Brandt. Image courtesy of Paula Modersohn-Becker-Stiftung, Bremen (fig. 21); Archiv der Paula Modersohn-Becker-Stiftung, Bremen, Photo: Rudolph Stickelmann, Bremen (fig. 29)

Princeton University, Marquand Library of Art and Archaeology (figs. 90, 101, 135, 136); © Nell Walden / Marquand Library of Art and Archaeology (fig. 148); Princeton University Library, General Collection (fig. 28)

Private collection (figs. 36, 37, 59, 64, 65, 109, 114, 128, 129, 170, 177, 193a, 193b, 194)

PSM Privatstiftung Schloßmuseum Murnau, Bildarchiv PSM Privatstiftung Schloßmuseum Murnau (figs. 60, 61, 62, 67, 68)

Reiss-Engelhorn-Museum, Mannheim © Private Loan, REM, Unnumbered, Photo: Lina Kaluza, Reiss-Engelhorn-Museen (fig. 15)

Rijksmuseum, Amsterdam (fig. 141)

RKD—Netherlands Institute for Art History, The Hague. Photographer: unknown (fig. 138)

Rudolf Steiner Online Archive, http://anthroposophie.byu.edu/ (fig. 121)

Scala Archives, Photo © Christie's Images, London / Scala, Florence (fig. 105)

Schloßmuseum Murnau, Bildarchiv, Photo: Schloßmuseum Murnau, Bildarchiv (figs. 79, 84); Photo © W. Pulver (fig. 83)

Smithsonian Libraries and Archives, Smithsonian Institution, Washington, DC (fig. 186)

Staats- und Universitätsbibliothek Hamburg Carl von Ossietzky, A/234724 (fig. 200)

Staatsbibliothek Preußischer Kulturbesitz, Berlin, Image: SPK—Staatsbibliothek Preußischer Kulturbesitz, Berlin (figs. 97, 99, 126, 127, 147, 150, 151); Staatsbibliothek zu Berlin, https://digital.staatsbibliothek-berlin.de/ (fig. 137); Staatsbibliothek zu Berlin, https://sturm-edition.de/index.html (figs. 142a, 142b)

Städtische Galerie im Lenbachhaus und Kunstbau München, Gabriele Münter Stiftung 1957 (figs. 54, 71, 76, 77, 80, 86, 89, 91, 108, 112, 116)

Stadtmuseum Landeshauptstadt Düsseldorf © Stadtmuseum Landeshauptstadt Düsseldorf (figs. 159, 201, 202)

Stadtmuseum Landeshauptstadt Düsseldorf © Stadtmuseum Landeshauptstadt Düsseldorf (figs. 159, 201, 202)

Sundsvalls Museum, Sweden (fig. 102)

Tate, London, Photo © Tate (figs. 184, 185, 195, 204)

Thüringer Universitäts- und Landesbibliothek Jena, Nachlass Rudolf Eucken III/5 (figs. 173a and b)

Ullsteinbild / TopFoto (fig. 3)

University of Toronto, Gerstein Medical Heritage Library (fig. 26)

Unknown photographer, reproduced in Ulrich Krempel, ed., *Am Anfang das Junge Rheinland: Zur Kunst und Zeitgeschichte einer Region, 1918–1945* (Düsseldorf: Städtische Kunsthalle Düsseldorf, 1985), p. 84 (fig. 8); reproduced in Jaarboek Nederlandische Ambachts en Nijverheidskunst, 1921, fig. 57 (fig. 155)

Victoria and Albert Museum, London © Victoria and Albert Museum, London (figs. 178, 179, 180, 181, 182, 188)

Warburg-Haus—Archiv Hamburger Kunst / Archive of Art in Hamburg (fig. 187)

Wikimedia Commons (figs. 4, 48); Klaus Bärwinkel, CC BY 3.0 (fig. 166)